Ice Worlds

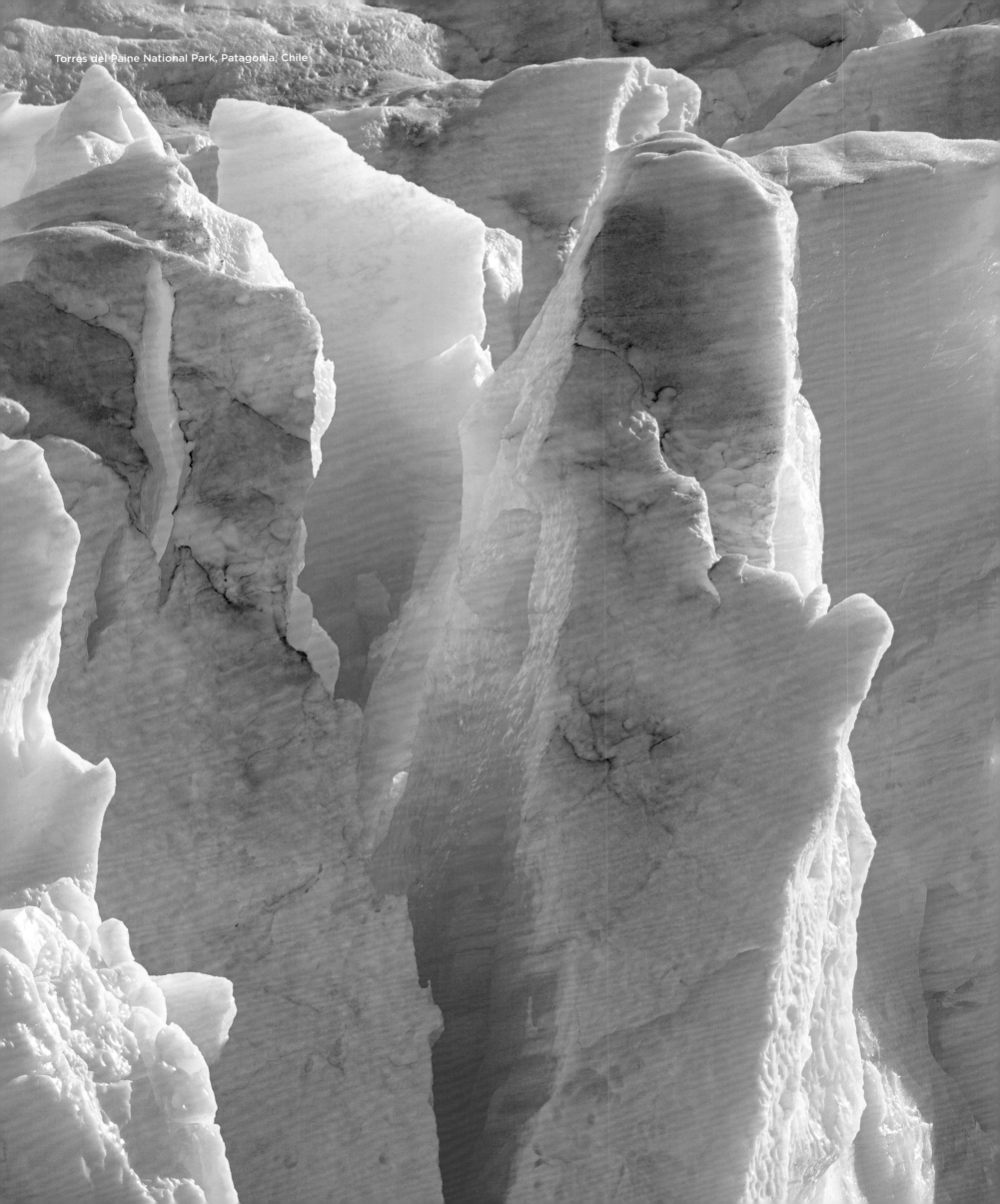

Torres del Paine National Park, Patagonia, Chile

Ice Worlds

Paysages glaciaires
Eiswelten
Mundos helados
Mundos gelados
IJswerelden

Udo Bernhart
Bernhard Mogge
Christian Nowak

ÉDITIONS
PLACE DES
VICTOIRES

KÖNEMANN

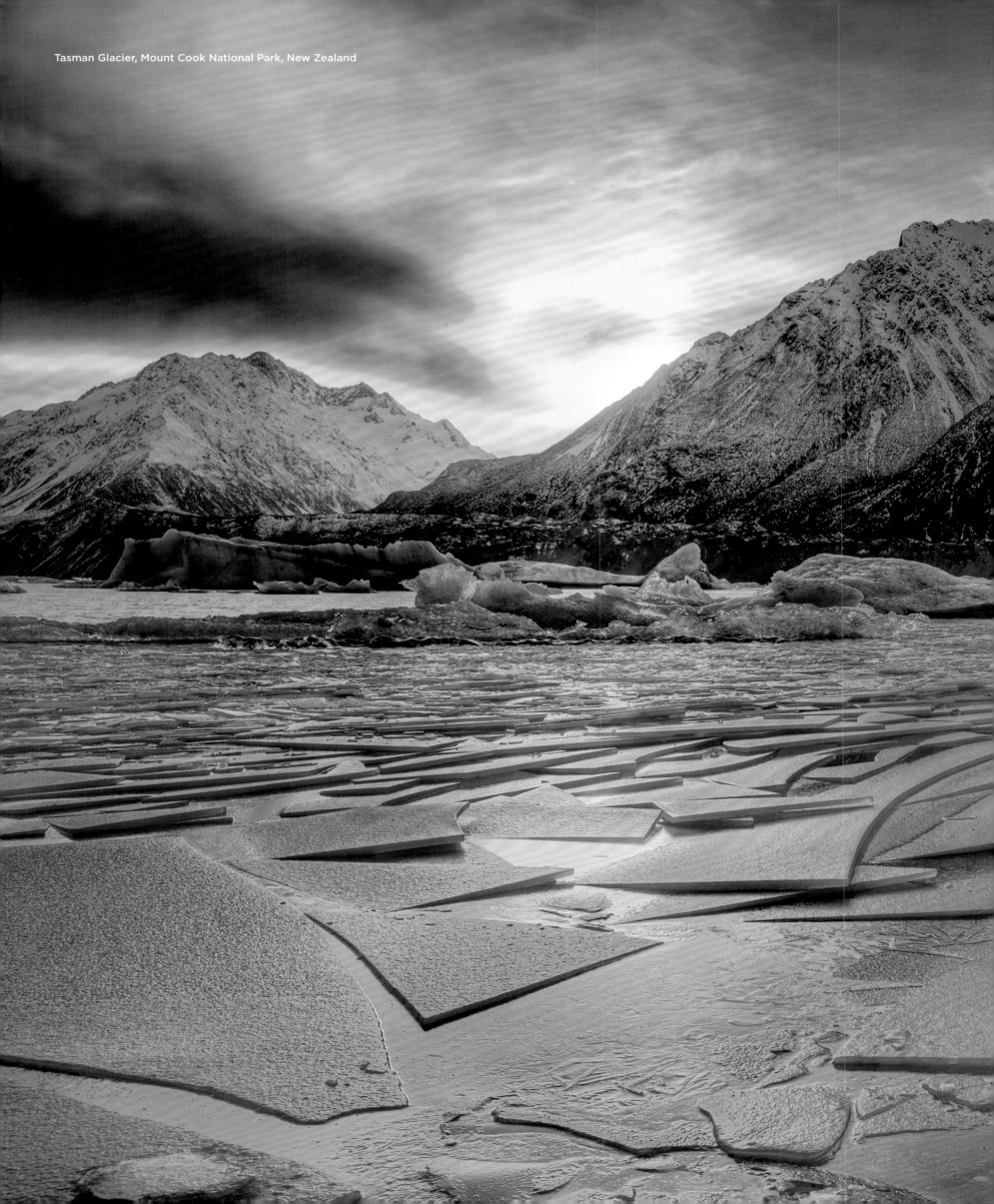
Tasman Glacier, Mount Cook National Park, New Zealand

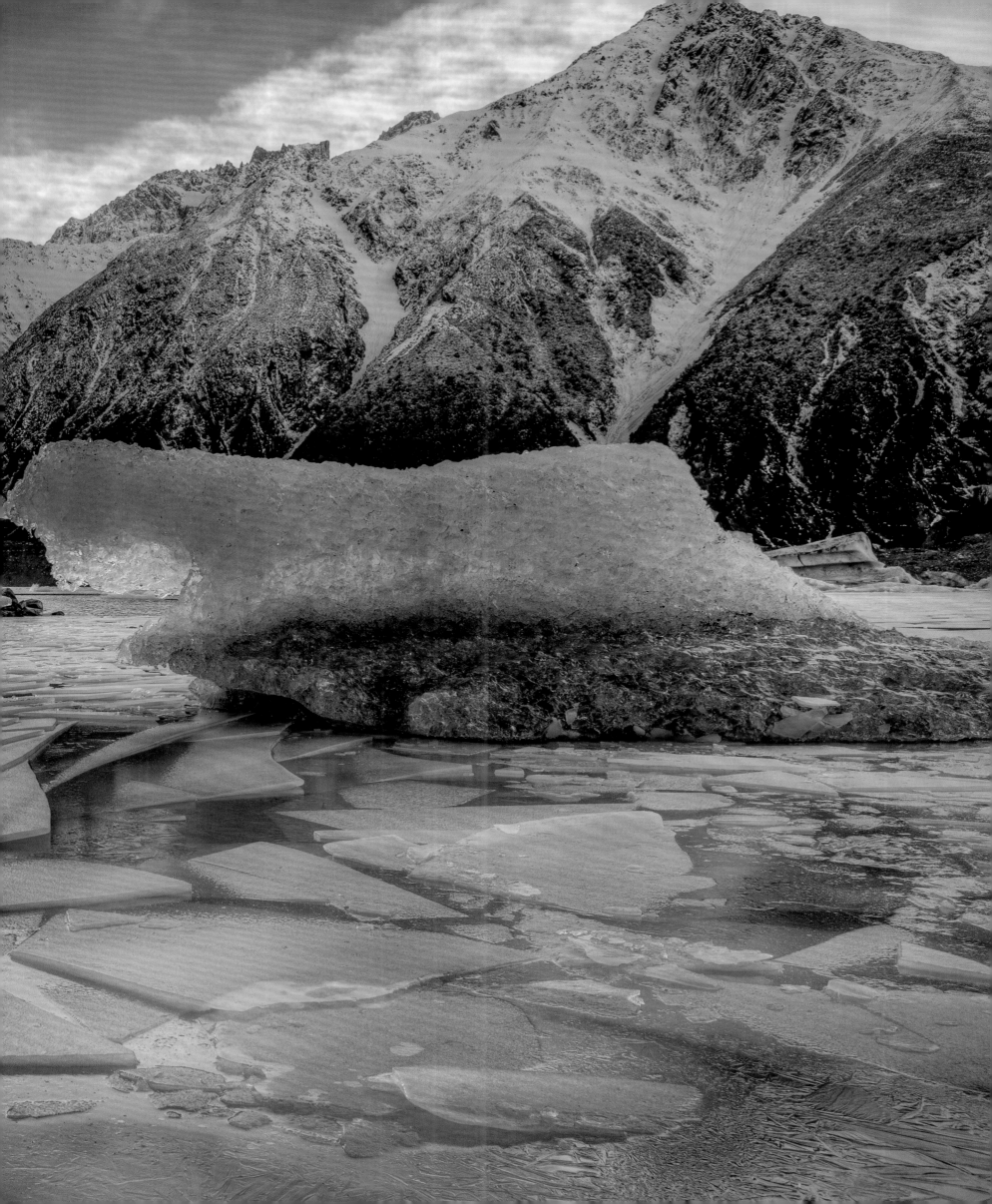

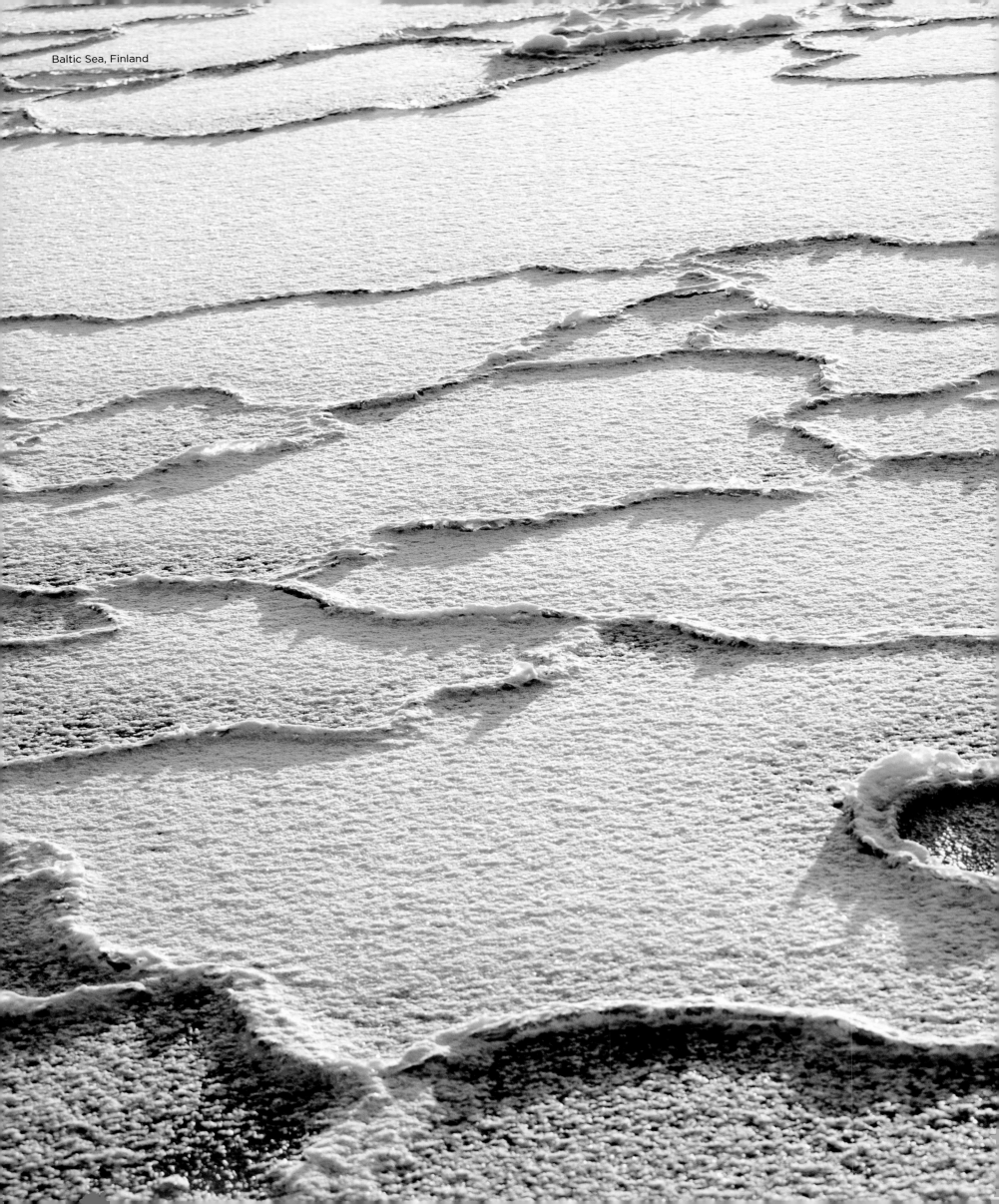

Baltic Sea, Finland

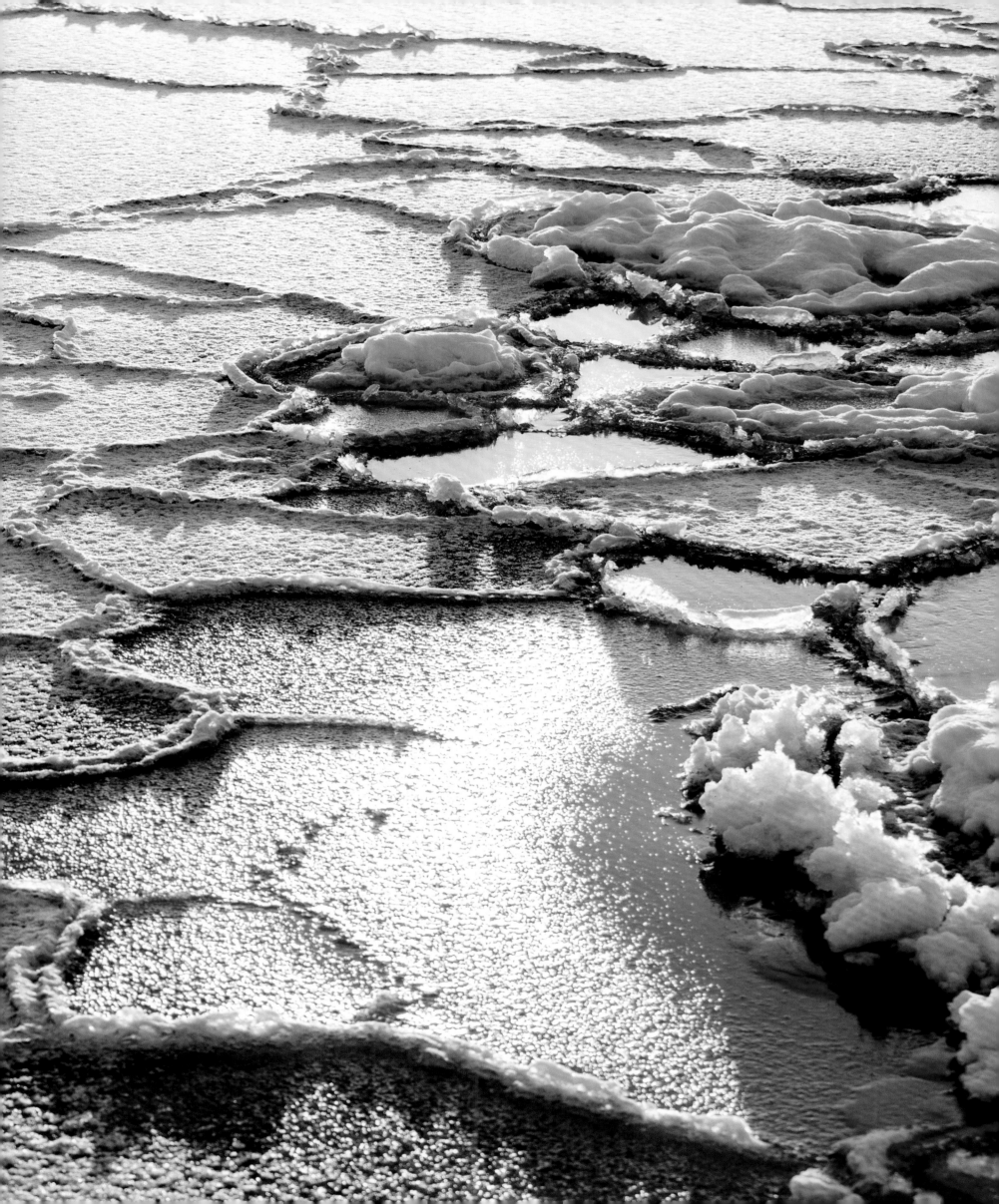

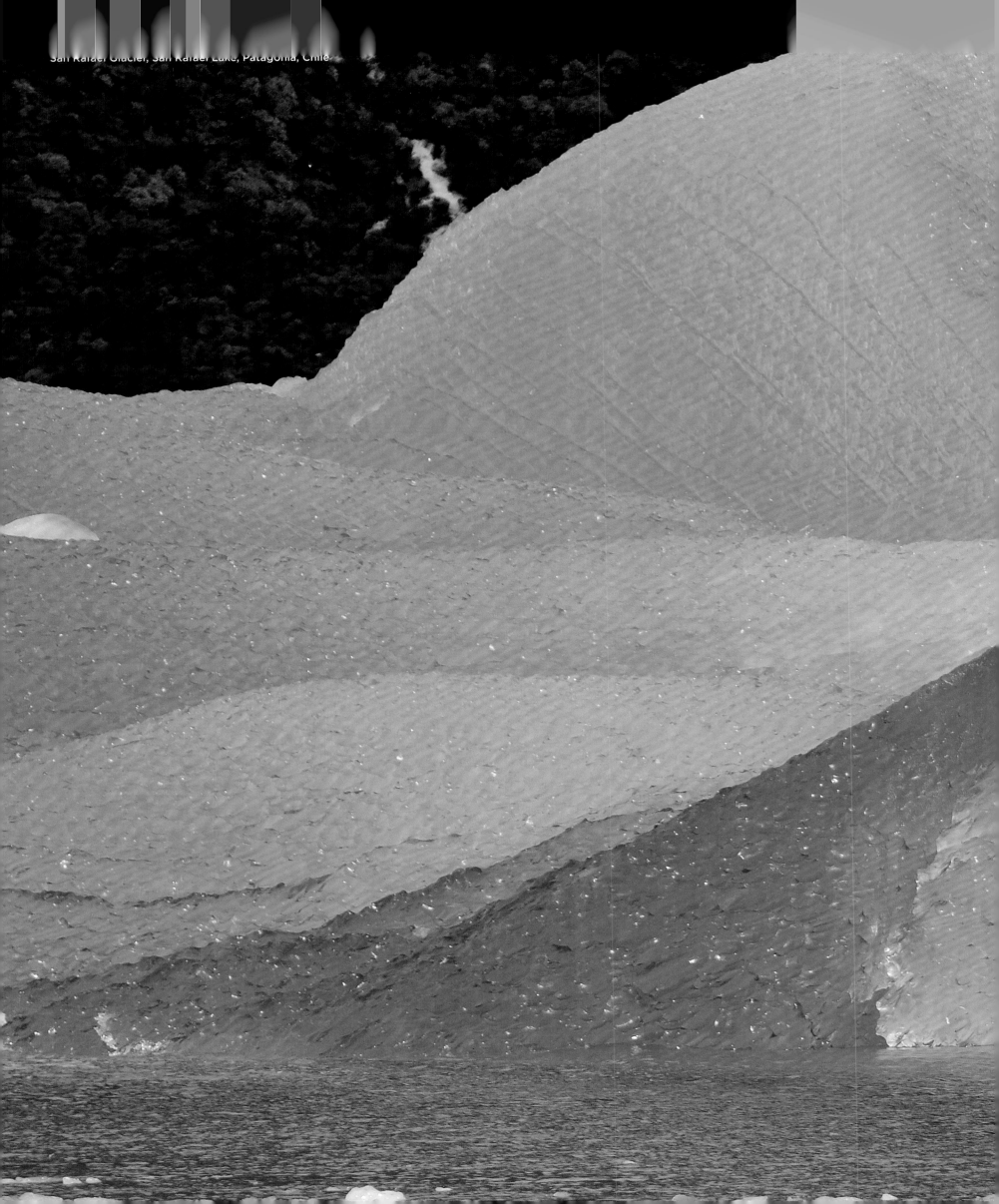

San Rafael Glacier, San Rafael Lake, Patagonia, Chile

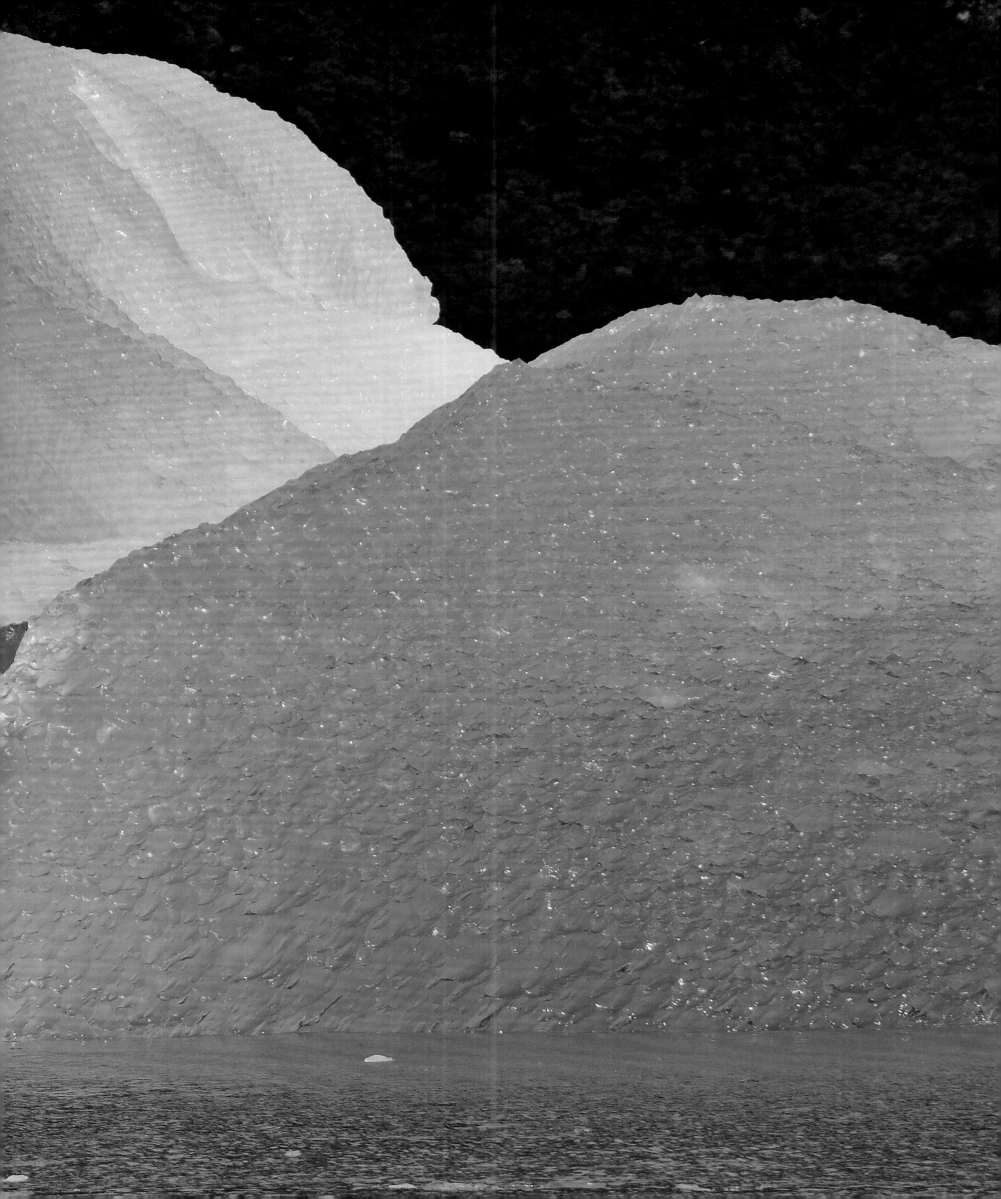

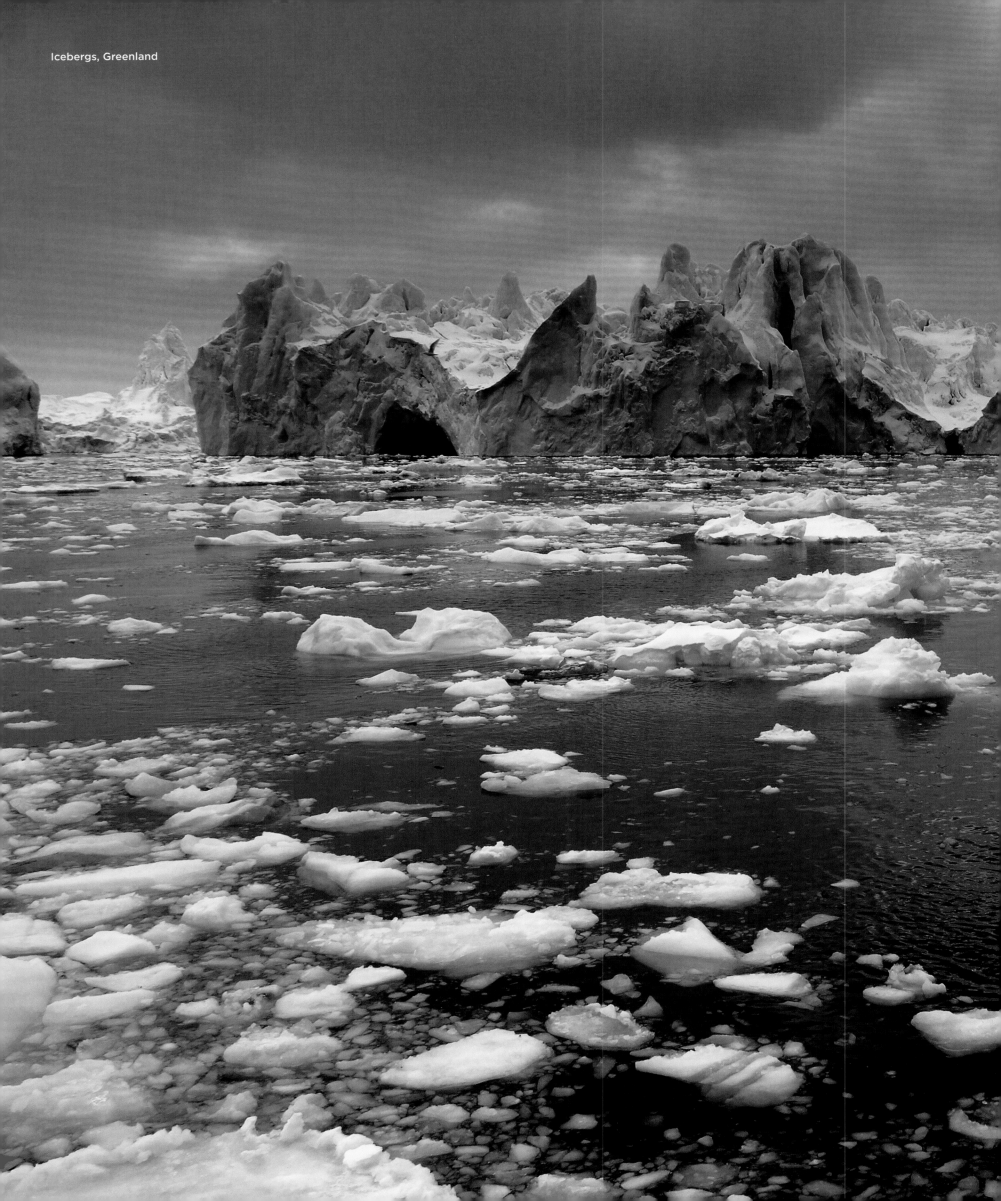

Icebergs, Greenland

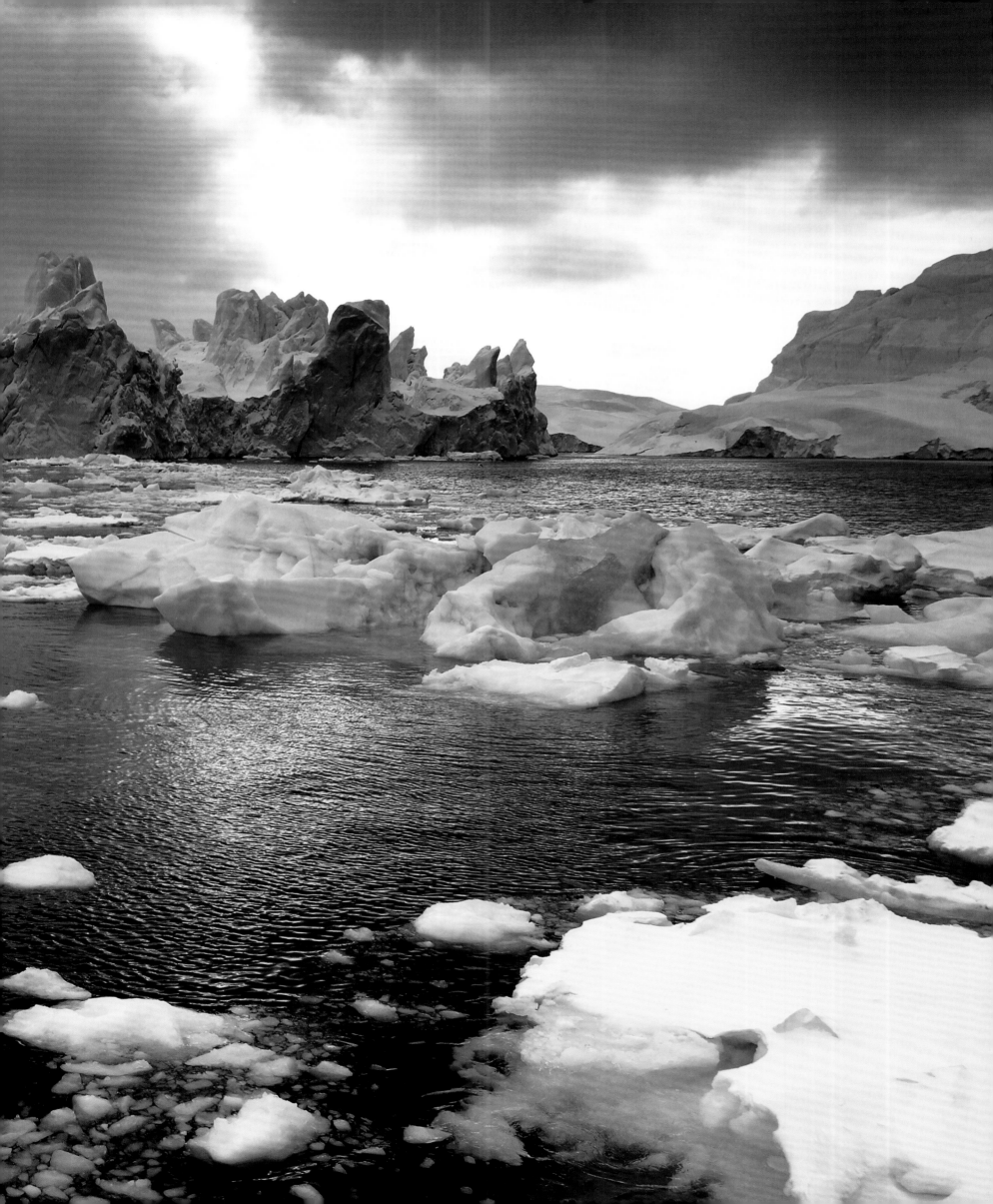

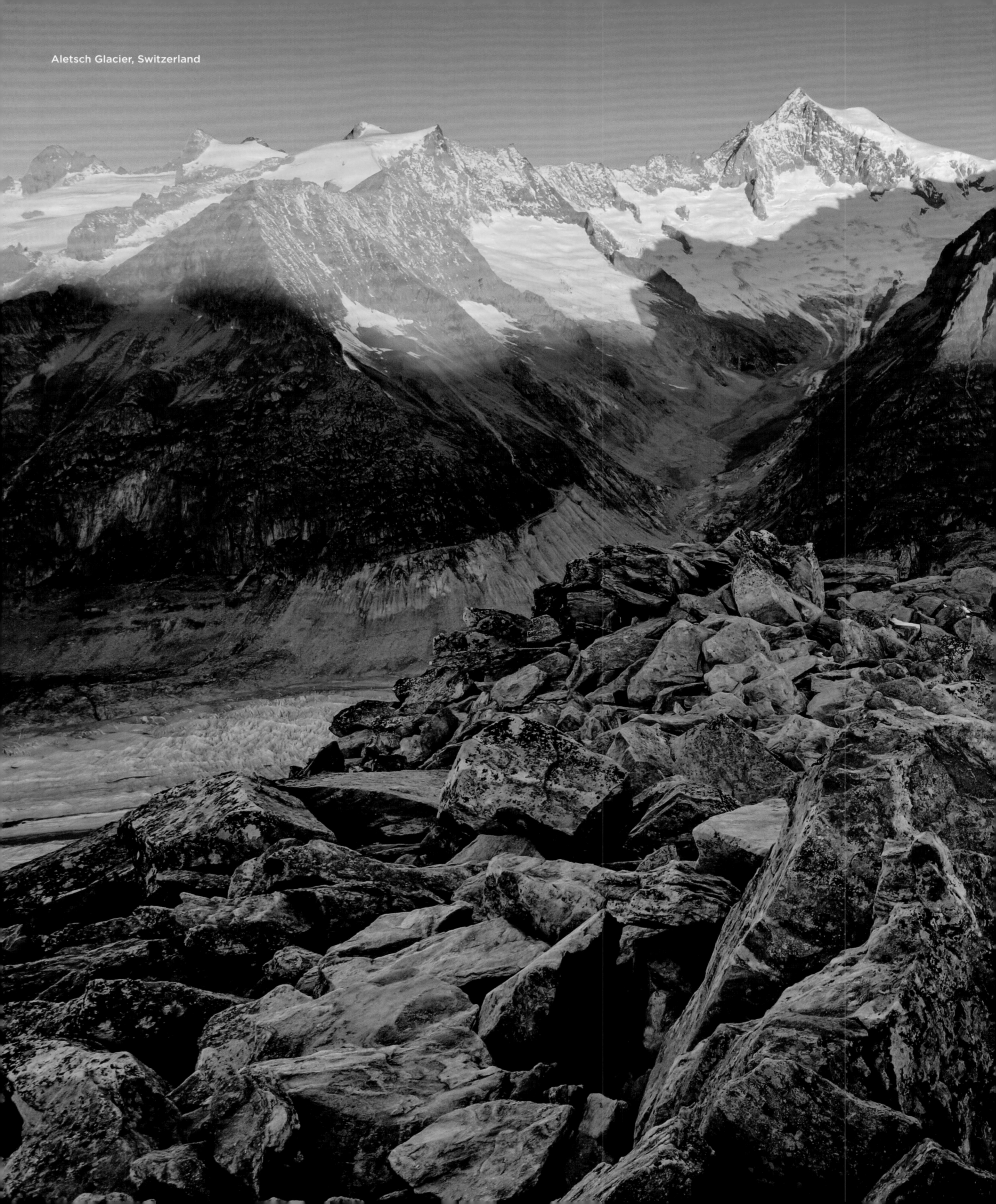

Aletsch Glacier, Switzerland

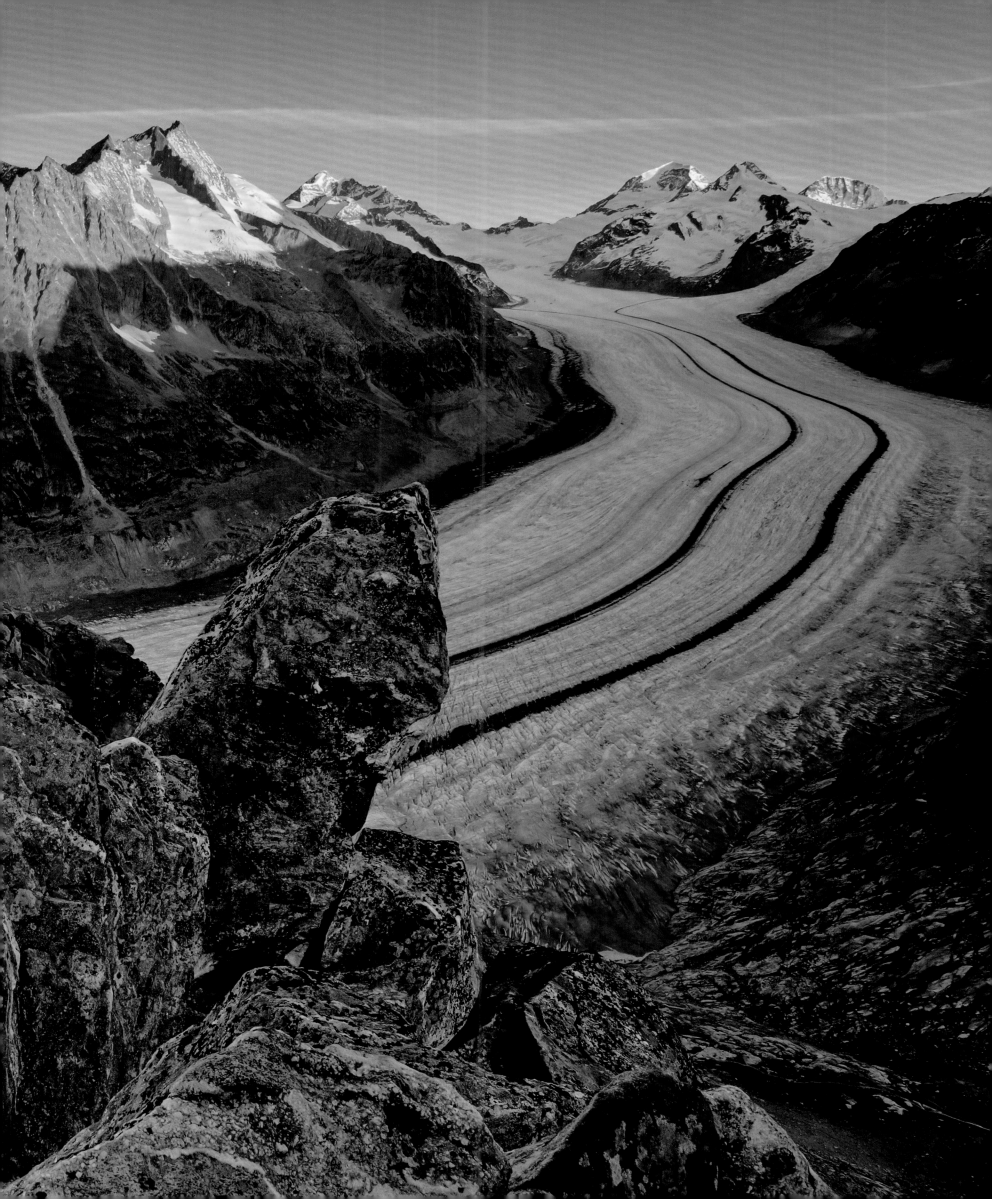

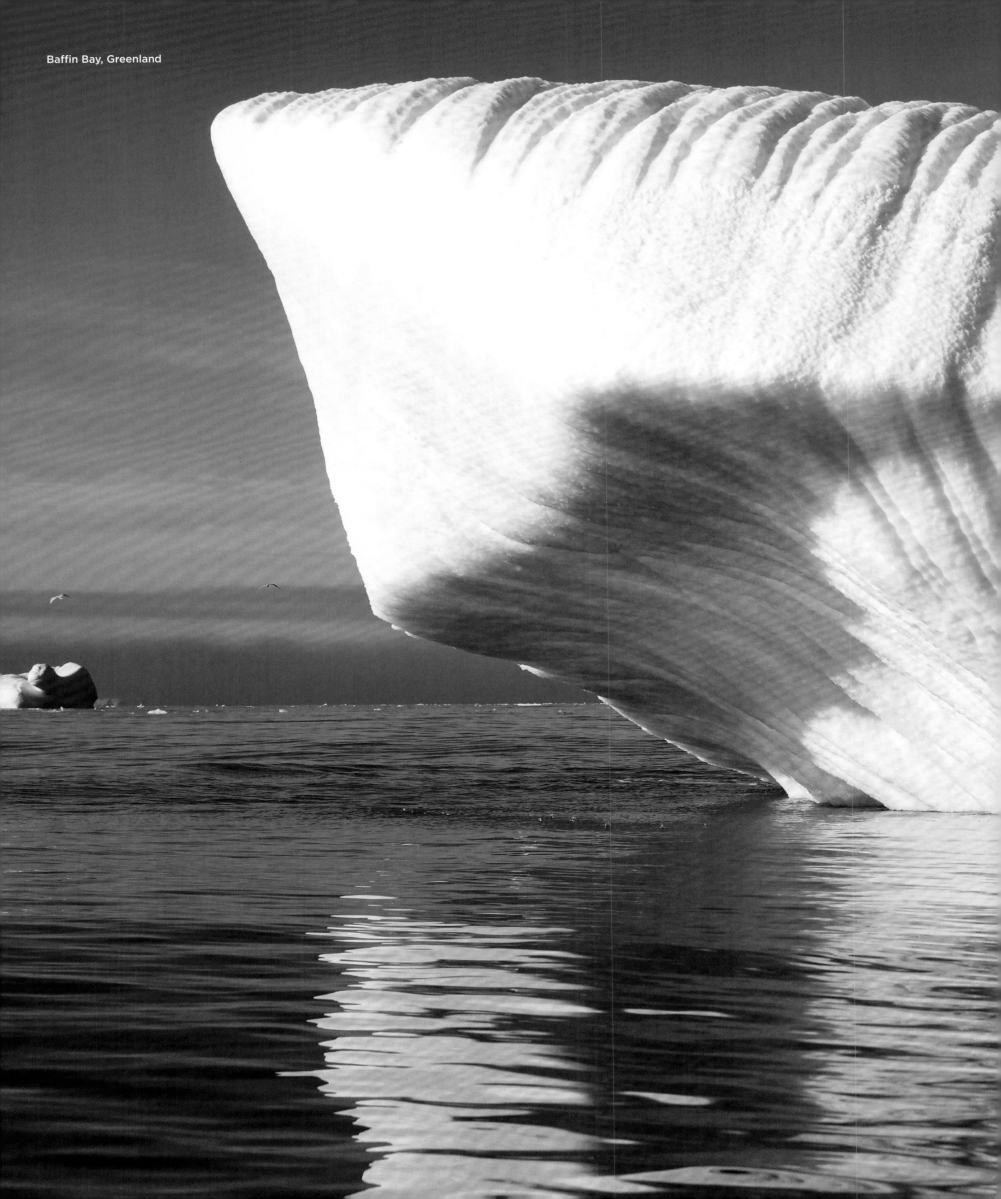

Baffin Bay, Greenland

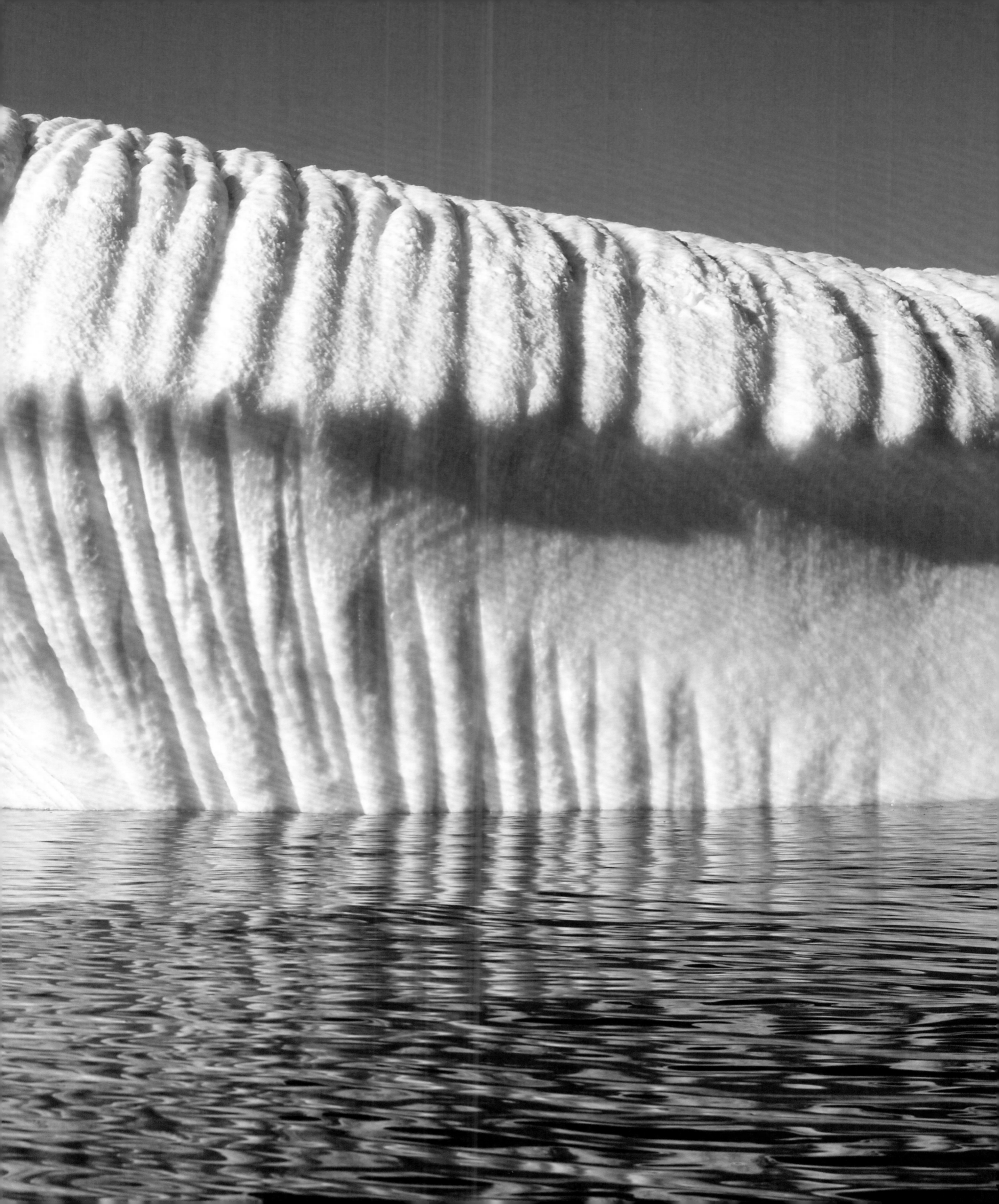

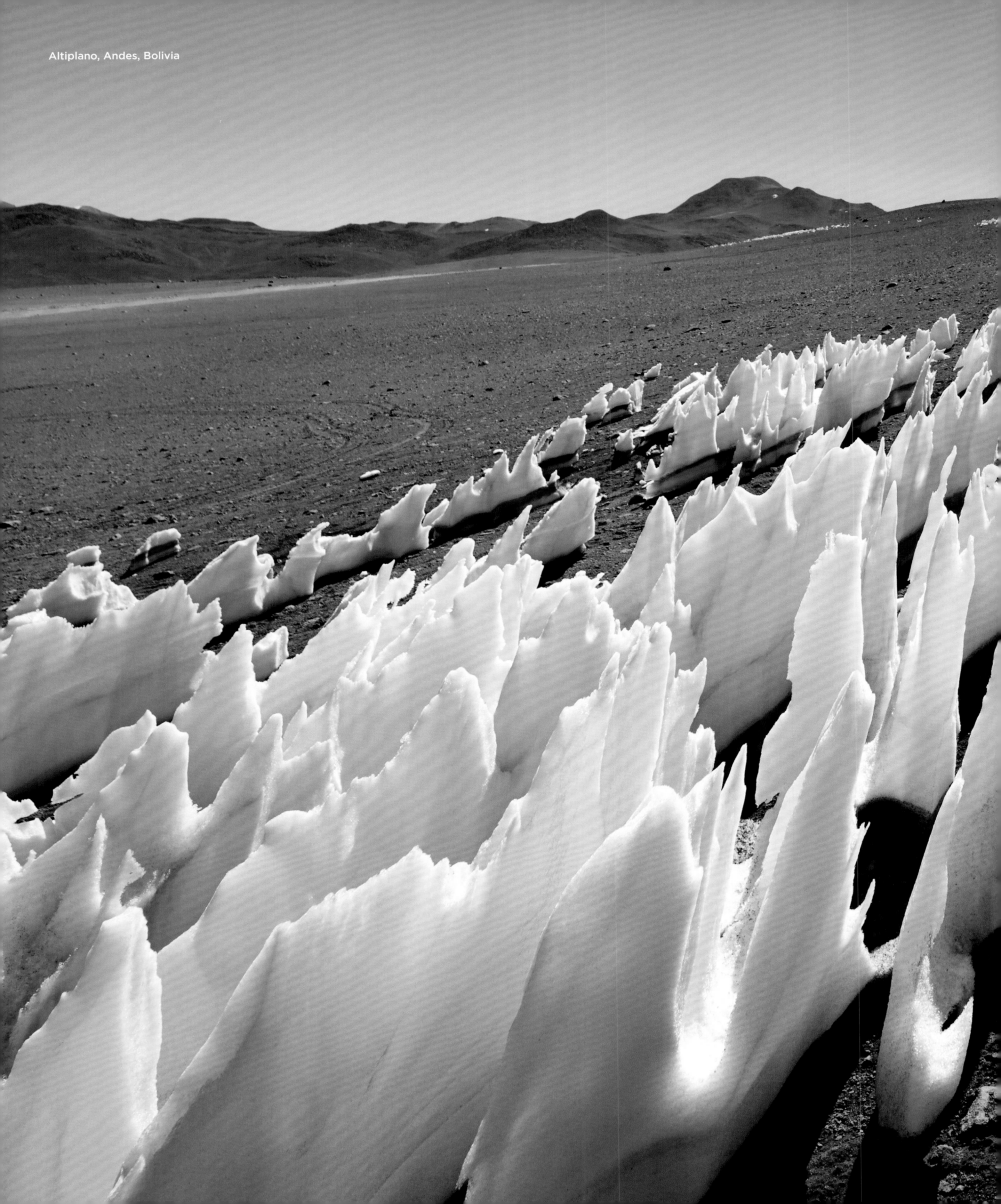

Altiplano, Andes, Bolivia

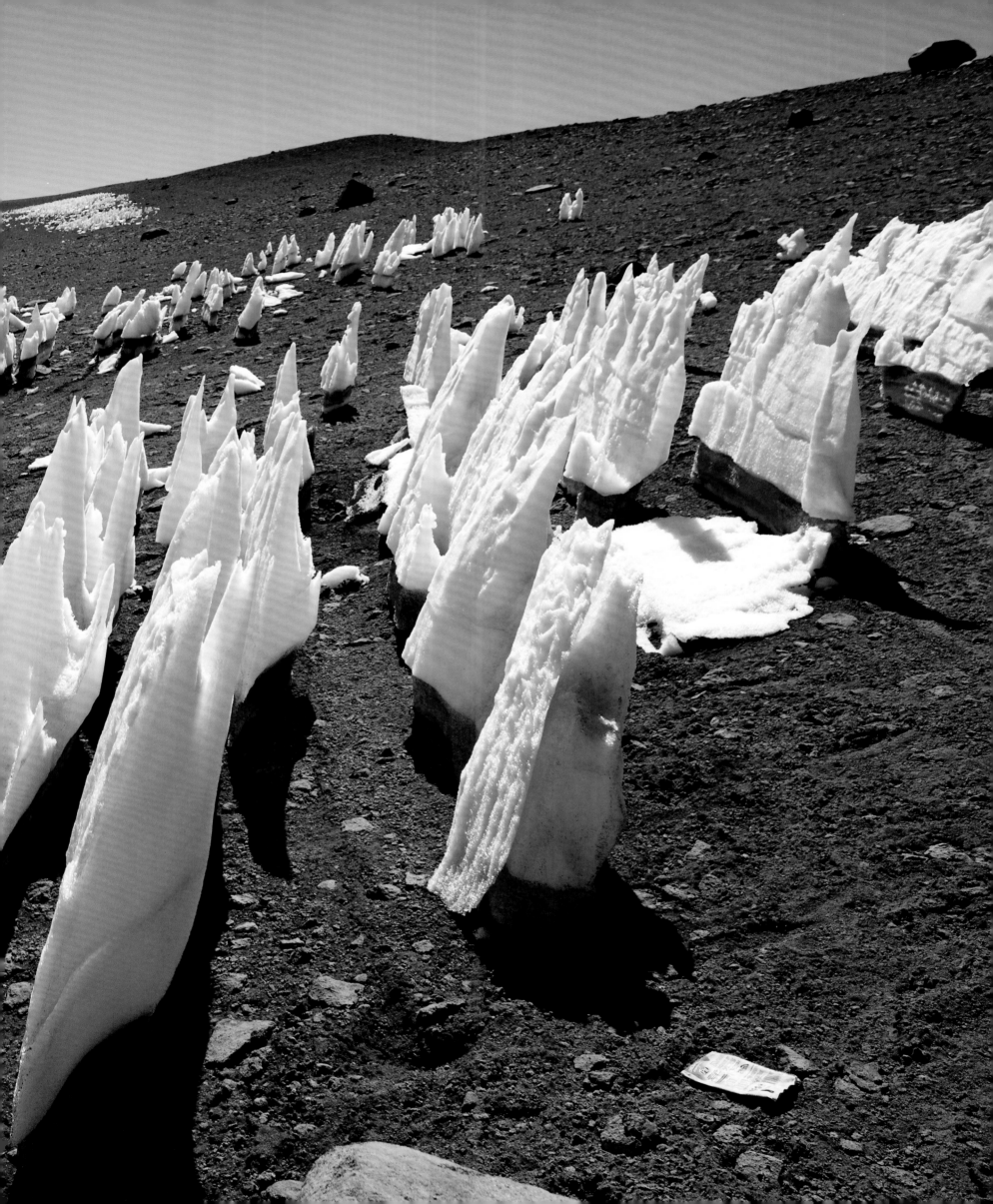

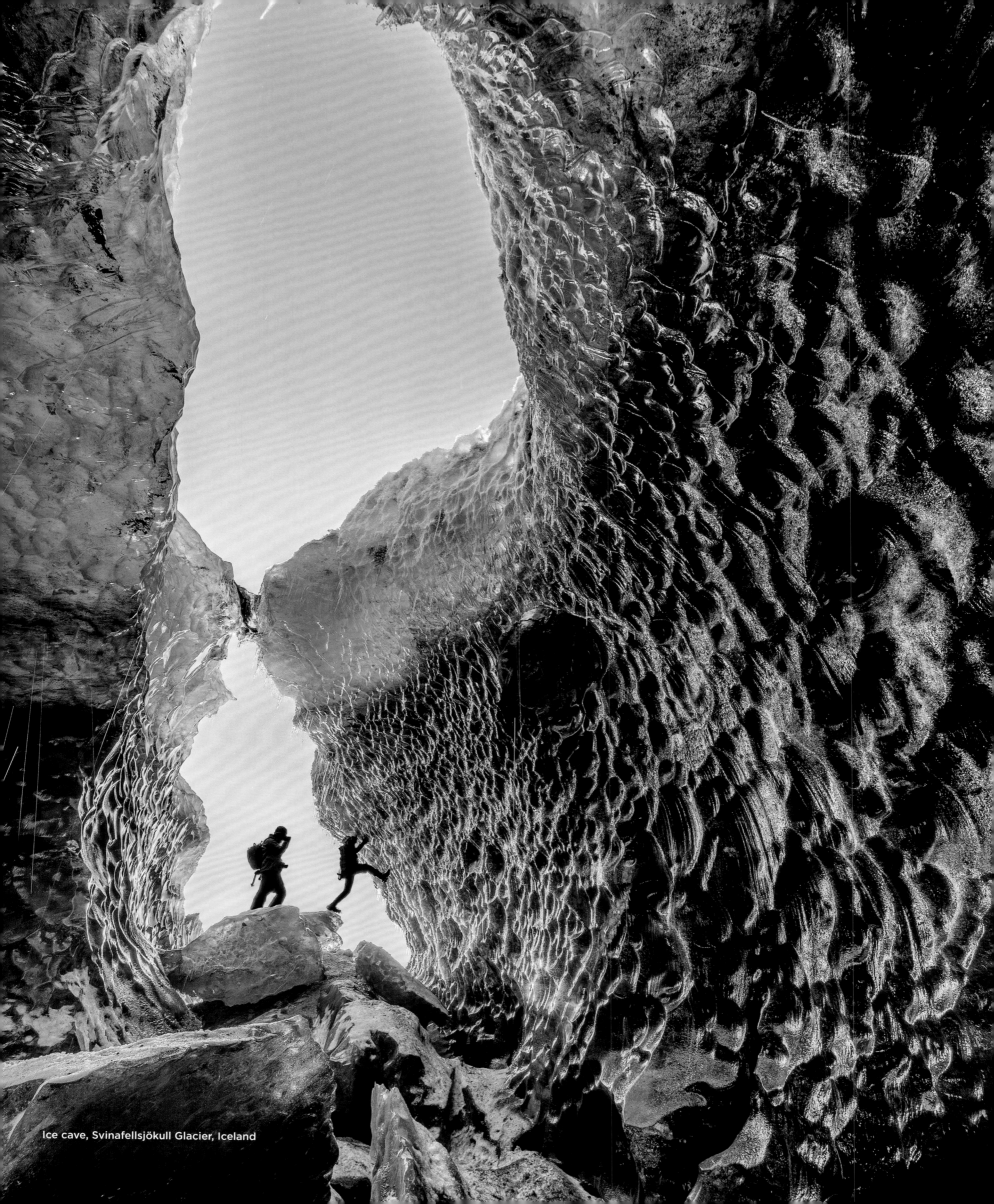

Ice cave, Svínafellsjökull Glacier, Iceland

Contents · Sommaire · Inhalt · Índice · Inhoud

Ice Worlds

Viewed from space, the Earth appears as a "blue planet"; its surface is covered to a large extent by water. The regions around the South and North Pole are particularly striking. The Antarctic is almost completely covered by an ice shield up to several thousand meters (several miles) thick, and in the Arctic, large areas around the North Pole and Greenland are covered by ice. The huge ice shelf areas in Antarctica are particularly impressive, but there is also ice in other parts of the world: even at the equator high peaks are glaciated. In the mountains, glaciers represent an essential freshwater reserve that feeds many rivers. Water is a very special liquid, as it at its highest density and smallest volume at 4 °C (39 °C). This property, described by physicists as the anomaly of water, means that ice is lighter than water, which is why icebergs float on water and lakes freeze on the surface. Ice forms a hostile environment, but humans and animals have adapted to life on the ice. Indigenous peoples such as the Inuit in the Arctic have developed survival strategies over thousands of years. However, the traditional way of life of Arctic inhabitants is changing, and they are being forced to adapt. Some species such as the polar bear are threatened with extinction. This is due to climate change, which is causing temperatures to rise worldwide, particularly rapidly in the Arctic and Antarctic. As a result, glaciers are melting ever more quickly. Ice, which has always fascinated people with its bizarre beauty, is disappearing, and the effects on the environment and the economy are serious.

Paysages glaciaires

Observée depuis l'espace, la Terre apparaît comme la « planète bleue ». Sa surface est en grande partie recouverte d'eau. Les régions du pôle Sud et du pôle Nord en particulier sautent aux yeux. L'Antarctique est presque entièrement dissimulé sous une calotte de glace pouvant atteindre plusieurs kilomètres d'épaisseur. En Arctique, de vastes espaces entourant le pôle Nord, de même que le Groenland, sont également recouverts de glace. Les énormes plates-formes de glace de l'Antarctique sont particulièrement impressionnantes. Mais la glace est aussi présente dans d'autres parties du monde. Même au niveau de l'équateur, certains hauts sommets sont ensevelis sous des glaciers. Dans les montagnes, les glaciers représentent une réserve d'eau douce essentielle, nourrissant de nombreuses rivières. L'eau est un liquide très étonnant car à 4° C, il détient à la fois sa densité la plus importante et son volume le plus restreint. Cette propriété, considérée par les physiciens comme une anomalie, a pour effet que la glace est plus légère que l'eau. C'est pourquoi les icebergs flottent et les lacs gèlent à la surface. La glace constitue un environnement hostile. Cela n'a cependant pas empêché les hommes et les animaux de s'y adapter. Des peuples indigènes tels que les Inuits, en Arctique, ont développé des stratégies de survie au fil des millénaires. Leur mode de vie traditionnel se modifie toutefois, les habitants de l'Arctique étant contraint à l'assimilation culturelle. Certaines espèces d'animaux, comme l'ours polaire, sont en voie d'extinction. En cause, le changement climatique faisant augmenter les températures dans le monde entier, et ce, à grande vitesse, notamment en Arctique et en Antarctique. Les glaciers fondent ainsi d'autant plus vite. La glace, qui a toujours fasciné les hommes par sa beauté singulière, disparaît, et cela a un impact grave sur l'écologie et sur l'économie à l'échelle mondiale.

Eiswelten

Aus dem Weltraum betrachtet, erscheint die Erde als „Blauer Planet". Ihre Oberfläche ist zu großen Teilen von Wasser bedeckt. Besonders auffällig sind die Regionen um Süd- und Nordpol. Die Antarktis liegt fast vollständig unter einem bis zu mehrere Tausend Meter dicken Eispanzer, in der Arktis sind weite Gebiete rund um den Nordpol und auch Grönland von Eis bedeckt. Besonders eindrucksvoll sind die riesigen Schelfeisflächen in der Antarktis. Aber auch in anderen Teilen der Welt gibt es Eis, selbst am Äquator sind hohe Gipfel vergletschert. In den Gebirgen stellen Gletscher eine existenzielle Süßwasserreserve dar, die viele Flüsse speisen. Wasser ist eine ganz besondere Flüssigkeit, denn sie hat bei 4 °C ihre größte Dichte und ihr kleinstes Volumen. Diese von Physikern als Anomalie des Wassers bezeichnete Eigenschaft hat zur Folge, dass Eis leichter als Wasser ist, weshalb Eisberge auf dem Wasser schwimmen und Seen von der Oberfläche zufrieren. Eis bildet eine lebensfeindliche Umwelt. Dennoch haben sich Menschen und Tiere an das Leben im Eis angepasst. Indigene Völker wie etwa die Inuit in der Arktis haben in Jahrtausenden Überlebensstrategien entwickelt. Doch die traditionelle Lebensweise der Arktisbewohner ändert sich, sie sind zur Assimilation gezwungen. Manche Tierarten wie der Eisbär sind vom Aussterben bedroht. Schuld ist der Klimawandel, der weltweit die Temperaturen ansteigen lässt, besonders schnell in der Arktis und Antarktis. Dadurch schmelzen die Gletscher immer schneller ab. Eis, das die Menschen immer mit seiner bizarren Schönheit fasziniert hat, verschwindet, die Auswirkungen auf Ökologie und Ökonomie sind gravierend.

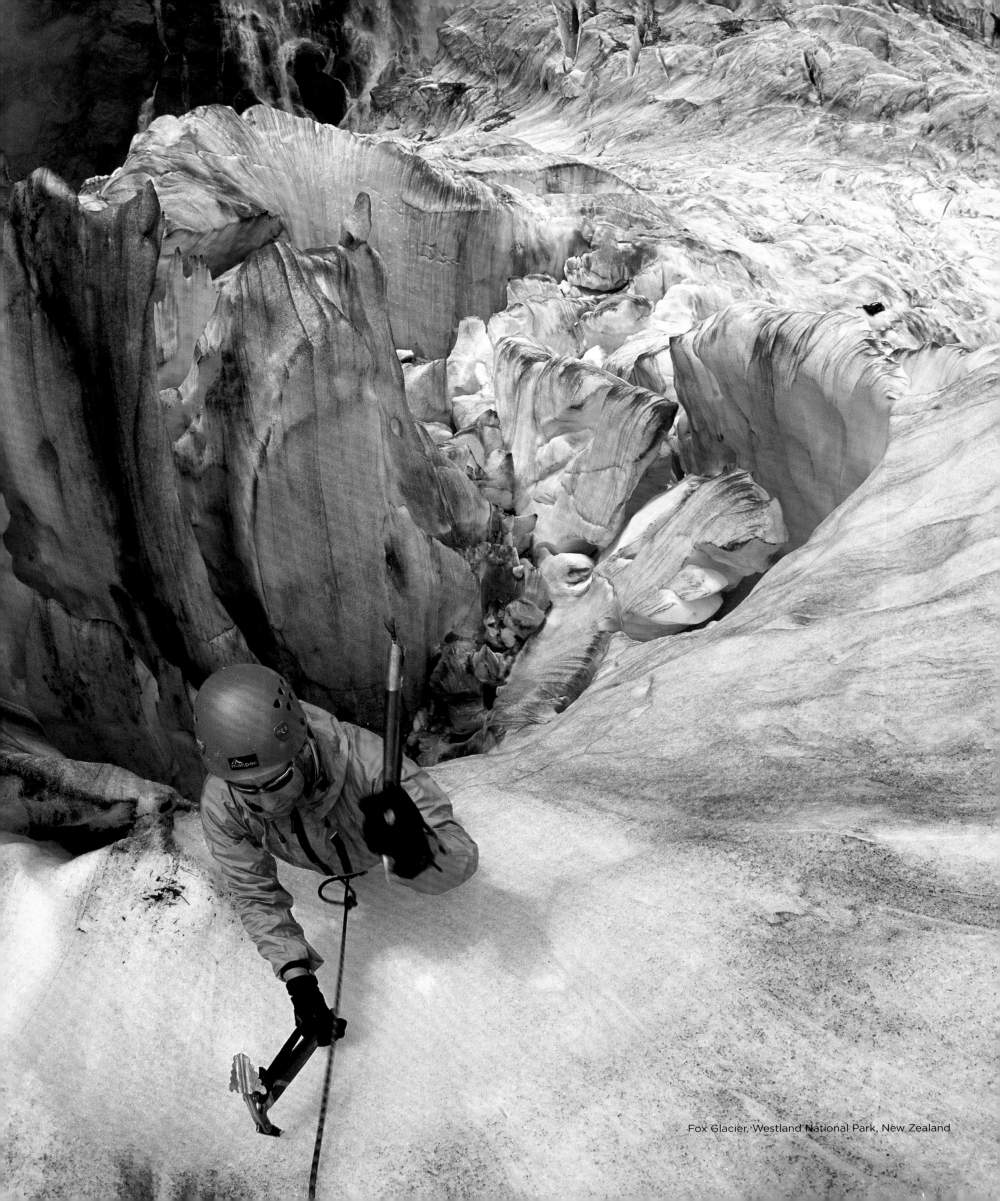

Fox Glacier, Westland National Park, New Zealand

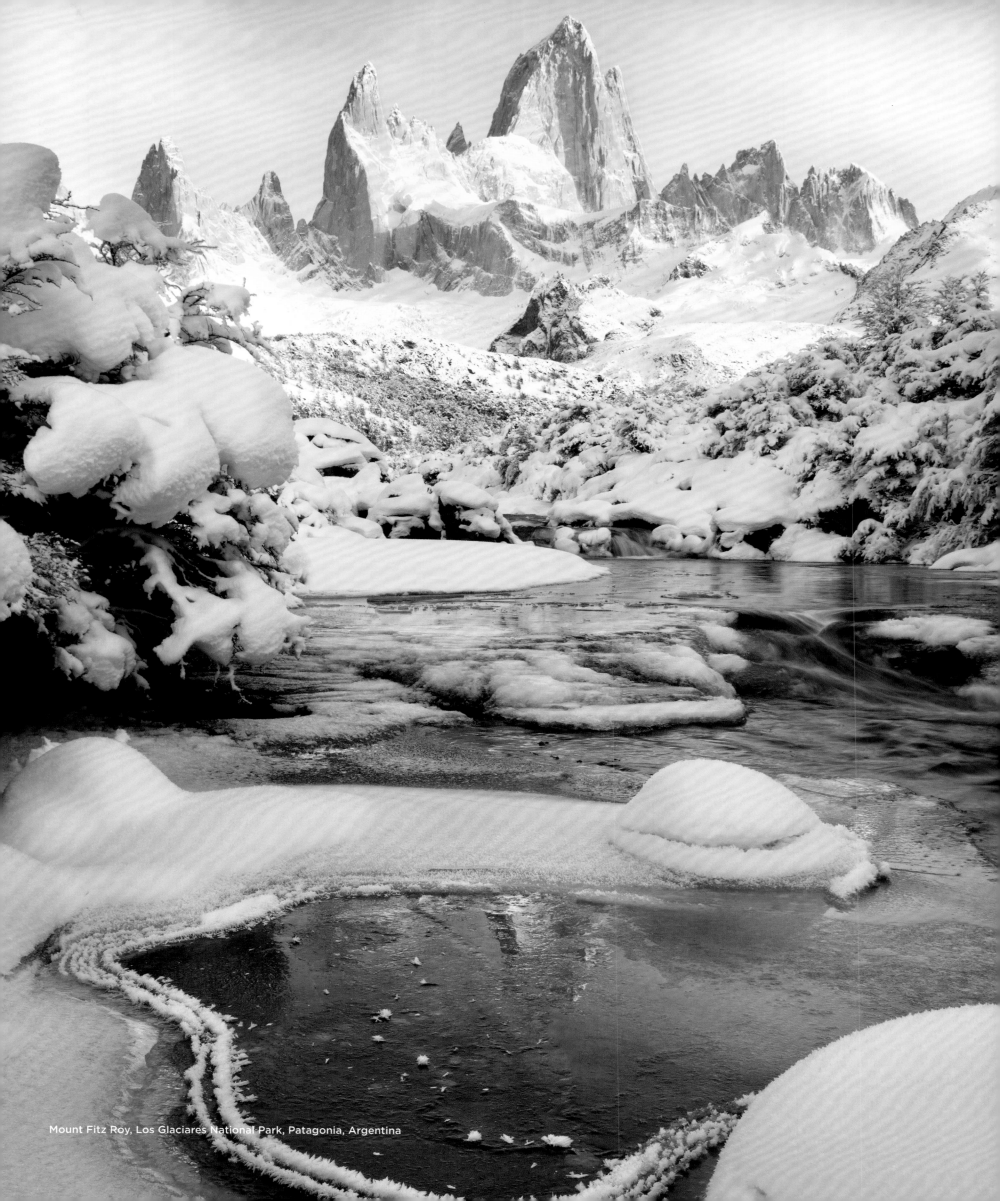

Mount Fitz Roy, Los Glaciares National Park, Patagonia, Argentina

Mundos helados

Vista desde el espacio, la Tierra aparece como un "planeta azul". Su superficie está cubierta en gran medida por agua. Las regiones alrededor del Polo Sur y del Polo Norte son particularmente llamativas. La Antártida está cubierta casi por completo por una capa de hielo de hasta varios miles de metros de espesor; en el Ártico, grandes áreas alrededor del Polo Norte y Groenlandia están cubiertas de hielo. Las enormes extensiones de hielo de la Antártida son particularmente impresionantes. Pero también hay hielo en otras partes del mundo, incluso en las altas cumbres del ecuador que son glaciadas. En las montañas, los glaciares representan una reserva existencial de agua dulce que alimenta muchos ríos. El agua es un líquido muy especial, ya que tiene su mayor densidad y su menor volumen a 4 °C. Esta propiedad, descrita por los físicos como la anomalía del agua, significa que el hielo pesa menos que el agua, por lo que los icebergs flotan en el agua y congelan los lagos de la superficie. El hielo forma un entorno hostil para la vida. Sin embargo, los seres humanos y los animales se han adaptado a la vida en el hielo. Los pueblos indígenas, como los inuits del Ártico, han desarrollado estrategias de supervivencia durante miles de años. Pero el modo de vida tradicional de los habitantes del Ártico está cambiando: se ven obligados a adaptarse. Algunas especies, como el oso polar, se encuentran en peligro de extinción. Esto se debe al cambio climático, que está provocando un aumento de las temperaturas en todo el mundo, especialmente en el Ártico y la Antártida. Como resultado, los glaciares se están derritiendo cada vez con mayor rapidez. El hielo, que siempre ha fascinado a las personas por su extraña belleza, desaparece, y los efectos que esto tiene en la ecología y la economía son muy graves.

Mundos gelados

Vista do espaço, a Terra aparece como um "planeta azul". A sua superfície é coberta em grande parte por água. As regiões em torno do Pólo Sul e do Pólo Norte são particularmente visíveis. A Antártida encontra-se quase completamente sob uma camada de gelo de até vários milhares de metros de espessura, no Ártico grandes áreas ao redor do Pólo Norte e da Groenlândia são cobertas por gelo. Particularmente impressionantes são as enormes prateleiras de gelo na Antártida. Mas há também gelo em outras partes do mundo, mesmo no Equador picos altos são glaciados. Nas montanhas, as geleiras representam uma reserva existencial de água doce, que alimenta muitos rios. A água é um líquido muito especial, pois tem a maior densidade e o menor volume a 4 °C. Esta propriedade, descrita pelos físicos como a anomalia da água, significa que o gelo é mais leve que a água, razão pela qual os icebergs nadam na água e congelam os lagos da superfície. O gelo forma um ambiente hostil. No entanto, humanos e animais adaptaram-se à vida no gelo. Povos indígenas como os inuítes no Ártico desenvolveram estratégias de sobrevivência ao longo de milhares de anos. Mas o modo de vida tradicional dos habitantes do Ártico está mudando, eles estão sendo levados à assimilação. Algumas espécies, como o urso polar, estão ameaçadas de extinção. Isto deve-se às alterações climáticas, que estão a provocar um aumento das temperaturas a nível mundial, particularmente acelerado no Ártico e na Antártida. Como resultado, os glaciares estão derretendo cada vez mais rápido. O gelo, que sempre fascinou as pessoas com a sua beleza bizarra, desaparece, e os efeitos sobre a ecologia e a economia são graves.

IJswerelden

Vanuit de ruimte gezien, verschijnt de aarde als een „blauwe planeet". Het oppervlak is grotendeels bedekt met water. Vooral de regio's rond de Zuid- en Noordpool zijn opvallend. Antarctica is bijna volledig bedekt met een ijsschild tot enkele duizenden meters dik, in het Noordpoolgebied zijn grote gebieden rond de Noordpool en Groenland bedekt met ijs. Bijzonder indrukwekkend zijn de grote ijskapgebieden op Antarctica. Maar er is ook ijs in andere delen van de wereld, zelfs op de evenaar zijn er hoge pieken vergletsjerd. In de bergen vertegenwoordigen gletsjers een existentieel zoetwaterreservaat dat vele rivieren voedt. Water is een zeer speciale vloeistof, omdat het met zijn hoogste dichtheid en kleinste volume bij 4 °C een zeer belangrijke bron van zoet water is. Deze eigenschap, door natuurkundigen beschreven als de anomalie van water, betekent dat ijs lichter is dan water, waardoor ijsbergen op het water zwemmen en meren van het oppervlak bevriezen. IJs vormt een vijandige omgeving. Toch hebben mens en dier zich aangepast aan het leven op het ijs. Inheemse volkeren zoals de Eskimo's in het Noordpoolgebied hebben in de loop van duizenden jaren overlevingsstrategieën ontwikkeld. Maar de traditionele manier van leven van de bewoners van het Noordpoolgebied is aan het veranderen, ze worden gedwongen om zich te assimileren. Sommige soorten, zoals de ijsbeer, worden met uitsterven bedreigd. Dit is te wijten aan de klimaatverandering, die ervoor zorgt dat de temperaturen wereldwijd stijgen, met name in het noordpoolgebied en op Antarctica. Als gevolg daarvan smelten gletsjers steeds sneller en sneller. Het ijs, dat de mensen altijd heeft gefascineerd door zijn bizarre schoonheid, verdwijnt en de effecten op de ecologie en de economie zijn ernstig.

Arctic

NORT

New York 5482

POLE

London 4288

Madrid 5519

Paris 4587

Amsterdam 4193

Luxembourg 4476

Berlin 4175

Cape Town 13741

Moscow 3820

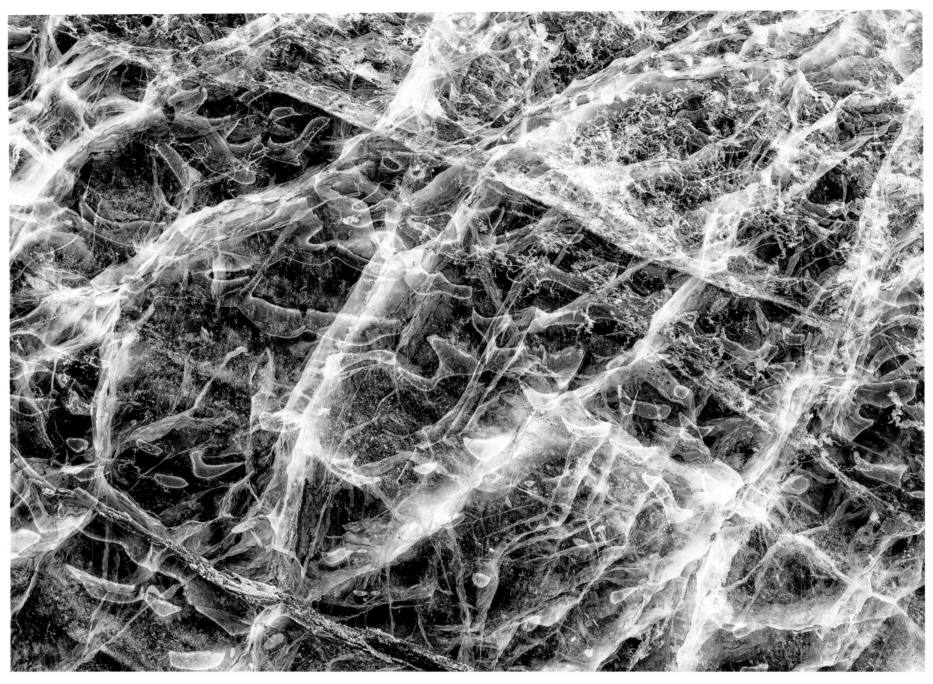

Ice detail

The Arctic

Large parts of the Arctic are covered by the Arctic Ocean, also known as the Arctic Sea. With a size of 14 million km² (5.5 million sq mi), for one million years the Arctic Ocean has been at least partially icy. In the past, the land masses and the sea north of the Arctic Circle were counted as part of the Arctic, but today we define it using the 10° July isotherm, an imaginary line that runs at different distances from the North Pole due to warm and cold ocean currents. However, the spread of the tundra vegetation (i.e. the absence of trees) can be also used to define the Arctic.

L'Arctique

De grandes parcelles de l'Arctique se trouvent sous l'océan Arctique, également connu sous les noms d'océan Glacial Arctique ou de mer Polaire Arctique. Depuis un million d'années, l'océan Arctique, vaste de 14 millions de km², est au moins partiellement gelé. Autrefois, les territoires et la mer, situés au nord du cercle polaire, étaient considérés comme partie intégrante de l'Arctique. Celui-ci est aujourd'hui délimité par la courbe isotherme des 10° C au mois de juillet, une ligne imaginaire plus ou moins proche du pôle Nord en fonction des courants marins chauds et froids. La propagation de la végétation caractéristique de la toundra, c'est-à-dire, l'absence d'arbres, peut également être utilisée pour définir l'Arctique.

Arktis

Große Teile der Arktis bedeckt das Nordpolarmeer, das auch Arktischer Ozean, Nördliches Eismeer oder Arktische See genannt wird. Seit einer Million Jahren ist das Nordpolarmeer mit einer Größe von 14 Millionen km² zumindest teilweise vereist. Früher hat man die Landmassen und das Meer nördlich des Polarkreises zur Arktis gezählt, heute nimmt man die 10°-Juli-Isotherme, eine imaginäre Linie, die wegen warmer und kalter Meeresströmungen unterschiedlich weit vom Nordpol verläuft. Aber auch die Ausbreitung der Tundravegetation, also das Fehlen von Bäumen, kann man zur Definition der Arktis heranziehen.

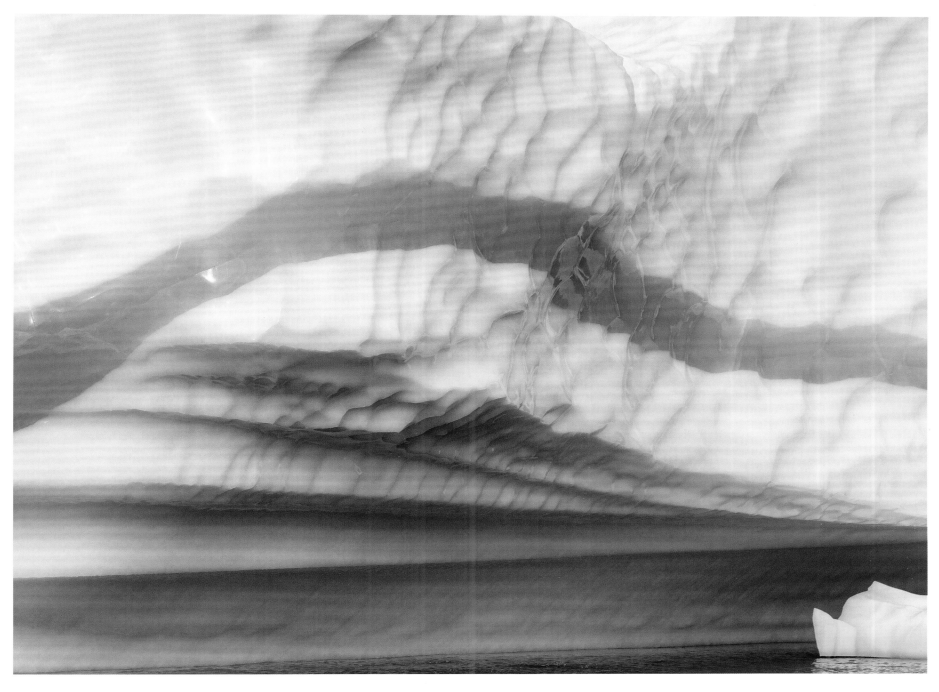

Iceberg detail

Ártico

Grandes partes del Ártico están cubiertas por el Océano Ártico, también conocido como el Océano Glacial Ártico. Desde hace un millón de años, el Océano Ártico, que tiene una superficie de 14 millones de km², ha estado al menos parcialmente helado. En el pasado, las masas terrestres y el mar al norte del círculo polar ártico se consideraban parte del Ártico, pero hoy en día tomamos la isoterma 10° de julio, una línea imaginaria que corre a diferentes distancias del Polo Norte debido a las corrientes oceánicas cálidas y frías. No obstante, para definir el Ártico también se puede utilizar la extensión de la vegetación de la tundra, es decir, la ausencia de árboles.

Ártico

Grande parte do Ártico é coberta pelo Oceano Glacial Ártico, também conhecido como Oceano Ártico. Durante um milhão de anos, o oceano Ártico, com uma superfície de 14 milhões de km², ficou pelo menos parcialmente congelado. Antigamente, as massas de terra e o mar ao norte do Círculo Polar Ártico eram contados como parte do Ártico, mas hoje utiliza-se a isoterma de 10 °C de média em julho, uma linha imaginária utilizada para definir a fronteira do Ártico, que devido às correntes quentes e frias do oceano percorre diferentes distâncias do Pólo Norte. Mas também a propagação da vegetação de tundra, ou seja, a ausência de árvores, pode ser usada para definir o Ártico.

Noordpoolgebied

Grote delen van de Noordpool worden bedekt door de Noordelijke IJszee, ook wel bekend als de Arctische Oceaan. De Noordelijke IJszee met een oppervlakte van 14 miljoen km² is al sinds een miljoen jaar gedeeltelijk bevroren. Vroeger werden de landmassa's en de zee ten noorden van poolcirkel als onderdeel van de poolcirkel geteld, maar tegenwoordig nemen we de isotherm van 10°-juli, een denkbeeldige lijn die vanwege warme en koude zeestromingen verschillend ver van de Noordpool verloopt. Maar ook de verspreiding van de toendravegetatie, d.w.z. de afwezigheid van bomen, kan worden gebruikt om het Noordpoolgebied te definiëren.

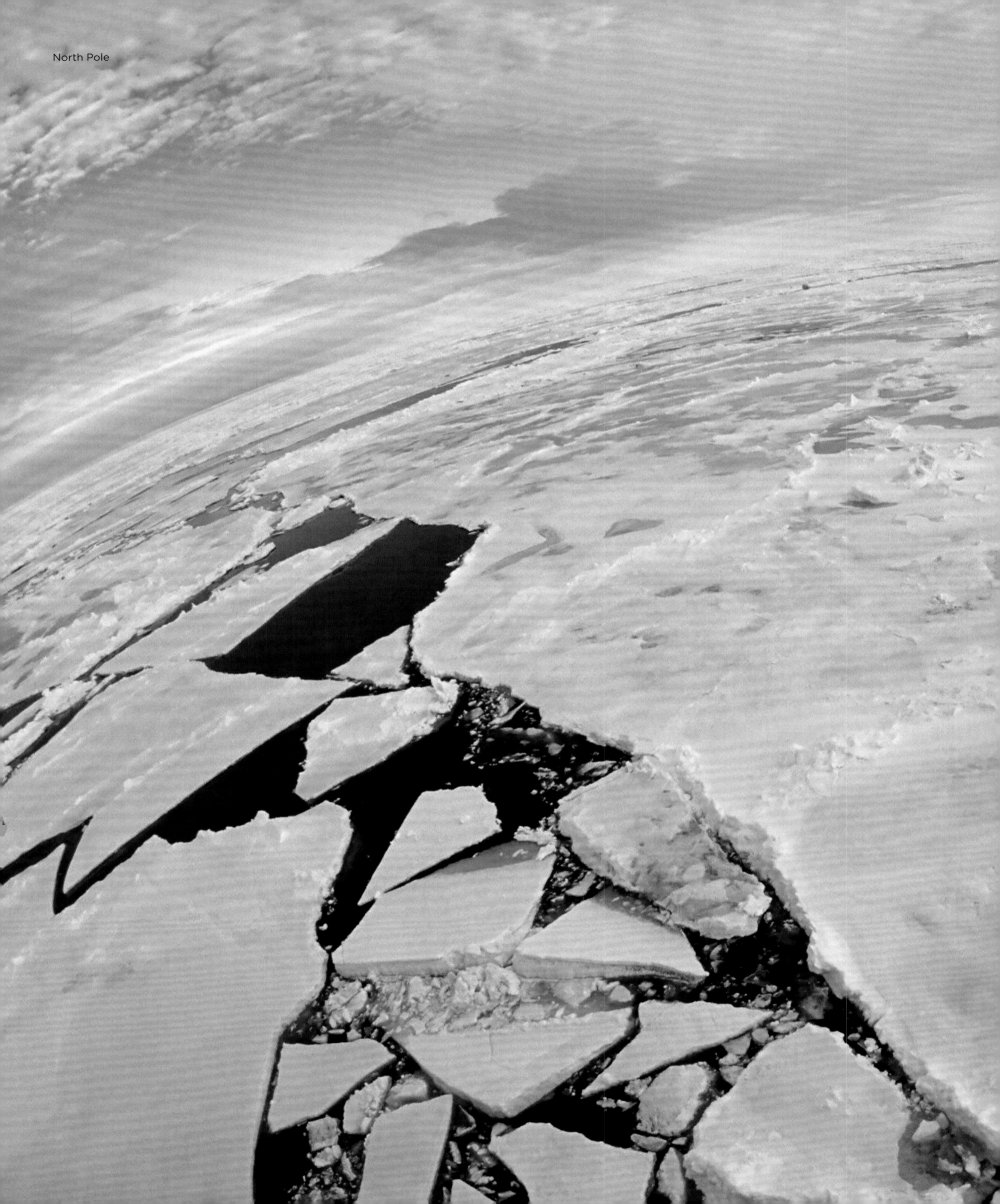

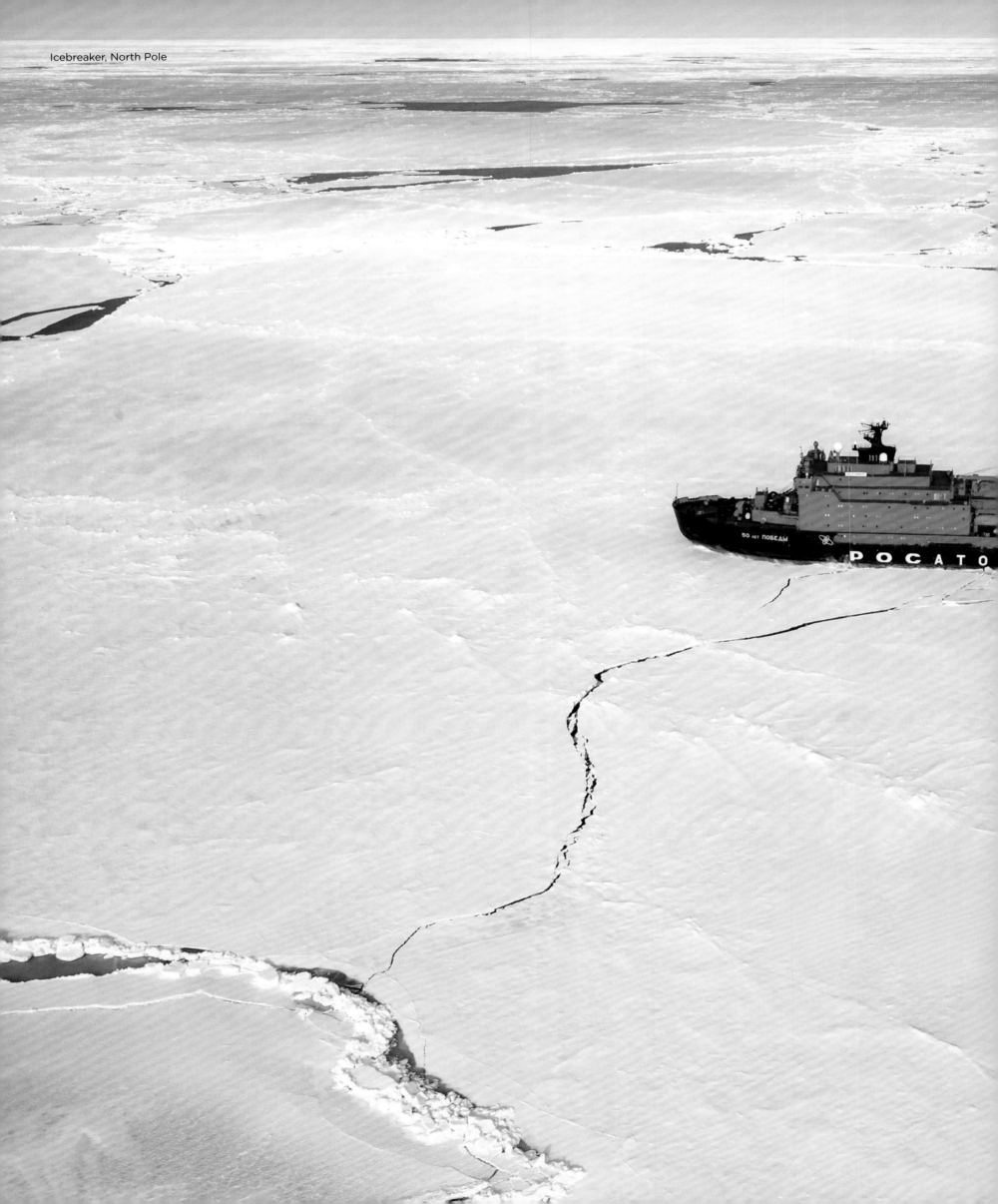

Icebreaker, North Pole

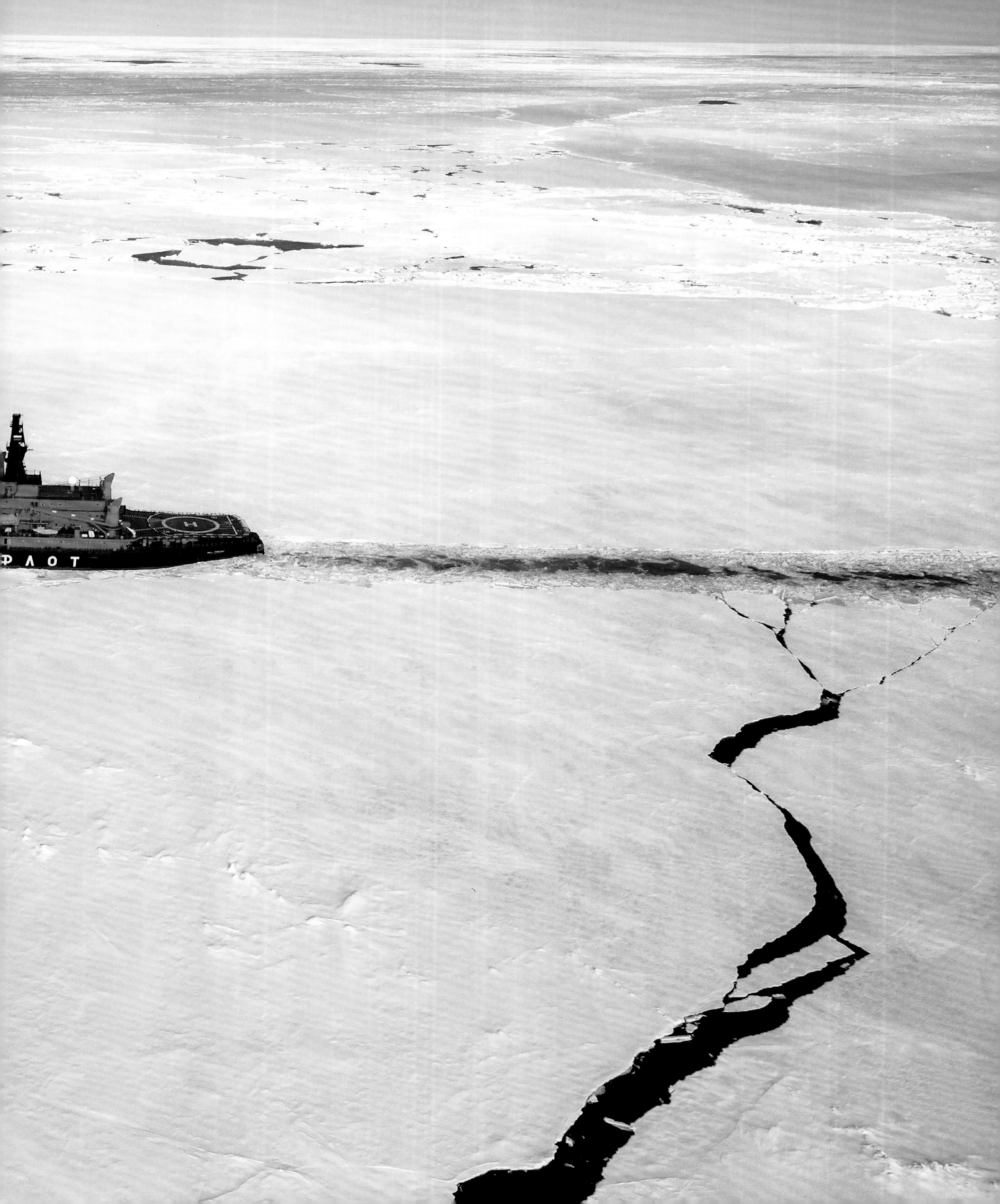

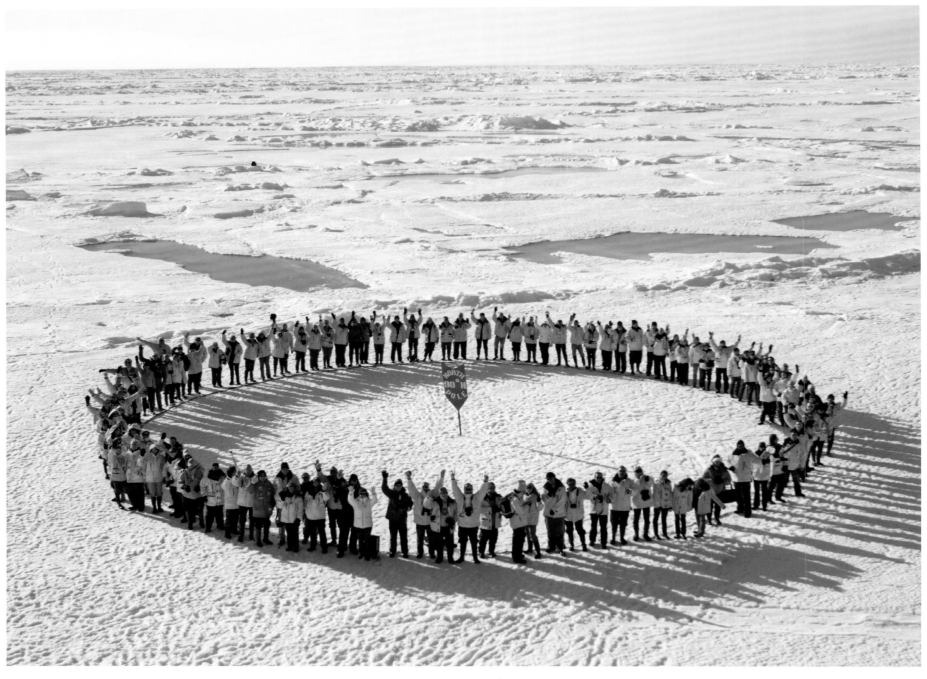

North Pole

The North Pole
Several adventurers have claimed to be the first to be reach the North Pole, but there has been no clear evidence. Among them were the polar explorers Peary and Cook, who at the beginning of the 20th century were involved in a race to the North Pole but probably did not reach it. However, the American Ralph Plaisted managed this in 1968.

Le pôle Nord
Bien qu'il n'existe pas de preuve tangible de ces assertions, plusieurs aventuriers revendiquèrent avoir été les premiers à poser le pied au pôle Nord. Parmi eux, les explorateurs polaires Robert Peary et Frederick Cook se livrèrent au début du xxe siècle à une course au pôle Nord, sans, cependant, l'avoir jamais probablement atteint. Ce n'est qu'en 1968 que l'Américain Ralph Plaisted y parvint.

Nordpol
Mehrere Abenteurer haben für sich reklamiert, als erste am Nordpol gewesen zu sein, doch eindeutige Beweise gab es nicht. Unter ihnen waren auch die Polarforscher Peary und Cook, die sich Anfang des 20. Jahrhunderts ein Wettrennen zum Nordpol geliefert, ihn aber wahrscheinlich nicht erreicht haben. Erst dem Amerikaner Ralph Plaisted gelang dies 1968.

Polo Norte
Varios aventureros han afirmado ser los primeros en estar en el Polo Norte, pero no había pruebas claras. Entre ellos estaban los exploradores polares Peary y Cook, que a principios del siglo XX realizaron una carrera hacia el Polo Norte, pero que probablemente no llegaron a él. El estadounidense Ralph Plaisted fue el primero que lo logró, en 1968.

Pólo Norte
Vários aventureiros afirmaram terem sido os primeiros a estar no Pólo Norte, mas não haviam provas claras. Entre eles estavam os exploradores polares Peary e Cook, que no início do século XX prestaram uma corrida ao Pólo Norte, mas provavelmente não o alcançaram. Só o americano Ralph Plaisted conseguiu isto em 1968.

Noordpool
Verschillende avonturiers claimen de eerste op de Noordpool te zijn geweest, maar hiervoor is geen duidelijk bewijs. Onder hen waren de poolreizigers Peary en Cook, die in het begin van de 20e eeuw volgens hun zeggen de Noordpool hadden bereikt, maar dit is na alle waarschijnlijkheid niet het geval. Alleen de Amerikaan Ralph Plaisted slaagde hier in 1968.

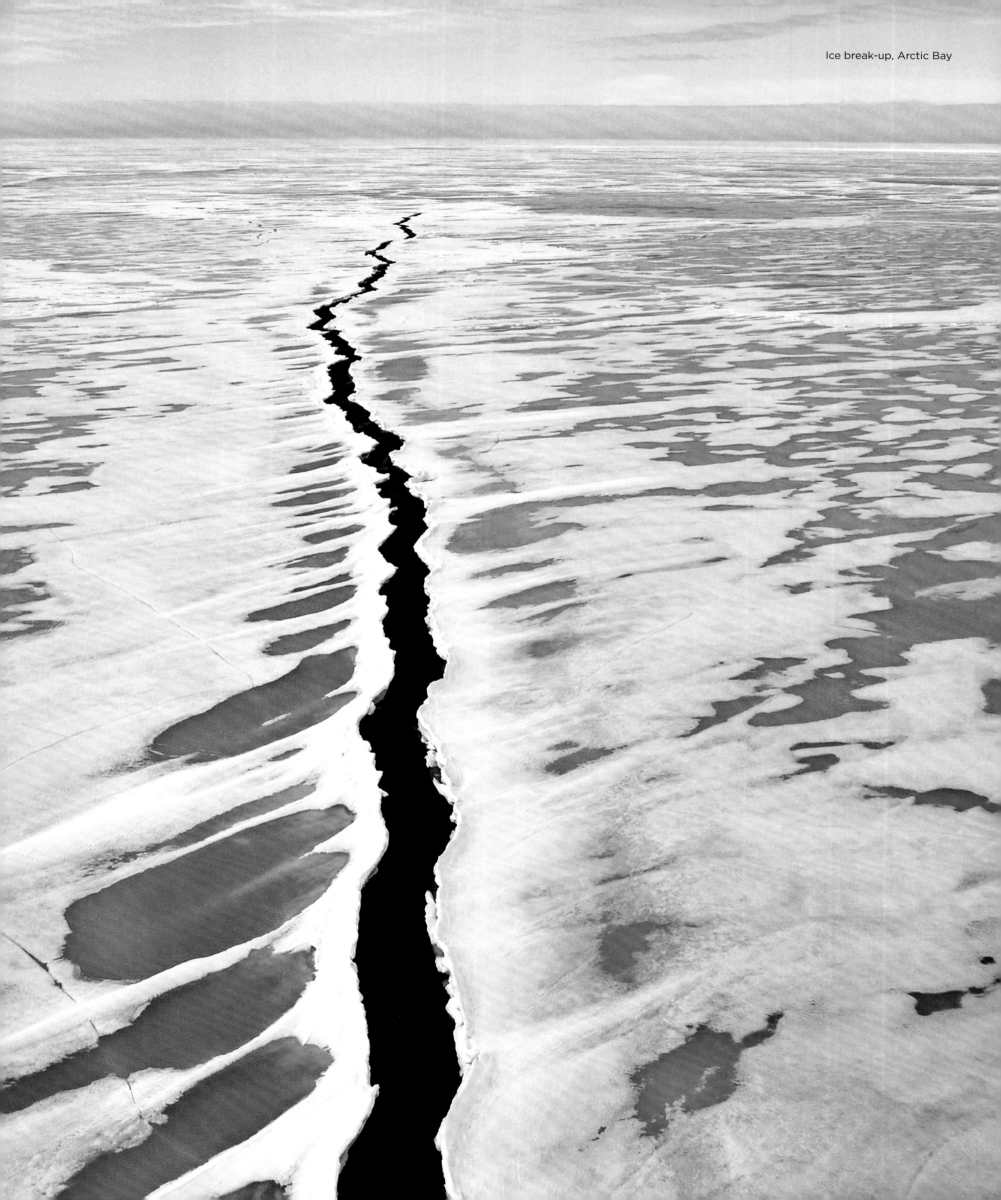

Ice break-up, Arctic Bay

Polar bear, midnight sun

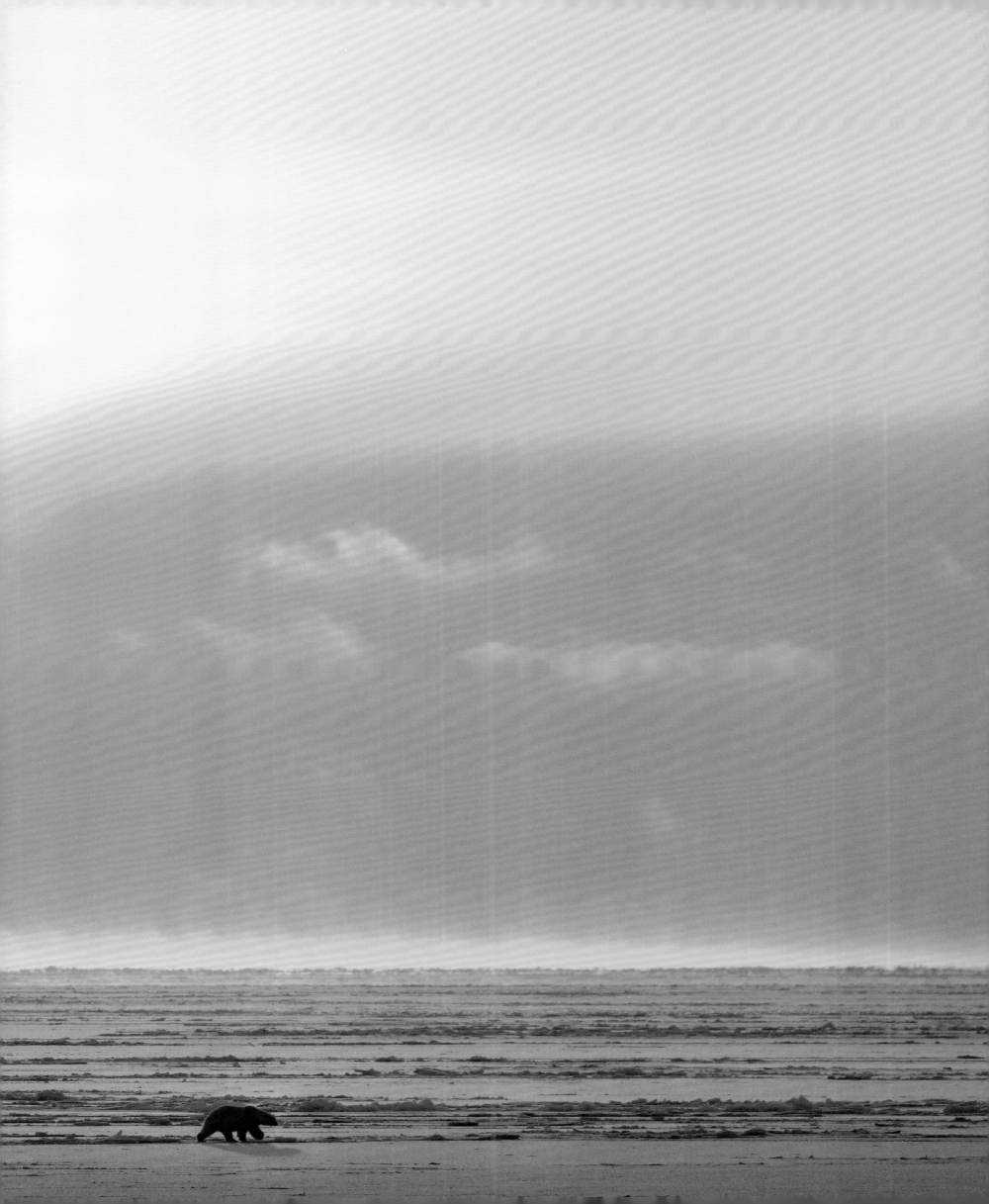

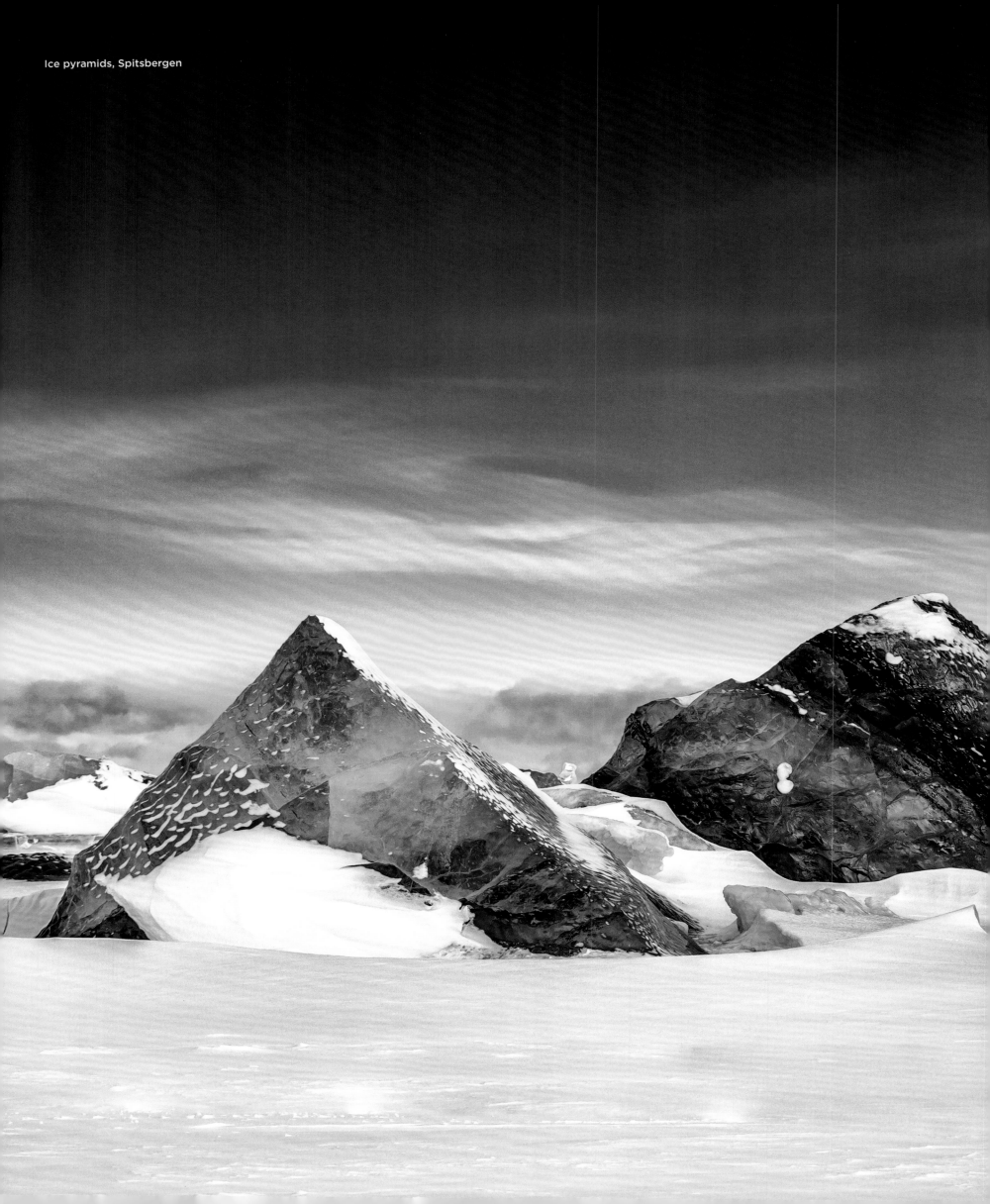

Ice pyramids, Spitsbergen

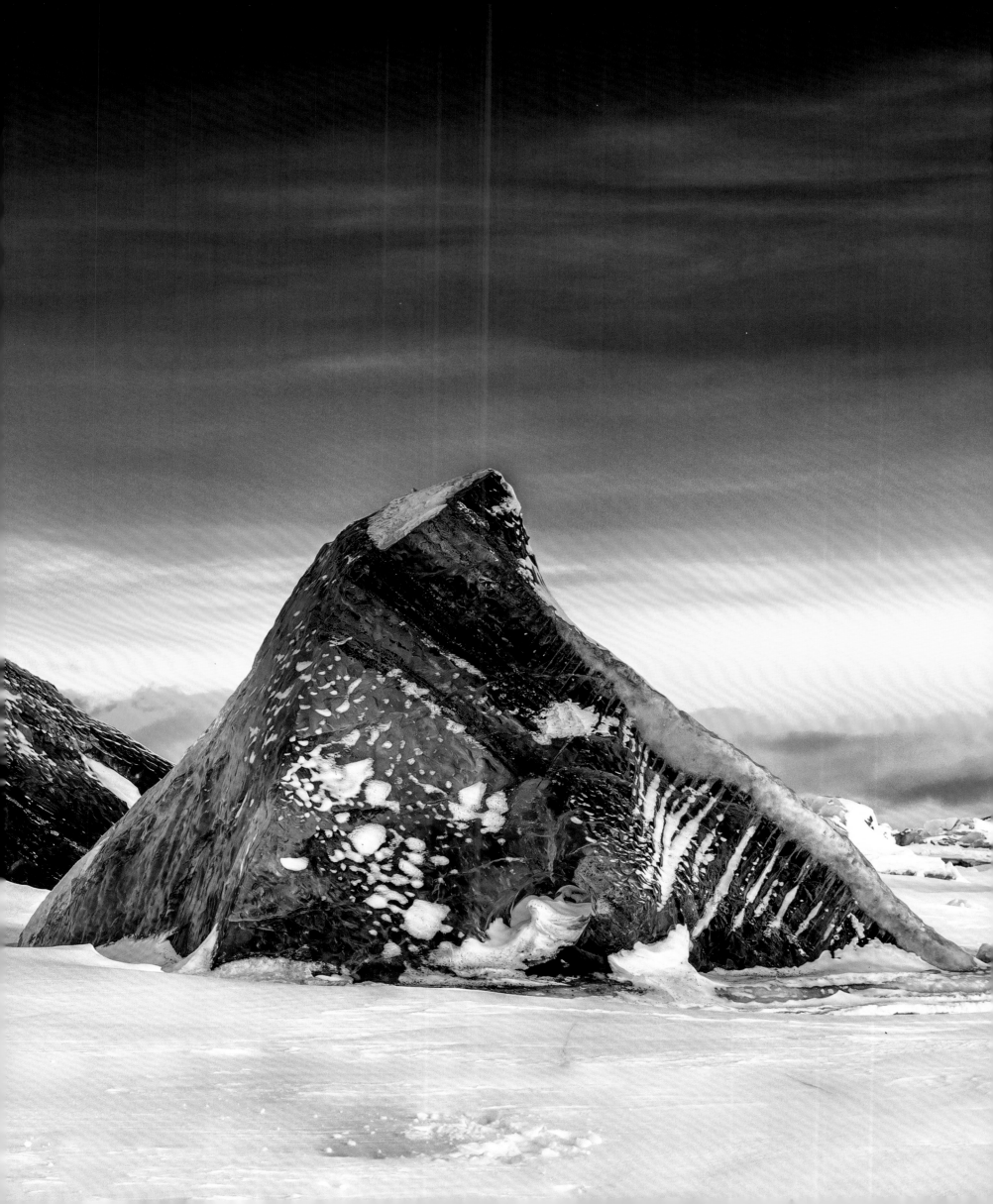

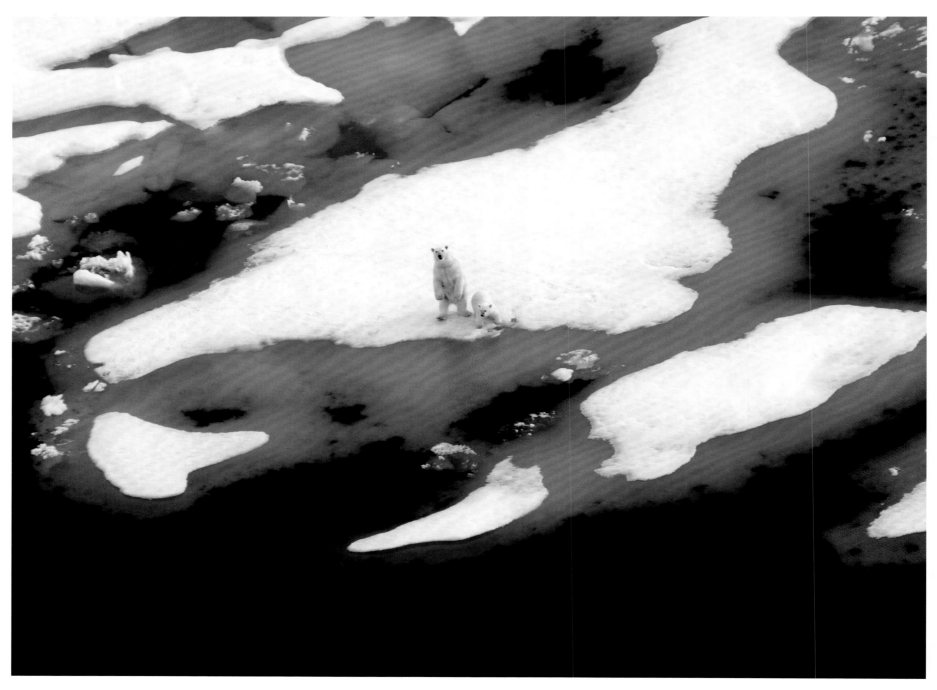

Polar bear, Chukchi Sea

Northeast Passage

The "50 Let Pobedy" ("50 Years of Victory", referring to the victory over Nazi Germany) is the most powerful Russian nuclear icebreaker. With a power of 75,000 hp, it can plough through ice up to three meters (10 feet) thick. The ship was built to escort research and cargo ships through the Northeast Passage, which connects the Atlantic and Pacific Oceans. In the summer months, the icebreaker makes some extra voyages with tourists to the North Pole. As global warming progresses, the "50 Let Pobedy" will be able to bring more tourists to the North Pole in the future, because in a few decades the Northeast Passage should be virtually ice-free during summer.

Le passage du Nord-Est

« Les cinquante ans de la Victoire » (il est ici question de la victoire sur l'Allemagne nazi) est le plus efficace des brise-glaces russes. Avec une puissance de 75 000 ch, il est capable de fendre de la glace allant jusqu'à 3 m d'épaisseur. Le bateau fut construit dans le but d'escorter les navires de recherche et les cargos le long du passage du Nord-Est qui relie l'Atlantique au Pacifique. L'été, le brise-glace effectue quelques voyages supplémentaires jusqu'au pôle Nord avec des touristes à son bord. Malheureusement, à cause du réchauffement progressif de la planète, « Les cinquante ans de la Victoire » pourra à l'avenir transporter des touristes jusqu'au pôle Nord plus fréquemment car dans quelques décennies, le passage du Nord-Est sera complètement dégelé l'été.

Nordostpassage

Die „50 Let Pobedy" („50 Jahre Sieg", bezogen auf den Sieg über Nazideutschland) ist der stärkste russische Atomeisbrecher. Mit der Kraft von 75 000 PS kann er bis zu drei Meter dickes Eis durchpflügen. Gebaut wurde das Schiff, um Forschungs- und Frachtschiffe durch die Nordostpassage, die Atlantik und Pazifik verbindet, zu eskortieren. In den Sommermonaten macht der Eisbrecher einige Extratouren mit Touristen zum Nordpol. Mit fortschreitender Erderwärmung wird die „50 Let Pobedy" in Zukunft öfter Touristen zum Nordpol bringen können, denn in wenigen Jahrzehnten dürfte die Nordostpassage im Sommer so gut wie eisfrei sein.

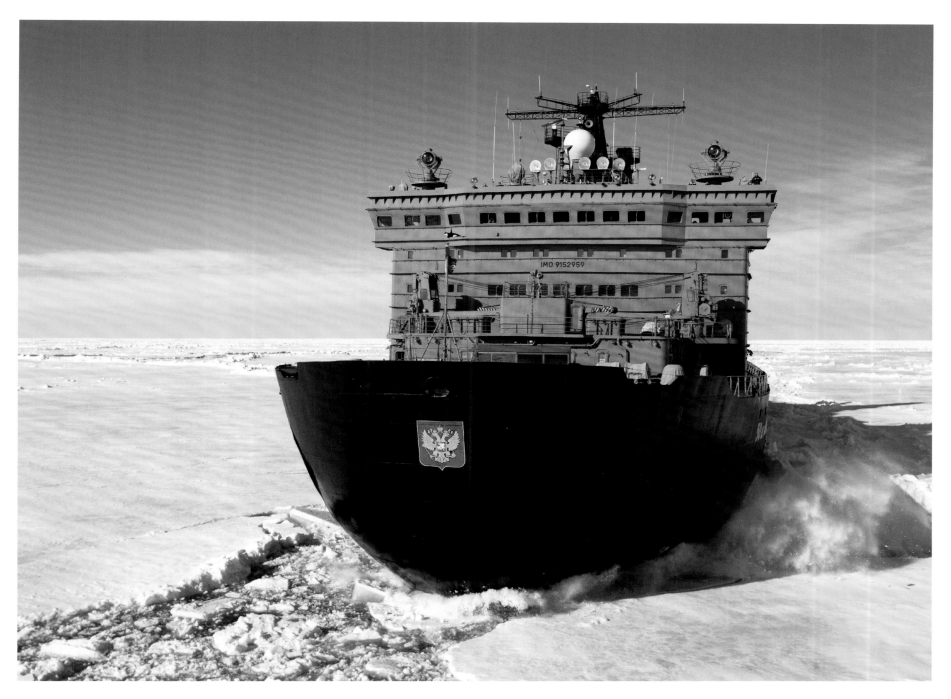

Russian nuclear-powered icebreaker, North Pole

Paso del Noreste

Los «50 Let Pobedy» («50 años de la victoria» es decir, la victoria sobre la Alemania nazi) es el rompehielos nuclear ruso más fuerte. Con una potencia de 75 000 CV, puede arar hielo de hasta tres metros de espesor. El buque fue construido para escoltar a los buques de investigación y carga a través del Paso Noreste, que conecta los Océanos Atlántico y Pacífico. En los meses de verano, el rompehielos realiza algunos tours extra con turistas al Polo Norte. A medida que avance el calentamiento global, la «50 Let Pobedy» podrá atraer a más turistas al Polo Norte en el futuro, porque en unas pocas décadas el Paso del Noreste debería ser tan bueno como un lugar libre de hielo en verano.

Passagem do Nordeste

Os "50 Let Pobedy" ("50 Anos de Vitória" que significa a vitória sobre a Alemanha nazista) é o nome do mais forte quebra-gelo nuclear russo (50 Let Pobedy). Com a potência de 75 000 hp, pode atravessar através do gelo de até três metros de espessura. O navio foi construído para escoltar navios de pesquisa e carga através da Passagem do Nordeste, que liga os oceanos Atlântico e Pacífico. Nos meses de verão, o quebra-gelo faz alguns passeios extras com turistas ao Pólo Norte. Com o avanço do aquecimento global, o navio "50 Let Pobedy" poderá trazer mais turistas para o Pólo Norte no futuro, pois em poucas décadas a Passagem do Nordeste deverá no verão estar praticamente sem gelo.

Noordoost Passage

De „50 Let Pobedy" („50 jaar van de overwinning", de overwinning op nazi-Duitsland) is de sterkste Russische atoomijsbreker. Met een vermogen van 75 000 pk kan hij zich tot drie meter dik ijs ploegen. Het schip is gebouwd om onderzoeks- en vrachtschepen te begeleiden door de Noordoost Passage, die de Atlantische en Stille Oceaan met elkaar verbindt. In de zomermaanden maakt de ijsbreker extra toeristenrondleidingen naar de Noordpool. Naarmate de opwarming van de aarde vordert, zal de „50 Let Pobedy" in staat zijn om in de toekomst meer toeristen naar de Noordpool te brengen, want over een paar decennia zou de Noordoost Passage in de zomer zo goed als ijsvrij moeten zijn.

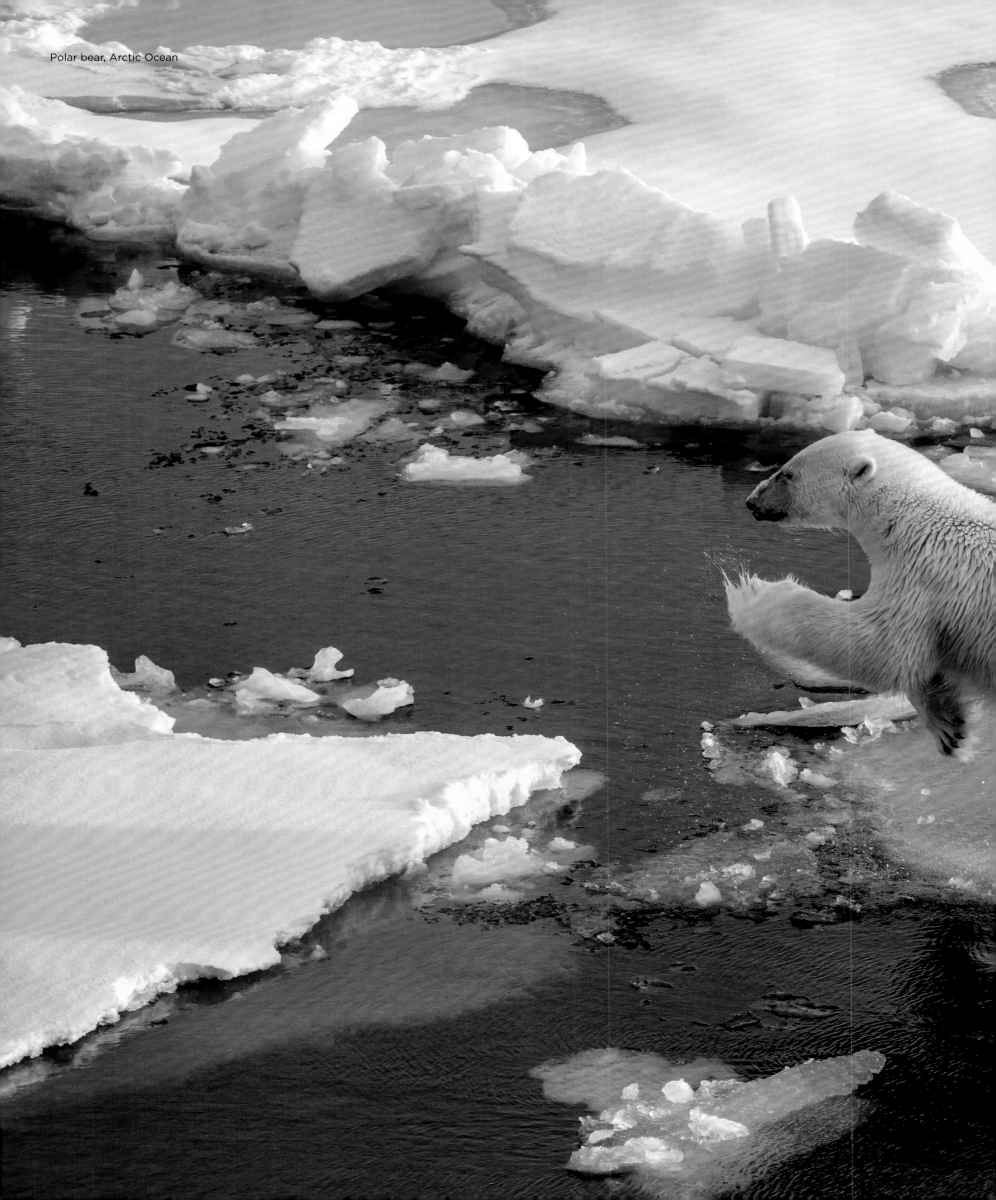

Polar bear, Arctic Ocean

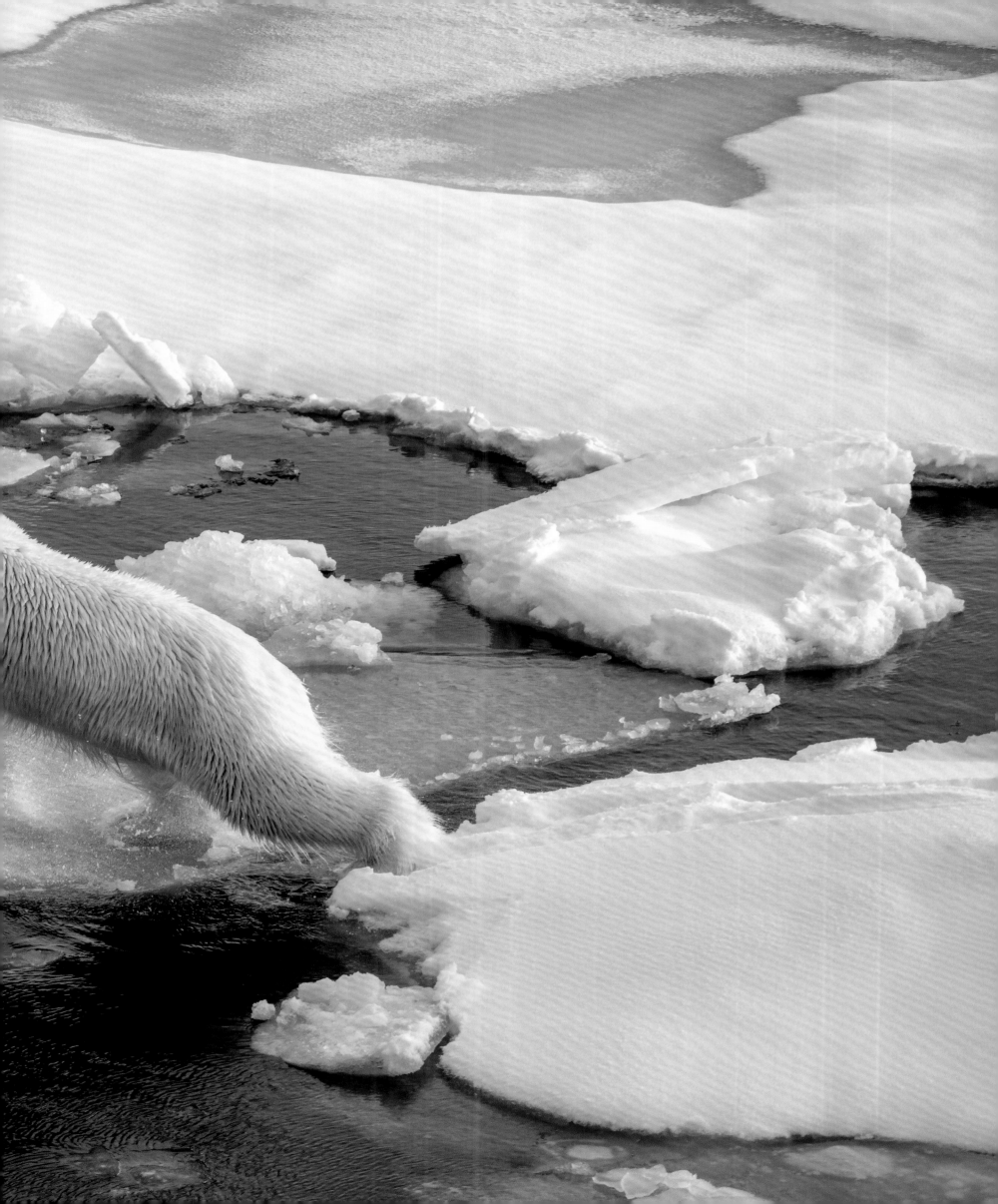

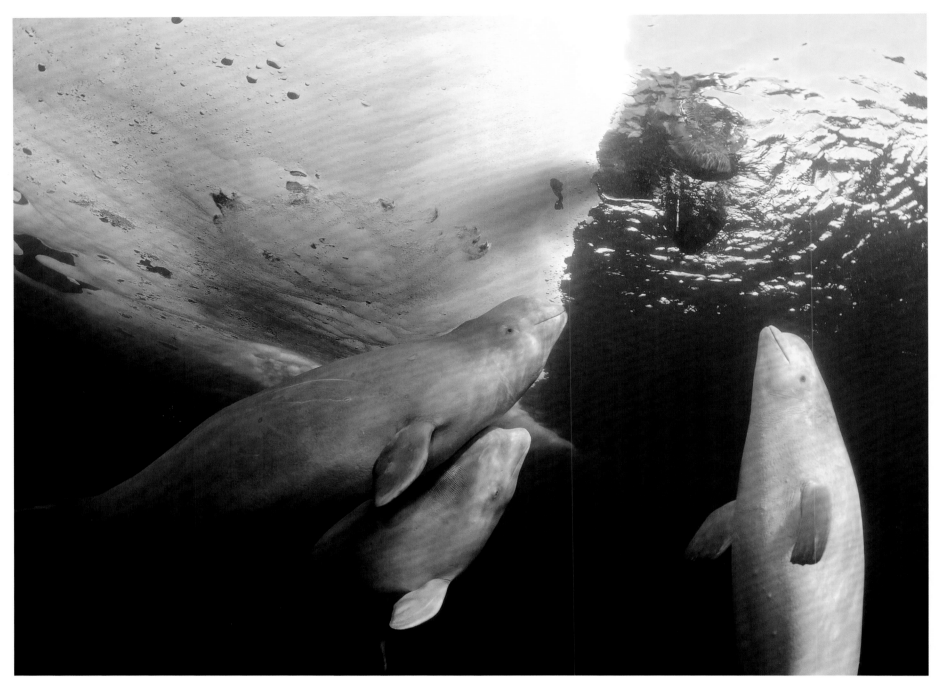

Beluga whales, White Sea, Russia

Beluga whales

Belugas or white whales have some distinctive characteristics, mainly their cream or bluish-white skin, but newborns are grey to brown. On the head of the adults there is a thickening called the melon. In contrast to many other whale species, Belugas have no dorsal fin. They can change their facial expression, but this has nothing to do with emotions. Belugas are very communicative and live in small groups, especially off the coasts of Alaska, Canada and Russia. Some animals swim in rivers from time to time.

Bélugas

Les bélugas, ou baleines blanches, possèdent un certain nombre de caractéristiques distinctives. La première d'entre elles étant leur peau couleur crème ou blanc bleuté. La couleur des nouveau-nés varie toutefois entre le gris et le brun. Les adultes ont sur la tête une protubérance que l'on appelle le melon. Contrairement à de nombreuses autres espèces de baleines, les bélugas n'ont pas d'aileron dorsal. Ils sont capables de modifier l'expression de leur visage, cela n'a cependant rien à voir avec l'expression de leurs sentiments. Les bélugas sont très communicatifs et vivent en petits groupes, principalement le long des côtes de l'Alaska, du Canada et de la Russie. Il arrive que des animaux solitaires se déplacent dans les rivières.

Belugawale

Belugas oder Weißwale besitzen einige unverwechselbare Eigenschaften. Dies ist vor allem ihre cremefarbene oder bläulich-weiße Haut – Neugeborene sind jedoch grau bis braun. Auf dem Kopf von erwachsenen Tieren gibt es eine Verdickung, die sogenannte Melone. Im Gegensatz zu vielen anderen Walarten haben Belugas keine Rückenfinne. Sie können ihren Gesichtsausdruck verändern, was aber wohl nichts mit Gefühlsäußerungen zu tun hat. Belugas sind sehr kommunikativ und leben in kleinen Gruppen, vor allem vor den Küsten Alaskas, Kanadas und Russlands. Einzelne Tiere schwimmen hin und wieder auch in Flüsse.

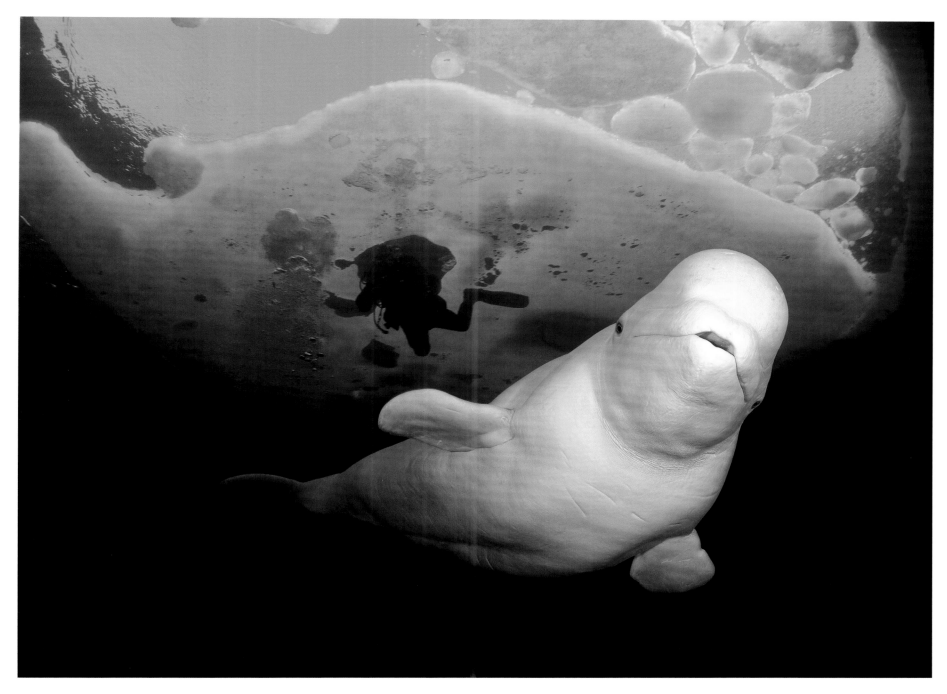

Beluga whales, White Sea, Russia

Belugas

Las belugas o ballenas blancas poseen algunas características distintivas. Se trata principalmente de su piel de color crema o blanco azulado, pero los recién nacidos son de color gris a marrón. En la cabeza de los animales adultos hay un engrosamiento llamado melón. A diferencia de muchas otras especies de ballenas, las belugas no tienen aleta dorsal. Pueden cambiar su expresión facial, pero esto no tiene nada que ver con las emociones. Las belugas son muy comunicativas y viven en pequeños grupos, especialmente en las costas de Alaska, Canadá y Rusia. Algunos animales nadan en los ríos de vez en cuando.

Baleias-beluga

As belugas ou baleias-brancas têm algumas características inconfundíveis. Esta é principalmente delas, a sua pele creme ou branco-azulada, mas os recém-nascidos são cinzentos a castanhos. Na cabeça dos animais adultos há um espessamento que abriga o órgão chamado melão. Ao contrário de muitas outras espécies de baleias, as belugas não tem barbatana dorsal. Eles podem mudar a sua expressão facial, mas isso provavelmente não tem nada a ver com as emoções. As belugas são muito comunicativas e vivem em pequenos grupos, especialmente ao largo das costas do Alasca, Canadá e Rússia. Alguns animais nadam em rios de vez em quando.

Witte Walvissen

Beloega's of witte walvissen hebben een aantal unieke eigenschappen. Dit is voornamelijk hun crème of blauwachtig witte huid, pasgeborenen daarentegen zijn grijs tot bruin. Op de kop van volwassen dieren zit een verdikking die meloen wordt genoemd. In tegenstelling tot veel andere walvissoorten hebben Beloega's geen rugvin. Ze kunnen hun gelaatsuitdrukking veranderen, maar dit heeft niets met emoties te maken. Beloega's zijn zeer communicatief en leven in kleine groepen, vooral voor e kust van Alaska, Canada en Rusland. Sommige ieren zwemmen af en toe in rivieren.

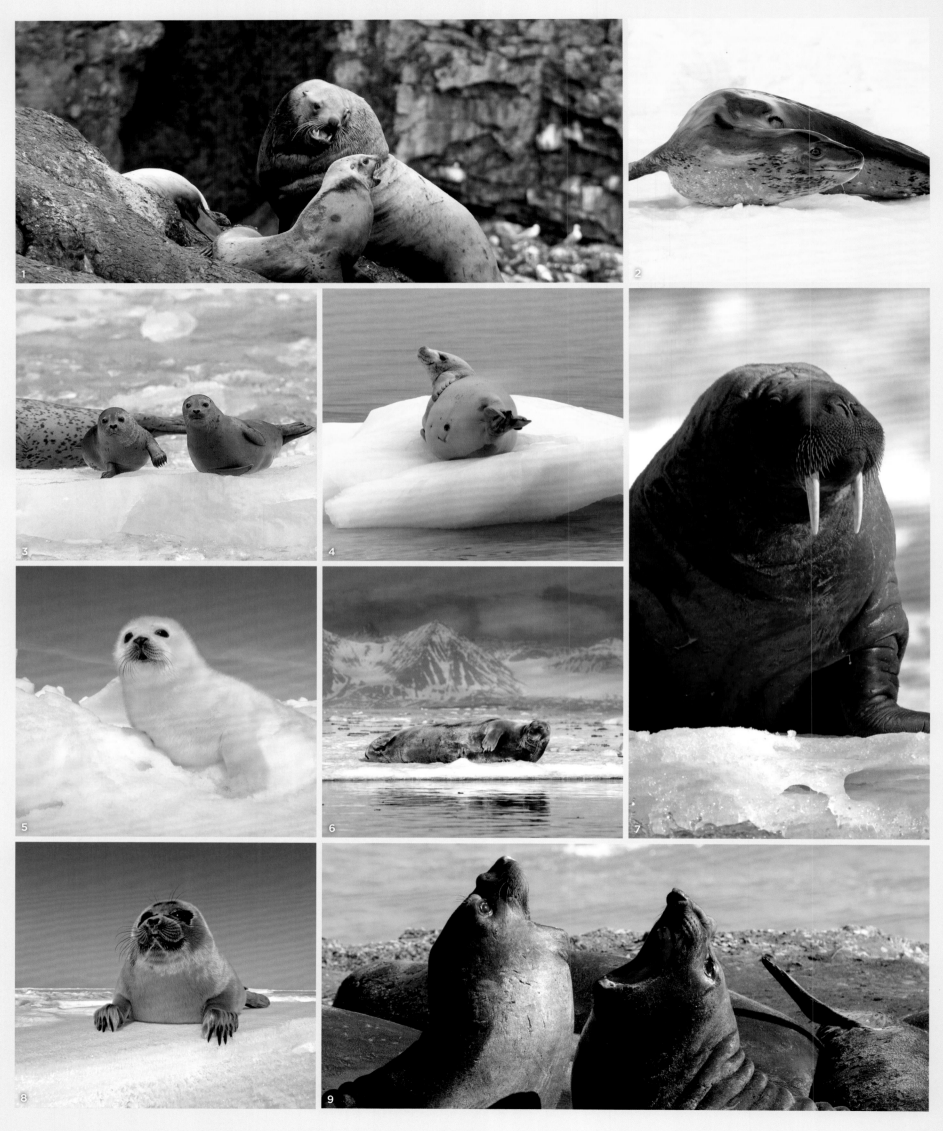

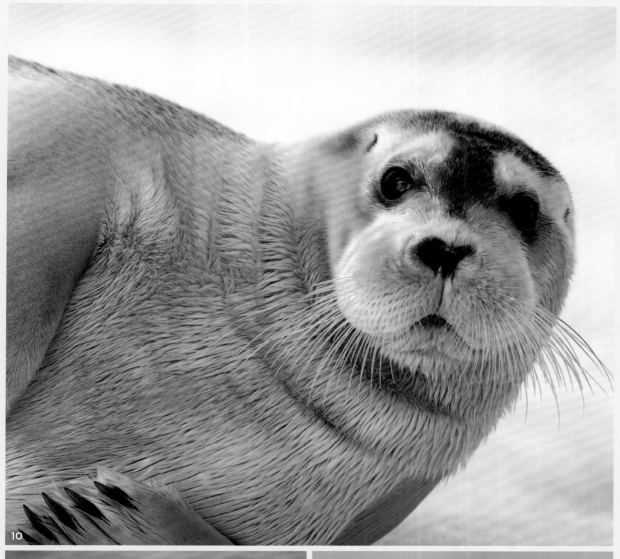

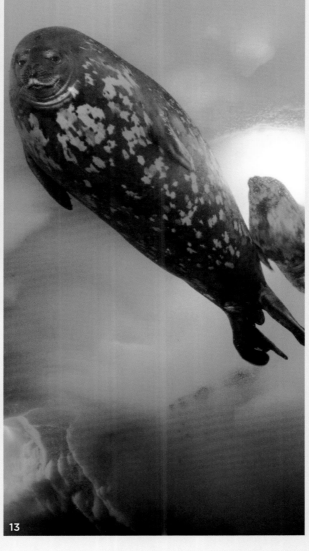

Seals

1 Steller sea lion, Lion de mer de Steller, Stellerscher Seelöwe, León marino de Steller, Leão-marinho-de-steller, Stellerzeeleeuw

2 Leopard seal, Léopard de mer, Seeleopard, Leopardo marino, Foca-leopardo, Zeeluipaard

3 Harbor seal, Phoque commun, Seehund, Foca, Gewone zeehond

4 Crabeater seal, Phoque crabier, Krabbenfresser Robbe, Foca cangrejera, Foca-caranguejeira, Krabbenrob

5 Harp seal, Phoque du Groenland, Sattelrobbe, Foca pía, Foca-da-groelândia, Zadelrob

6, 9 Bearded seal, Phoque barbu, Bartrobbe, Foca barbuda, Foca-barbuda, Baardrob

7 Walrus, Morse, Walross, Morsa, Walrus

8 Baikal seal, Phoque de Sibérie, Baikalrobbe, Nerpa, Foca-de-baikal, Baikalrob

9, 11 Southern elephant seal, Éléphant de mer du sud, Südlicher See-Elefant, Elefante marino del sur, Elefante-marinho-do-sul, Zuidelijk zeeolifant

12 Weddell seal, Phoque de Weddell, Weddellrobbe, Foca de Weddell, Foca-de-weddell, Weddellzeehond

13 Ringed seal, Phoque annelé, Ringelrobbe, Foca anillada, Foca-anelada, Ringelrob

Canada

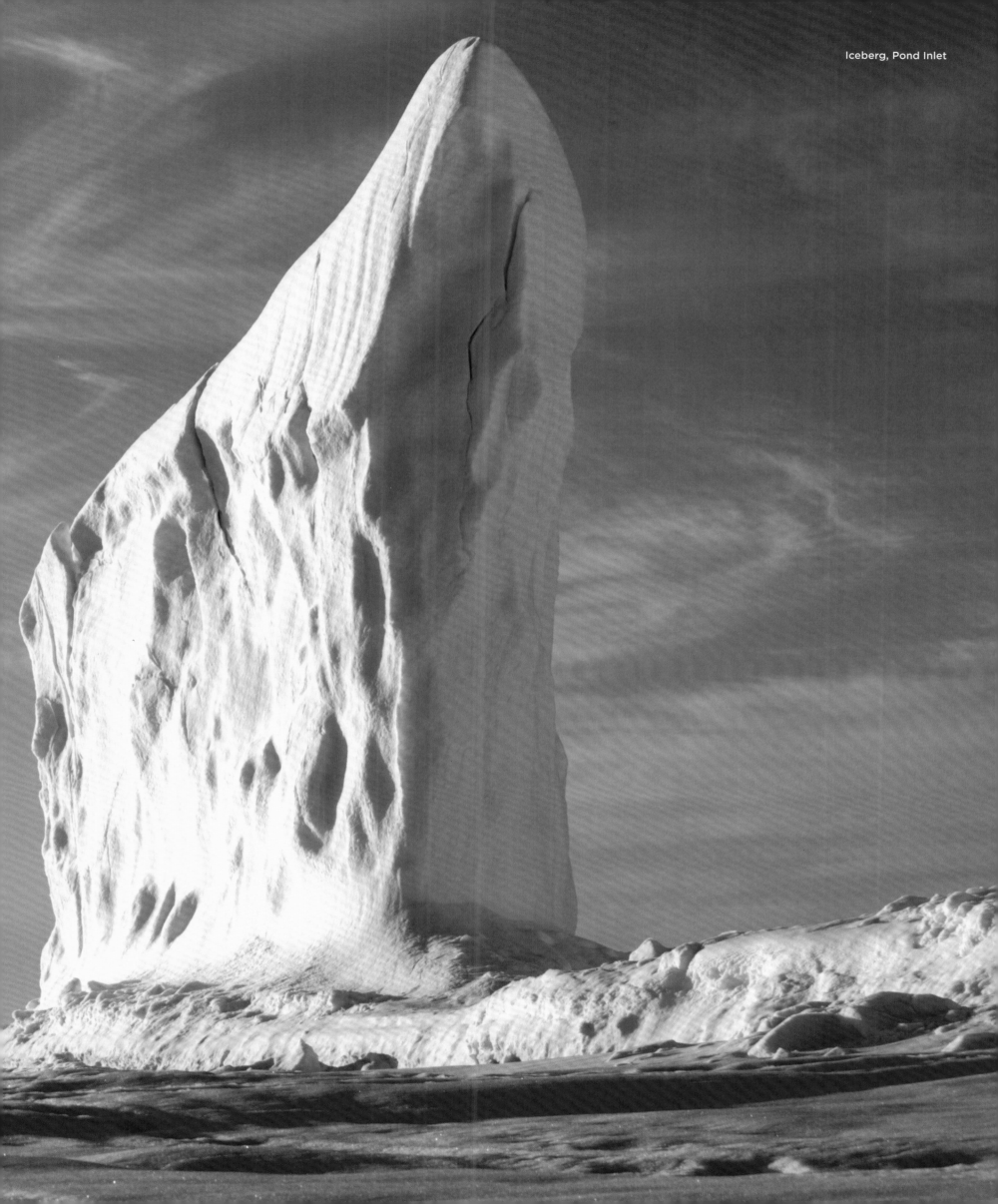

Iceberg, Pond Inlet

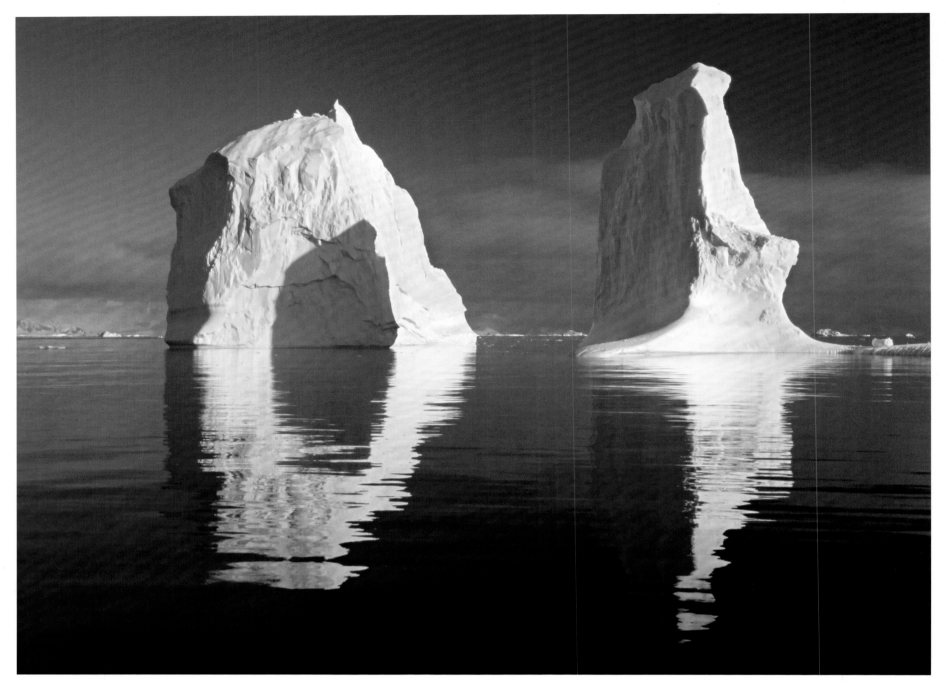

Iceberg, Pond Inlet

Canada

With an area of almost 10 million km² (4 million sq mi)
Canada is almost as big as Europe. Of the 37 million
inhabitants, 5.6 million live in Toronto and 1.2 million
in the capital Ottawa. Large areas are still almost
untouched tundra and mountains. The winters are
long and sometimes very cold, and temperatures of
minus 30 to 40 °C (-22 to -40 °F) are not uncommon.
At these temperatures even the Niagara Falls freeze
into a bizarre ice landscape, and the Ottawa Canal
becomes the longest ice rink in the world. The skiing
season in the mountains lasts from November to May,
with long deep snow runs in almost deserted nature
being one of the most impressive experiences.

Canada

Avec une surface de près de 10 millions de km²,
le Canada est presque aussi grand que l'Europe.
Parmi les 37 millions d'habitants du Canada, 5,6
vivent à Toronto et 1,2 dans la capitale, Ottawa. De
vastes territoires de toundra et de montagne restent
aujourd'hui encore presque vierges. Au Canada, les
hivers sont longs et très froids. Il n'est pas rare de
voir le thermomètre descendre jusqu'à -30° C ou
-40° C. Les chutes du Niagara en viennent même
à geler pour former d'étranges paysages de glace
et le canal Rideau, à Ottawa, se transforme en la
plus longue patinoire du monde. La saison de ski
dans les montagnes s'étend de novembre à mai et
offre des descentes en hors-piste au cœur d'une
nature presque déserte, pour une expérience des
plus impressionnantes.

Kanada

Mit knapp 10 Millionen km² ist Kanada fast so groß
wie Europa. Von den 37 Millionen Einwohnern leben
5,6 Millionen in Toronto und 1,2 Millionen in der
Hauptstadt Ottawa. Weite Gebiete sind bis heute
fast unberührte Tundra und Gebirge. Die Winter sind
lang und zum Teil sehr kalt, minus 30 bis 40 °C sind
keine Seltenheit. Dann frieren selbst die Niagarafälle
zu einer bizarren Eislandschaft und auf dem
Ottawa-Kanal entsteht die längste Eisbahn der Welt.
Die Skisaison in den Bergen reicht von November
bis Mai, wobei lange Tiefschneeabfahrten in fast
menschenleerer Natur zu den beeindruckendsten
Erlebnissen gehören.

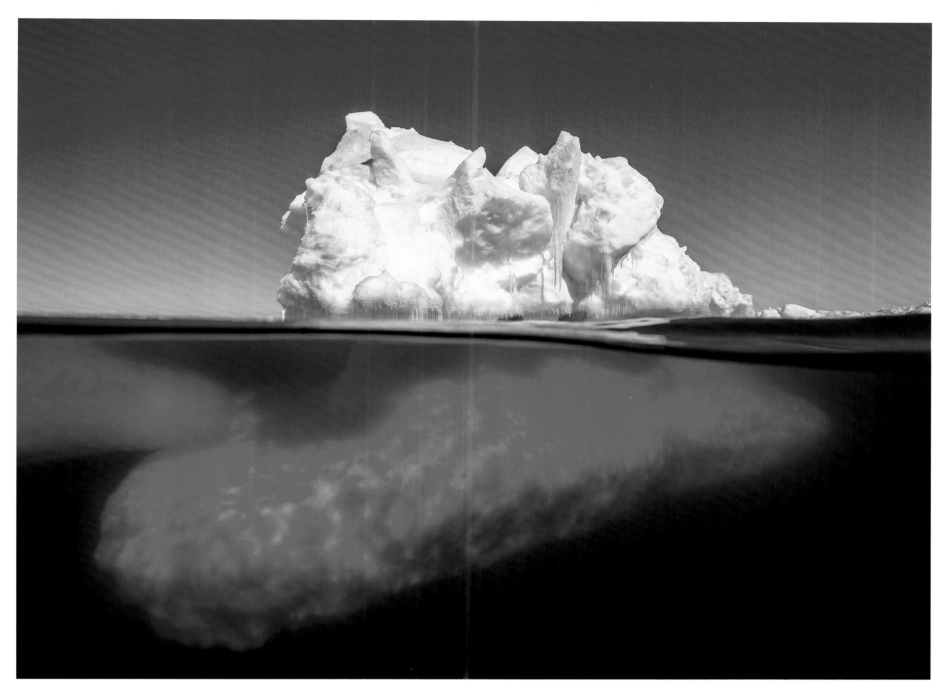

Iceberg, Admiralty Sound

Canadá

Con casi 10 millones de km², Canadá es casi tan grande como Europa. De sus 37 millones de habitantes, 5,6 millones viven en Toronto y 1,2 millones en la capital, Ottawa. Grandes áreas son todavía tundra y montañas que se encuentran casi intactas. Los inviernos son largos y a veces muy fríos: no es raro que haga de -30 a -40 °C. Entonces, incluso las cataratas del Niágara se congelan en un extraño paisaje de hielo y el Canal de Ottawa se convierte en la pista de hielo más larga del mundo. La temporada de esquí en la montaña dura de noviembre a mayo, con largas y profundas pistas de nieve en una naturaleza casi desierta, siendo una de las experiencias más impresionantes.

Canadá

Com quase 10 milhões de km², o Canadá é quase tão grande quanto a Europa. Dos 37 milhões de habitantes, 5,6 milhões vivem em Toronto e 1,2 milhões na capital Ottawa. Grandes áreas ainda são quase tundra e montanhas intocadas. Os invernos são longos e, por vezes, muito frios, não sendo incomuns os invernos com 30 a 40 °C negativos. Então, até mesmo as Cataratas do Niágara congelam em uma paisagem de gelo bizarra e o Canal de Ottawa se torna o maior rinque de patinação no gelo do mundo. A temporada de esqui nas montanhas dura de novembro a maio, com longas descidas profundas de neve na natureza quase deserta sendo uma das experiências mais impressionantes.

Canada

Met bijna 10 miljoen km² is Canada bijna net zo groot als Europa. Van de 37 miljoen inwoners wonen er 5,6 miljoen in Toronto en 1,2 miljoen in de hoofdstad Ottawa. Grote gebieden zijn nog steeds bijna onaangetaste toendra's en bergen. De winters zijn lang en soms erg koud, min 30 tot 40 °C zijn niet ongewoon. Zelfs de Niagara watervallen bevriezen in een ongewoon ijslandschap en wordt het Ottawa-river de langste ijsbaan ter wereld. Het skiseizoen in de bergen duurt van november tot mei, met lange diepsneeuwloipes in de bijna verlaten natuur is een van de meest indrukwekkende ervaringen.

Baffin Island, Nunavut

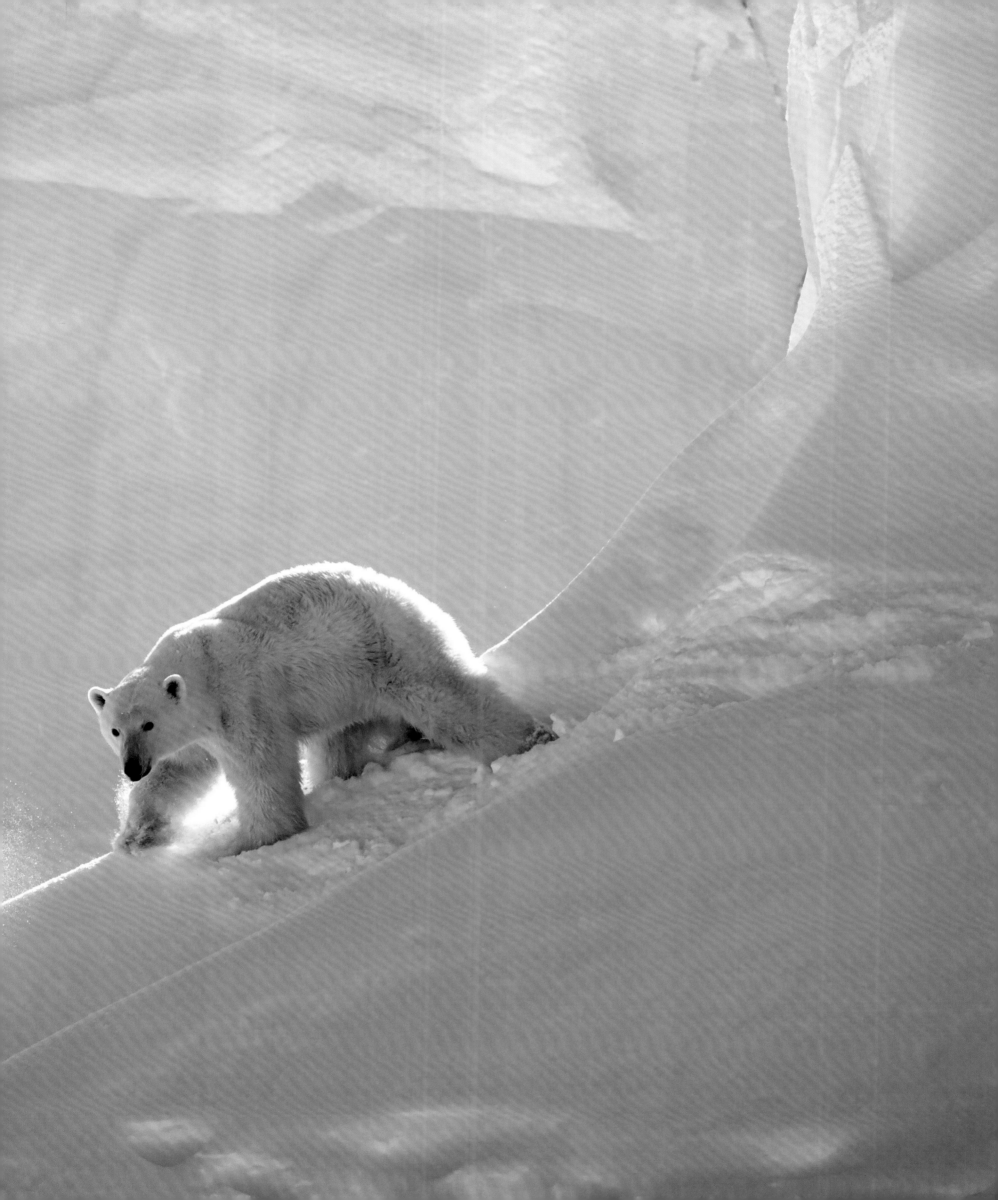

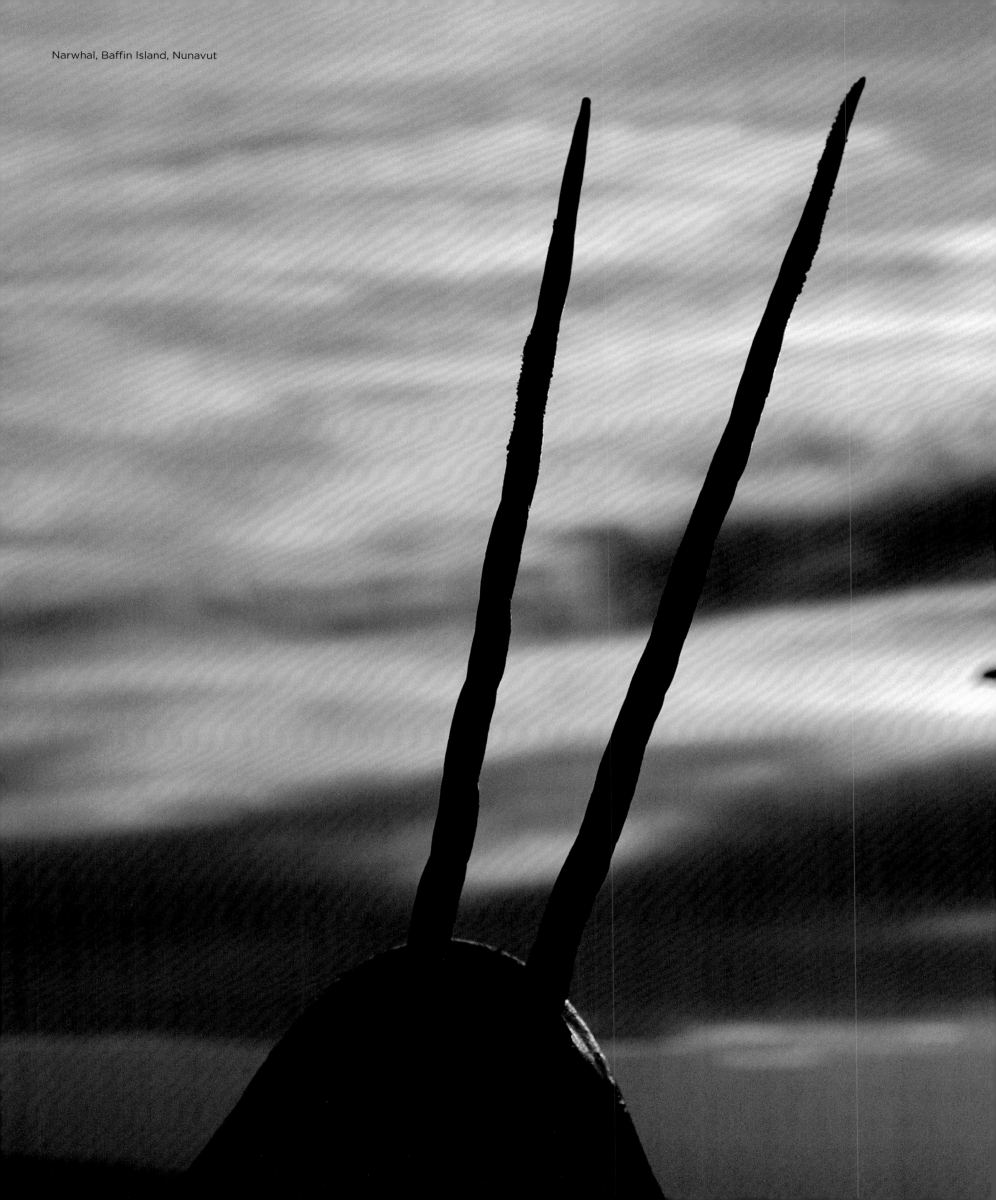

Narwhal, Baffin Island, Nunavut

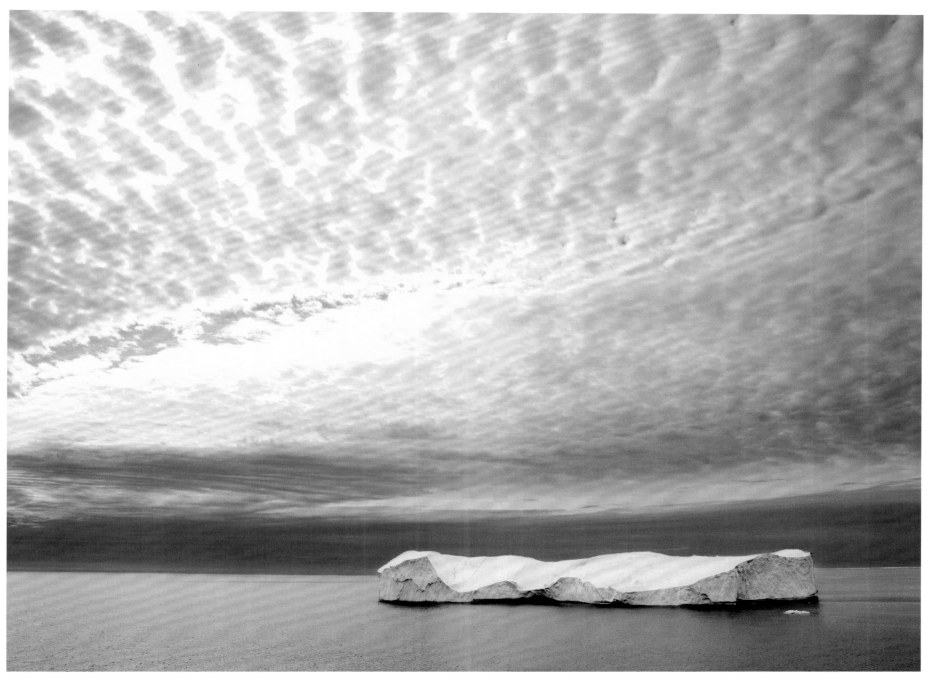

Baffin Island, Nunavut

Narwhals

In the past, the tusks of narwhals were worth their weight in gold because it was believed that they came from unicorns. However, these tusks are the extremely elongated left incisor of the upper jaw. It has spiral structures and can grow up to 3 m (10 ft) long. In fact, narwhals have two of these, but the one on the right often withers and falls out.

Narvals

Autrefois, les défenses des narvals avaient à la pesée la même valeur que l'or car on pensait qu'elles provenaient des licornes. En réalité, il s'agit de l'incisive gauche de la mâchoire supérieure des narvals, dont la structure est torsadée et qui, poussant à l'extrême, peut atteindre jusqu'à 3 m de long. D'ailleurs, les narvals possèdent deux de ces dents, mais la plupart du temps la droite s'atrophie et finit par tomber.

Narwale

Früher wurden Stoßzähne von Narwalen mit Gold aufgewogen, denn man glaubte, dass sie von Einhörnern stammten. Es ist jedoch der extrem verlängerte linke Schneidezahn des Oberkiefers, der spiralförmige Strukturen hat und bis zu 3 m lang werden kann. Eigentlich haben Narwale sogar zwei solcher Zähne, doch der rechte verkümmert oft und fällt aus.

Narvales

En el pasado, los colmillos de los narvales valían su peso en oro porque se creía que provenían de los unicornios. Sin embargo, es el incisivo izquierdo extremadamente alargado del maxilar superior el que tiene estructuras en espiral y puede crecer hasta 3 m de largo. De hecho, los narvales tienen dos de esos dientes, pero el derecho a menudo se atrofia y se cae.

Narvais

No passado, as presas dos narvais eram pesadas com ouro, porque se acreditava que vinham de unicórnios. No entanto, é o incisivo esquerdo extremamente alongado da mandíbula superior que possui estruturas em forma de espiral e pode crescer até 3 m de comprimento. Na verdade, os narvais têm dois desses dentes, mas o do lado direito muitas vezes é atrofiado e cai.

Narwallen

Vroeger waren slagtanden van narwallen net zo kostbaar als goud, omdat men dacht dat ze van eenhoorns afkomstig waren. Het is echter de extreem langgerekte linker snijtand van de bovenkaak die spiraalvormige structuren heeft en tot 3 m lang kan worden. In feite hebben narwallen twee van deze tanden, maar de rechter tand artrofieert en valt uit.

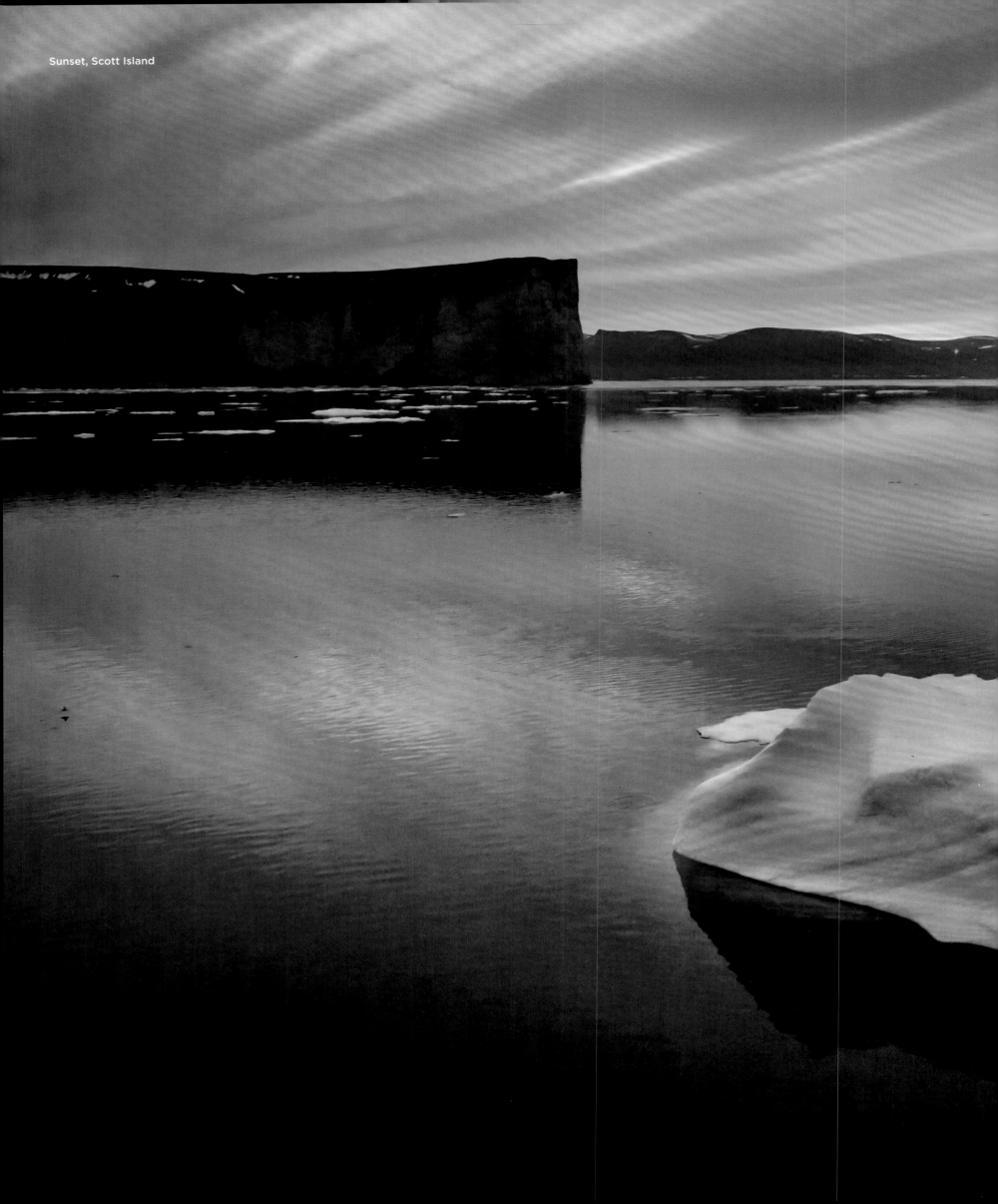

Sunset, Scott Island

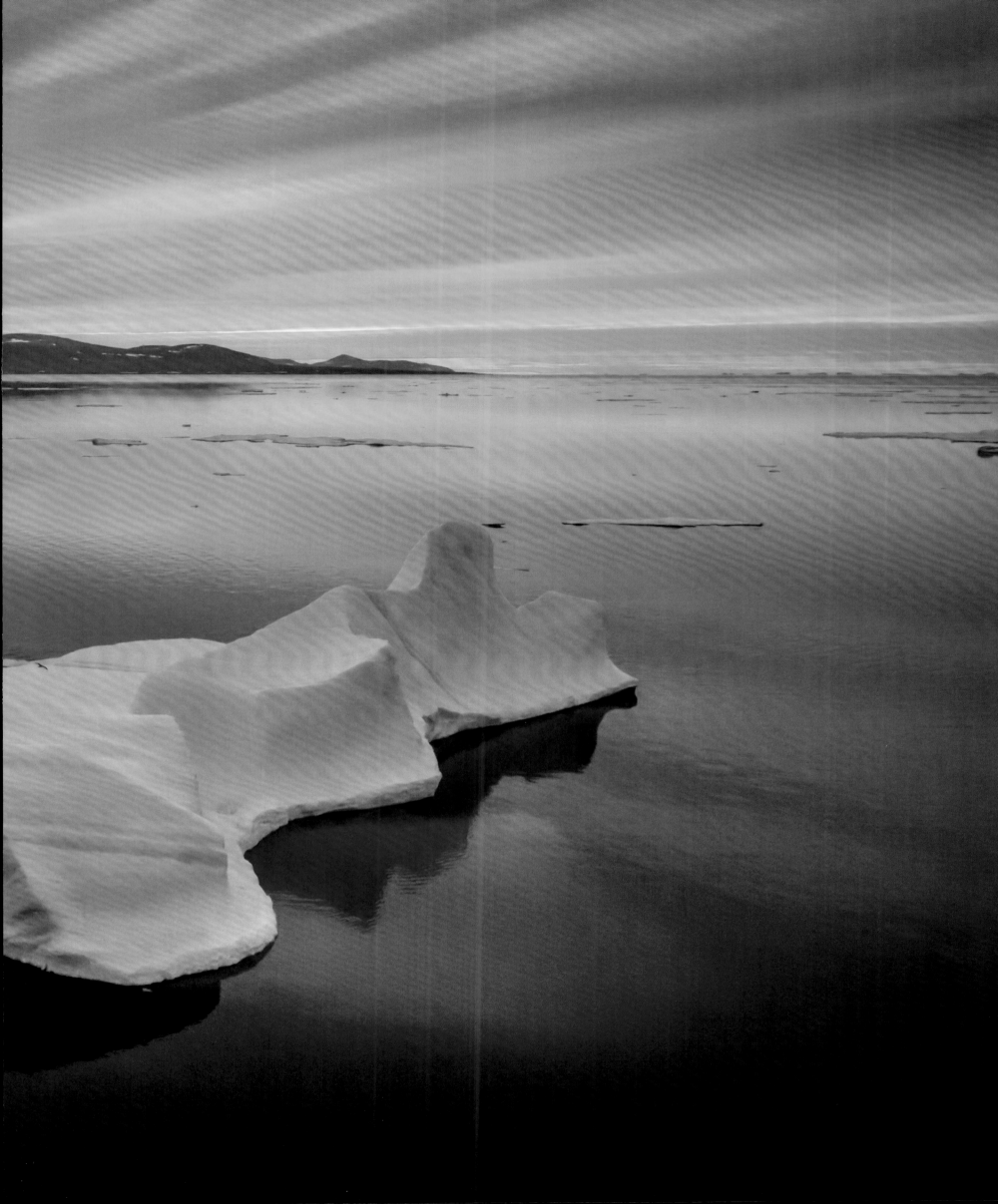

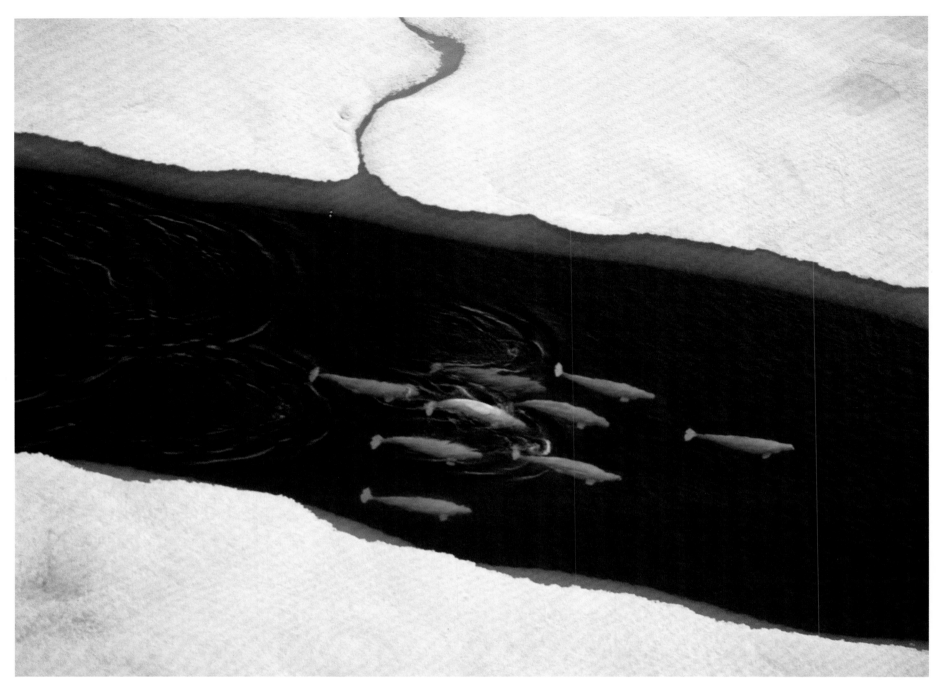

Beluga whales, Nunavut

Greenland Sharks

Greenland sharks or ice sharks are the most long-lived vertebrates, and can reach a maximum age of up to 400 years. The Latin name Somniosus microcephalus is not very flattering and can be translated as "the sleep drunk with the small brain". Ice sharks probably feed on seals and fish, which they also hunt at great depths. Attacks on humans are not known. The flesh of this shark must first be fermented for months before it becomes edible, and then it is known as Hákarl. In Greenland and Iceland, Hákarl is considered a delicacy by some, despite its strong taste.

Requins du Groenland

Les requins du Groenland sont les vertébrés ayant la plus longue espérance de vie avec un âge maximal pouvant atteindre 400 ans. Leur nom latin, *somniosus microcephalus,* est peu flatteur puisqu'il signifie « celui qui somnole et a une petite cervelle ». Les requins du Groenland se nourrissent probablement de phoques et de poissons qu'ils chassent également dans les grandes profondeurs. Néanmoins, aucune attaque contre un humain n'a jamais été rapportée. La chair de ces requins doit fermenter des mois durant avant de pouvoir être consommée sous forme d'Hákarl. Au Groenland et en Islande, cette spécialité culinaire est considérée comme un produit raffiné, malgré son goût prononcé.

Grönlandhaie

Grönlandhaie oder Eishaie sind die langlebigsten Wirbeltiere, sie können ein maximales Alter von bis zu 400 Jahren erreichen. Der lateinische Name Somniosus microcephalus ist wenig schmeichelhaft und lässt sich mit „der Schlaftrunkene mit dem kleinen Gehirn" übersetzen. Wahrscheinlich ernähren sich Eishaie von Robben und Fischen, die sie auch in großen Tiefen jagen. Angriffe auf Menschen sind nicht bekannt. Das Fleisch muss erst monatelang fermentiert werden, bevor es als Hákarl genießbar wird. In Grönland und Island gilt Hákarl, trotz des strengen Geschmacks, einigen als Delikatesse.

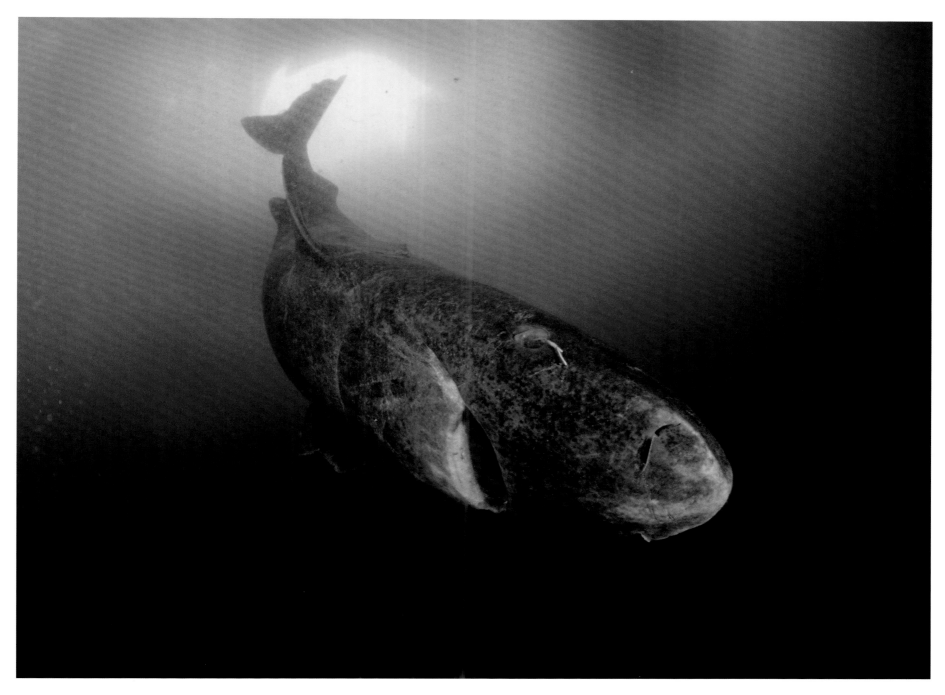

Greenland shark, Lancaster Sound

Tiburones de Groenlandia

Los tiburones de Groenlandia o tiburones boreales son los vertebrados más longevos: pueden alcanzar una edad máxima de hasta 400 años. El nombre latino Somniosus microcephalus no es muy halagador y puede traducirse como «el somnoliento con el cerebro pequeño». Probablemente los tiburones boreales se alimenten de focas y peces, que también cazan a grandes profundidades. No se conoce que se hayan producido ataques a los seres humanos. La carne debe ser fermentada durante meses antes de convertirse en comestible como hákarl. En Groenlandia e Islandia, el hákarl es considerado un manjar por algunos, a pesar de su intenso sabor.

Tubarões-da-groenlândia

Os tubarões-da-groenelândia ou tubarões de gelo são os vertebrados que têm a vida mais longa, podendo atingir uma idade máxima de até 400 anos. O nome latino Somniosus microcephalus não é muito lisonjeiro e pode ser traduzido como «o bêbado que dorme com o cérebro pequeno". Provavelmente os tubarões de gelo alimentam-se de focas e peixes, que também caçam a grandes profundidades. Os ataques a humanos não são conhecidos. A carne deve ser primeiro fermentada durante meses antes de se tornar comestível como "Hákarl". Na Gronelândia e na Islândia, o Hákarl é considerado uma iguaria por alguns, apesar do seu forte sabor.

Groenlandse haaien

Groenlandse haaien of ijshaaien zijn de meest langlevende gewervelde dieren, ze kunnen een maximale leeftijd van 400 jaar bereiken. De Latijnse naam Somniosus microcephalus is niet erg vleiend en kan vertaald worden als „de slaap dronken met de kleine hersenen". Waarschijnlijk voeden de ijshaaien zich met zeehonden en vissen, waarop ze ook op grote diepte jagen. Aanvallen op mensen zijn niet bekend. Het vlees moet eerst maandenlang worden gefermenteerd voordat het als Hákarl eetbaar wordt. In Groenland en IJsland wordt Hákarl door sommigen beschouwd als een delicatesse, ondanks de strenge smaak.

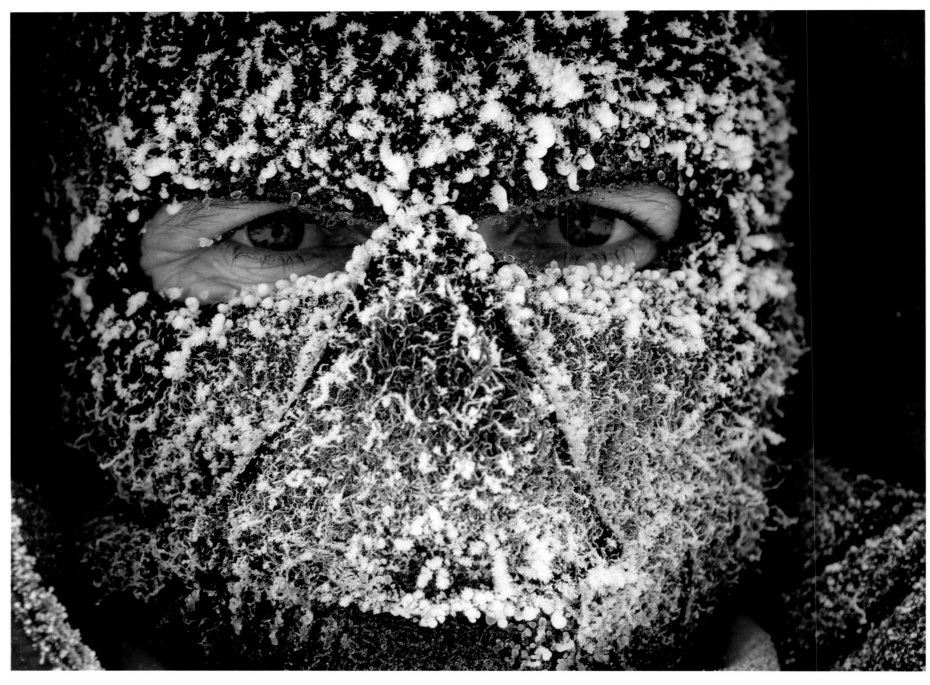

Iced face mask, Pelly Crossing

Fulda Challenge

Every year since 2001, athletes and celebrities have been competing in the Fulda Challenge in the Yukon Territory. This extreme sports event takes place in January at temperatures as low as minus 40 °C (-40 °F). The event is held in the Yukon Territory every year. The organizers always come up with new competitions such as speed skating, skidoo races, biathlon, ice climbing, skijoring or dog sled races.

Fulda Challenge

Desde 2001, atletas y celebridades han estado compitiendo en el Fulda Challenge todos los años en el territorio del Yukón. El evento de deportes extremos tiene lugar en enero a temperaturas tan bajas como -40 °C. El evento se celebra en el territorio del Yukón todos los años. Los organizadores siempre organizan nuevas competiciones como patinaje de velocidad, carreras de skidoo, biatlón, escalada en hielo, skijoring o carreras de trineos de perros.

Le Fulda Challenge

Depuis 2001, athlètes et célébrités se retrouvent chaque année sur le territoire du Yukon pour le Fulda Challenge. Cette rencontre de sports extrêmes a lieu en janvier, par des températures allant jusqu'à -40° C. Les organisateurs regorgent de nouvelles idées et proposent des disciplines telles que le patinage de vitesse, la course de motoneiges, le biathlon, l'escalade glaciaire, le ski joëring ou la course de chiens de traîneau.

Desafio de Fulda

Desde 2001, atletas e celebridades têm competido no "Fulda Challenge" todos os anos no território de Yukon. O evento de esportes radicais acontece em janeiro a temperaturas tão baixas quanto menos 40 °C. Os organizadores sempre aparecem com novas competições como patinação de velocidade, corridas de skidoo, biatlo, escalada no gelo, skijoring ou corridas de trenó para cães.

Fulda-Challenge

Seit 2001 treten im Yukon-Territorium alljährlich Athleten und Prominente zur Fulda-Challenge an. Das Extremsportevent findet im Januar bei Temperaturen von bis zu minus 40 °C statt. Die Veranstalter lassen sich immer wieder neue Wettkämpfe wie Eisschnelllauf, Skidoo-Rennen, Biathlon, Eisklettern, Skijöring oder Hundeschlittenrennen einfallen.

Fulda Challenge

Elk jaar sinds 2001 doen atleten en beroemdheden mee aan de Fulda Challenge in het Yukon-territorium Het extreme sportevenement vindt plaats in januari bij temperaturen tot -40 °C. De organisatoren komen altijd met nieuwe wedstrijden zoals schaatsen, sneeuwscooter wedstrijden, biatlon, ijsklimmen, skijøring of hondensleeën.

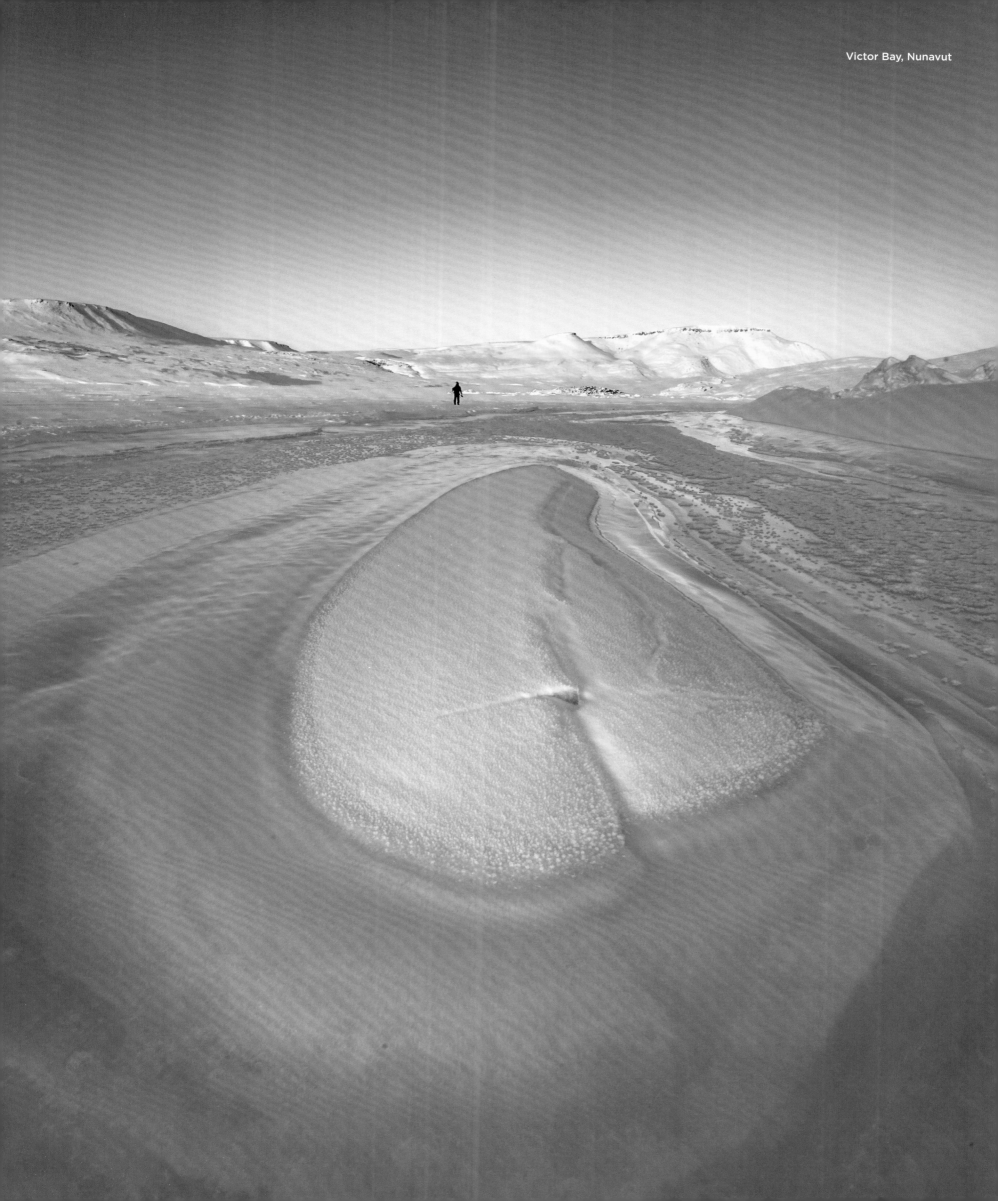

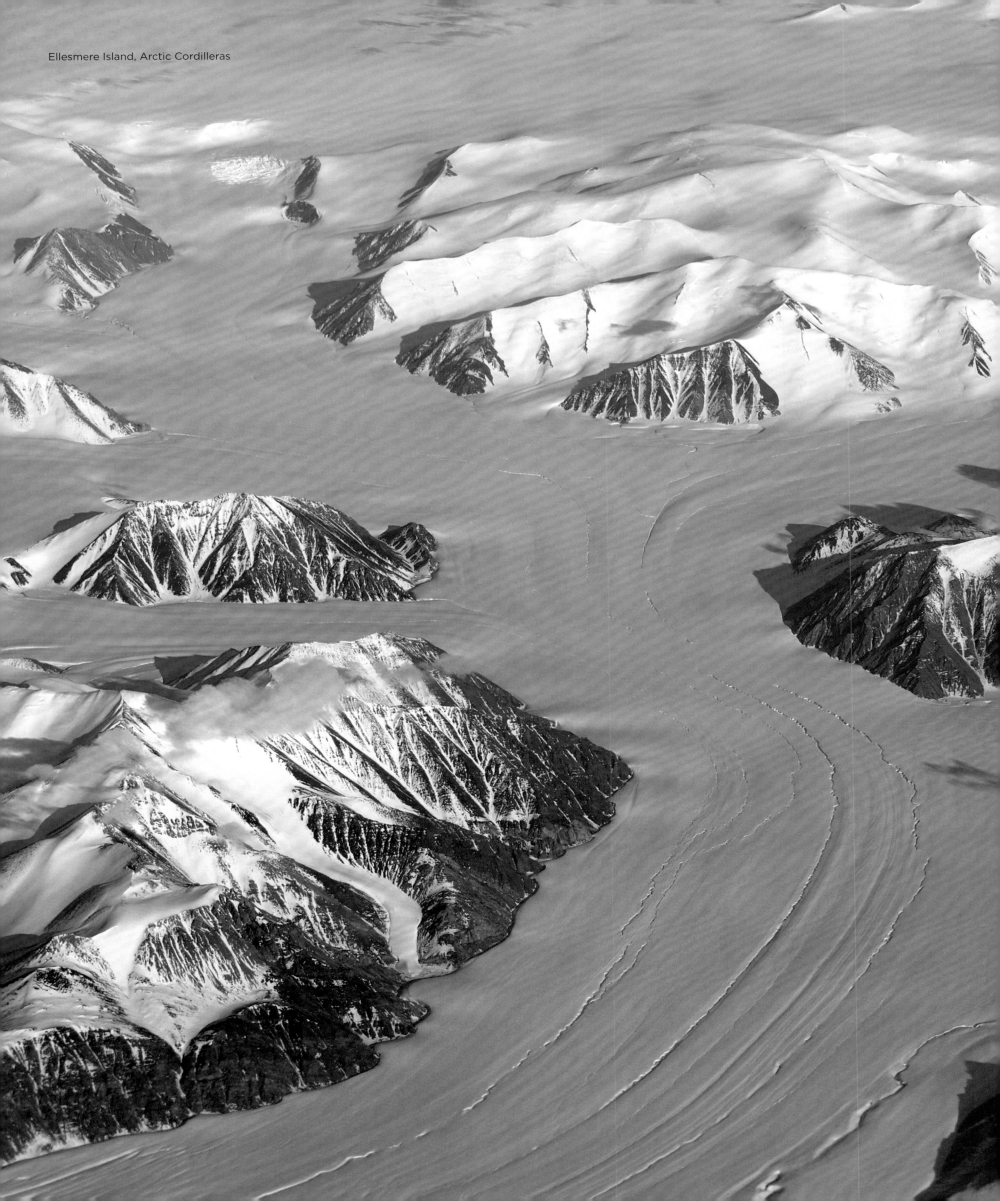
Ellesmere Island, Arctic Cordilleras

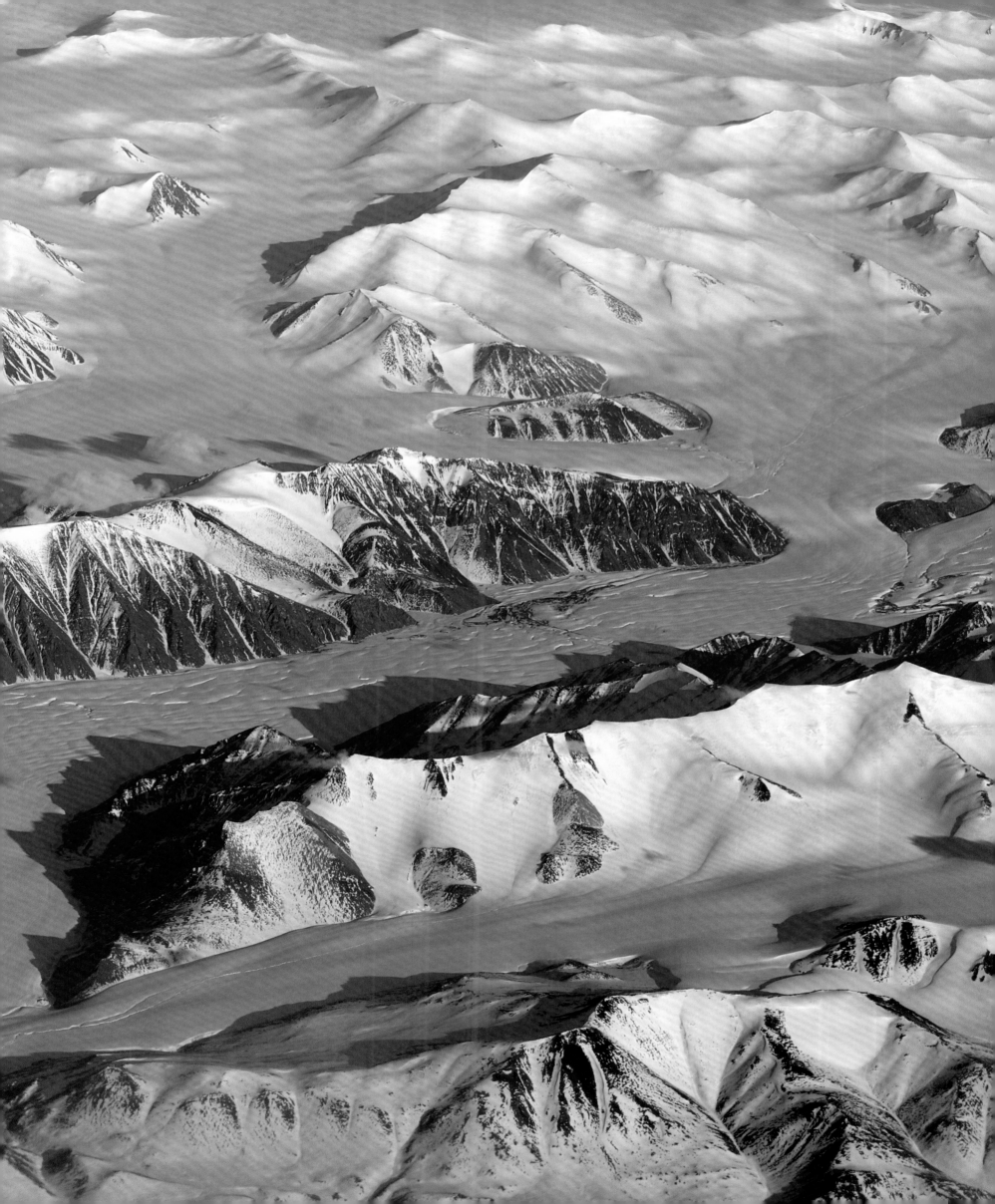

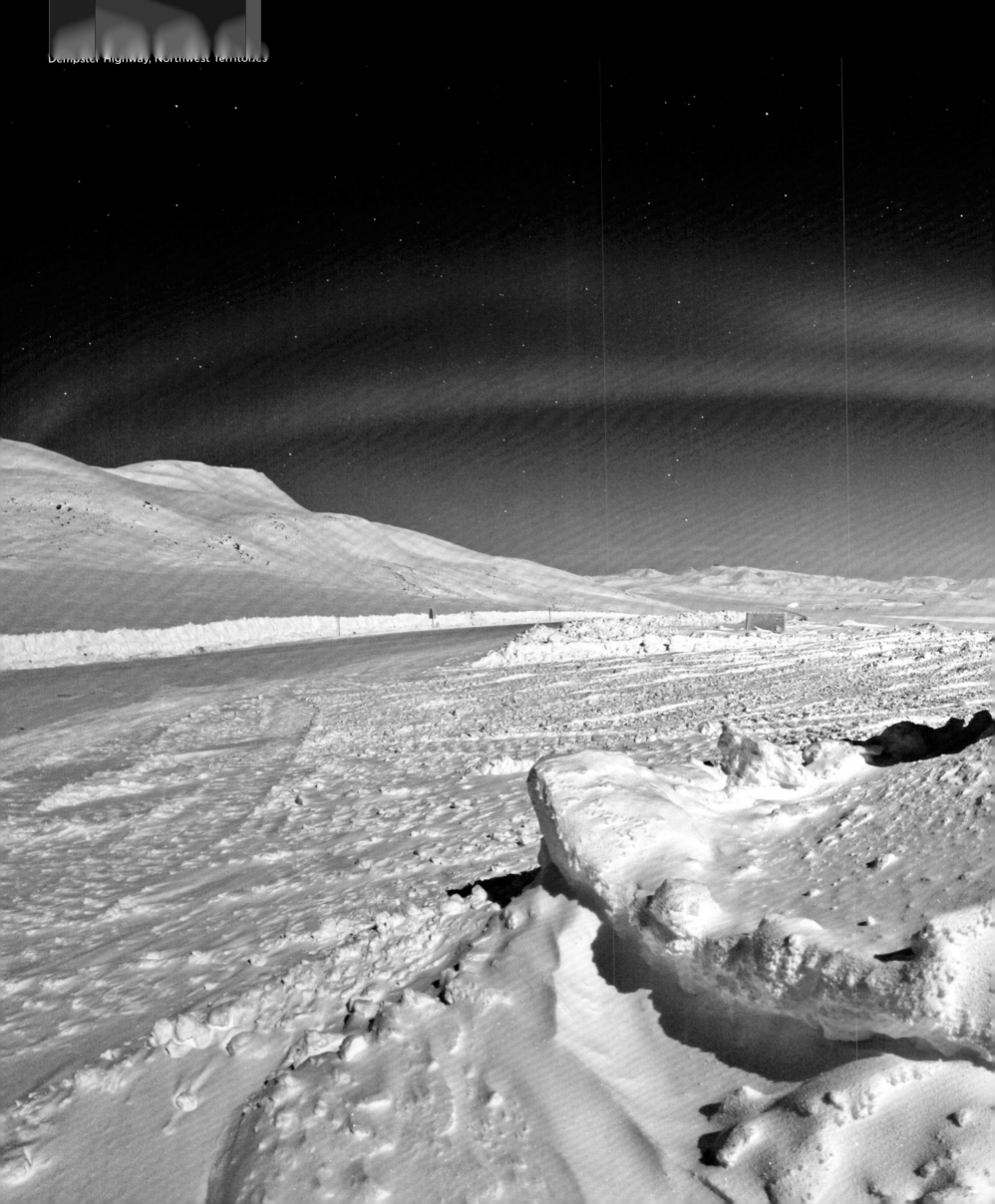
Dempster Highway, Northwest Territories

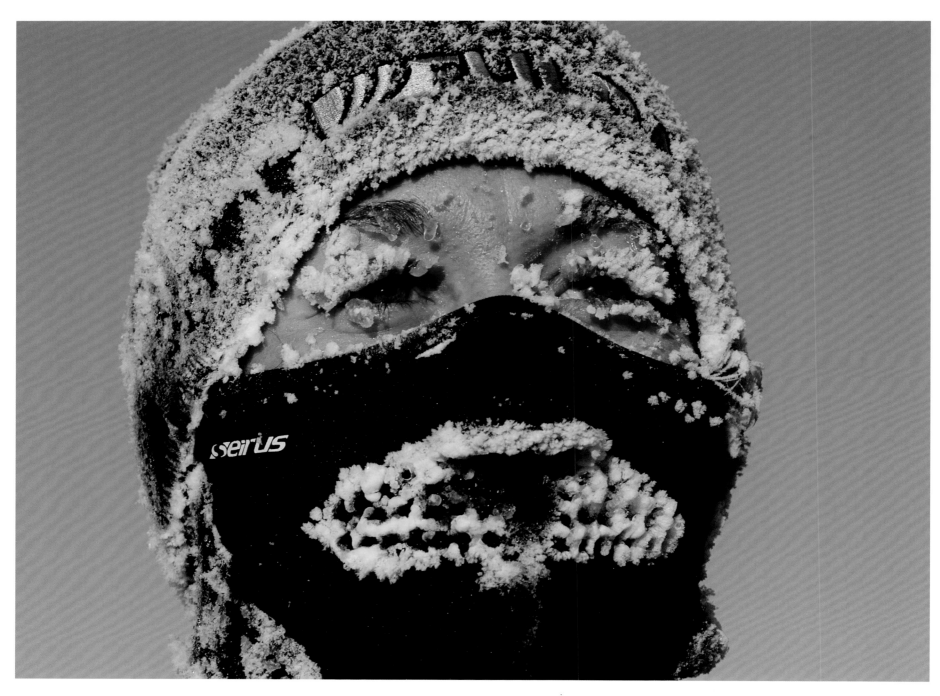

Iced face mask, Yukon

Polar Circles

The polar circles at 66° 33′ 55″of the northern and
southern hemispheres form the border for midnight
sun and polar night. The further one moves away
from the polar circles towards the poles, the longer
the midnight sun shines and polar night prevails. At
the geographic north and south poles, the polar night
lasts half a year and at the polar circles, it lasts one
day. This is due to the current inclination of the Earth's
axis of 23.43°. However, since the Earth's axis varies
between 22.1° and 24.5° over the course of several
tens of thousands of years, the Arctic Circle migrates
north by about 14 m (46 ft) each year.

Cercles polaires

Les cercles polaires, situés à 66° 33′ 55″ de latitude
dans les hémisphères nord et sud, délimitent les
zones de jour polaire – ou soleil de minuit – et de
nuit polaire. Plus on s'éloigne des cercles polaires
en direction des pôles, plus le soleil de minuit brille
et la nuit polaire perdure. Aux pôles géographiques
Nord et Sud, la nuit polaire dure six mois, au niveau
des cercles polaires, une journée. Cela est dû à
l'inclinaison actuelle de l'axe de la Terre de 23,43°.
Ce dernier oscillant entre 22,1 et 24,5° au fil des
millénaires, le cercle polaire arctique se déplace
chaque année d'environ 14 m vers le nord.

Polarkreise

Die Polarkreise der Nord- und Südhalbkugel auf
66° 33′ 55″ bilden die Grenze für Mitternachtssonne
und Polarnacht. Je weiter man sich von den
Polarkreisen in Richtung der Pole entfernt, desto
länger scheint die Mitternachtssonne und herrscht
Polarnacht. Am geografischen Nord- und Südpol
dauert die Polarnacht jeweils ein halbes Jahr, an
den Polarkreisen einen Tag. Verantwortlich dafür ist
die Neigung der Erdachse von gegenwärtig 23,43°.
Da die Erdachse jedoch im Verlauf von mehreren
Zehntausend Jahren zwischen 22,1° und 24,5° taumelt,
wandert der nördliche Polarkreis jedes Jahr um rund
14 m nach Norden.

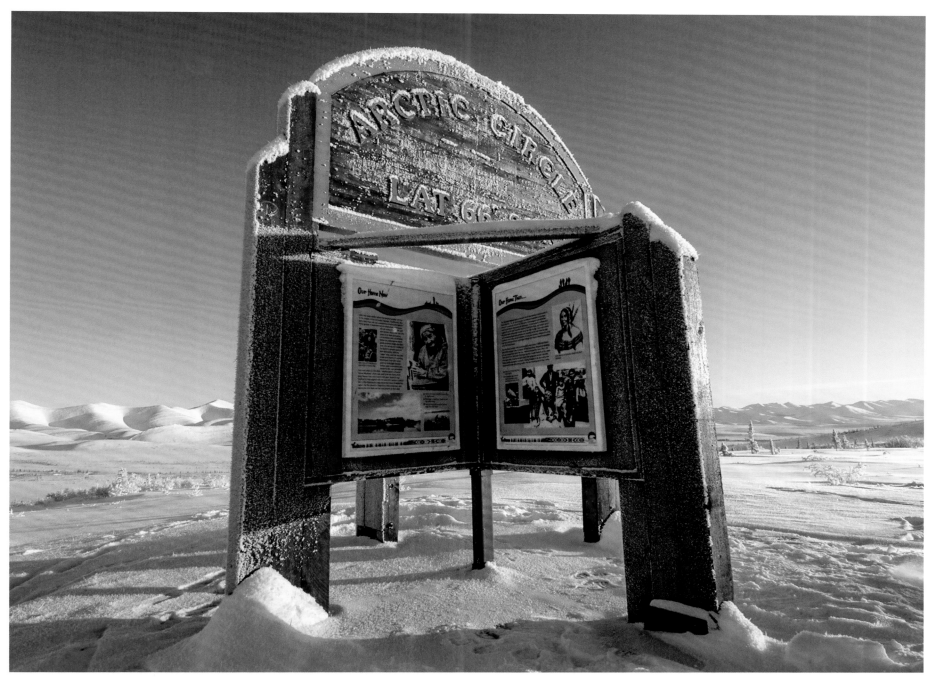

Arctic Circle, Yukon

Círculos polares

Los círculos polares de los hemisferios norte y sur a 66° 33′ 55″ forman la frontera entre el sol de medianoche y la noche polar. Cuanto más nos alejamos de los círculos polares hacia los polos, más tiempo brilla el sol de medianoche y prevalece la noche polar. En los polos norte y sur la noche polar dura medio año, y en los círculos polares un día. Esto se debe a la inclinación actual del eje terrestre de 23,43°. Sin embargo, dado que el eje de la Tierra desciende entre 22,1° y 24,5° en el curso de varias decenas de miles de años, el círculo polar ártico migra hacia el norte unos 14 m cada año.

Círculos polares

Os círculos polares dos hemisférios norte e sul na latitude 66° 33′ 55″ formam a fronteira para o sol da meia-noite e a noite polar. Quanto mais se afasta dos círculos polares em direção aos pólos, mais tempo o sol da meia-noite brilha e prevalece a noite polar. Nos pólos geográficos norte e sul a noite polar dura meio ano, nos círculos polares um dia. Isto se deve à inclinação atual do eixo da Terra de 23,43°. No entanto, como o eixo da Terra vem oscilando entre 22,1° e 24,5° ao longo de várias dezenas de milhares de anos, o Círculo Polar Ártico tem migrado para o norte cerca de 14 m por ano.

Poolcirkels

De poolcirkels van het noordelijke en zuidelijke halfrond op 66° 33′ 55″ vormen de grens voor middernachtzon en poolnacht. Hoe verder men zich van de poolcirkels naar de polen beweegt, hoe langer de middernachtzon schijnt en de poolnacht overheerst. Op de geografische noord- en zuidpolen duurt de poolnacht een half jaar, op een dag in de poolcirkels. Dit komt door de huidige inclinatie van de aardas van 23,43°. Maar omdat de aardas in de loop van enkele tienduizenden jaren tussen 22,1° en 24,5° tuimelt, trekt de poolcirkel elk jaar met ongeveer 14 m naar het noorden.

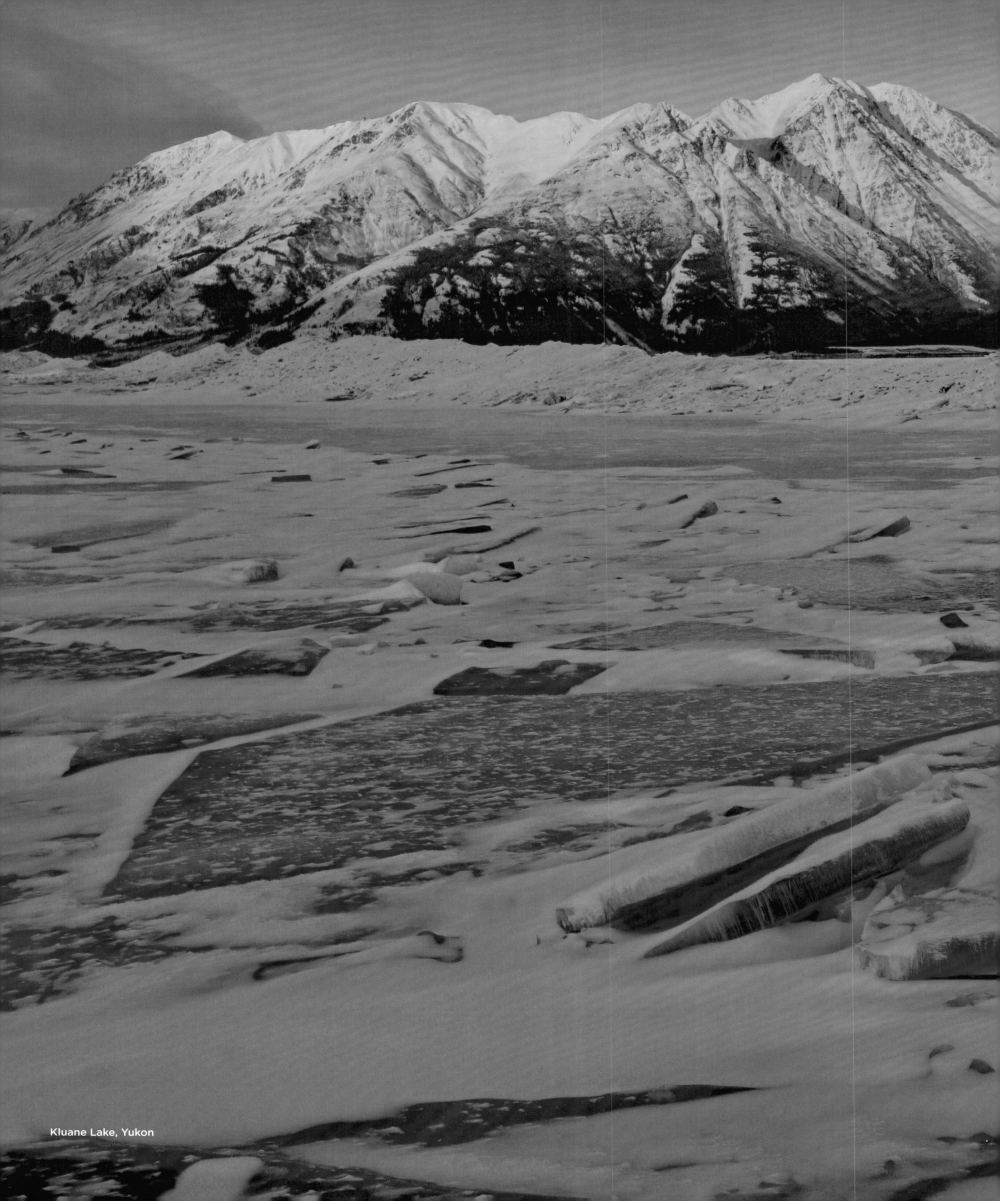

Kluane Lake, Yukon

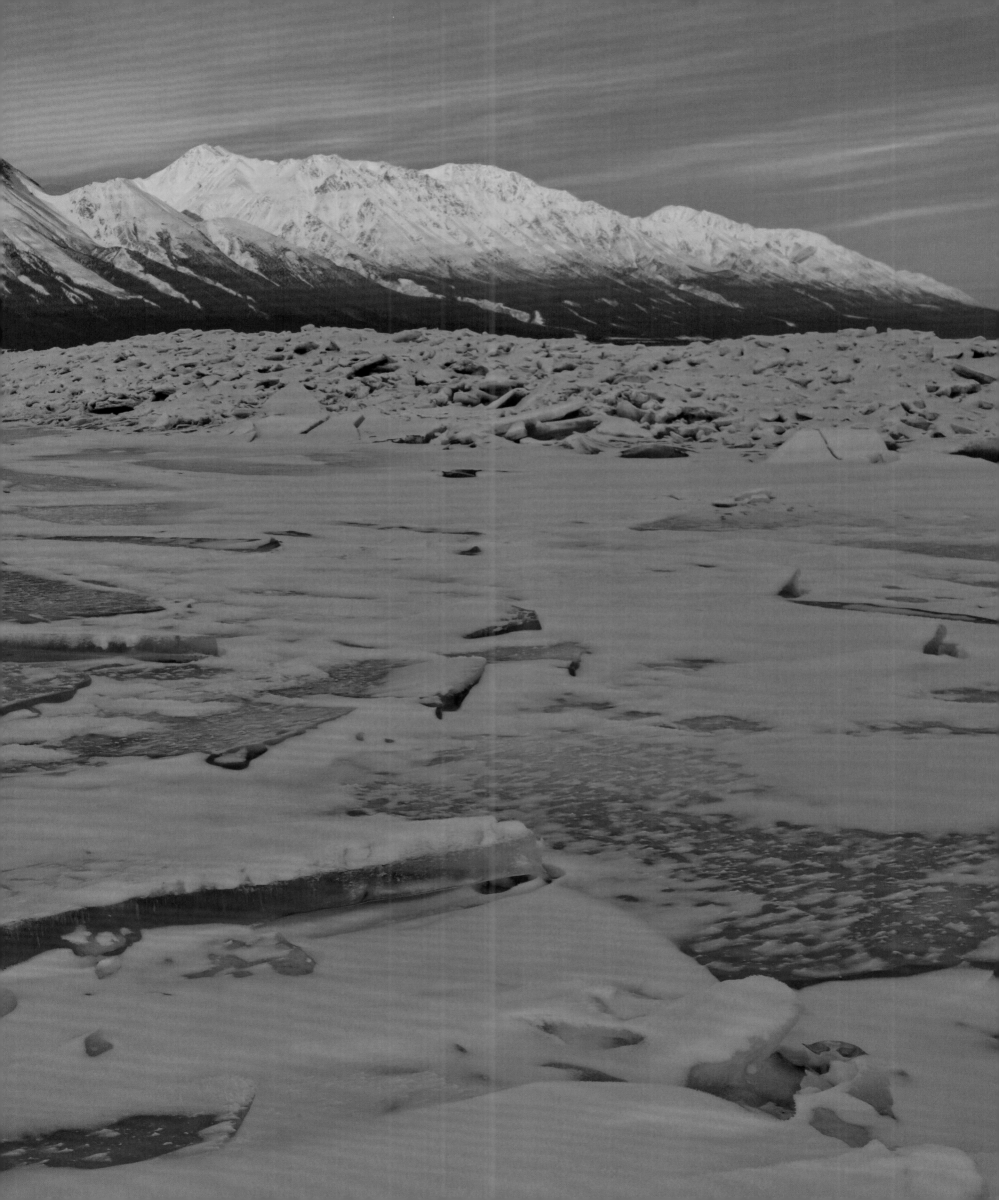

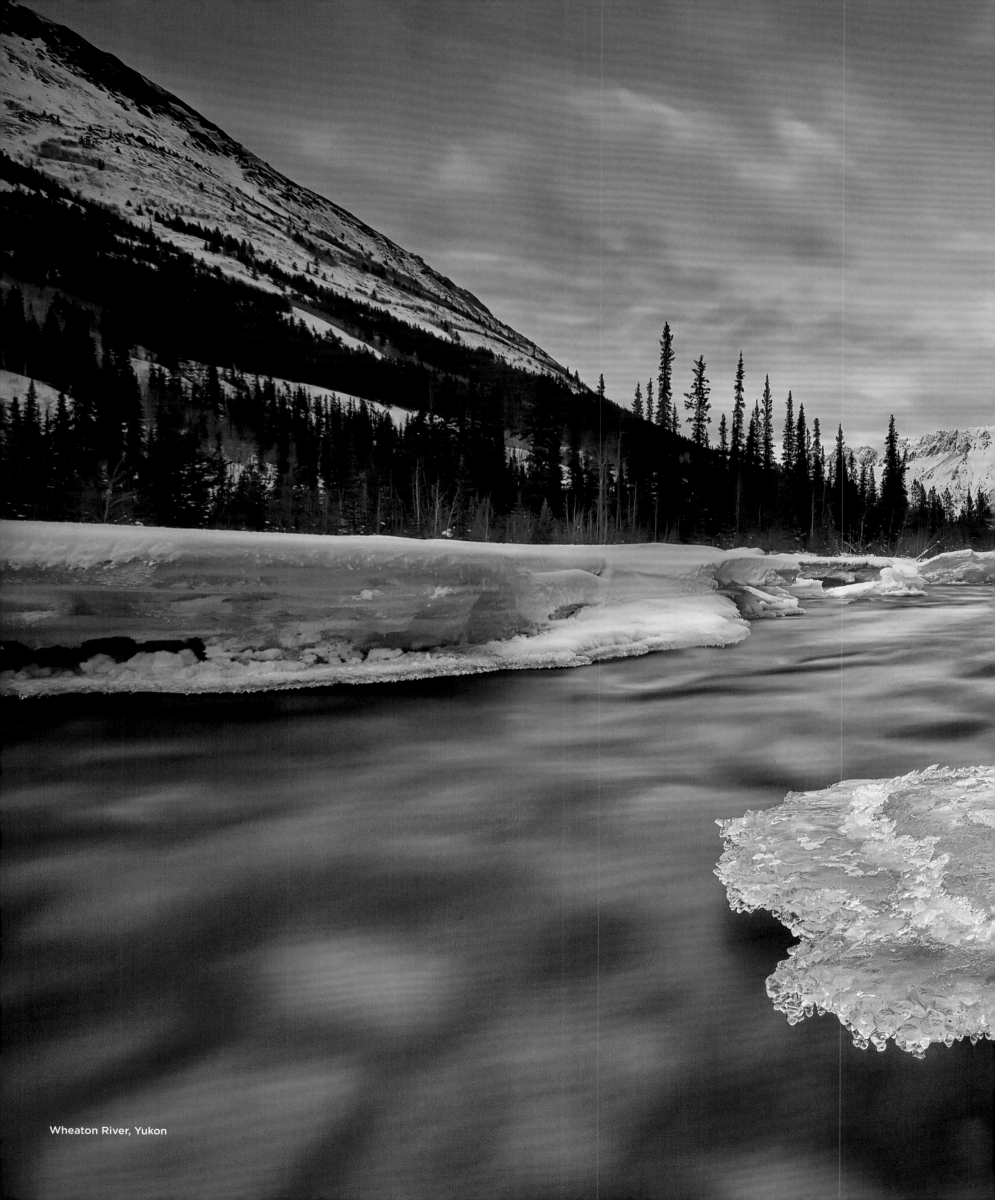

Wheaton River, Yukon

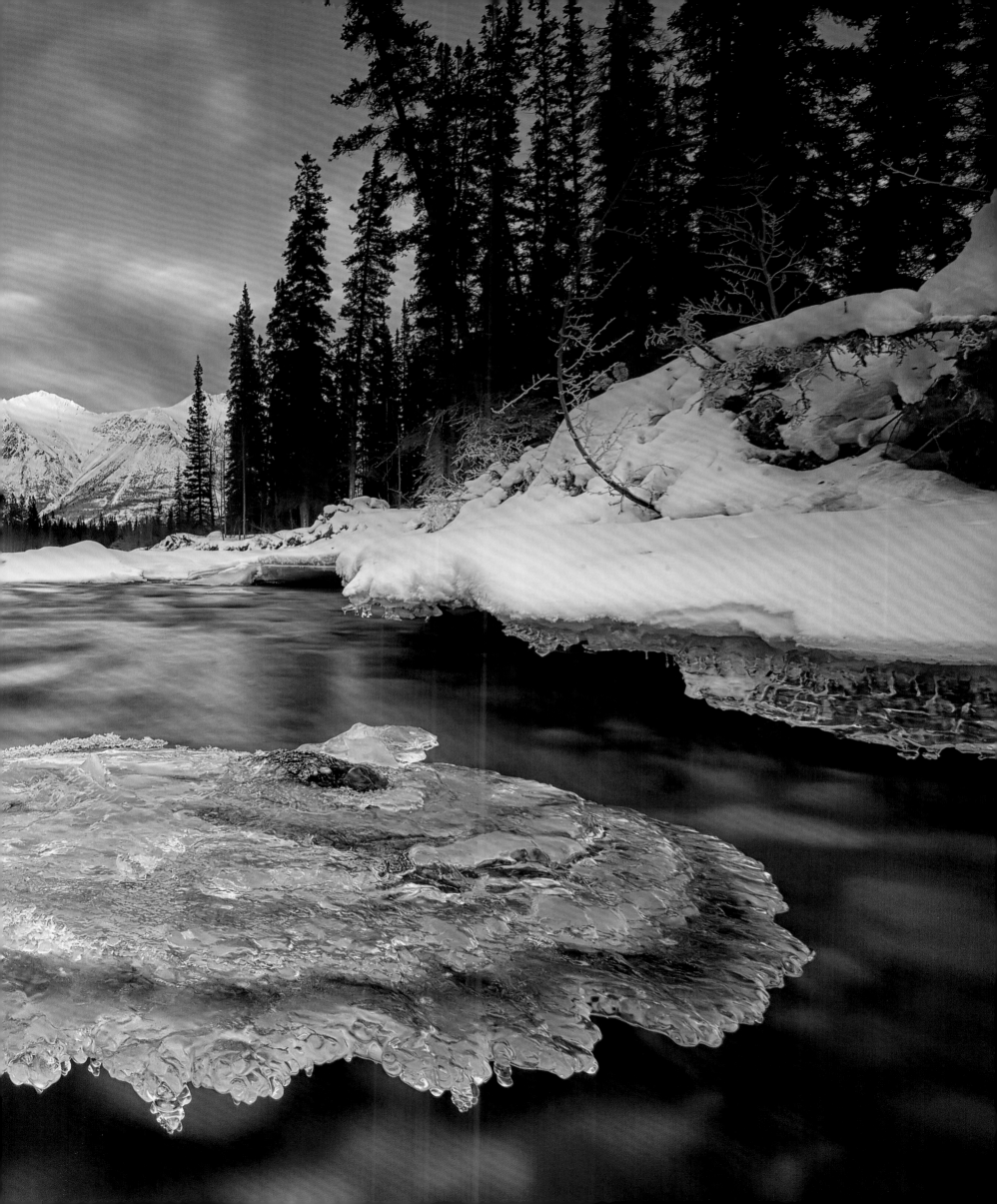

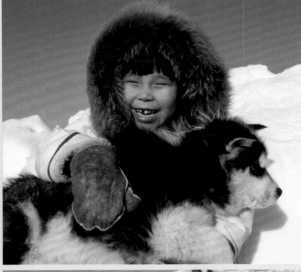
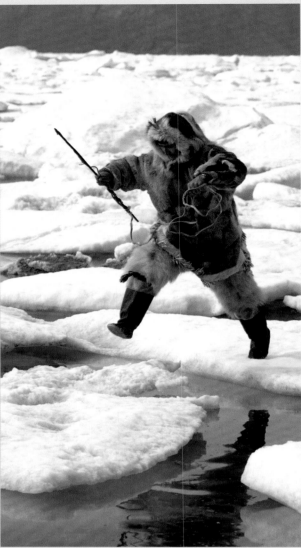
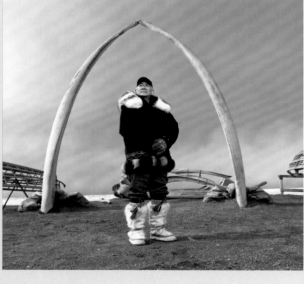
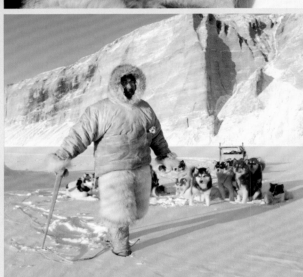
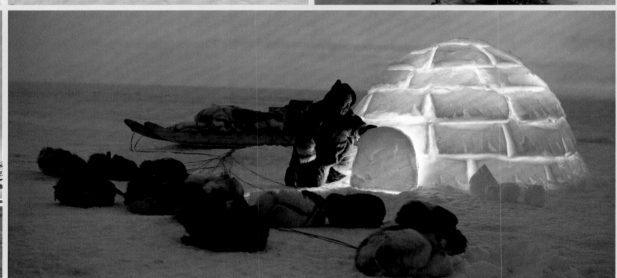

Humans in the Arctic

For thousands of years people have been living in the Arctic in a hostile environment in which only those who are perfectly adapted can survive, for example through suitable clothing and housing. Indigenous peoples such as the Inuit, Nenets and Sami are mostly hunters. Nomadic lifestyles are still widespread, although many indigenous people have been forced to assimilate.

Les hommes dans l'Arctique

Depuis des millénaires, les hommes vivent en Arctique dans un environnement hostile dans lequel seuls peuvent survivre ceux qui y sont parfaitement préparés, grâce par exemple à des vêtements et des habitations appropriés. Les peuples indigènes tels que les Inuits, les Nénètses ou les Samis sont pour la plupart des chasseurs et le mode de vie nomade reste très répandu, quoique de nombreux autochtones soient contraints à l'assimilation culturelle.

Menschen in der Arktis

Seit Jahrtausenden leben Menschen in der Arktis, in einer lebensfeindlichen Umgebung, in der nur überleben kann, wer perfekt angepasst ist, etwa durch geeignete Kleidung und Behausung. Indigene Völker wie die Inuit, Nenzen und Samen sind meist Jäger, nomadische Lebensweise ist noch weit verbreitet, obwohl viele Indigene zur Assimilation gezwungen werden.

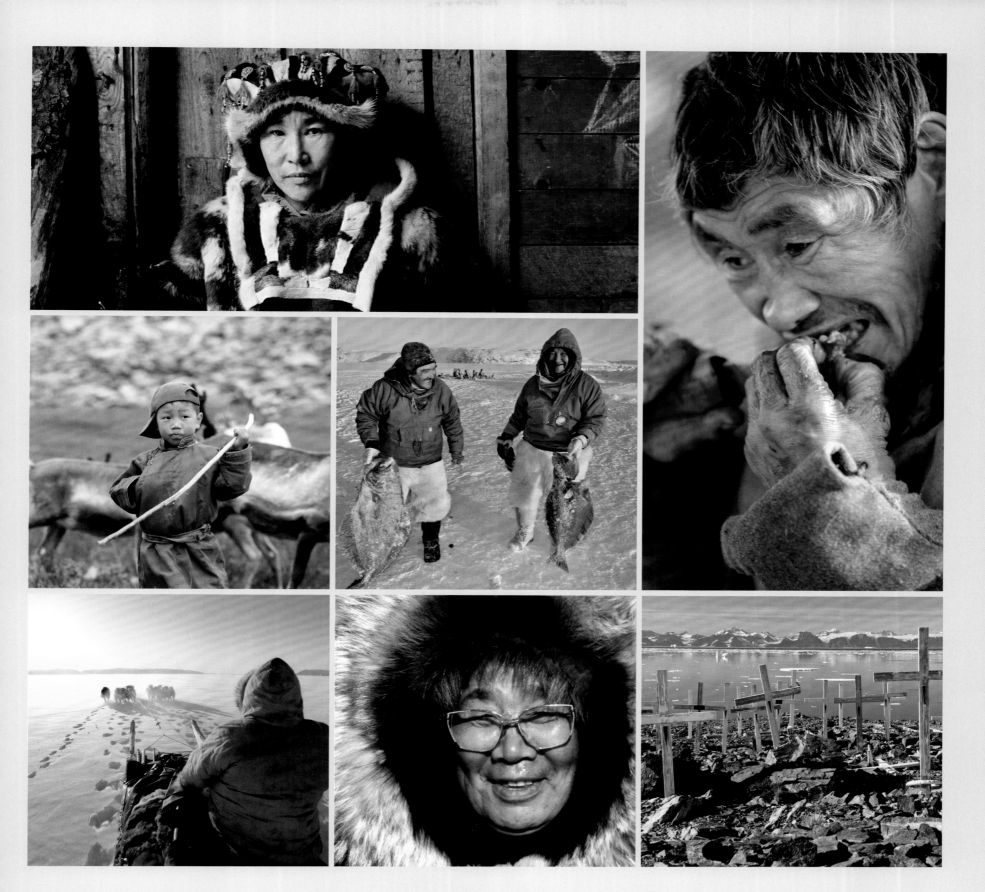

La gente del Ártico

Durante miles de años, la gente ha vivido en el Ártico en un entorno hostil en el que solo aquellos que están perfectamente adaptados pueden sobrevivir, por ejemplo, con ropa y viviendas adecuadas. Los pueblos indígenas, como los inuit, nénets y samis, son en su mayoría cazadores, y los estilos de vida nómadas siguen estando muy extendidos, aunque muchos de ellos se ven obligados a asentarse.

Pessoas no Ártico

Há milhares de anos que as pessoas vivem no Ártico, num ambiente hostil em que só aqueles que estão perfeitamente adaptados podem sobreviver, por exemplo, através de vestuário e habitação adequados. Os povos indígenas como os Inuítes, Nenets e Sami são na sua maioria caçadores, e os estilos de vida nómadas continuam a ser generalizados, embora muitos povos indígenas sejam forçados a se assimilar.

Mensen in het Noordpoolgebied

Al duizenden jaren leven er mensen in het Noordpoolgebied, ze leven in een vijandige omgeving waarin alleen mensen die zich perfect hebben aangepast, kunnen overleven, bijvoorbeeld door geschikte kleding en huisvesting. Inheemse volkeren zoals de Inuit, de Nenets en de Sami zijn meestal jagers, en nomadische levensstijlen zijn nog steeds wijdverbreid, hoewel veel inheemse volkeren gedwongen worden om zich te assimileren.

Alaska

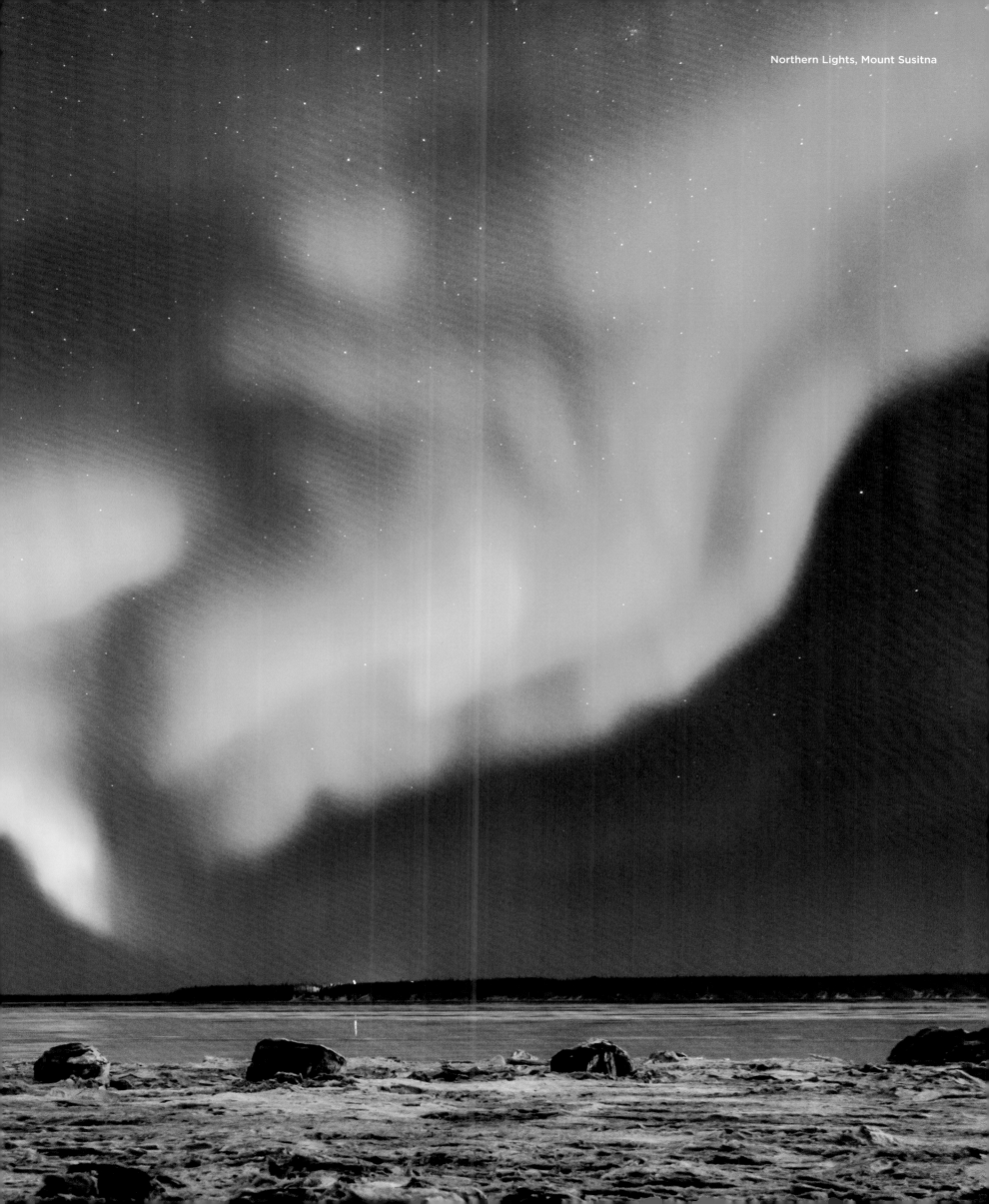

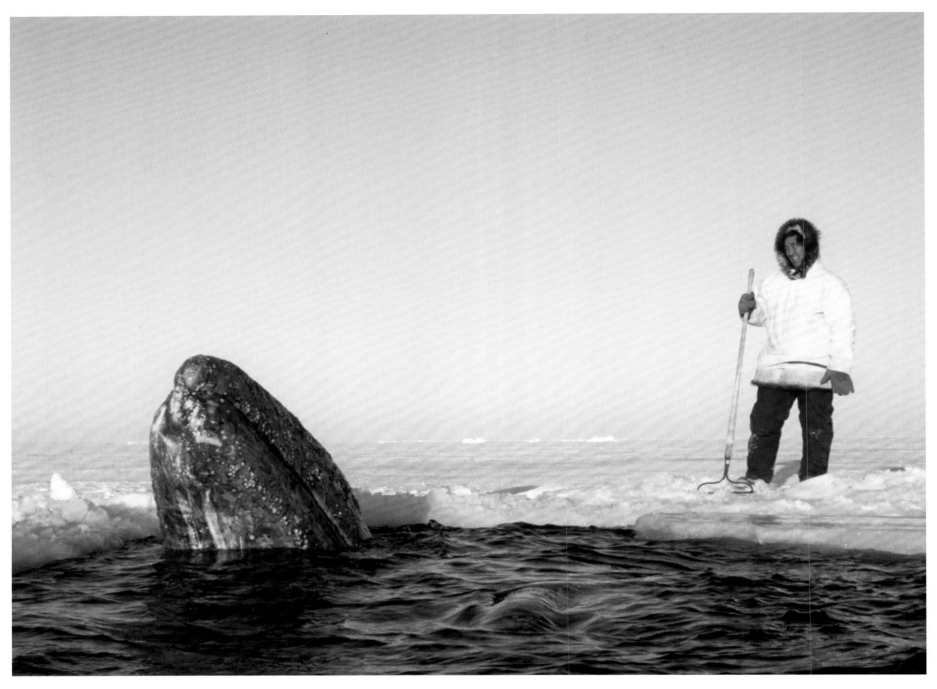

California gray whale, Point Barrow

Alaska

The name Alaska comes from the Aleut word "Alakshak", which means "big country". With an area of almost 1.5 million km² (500,000 sq mi), Alaska is the largest state in the USA. However, there are only about 740,000 people inhabitants, 30,000 of whom belong to the ethnic group of the Inuit. Until today, in remote settlements the Inuit still live by hunting sea mammals such as seals, whales and walruses, but caribou and polar bears are also among their prey. Their most important weapon is the harpoon, but some Inuit also hunt using bows and arrows. At sea they use kayaks to track down their prey, and on land they use sled dog teams.

Alaska

Le nom d'Alaska est dérivé du mot aléoutien « Alakshak », signifiant « vastes terres ». Avec près de 1,5 million de km², l'Alaska est le plus grand des états américains. Il ne compte pourtant que 740 000 habitants environ, dont bien 30 000 appartiennent à la population indigène Inuit. Établis dans des villages reculés, ceux-ci vivent aujourd'hui encore de la chasse aux mammifères marins tels que les phoques, les baleines ou les morses. Bien que les caribous et les ours polaires fassent également partie de leurs proies. Leur arme de prédilection est le harpon, même si certains Inuits chassent aussi à l'arc et aux flèches. Pour traquer leurs proies en mer ils se déplacent en kayaks et sur terre des traîneaux en chiens.

Alaska

Der Name Alaska geht auf das aleutische Wort „Alakshak" zurück, das so viel wie „Großes Land" bedeutet. Mit fast 1,5 Millionen km² ist Alaska der größte Bundesstaat der USA, in dem aber nur etwa 740 000 Menschen leben, davon gehören gut 30 000 der indigenen Volksgruppe der Inuit an. In abgelegenen Siedlungen leben sie bis heute von der Jagd auf Meeressäuger wie Robben, Wale und Walrosse, aber auch Karibus und Eisbären gehören zu ihrer Beute. Ihre wichtigste Waffe ist die Harpune, einige Inuit jagen aber auch mit Pfeil und Bogen. Auf dem Meer nutzen sie Kajaks zum Aufspüren der Beute, an Land Schlittenhundegespanne.

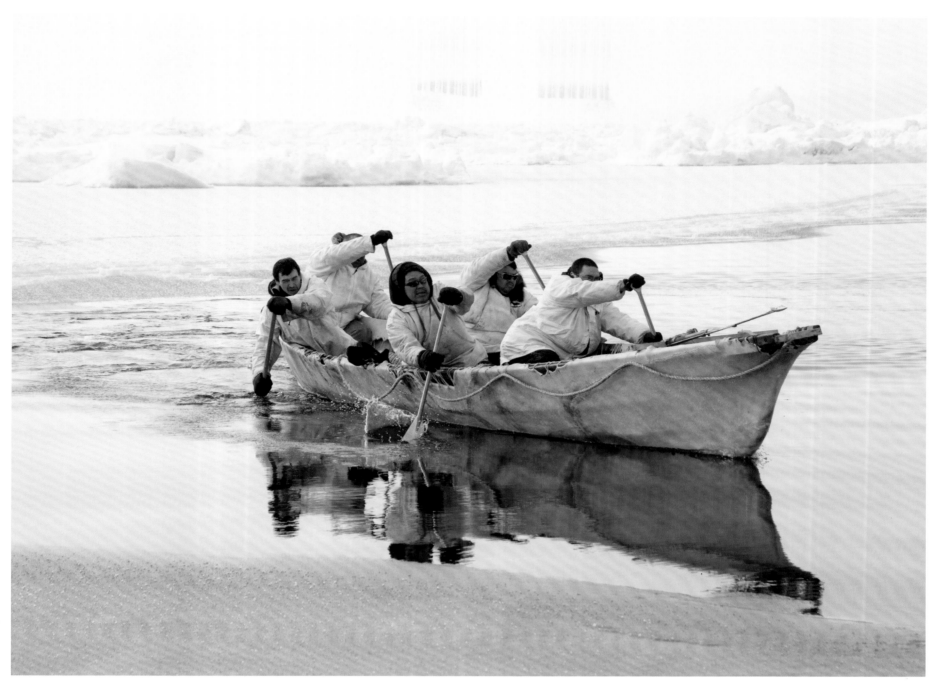

Umiak, Chukchi Sea, Barrow

Alaska

El nombre Alaska procede de la palabra aleutiana «Alakshak», que significa «país grande». Con casi 1,5 millones de km², Alaska es el estado más grande de los EE. UU., pero solo viven en él unas 740 000 personas, y 30 000 de ellas pertenecen a la tribu inuit. En asentamientos remotos, viven hasta el día de hoy de la caza de mamíferos marinos como focas, ballenas y morsas, pero también del caribú y los osos polares. Su arma más importante es el arpón, pero algunos inuit también cazan con arco y flecha. En el mar utilizan kayaks para localizar a sus presas y, en la tierra, equipos de perros de trineo.

Alasca

O nome Alasca remonta à palavra Aleut "Alakshak", que significa algo como "grande país". Com quase 1,5 milhões de km², o Alasca é o maior estado dos EUA, mas apenas cerca de 740.000 pessoas vivem nele. 30.000 delas pertencem à tribo dos indígenas inuítes. Em assentamentos remotos, eles vivem da caça de mamíferos marinhos como focas, baleias e morsas até hoje, mas também os caribus e ursos polares pertencem à sua presa. Sua arma mais importante é o arpão, mas alguns inuítes também caçam com arco e flecha. No mar, usam caiaques para localizar as suas presas, na terra usam equipes de cães de trenó..

Alaska

De naam Alaska gaat terug op het Aleoet woord „Alaxsxaq", wat „vasteland" betekent. Alaska is met bijna 1,5 miljoen km² de grootste staat van de VS, er wonen slechts 740.000 mensen. 30.000 van hen behoren tot de Inuitstam. In afgelegen nederzettingen leven ze tot op heden van de jacht op zeezoogdieren zoals zeehonden, walvissen en walrussen, maar ook kariboes en ijsberen behoren tot hun prooi. Hun belangrijkste wapen is de harpoen, maar sommige Inuit jagen ook met pijl en boog. Op zee gebruiken ze kajaks om hun prooi op te sporen, op het land gebruiken ze sledehondenteams.

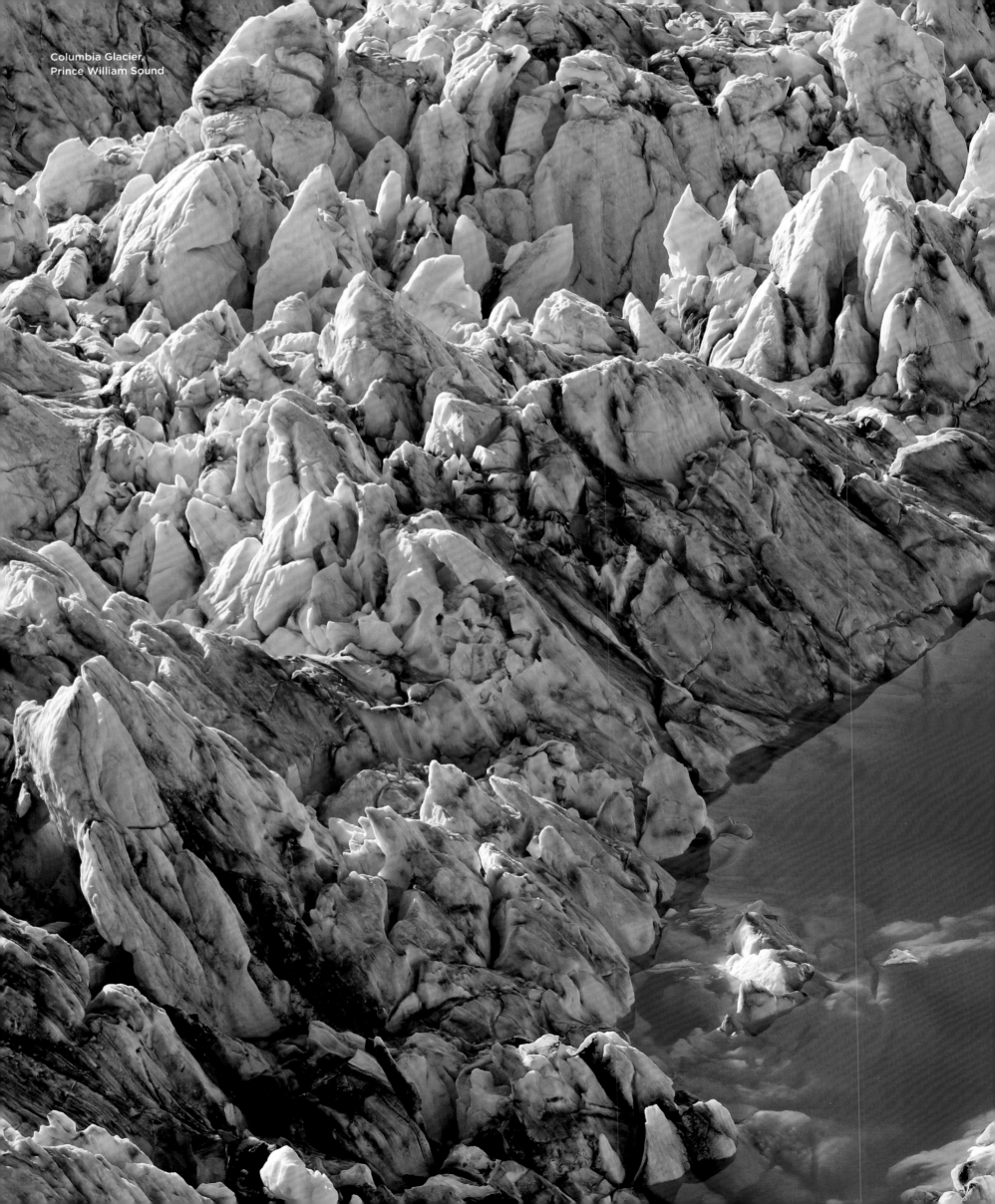

Columbia Glacier,
Prince William Sound

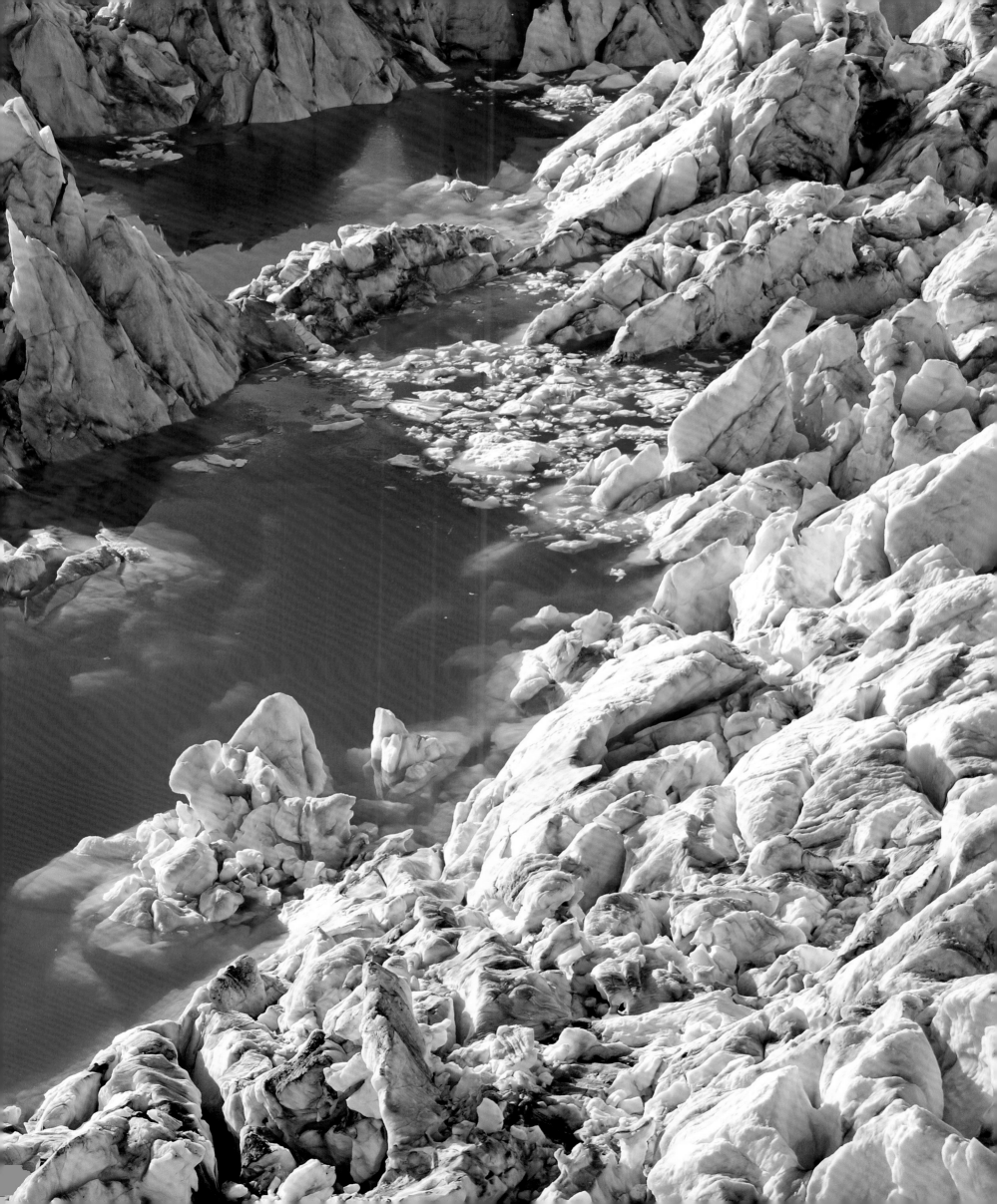

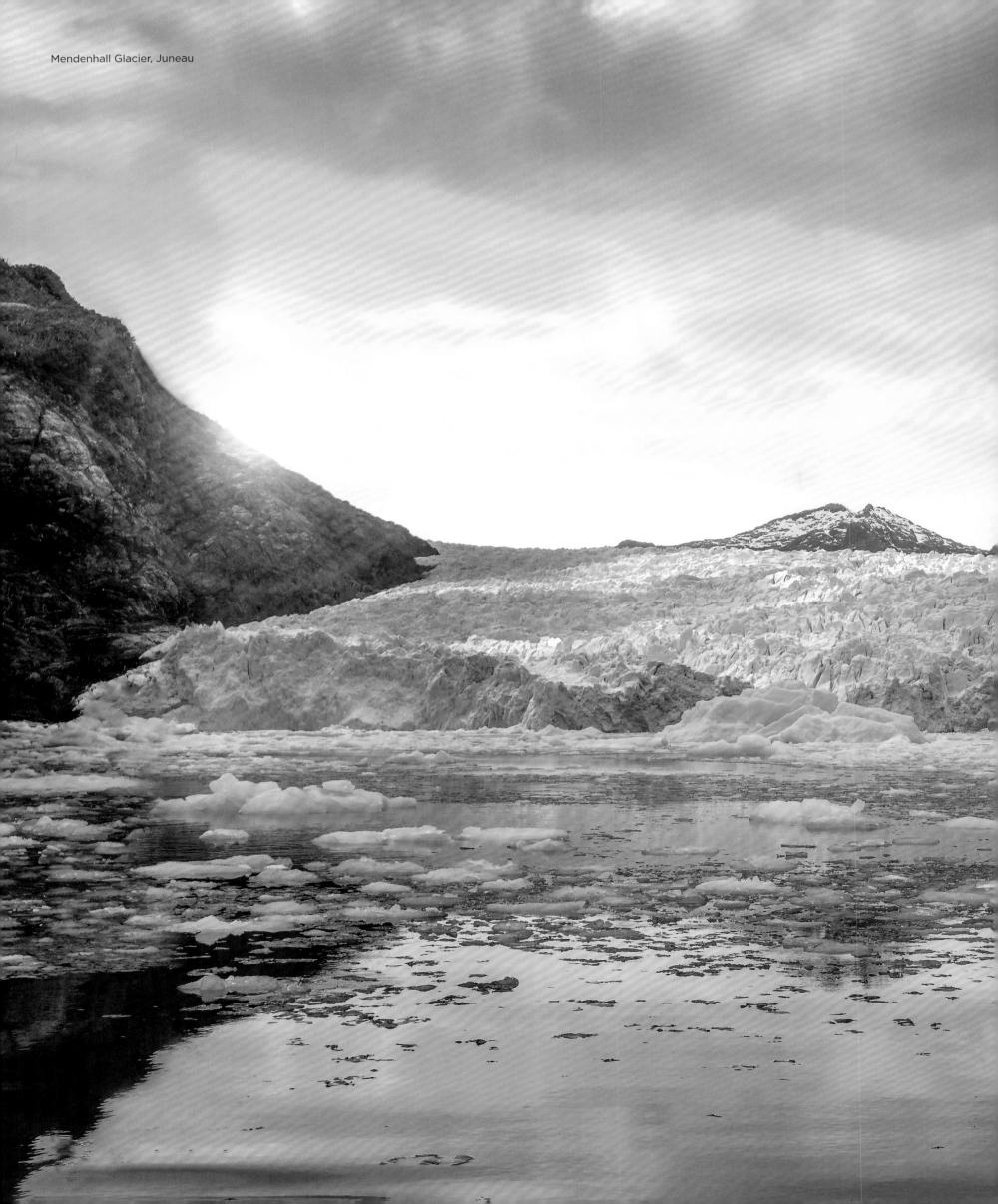

Mendenhall Glacier, Juneau

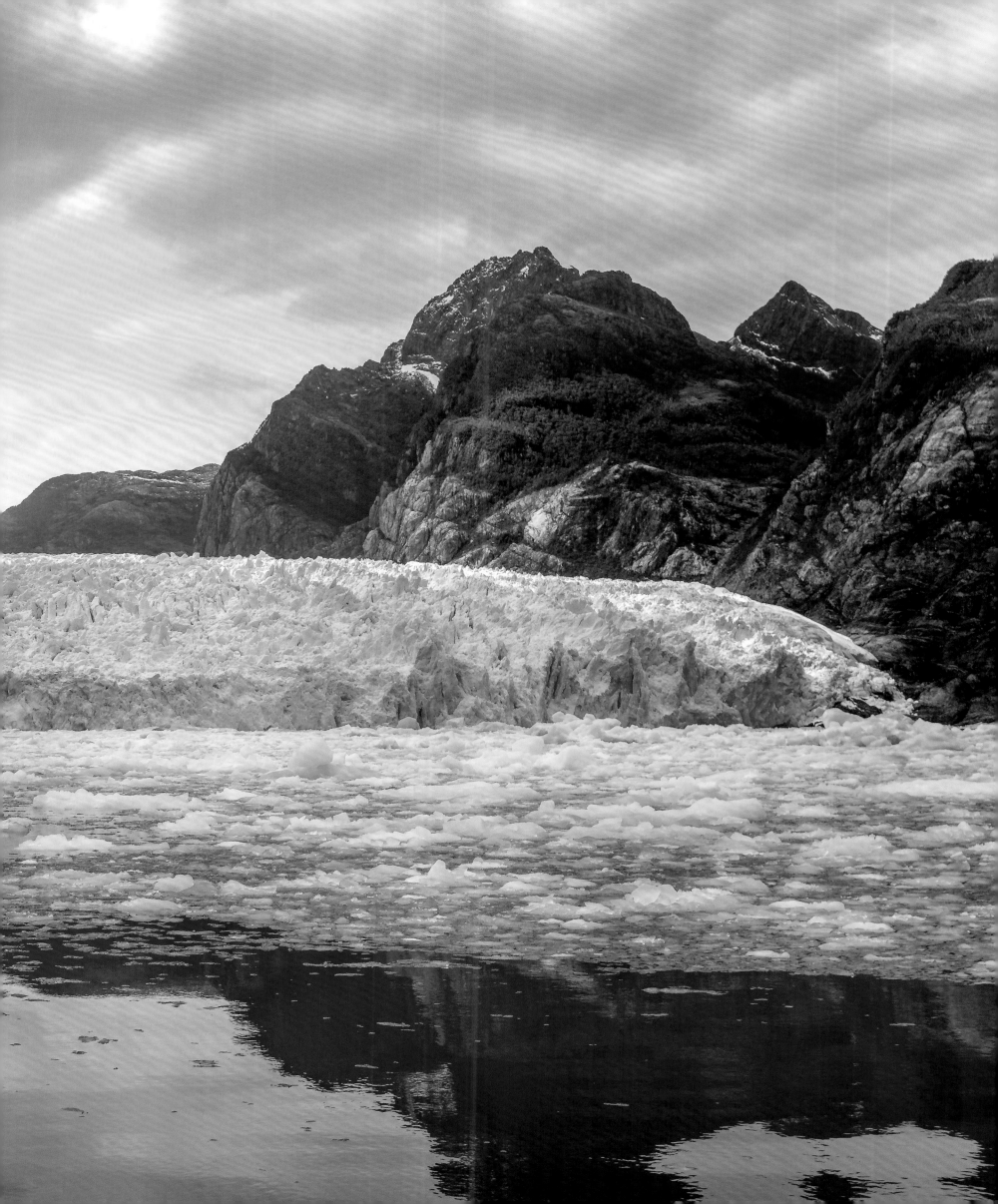

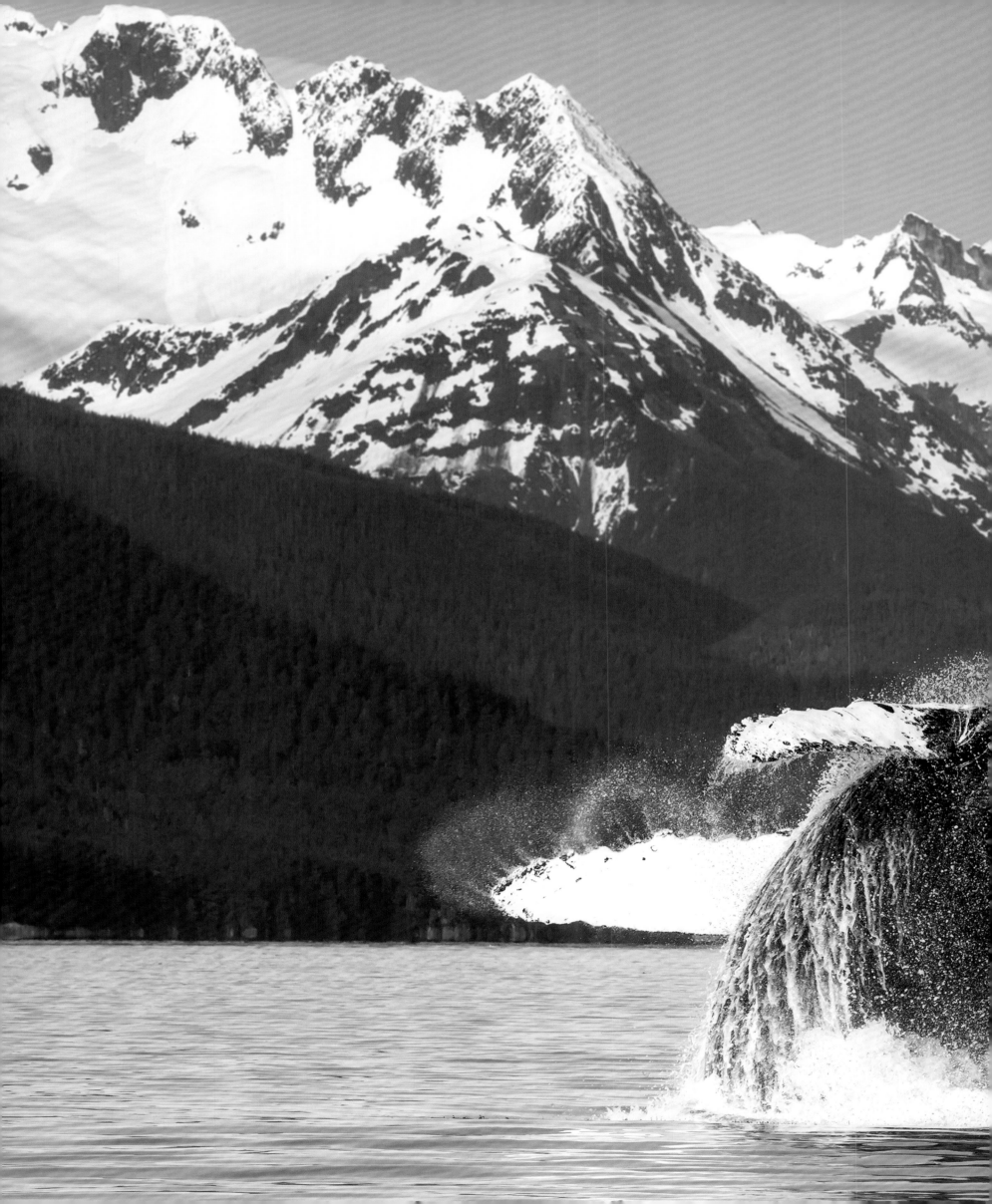

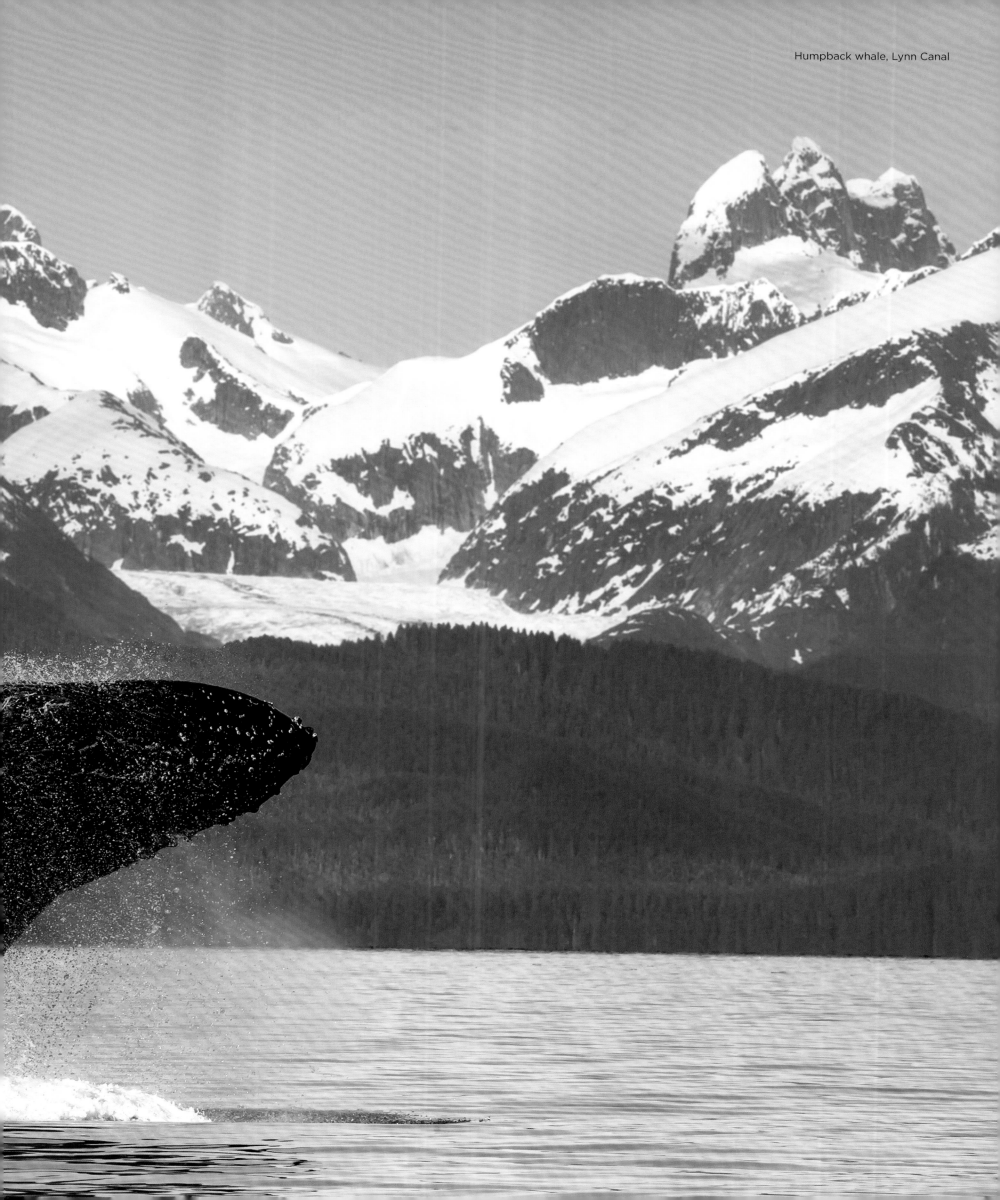

Humpback whale, Lynn Canal

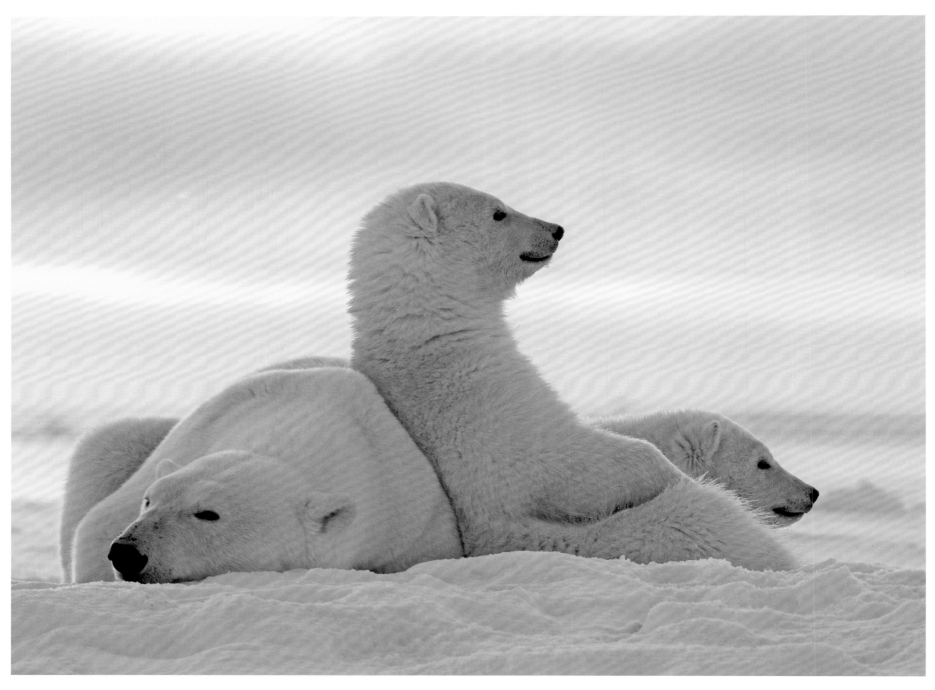

Polar bears, Barter Island, Kaktovik

Polar Bear Teenage Years

The mating season for polar bears lasts about a week and falls in the months March to June, followed by birth which takes place between November and January—in the middle of the coldest season. A few weeks before the birth, the female retreats into a birth cave. The mothers do not leave the cave with their offspring (usually two of them) until four months after the birth. The birth weight is less than one kilo (2 lbs), but by the time they leave the cave they already weigh 10-15 kg (22—33 lbs). The young are suckled for about two years, but only half of them survive the first years of life.

Jeunes ours polaires

La période d'accouplement chez les ours polaires dure environ une semaine et a lieu entre les mois de mars et de juin. Les naissances arrivent ensuite entre novembre et janvier, au cœur de la saison la plus froide. Quelques semaines avant la mise bas, la femelle se retire dans une cavité rocheuse qu'elle ne quittera avec ses petits – généralement deux – que quatre mois après la naissance. À leur venue au monde, les oursons pèsent moins d'un kilo, ils en font entre 10 et 15 à leur sortie de la grotte. Les jeunes sont allaités pendant environ deux ans, mais seul un sur deux survit à la première année.

Eisbären-Jugendjahre

Die Paarungszeit bei Eisbären dauert rund eine Woche und fällt in die Monate März bis Juni, die Geburt erfolgt dann zwischen November und Januar - mitten in der kältesten Jahreszeit. Einige Wochen vor dem Geburtstermin zieht sich das Weibchen in eine Geburtshöhle zurück. Erst vier Monate nach der Geburt verlassen die Mütter mit ihrem Nachwuchs - meistens sind es zwei - die Höhle. Das Geburtsgewicht liegt bei unter einem Kilo, beim Verlassen der Höhle sind es schon 10–15 kg. Die Jungen werden insgesamt rund zwei Jahre lang gesäugt, aber nur jedes zweite überlebt die ersten Lebensjahre.

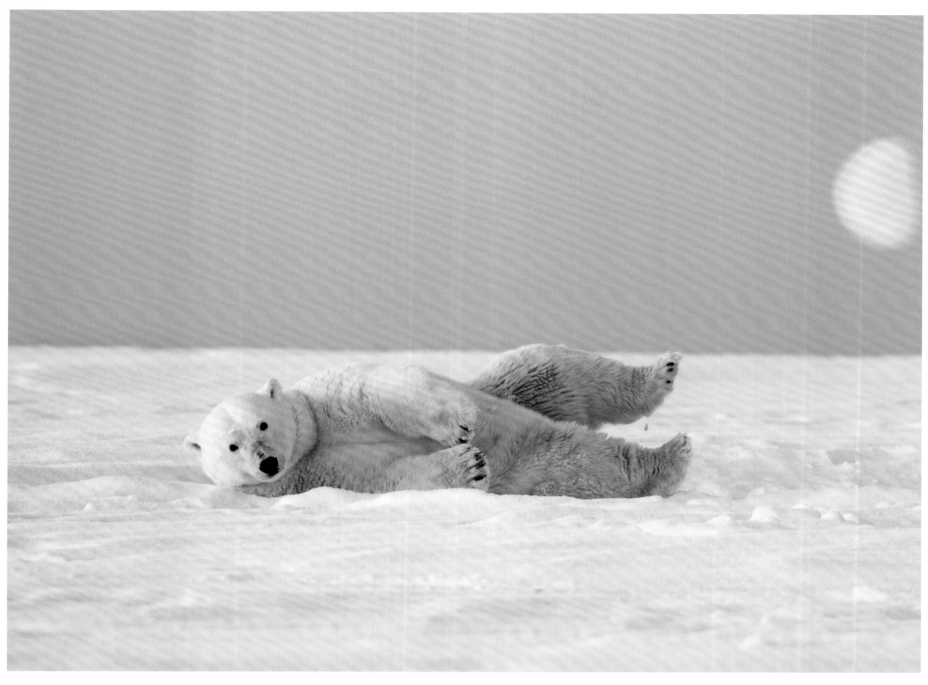

Polar bears, Barter Island, Kaktovik

Osos polares jóvenes

La temporada de apareamiento de los osos polares dura alrededor de una semana y cae en los meses de marzo a junio. El nacimiento tiene lugar entre noviembre y enero, en medio de la estación más fría. Unas semanas antes de la fecha de nacimiento, la hembra se retira a una cavidad donde tendrá lugar el parto. Las madres no salen de la cueva con sus hijos (generalmente dos) hasta cuatro meses después del nacimiento de estos. El peso al nacer es inferior a un kilo, y al salir de la cueva ya es de 10-15 kg. Las crías son amamantadas durante unos dos años, pero solo uno de cada dos sobrevive a los primeros años de vida.

Ursos polares jovens

A estação de acasalamento dos ursos polares dura cerca de uma semana e cai nos meses de março a junho, o nascimento ocorre entre novembro e janeiro – no meio da estação mais fria. Algumas semanas antes da data de nascimento, a fêmea retira-se para a caverna, uma cavidade para o parto. Apenas quatro meses após o parto, as mães deixam a toca com seus filhos - geralmente dois. O peso ao nascer é inferior a um quilo, ao sair da toca já é de 10-15 kg. Os jovens são amamentados durante cerca de dois anos, mas apenas cada segundo sobrevive nos primeiros anos de vida.

IJsberen (tienerjaren)

De paartijd bij ijsberen duurt ongeveer een week en valt in de maanden maart tot juni, de geboorte vindt dan plaats tussen november en januari – midden in het koudste seizoen. Een paar weken voor de geboortedatum trekt het vrouwtje zich in een geboorteholte terug. Pas vier maanden na de geboorte verlaten de moeders de grot met hun nakomelingen - meestal zijn het er twee. Het geboortegewicht is minder dan een kilo, bij het verlaten van de grot is het al 10-15 kg. De jongeren worden ongeveer twee jaar lang gezoogd, maar slechts elk tweede overleefd de eerste jaren van hun leven.

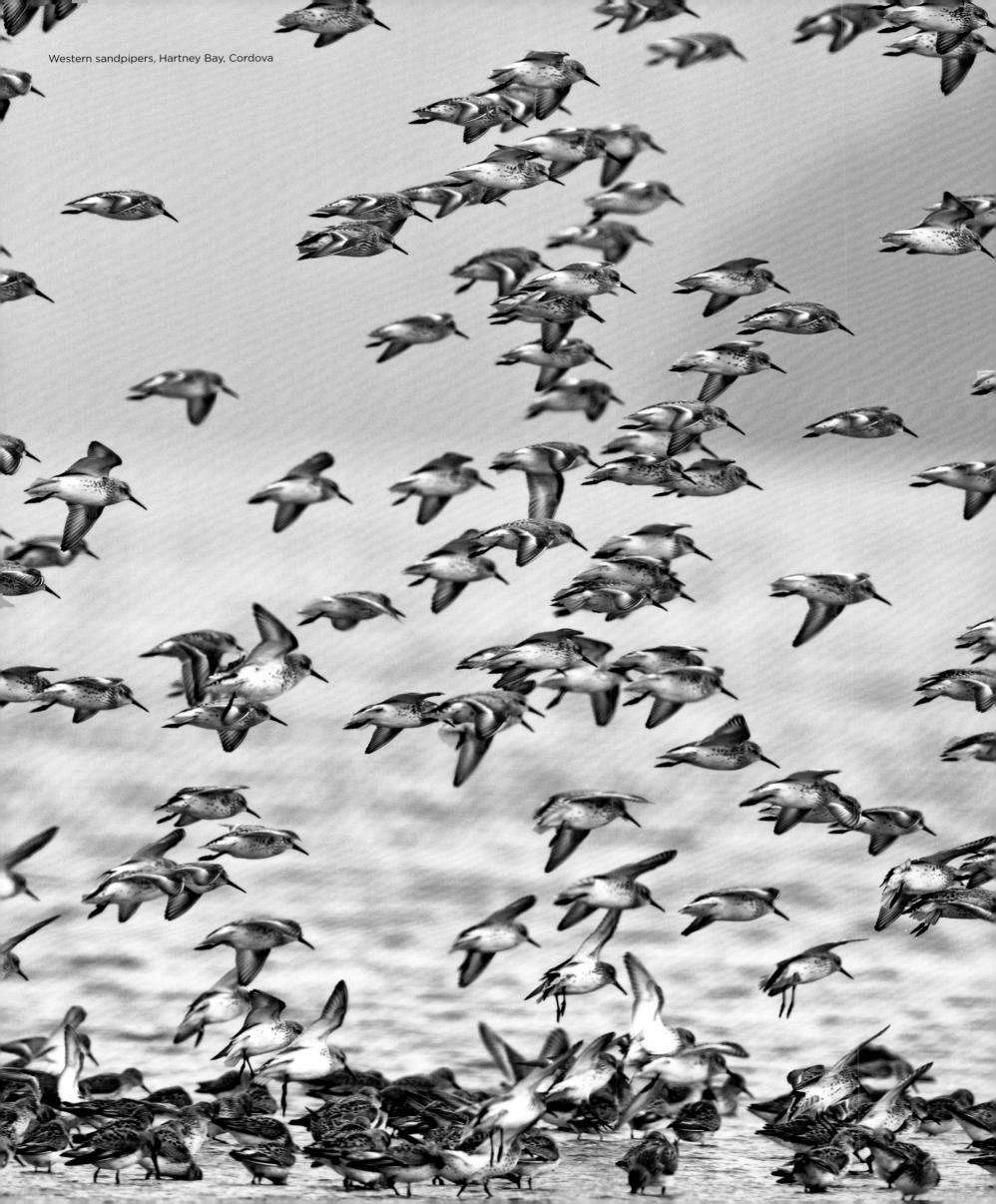

Western sandpipers, Hartney Bay, Cordova

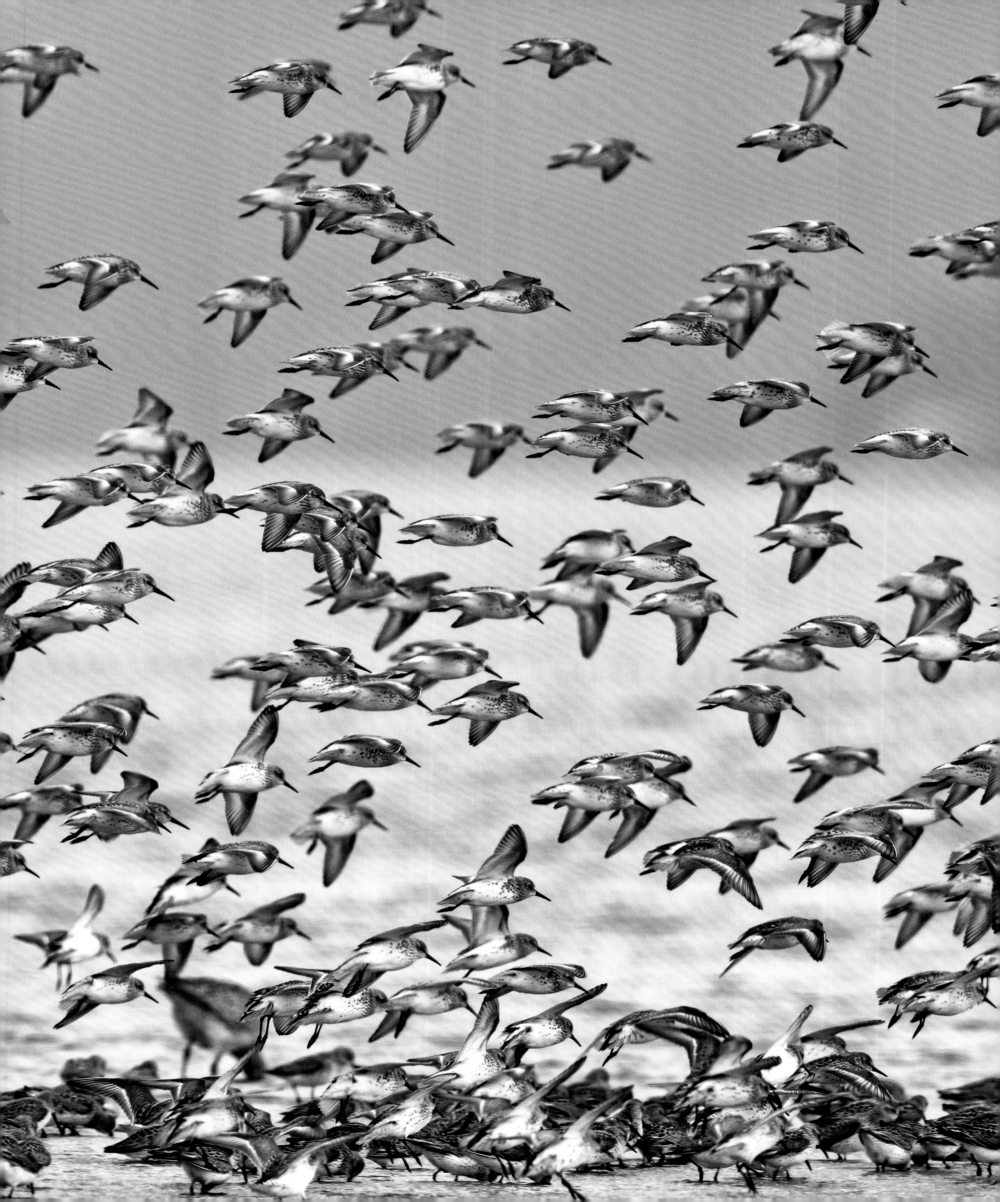

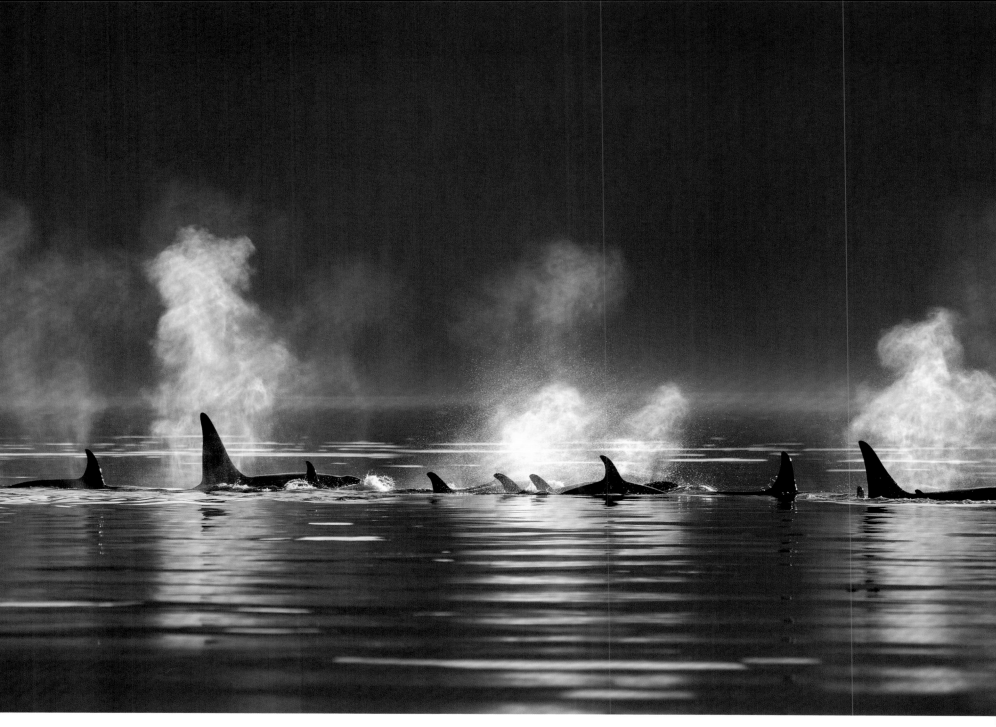

Orcas, Lynn Canal

Orcas

Orcas or killer whales belong to the dolphin family.
They occur all over the world, but they are particularly
common in the coastal waters of higher latitudes.
They are social, communicative animals and are
capable of sophisticated hunting strategies and
coordinated group attacks, which they even adapt
to locally occurring prey. In Antarctica, it has been
observed that orcas break up ice floes on which
seals are found into smaller pieces, and then swim in
formation to create a large wave that flushes the seals
from the ice floe.

Orques

Les orques, ou épaulards, appartiennent à la famille
des dauphins. On les trouve dans le monde entier,
mais plus particulièrement dans les eaux côtières
des hautes latitudes. Vivant en groupes, ce sont
des animaux sociaux et communicatifs, capables
de stratégies de chasse et d'attaques en groupe
sophistiquées, qu'ils savent même adapter aux proies
locales. En Antarctique, ils furent observés brisant
les blocs de glaces sur lesquels se trouvaient des
phoques, en de plus petits morceaux, produisant
ainsi une grosse vague éjectant les phoques du bloc
de glace.

Orcas

Orcas oder Schwertwale gehören zur Familie der
Delfine, sie kommen weltweit vor, man trifft sie aber
besonders häufig in küstennahen Gewässern der
höheren Breiten an. Die in Verbänden lebenden Tiere
sind sozial, kommunikativ und zu ausgeklügelten
Jagdstrategien und koordinierten Gruppenangriffen
in der Lage, die sie sogar an örtlich vorkommende
Beutetiere anpassen. In der Antarktis hat man
beobachtet, wie Orcas Eisschollen, auf denen sich
Robben befinden, in kleinere Teile zerlegen und dann
durch ein Formationsschwimmen eine große Welle
erzeugen, die die Robben von der Eisscholle spült.

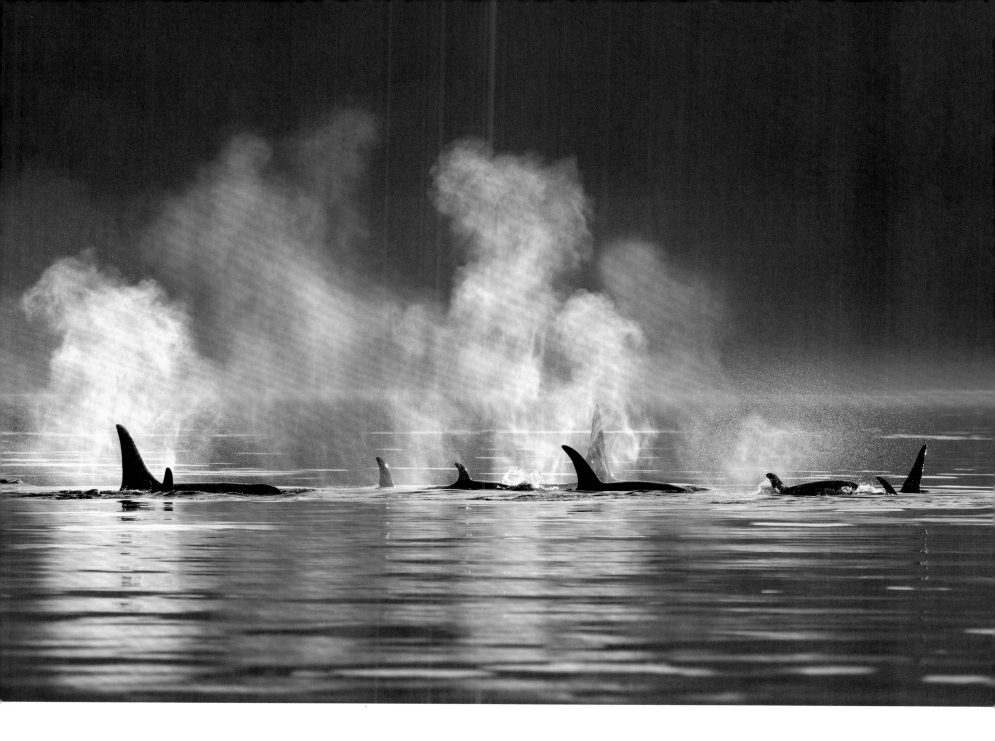

Orcas

Las orcas, que pertenecen a la familia de los delfines, se encuentran en todo el mundo, pero son particularmente comunes en aguas costeras de latitudes más altas. Estos animales viven en grupos y son sociales, comunicativos y capaces de desarrollar sofisticadas estrategias de caza y de realizar ataques coordinados de grupo, que incluso adaptan a las presas locales. En la Antártida, se ha observado cómo las orcas rompen los témpanos de hielo en los que se encuentran las focas en trozos más pequeños y luego nadan en una formación para crear una gran ola que expulsa a las focas de los témpanos de hielo.

Orcas

As orcas ou baleias assassinas pertencem à família dos golfinhos, são encontradas em todo o mundo, mas são particularmente comuns em águas costeiras de latitudes mais elevadas. Os animais que vivem em associações são sociais, comunicativos e capazes de estratégias de caça sofisticadas e ataques de grupo coordenados, até mesmo se adaptando às presas existentes no local. Na Antártida, observou-se como as orcas quebram os blocos de gelo, sobre as quais são encontradas focas em pedaços menores, e depois nadam em uma formação para criar uma grande onda, que lança as focas para fora do bloco de gelo.

Orka's

Orka's of zwaardwalvis behoren tot de dolfijnenfamilie, ze komen overal ter wereld voor, maar ze komen vooral voor in het koude water van hogere breedtegraden. De dieren die in associaties leven zijn sociaal, communicatief en in staat tot verfijnde jachtstrategieën en gecoördineerde groepsaanvallen, die ze zelfs aanpassen aan lokaal voorkomende prooien. Op Antarctica is waargenomen hoe orka's ijsschotsen waar zeehonden zich bevinden in kleinere stukken breken. Vervolgens zwemmen ze in een formatie om een grote golf te creëren die de zeehonden van de ijsschotsen spoelen.

Sukakpak Mountain, Brooks Range

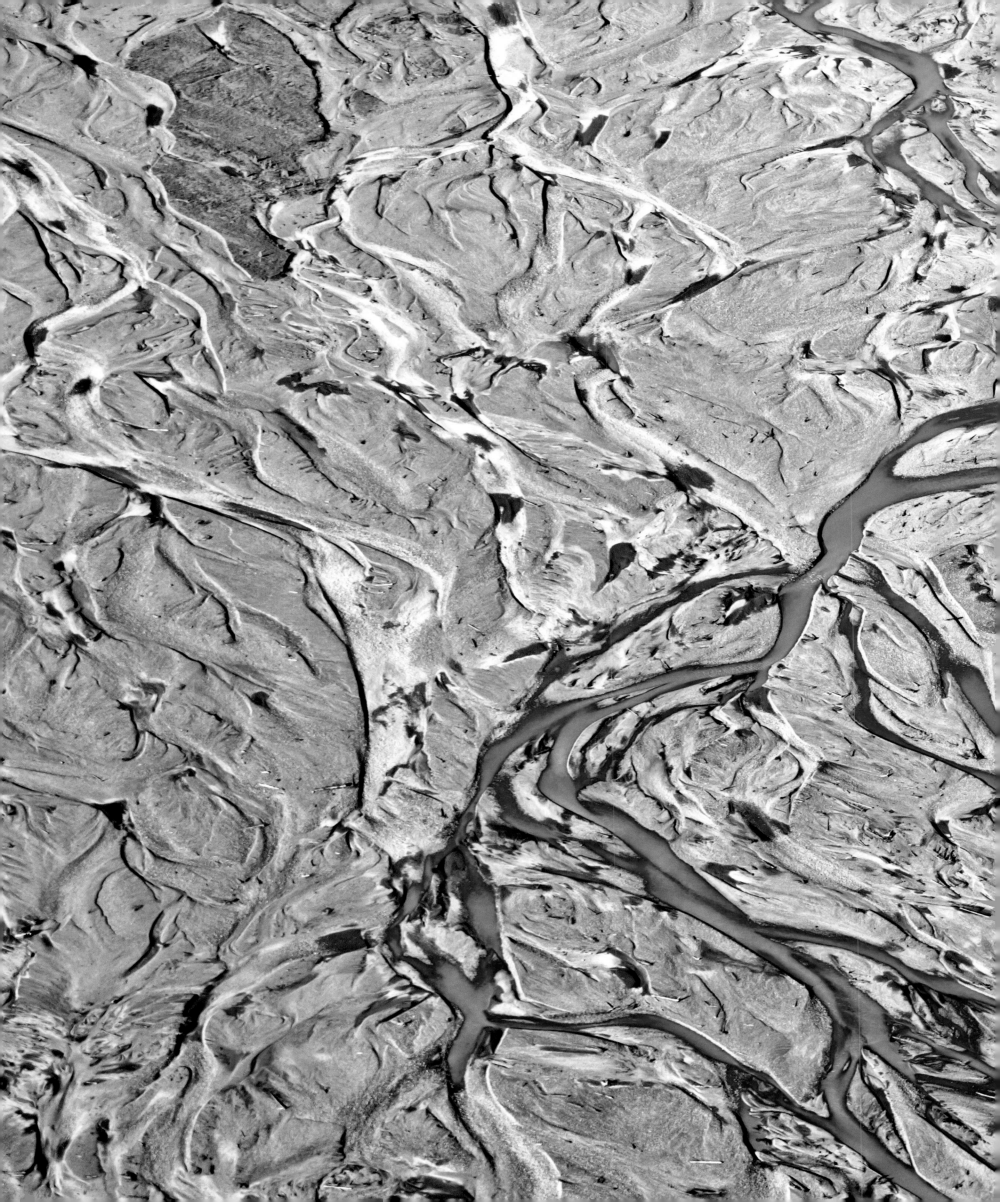

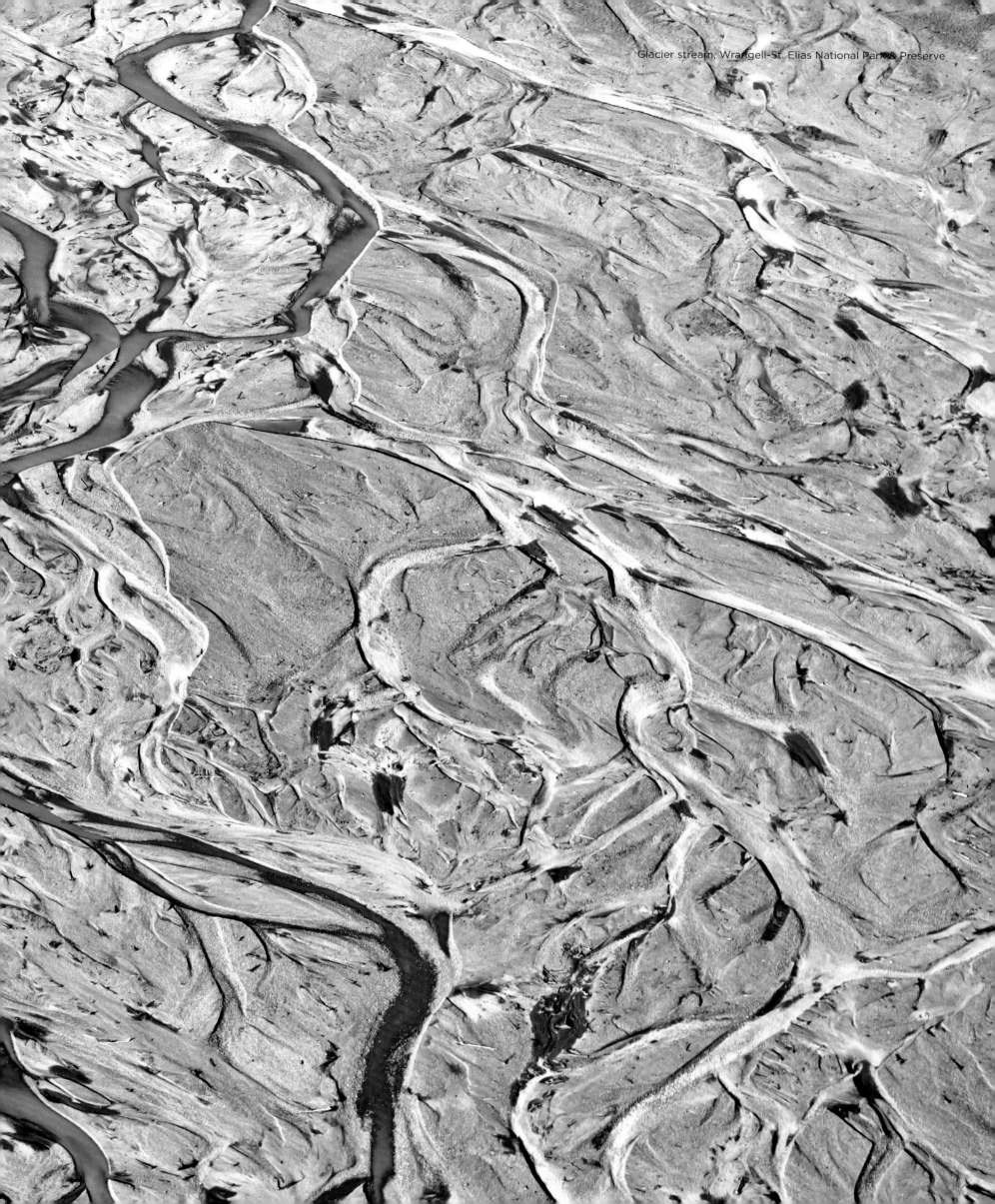

Glacier stream, Wrangell-St. Elias National Park & Preserve

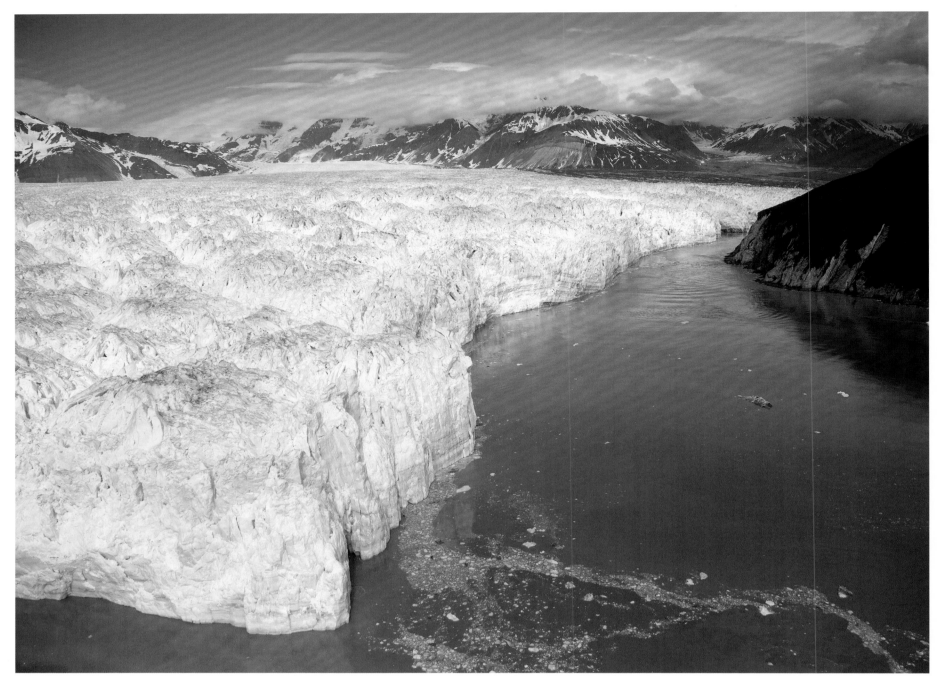

Hubbard Glacier, Wrangell-St. Elias National Park & Preserve

Glaciers

Glacier tongues are constantly in motion; like icy streams they flow down to the valley, driven by gravity. Most only manage a few millimeters or centimeters (inches) a day, the fastest a few meters (feet). This flow leads to surface cracks, crevasses and ice towers, the so-called seracs. If you look into one of these crevasses, which are up to 30 m (98 ft) deep, you can see blue ice from which all of the air bubbles have been pressed out. Even deeper inside the glacier, the ice is under such enormous pressure that it no longer ruptures but only undergoes plastic deformation.

Glaciers

Les langues glaciaires sont en mouvement perpétuel, puisqu'elles coulent sous l'effet de la gravité telles des rivières gelées vers les vallées. La plupart n'avancent que de quelques millimètres ou centimètres par jour, les plus rapides de quelques mètres. Cette progression engendre à leur surface des fissures, des crevasses ainsi que des amas de blocs de glace, les fameux séracs. Si l'on regarde à l'intérieur de l'une de ces crevasses, qui peut atteindre 30 m de profondeur, on observe de la glace bleue, dont toutes les bulles d'air ont été expulsées. Plus profondément encore dans ces fentes, la glace subit une telle pression qu'elle ne se déchire plus, mais se déforme.

Gletscher

Gletscherzungen sind ständig in Bewegung, wie eisige Ströme fließen sie von der Schwerkraft angetrieben zu Tal. Die meisten schaffen nur einige Millimeter oder Zentimeter pro Tag, die schnellsten jedoch einige Meter. Dieses Fließen führt an der Oberfläche zu Rissen, Spalten und Eistürmen, den sogenannten Seracs. Blickt man in eine dieser bis zu 30 m tiefen Spalten, sieht man blaues Eis, aus dem alle Luftblasen herausgepresst worden sind. Noch tiefer im Gletscherinnern steht das Eis unter solch gewaltigem Druck, dass es nicht mehr aufreißt, sondern sich nur noch plastisch verformt.

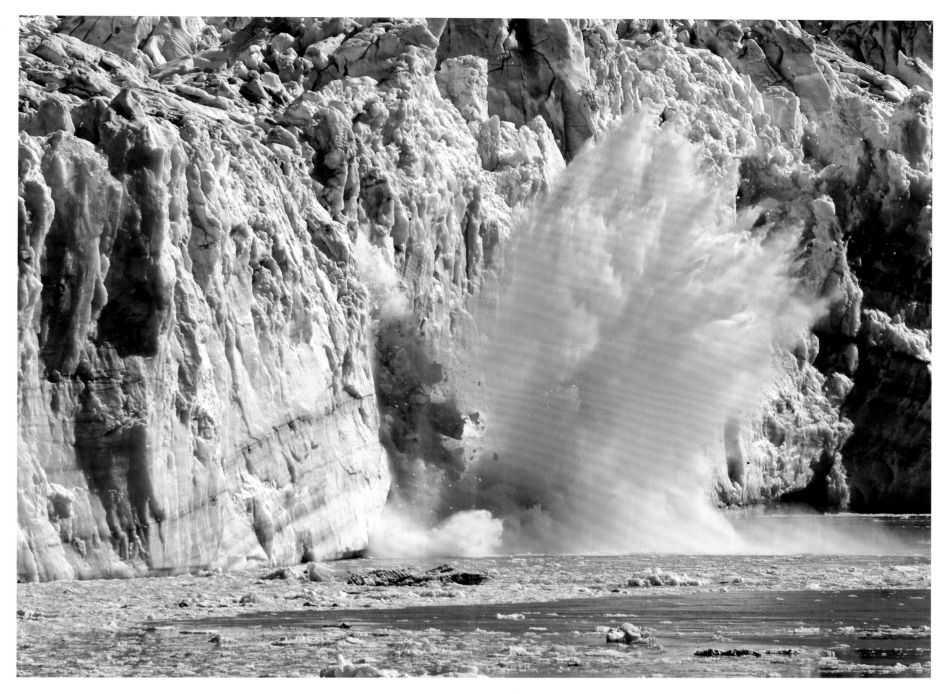

Hubbard Glacier, Wrangell-St. Elias National Park & Preserve

Glaciares

Las lenguas de los glaciares están en constante movimiento, como corrientes heladas que fluyen hacia el valle impulsadas por la gravedad. La mayoría solo avanzan unos pocos milímetros o centímetros al día; las más rápidas, unos pocos metros. Este flujo hace que en la superficie se formen grietas, fisuras y bloques de hielo, los llamados seracs. Si se observa una de estas fisuras, de hasta 30 m de profundidad, se observa un hielo azul del que se han expulsado todas las burbujas de aire. Aún más profundo dentro del glaciar, el hielo está bajo una presión tan grande que ya no se rompe, sino que solo se deforma plásticamente.

Geleiras

As línguas de gelo estão em constante movimento, como correntes geladas que fluem para o vale movidos pela gravidade. A maioria só consegue alguns milímetros ou centímetros por dia, o mais rápido alguns metros. Este fluxo leva a rachaduras superficiais, fendas e torres de gelo, os chamados seracs. Se olharmos para uma destas fendas, que têm até 30 m de profundidade, vemos gelo azul, do qual todas as bolhas de ar foram pressionadas para fora. Ainda mais profundo dentro da geleira, o gelo está sob uma pressão tão enorme que já não se rompe, mas apenas se deforma plasticamente.

Gletsjers

Gletsjertongen zijn voortdurend in beweging, een ijzige stroom die door de zwaartekracht naar de vallei wordt gedreven. De meesten halen slechts enkele millimeters of centimeters per dag, de snelste een paar meter. Deze stroming leidt tot oppervlaktescheuren, spleten en ijstorens, de zogenaamde seracs. Wanneer je in een van deze tot 30 m diepe spleten kijkt, zie je blauw ijs waaruit alle luchtbellen zijn geperst. Nog dieper in de gletsjer staat het ijs onder een zodanig enorme druk dat het niet meer breekt, maar slechts plastisch vervormt.

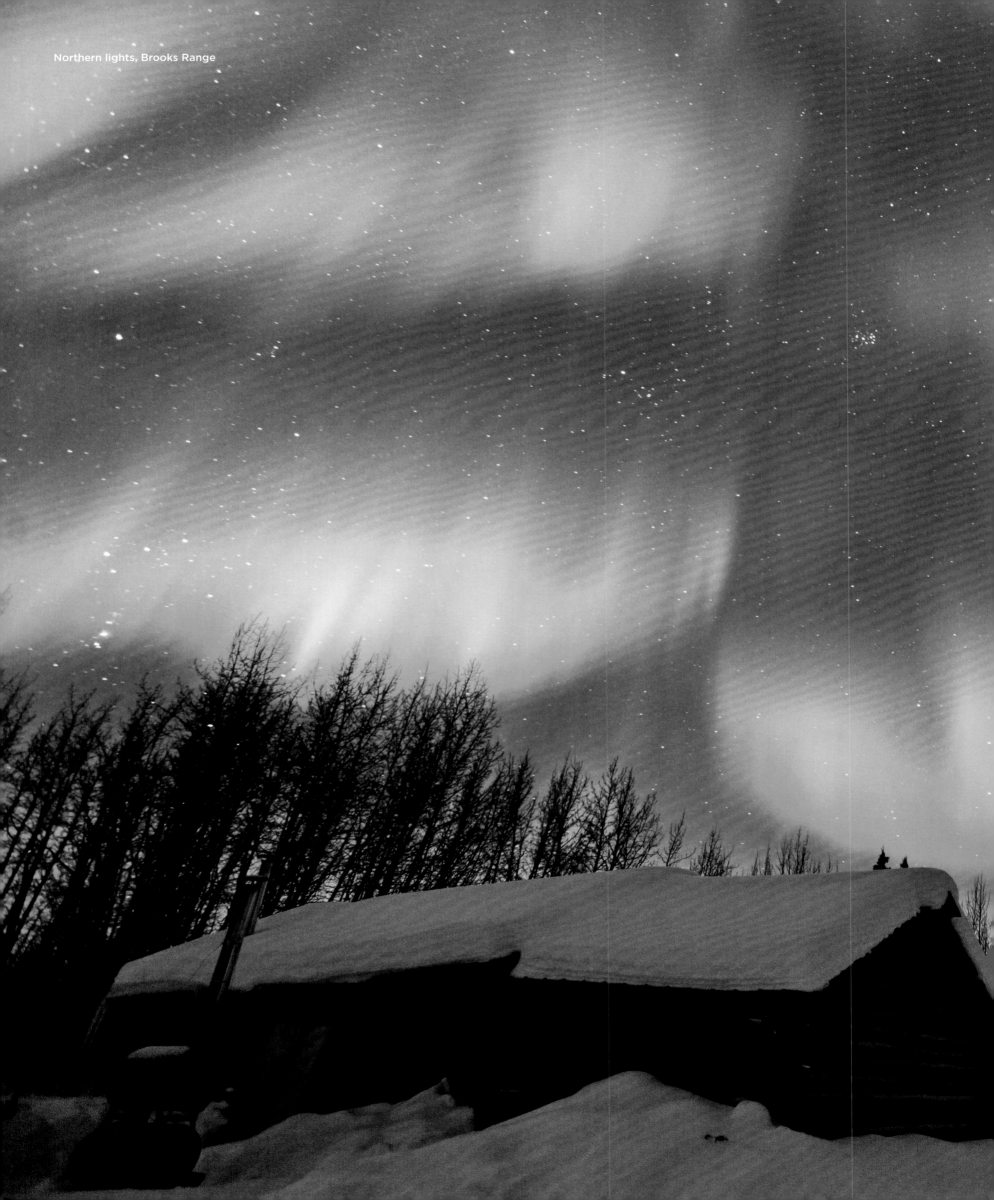

Northern lights, Brooks Range

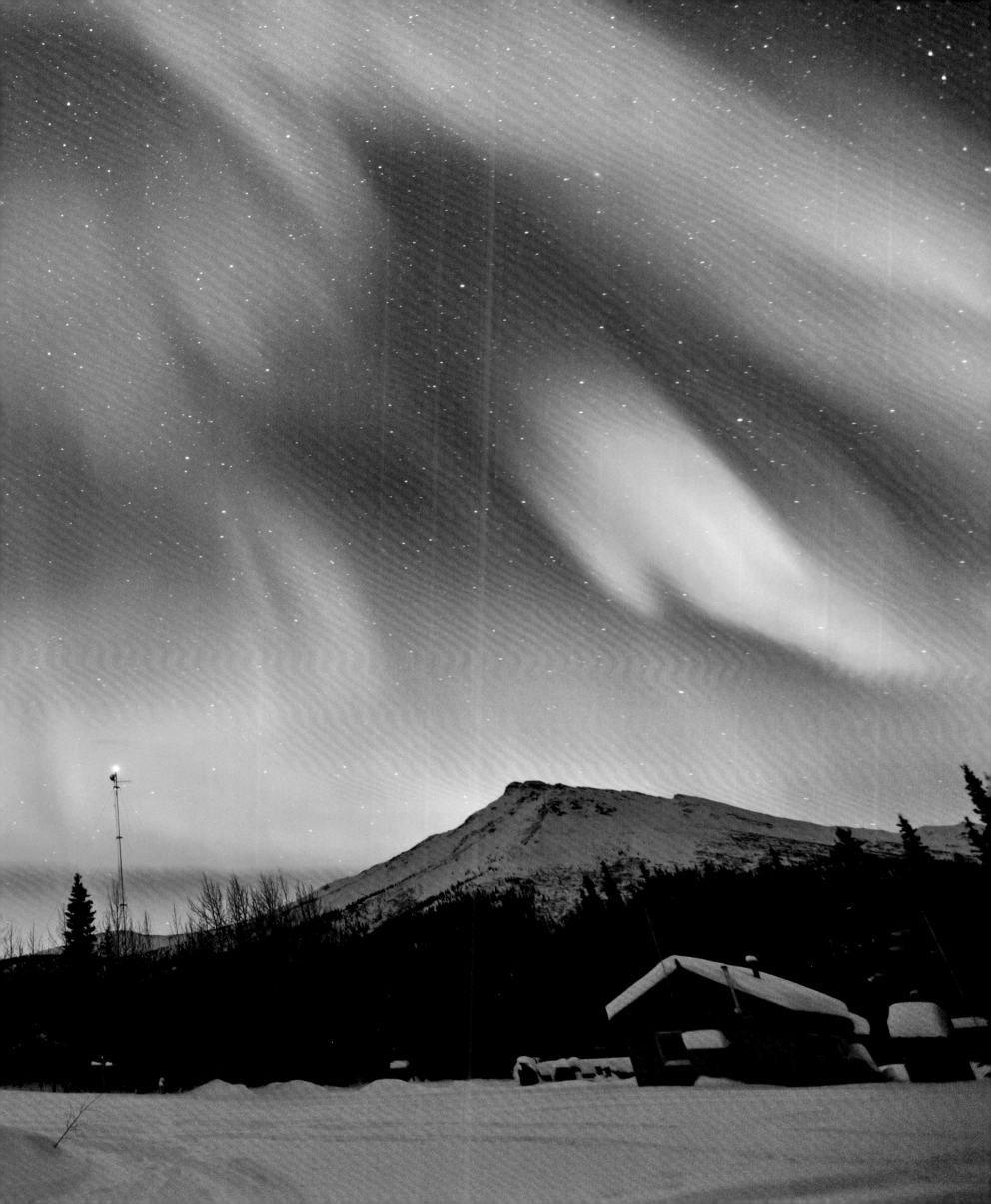

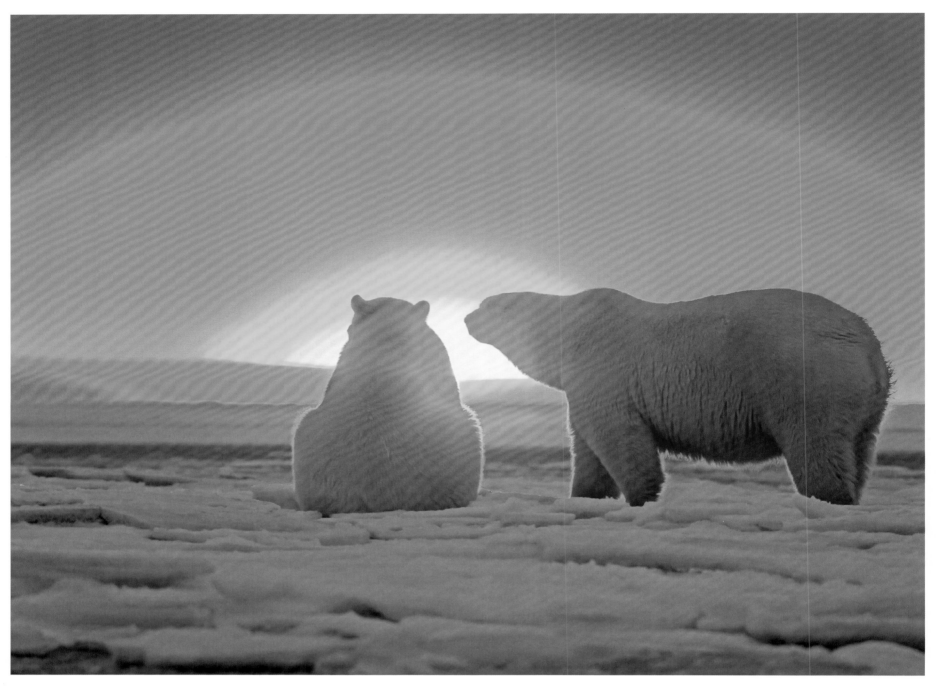

Polar bears, Kaktovik

Endangering the Polar Bears

The polar bear is perfectly adapted to the harsh arctic climate. Unlike its relative, the brown bear, it has cut off almost all connections to land and has become Ursus maritimus, which would love to hunt seals on ice floes all year round. However, climate change is making this increasingly difficult for them. In summer, the animals live off their fat reserves and wait for the Arctic Ocean to freeze over, but this is now consistently happening later in the season. If this trend continues, as can be assumed, polar bears could be extinct in 50 years, or 100 years at the latest.

Ours polaires menacés

Les ours polaires, ou ours blancs, sont parfaitement adaptés à la rudesse du climat arctique. Contrairement à leur cousin, l'ours brun, ils ont coupé presque tous les liens avec la terre et sont ainsi devenus *ursus maritimus,* chassant toute l'année et de préférence les phoques sur leurs blocs de glace. Le changement climatique leur rend toutefois la tâche de plus en plus difficile. L'été, ils vivent de leurs réserves de graisse et attendent le gel de l'océan Arctique qui arrive de plus en plus tard chaque année. Si cette tendance perdure, et il faut s'y attendre, les ours polaires pourraient avoir disparu au plus tard dans les cinquante ou cent ans à venir.

Gefährdung der Eisbären

An das harte arktische Klima ist der Eisbär oder Polarbär perfekt angepasst. Anders als sein Verwandter, der Braunbär, hat er fast alle Verbindungen zum Land gekappt und ist zum Ursus maritimus geworden, der am liebsten das ganze Jahr über auf Eisschollen Robben jagen würde. Doch dies macht ihm der Klimawandel immer schwerer. Im Sommer leben die Tiere von ihren Fettreserven und warten auf das Zufrieren des arktischen Ozeans, was mittlerweile aber immer später passiert. Falls dieser Trend anhält, wovon auszugehen ist, könnten Eisbären schon in 50 oder spätestens 100 Jahren ausgestorben sein.

Midnight Sun, Chukchi Sea

Osos polares amenazados

El oso polar está perfectamente adaptado al duro clima ártico. A diferencia de su pariente, el oso pardo, ha cortado casi todas las conexiones con la tierra y se ha convertido en el Ursus maritimus, a quien le encantaría cazar focas en témpanos de hielo durante todo el año. Pero el cambio climático le está dificultando cada vez más las cosas. En verano, estos animales viven de sus reservas de grasa y esperan a que el Océano Ártico se congele, pero esto sucede cada vez más tarde. Si esta tendencia continúa, como es de suponer, los osos polares podrían extinguirse, a más tardar, en 50 o 100 años.

Ameaça aos ursos polares

O urso polar também conhecido como urso-branco é perfeitamente adaptado ao clima ártico rigoroso. Ao contrário do seu parente, o urso pardo, ele cortou quase todas os laços com a terra e tornou-se o Ursus maritimus, que adoraria caçar focas em blocos de gelo durante todo o ano. Mas as alterações climáticas estão a tornar isto cada vez mais difícil para ele. No verão, os animais vivem de suas reservas de gordura e esperam que o Oceano Ártico congele, mas isso sempre acontece mais tarde. Se esta tendência se mantiver, como se pode supor, os ursos polares poderão estar extintos em 50 ou 100 anos, o mais tardar.

De bedreiging van ijsberen

De ijsbeer is perfect aangepast aan het harde Arctische klimaat. In tegenstelling tot zijn familielid, de bruine beer, heeft hij bijna alle verbindingen met het land verbroken en is hij de Ursus maritimus geworden, die het hele jaar door op ijsschots zittende zeehonden wil jagen. Maar de klimaatverandering maakt dit voor hem steeds moeilijker. In de zomer leven de dieren van hun vetreserves en wachten ze tot de Noordelijke IJszee bevriest, maar dit vind steeds later plaats. Als deze trend doorzet, zoals mag worden aangenomen, kunnen ijsberen uiterlijk over 50 of 100 jaar zijn uitgestorven.

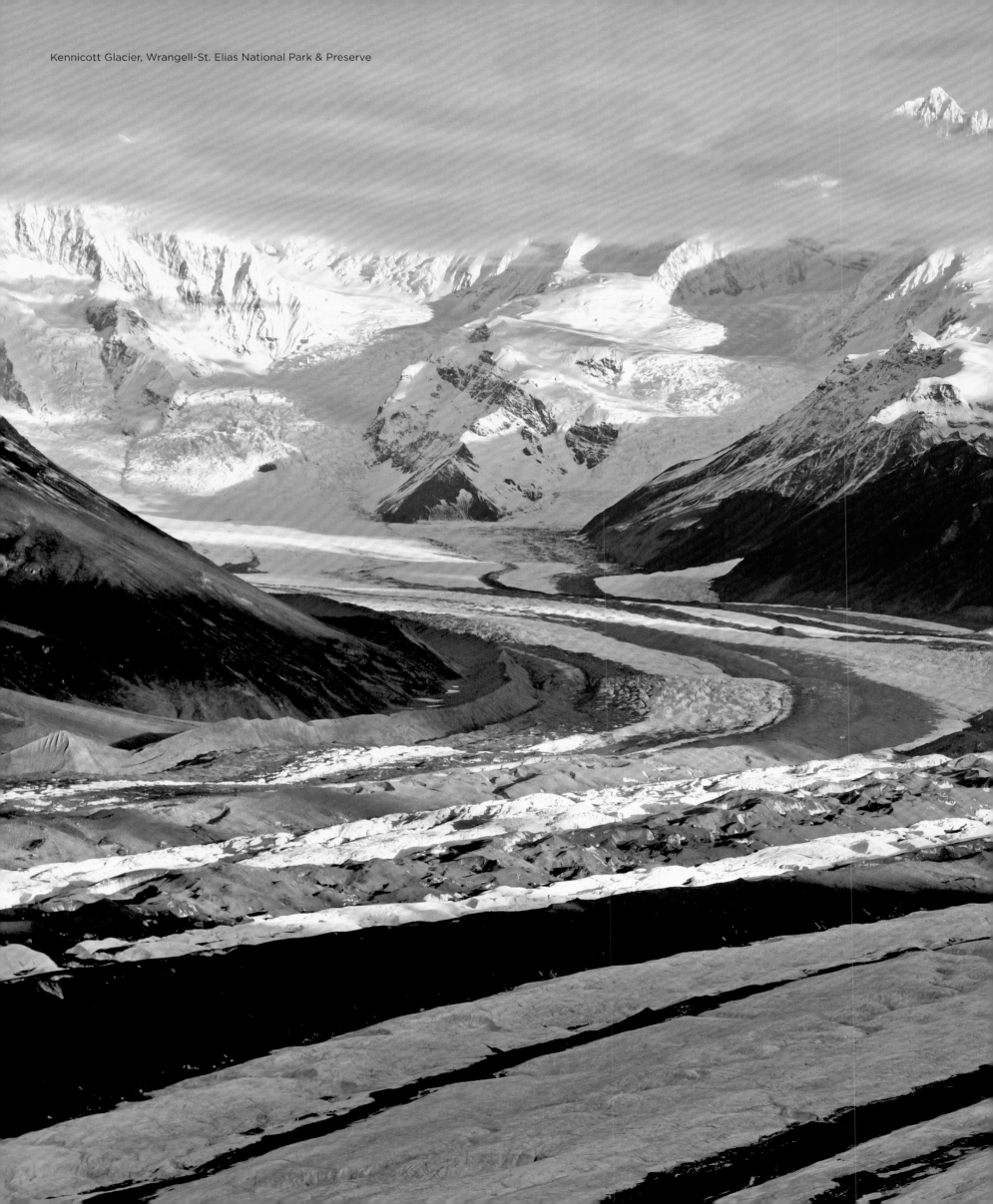

Kennicott Glacier, Wrangell-St. Elias National Park & Preserve

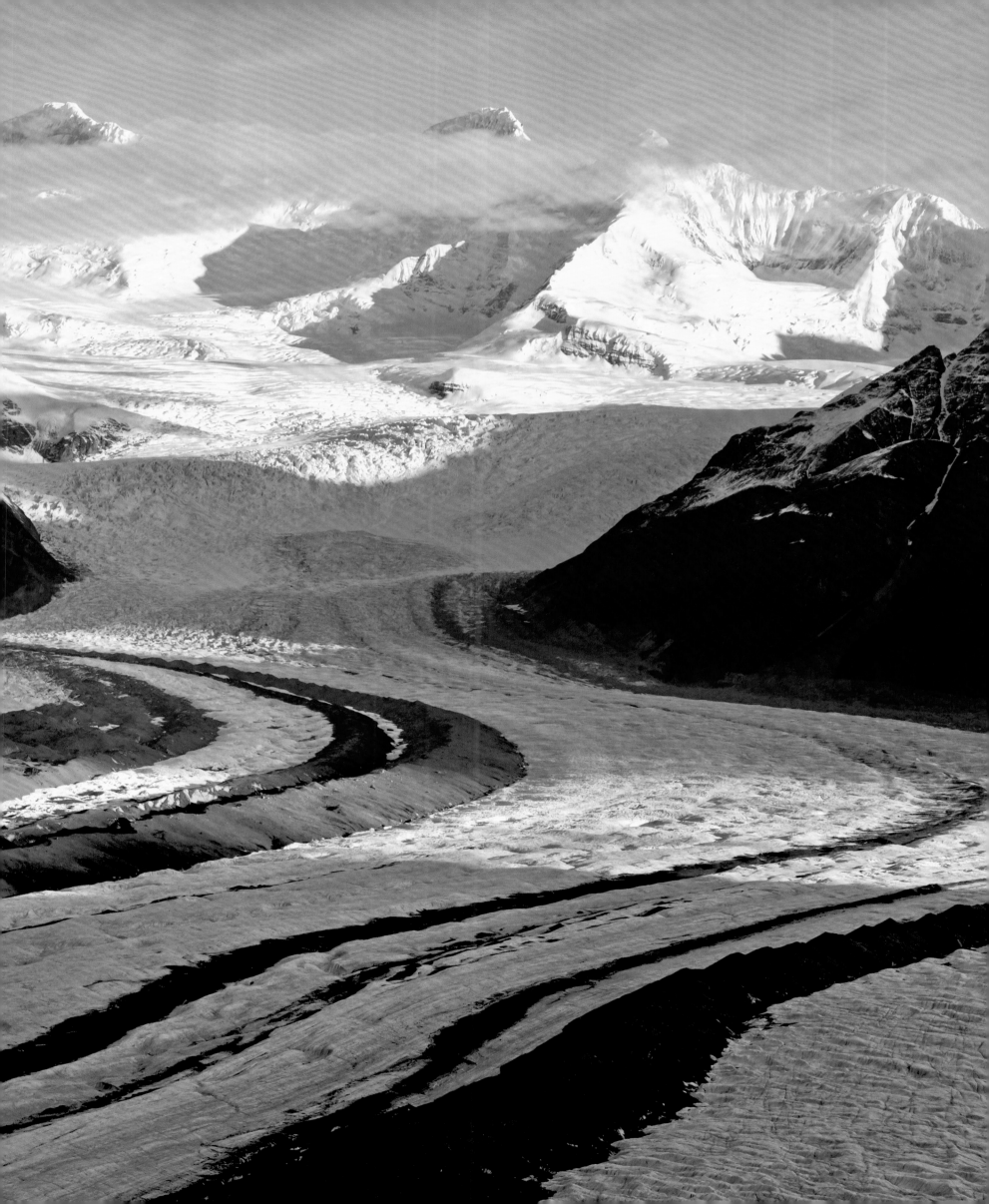

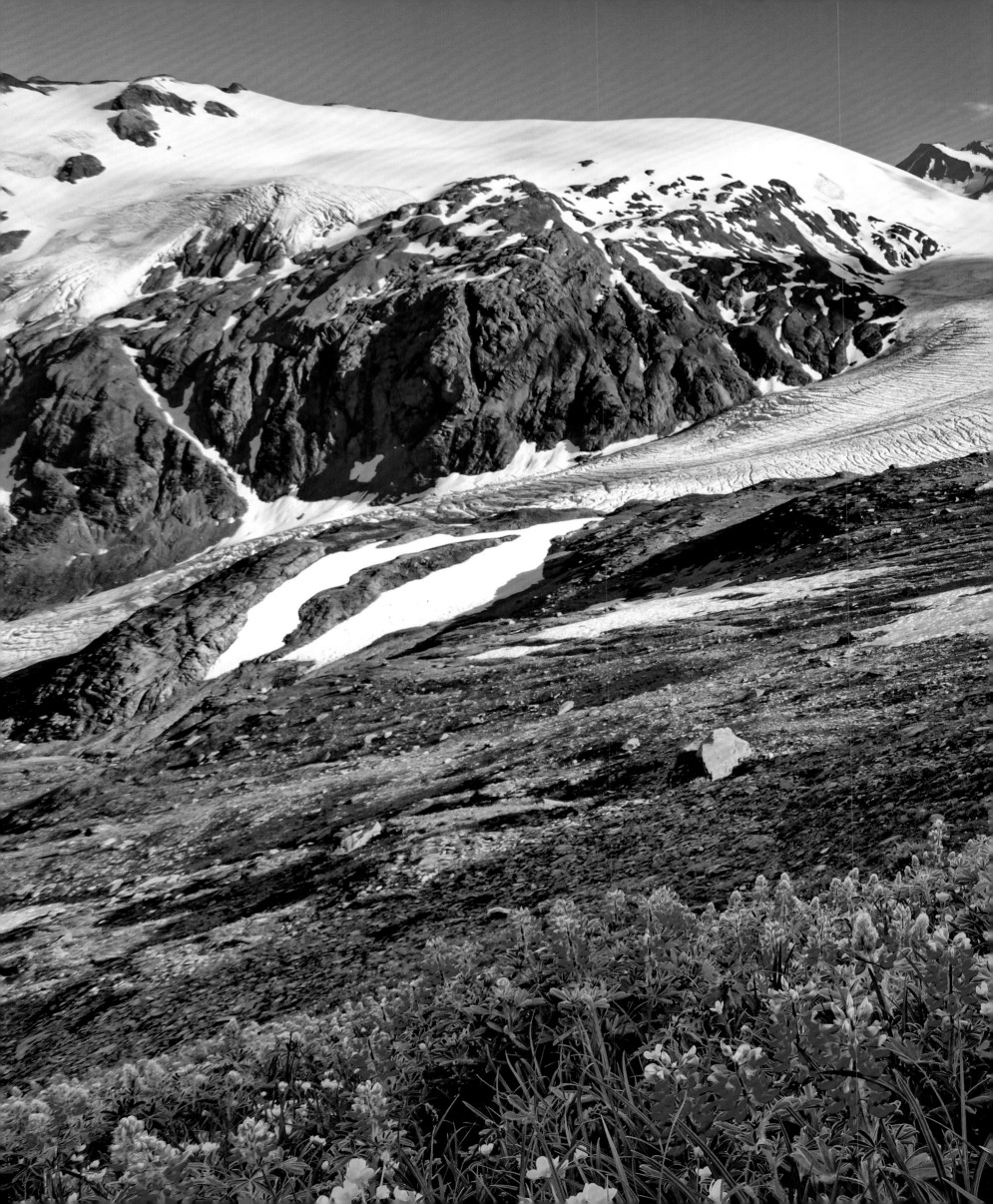

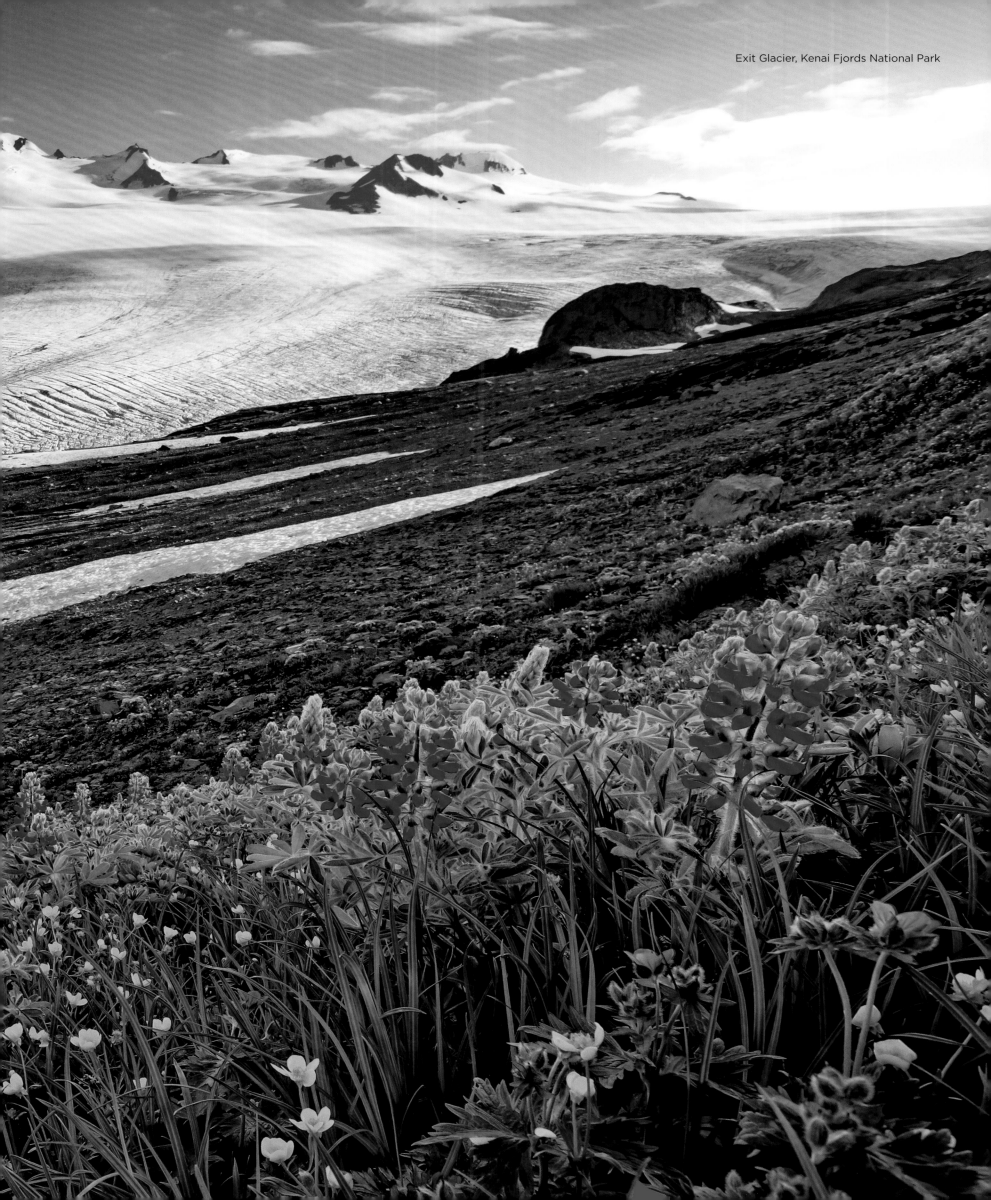

Exit Glacier, Kenai Fjords National Park

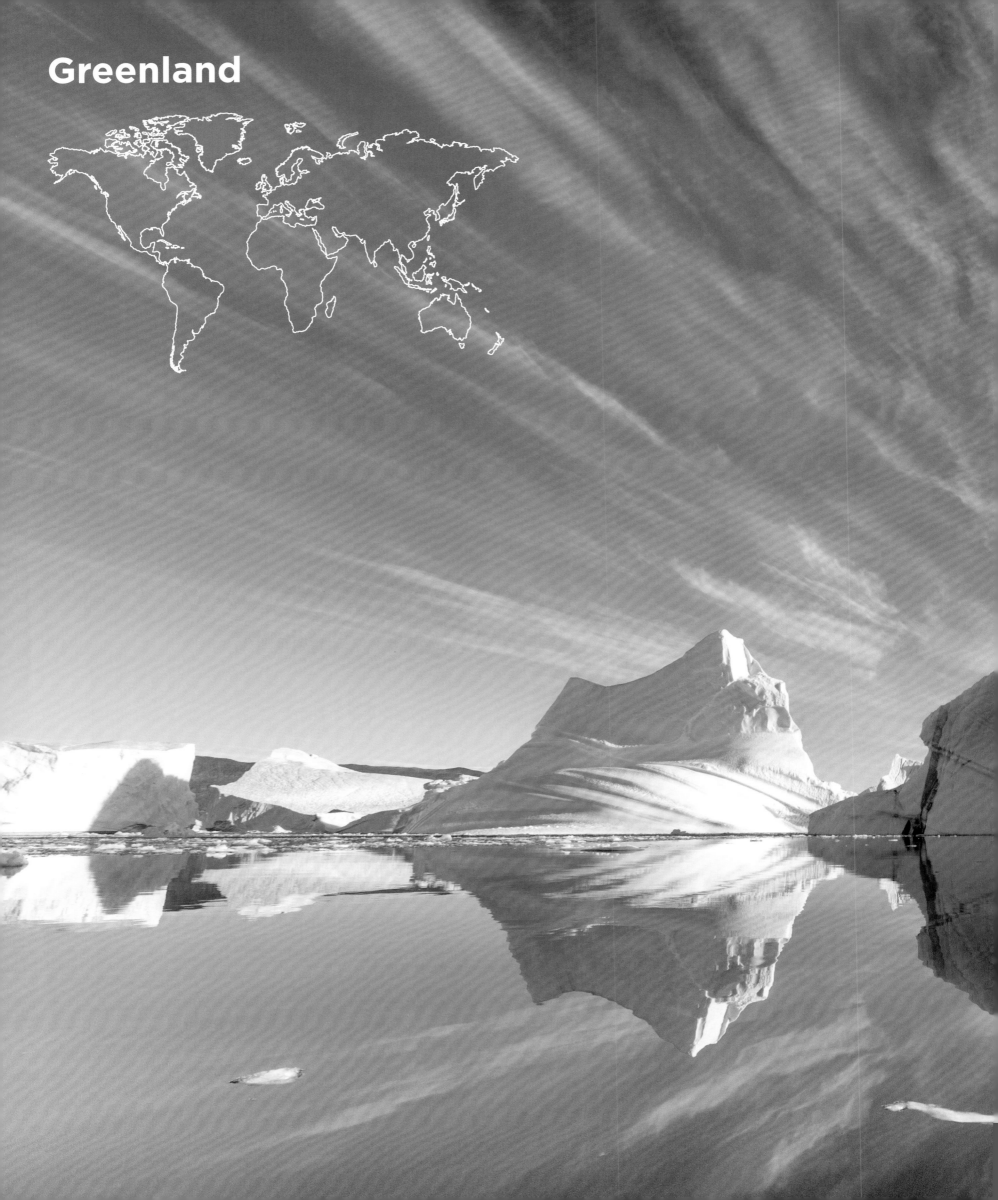

Greenland

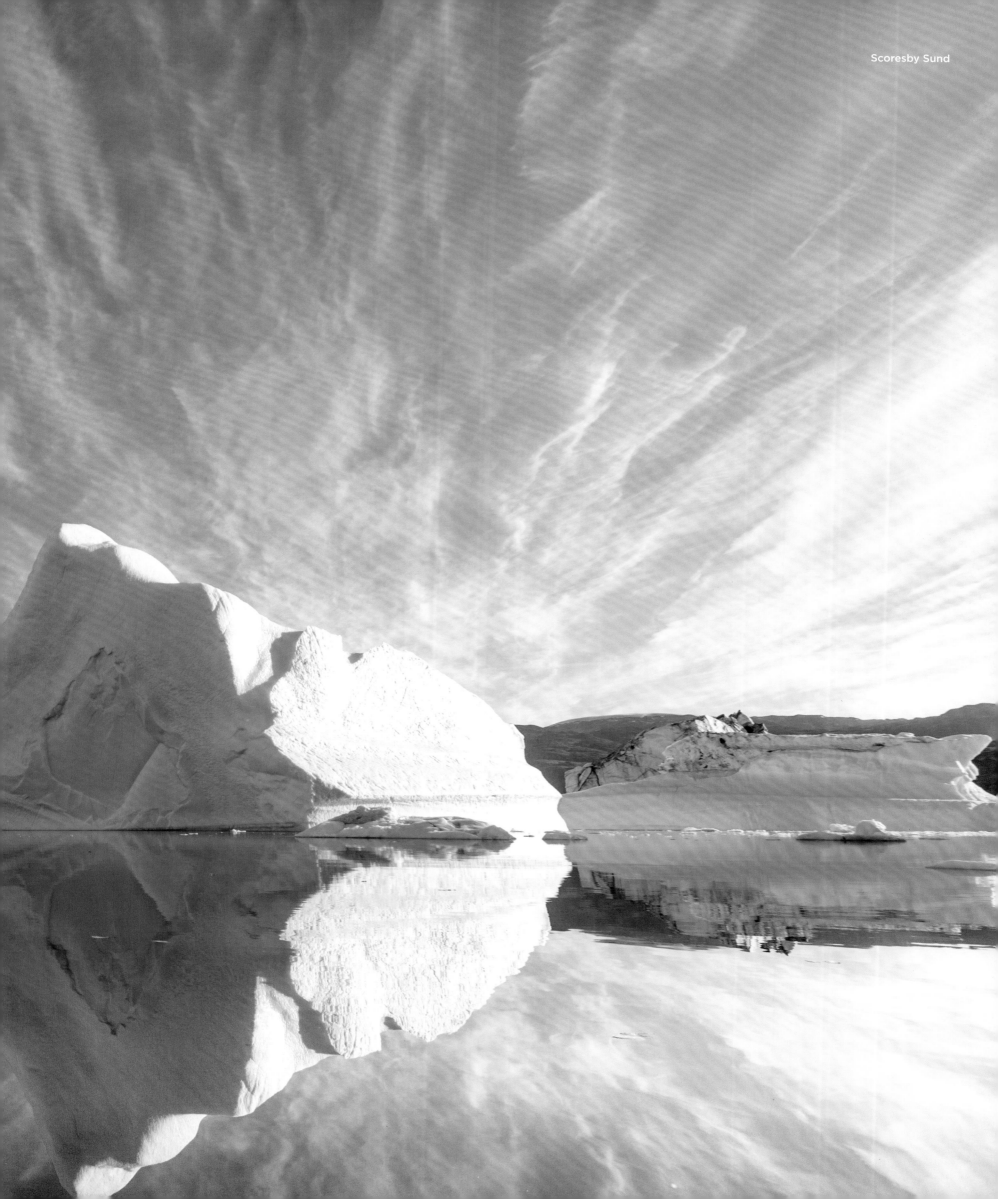

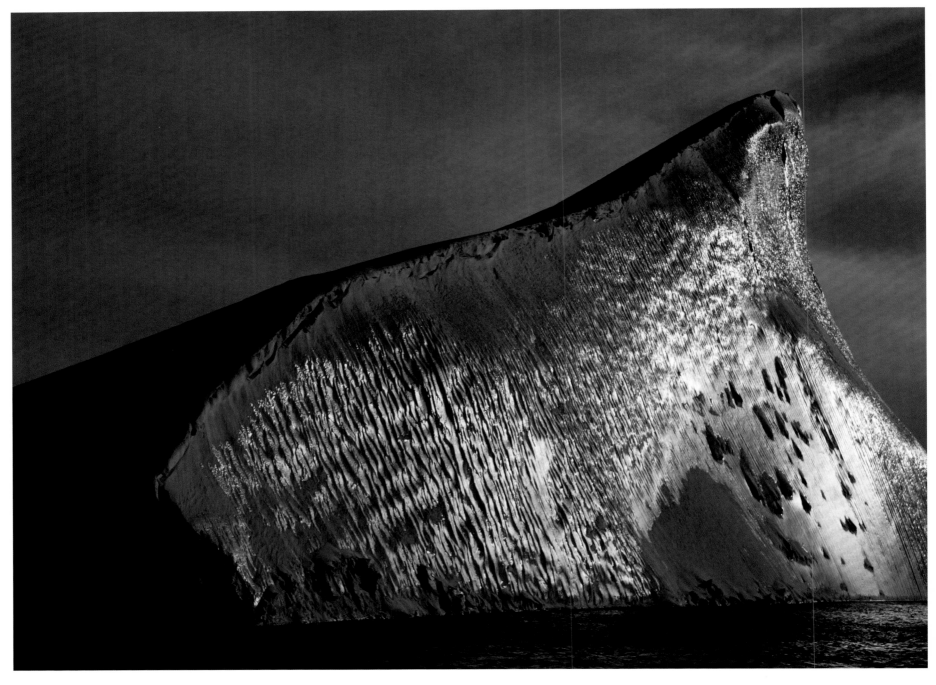

Iceberg, Disko Bay

Greenland

Kalaallit Nunaat—the land of the people—is what Greenlanders call their homeland. They live on the largest island on earth with an area of almost 2,170,000 km² (837,841 sq mi). The southern part of Greenland consists of undulating highlands, and the coastline is divided by bays and fjords. In the north and east the landscape is rougher, and the highest elevation is Gunnbjørns Fjeld, at 3694 m (12119 ft) high and known as Nunatak, an ice-free, rugged peak. More than 80 per cent of Greenland is covered by inland ice. In places it reaches a thickness of 3000 m (2 mi) and stores around 10 per cent of the world's fresh water.

Groenland

Les Groenlandais appellent leur pays « Kalaallit Nunaat », la « terre des hommes » et vivent sur l'une des plus grandes îles de la planète, d'une surface de presque 2 170 000 km². Le sud du Groenland est constitué de hautes terres vallonnées, les côtes, quant à elles, sont découpées par des baies et des fjords. Au nord et à l'est, les paysages sont plus abrupts. C'est également là que s'élève le plus haut sommet de l'île, le Gunnbjørn, à 3 694 m d'altitude. Le Gunnbjørn est ce que l'on appelle un nunatak, un pic rocheux libéré de toute glace. Plus de 80 % du Groenland sont ensevelis sous l'inlandsis, qui atteint à certains endroits une épaisseur de 3 000 m et représente 10 % des ressources mondiales en eau douce.

Grönland

Kalaallit Nunaat – Land der Menschen – nennen die Grönländer ihre Heimat. Sie leben auf der größten Insel der Erde mit einer Fläche von fast 2 170 000 km². Der südliche Teil Grönlands besteht aus welligem Hochland, die Küsten sind durch Buchten und Fjorde gegliedert. Im Norden und Osten ist die Landschaft rauer, hier liegt auch die höchste Erhebung, der 3694 m hohe Gunnbjørns Fjeld, ein sogenannter Nunatak, ein eisfreier, zerklüfteter Gipfel. Mehr als 80 Prozent Grönlands sind vom Inlandeis bedeckt, stellenweise erreicht es eine Dicke von 3000 m; es speichert etwa 10 Prozent des weltweiten Frischwassers.

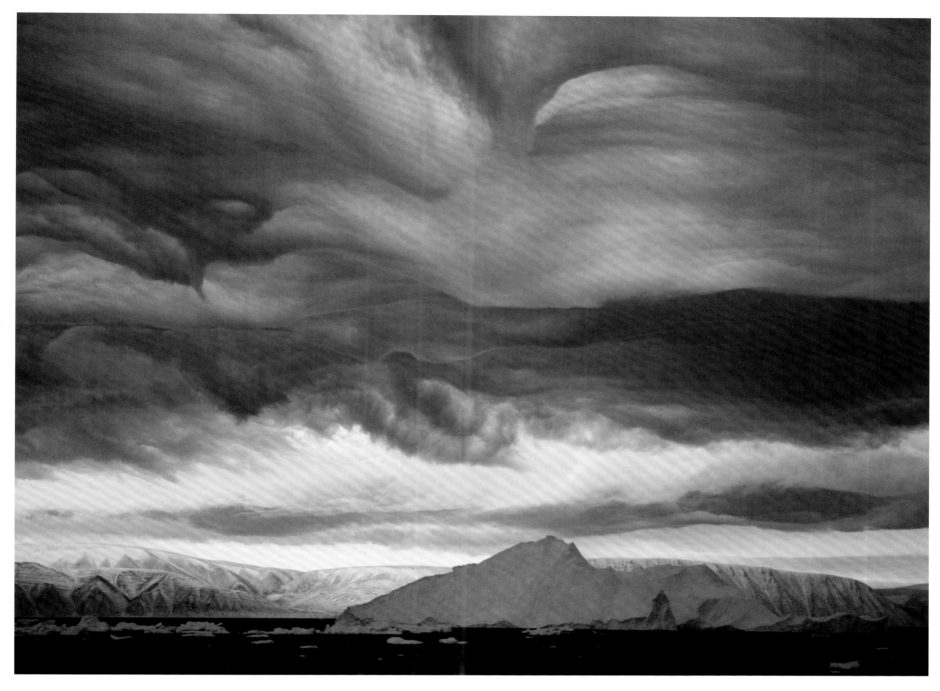

Qaanaaq, Inglefield Fjord

Groenlandia

Kalaallit Nunaat (tierra de los hombres) es lo que los groenlandeses llaman su patria. Viven en la isla más grande del mundo, con una superficie de casi 2 170 000 km². La parte sur de Groenlandia consiste en tierras altas onduladas, las costas están divididas por bahías y fiordos. En el norte y el este, el paisaje es más agreste, y la elevación más alta es Gunnbjørns Fjeld, de 3694 m de altura y conocida como Nunatak, un pico escarpado y sin hielo. Más del 80 por ciento de Groenlandia está cubierta de hielo interior, en algunos lugares alcanza un espesor de 3000 m; almacena alrededor del 10 por ciento del agua dulce del mundo.

Groenlândia

Kalaallit Nunaat - terra do povo - é como os groenlandeses chamam a sua pátria. Eles vivem na maior ilha do mundo, com uma área de quase 2 170 000 km². A parte sul da Groenlândia é constituída por planaltos ondulados, as costas são divididas por baías e fiordes. No norte e no leste, a paisagem é mais agreste, aqui se encontra a maior elevação, o Gunnbjørns Fjeld com 3694 m de altura, também conhecida como Nunatak, um pico sem gelo e acidentado. Mais de 80 por cento da Groenlândia está coberta por gelo interior, em locais onde atinge uma espessura de 3000 m; ele armazena cerca de 10 por cento da água doce do mundo.

Groenland

Kalaallit Nunaat - land van de mensen – is wat Groenlanders hun thuisland noemen. Ze wonen op het grootste eiland ter wereld met een oppervlakte van bijna 2 170 000 km². Het zuidelijke deel van Groenland bestaat uit golvende hooglanden, de kusten zijn verdeeld door baaien en fjorden. In het noorden en oosten is het landschap ruwer en de hoogste berg is Gunnbjørns Fjeld, 3694 m hoog en bekent als Nunatak, een ijsvrije, ruige top. Meer dan 80 procent van Groenland is bedekt met landijs, op sommige plekken bereikt het een dikte van 3000 m; het slaat ongeveer 10 procent van het zoete water in de wereld op.

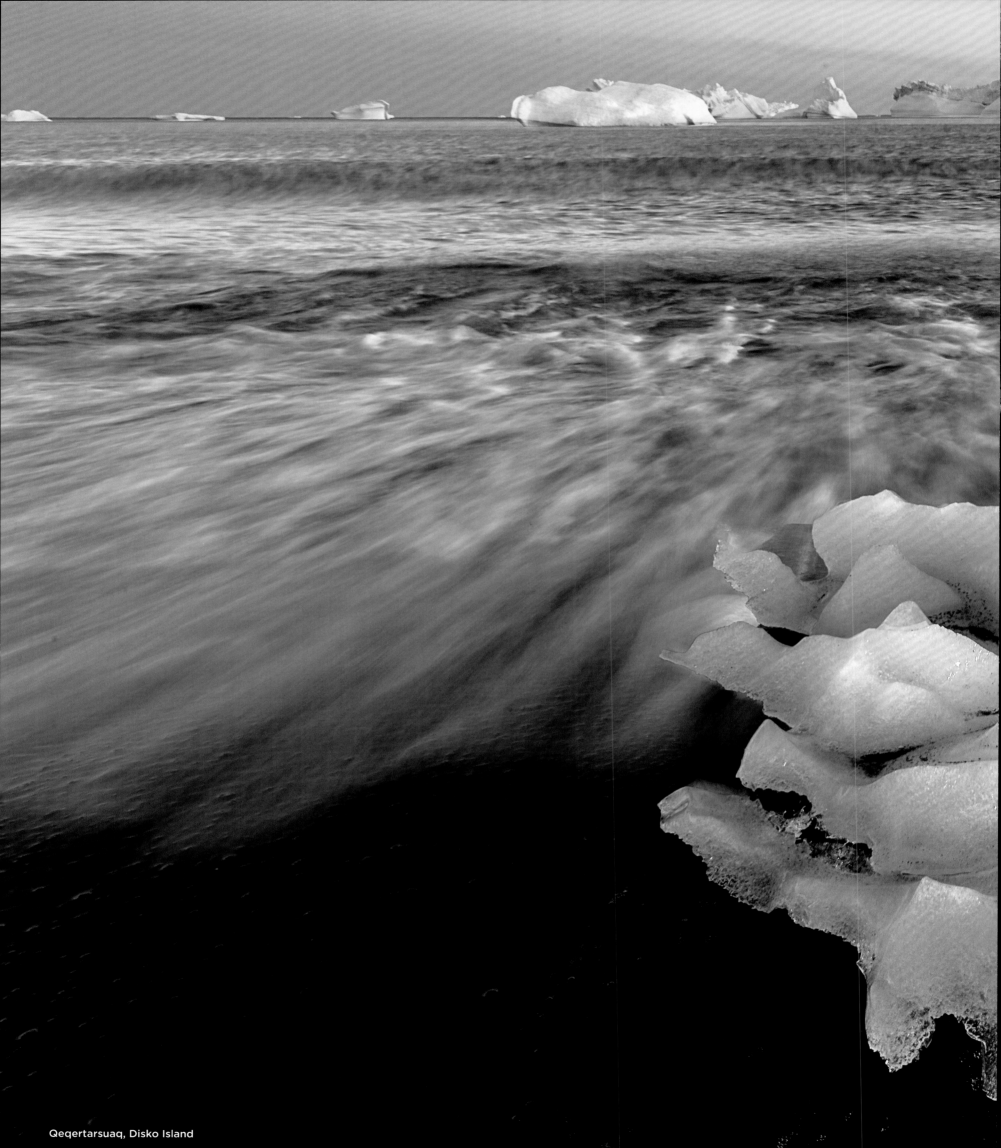

Qeqertarsuaq, Disko Island

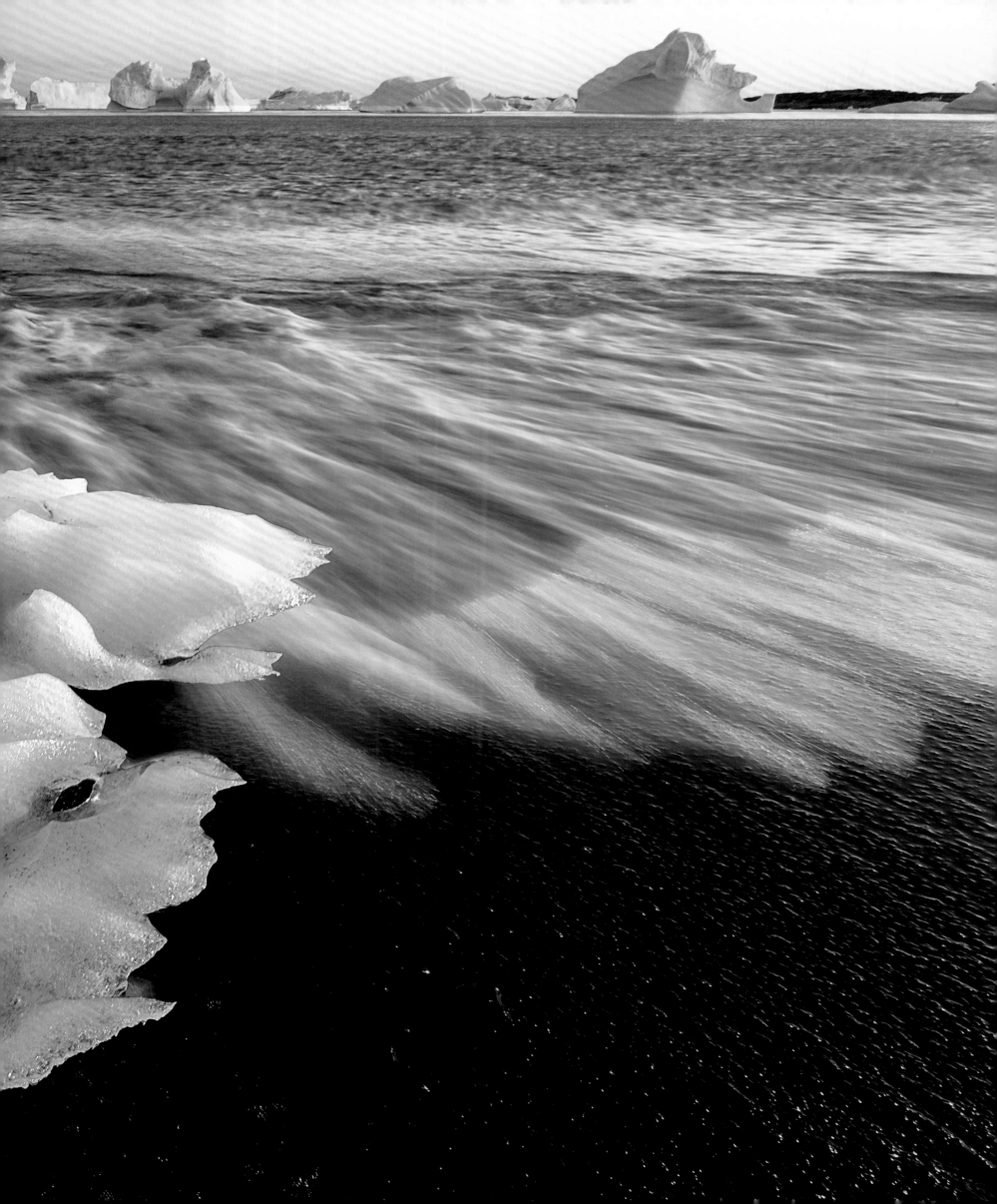

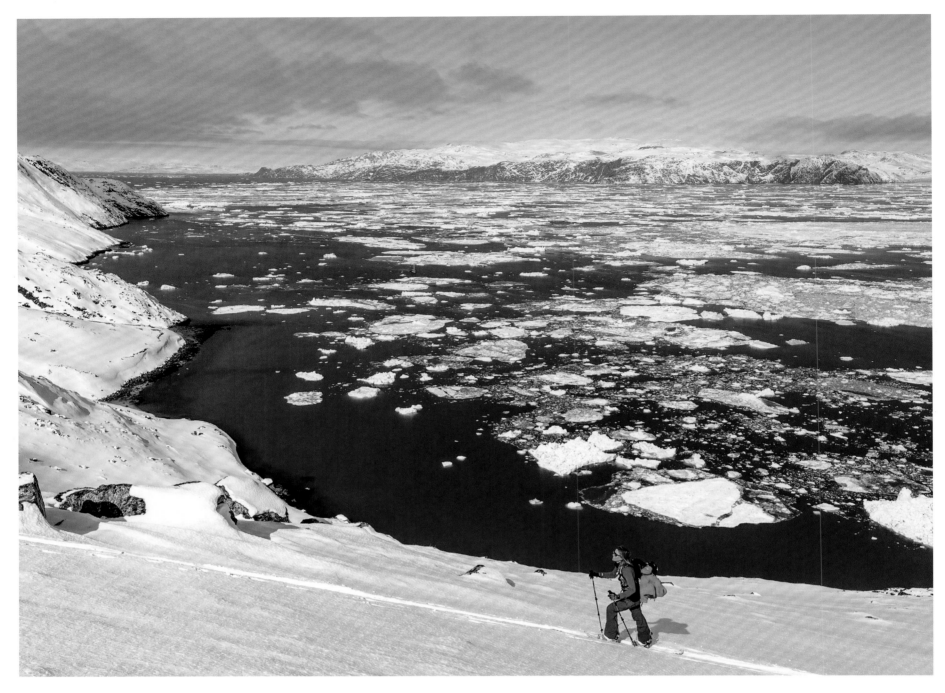

Nuuk Fjord

Outdoor Activities

Skiing in the warm spring sun on the slopes of Nuuk's extensive fjord system is an unforgettable experience for visitors to Greenland. The Inuit, however, prefer the so-called Arctic sports, which are not only used as sporting activities but also to preserve old traditions. These include arm, finger and neck pulling, or the Akratcheak air-jumping technique. Every two years, the Inuit meet at different locations for the "Arctic Winter Games", which are as important to them as the classic Olympic Games are to the rest of the world.

Activités d'extérieur

Pour les visiteurs du Groenland, une excursion à ski sous les rayons du soleil printanier et sur les pentes du vaste labyrinthe du système de fjords de Nuuk peut être une expérience inoubliable. Les fameux sports arctiques sont toutefois encore plus appréciés des Inuits car ils représentent pour eux, en plus d'une activité physique, le maintien de vieilles traditions. Parmi elles, des jeux consistant à tirer le bras, le doigt ou la nuque de son adversaire, ou la technique du Akratcheak, un jeu de saut. Tous les deux ans, les Inuits se retrouvent en divers lieux à l'occasion des Jeux d'hiver de l'Arctique, qui revêtent pour eux l'importance des Jeux olympiques pour le reste du monde.

Outdooraktivitäten

Skitouren in der wärmenden Frühjahrssonne an den Hängen des weitverzweigten Fjordsystems von Nuuk sind für Grönlandbesucher ein unvergessliches Erlebnis. Bei den Inuit sind jedoch die sogenannten Arktischen Sportarten viel beliebter, denn sie dienen neben der sportlichen Betätigung auch der Bewahrung alter Traditionen. Dazu gehören Arm-, Finger- und Nackenziehen oder die Luftsprungtechnik Akratcheak. Alle zwei Jahre treffen sich die Inuit an wechselnden Orten zu den „Arctic Winter Games", die für sie ähnlich wichtig sind wie für den Rest der Welt die klassischen Olympischen Spiele.

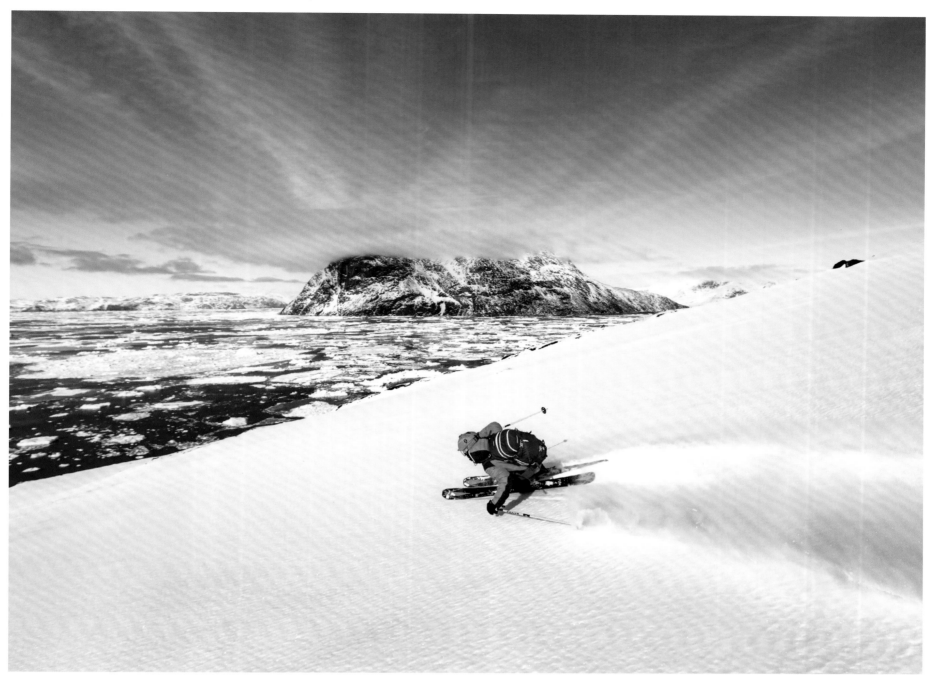

Nuuk Fjord

Actividades al aire libre

Esquiar bajo el cálido sol primaveral en las pistas del extenso sistema de fiordos de Nuuk es una experiencia inolvidable para los visitantes de Groenlandia. Los inuit, sin embargo, prefieren los llamados deportes árticos, que no solo se utilizan con el fin de realizar actividades deportivas, sino también para preservar las viejas tradiciones. Estos incluyen el tirón de brazos, dedos y cuello o la técnica de patada en altura a dos pies (Akratcheak). Cada dos años, los inuit se reúnen en diferentes lugares para los «Juegos de Invierno del Ártico», que son tan importantes para ellos como lo son los clásicos Juegos Olímpicos para el resto del mundo.

Atividades ao ar livre

Passeios de esqui no sol quente da primavera nas encostas do extenso sistema de fiorde de Nuuk é uma experiência inesquecível para os visitantes da Groenlândia. Os inuítes, porém, preferem os chamados desportos do Ártico, que não são utilizados apenas para atividades desportivas, mas também para preservar tradições antigas. Estes incluem puxar o braço, o dedo e o pescoço ou a técnica de salto aéreo Akratcheak. A cada dois anos, os inuítes se reúnem em diferentes locais para os "Jogos de Inverno do Ártico", que são tão importantes para eles quanto os Jogos Olímpicos clássicos são para o resto do mundo.

Buitenactiviteiten

Voor bezoekers aan Groenland is skiën in de warme lentezon op de hellingen van Nuuk's uitgebreide fjord-systeem een onvergetelijke ervaring. De Inuit geven echter de voorkeur aan de zogenaamde Arctische sporten, dit niet alleen voor sportactiviteiten, maar ook om oude tradities te behouden. Deze omvatten arm, vinger en nek trekken of de Akratcheak lucht-spring techniek. Om de twee jaar ontmoeten de Inuit's op verschillende locaties voor de „Arctische Winterspelen", die voor hen even belangrijk zijn als de klassieke Olympische Spelen voor de rest van de wereld.

Iceberg, Baffin Bay near Iluissat

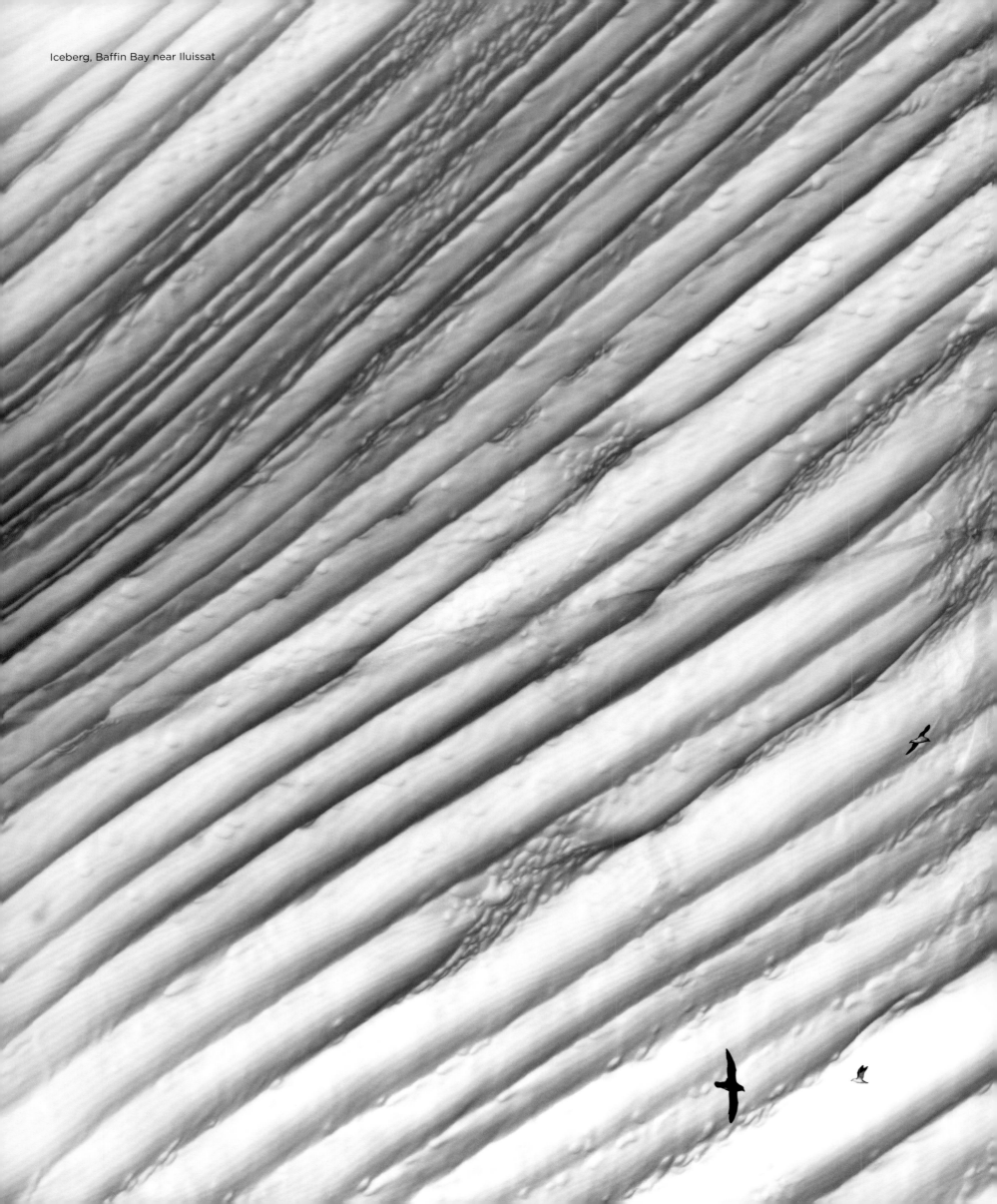

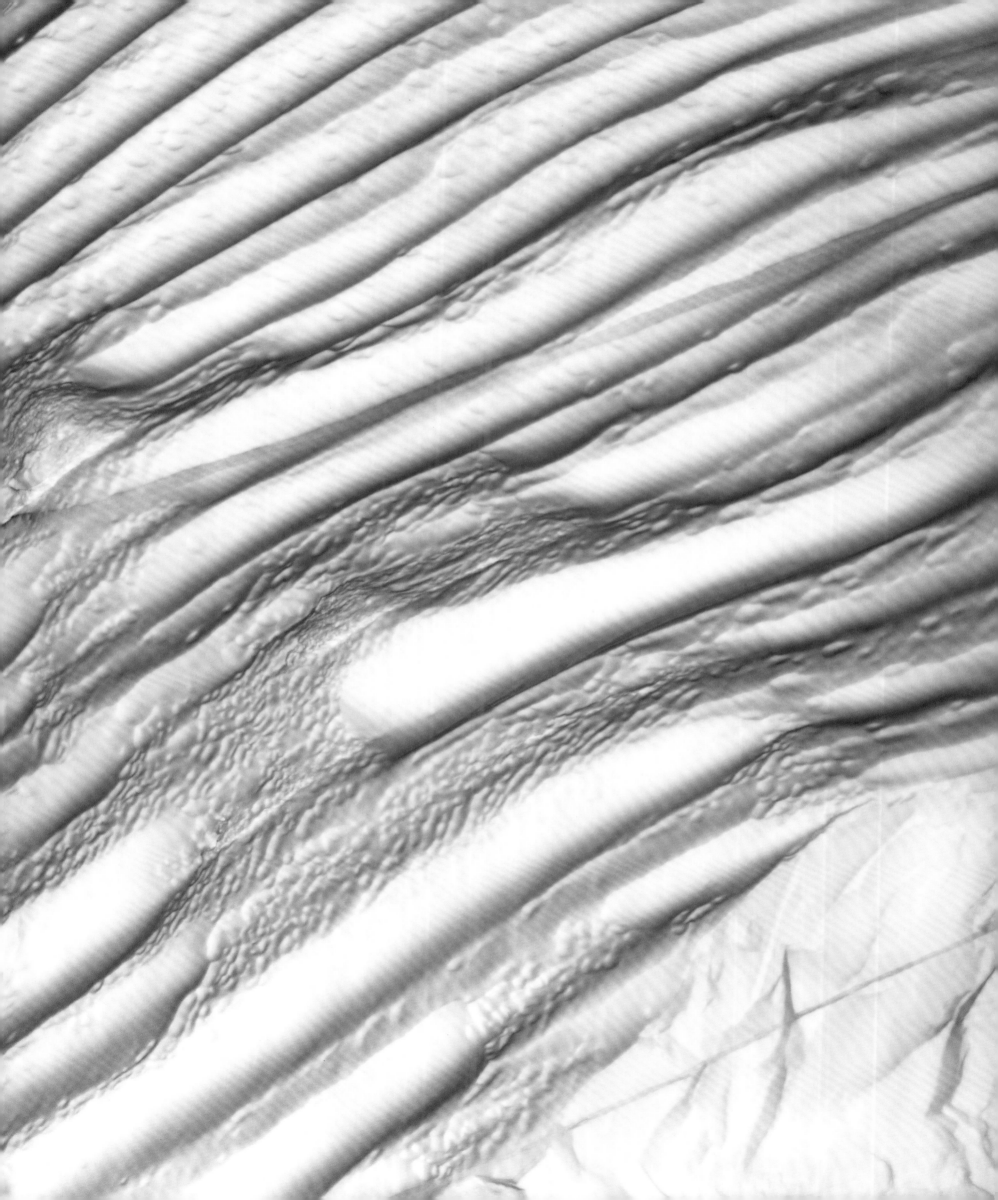

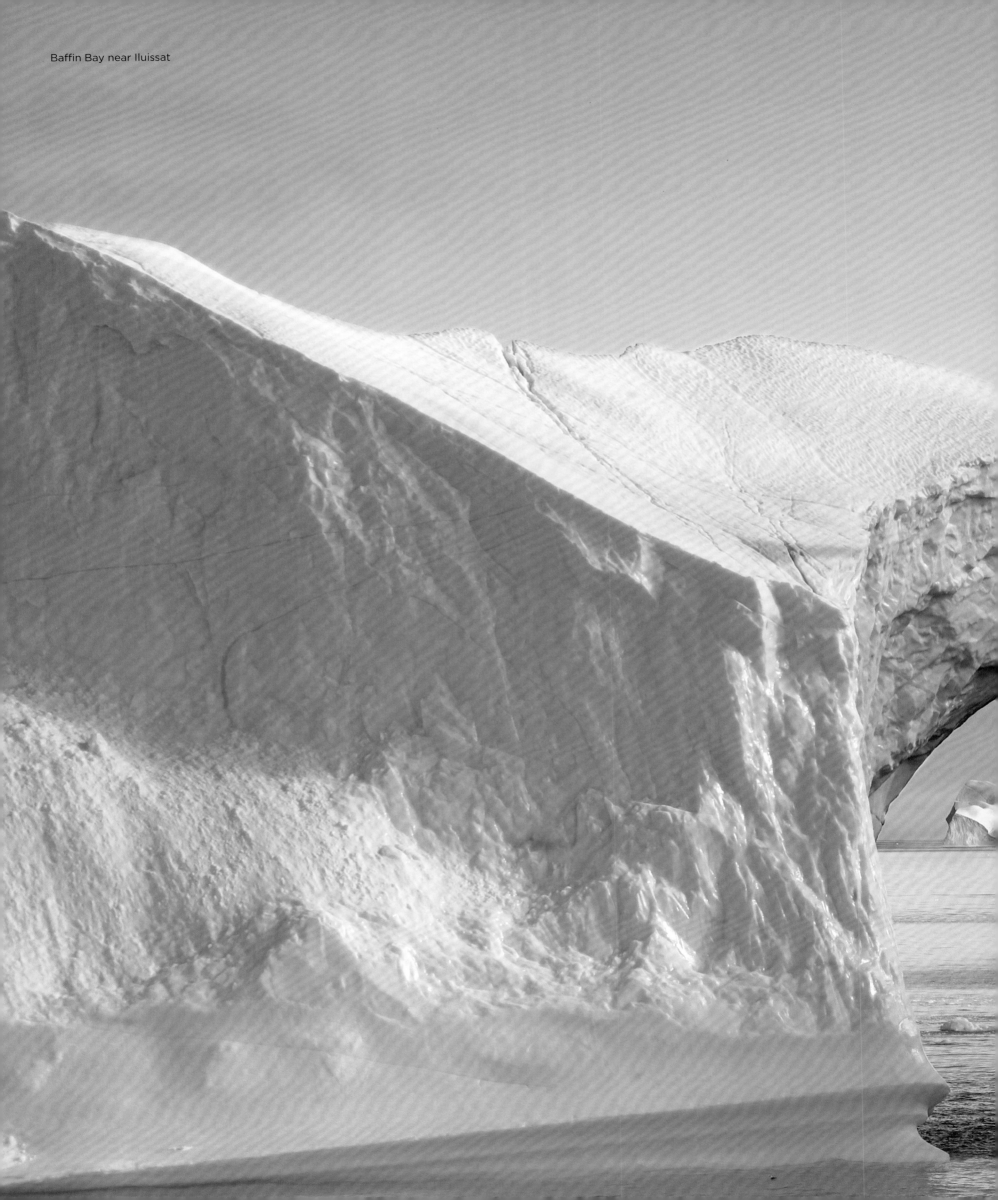

Baffin Bay near Iluissat

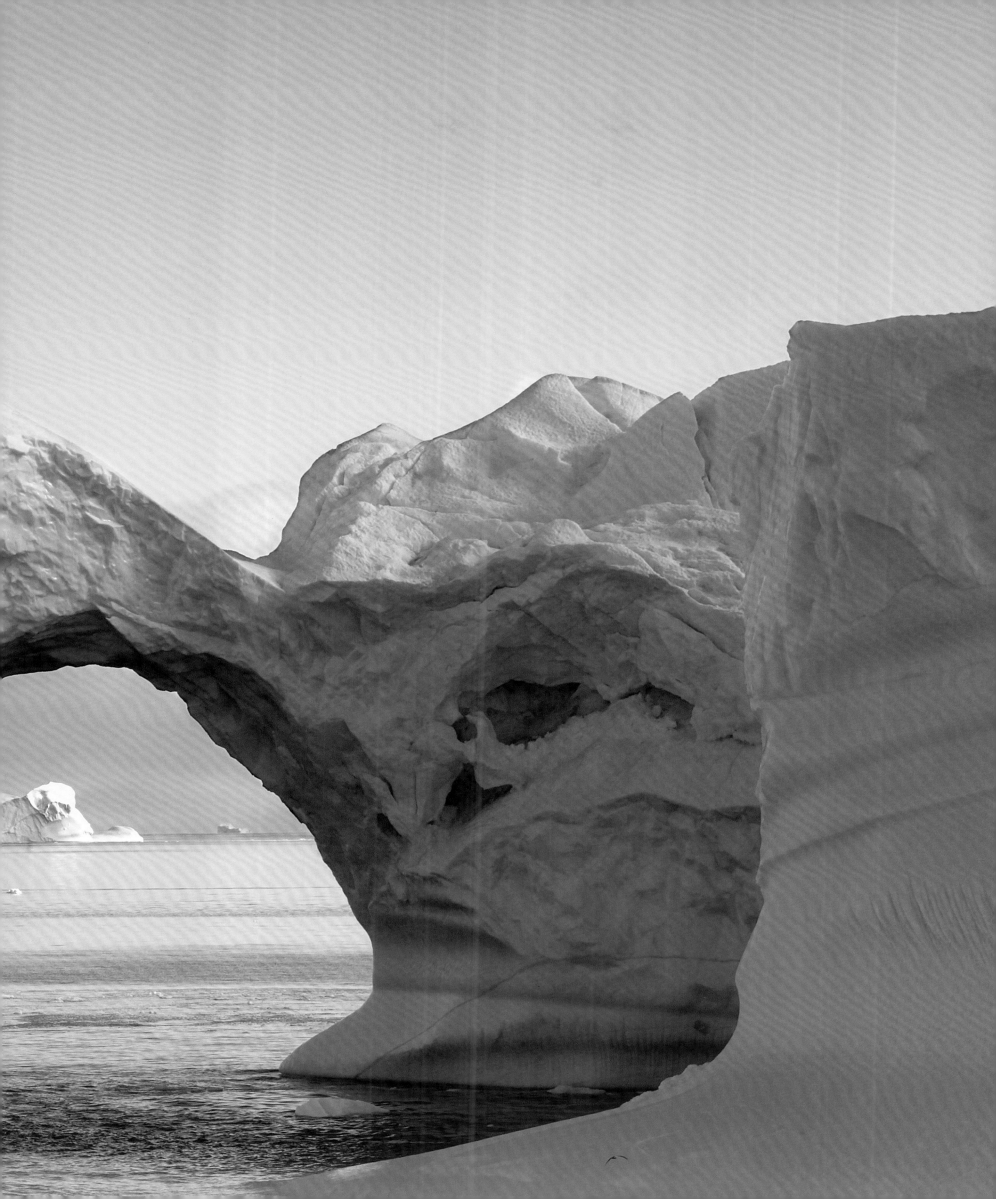

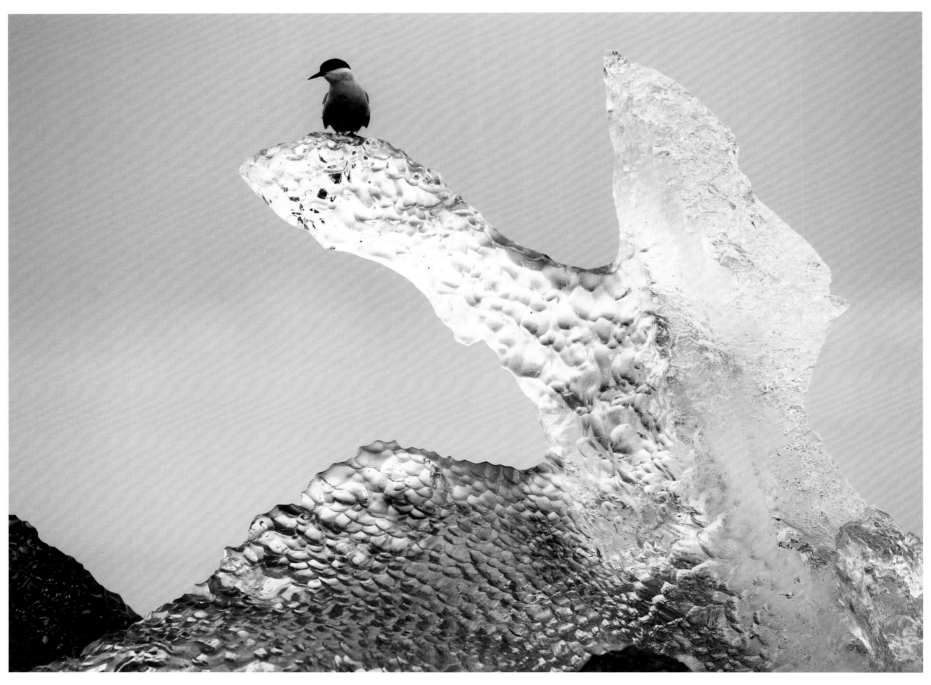

Arctic tern

Nuuk

With just under 18,000 inhabitants and located at the mouth of a branched fjord system, Nuuk is considered to be one of the smallest capitals in the world, but more than a quarter of Greenland's total population lives here. Worth seeing are the historical quarter at the old harbor, as well as the fish market. In the Greenland National Museum, you can find out about about the history and culture of the country and the Inuit, as well as visit the mummies of Qilakitsoq that date back to around 1475. One of the city's most striking buildings is the Kutuaq Cultural Centre, an outstanding architecturally designed building that is used as a cinema, theatre and gallery.

Nuuk

Avec près de 18 000 habitants, la ville de Nuuk, nichée à l'embouchure d'un système de fjords ramifié, est l'une des plus petites capitales du monde. Pourtant, c'est plus d'un quart de la population totale du Groenland qui y vit. Le quartier historique du vieux port ainsi que le marché aux poissons valent le détour. Au musée national du Groenland, il est possible d'en apprendre un peu plus sur l'histoire et la culture du pays et des Inuits mais également d'admirer les momies de Qilakitsoq, datant d'environ 1475. L'un des bâtiments les plus marquants de la ville est le centre culturel Kutuaq, chef-d'œuvre architectural servant de cinéma, de théâtre et de galerie d'art.

Nuuk

Mit nur knapp 18 000 Einwohnern gilt Nuuk in der Mündung eines verzweigten Fjordsystems als eine der kleinsten Hauptstädte der Welt. Doch hier wohnt mehr als ein Viertel der gesamten Bevölkerung Grönlands. Sehenswert sind das historische Viertel am alten Hafen sowie der Fischmarkt. Im Grönländischen Nationalmuseum kann man sich über Geschichte und Kultur des Landes und der Inuit informieren sowie die Mumien von Qilakitsoq besichtigen, die aus der Zeit um 1475 stammen. Eines der auffälligsten Gebäude der Stadt ist das architektonisch gelungene Kulturzentrum Kutuaq, das als Kino, Theater und Galerie genutzt wird.

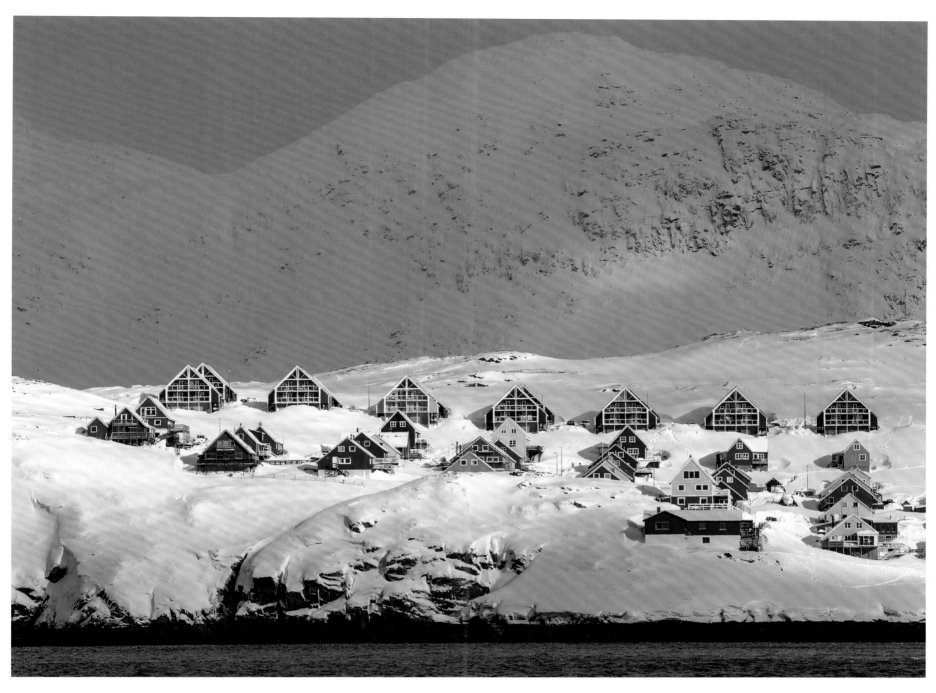
Nuuk

Nuuk

Con poco menos de 18 000 habitantes, Nuuk es
considerada una de las capitales más pequeñas del
mundo en la desembocadura de un sistema de fiordos
ramificados. Pero más de un cuarto de la población
total de Groenlandia vive aquí. Destacan el casco
histórico del antiguo puerto y la lonja de pescado.
En el Museo Nacional de Groenlandia, uno puede
informarse sobre la historia y la cultura del país y de
los inuit, así como visitar las momias de Qilakitsoq
que datan de alrededor de 1475. Uno de los edificios
más llamativos de la ciudad es el Centro Cultural
Kutuaq, un edificio arquitectónicamente logrado que
se utiliza como cine, teatro y galería.

Nuuk

Com pouco menos de 18.000 habitantes, Nuuk é
considerada uma das menores capitais do mundo
no estuário de um sistema de fiorde ramificado. Mas
mais de um quarto da população total da Groenlândia
vive aqui. Vale a pena ver o bairro histórico do antigo
porto, bem como o mercado de peixe. No Museu
Nacional da Groenlândia, é possível informar-se
sobre a história e a cultura do país e dos inuítes, bem
como visitar as múmias de Qilakitsoq que remontam
a cerca de 1475. Um dos edifícios mais marcantes
da cidade é o Centro Cultural Kutuaq, um edifício
de sucesso arquitetônico que é usado como cinema,
teatro e galeria.

Nuuk

Nuuk gelegen aan de monding van een vertakt
fjordsysteem geldt met iets minder dan 18.000
inwoners als een van de kleinste hoofdsteden ter
wereld. Toch wonen meer dan een kwart van de totale
bevolking van Groenland hier. Bezienswaardig is de
historische wijk aan de oude haven en de vismarkt.
In het Nationaal Museum van Groenland kan men
zich informeren over de geschiedenis en de cultuur
van het land. Ook kan men de Inuit en mummies
van Qilakitsoq gedateerd rond 1475 bezoeken. Een
van de meest opvallende gebouwen van de stad is
het Kutuaq Cultureel Centrum, een architectonisch
succesvol gebouw dat wordt gebruikt als bioscoop,
theater en galerie.

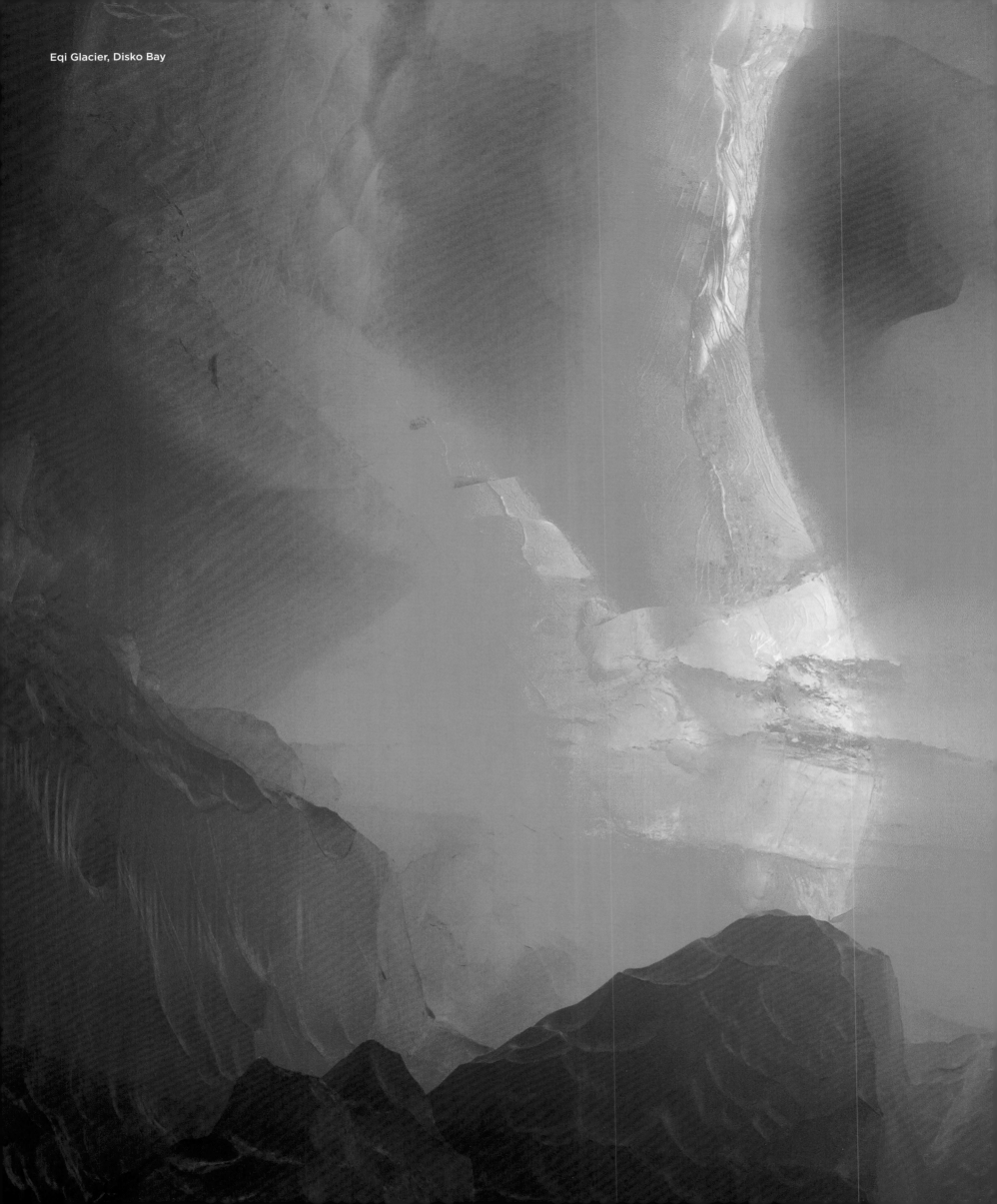

Eqi Glacier, Disko Bay

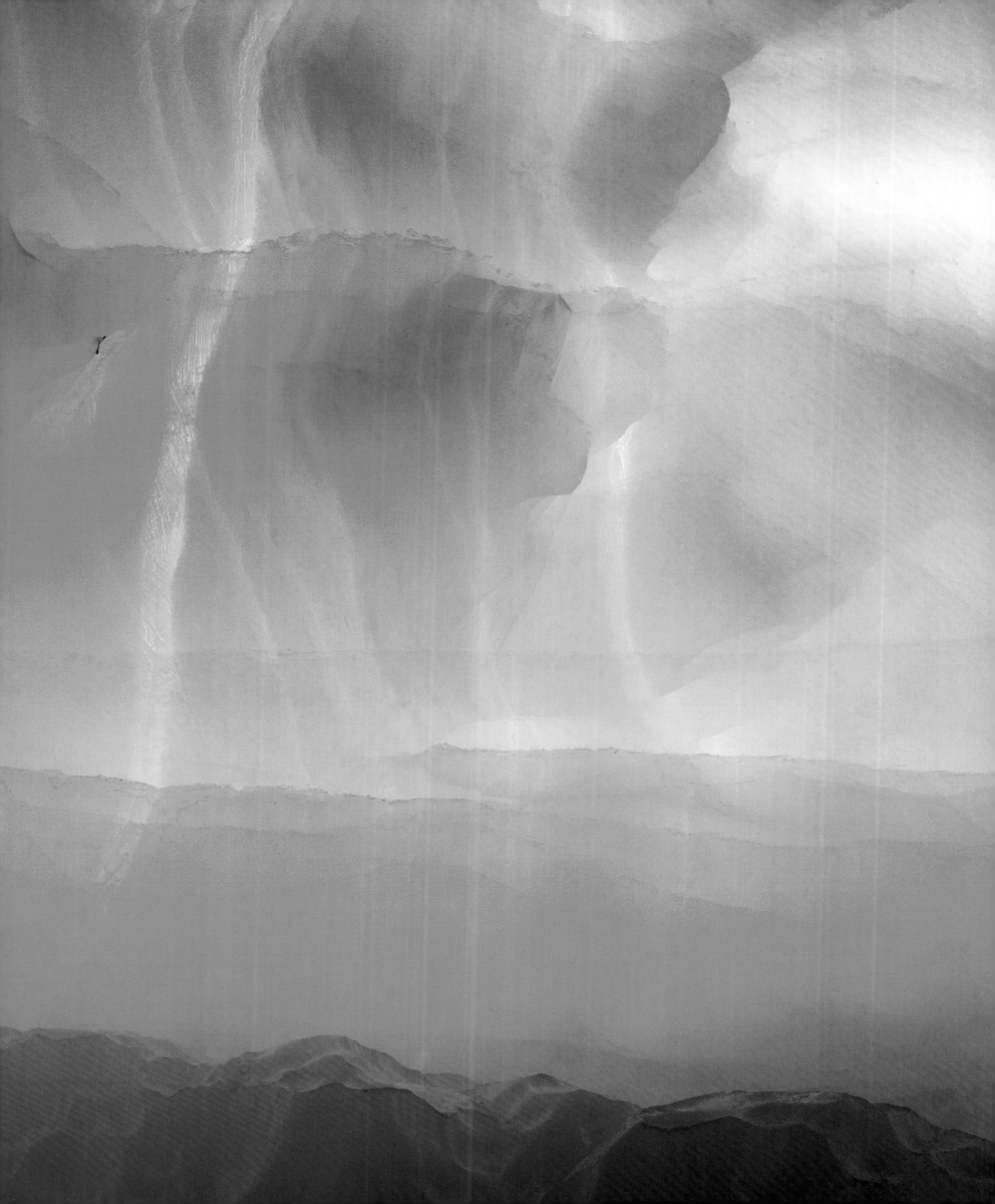

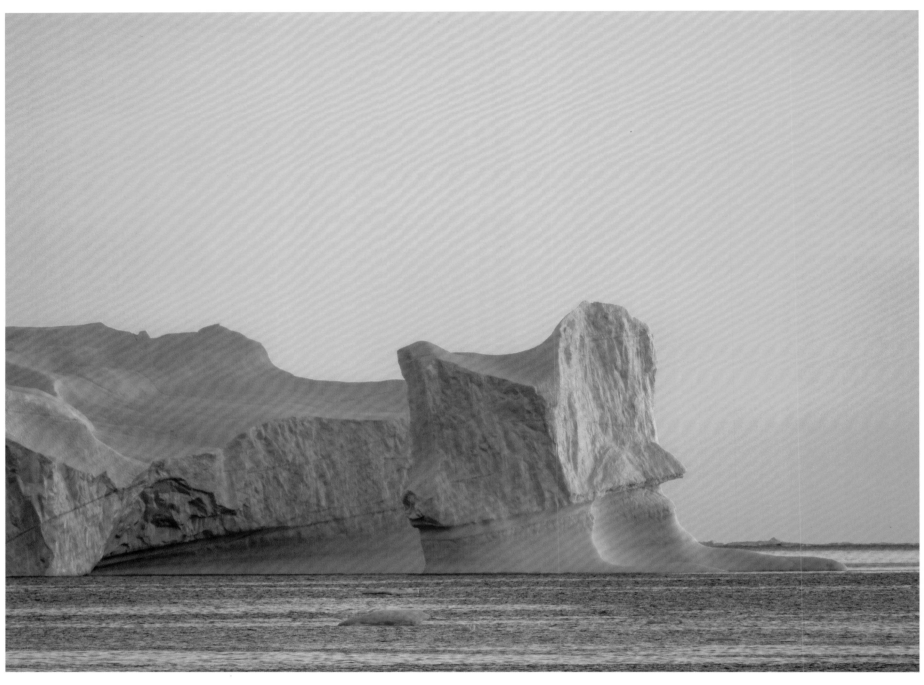

Disko Bay

Midnight Sun

After the long, dark winter months, the week-long glow of the midnight sun is the best medicine against depression. It is also a fair compensation for enduring the polar night. When day and night are no longer important, the body reduces its need for sleep. Some travelers to the north become almost addicted to the constant brightness, while others are driven to despair by insomnia. In any case, the hours when the sun lingers near the horizon often create magical atmospheres that you will never experience in temperate latitudes.

Soleil de minuit

Après les longs mois d'obscurité hivernale, la pluie de lumière du soleil de minuit est le meilleur remède contre la dépression. Elle compense en outre la longue attente pendant la nuit polaire. Lorsque jour et nuit n'ont plus de signification, le corps réduit ses besoins en sommeil. Pour certains visiteurs des contrées nordiques, cette lumière perpétuelle devient addictive, l'insomnie en rend d'autres presque fous. Quoi qu'il en soit, l'omniprésence du soleil à l'horizon offre souvent des ambiances lumineuses féeriques, impossibles à observer depuis des latitudes moins élevées.

Mitternachtssonne

Nach den langen, dunklen Wintermonaten bildet die wochenlange Lichtdusche der Mitternachtssonne die beste Medizin gegen Depressionen. Zudem ist sie ein gerechter Ausgleich für das Ausharren während der Polarnacht. Wenn Tag und Nacht keine Bedeutung mehr haben, reduziert der Körper sein Schlafbedürfnis. Manche Nordlandreisenden werden geradezu süchtig nach der andauernden Helligkeit, andere treibt Schlaflosigkeit schier zur Verzweiflung. In jedem Fall sorgt das stundenlange Verweilen der Sonne in der Nähe des Horizonts oft für magische Lichtstimmungen, die man in gemäßigten Breiten so nie erleben wird.

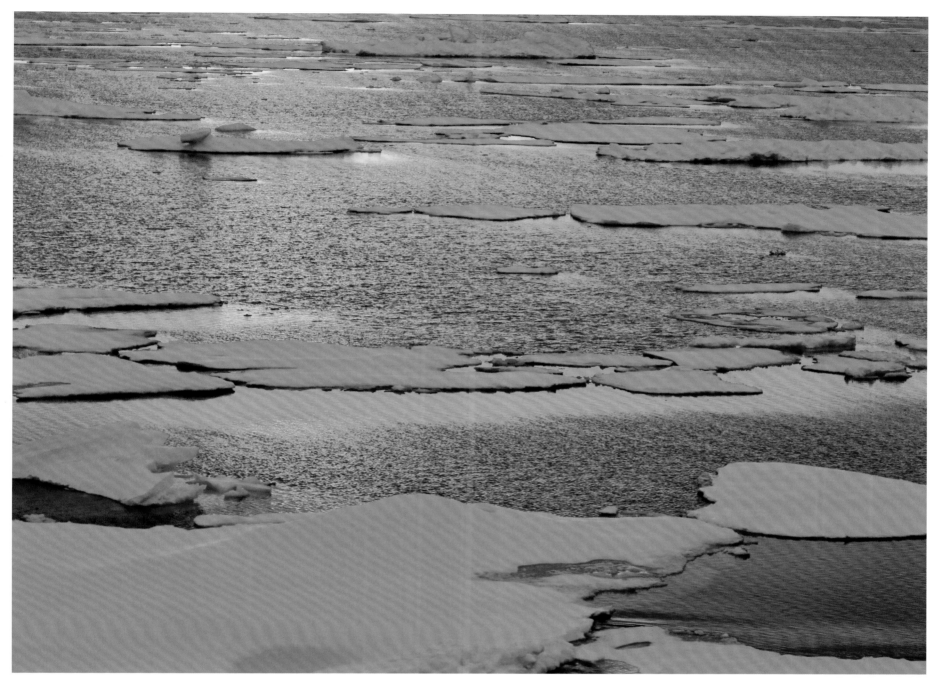

Greenland Sea, East Coast

Sol de medianoche

Después de los largos y oscuros meses de invierno, la lluvia de luz del sol de medianoche, que dura una semana, es la mejor medicina contra la depresión. También es una compensación justa por la resistencia durante la noche polar. Cuando el día y la noche dejan de tener significado, el cuerpo reduce su necesidad de dormir. Algunas personas que viajan al norte se vuelven casi adictos al brillo constante del sol, mientras que otros se desesperan por el insomnio. En cualquier caso, las horas que el sol permanece en las cercanías del horizonte a menudo crean estados de ánimo mágicos que nunca se experimentan en latitudes templadas.

Sol da meia-noite

Depois dos longos e escuros meses de inverno, a chuva de luz do sol de meia-noite de uma semana é o melhor remédio contra a depressão. É também uma compensação justa pela resistência durante a noite polar. Quando o dia e a noite já não são mais tão importantes, o corpo reduz a sua necessidade de dormir. Alguns viajantes de Northland tornam-se quase viciados no brilho constante, enquanto outros são levados ao desespero pela insónia. Em qualquer caso, as horas que o sol perdura nas proximidades do horizonte muitas vezes cria um clima mágico de luz que você nunca experimentará em latitudes temperadas.

Middernachtzon

Na de lange en donkere wintermaanden is de licht van de middernachtzon die een week lang duurt, de beste medicijn tegen depressie. Het is ook een compensatie voor het volhouden tijdens de poolnacht. Wanneer dag en nacht niet langer belangrijk zijn, vermindert het lichaam zijn behoefte aan slaap. Sommige Northland reizigers raken bijna verslaafd aan de constante helderheid, terwijl anderen door slapeloosheid tot wanhoop worden gedreven. In ieder geval zorgen de uren die de zon in de buurt van de horizon doorbrengt vaak voor magische lichtstemmingen die je in gematigde breedtegraden nooit zult ervaren.

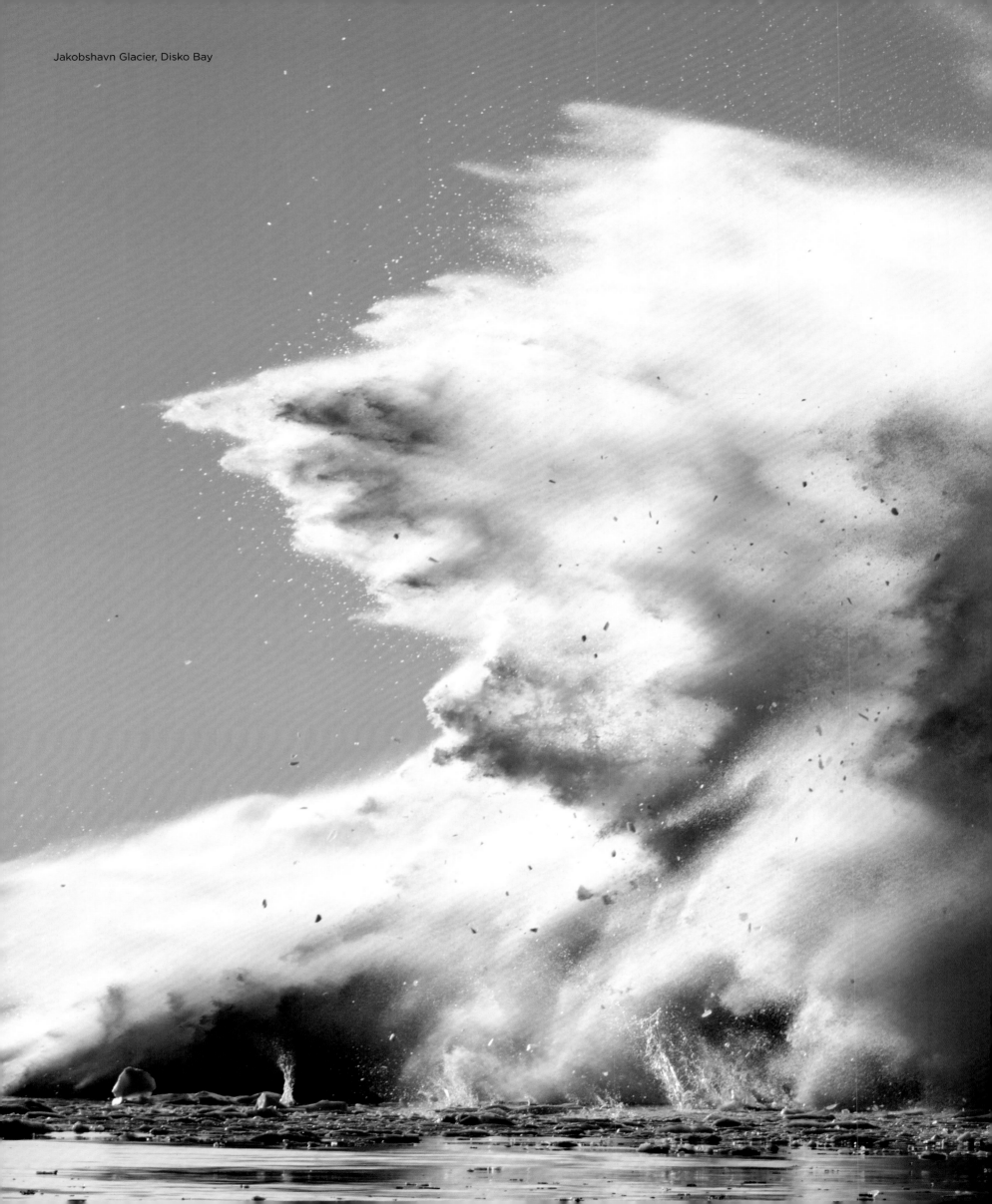

Jakobshavn Glacier, Disko Bay

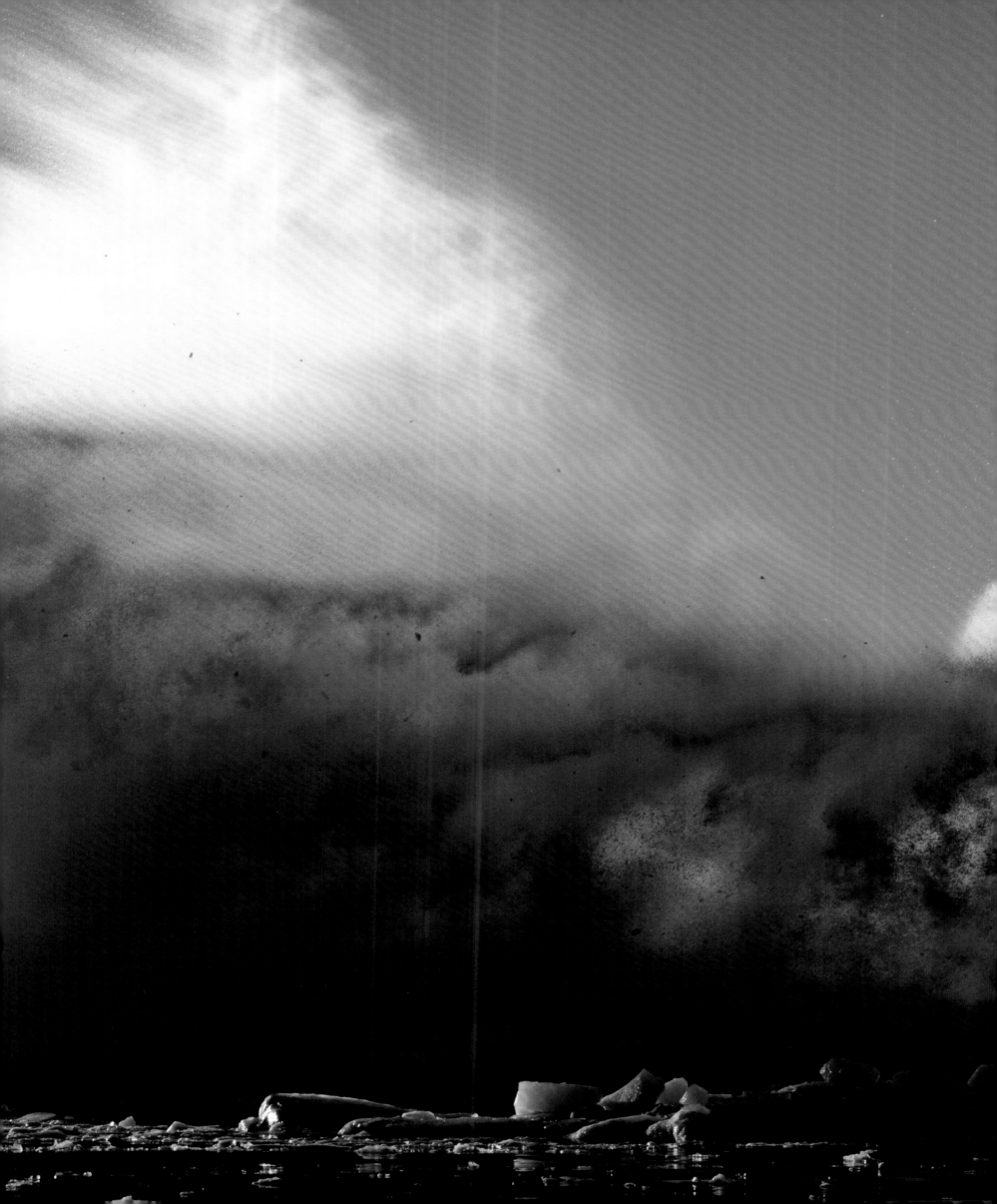

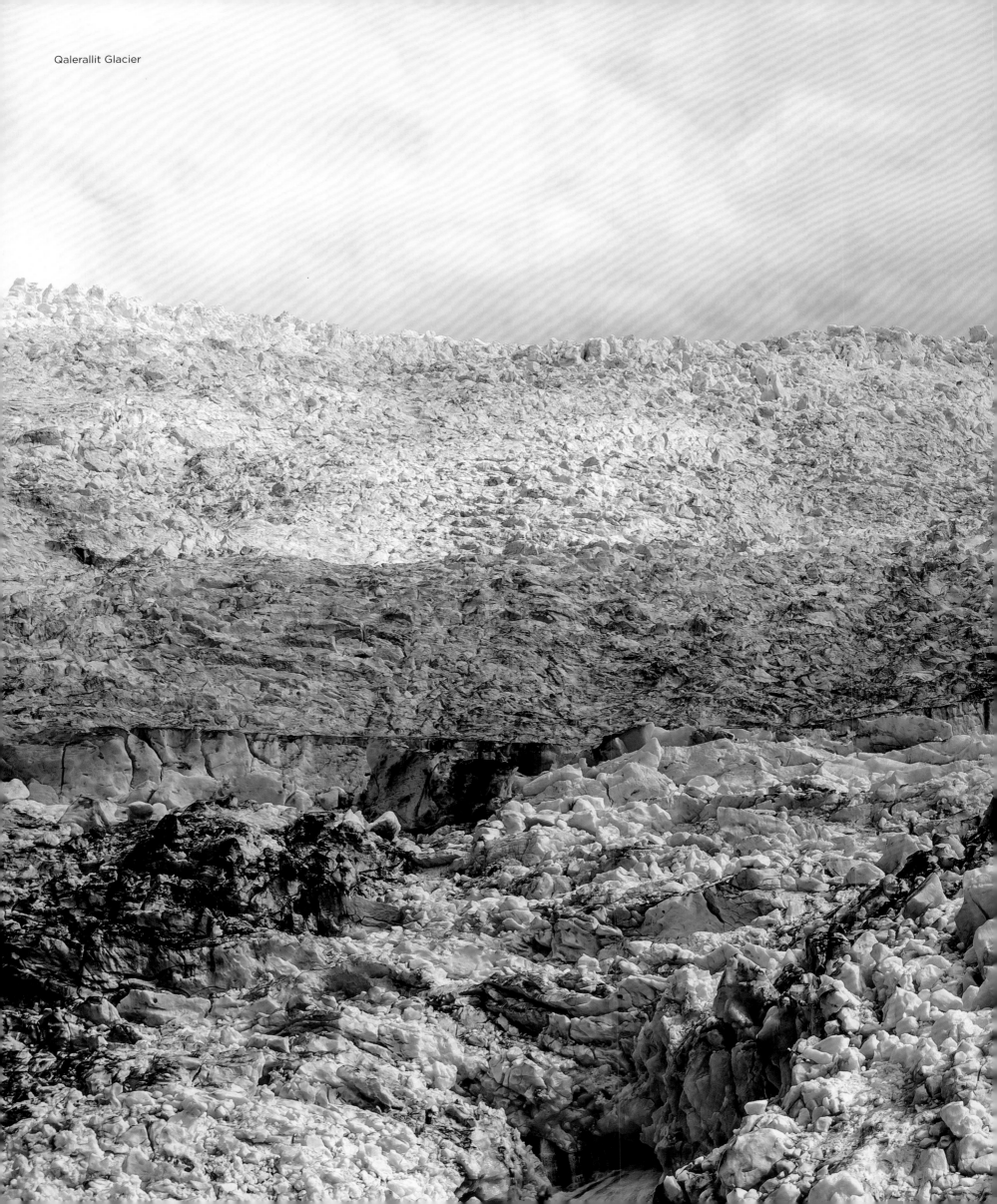

Qalerallit Glacier

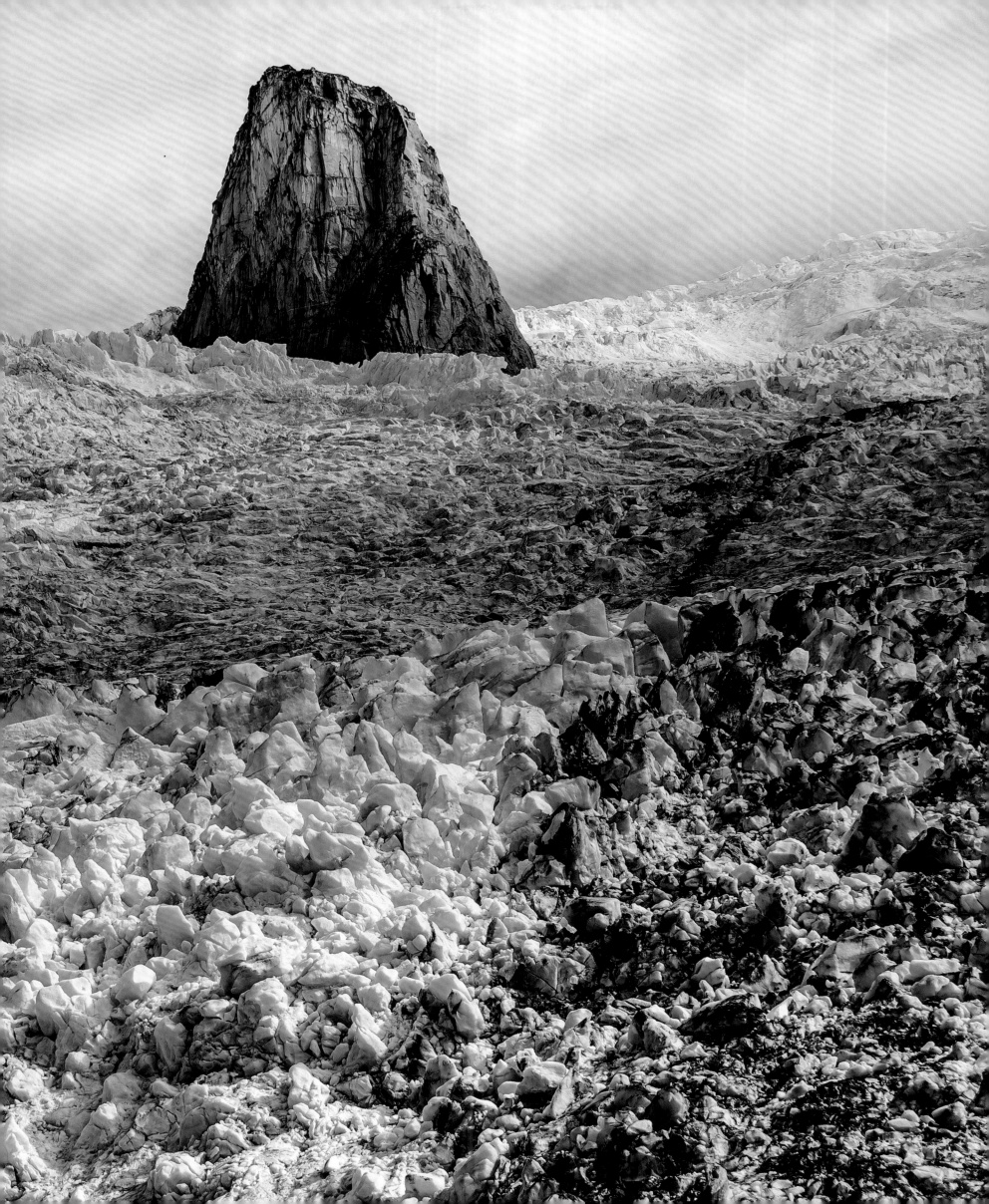

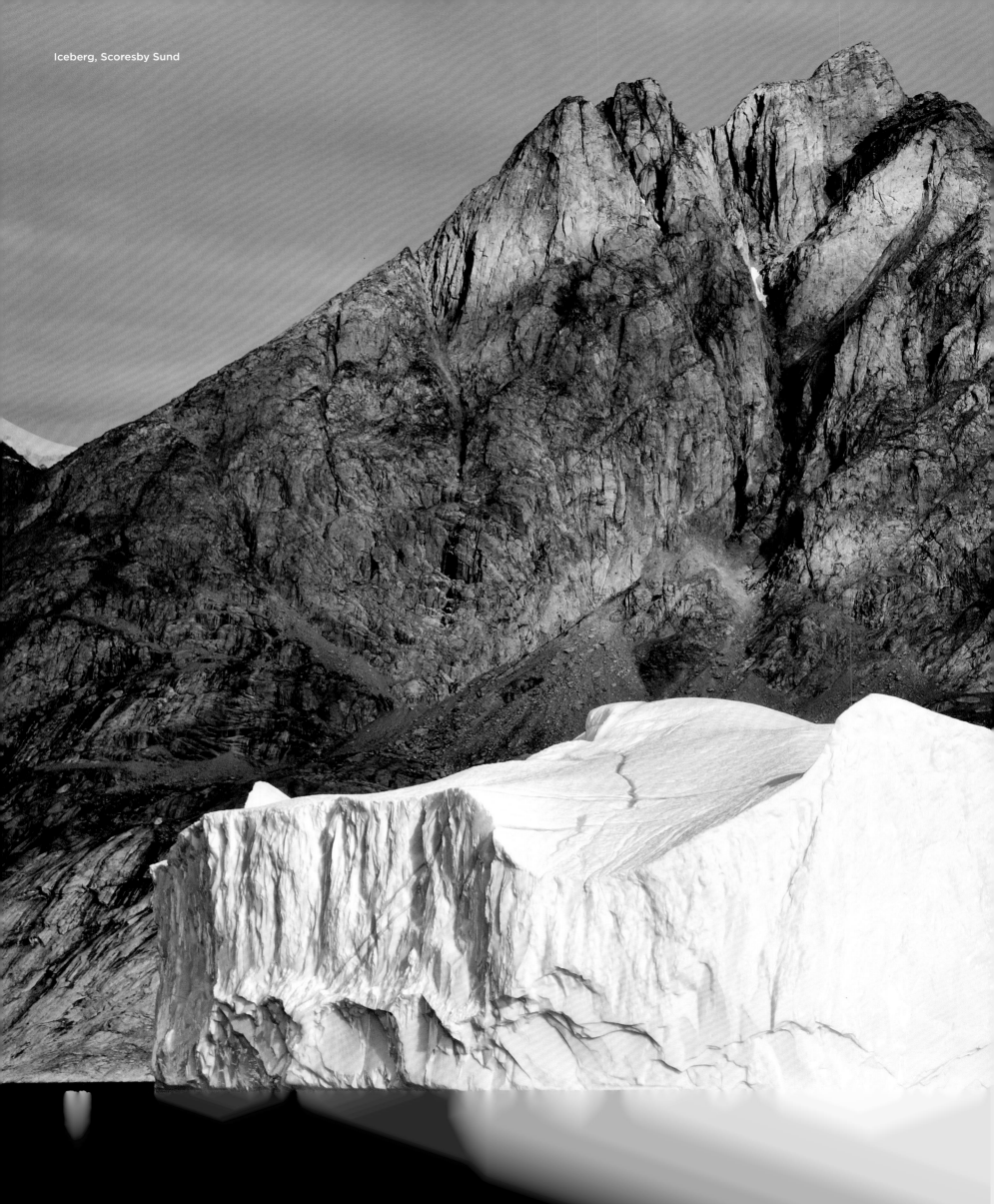

Iceberg, Scoresby Sund

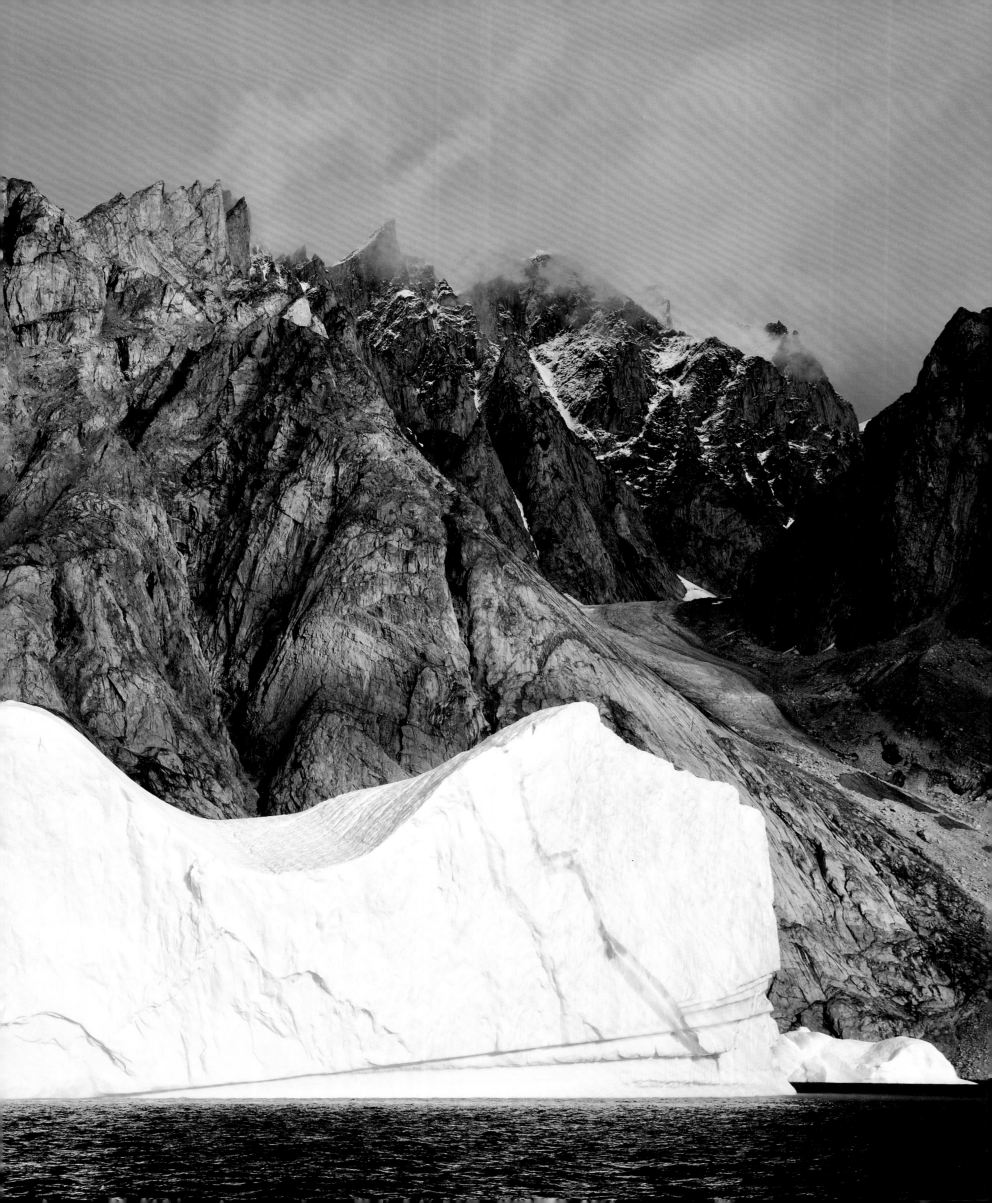

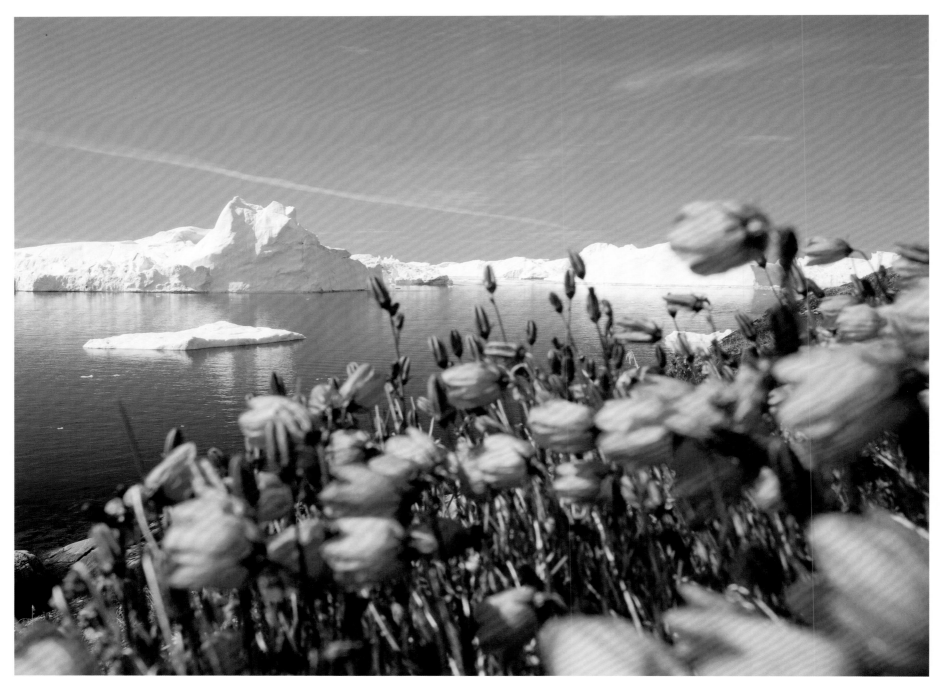

Icebergs, Jakobshavn Glacier

Green Greenland

Ice cores tell us that Greenland justifiably used to bear its name "Green Land". At least the south of the island was densely wooded with conifers for a long period of time. Even the Vikings, who settled the island about 1000 years ago, found a warmer climate and more luxuriant vegetation than today. Although the Arctic summer is short, the many hours of daylight ensure a rapid growth of plants. Around 500 plant species grow along the coasts: flowers, herbs, mosses, heather, ferns, horsetails and even orchids.

Groenland vert

Des carottes glaciaires ont permis de découvrir que le Groenland ne portait autrefois pas son nom de « terre verte » pour rien. Le sud de l'île au moins fut longtemps densément boisé de conifères. Même les Vikings rencontrèrent un climat plus doux et une végétation plus fournie, lorsqu'ils s'installèrent sur l'île il y a environ mille ans, qu'ils ne le sont de nos jours. L'été arctique est certes court, mais les nombreuses heures d'ensoleillement offrent aux plantes une croissance accélérée. Le long des côtes, poussent environ 500 espèces de plantes : fleurs, herbes, mousses, bruyères, fougères, prêles herbacées et même orchidées.

Grünes Grönland

Durch Eisbohrkerne weiß man, dass Grönland seinen Namen „Grünes Land" früher zu Recht getragen hat. Zumindest der Süden der Insel war über lange Zeit dicht mit Nadelbäumen bewaldet. Und selbst die Wikinger, die die Insel vor rund 1000 Jahren besiedelten, fanden noch ein wärmeres Klima und eine üppigere Vegetation als heute vor. Der arktische Sommer ist zwar kurz, aber die vielen Stunden Tageslicht sorgen für ein Turbowachstum der Pflanzen. Entlang der Küsten wachsen rund 500 Pflanzenarten: Blumen, Kräuter, Moose, Heidekraut, Farne, Schachtelhalmgewächse und sogar Orchideen.

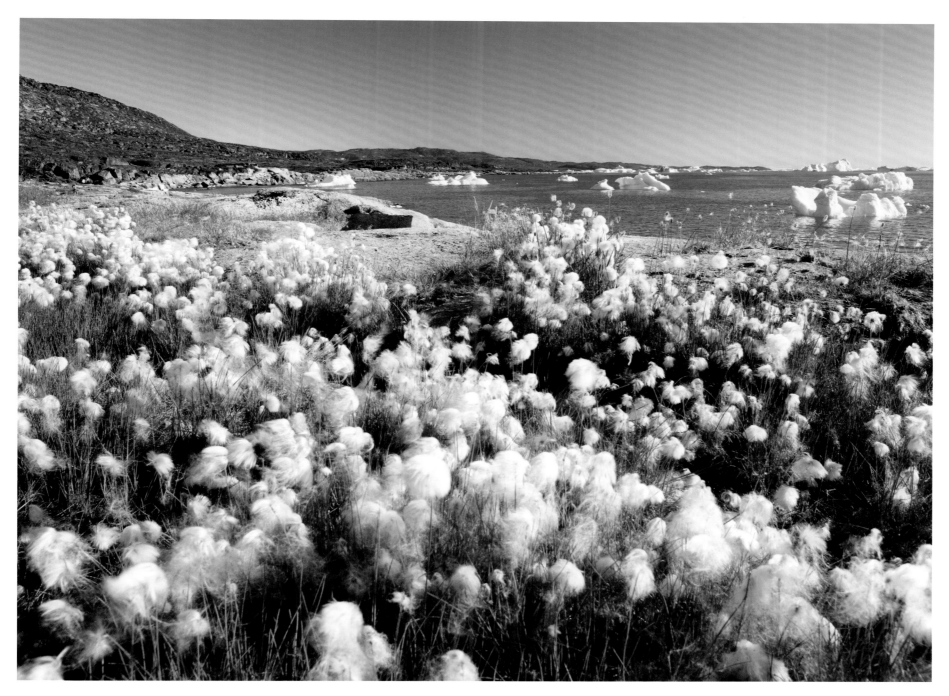

Cottongrass near Oqaatsut, Ilulissat, Disko Bay

Groenlandia verde

Los núcleos de hielo nos dicen que Groenlandia solía llevar su nombre «Tierra Verde » con razón. Al menos el sur de la isla estuvo densamente arbolado de coníferas durante mucho tiempo. E incluso los vikingos, que se asentaron en la isla hace unos 1000 años, encontraron un clima más cálido y una vegetación más exuberante que la actual. Aunque el verano ártico es corto, las muchas horas de luz del día aseguran un rápido crecimiento de las plantas. A lo largo de las costas crecen alrededor de 500 especies de plantas: flores, hierbas, musgos, brezos, helechos, colas de caballo e incluso orquídeas.

Groenlândia – Terra Verde

Através dos núcleos de gelo, sabemos que a Groenlândia costumava ter no passado, com razão, o seu nome "Terra Verde" . Pelo menos o sul da ilha foi densamente arborizado com coníferas durante muito tempo. E mesmo os Vikings, que colonizaram a ilha há cerca de 1000 anos, encontraram um clima mais quente e uma vegetação mais exuberante do que hoje. Embora o verão do Ártico seja curto, as muitas horas de luz do dia garantem um crescimento super rápido das plantas. Cerca de 500 espécies de plantas crescem ao longo das costas: flores, ervas, musgos, urzes, samambaias, cavalinhas e até orquídeas.

Groene Groenland

IJskernen vertellen ons dat Groenland zijn naam „Groene Land" vroeger terecht droeg. Het zuiden van het eiland was lange tijd dicht bebost met naaldbomen. Zelfs de Vikingen, die zich ongeveer 1000 jaar geleden op het eiland vestigden, troffen een warmer klimaat en een weelderigere vegetatie als tegenwoordig aan. Hoewel de Arctische zomer kort is, zorgen de vele uren daglicht voor een turbogroei van planten. Langs de kusten groeien ongeveer 500 plantensoorten: bloemen, kruiden, mossen, heide, varens, paardenstaarten en zelfs orchideeën.

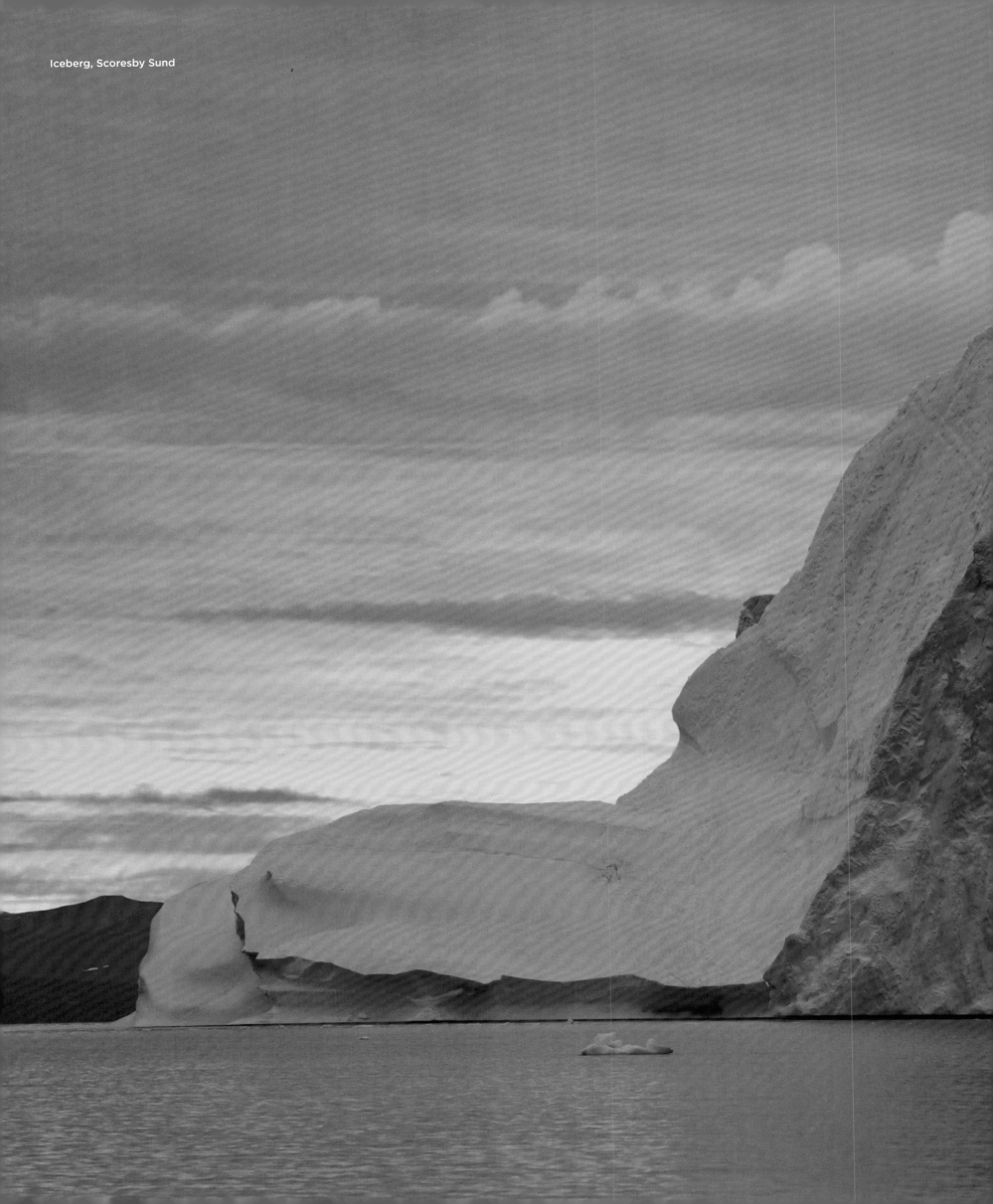

Iceberg, Scoresby Sund

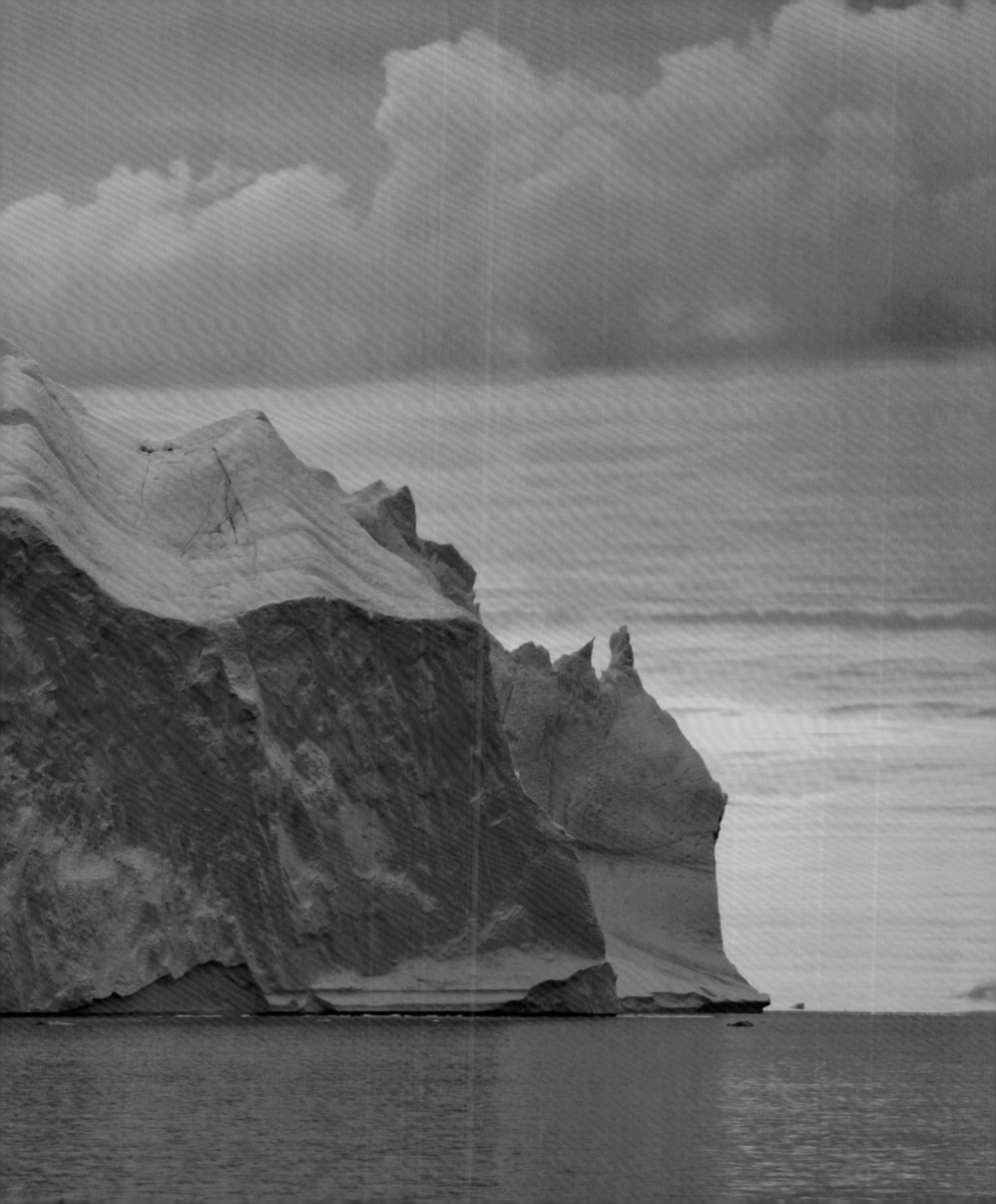

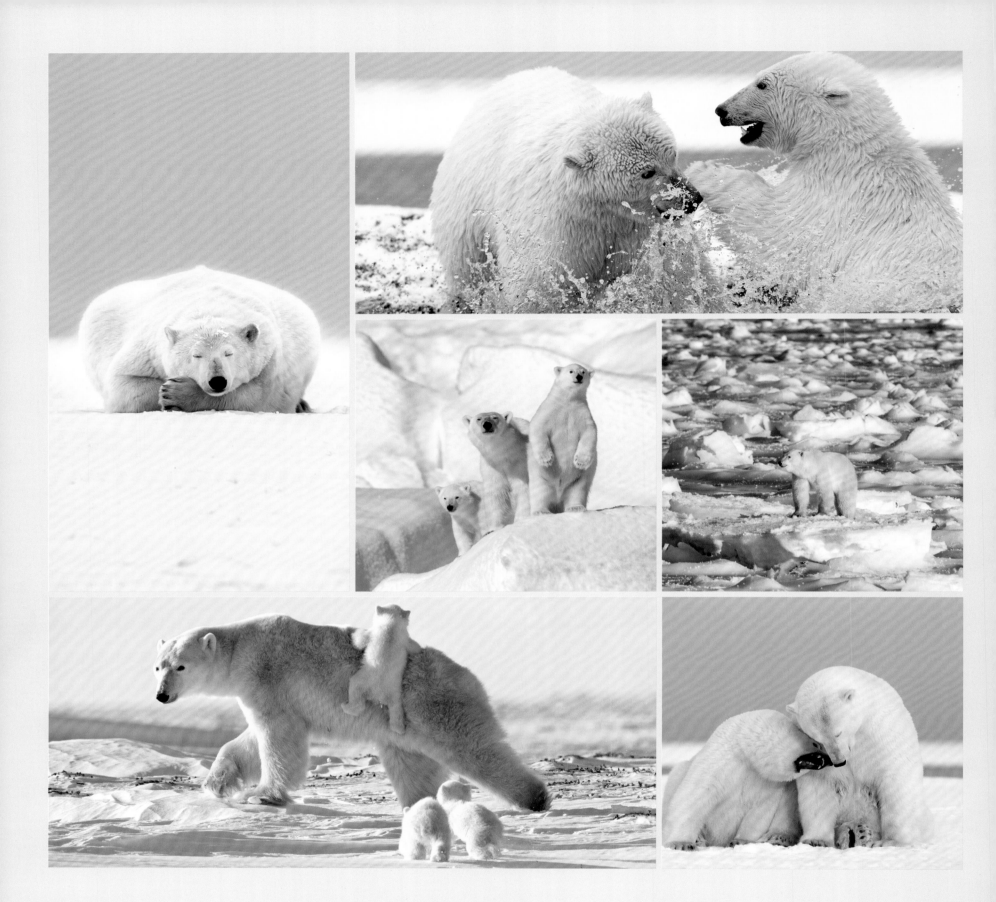

Polar Bears

Polar bears are perfectly adapted to the cold in the far north. Their yellowish-white, water-repellent fur consists of hollow outer hair and a dense undercoat. Together with the up to 10 cm (4 inch) thick layer of fat under the black skin, which absorbs the sun's rays, this results in excellent insulation so that polar bears emit practically no heat.

Ours polaires

Les ours polaires sont parfaitement adaptés au froid du Grand Nord. Leur pelage blanc jaunâtre, étanche, est composé de poils externes creux et d'un sous-poil dense. Celui-ci, ainsi que la couche de graisse allant jusqu'à 10 cm d'épaisseur sous leur peau noire qui absorbe les rayons du soleil, leur procure une excellente isolation. Les ours blancs ne perdent ainsi presque aucune chaleur.

Eisbären

Polarbären sind perfekt an die Kälte im hohen Norden angepasst. Das gelblich-weiße, wasserabweisende Fell besteht aus hohlen äußeren Haaren und einer dichten Unterwolle. Zusammen mit der bis zu 10 cm dicken Fettschicht unter der schwarzen Haut, die Sonnenstrahlen absorbiert, führt dies zu einer hervorragenden Isolierung, sodass Polarbären praktisch keine Wärme abstrahlen.

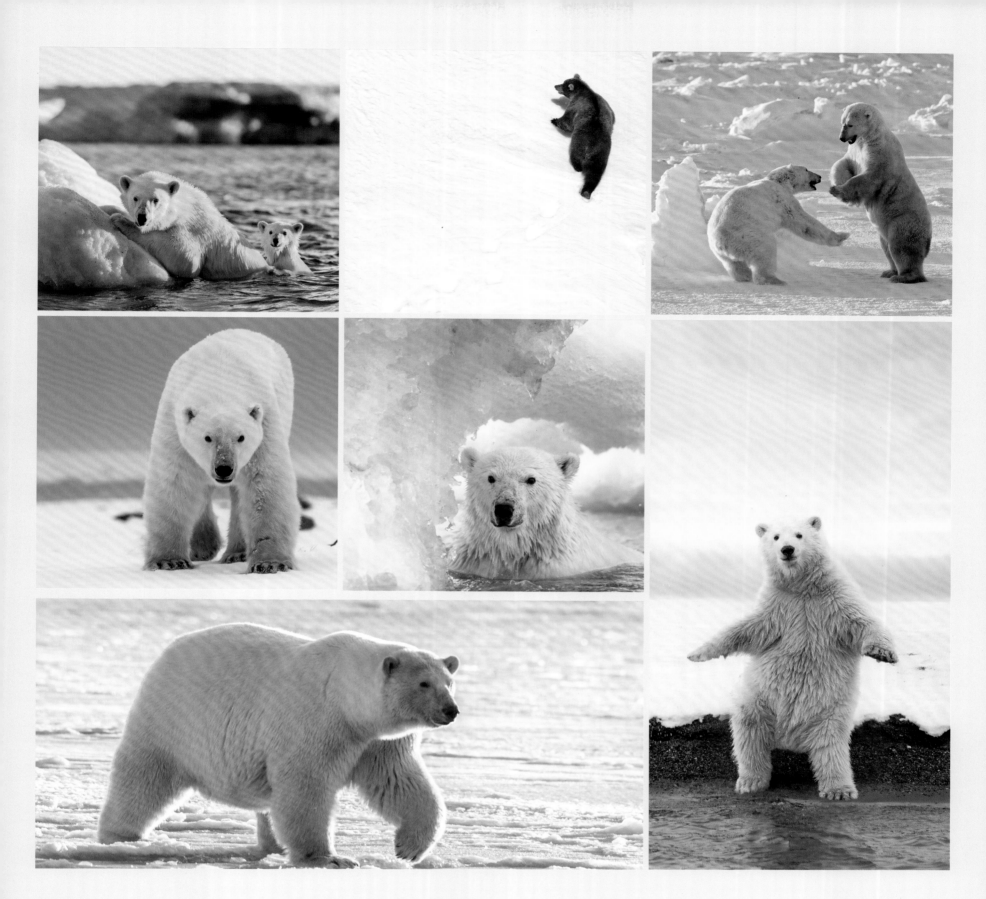

Osos polares

Los osos polares están perfectamente adaptados al frío en el extremo norte. La piel, de color blanco amarillento e hidrófugo, está cubierta por un pelo exterior hueco y una capa inferior de pelo denso. Junto con la capa de grasa de hasta 10 cm de grosor bajo la piel negra, que absorbe los rayos del sol, logran un excelente aislamiento, de modo que los osos polares prácticamente no emiten calor.

Ursos polares

Os ursos polares estão perfeitamente adaptados ao frio no extremo norte. O pêlo branco-amarelado e repelente à água é constituído por pêlos ocos exteriores e uma subcamada densa. Juntamente com a camada de gordura até 10 cm de espessura sob a pele negra, que absorve os raios solares, faz resultar num excelente isolamento, de modo que os ursos polares praticamente não emitem calor.

IJsberen

Poolberen hebben zich perfect aan de kou in het hoge noorden aangepast. De geelwitte, waterafstotende vacht bestaat uit hol haar en een dichte ondervacht. Samen met de tot 10 cm dikke vetlaag onder de zwarte huid, die de zonnestralen absorbeert, zorgt dit voor een uitstekende isolatie, zodat ijsberen vrijwel geen warmte afgeven.

Iceland

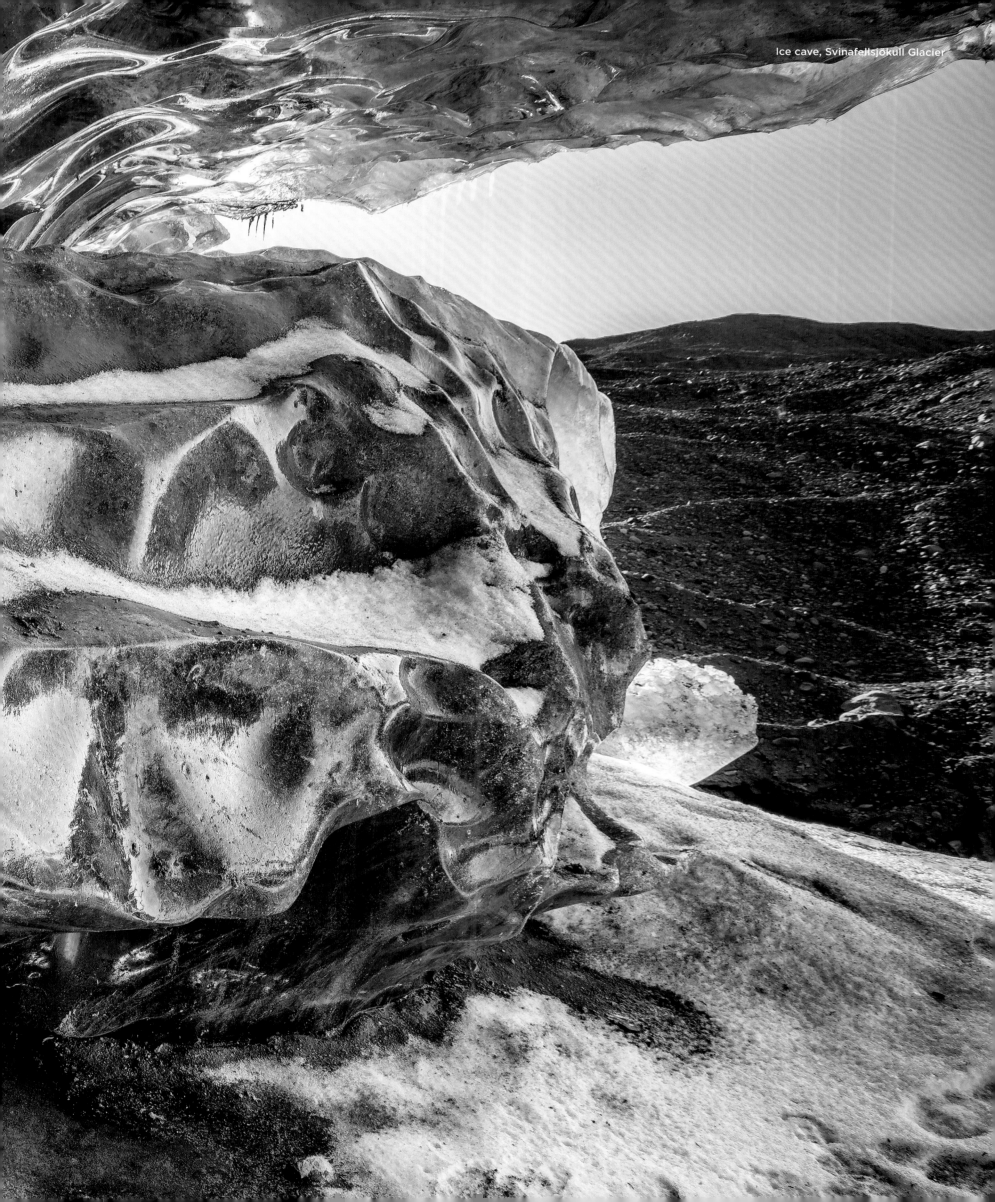

Ice cave, Svínafellsjökull Glacier

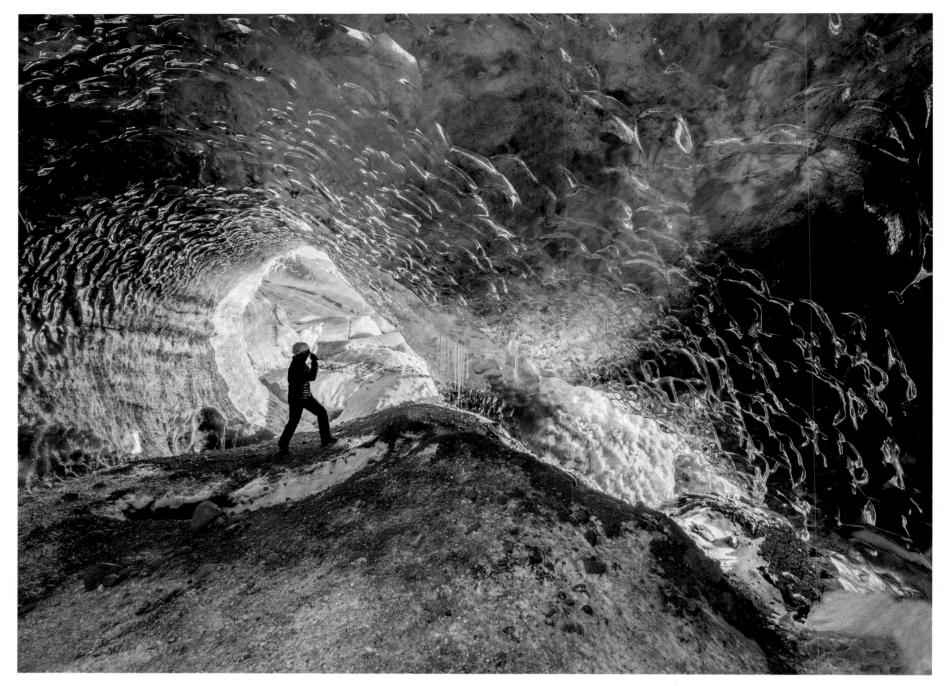

Ice cave, Svinafellsjökull Glacier

Iceland

Fire and ice characterize this volcanic island in
the middle of the Atlantic Ocean. The volcanoes,
glaciers and deserts are as fascinating as they are
inhospitable. Surrounded by the Gulf Stream, heated
by volcanoes and pampered by thermal water, around
360,000 people live here despite frequent natural
disasters. Most visitors come in summer, but only in
winter do you experience Iceland's rough side, when
the island lies under a thick blanket of snow and there
are storms which even turn a drive on the Ring Road
into an adventure. Visitors can be rewarded with the
sight of bizarre frozen waterfalls and fairytale ice
caves under the glaciers.

Islande

Le feu et la glace façonnent cette île volcanique
plantée au milieu de l'Atlantique. Volcans, glaciers et
déserts sont tout aussi fascinants qu'inhospitaliers.
Inondées par le Gulf Stream, réchauffées par les
volcans et gâtées en eaux thermales, près de
360 000 personnes vivent en Islande malgré les
fréquentes catastrophes naturelles. La plupart des
visiteurs viennent en été; ce n'est pourtant qu'en
hiver qu'il est possible de goûter à la rudesse du
pays, lorsque l'île repose sous un épais manteau de
neige et que même suivre la route circulaire en faisant
le tour devient une aventure sous les tempêtes.
Les courageux sont cependant récompensés par
le spectacle des chutes d'eau gelées aux formes
étranges et par des grottes de glace féeriques
sous les glaciers.

Island

Feuer und Eis prägen die Vulkaninsel mitten im
Atlantik. Vulkane, Gletscher und Wüsten sind
gleichermaßen faszinierend wie unwirtlich. Vom
Golfstrom umflossen, von Vulkanen beheizt und von
Thermalwasser verwöhnt, leben hier, trotz häufiger
Naturkatastrophen, rund 360 000 Menschen. Die
meisten Besucher kommen im Sommer, doch nur im
Winter erlebt man Islands raue Seite, wenn die Insel
unter einer dicken Schneedecke liegt und Stürme
selbst die Fahrt auf der Ringstraße zum Abenteuer
machen. Belohnt wird man mit dem Anblick
bizarr gefrorener Wasserfälle und märchenhafter
Eishöhlen unter den Gletschern.

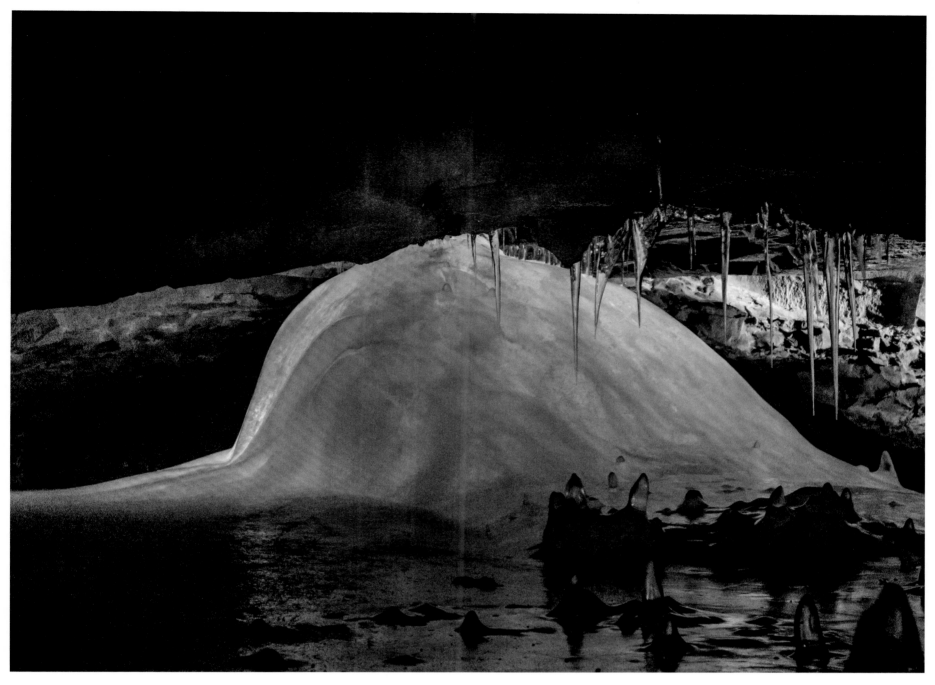

Lava cave, Krafla

Islandia

El fuego y el hielo caracterizan la isla volcánica en medio del Océano Atlántico. Los volcanes, glaciares y desiertos son tan fascinantes como inhóspitos. Rodeadas por la corriente del Golfo, calentadas por los volcanes y consentidas por el agua termal, alrededor de 360 000 personas viven aquí a pesar de los frecuentes desastres naturales. La mayoría de los visitantes vienen en verano, pero solo en invierno se experimenta el lado áspero de Islandia, cuando la isla se encuentra bajo una gruesa manta de nieve y las tormentas convierten incluso el paseo por la carretera de circunvalación en una aventura. Uno se ve recompensado con la vista de extrañas cascadas heladas y cuevas de hielo de cuento de hadas bajo los glaciares.

Islândia

O fogo e o gelo caracterizam a ilha vulcânica no meio do Oceano Atlântico. Vulcões, glaciares e desertos são tão fascinantes quanto inóspitos. Rodeada pela corrente do Golfo, aquecida por vulcões e previlegiada pela água termal, vivem aqui cerca de 360.000 pessoas, apesar dos frequentes desastres naturais. A maioria dos visitantes vem no verão, mas apenas no inverno você vivencia o lado severo da Islândia, quando a ilha fica sob uma espessa manta de neve e as tempestades até transformam o passeio pela rota 1 (Ring Road) em uma aventura. Uma recompensa é a visão de bizarras cachoeiras congeladas e cavernas de gelo de conto de fadas sob as geleiras.

IJsland

Vuur en ijs kenmerken het vulkanische eiland in het midden van de Atlantische Oceaan. Vulkanen, gletsjers en woestijnen zijn even fascinerend als onherbergzaam. Omringd door de Golfstroom, verwarmd door vulkanen en thermaal water, wonen hier ondanks frequente natuurrampen ongeveer 360.000 mensen. De meeste bezoekers komen in de zomer, maar alleen in de winter ervaar je de ruige kant van IJsland, wanneer het eiland onder een dikke deken van sneeuw ligt en stormen de rit op de Ringweg zelfs tot een avontuur maken. Men wordt beloond met de aanblik van bizarre bevroren watervallen en sprookjesachtige ijsgrotten onder de gletsjers.

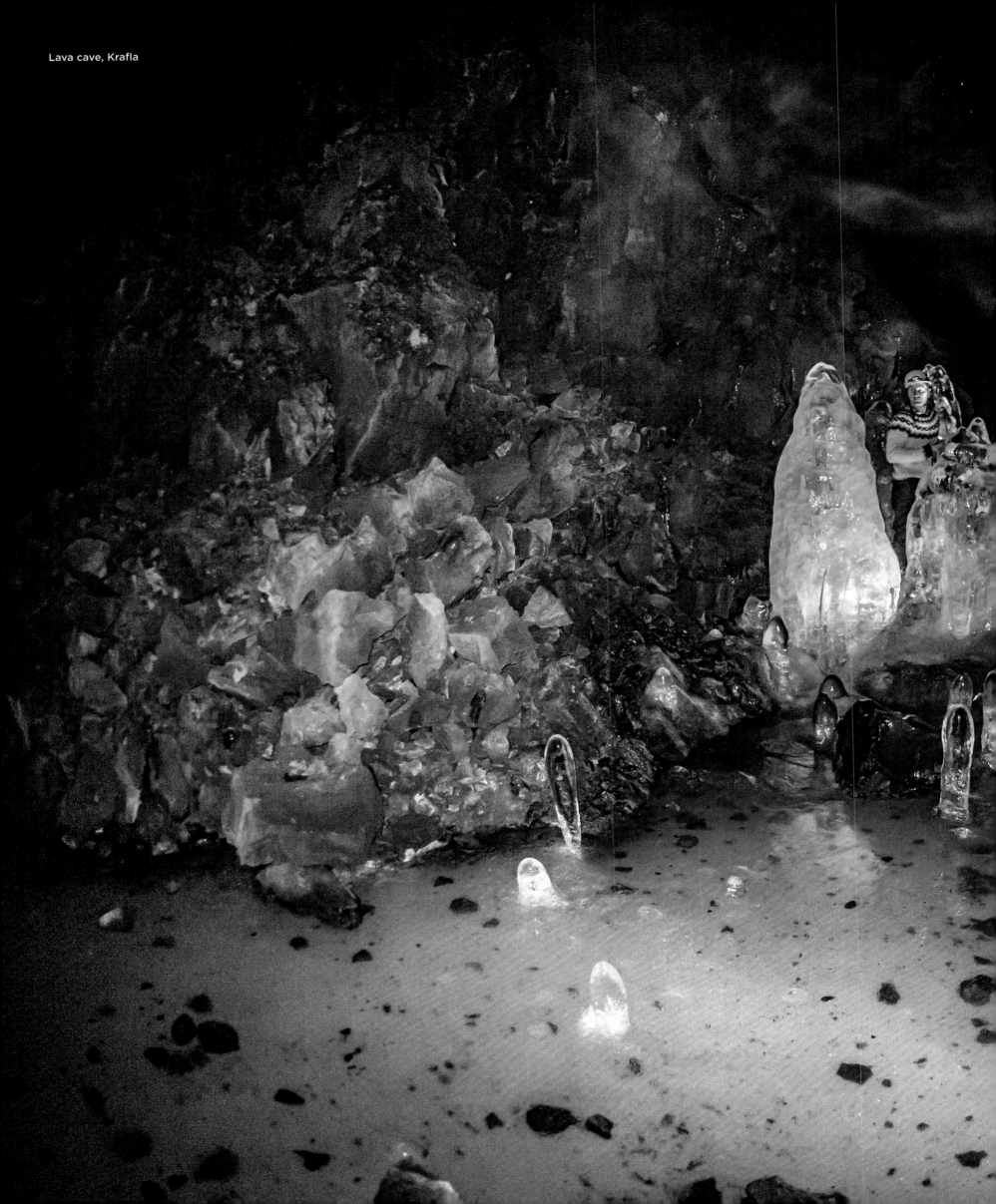

Lava cave, Krafla

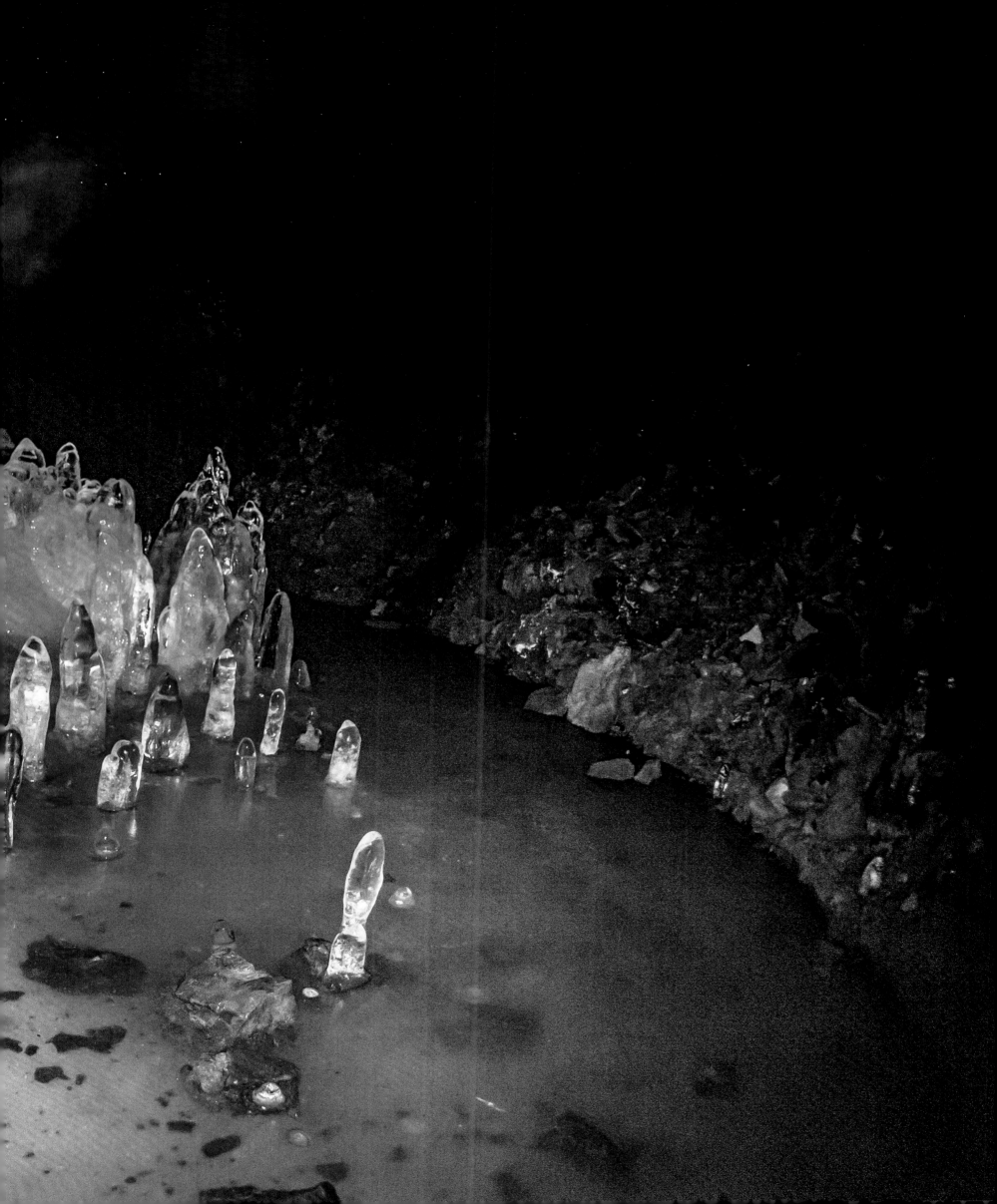

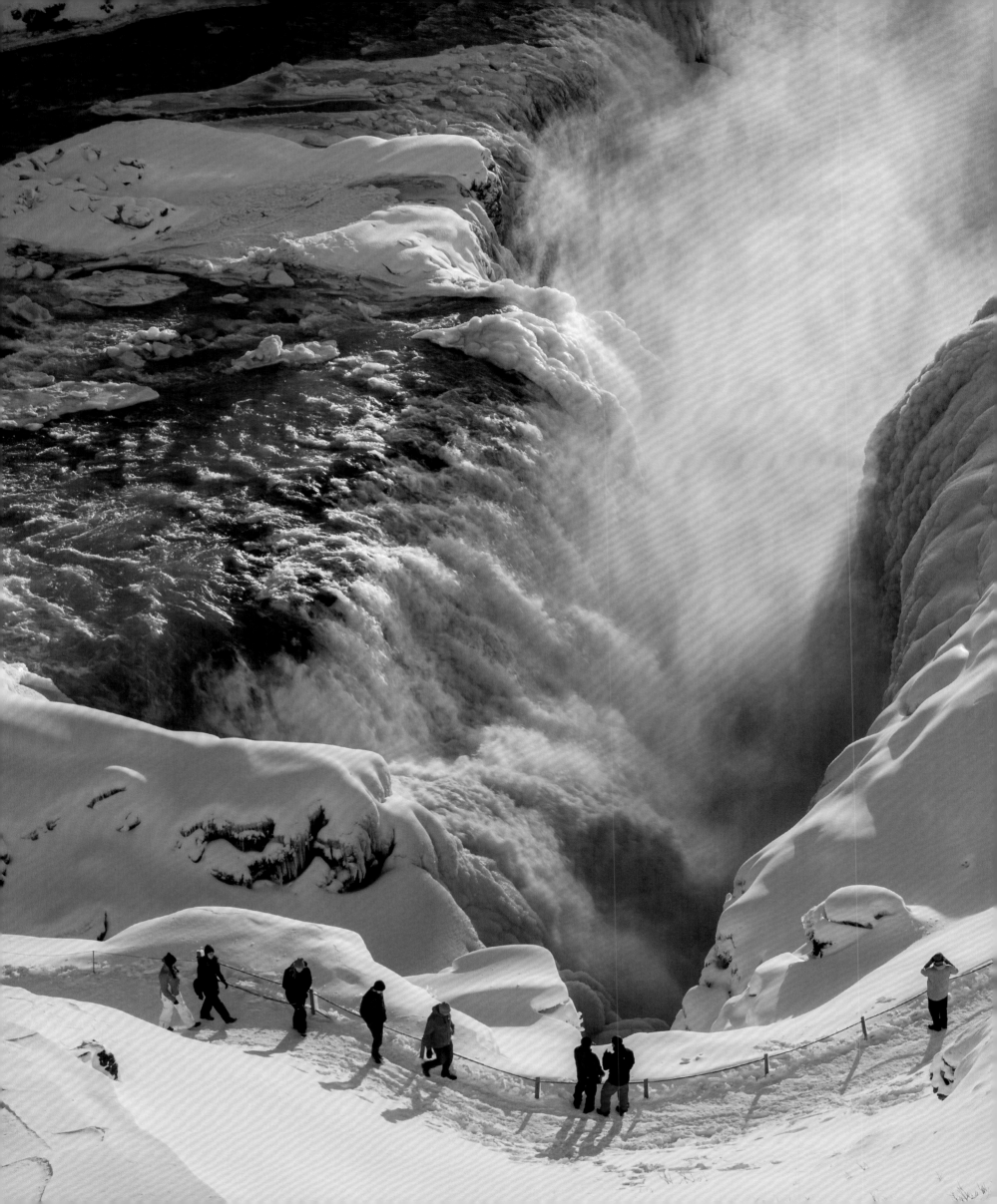

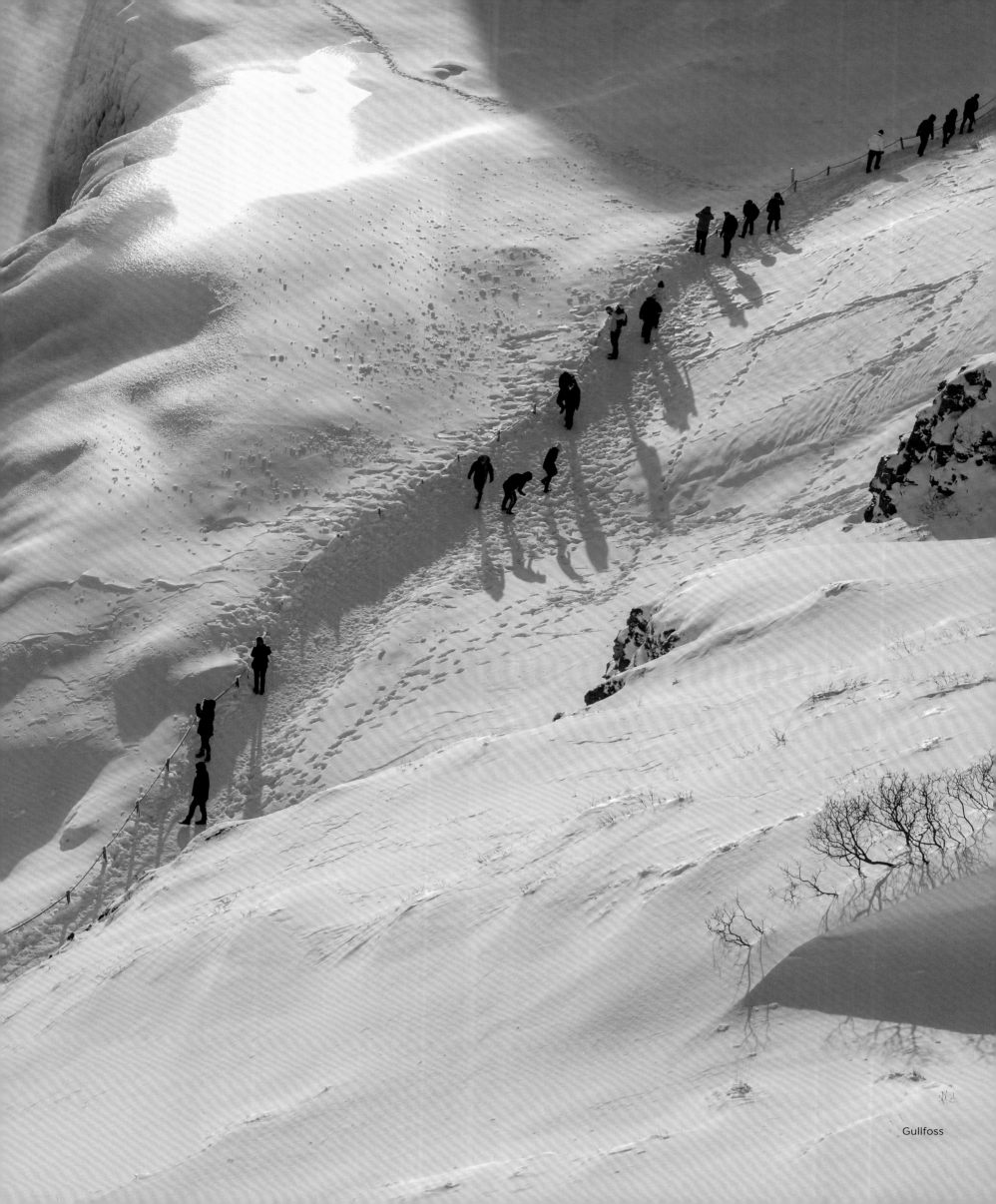

Gullfoss

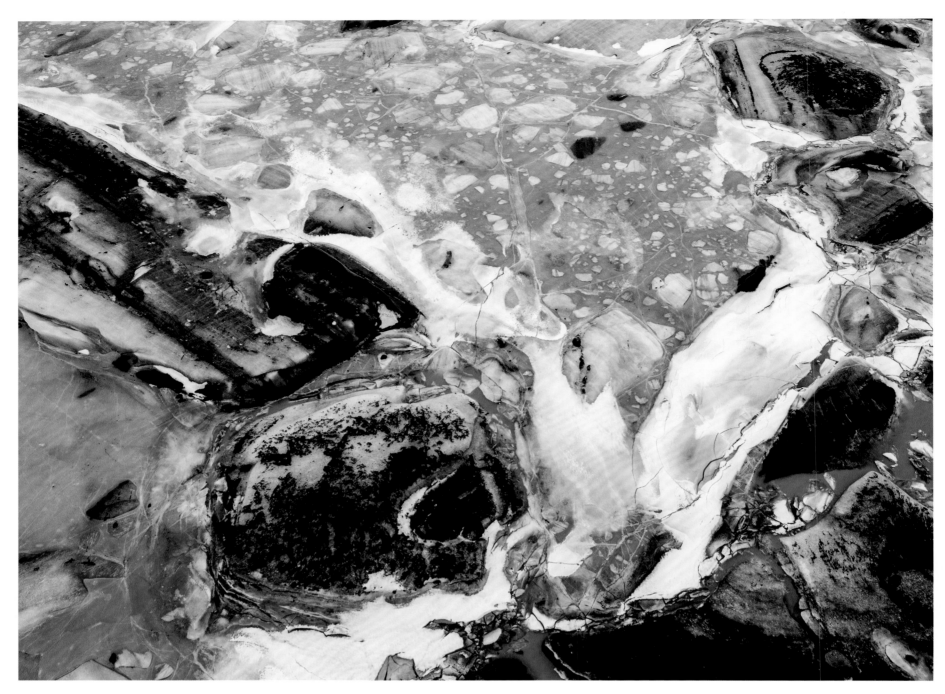

Vatnajökull Glacier

Vatnajökull

Covering 8100 km² (3127 sq mi), Vatnajökull is the largest glacier of Iceland. Under its ice lie active volcanoes and the highest mountain of Iceland, the Hvannadalshnúkur. In 2008, Vatnajökull National Park was established, covering more than 12,000 km² (4633 sq mi),. Another glacier, Okjökull, lost its status as a glacier in 2019; it melted and is now just called Ok.

Vatnajökull

Con sus 8100 km², el Vatnajökull es el glaciar más grande de Islandia. Bajo su hielo se encuentran volcanes activos y la montaña más alta de Islandia, el Hvannadalshnúkur. En 2008 se creó el Parque Nacional de Vatnajökull, que tiene una superficie de más de 12 000 km². Otro glaciar, Okjökull, perdió su condición de glaciar en 2019; se derritió y ahora se llama Ok.

Vatnajökull

Avec ses 8 100 km², le Vatnajökull est le plus grand glacier d'Islande. Sous la glace se trouvent des volcans actifs ainsi que le plus haut sommet du pays, le Hvannadalshnjúkur. En 2008 fut fondé le parc national du Vatnajökull, d'une surface de plus de 12 000 km². Un autre glacier, l'Okjökull, a perdu son titre en 2019, puisqu'en effet, il a disparu à cause du réchauffement climatique et s'appelle désormais Ok, le nom de son volcan.

Vatnajökull

Com 8100 km² o Vatnajökull é o maior glaciar da Islândia. Sob o seu gelo encontram-se vulcões ativos e a montanha mais alta da Islândia, o Hvannadalshnúkur. Em 2008, foi criado o Parque Nacional de Vatnajökull, com mais de 12.000 km². Outra geleira, a Okjökull, perdeu seu status de geleira em 2019; ela derreteu e agora é chamada somente de Ok.

Vatnajökull

Mit 8100 km² ist der Vatnajökull der größte Gletscher Islands. Unter seinem Eis liegen aktive Vulkane sowie der höchste Berg Islands, der Hvannadalshnúkur. 2008 wurde der mehr als 12 000 km² umfassende Vatnajökull-Nationalpark eingerichtet. Ein anderer Gletscher, der Okjökull, hat 2019 seinen Status als Gletscher verloren; er ist geschmolzen und heißt nur noch Ok.

Vatnajökull

Met 8100 km² is de Vatnajökull de grootste gletsjer van IJsland. Onder het ijs liggen actieve vulkanen evenals de hoogste berg van IJsland, de Hvannadalshnúkur. In 2008 werd het nationaal park Vatnajökull, met een oppervlakte van meer dan 12.000 km², opgericht. Een andere gletsjer, Okjökull, verloor in 2019 zijn status als gletsjer; hij is gesmolten en heet nu Ok.

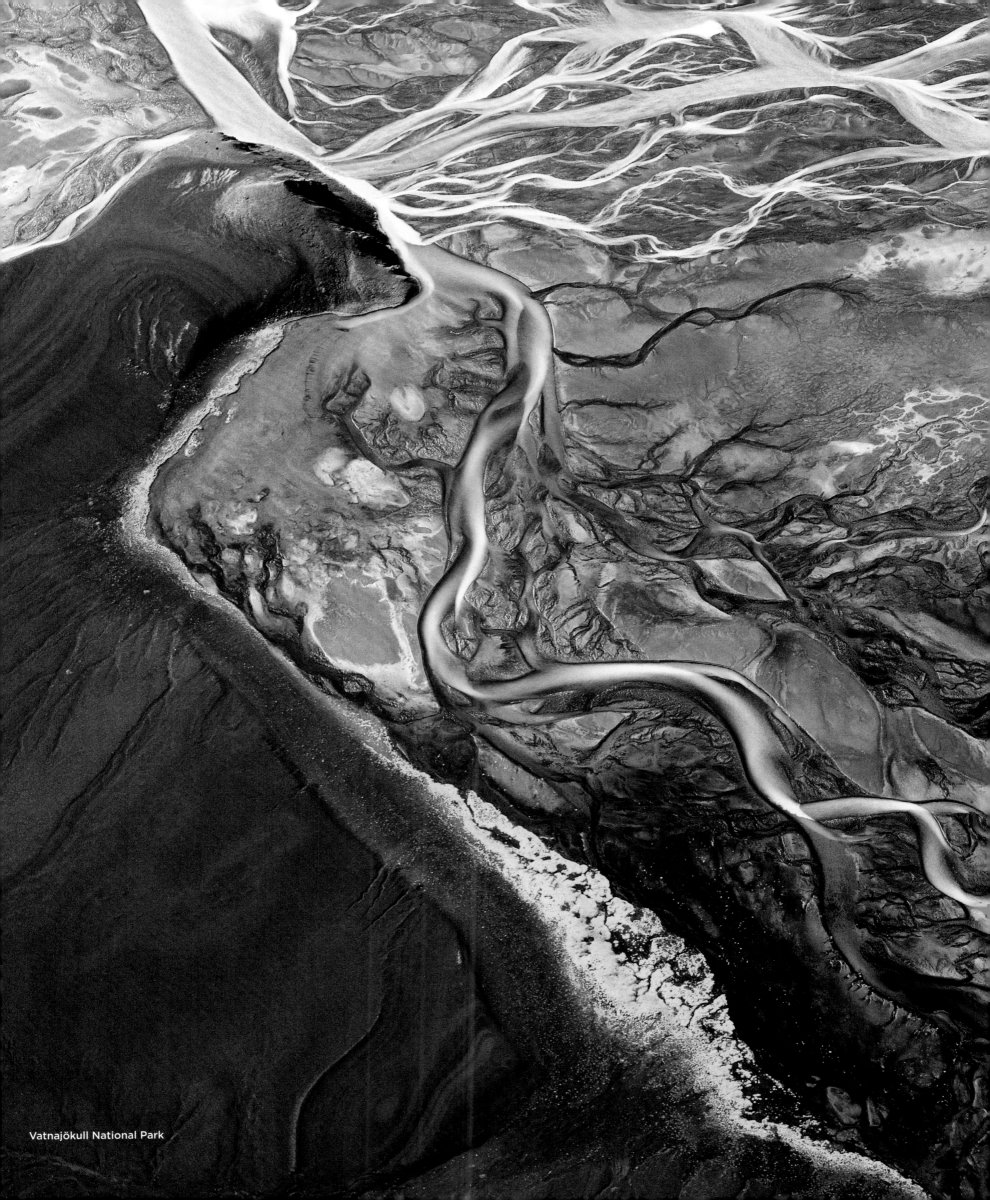
Vatnajökull National Park

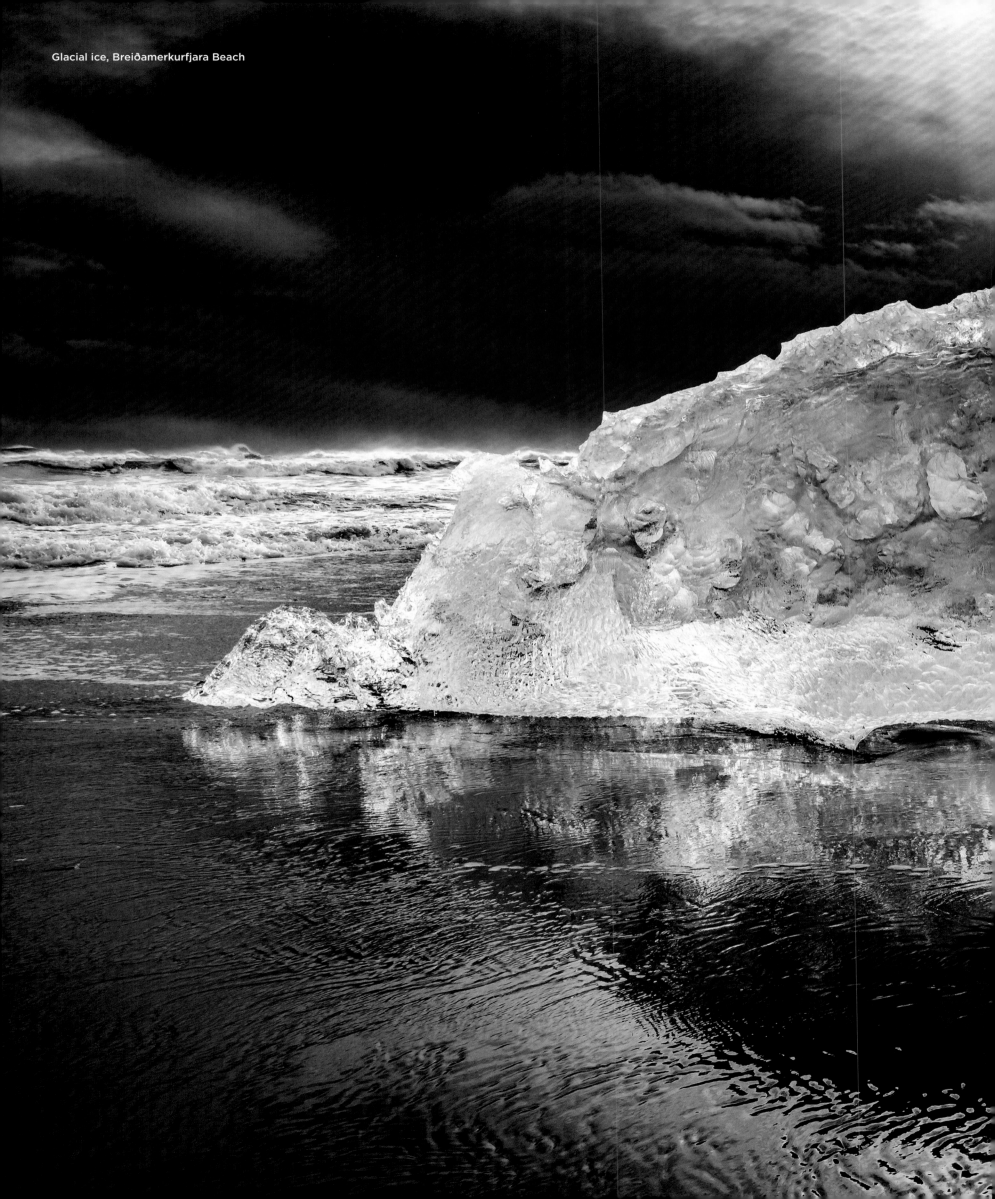

Glacial ice, Breiðamerkurfjara Beach

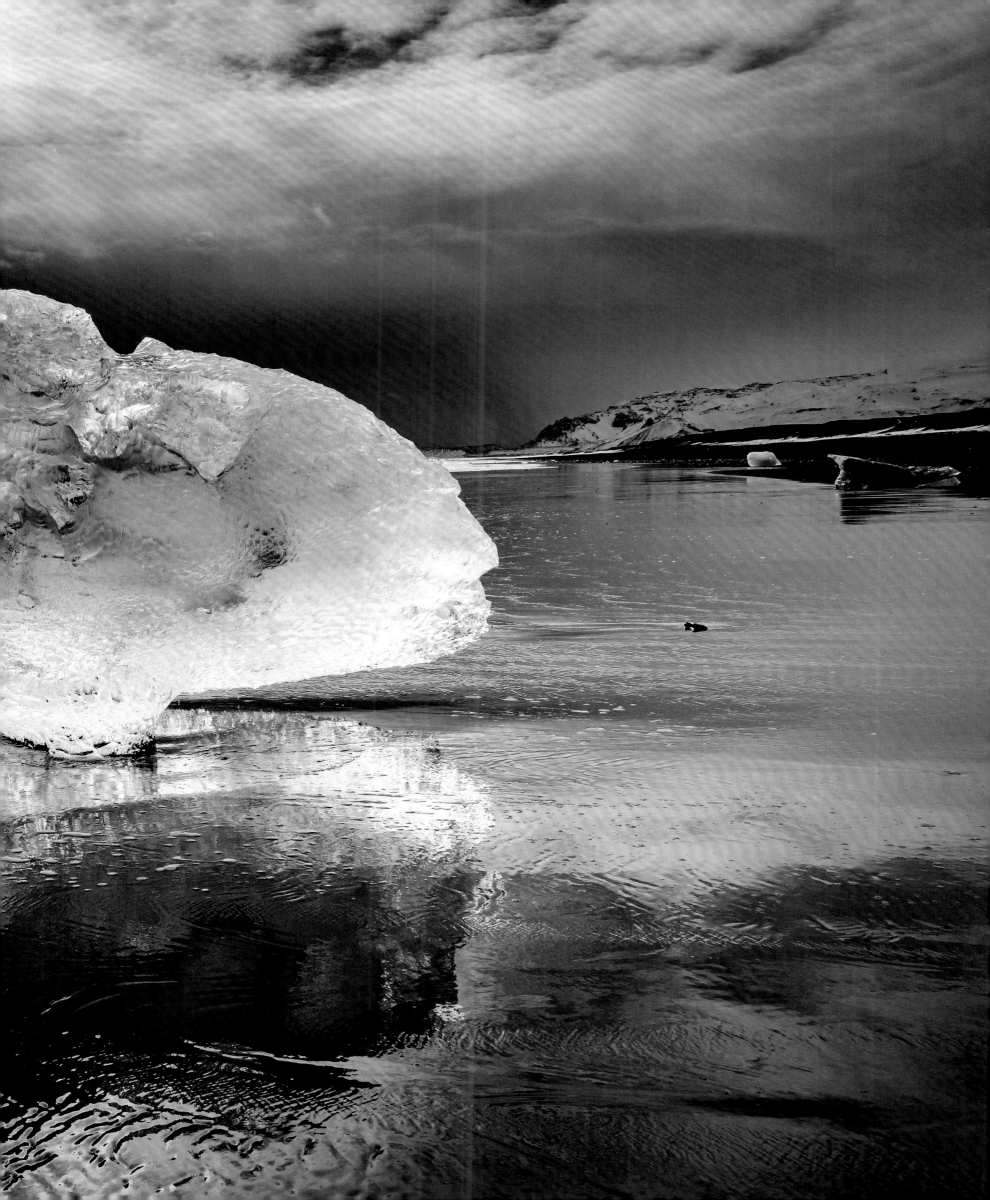

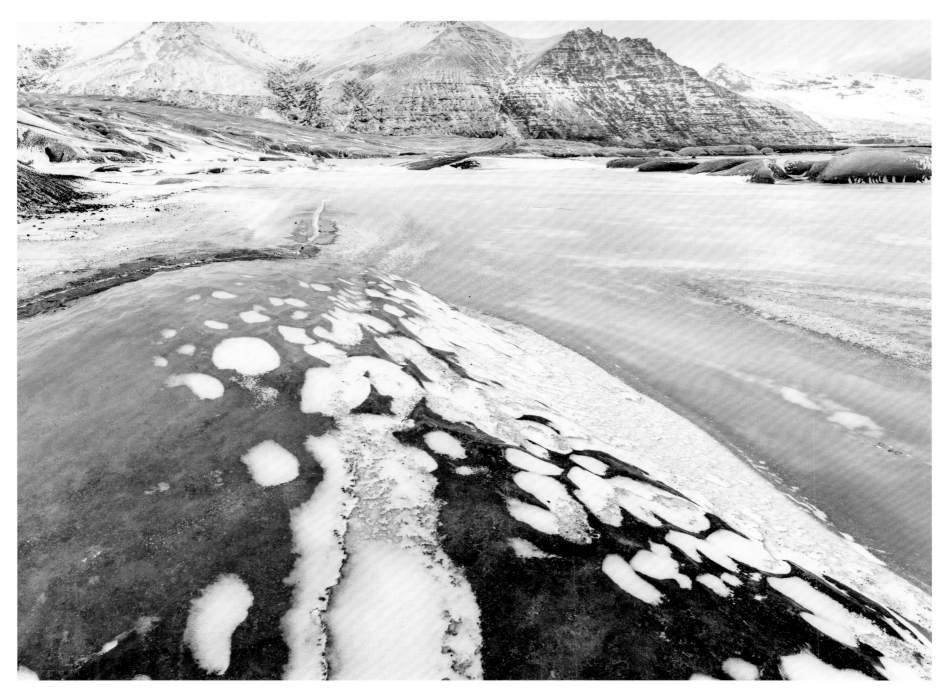

Skaftafelljökull Glacier, Vatnajökull National Park

Gullfoss

Gullfoss, the "Golden Waterfall", is one of the most famous sights of Iceland. The "Golden Ring", the most popular day trip from the capital Reykjavík, visits here as well as Þingvellir National Park and the Geysir Strokkur. Supplied by the glacial river Hvítá, the waters of Gullfoss flow in two stages into a deep crevasse. With a bit of luck you will see a rainbow in its spray. Twice already the Gullfoss was to be tamed by a hydroelectric power station; by the dedication of a local farmer's daughter it was saved, and today it is under nature protection.

Gullfoss

L'un des sites touristiques les plus célèbres d'Islande est la Gullfoss, la « chute d'or ». Le « cercle d'or », l'excursion à la journée la plus prisée depuis la capitale, Reykjavik, s'y arrête, de même qu'au parc national de Þingvellir et au geyser Strokkur. Nourries par la rivière glaciaire Hvítá, les masses d'eau de la Gullfoss se déversent en deux étapes dans une profonde crevasse. Avec un peu de chance, il est possible d'apercevoir un arc-en-ciel se former dans ses embruns. Par deux fois, la Gullfoss fut menacée d'être domptée par une centrale hydroélectrique, mais elle fut sauvée par l'engagement de Sigríður Tómasdóttir la fille du propriétaire du site naturel, aujourd'hui protégé.

Gullfoss

Zu den bekanntesten Sehenswürdigkeiten Islands gehört der Gullfoss, der „Goldene Wasserfall". Der „Goldene Ring", der beliebteste Tagesausflug von der Hauptstadt Reykjavík, legt an ihm ebenso einen Stopp ein wie am Nationalpark Þingvellir und am Geysir Strokkur. Vom Gletscherfluss Hvítá gespeist, ergießen sich die Wassermassen des Gullfoss in zwei Stufen in eine tiefe Spalte. Mit etwas Glück sieht man in seiner Gischt einen Regenbogen. Zweimal bereits sollte der Gullfoss durch ein Wasserkraftwerk gezähmt werden; durch das Engagement einer Bauerntochter wurde er gerettet und steht heute unter Naturschutz.

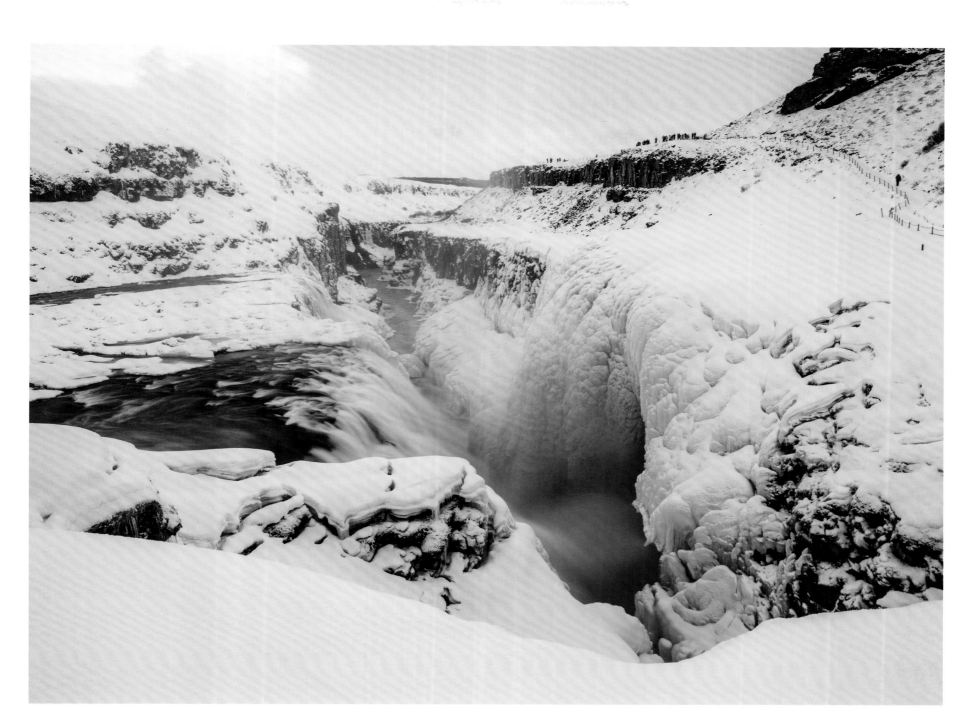

Gullfoss

Gullfoss

La Gullfoss, la «Cascada de Oro» es uno de los
lugares de interés más famosos de Islandia. El «Anillo
de Oro», la excursión de un día más popular desde
la capital Reikiavík, se detiene aquí, así como en
el Parque Nacional Þingvellir y el Geysir Strokkkur.
Suministradas por el río glaciar Hvítá, las aguas de
Gullfoss fluyen en dos etapas en una profunda grieta.
Con un poco de suerte se puede ver un arco iris en
su espuma. En dos ocasiones se intentó utilizar la
Gullfoss como central hidroeléctrica, pero gracias
al compromiso de la hija de un agricultor se salvó y
actualmente se encuentra protegida.

Gullfoss

A Gullfoss, a "Cachoeira Dourada" é um dos pontos
turísticos mais famosos da Islândia. No "Anel de
Ouro", o passeio de um dia mais popular a partir
da capital Reykjavík, deve-se fazer uma parade,
bem como no Parque Nacional Þingvellir e no
Geysir Strokkur. Alimentadas pelo rio Hvítá, as
águas de Gullfoss caem em duas etapas em uma
fenda profunda. Com um pouco de sorte, você
verá um arco-íris em sua espuma d'água. Por duas
vezes o Gullfoss foi guase domado por uma central
hidroelétrica; foi salvo pelo engajamento da filha de
um agricultor e hoje está sob proteção ambiental.

Gullfoss

De Gullfoss, de „Gouden Waterval" is een van de
bekendste bezienswaardigheden van IJsland. De
„Gouden Cirkel", de meest populaire dagtocht vanuit
de hoofdstad Reykjavík, stopt hier, evenals bij het
Nationaal Park Þingvellir en de Geysir Strokkur. Het
water van Gullfoss, dat wordt aangevoerd door de
gletsjerrivier Hvítá, stroomt in twee etappes uit in
een diepe kloof. Met een beetje geluk zie je een
regenboog. De Gullfoss moest al twee keer worden
getemd door een waterkrachtcentrale; door de inzet
van een boerendochter werd hij gered en staat nu
onder natuurbescherming.

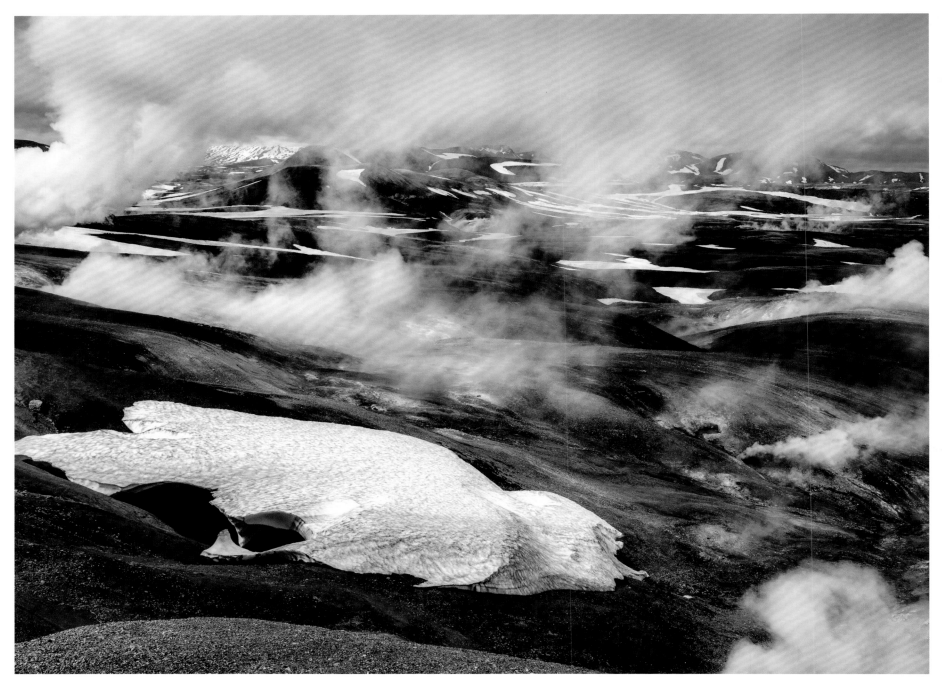

Geothermal areas, Mount Hrafntinnusker

The Highlands
Only a narrow coastal strip of Iceland is populated, the vast remainder is made up of highlands. The interior of the island is barren and hostile to life, but it fascinates with colorful rhyolite mountains, rugged, eroded peaks, hot springs, deep gorges and dramatic volcanic landscapes. Only a few tracks lead through this inhospitable wilderness.

Las Tierras Altas
Solo una estrecha franja costera de Islandia está poblada; todo lo demás está formado por las Tierras Altas. El interior de la isla es estéril y hostil a la vida, pero fascina con sus coloridas montañas de riolita, sus escarpadas cumbres erosionadas, sus aguas termales, sus profundos desfiladeros y sus espectaculares paisajes volcánicos. Solo unas pocas laderas conducen a través de esta soledad inhóspita.

Les Hautes Terres
Seule une étroite bande de côte islandaise est habitée, le reste formant les Hautes Terres. L'intérieur de l'île est inoccupé et hostile, mais fascine par ses montagnes de rhyolite colorées, ses sommets escarpés et érodés, ses sources chaudes, ses canyons profonds et ses paysages volcaniques grandioses. Seuls quelques chemins traversent ce désert inhospitalier.

Os planaltos
Apenas uma estreita faixa costeira da Islândia é povoada, o grande resto é formado pelos planaltos. O interior da ilha é estéril e hostil à vida, mas fascina pelas coloridas montanhas de riólito, picos escarpados e erodidos, fontes termais, gargantas profundas e paisagens vulcânicas dramáticas. Apenas algumas encostas conduzem a esta solidão inóspita.

Das Hochland
Nur ein schmaler Küstenstreifen Islands ist besiedelt, den großen Rest bildet das Hochland. Das Inselinnere ist karg und lebensfeindlich, es fasziniert aber mit farbigen Rhyolithbergen, schroffen, erodierten Gipfeln, heißen Quellen, tiefen Schluchten und dramatischen Vulkanlandschaften. Nur wenige Pisten führen durch diese unwirtliche Einsamkeit.

De Hooglanden
Alleen een smalle kuststrook van IJsland is bewoond, de rest wordt gevormd door de hooglanden. Het binnenland van het eiland is kaal en onherbergzaam ten opzichte van het leven, maar het fascineert met kleurrijke rhyolieten bergen, ruige, geërodeerde toppen, warmwaterbronnen, diepe kloven en vulkaanlandschappen. Slechts enkele hellingen leiden door deze onherbergzame eenzaamheid.

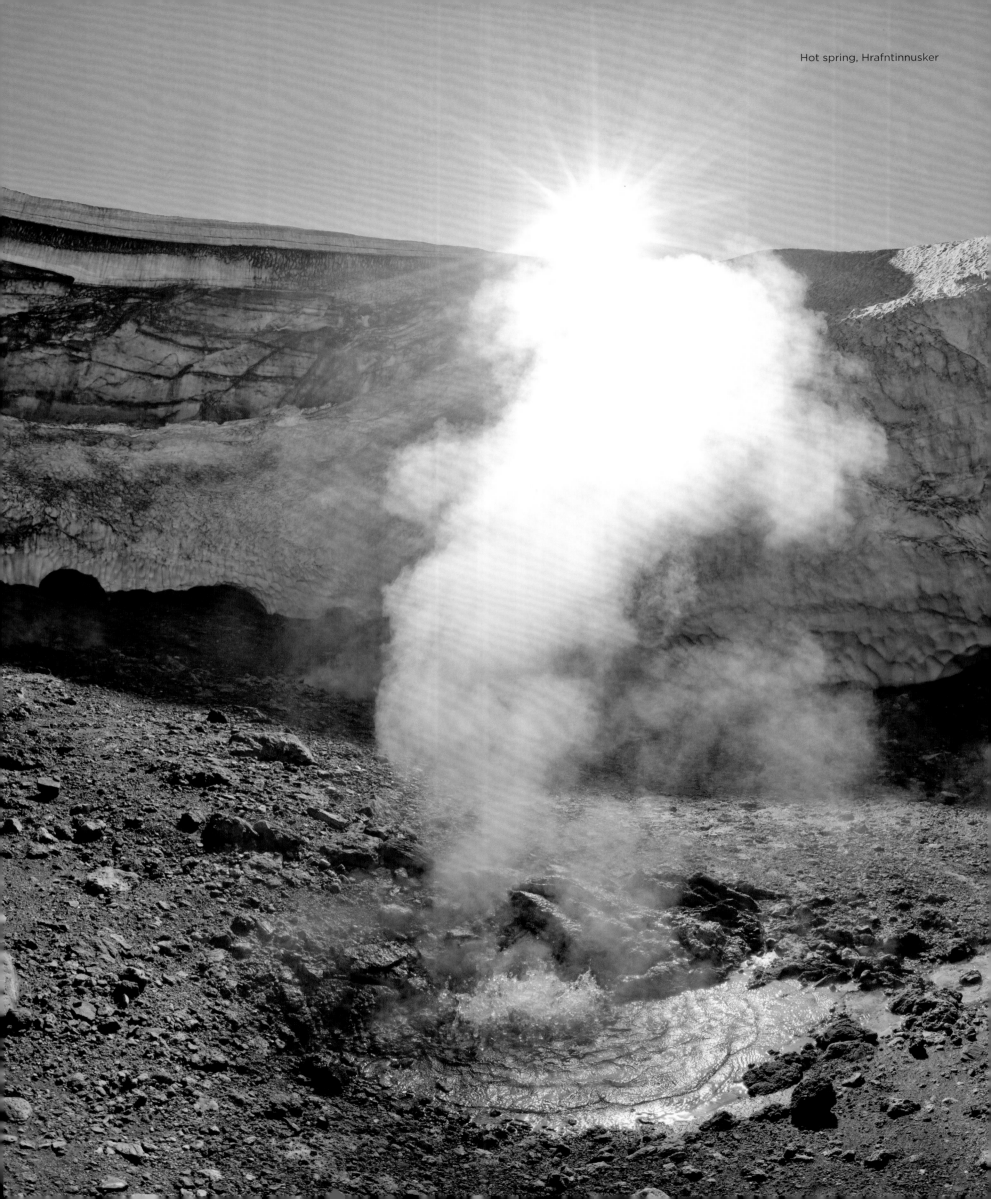

Hot spring, Hrafntinnusker

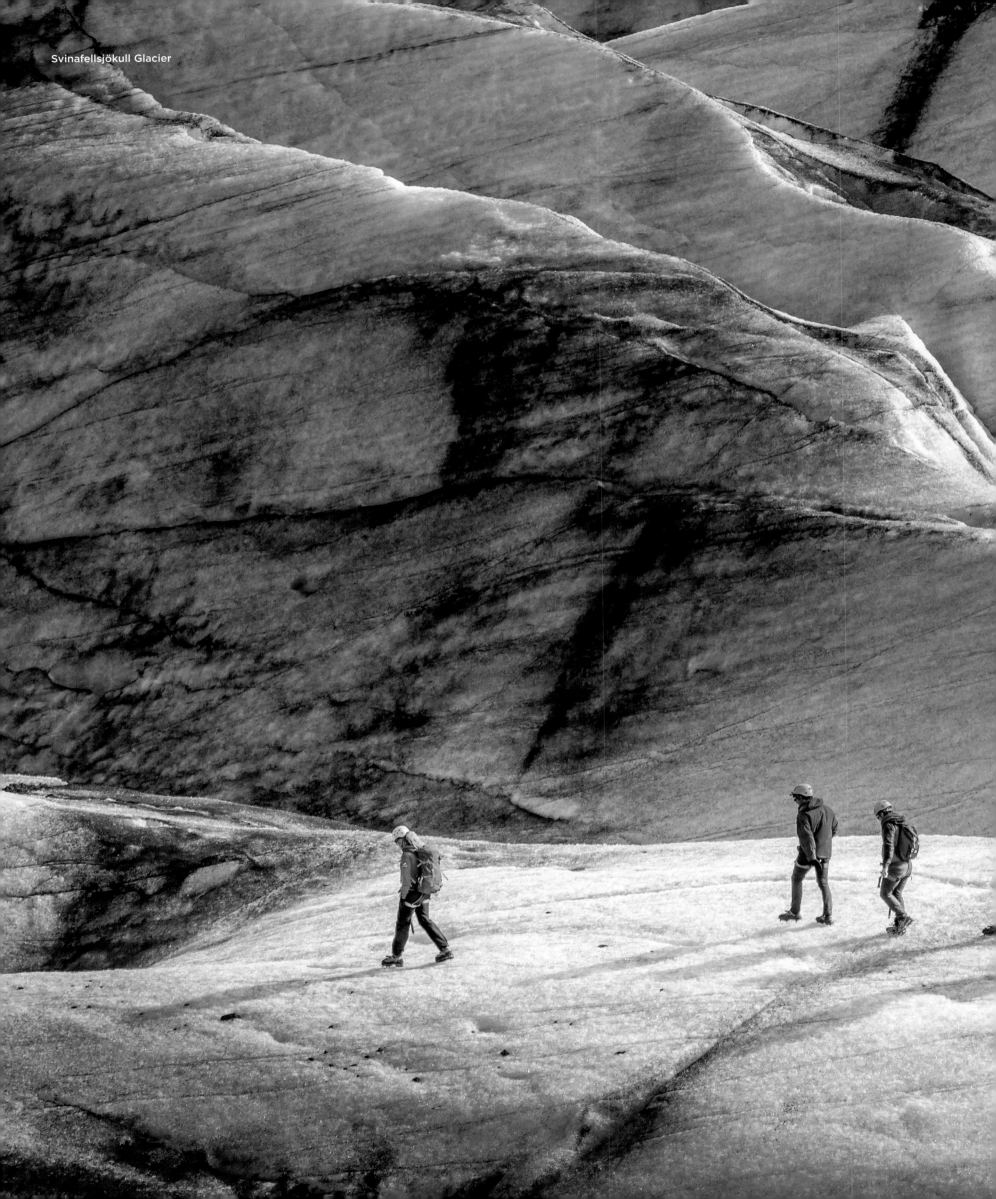
Svinafellsjökull Glacier

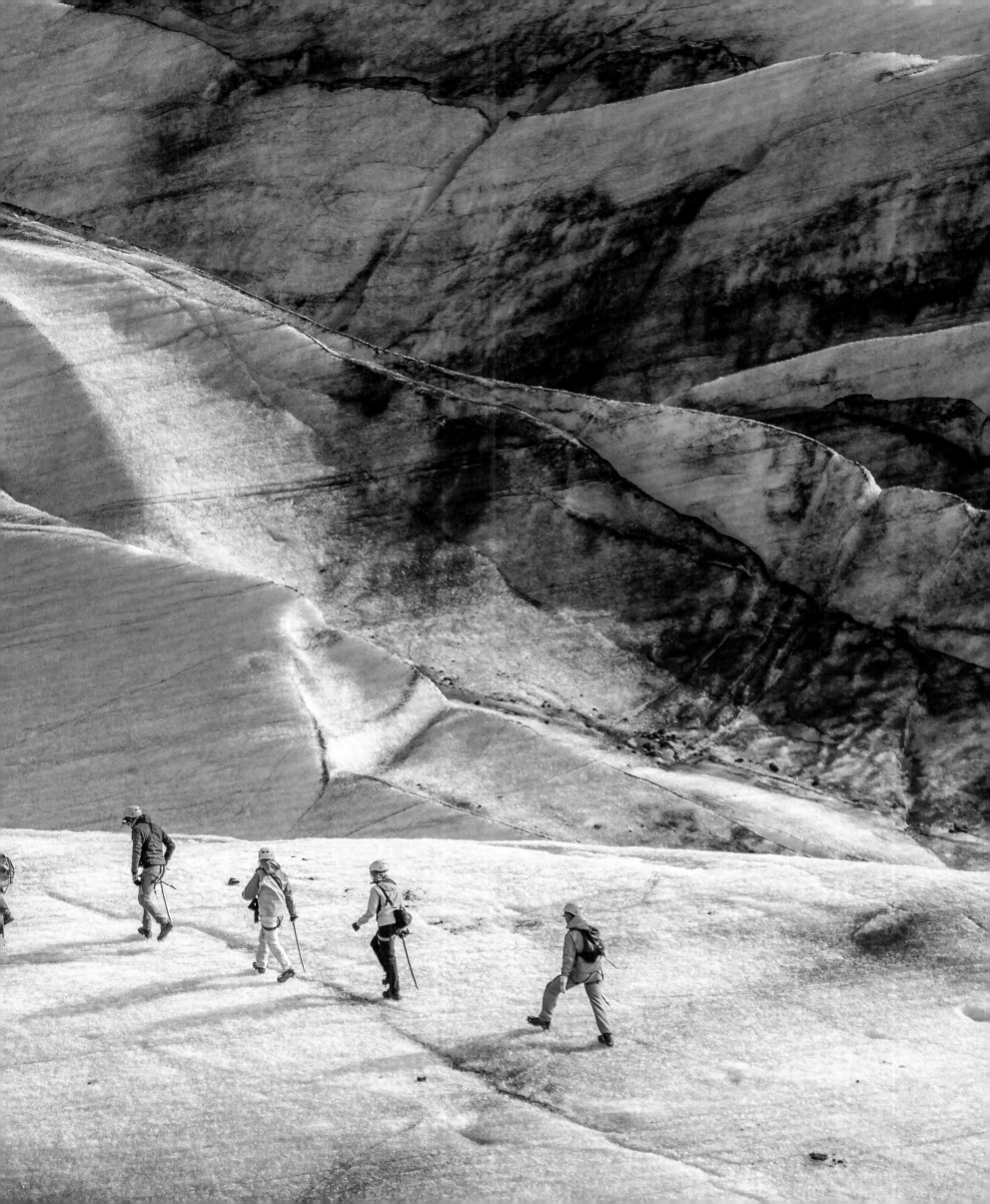

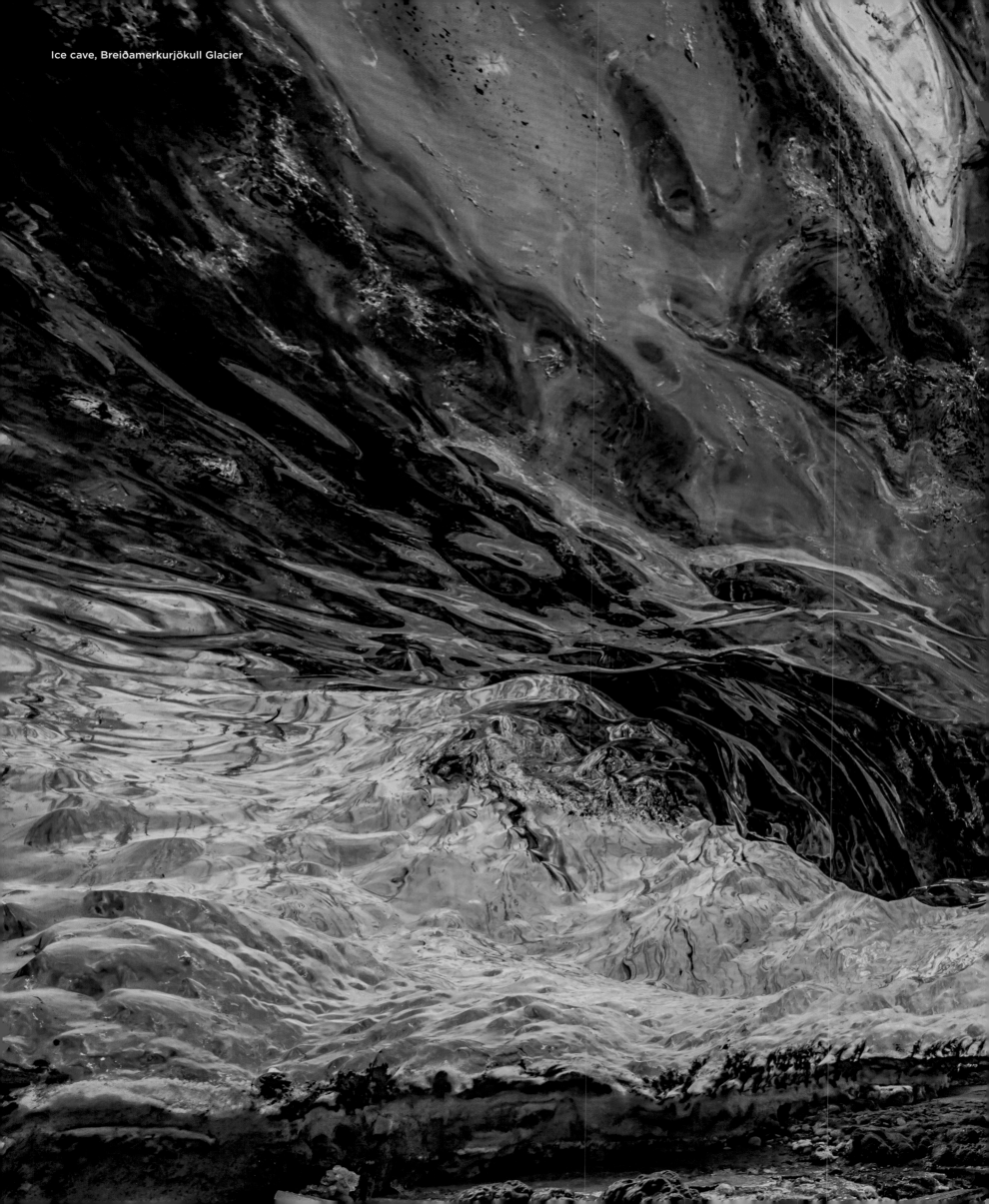

Ice cave, Breiðamerkurjökull Glacier

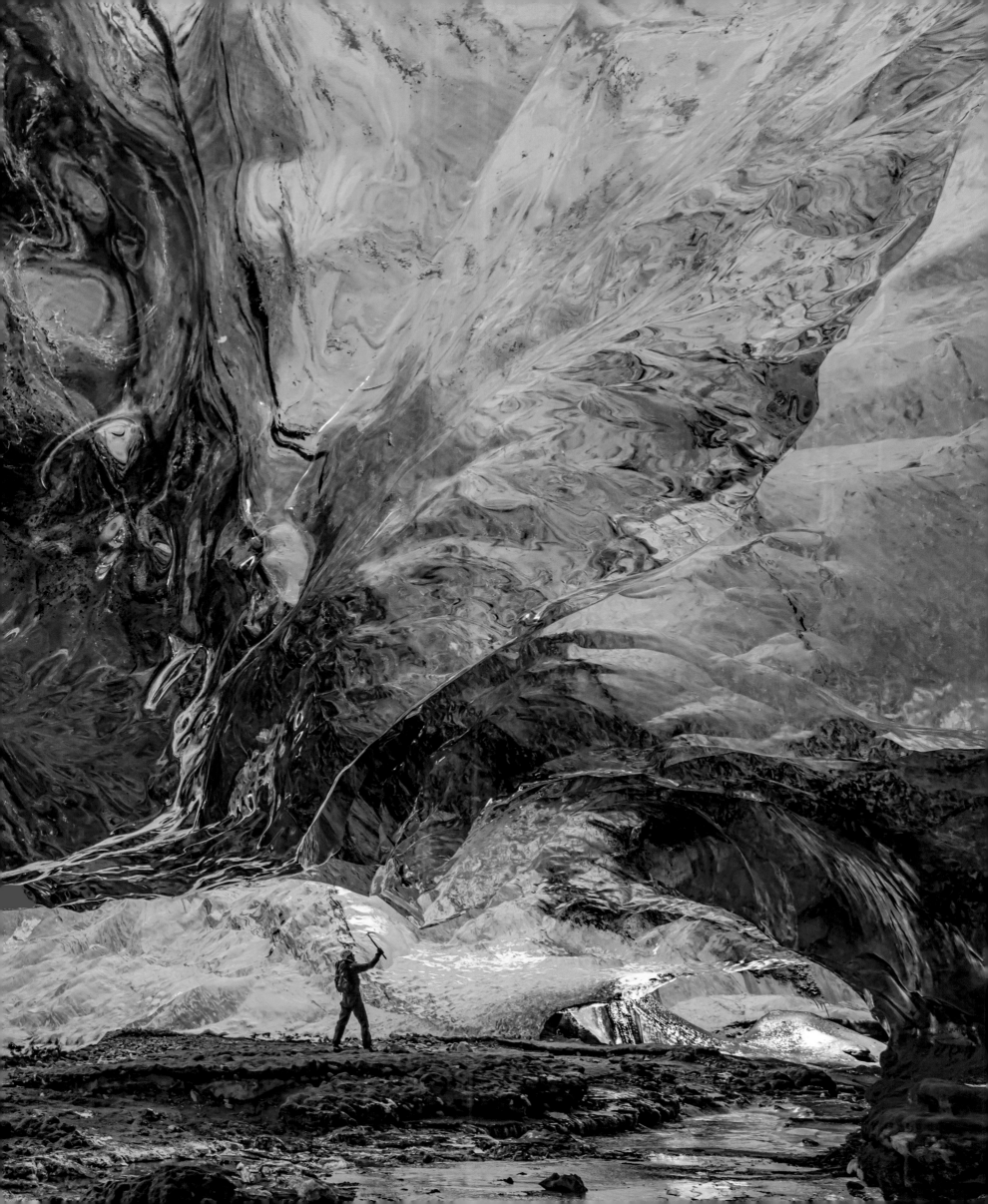

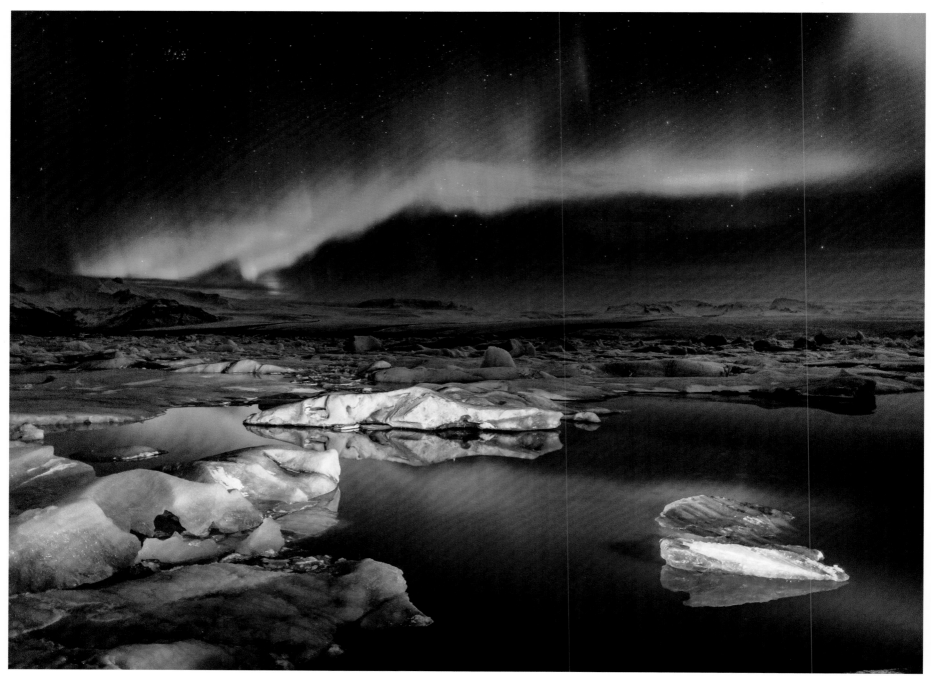

Northern lights, Jökulsárlón

Northern Lights

In winter, the sky over both the Arctic and the Antarctic offers a special light show when green, red or blue veils waft over the firmament. In the northern hemisphere this is known as the northern lights or Aurora Borealis, and in the southern hemisphere it is the Aurora Australis. In former times, polar lights were regarded as signs of the gods, messages from the deceased or harbingers of war and famine. Today we know that the green, red and blue polar lights are formed when the electrically charged particles of the solar wind meet oxygen and nitrogen atoms in the Earth's atmosphere at an altitude of 100 to 200 km (50—120 mi).

Aurores polaires

En hiver, le ciel offre, au-dessus de l'Arctique et de l'Antarctique, un spectacle lumineux d'un genre particulier au cours duquel des voiles verts, rouges ou bleus vacillent au firmament. Dans l'hémisphère nord, on parle d'aurores boréales (aurora borealis), dans l'hémisphère sud, d'aurores australes (aurora australis). Autrefois, les aurores polaires étaient considérées comme des signes des dieux, comme des messages de l'au-delà ou encore comme des signes annonciateurs de guerres ou de famines. Aujourd'hui, nous savons que les aurores polaires vertes, rouges et bleues apparaissent lorsque des particules de vent solaire chargées électriquement rencontrent des atomes d'oxygène et d'azote dans l'atmosphère terrestre à une altitude de 100 à 200 km.

Polarlichter

Im Winter bietet der Himmel über der Arktis und Antarktis eine besondere Lichtershow, denn dann wabern grüne, rote oder blaue Schleier über das Firmament. Auf der Nordhalbkugel spricht man von Nordlicht oder Aurora borealis, auf der Südhalbkugel von Aurora australis. Früher galten Polarlichter als Zeichen der Götter, Botschaften von Verstorbenen oder Vorboten von Kriegen und Hungersnöten. Heute wissen wir, dass grüne, rote und blaue Polarlichter entstehen, wenn elektrisch geladene Teilchen des Sonnenwindes in der Erdatmosphäre auf Sauerstoff- und Stickstoffatome in 100 bis 200 km Höhe treffen.

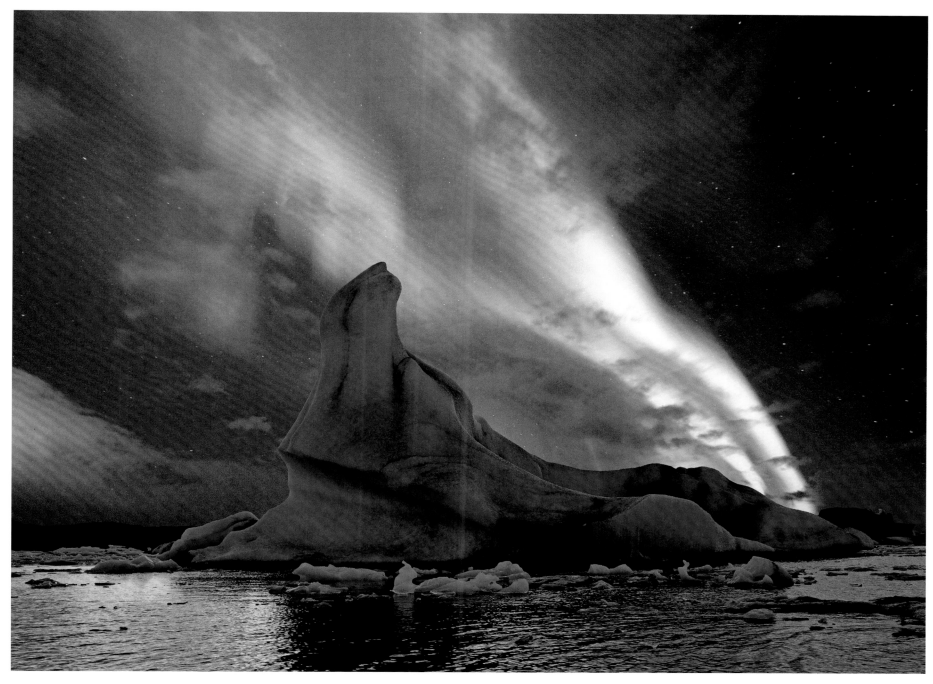

Northern lights, Jökulsárlón

Aurora polar

En invierno, el cielo sobre el Ártico y la Antártida ofrece un espectáculo de luces muy especial, porque sobre el firmamento ondean velos verdes, rojos o azules. En el hemisferio norte se conoce como aurora boreal, y en el hemisferio sur como aurora austral. Antiguamente, las auroras boreales eran consideradas signos de los dioses; mensajes de los difuntos o presagios de guerras y hambrunas. Hoy sabemos que se forman luces polares verdes, rojas y azules cuando las partículas cargadas eléctricamente del viento solar se encuentran con átomos de oxígeno y nitrógeno en la atmósfera de la Tierra a una altitud de 100 a 200 km.

Luzes do Norte

No inverno, o céu sobre o Ártico e a Antártida oferece um show especial de luzes, porque então véus verdes, vermelhos ou azuis se movem sobre o firmamento. No hemisfério norte fala-se de luzes do norte ou Aurora borealis, no hemisfério sul de Aurora australis. Em tempos passados, a aurora boreal era considerada como sinal dos deuses, mensagens dos mortos ou arautos de guerras e fomes. Hoje sabemos que as luzes polares verdes, vermelhas e azuis se formam quando partículas carregadas eletricamente do vento solar encontram átomos de oxigênio e nitrogênio na atmosfera da Terra a uma altitude de 100 a 200 km.

Poollicht

In de winter biedt de lucht boven de Noordpool en Antarctica een bijzondere lichtshow, groene, rode of blauwe sluiers waaien over het firmament. Op het noordelijk halfrond spreekt men van noorderlicht of Aurora borealis, op het zuidelijk halfrond van Aurora australis. Vroeger werd het noorderlicht beschouwd als een teken van de goden, boodschappen van de overledenen of voorbode van oorlogen en hongersnood. Tegenwoordig weten we dat groen, rood en blauw poollicht wordt gevormd wanneer elektrisch geladen deeltjes van de zonnewind op een hoogte van 100 tot 200 km zuurstof- en stikstofatomen in de atmosfeer van de aarde ontmoeten.

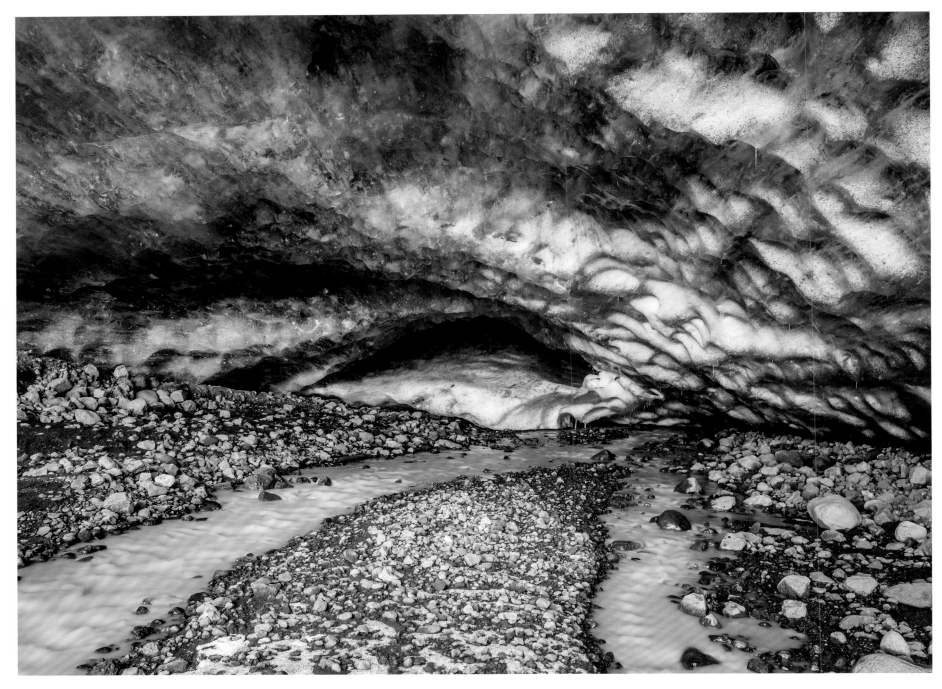

Ice cave, Fallsjökull Glacier

Ice Caves in Vatnajökull

Under the up to 900 m (3000 ft) thick ice shield of the Vatnajökull, volcanoes feed hot springs. These form hot-water rivers, which make their way under the glacier ice and form caves. The cave walls are especially fascinating, because the warm water thaws the ice surface and then when it freezes again, unreal glittering patterns form on the walls. Only in winter from November to March are some of the caves safe to walk through under expert guidance. In summer many of the fairy caves collapse, but next winter new, equally fascinating ones form.

Grottes de glace à Vatnajökull

Sous la calotte glaciaire du Vatnajökull, épaisse de 900 m en certains endroits, des volcans nourrissent des sources chaudes. Celles-ci forment des courants d'eau chaude se frayant un passage sous la glace et creusant ainsi des grottes. Les parois de ces cavités sont particulièrement fascinantes car l'eau chaude fait fondre la surface gelée sur laquelle, lorsqu'elle gèle de nouveau, se forment ensuite des motifs aléatoires scintillants. En hiver, de novembre à mars, seulement quelques-unes de ces grottes peuvent être visitées sans danger aux côtés d'un guide bien informé. En été, nombre de ces grottes féeriques s'écroulent, mais de nouvelles, tout aussi impressionnantes, se formeront l'hiver suivant.

Eishöhlen im Vatnajökull

Unter dem bis zu 900 m dicken Eispanzer des Vatnajökull speisen Vulkane heiße Quellen. Diese bilden Heißwasserflüsse, die sich unter dem Gletschereis ihren Weg suchen und dabei Höhlen bilden. Besonders faszinierend sind die Höhlenwände, denn das warme Wasser taut die Eisoberfläche an, wenn es dann wieder gefriert, bilden sich unwirklich glitzernde Muster an den Wänden. Nur im Winter von November bis März sind einige der Höhlen gefahrlos unter kundiger Führung zu begehen. Im Sommer stürzen viele der Feengrotten ein, doch im nächsten Winter bilden sich neue, ebenso faszinierende.

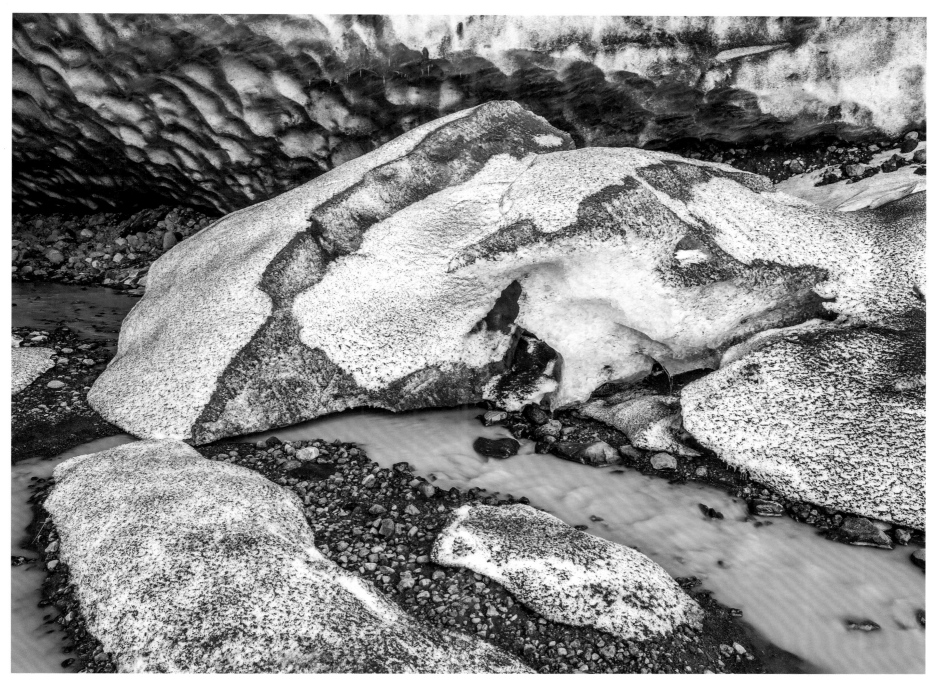

Ice Cave, Fallsjökull Glacier

Cuevas de hielo en Vatnajökull

Bajo el escudo de hielo de hasta 900 m de espesor de los volcanes Vatnajökull se alimentan las aguas termales. Estas forman ríos de agua caliente que se abren paso bajo el hielo de los glaciares y forman cuevas. Especialmente fascinantes son las paredes de las cuevas, porque el agua caliente descongela la superficie de hielo y, cuando se congela de nuevo, se forman patrones irreales y brillantes en las paredes. Solo en invierno, de noviembre a marzo, algunas de las cuevas son seguras para caminar bajo la guía de un experto. En verano se derrumban muchas de estas mágicas cuevas, pero en el siguiente invierno se vuelven a formar otras fascinantes.

Cavernas de gelo em Vatnajökull

Os vulcões alimentam fontes termais sob o escudo de gelo de Vatnajökull, com até 900 metros de espessura estes formam rios de água quente, que procuram o seu caminho sob o gelo glacial e formam cavernas. Especialmente fascinantes são as paredes das cavernas, porque a água quente descongela a superfície de gelo, mas quando ela congela novamente, imagens brilhantes irreais se formam nas paredes. Somente no inverno, de novembro a março, algumas das cavernas são seguras para caminhar sob orientação de especialistas. No verão, muitas das cavernas de fadas desmoronam, mas no inverno seguinte formam-se novas e igualmente fascinantes.

IJsgrotten in Vatnajökull

Onder het tot 900 m dikke ijsschild van de Vatnajökull-vulkanen voeden warmwaterbronnen. Deze vormen warmwaterrivieren, die hun weg zoeken onder het gletsjerijs en grotten vormen. Bijzonder fascinerend zijn de grotwanden, omdat het warme water het ijsoppervlak ontdooit, wanneer het weer bevriest, vormen zich onwerkelijk glinsterende patronen op de muren. Alleen in de winter van november tot maart zijn sommige grotten veilig om onder deskundige begeleiding door te lopen. In de zomer storten veel van de sprookjesgrotten in, maar de winter erna zorgen weer voor nieuwe, even fascinerende grotten.

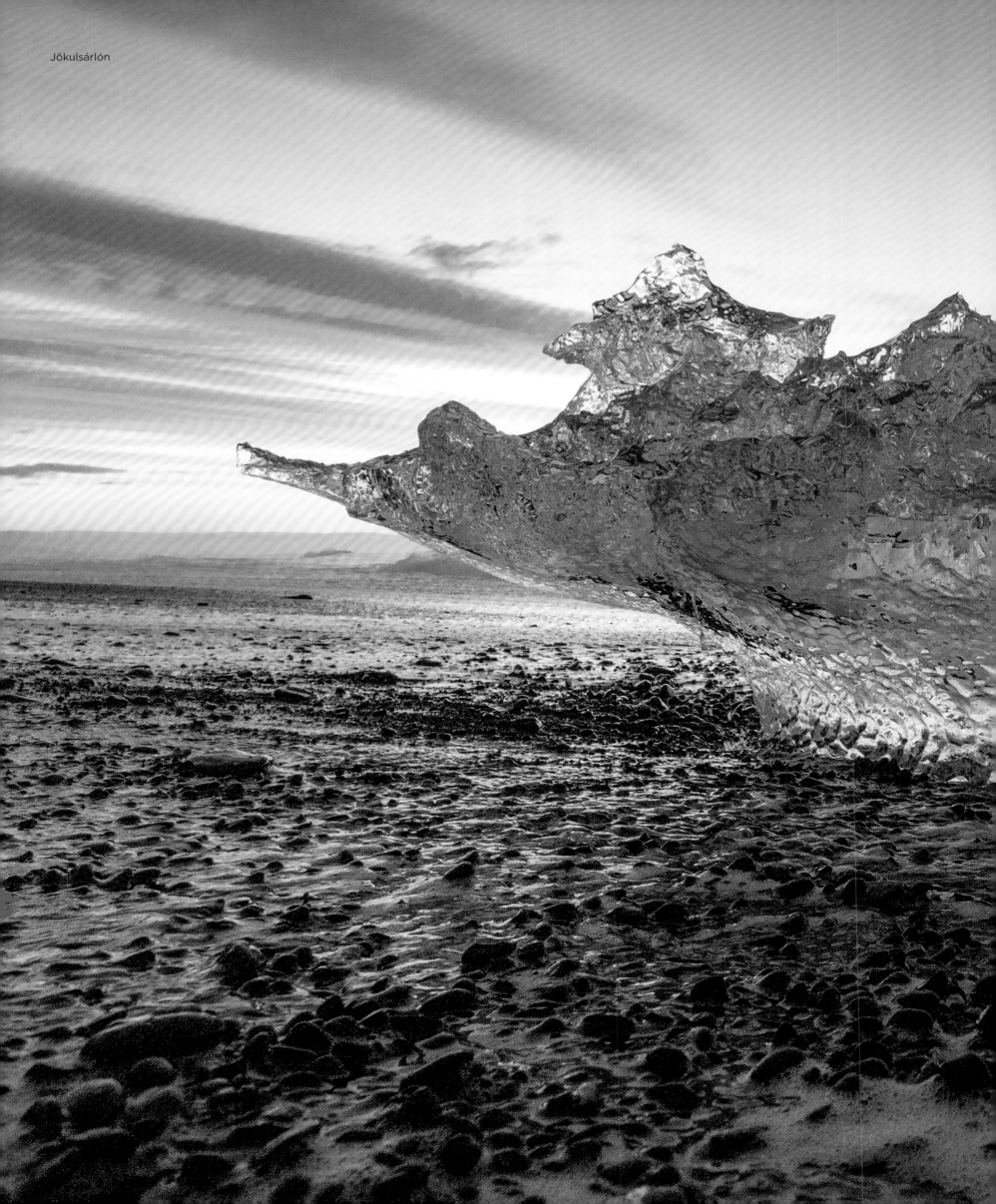

Jökulsárlón

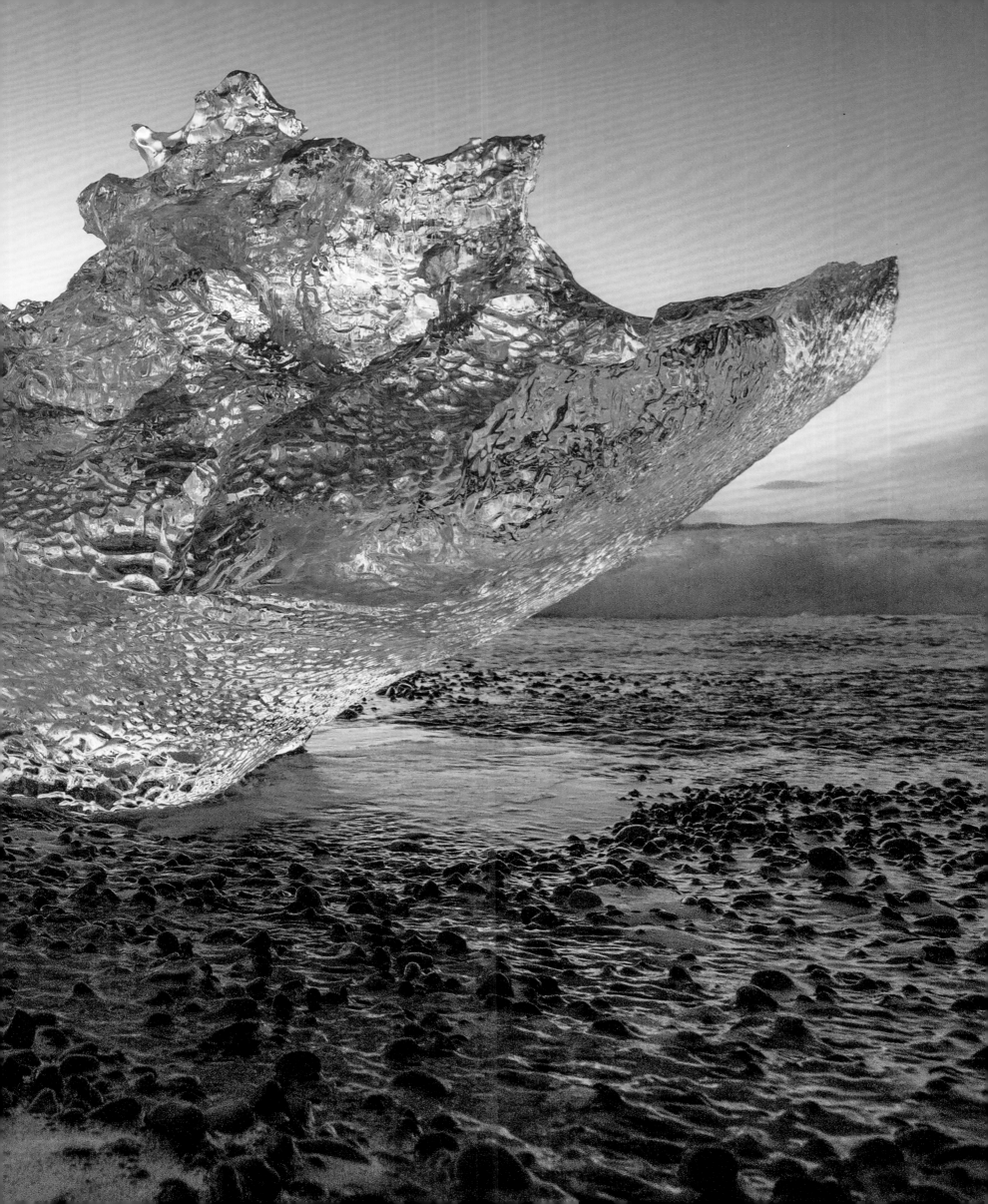

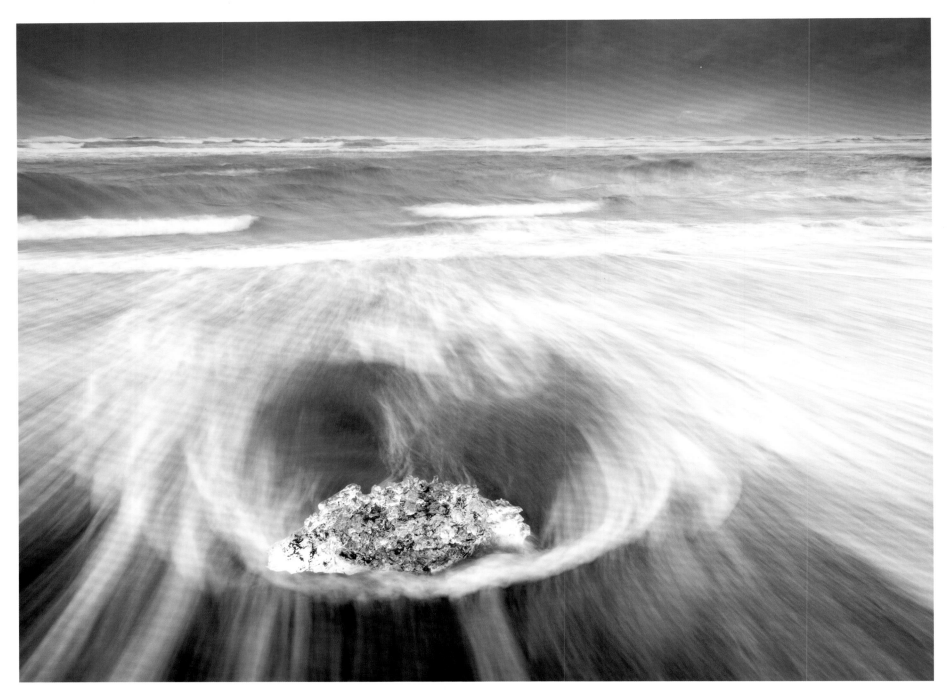

Jökulsárlón Beach

Jökulsárlón

The tongue of Breiðamerkurjökull Glacier flows from the south-eastern edge of Icelandic Vatnajökull into the valley below. It used to calve close to the sea, but due to climate change it has now retreated a few kilometers. Glacial lakes such as Jökulsárlón, on which icebergs constantly float, have formed as a result. These have every conceivable shape: some are blue, others white, some show black bands of volcanic ash. Sooner or later they all drift down a small river to the black beach and become smaller and smaller due to water and waves.

Le Jökulsárlón

La langue glaciaire du Breiðamerkurjökull s'étend du bord sud-est du glacier islandais Vatnajökull à la vallée. Jadis, elle vêlait au bord de la mer. En raison du réchauffement climatique, elle a cependant désormais reculé de plusieurs kilomètres. Des lacs glaciaires tels que le Jökulsárlón, sur lesquels des icebergs flottent, se sont ainsi formés. Les icebergs peuvent prendre toutes les formes possibles et imaginables ; certains sont bleus, d'autres blancs, quelques-uns présentent des stries noires de cendres volcaniques. Portés par une petite rivière, tous finissent un jour par s'échouer sur la plage noire et rapetisser sous l'effet de l'eau et des vagues.

Jökulsárlón

Die Gletscherzunge des Breiðamerkurjökull fließt vom Südostrand des isländischen Vatnajökull zu Tal. Früher kalbte sie in unmittelbarer Nähe zum Meer, doch durch den Klimawandel hat sie sich mittlerweile einige Kilometer zurückgezogen. Dadurch haben sich Gletscherseen wie der Jökulsárlón gebildet, auf dem ständig Eisberge schwimmen. Diese haben alle erdenklichen Formen, einige sind blau, andere weiß, einige zeigen schwarze Bänder aus Vulkanasche. Durch einen kleinen Fluss treiben sie früher oder später alle auf den schwarzen Strand und werden dort durch Wasser und Wellen immer kleiner.

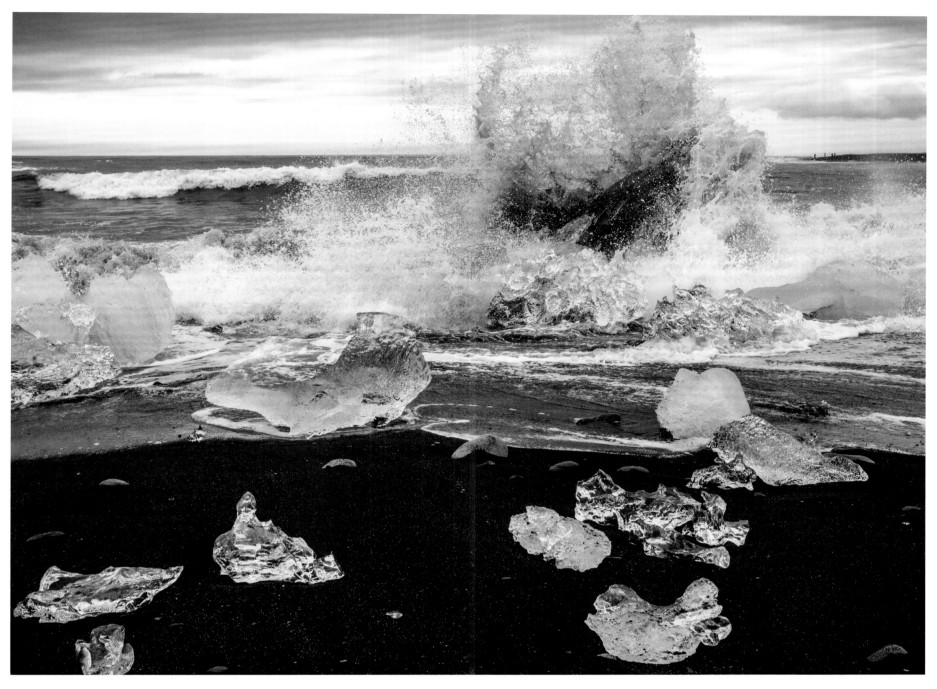

Jökulsárlón Beach

Jökulsárlón

La lengua glaciar de Breiðamerkurjökull fluye desde
la playa sureste del Vatnajökull islandés hasta el
valle. Antes acababa muy cerca del mar, pero debido
al cambio climático ha retrocedido unos pocos
kilómetros. Como resultado, se han formado lagos
glaciares como el Jökulsárlón, sobre el que flotan
constantemente icebergs. Estos tienen todas las
formas imaginables, y algunos son azules, otros
blancos, algunos muestran bandas negras de ceniza
volcánica. Tarde o temprano todos van a la deriva a
través de un pequeño río hasta la playa negra y se
vuelven cada vez más pequeños debido al agua y
las olas.

Jökulsárlón

A língua de gelo do glaciar Breiðamerkurjökull flui do
sudeste da Vatnajökull islandesa e corre para o vale.
Costumava desaguar perto do mar, mas devido às
alterações climáticas já recuou alguns quilómetros.
Como resultado, formaram-se lagos glaciais como
o Jökulsárlón, sobre o qual flutuam constantemente
icebergs. Estes têm todas as formas concebíveis,
alguns são azuis, outros brancos, alguns mostram
faixas pretas de cinzas vulcânicas. Mais cedo ou mais
tarde, todos eles correm por um pequeno rio até a
praia negra e se tornam menores e menores devido
às águas e às ondas.

Jökulsárlón

De gletsjertong van Breiðamerkurjökull stroomt van
het zuidoostelijke strand van het IJslandse Vatnajökull
naar het dal. Vroeger kalfde het dicht bij de zee,
maar door de klimaatverandering heeft het zich nu
enkele kilometers teruggetrokken. Als gevolg hiervan
zijn er gletsjermeren ontstaan, zoals Jökulsárlón,
waarop voortdurend ijsbergen drijven. Deze hebben
alle denkbare vormen, sommige zijn blauw, andere
wit, andere zwart, sommige tonen zwarte banden
bestaande uit vulkanische as. Vroeg of laat drijven ze
allemaal door een riviertje naar het zwarte strand en
worden steeds kleiner door water en golven.

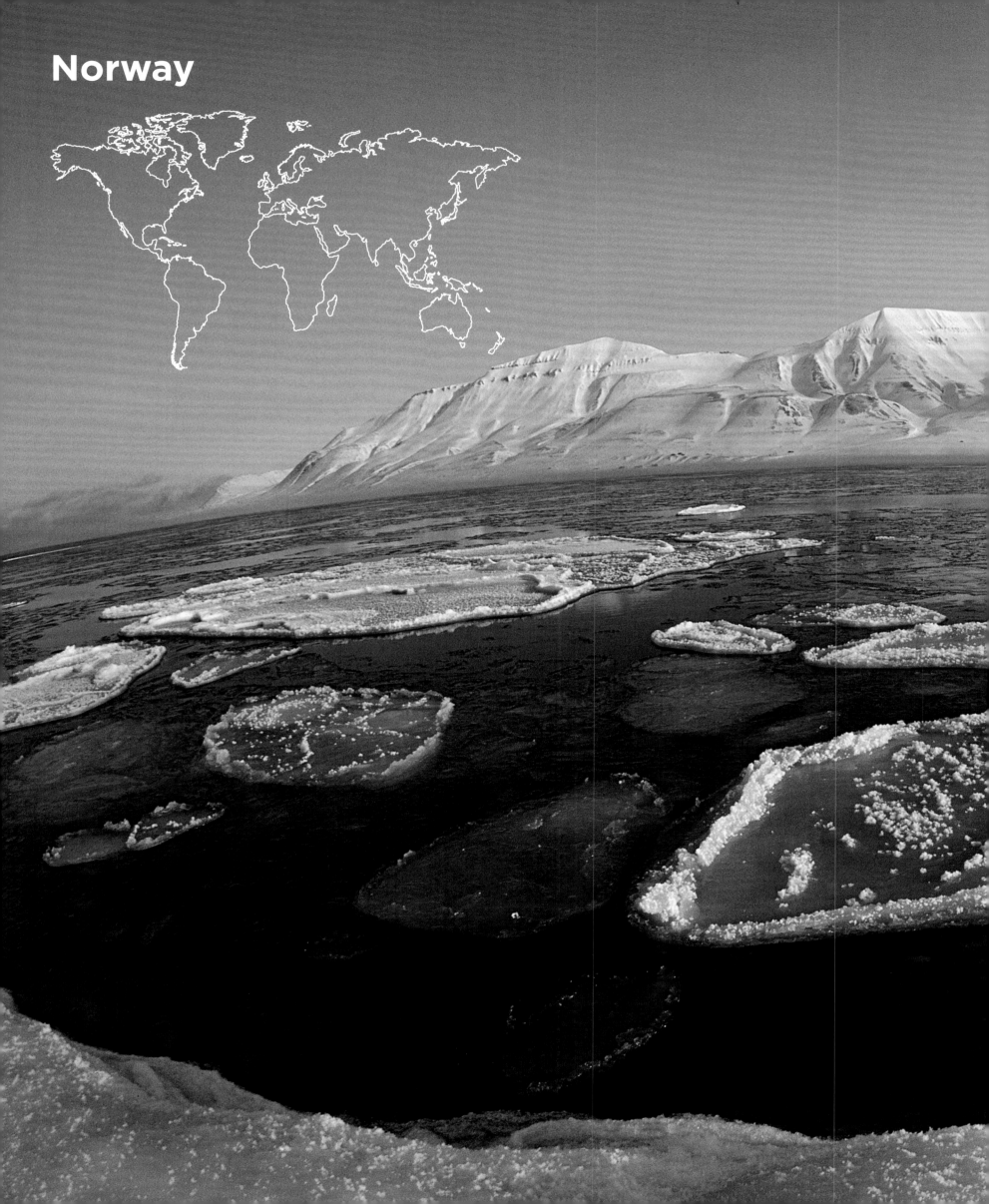

Norway

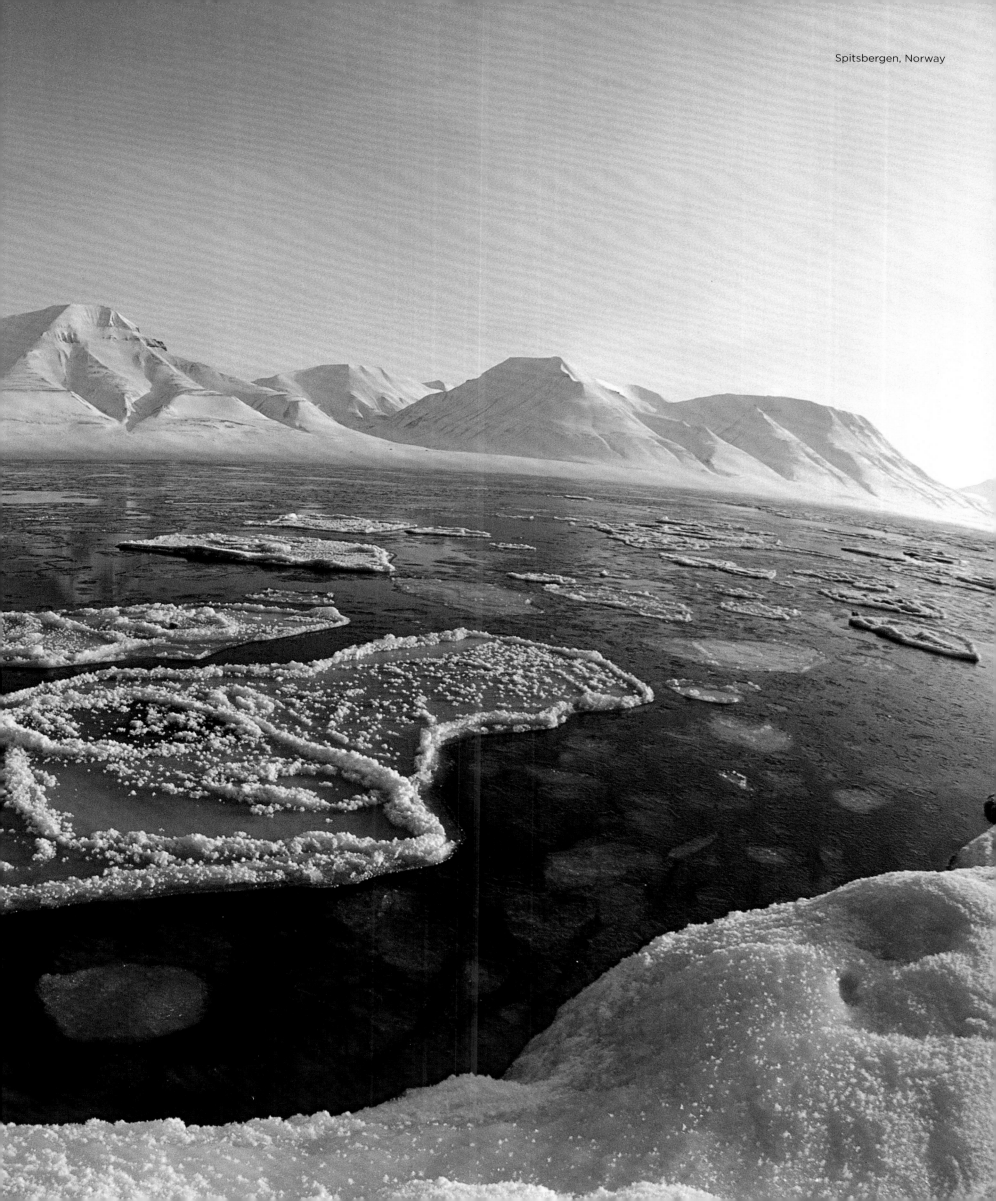

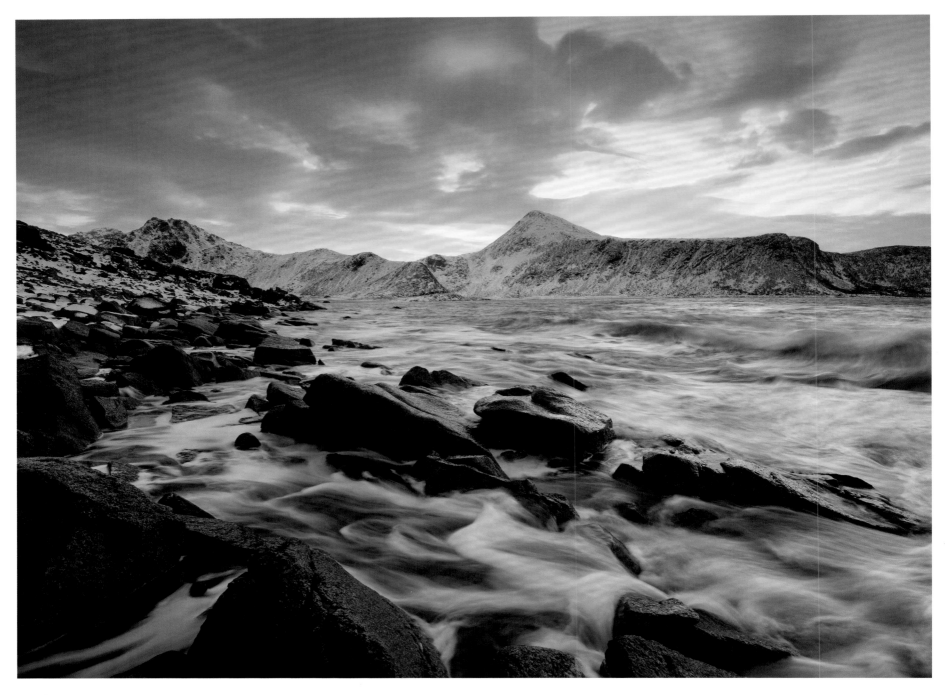

Vestvågøy, Lofoten Islands

Norway

From the sun-drenched archipelago in the south to the Arctic North Cape, from the deep fjords in the west to treeless plateaus and mountains, Norway offers scenic beauty like barely any other country in Europe. In winter the snow-covered countryside is quiet, and many Norwegians are drawn to their own spartan hut in the mountains, or they go on tour with wide cross-country skis. When the sun warms up again around Easter and the days become longer, the treeless mountains turn into a glittering snowy landscape of ancient beauty.

Norvège

De ses îlots rocheux ensoleillés au sud du cap Nord arctique, de ses fjords profondément taillés à l'ouest à ses hauts plateaux dépourvus d'arbres, la Norvège offre des paysages d'une beauté à couper le souffle, comme aucun autre pays d'Europe. En hiver, le calme tombe sur le pays profondément enneigé. Les Norvégiens aiment alors à se retirer dans les montagnes, dans leur propre cabane aménagée de manière spartiate, ou à partir en excursion sur de larges skis de randonnée. Lorsque, à Pâques, le soleil se fait de nouveau plus chaud et les jours plus longs, les hauts plateaux sans arbres se transforment en paysages blancs scintillants d'une beauté archaïque.

Norwegen

Wie kaum ein anderes Land in Europa bietet Norwegen landschaftliche Schönheit: von den sonnenverwöhnten Schären im Süden bis zum arktischen Nordkap, von den tief eingeschnittenen Fjorden im Westen bis zu den baumlosen Hochebenen und Fjells. Im Winter legt sich Ruhe über das tief verschneite Land, dann zieht es viele Norweger ins Gebirge, in die eigene, spartanisch eingerichtete Hütte, oder sie gehen mit breiten Langlaufskiern auf Tour. Wenn zu Ostern die Sonne schon wieder wärmt und die Tage länger werden, verwandeln sich die baumlosen Fjells in eine glitzernde Schneelandschaft von archaischer Schönheit.

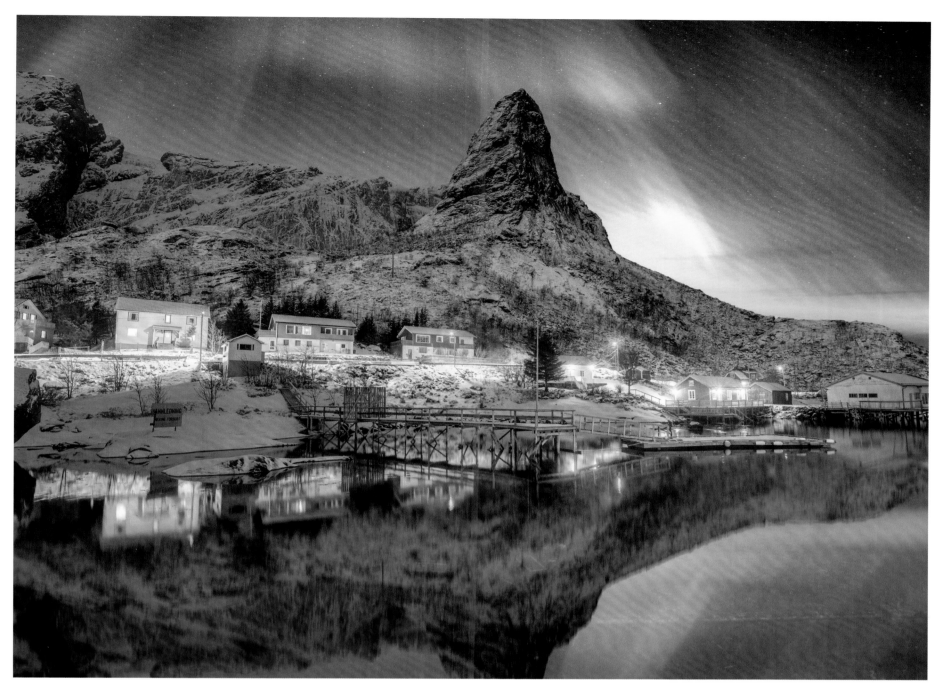

Lofoten Islands

Noruega

Como casi ningún otro país de Europa, Noruega ofrece belleza escénica: desde el soleado archipiélago en el sur hasta el Cabo Norte del Ártico; desde los profundos fiordos en el oeste hasta las mesetas y montañas sin árboles. En invierno, el paisaje nevado es tranquilo y muchos noruegos se sienten atraídos por las montañas, por su propia cabaña espartana, o se van de excursión con esquís de fondo. Cuando el sol vuelve a calentarse en Semana Santa y los días se alargan, las montañas sin árboles se convierten en un brillante paisaje nevado de arcaica belleza.

Noruega

Como quase nenhum outro país da Europa, a Noruega oferece beleza paisagística: do arquipélago ensolarado no sul até o Cabo Norte do Ártico, dos fiordes profundos no oeste até os planaltos e montanhas sem árvores. No inverno, a paz e o sossego se instalam no país coberto de neve, então muitos noruegueses são atraídos para as montanhas, para sua própria cabana espartana, ou eles saem para fazer um passeio com grandes esquis de fundo. Quando o sol se aquece novamente na Páscoa e os dias ficam mais longos, as montanhas sem árvores se transformam em uma paisagem nevada brilhante de beleza arcaica.

Noorwegen

Zoals bijna geen ander land in Europa biedt Noorwegen een prachtig landschap: van de zonovergoten archipel in het zuiden tot de Noordkaap, van de diepe fjorden in het westen tot de boomloze plateaus en bergen. In de winter is het besneeuwde landschap rustig, dan trekken veel Noren naar de bergen, naar hun eigen Spartaanse hut of ze gaan met brede langlaufloipes op pad. Als de zon met Pasen weer opwarmt en de dagen langer worden, veranderen de boomloze bergen in een glinsterend besneeuwd landschap van archaïsche schoonheid.

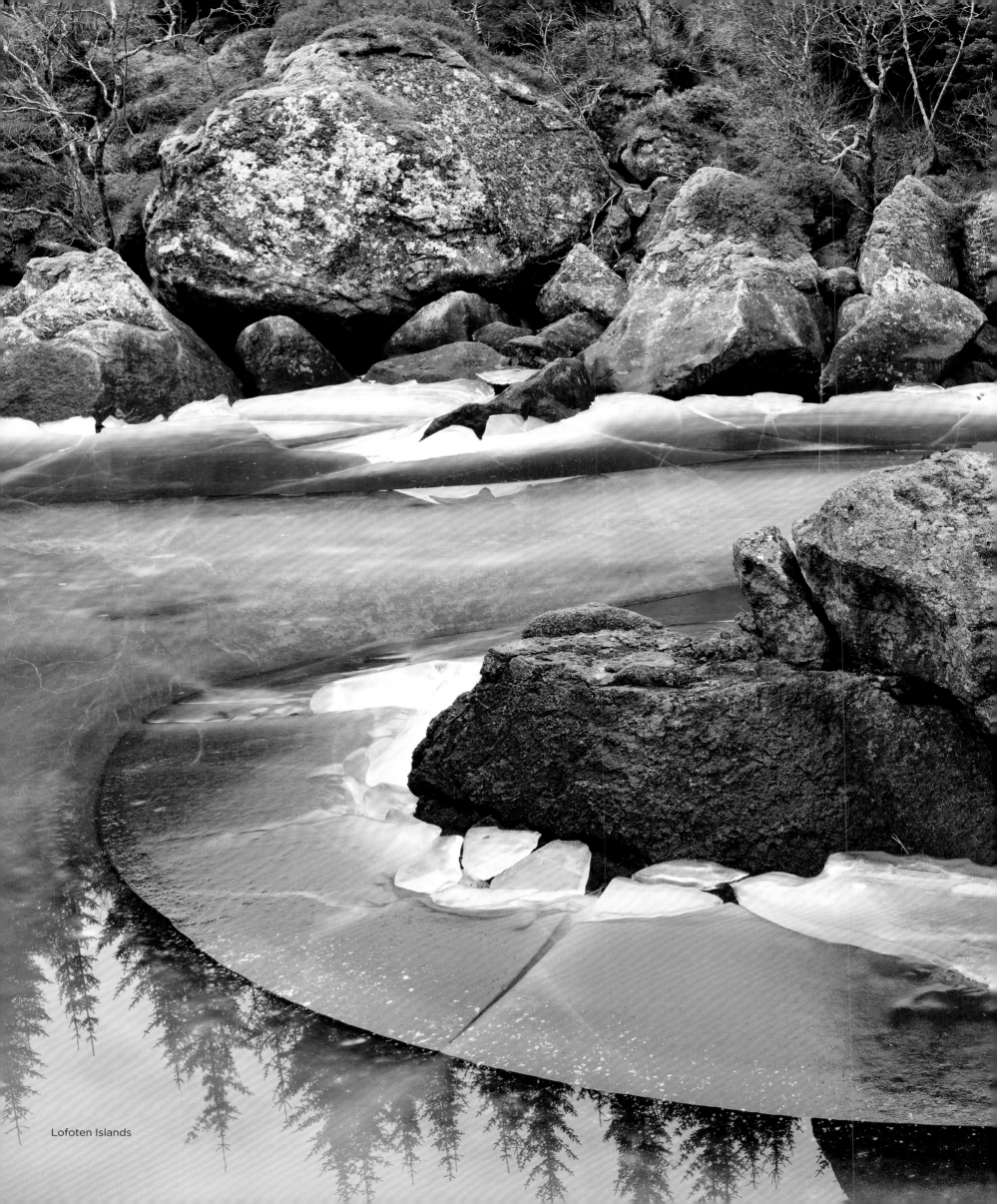

Lofoten Islands

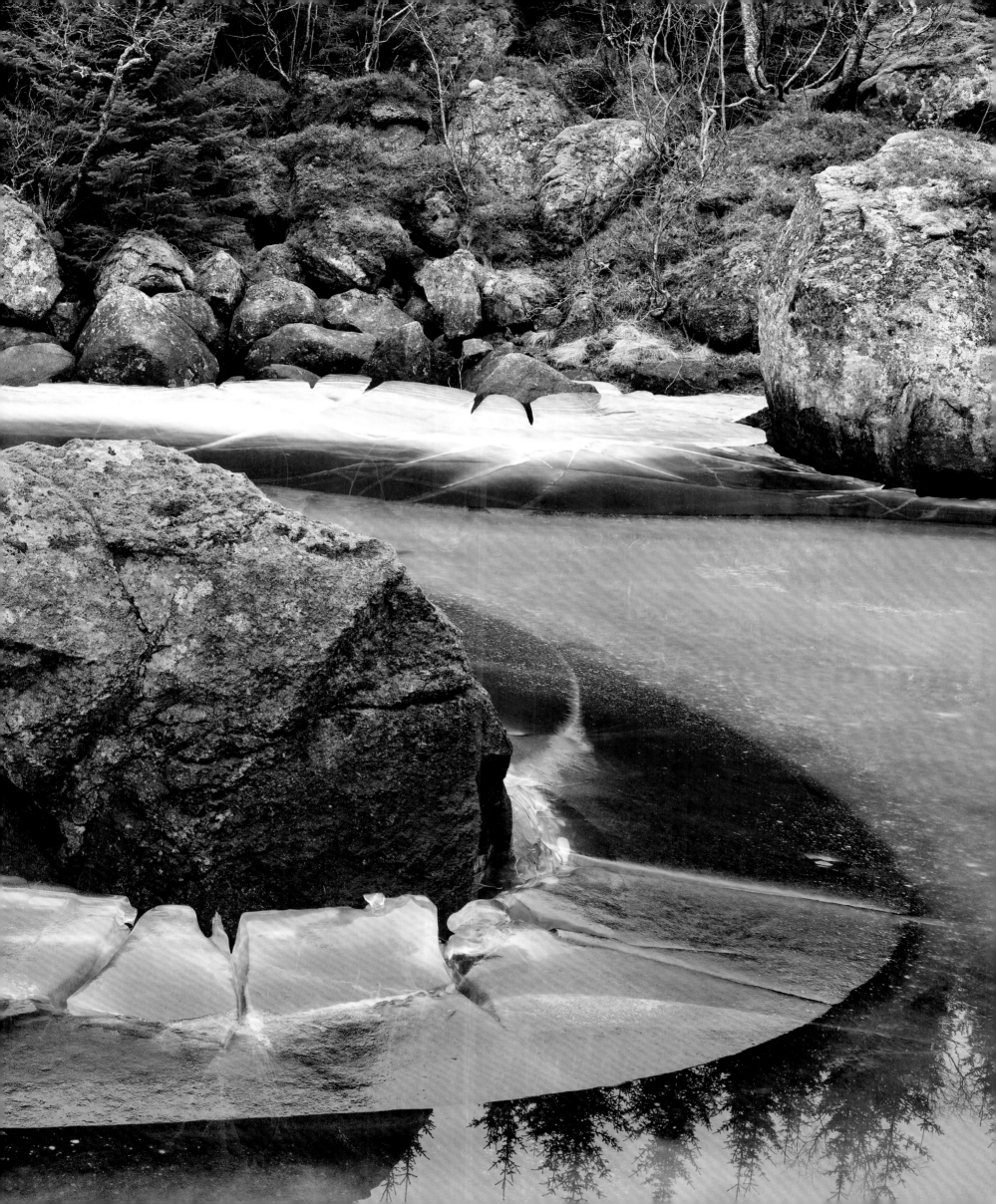

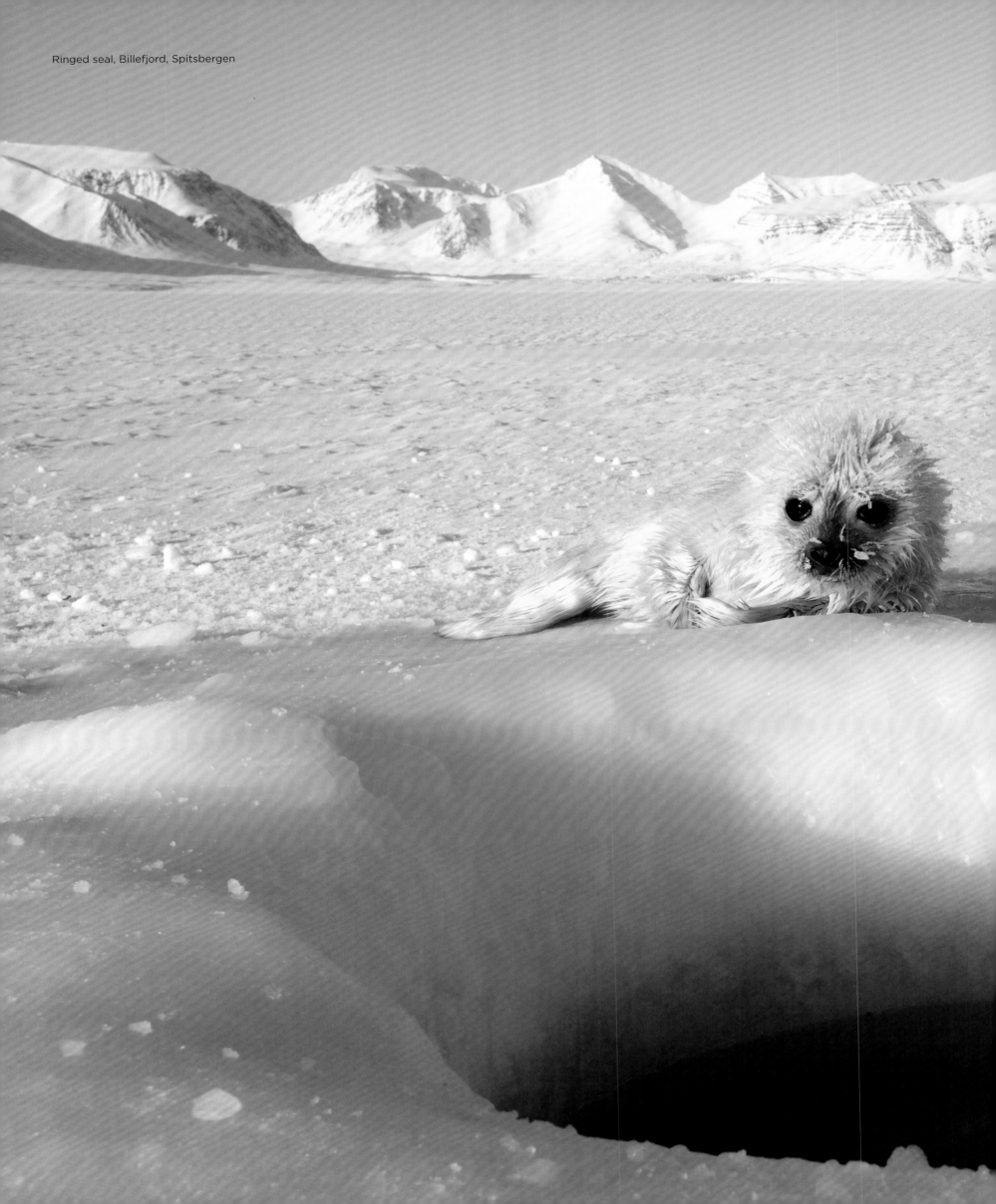

Ringed seal, Billefjord, Spitsbergen

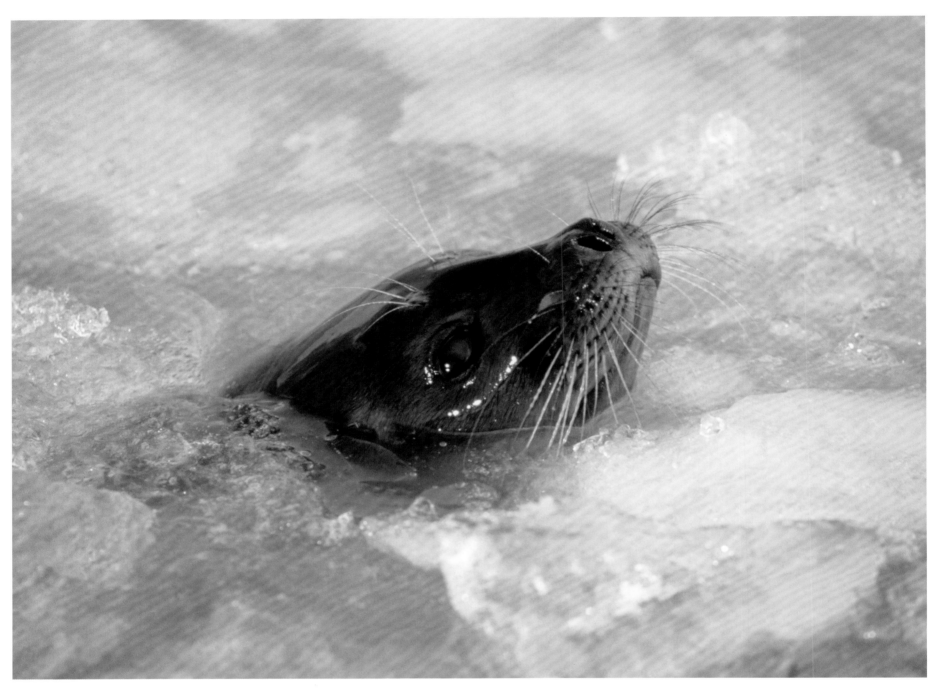

Ringed seal, Liefdefjord, Svalbard

Ringed seals and Bearded Seal

Both Ringelrobben and Bartrobben populate the entire Arctic region, as well as the Spitsbergen archipelago which belongs to Norway. Ringed seals are the most common seal species found in the Arctic. They owe their name to their grey fur with dark spots surrounded by a light ring. If they have developed enough winter fat, Bartrobben are the heaviest of the the seals, weighing up to 360 kg (793 lbs). Their distinguishing feature and source of their name is their long white beard hairs. Both of these seal species are hunted by the Inuit to this day, without endangering the population.

Phoques annelés et phoques barbus

Les phoques annelés aussi bien que les phoques barbus peuplent l'ensemble de l'Arctique, de même que l'archipel du Svalbard qui appartient à la Norvège. Le phoque annelé est l'espèce de phoques la plus répandue de l'Arctique. Son nom est dû à son pelage gris marqué de taches sombres à la bordure claire. Les phoques barbus, quant à eux, pèsent jusqu'à 360 kg avec leurs réserves de graisse hivernales et sont les plus imposants parmi les phoques. Ils se caractérisent par leurs longs poils de barbe blancs, également à l'origine de leur nom. Ces deux espèces de phoques sont aujourd'hui encore chassées par les Inuits, sans qu'ils ne soient menacés de disparition.

Ringelrobbe und Bartrobbe

Sowohl Ringelrobben als auch Bartrobben bevölkern die gesamte Arktis und auch den zu Norwegen gehörenden Archipel Spitzbergen. Ringelrobben sind die am häufigsten vorkommende Robbenart der Arktis. Ihren Namen verdanken sie dem grauen Fell mit dunklen Flecken, die von einem hellen Ring umgeben sind. Bartrobben sind, wenn sie sich Winterspeck angefressen haben, mit bis zu 360 kg die Schwergewichte unter den Robben. Ihr Markenzeichen und namensgebend sind die langen weißen Barthaare. Beide Robbenarten werden von den Inuit bis heute bejagt, ohne dass dies den Bestand bedroht.

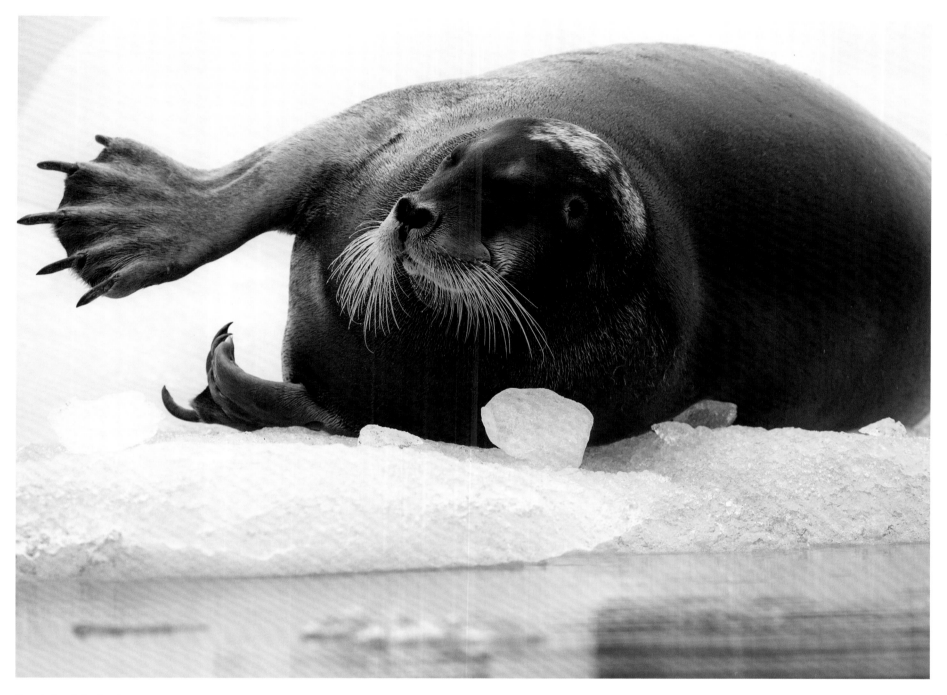

Bearded seal, Svalbard

Foca anillada y foca barbuda

Tanto las focas anilladas como las focas barbudas
pueblan todo el Ártico y también el archipiélago de
Spitsbergen, que pertenece a Noruega. Las focas
anilladas son la especie de foca más común en el
Ártico. Deben su nombre a su pelaje gris con manchas
oscuras rodeadas de un anillo claro. Las focas
barbudas, si han adquirido una mayor capa de grasa
para el invierno, son los pesos más pesados entre
las focas, con un peso de hasta 360 kg. Sus marcas
y nombres son los largos pelos blancos de la barba.
Ambas especies de focas son cazadas por los inuit
hasta el día de hoy sin amenazar a la población.

Foca-anelada e foca-barbuda

Tanto as focas aneladas como as focas barbudas
povoam todo o Ártico e também o arquipélago
de Spitsbergen, pertencente à Noruega. As focas
aneladas são as espécies de focas mais comuns no
Ártico. Elas devem o seu nome ao seu pêlo cinzento
com manchas escuras rodeadas por um anel claro.
As focas barbudas, quando estão com a camada da
gordura de inverno de inverno, são as mais pesadas
entre as focas, pesando até 360 kg. As suas marcas
registadas e seus nomes devem-se aos longos
pêlos de barba branca. Ambas as espécies de focas
são caçadas pelos inuítes até hoje sem ameaçar
a população.

Ringelrob en baardrob

Zowel Ringelrobben als Bartrobben bevolken
het hele Noordpoolgebied en ook de archipel
Spitsbergen van Noorwegen. De ringelrob is
de meest voorkomende zeehondensoort in het
Noordpoolgebied. Ze danken hun naam aan hun
grijze vacht met donkere vlekken omgeven door
een lichte ring. Baardrobben worden tot 360 kg
zwaar, dankzij de winterspek die ze hebben
opgebouwd, en zijn daardoor het zwaargewicht
onder de robben.

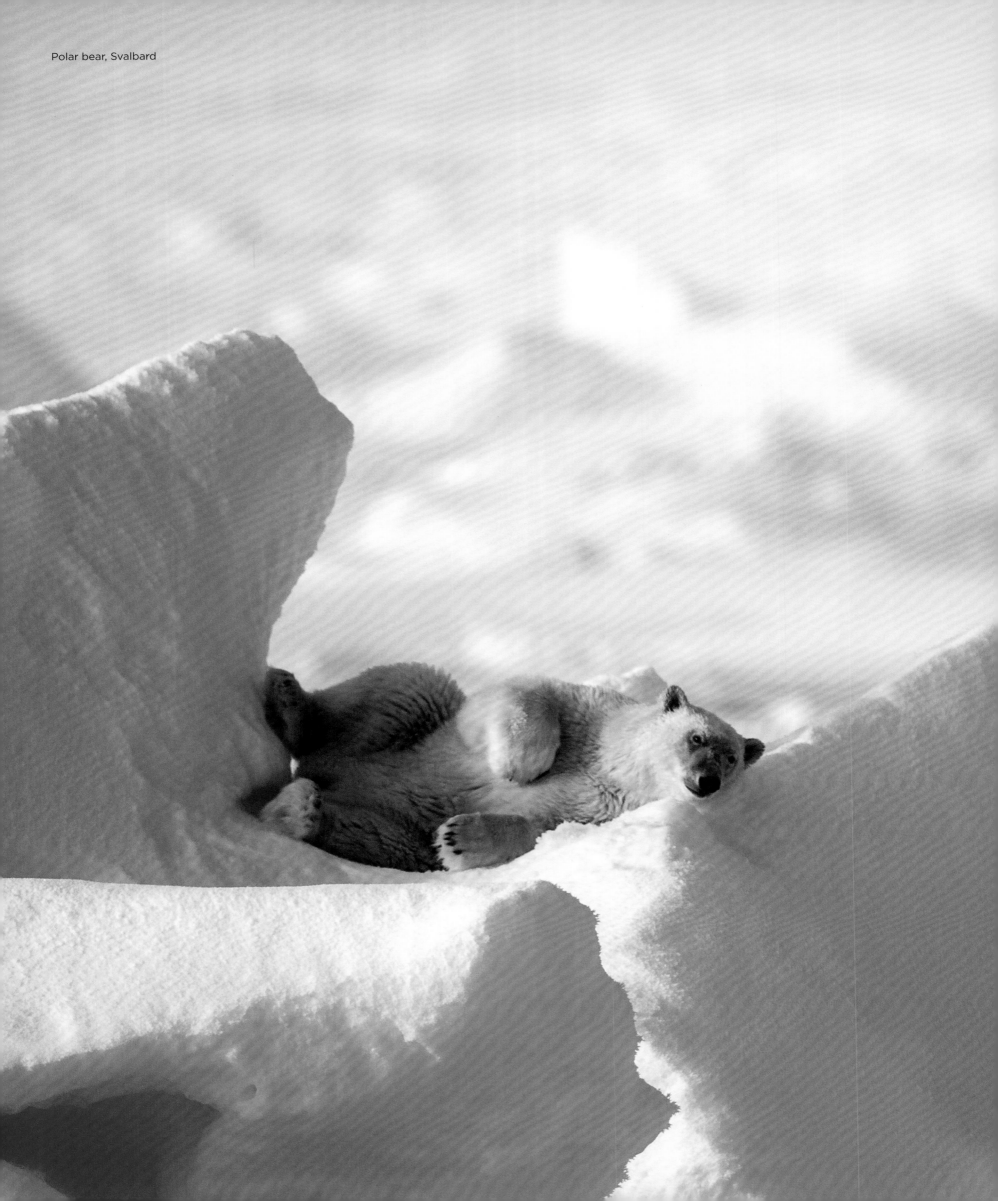

Polar bear, Svalbard

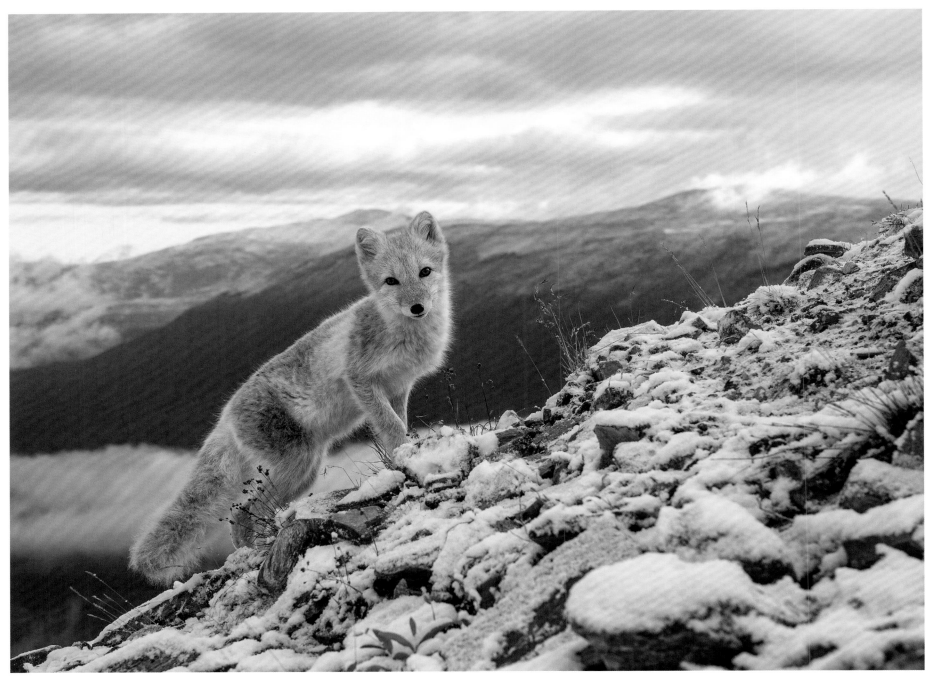

Arctic fox, Dovrefjell-Sunndalsfjella National Park

Musk Ox

The treeless plateaus of the Dovrefjell-Sunndalsfjella National Park are home to around 200 musk ox, whose ancestors came from Greenland after the Second World War. After the last ice age, these ancient animals populated all ice-free areas, and as the climate became warmer they disappeared in many places, including Norway. In 1917 they were placed under protection, which once again stabilized the population in the Arctic. These pony-sized animals resemble bison, but are related to goats. Their dense fur, which reaches almost to the ground, perfectly protects them from cold and snowstorms.

Bœufs musqués

Sur les hauts plateaux dégarnis du parc national de Dovrefjell-Sunndalsfjella vivent environ 200 bœufs musqués, dont les ancêtres furent introduits depuis le Groenland après la Seconde Guerre mondiale. Suite au dernier âge de glace, ces animaux primitifs occupèrent toutes les zones qui n'étaient plus recouvertes de glace. Lorsque le climat se réchauffa, ils disparurent de nombreux endroits, y compris de la Norvège. Ils furent placés sous protection en 1917, ce qui permit de stabiliser leur effectif en Arctique. Ces animaux de la taille des poneys ressemblent aux bisons mais appartiennent à la famille des chèvres. Leur épais pelage, qui touche presque le sol, les protège parfaitement contre le froid et les tempêtes de neige.

Moschusochsen

Auf den baumlosen Hochebenen des Dovrefjell-Sunndalsfjella-Nationalparks leben rund 200 Moschusochsen, deren Vorfahren nach dem Zweiten Weltkrieg aus Grönland hier angesiedelt wurden. Die urtümlichen Tiere besiedelten nach der letzten Eiszeit alle eisfreien Gebiete, als das Klima wärmer wurde, verschwanden sie vielerorts, so auch in Norwegen. 1917 wurden sie unter Schutz gestellt, was den Bestand in der Arktis wieder stabilisierte. Die ponygroßen Tiere ähneln Bisons, sind aber mit Ziegen verwandt. Ihr dichtes Fell, das fast bis auf den Boden reicht, schützt sie perfekt vor Kälte und Schneestürmen.

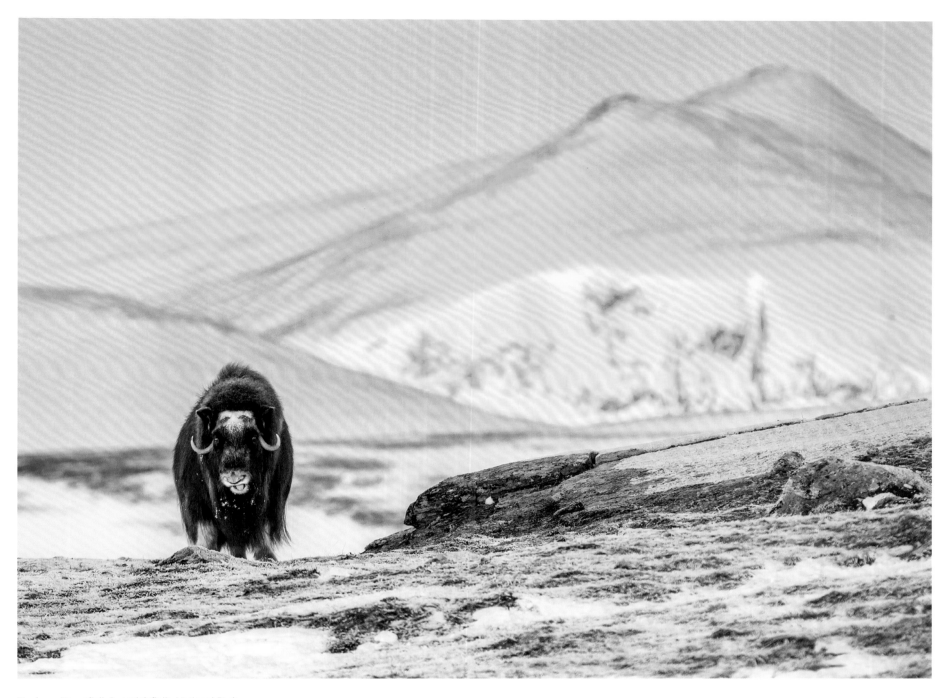

Musk ox, Dovrefjell–Sunndalsfjella National Park

Bueyes almizcleros

En las mesetas sin árboles del Parque Nacional de Dovrefjell-Sunndalsfjella hay unos 200 bueyes almizcleros cuyos antepasados procedían de Groenlandia después de la Segunda Guerra Mundial. Después de la última era glacial, estos primitivos animales poblaron todas las áreas libres de hielo y, a medida que el clima se iba haciendo más cálido, fueron desapareciendo de muchos lugares, incluida Noruega. En 1917 se pusieron bajo protección, lo que estabilizó de nuevo la población en el Ártico. Estos animales, que son del tamaño de un poni, se parecen a los bisontes, pero son parientes de las cabras. Su denso pelaje, que llega casi hasta el suelo, los protege perfectamente del frío y de las tormentas de nieve.

Bois-almiscarado

Os planaltos sem árvores do Parque Nacional de Dovrefjell-Sunndalsfjella albergam cerca de 200 bois almiscarados, cujos antepassados vieram da Groenlândia após a Segunda Guerra Mundial. Após a última era glacial, os animais primitivos povoaram todas as áreas livres de gelo e, à medida que o clima se tornou mais quente, desapareceram em muitos lugares, incluindo na Noruega. Em 1917, foram colocados sob protecção, o que voltou a estabilizar a população no Ártico. Os animais do tamanho de um pónei assemelham-se a bisontes, mas são parentes de cabras. O seu pêlo denso, que chega quase ao chão, protege-os perfeitamente do frio e das tempestades de neve.

Muskusossen

Op de boomloze plateaus van het Dovrefjell-Sunndalsfjella-Nationalpark leven ongeveer 200 muskusossen waarvan de voorouders na de Tweede Wereldoorlog uit Groenland kwamen. Na de laatste ijstijd bevolkten de oerdieren alle ijsvrije gebieden en naarmate het klimaat warmer werd, verdwenen ze op veel plaatsen, waaronder Noorwegen. In 1917 werden ze onder bescherming geplaatst, waardoor de bevolking in het Noordpoolgebied zich weer stabiliseerde. De ponygrootte dieren lijken op bizons, maar zijn verwant aan geiten. Hun dichte vacht, die bijna tot op de grond reikt, beschermt hen perfect tegen kou en sneeuwstormen.

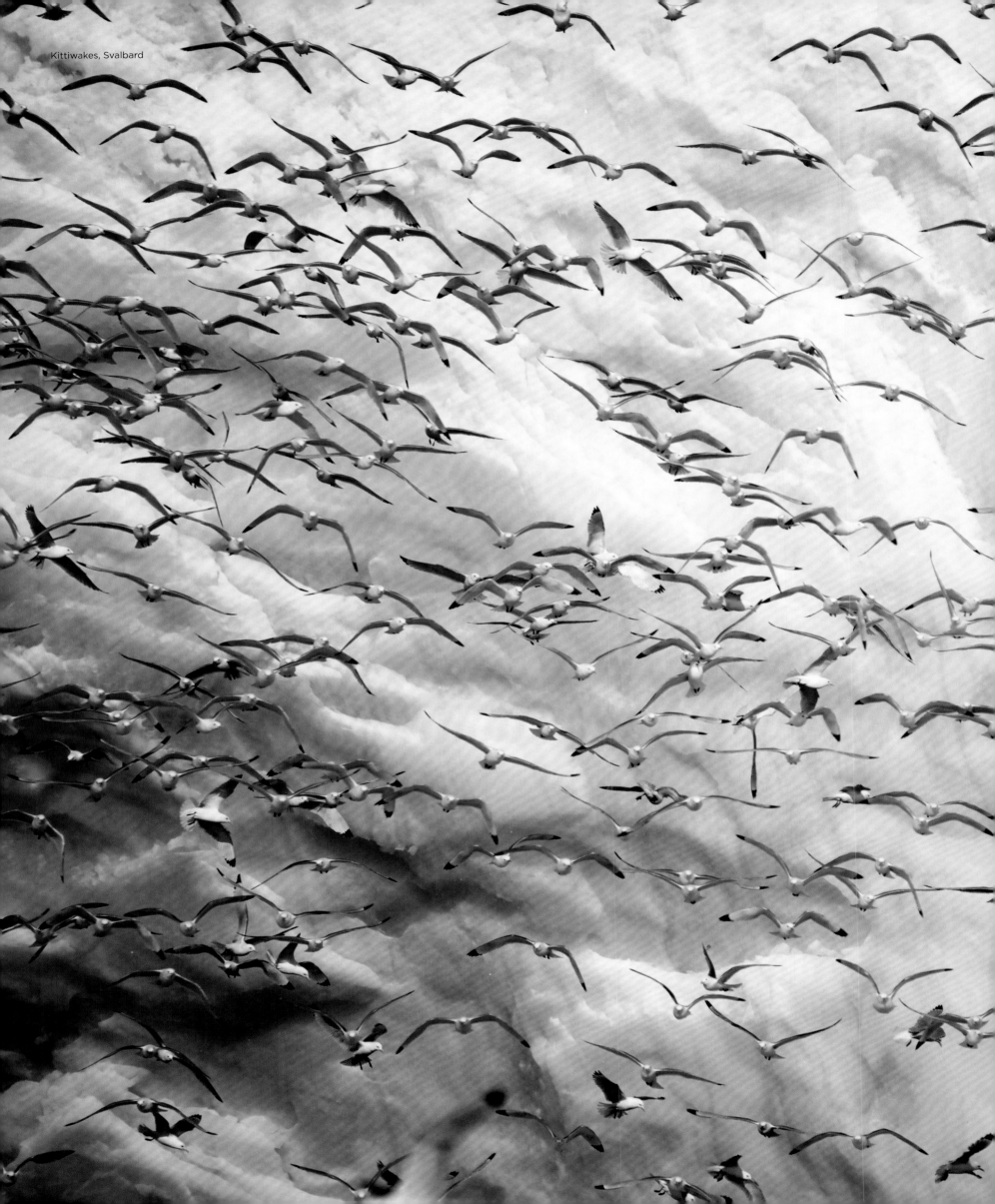

Kittiwakes, Svalbard

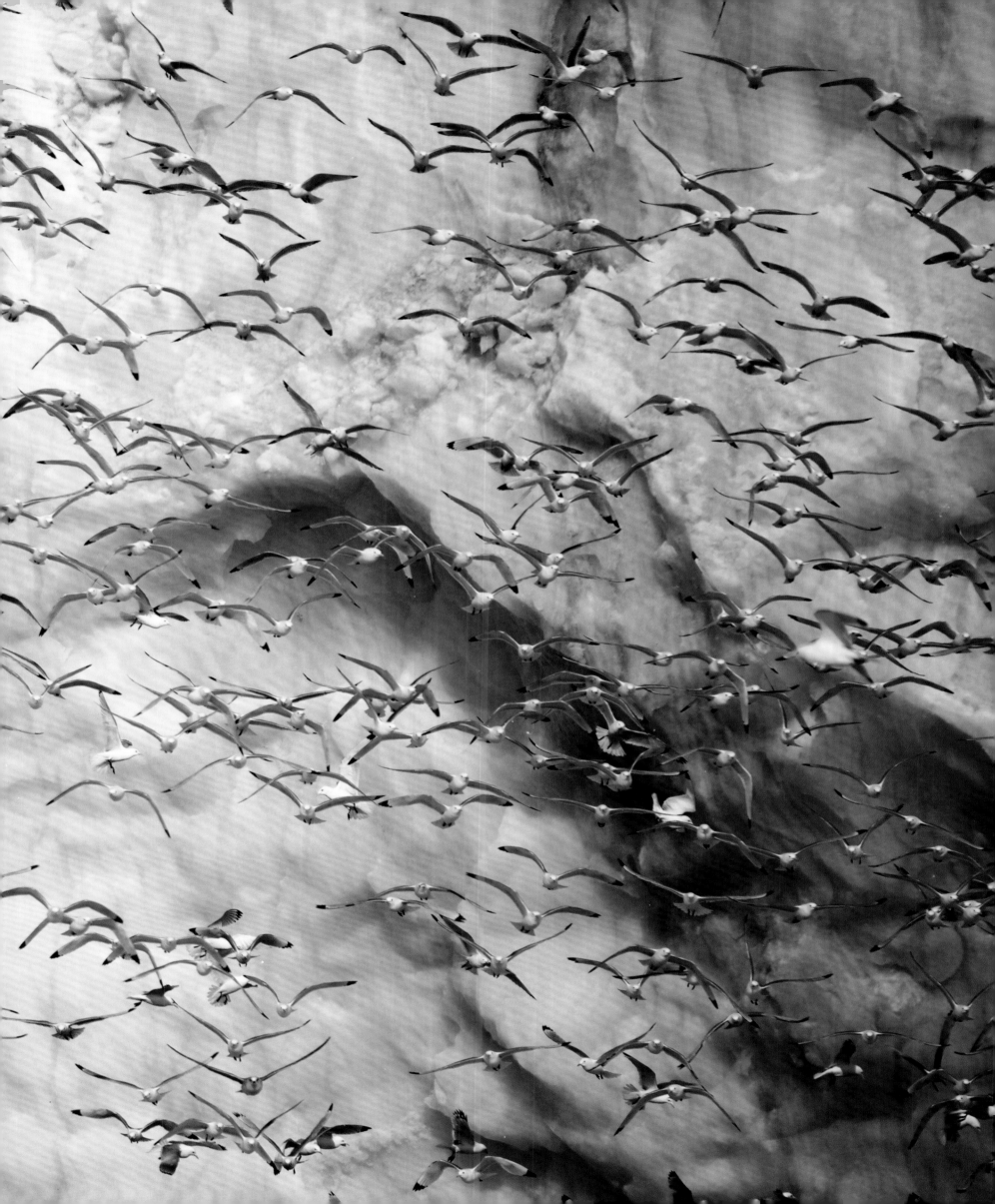

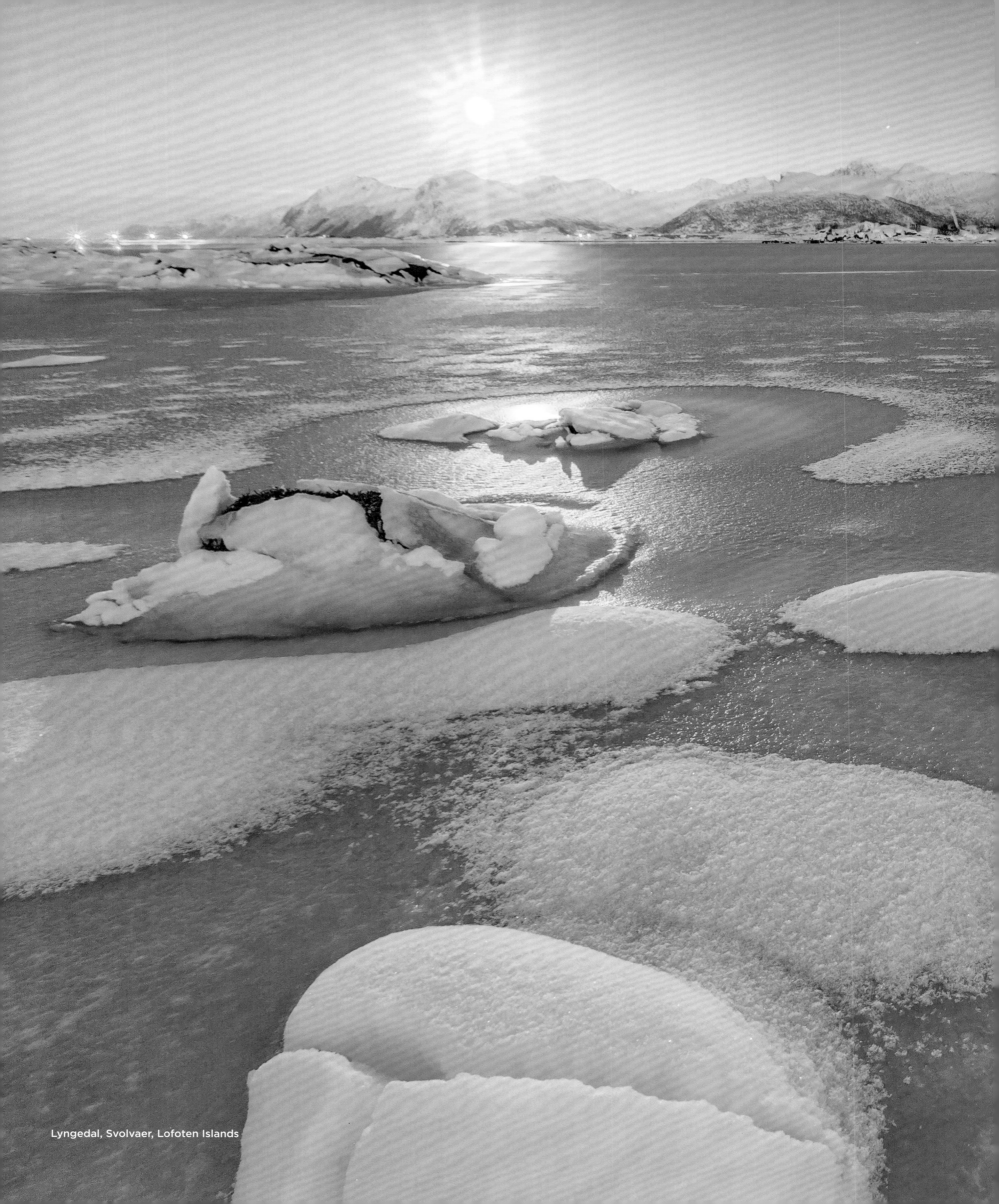

Lyngedal, Svolvaer, Lofoten Islands

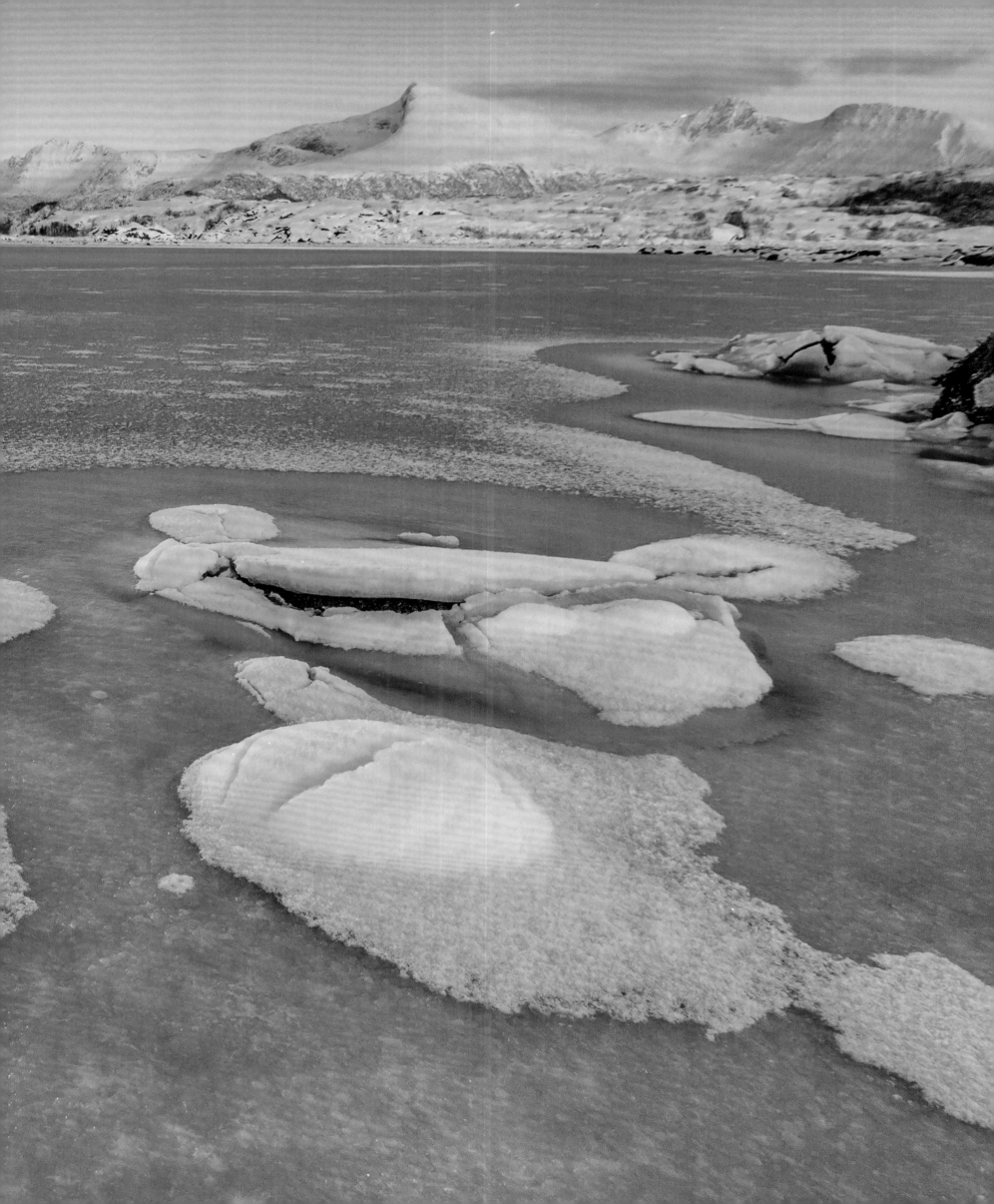

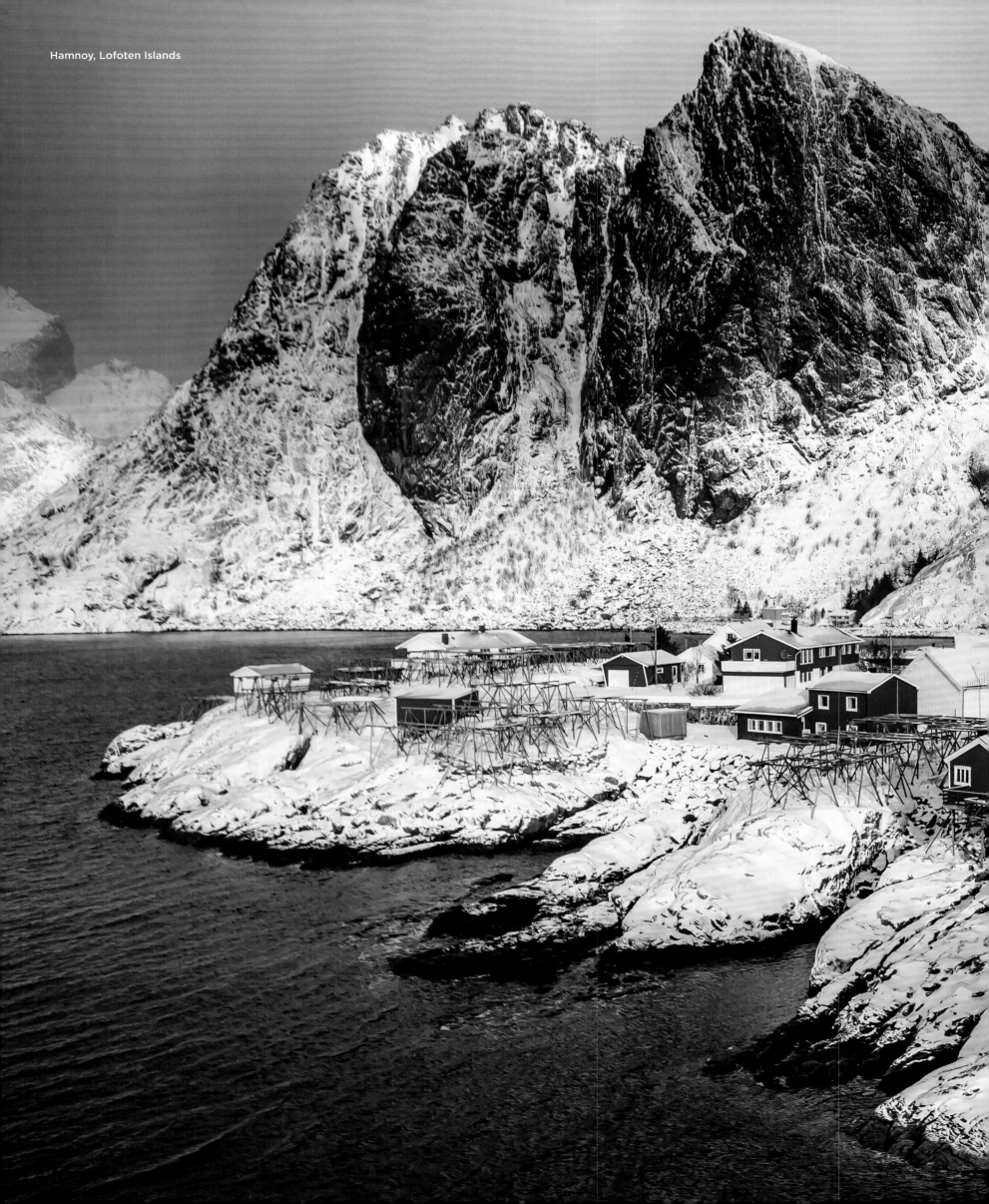

Hamnoy, Lofoten Islands

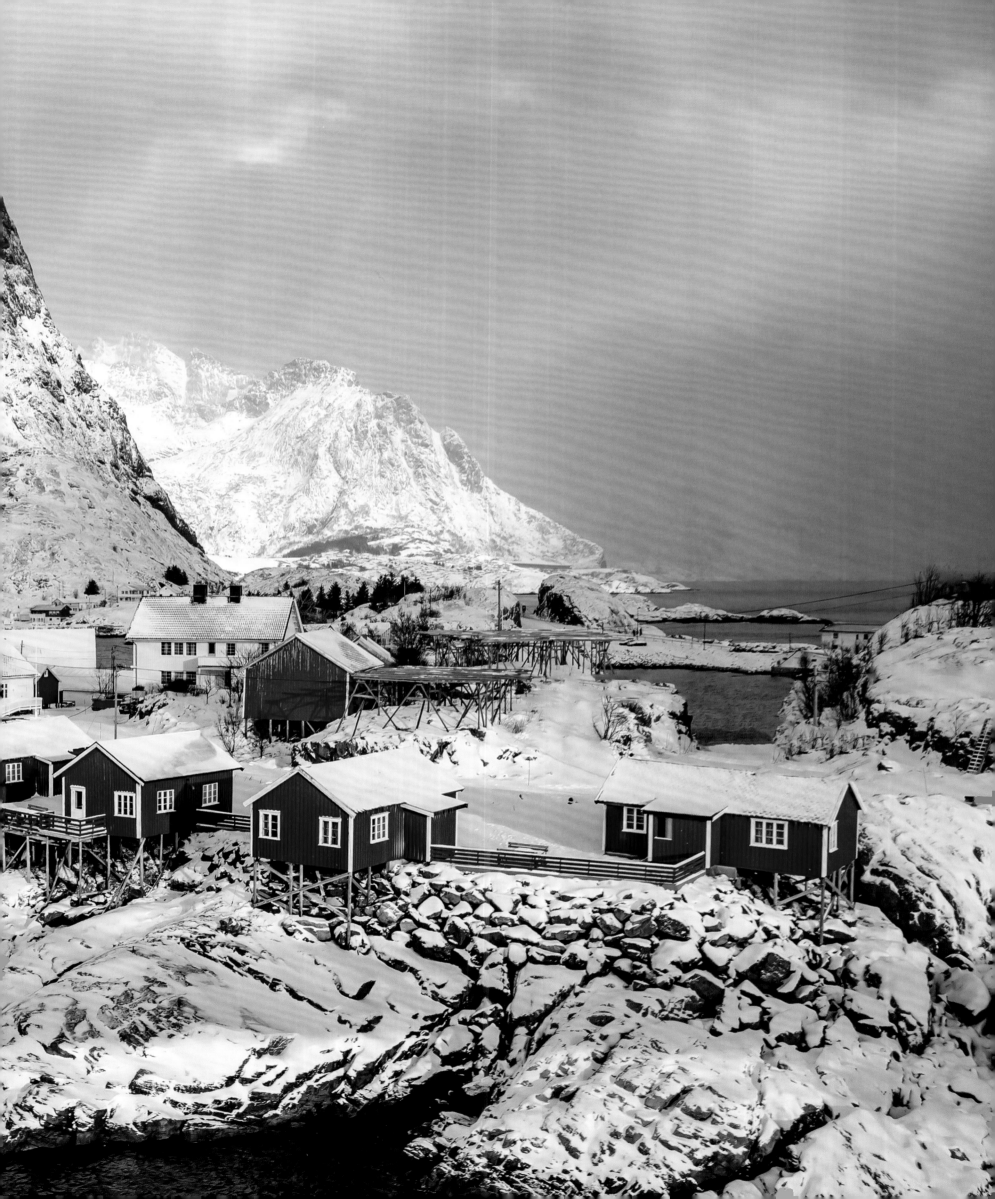

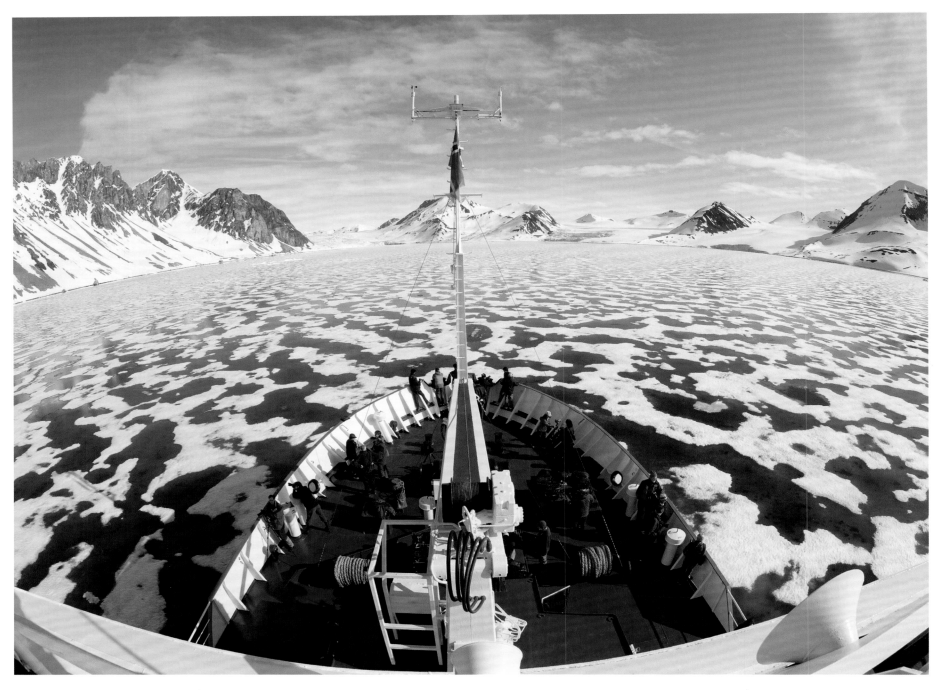

Hornsund, Svalbard

North Cape

At a latitude of 71° 10′ 21″ north, North Cape is the dream destination of many Norwegian travelers. It lies in the middle of Norway's only truly Arctic landscape about 500 km (310 mi) north of the Arctic Circle and 2100 km (1300 mi) south of the North Pole. The view of the Arctic Ocean from the 300 m (84 ft) high rock offers a breathtaking spectacle when the weather is fine.

Cabo Norte

El Cabo Norte en 71° 10′ 21″ latitud norte es el destino anhelado de muchos conductores noruegos. Se encuentra a unos 500 km al norte del Círculo Polar Ártico y a 2100 km al sur del Polo Norte, en medio del único paisaje verdaderamente ártico de Noruega. La vista del Océano Ártico desde la roca de 300 m de altura ofrece un espectáculo impresionante cuando hace buen tiempo.

Le cap Nord

Le cap Nord, situé à une latitude nord de 71° 10′ 21″, est la destination de prédilection de nombreux automobilistes norvégiens. Il se trouve à environ 500 km au nord du cercle polaire et à 2 100 km au sud du pôle Nord, au cœur du seul véritable paysage arctique de Norvège. Par beau temps, la vue sur la mer polaire depuis des pics rocheux de 300 m de hauteur est à couper le souffle.

Cabo Norte

O Cabo Norte na latitude 71° 10′ 21″ norte é o destino longínquo de muitos motoristas norueguses. Situa-se cerca de 500 km a norte do Círculo Polar Ártico e 2100 km ao sul do Pólo Norte, no meio da única paisagem verdadeiramente ártica da Noruega. A vista do Oceano Ártico a partir da rocha de 300 m de altura, oferece um espetáculo de tirar o fôlego quando o tempo está bom.

Nordkap

Das Nordkap auf 71° 10′ 21″ nördlicher Breite ist das Sehnsuchtsziel vieler Norwegenfahrer. Es liegt rund 500 km nördlich des Polarkreises sowie 2100 km südlich des Nordpols inmitten Norwegens einziger wirklich arktischer Landschaft. Der Blick vom 300 m hohen Felsen auf das Eismeer bietet bei schönem Wetter ein atemberaubendes Schauspiel.

Noordkaap

De Noordkaap op 71° 10′ 21″ noorderbreedte is de droombestemming van veel Noorse chauffeurs. Het ligt ongeveer 500 km ten noorden van de poolcirkel en 2100 km ten zuiden van de Noordpool in het midden van het enige echte Noordpoollandschap van Noorwegen. Het uitzicht op de Noordelijke IJszee vanaf de 300 m hoge rots biedt bij mooi weer een adembenemend schouwspel.

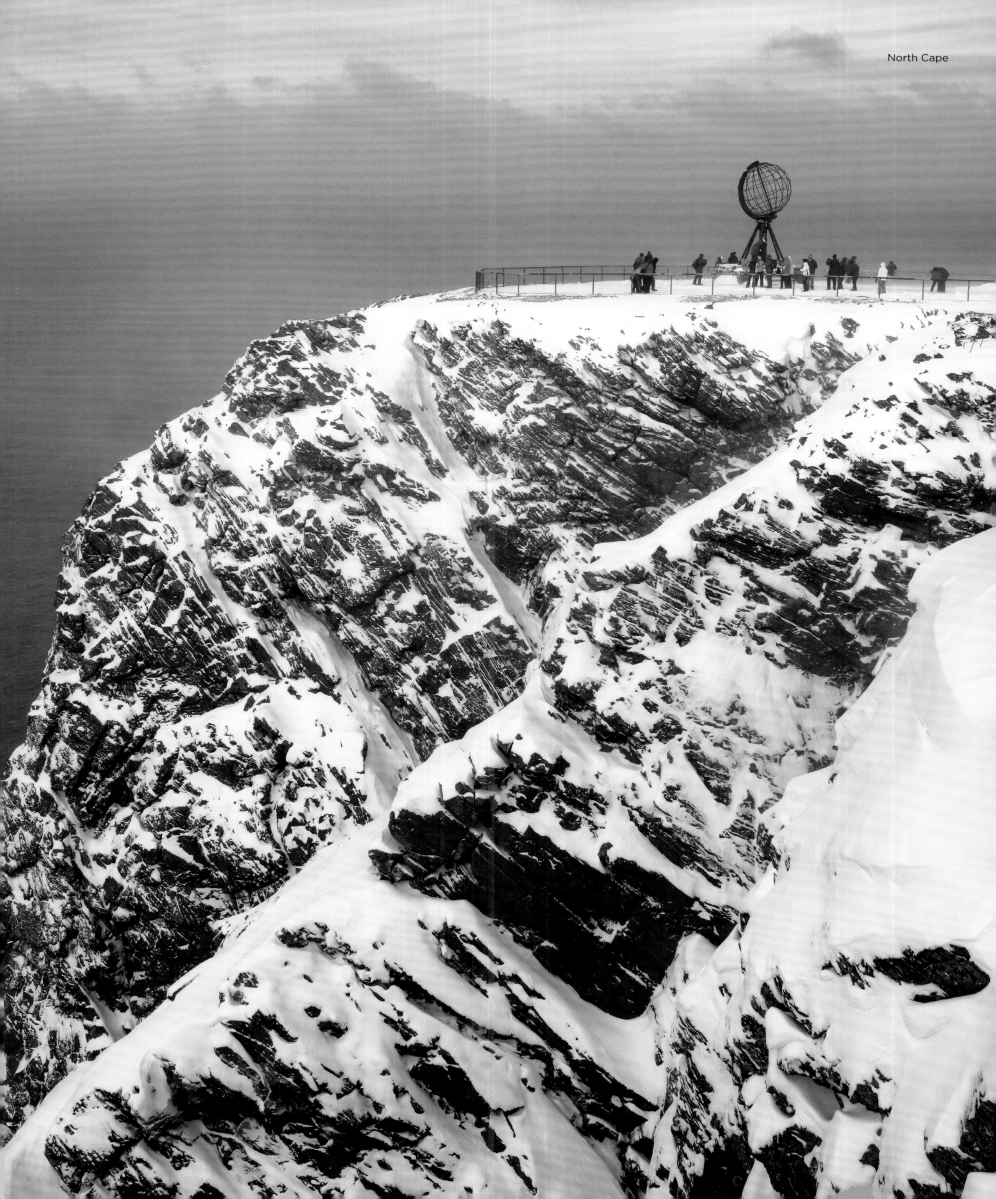

Sommarøy, Troms

Fjell, Saltfjellet-Svartisen National Park

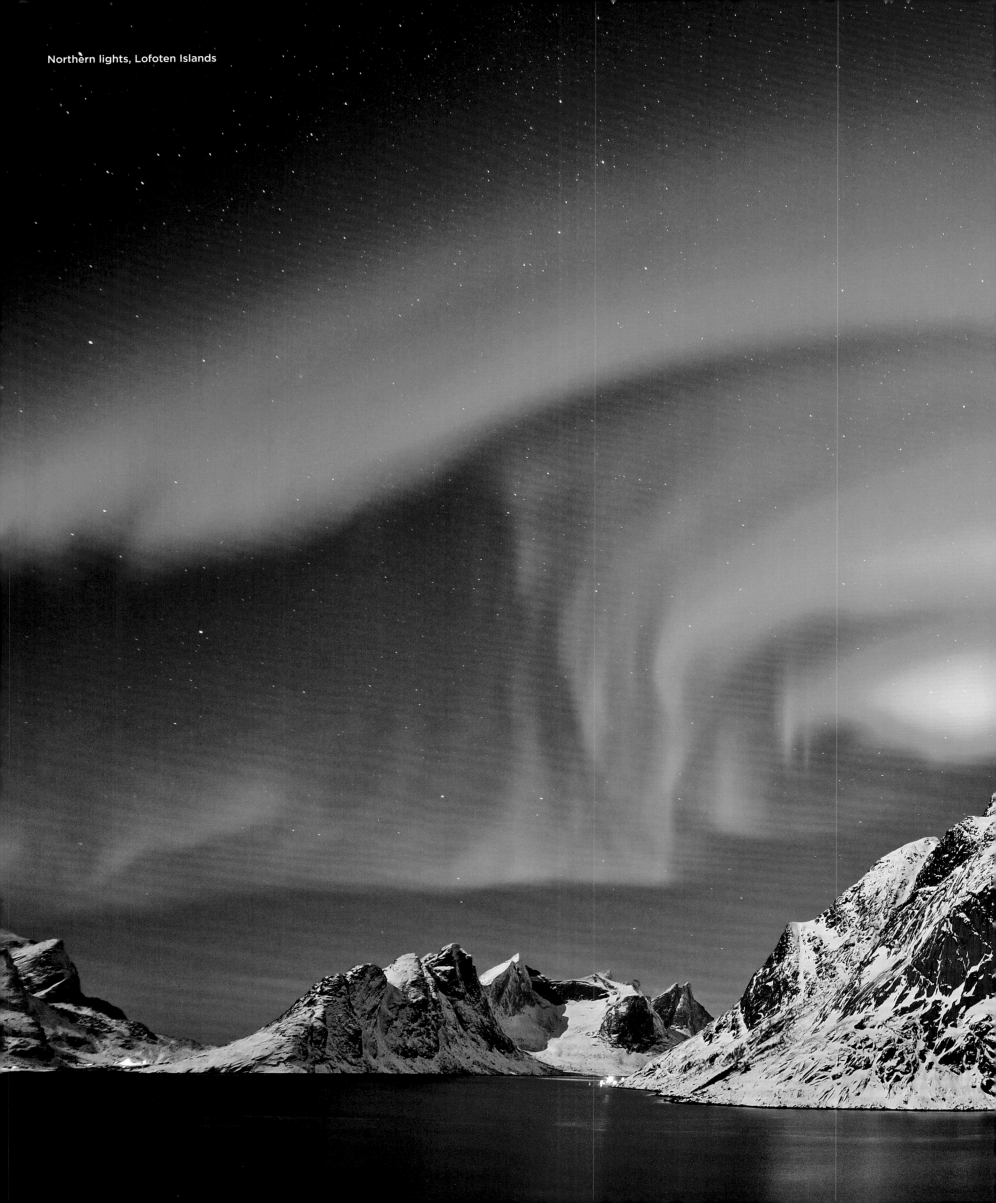

Northern lights, Lofoten Islands

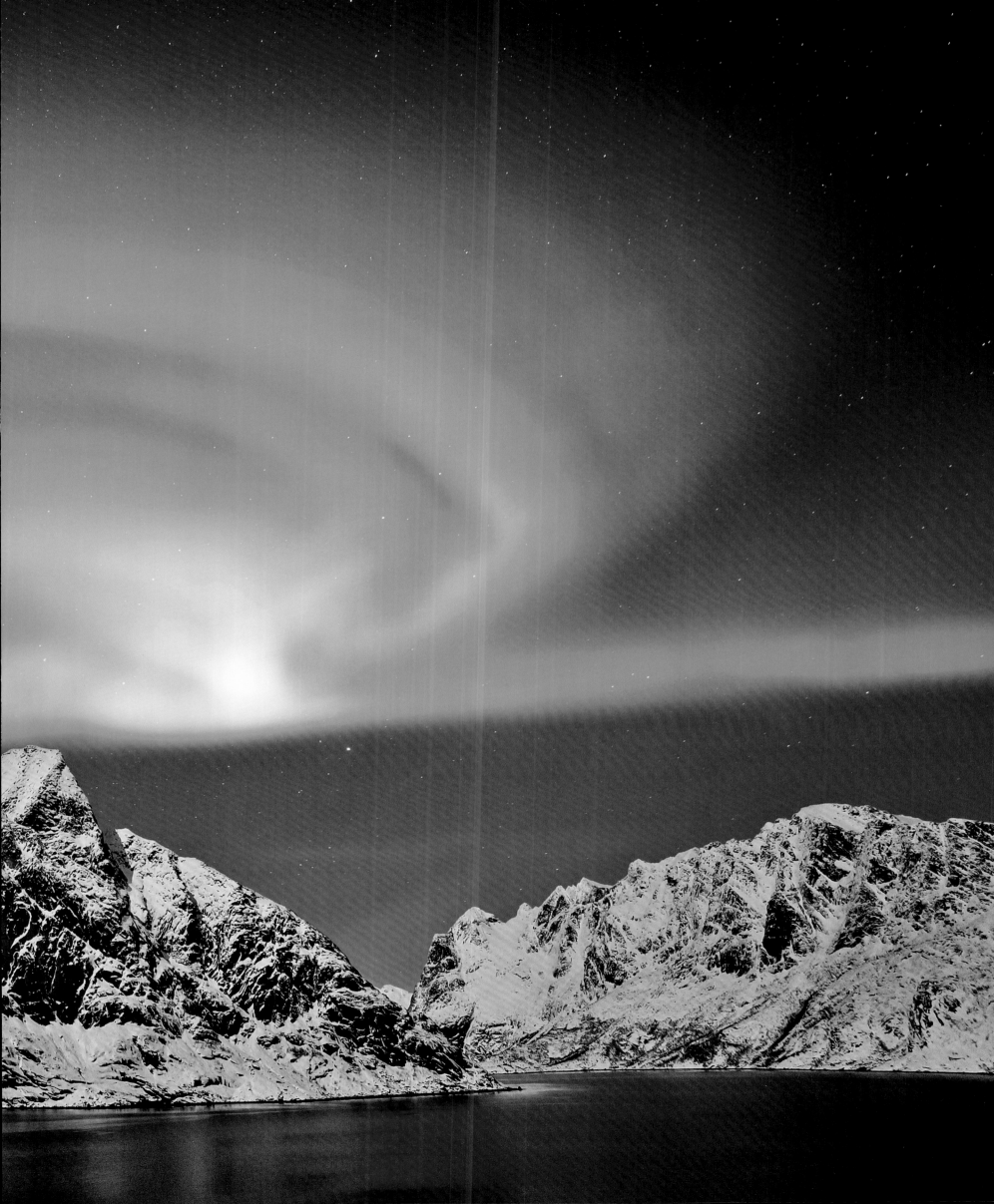

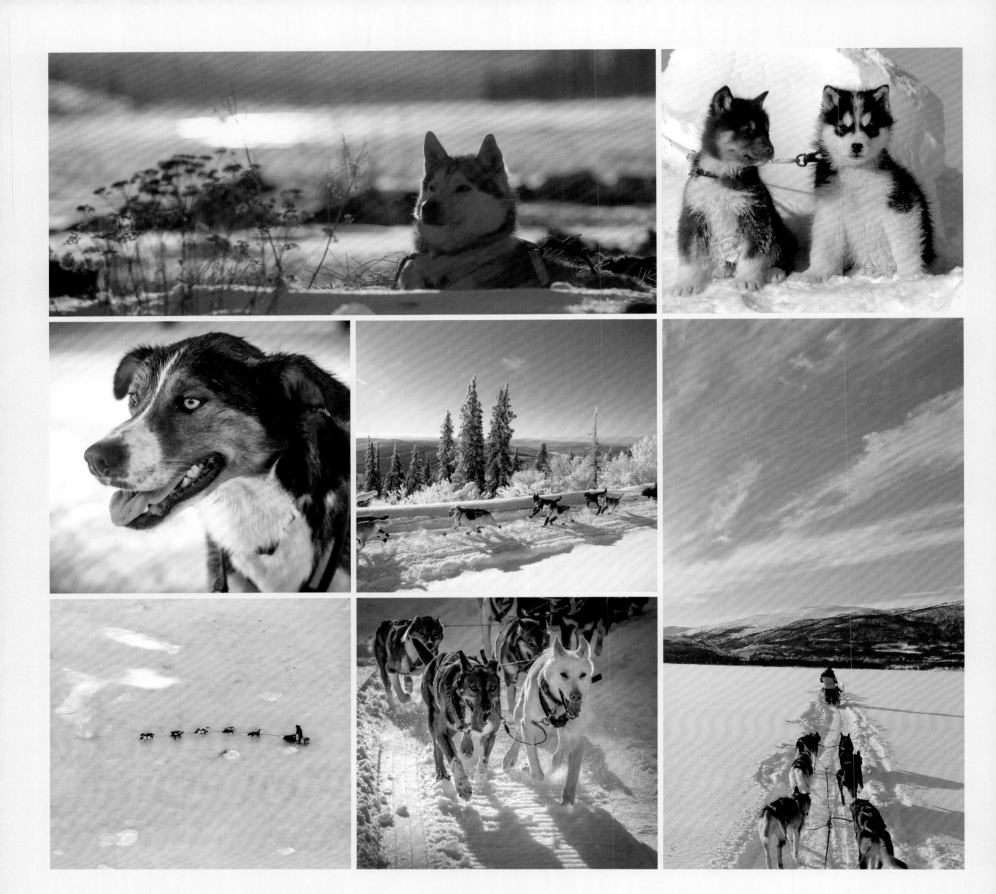

Sled dogs

It is believed that the indigenous peoples of Siberia were the first to use dogs as draft animals when travelling in winter. Roald Amundsen probably only won the legendary race to the South Pole because he used sled dogs. Among the most famous long-distance races for dog teams are the Iditarod in Alaska and the Yukon Quest in Alaska and Canada.

Chiens de traîneau

Les peuples indigènes de Sibérie furent vraisemblablement les premiers à utiliser les chiens comme animaux de trait pour voyager en hiver. Roald Amundsen remporta probablement sa légendaire course au pôle Sud grâce à son recours aux chiens de traîneau. Parmi les courses d'endurance les plus célèbres, on compte l'Iditarod, en Alaska, et la Yukon Quest, en Alaska et au Canada.

Schlittenhunde

Vermutlich haben indigene Völker in Sibirien als Erste Hunde bei Reisen im Winter als Zugtiere verwendet. Das legendäre Wettrennen zum Südpol hat Roald Amundsen wahrscheinlich nur durch den Einsatz von Schlittenhunden gewonnen. Zu den bekanntesten Langstreckenrennen für Hundegespanne zählen das Iditarod in Alaska und das Yukon Quest in Alaska und Kanada.

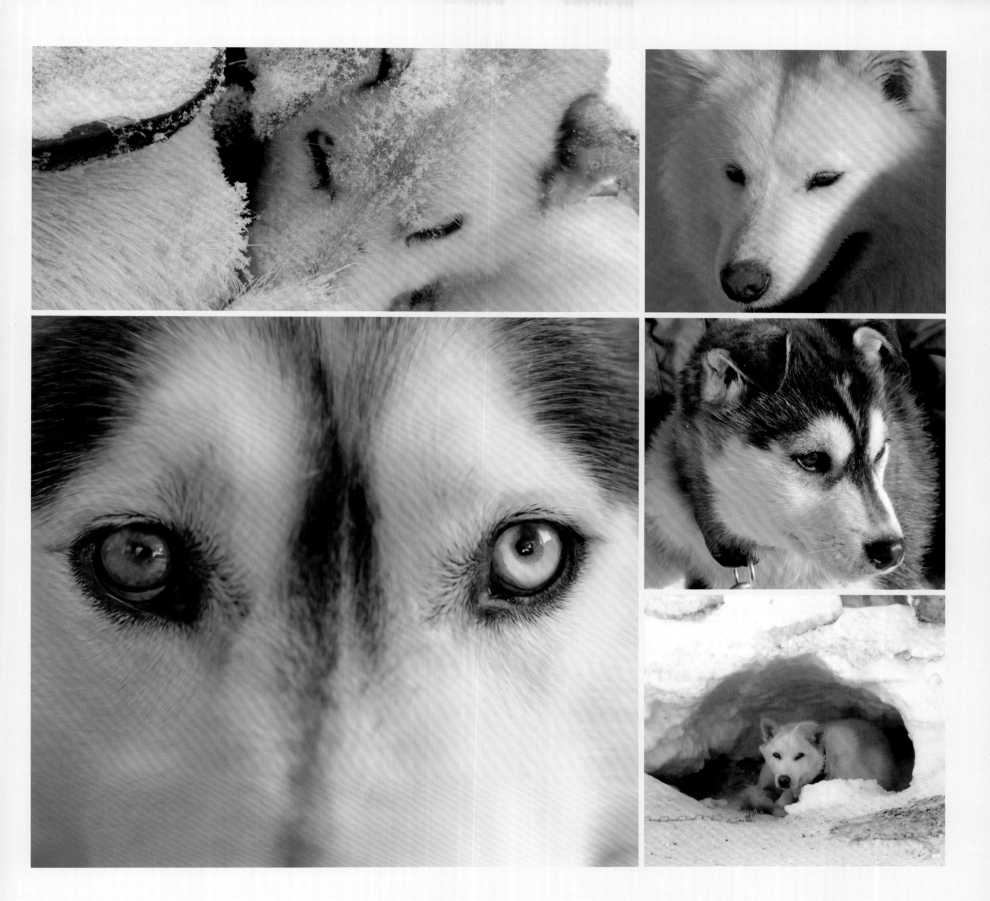

Perros de trineo

Los pueblos indígenas de Siberia fueron probablemente los primeros en utilizar perros como animales de entrenamiento cuando viajaban en invierno. Roald Amundsen probablemente solo ganó la legendaria carrera hacia el Polo Sur utilizando perros de trineo. Entre las carreras de larga distancia más famosas para los equipos de perros están la Iditarod en Alaska y la Yukon Quest en Alaska y Canadá.

Cães de trenó

Os povos indígenas da Sibéria foram provavelmente os primeiros a usar cães como animais de tração quando viajavam no inverno. Roald Amundsen provavelmente só ganhou a lendária corrida para o Pólo Sul usando cães de trenó. Entre as corridas de longa distância mais famosas para equipas de cães estão a Iditarod no Alasca e a Yukon Quest no Alasca e no Canadá.

Sledehonden

Inheemse volken in Siberië waren waarschijnlijk de eersten die honden gebruikten wanneer ze in de winter op reis waren. Roald Amundsen won waarschijnlijk alleen de legendarische race naar de Zuidpool met behulp van sledehonden. Tot de bekendste langeafstandsraces voor hondenteams behoren de Iditarod in Alaska en de Yukon Quest in Alaska en Canada.

Finland

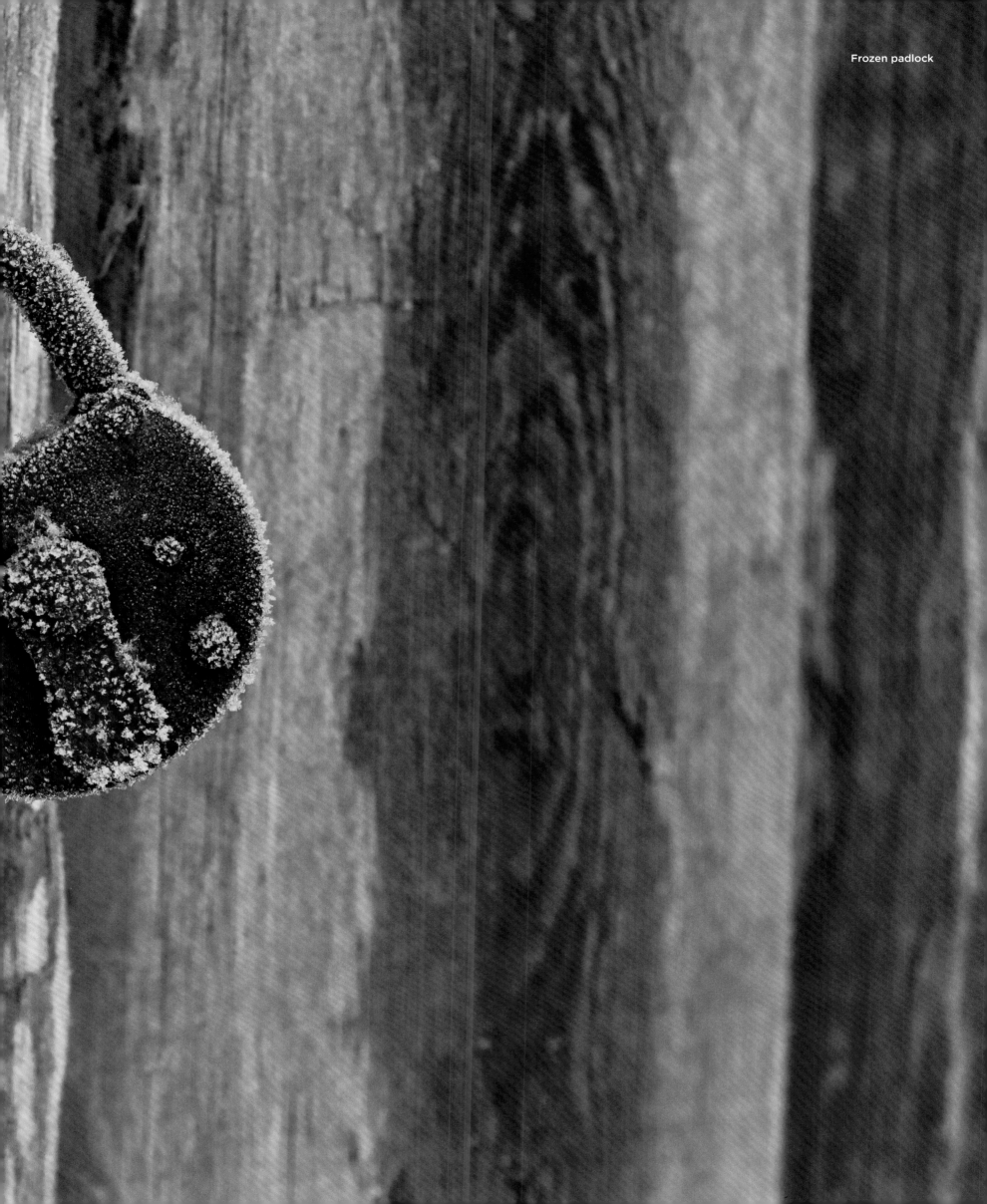

Frozen padlock

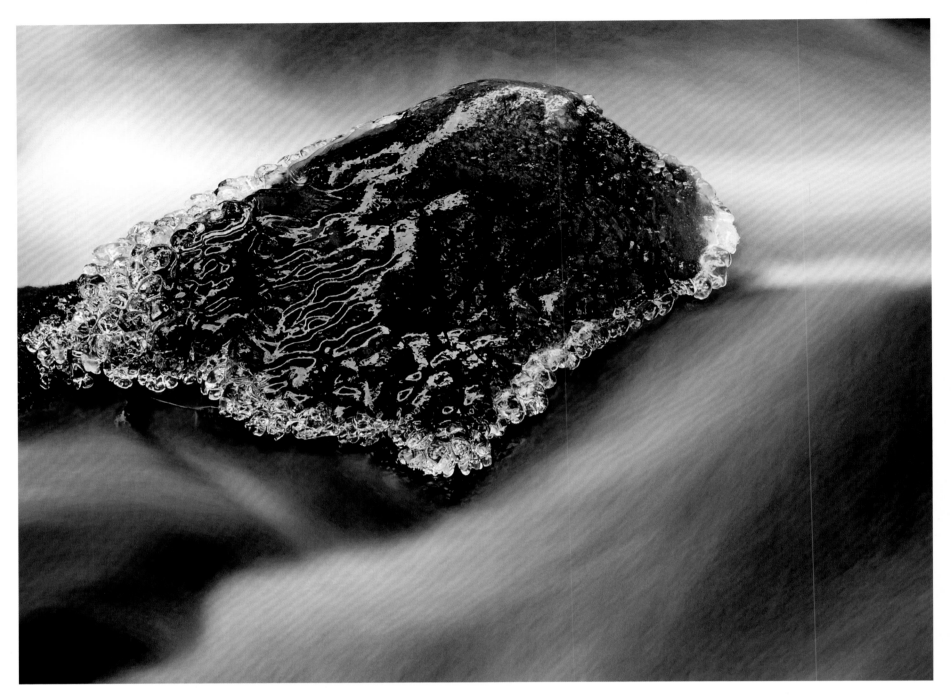

Ice river

Finland

The climate in this Scandinavian country clearly separates the warmer south and the cold north. In Lapland there can be up to 200 winter days when the temperatures are permanently below 0 °C (32°F). The coldest temperature ever measured was minus 51.5 °C (-60 °F). Lakes and rivers often freeze over for months. Their best-known institution, the sauna, helps the Finns cope with sub-zero temperatures and the dark season. It is an indispensable part of Finnish society. In the countryside at least there is hardly a house without a sauna, and it is a special honor for visitors to be invited to take a sauna together.

Finlande

Les climats chauds du sud et froids du nord de ce pays scandinave sont nettement marqués. En Laponie, il arrive que l'hiver dure jusqu'à deux cents jours avec un thermomètre ne remontant pas au-dessus de 0° C. La température la plus froide jamais enregistrée indiquait -51,5° C. Les lacs et les rivières y sont souvent gelés pendant des mois. Pour lutter contre les températures négatives et la saison sombre, rien de tel que l'institution finlandaise la plus célèbre : le sauna. Impossible d'imaginer la société finlandaise sans lui. À la campagne tout du moins, il n'existe pas de maison sans sauna et une invitation à y partager un moment avec leurs hôtes est un honneur pour les visiteurs.

Finnland

Das Klima in dem skandinavischen Land unterscheidet deutlich zwischen dem wärmeren Süden und dem kalten Norden. In Lappland kann es bis zu 200 Wintertage geben, die Temperaturen liegen dauerhaft unter 0 °C, die kälteste je gemessene Temperatur betrug minus 51,5 °C. Seen und Flüsse frieren oft monatelang zu. Gegen Minusgrade und die dunkle Jahreszeit hilft den Finnen ihre bekannteste Institution: die Sauna. Sie ist aus der finnischen Gesellschaft nicht wegzudenken. Zumindest auf dem Land gibt es wohl kaum ein Haus ohne Sauna, und eine besondere Ehre für Besucher ist eine Einladung zum gemeinsamen Saunen.

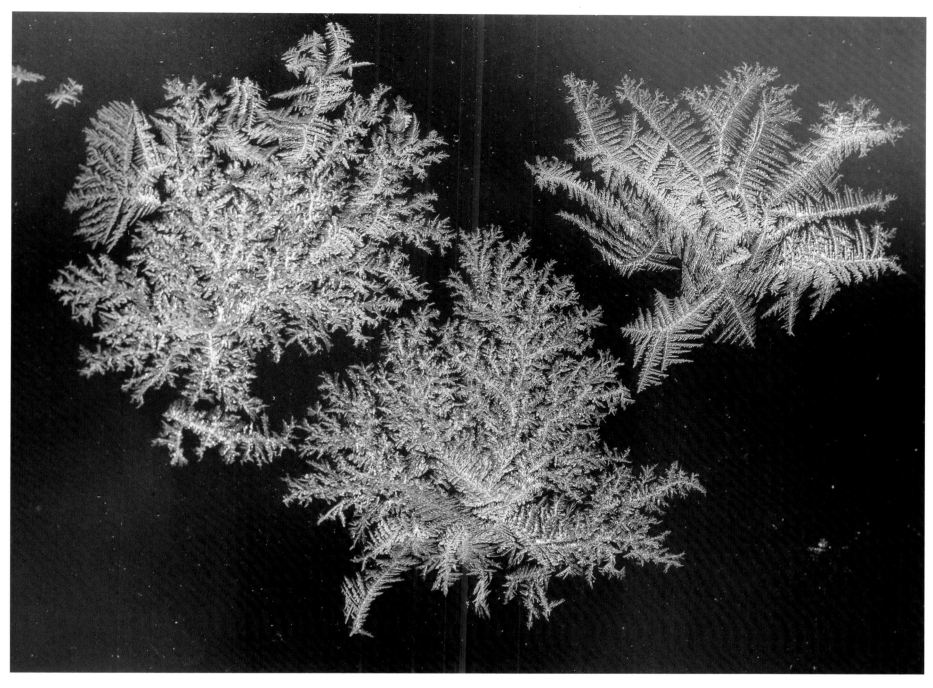

Ice crystals

Finlandia

El clima del país escandinavo distingue claramente entre el sur más cálido y el norte frío. En Laponia puede haber hasta 200 días de invierno; las temperaturas se encuentran permanentemente por debajo de 0 °C. La temperatura más fría jamás medida fue de -51,5 °C. El clima en Laponia es muy frío y la temperatura en el norte es muy fría. Los lagos y ríos a menudo se congelan durante meses. Contra las temperaturas bajo cero y la estación oscura, los finlandeses son ayudados por su institución más conocida: la sauna. Es una parte indispensable de la sociedad finlandesa. Al menos en el campo no hay apenas una casa sin sauna, y un honor especial para los visitantes es una invitación a tomar una sauna juntos.

Finlândia

O clima do país escandinavo distingue claramente entre o sul mais quente e o norte mais frio. Na Lapónia pode chegar a ter até 200 dias de inverno, as temperaturas são permanentemente inferiores a 0 °C, a temperatura mais fria uma vez medida foi inferior a 51,5 °C. Os lagos e rios muitas vezes congelam durante meses. Contra as temperaturas negativas e a estação escura, os finlandeses são ajudados pela sua instituição mais conhecida: a sauna. É uma parte indispensável da sociedade finlandesa. Pelo menos no campo dificilmente há uma casa sem sauna, e uma honra especial para os visitantes é um convite para fazer uma sauna juntos.

Finland

Het klimaat in het Scandinavische land verschilt tussen het warmere zuiden en het koude noorden. In Lapland kunnen tot 200 winterdagen zijn, de temperaturen zijn permanent lager dan 0 °C. De koudste temperatuur ooit gemeten was min 51,5 °C. Meren en rivieren zijn vaak maandenlang bevroren. Tegen temperaturen onder het vriespunt en het donkere seizoen hebben de Finnen een goede oplossing: de sauna. In ieder geval is er op het platteland nauwelijks een huis zonder sauna en een bijzondere eer voor bezoekers is een uitnodiging om samen een sauna te nemen.

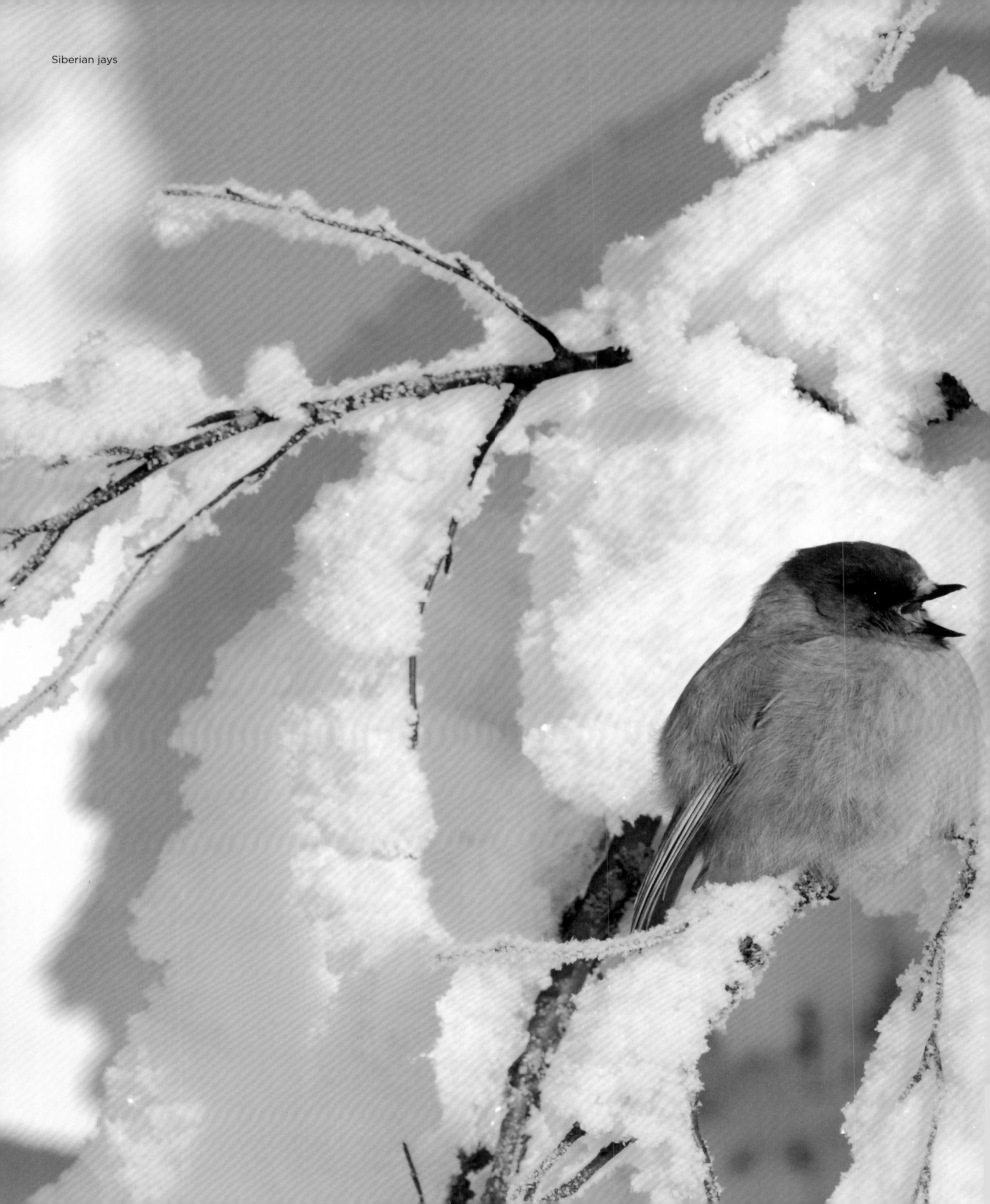

Siberian jays

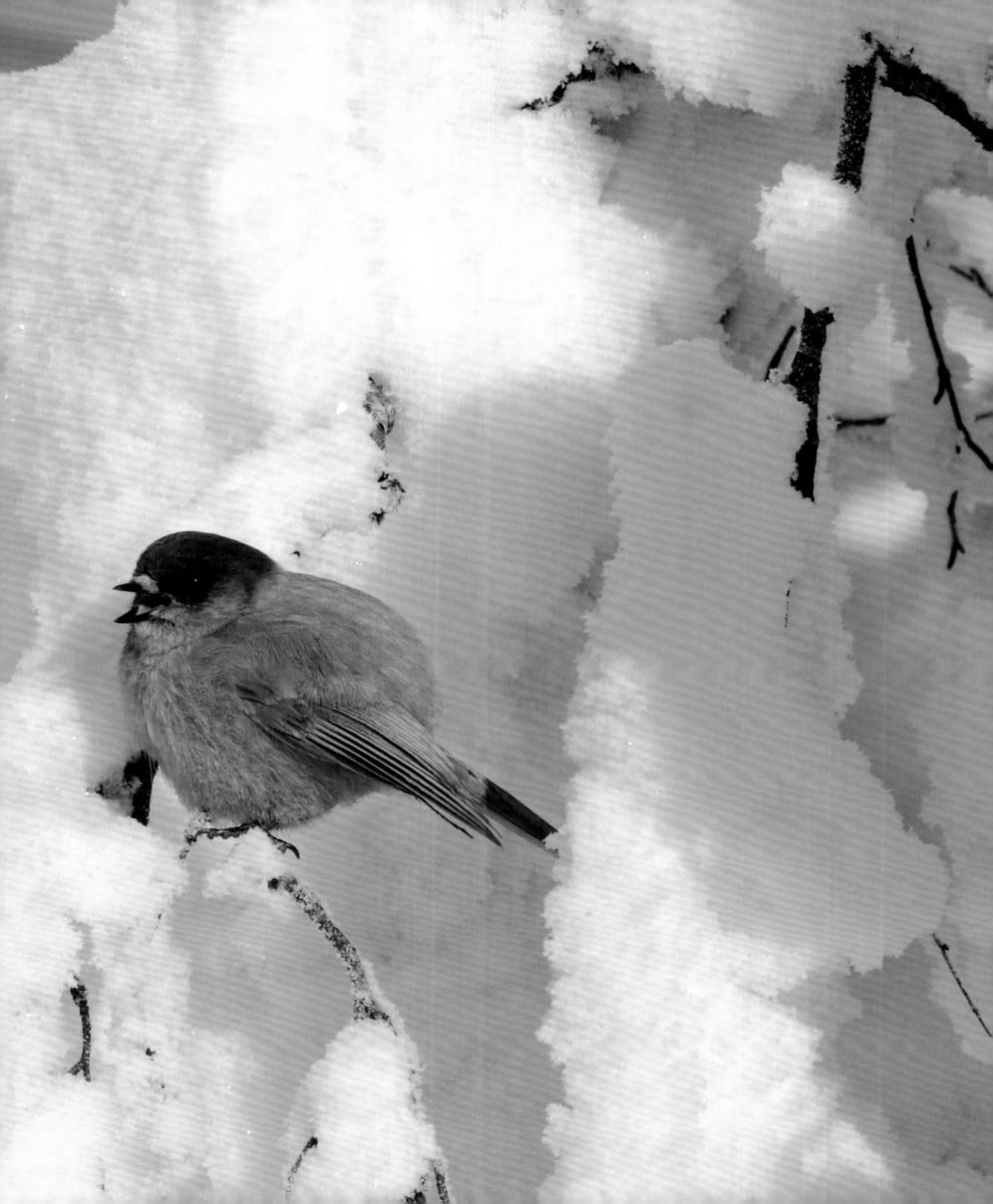

Snowy owl

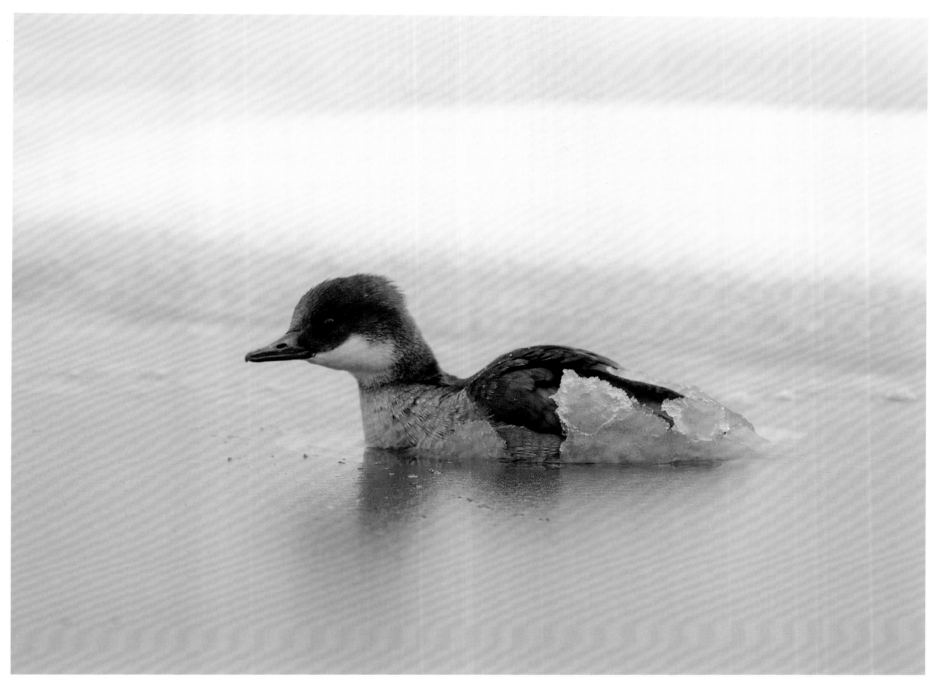

Female smew

Snowy Owl

These large birds of prey who live in treeless areas of northern Scandinavia, amongst other places, also hunt during the day, usually for small animals such as mice. Their almost pure-white plumage is very characteristic, but only adult males display this. A (fictitious) snowy owl named Hedwig gained worldwide fame in the Harry Potter novels and films as the pet of the young magician.

Chouettes harfangs

Ces oiseaux de proie, vivant entre autres dans les zones dépourvues d'arbres du nord de la Scandinavie, chassent également de jour, le plus souvent de petits animaux tels des souris. Leur plumage d'un blanc presque immaculé est caractéristique, quoique seuls les mâles adultes l'arborent, les femelles étant tachetées. Une chouette harfang (fictive) du nom d'Hedwige devint une célébrité mondiale : c'est l'animal de compagnie du jeune Harry Potter dans les romans et films contant l'histoire du sorcier.

Schnee-Eule

Die großen Raubvögel, die u. a. in baumfreien Gebieten Nordskandinaviens leben, jagen auch tagsüber, meist kleine Tiere wie Mäuse. Typisch ist ihr fast reinweißes Gefieder, das allerdings nur ausgewachsene Männchen tragen. Weltruhm erlangte eine (fiktive) Schnee-Eule namens Hedwig; in den Harry-Potter-Romanen und -Filmen ist sie das Haustier des jungen Zauberers.

Búho nival

Las grandes aves de rapiña, que viven en áreas libres de árboles en el norte de Escandinavia, cazan también durante el día, generalmente pequeños animales como ratones. Típico es su plumaje blanco casi puro, que sin embargo solo los machos adultos portan. Un búho nival (ficticio) llamado Hedwig ganó fama mundial. En las novelas y películas de Harry Potter, es la mascota del joven mago.

Coruja-das-neves

As grandes aves de rapina, que vivem entre outros em áreas livres de árvores do norte da Escandinávia, caçam também durante o dia, geralmente pequenos animais como ratos. Típico é a sua plumagem quase branco-puro, que no entanto só os machos adultos possuem. Uma coruja-de-neve (fictícia) chamada Hedwig ganhou fama mundial; nos romances e filmes de Harry Potter, ela é o animal de estimação do jovem mago.

Sneeuwuil

De grote roofvogels, die o.a. in boomvrije gebieden in Noord-Scandinavië leven, jagen ook overdag, meestal kleine dieren zoals muizen. Kenmerkend is het bijna zuiver witte verenkleed, dat echter alleen door volwassen mannetjes wordt gedragen. Een (fictieve) sneeuwuil genaamd Hedwig verwierf wereldfaam; in de Harry Potter romans en -films is ze het huisdier van de jonge tovenaar.

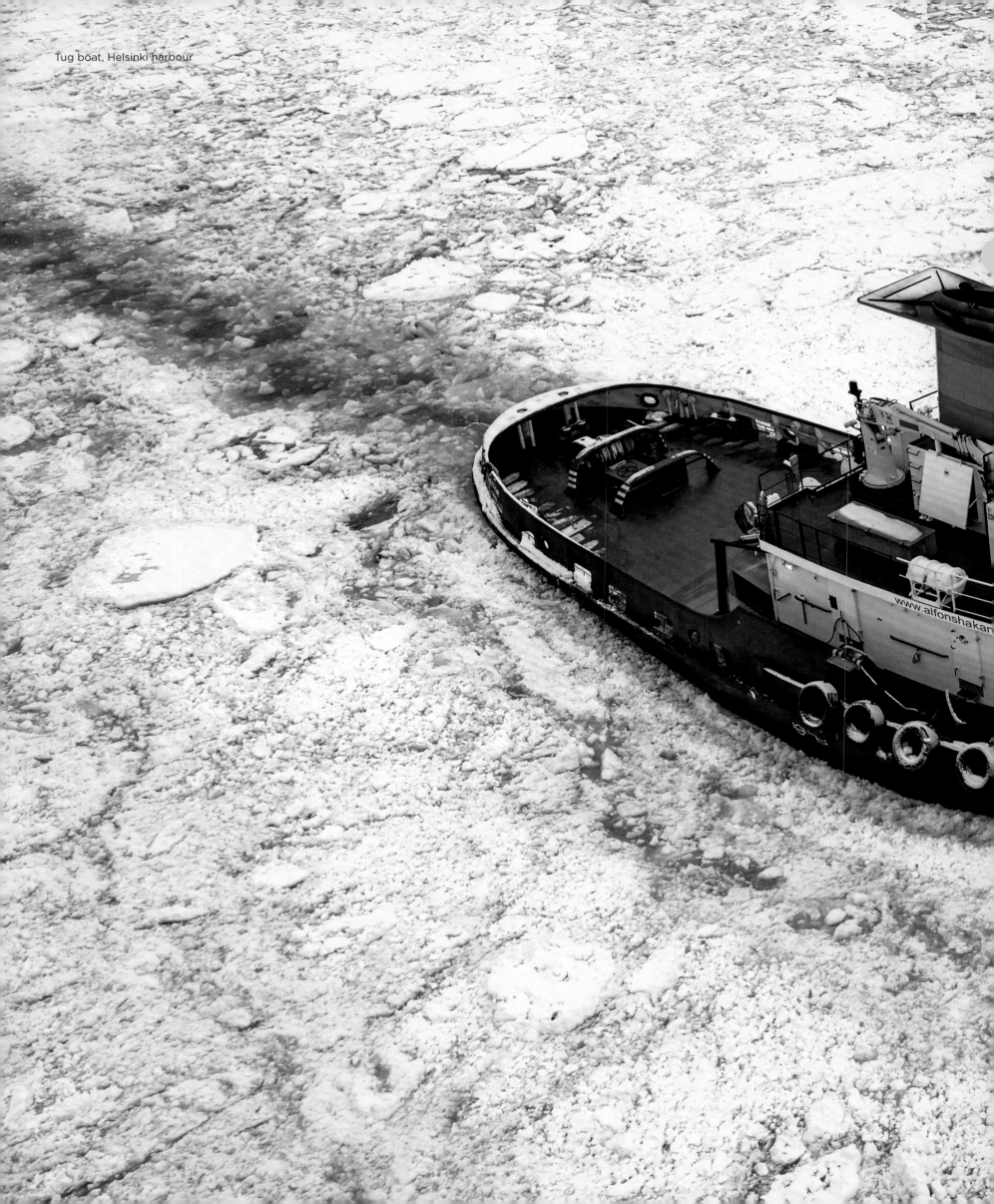

Tug boat, Helsinki harbour

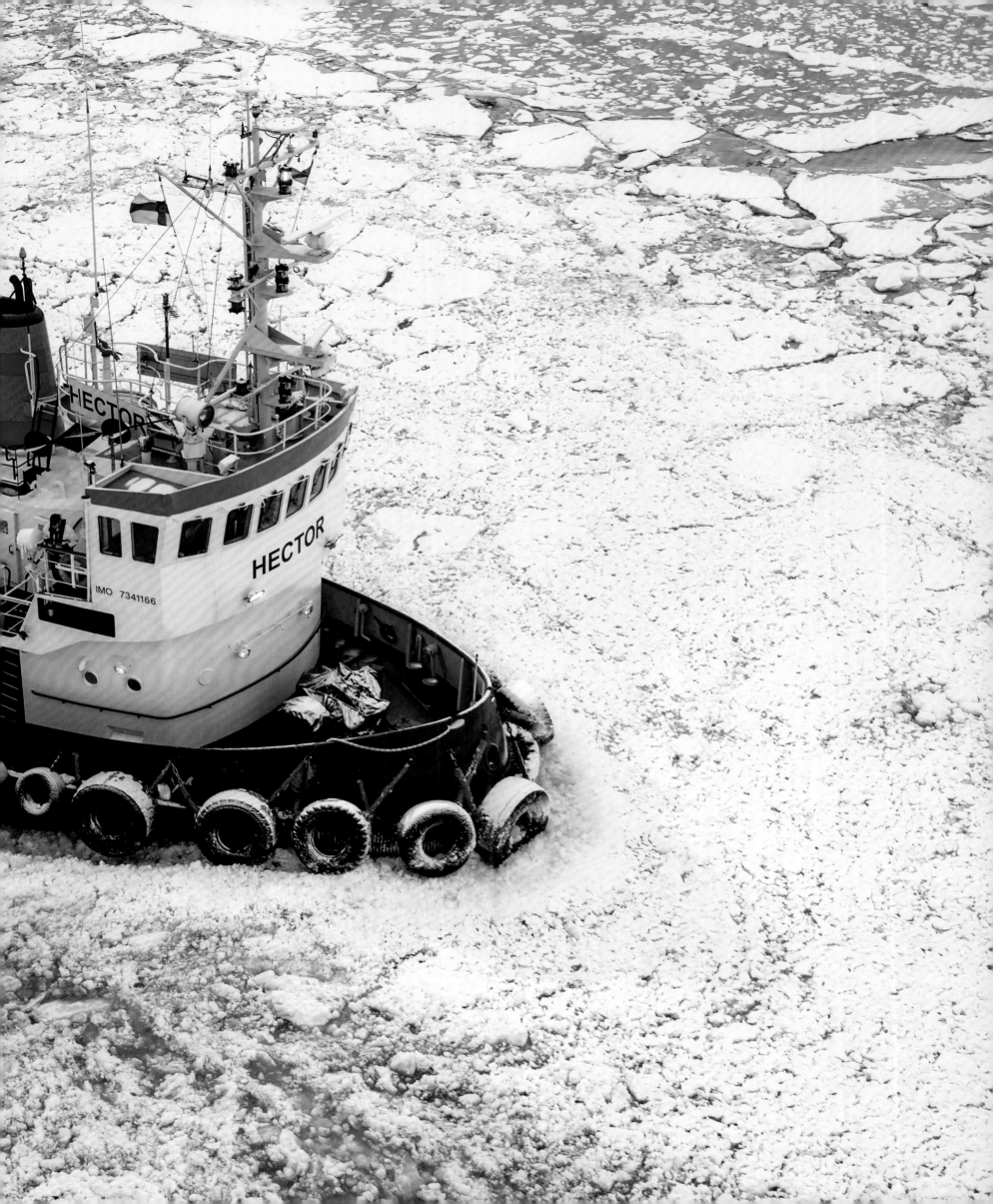

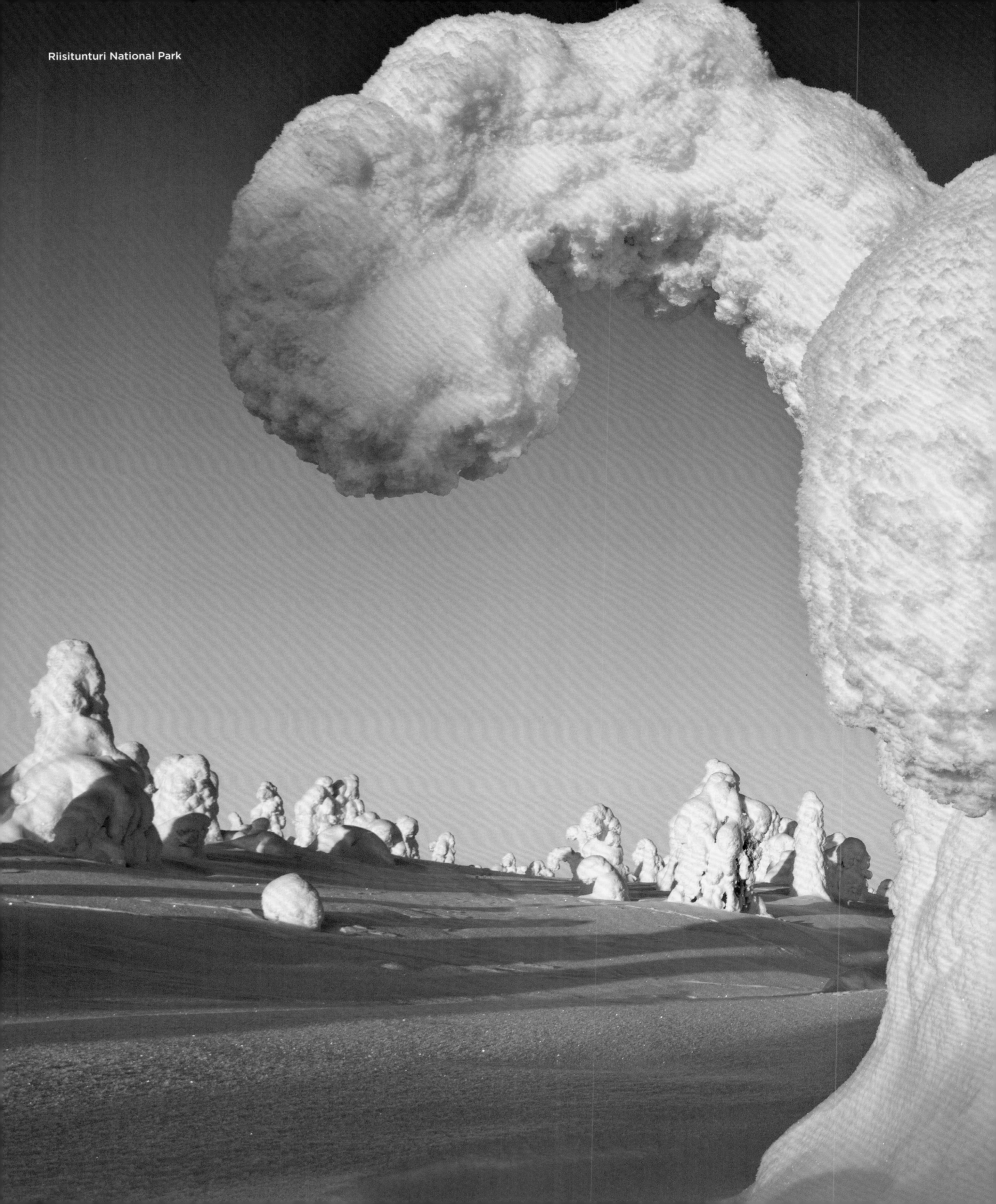

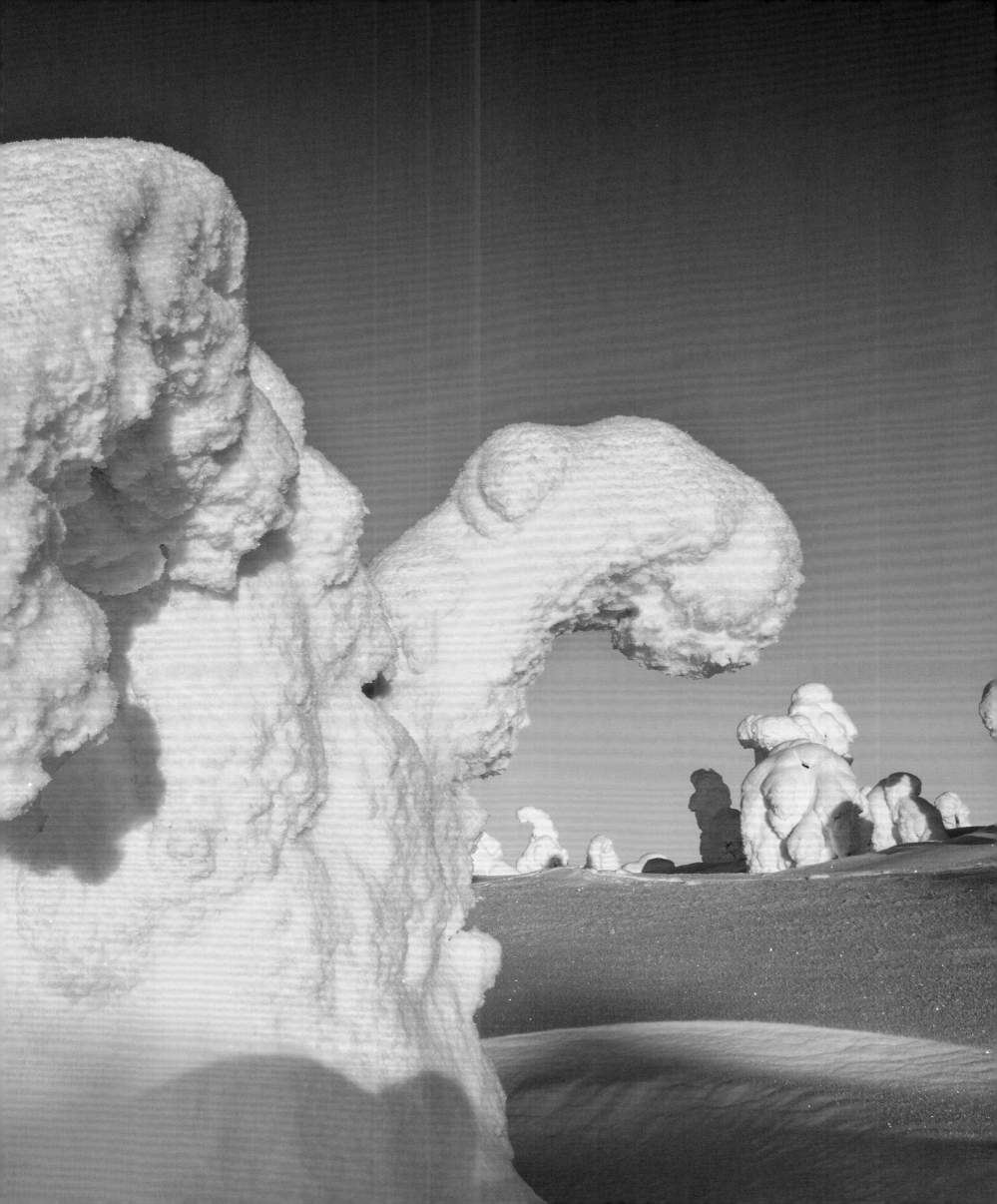

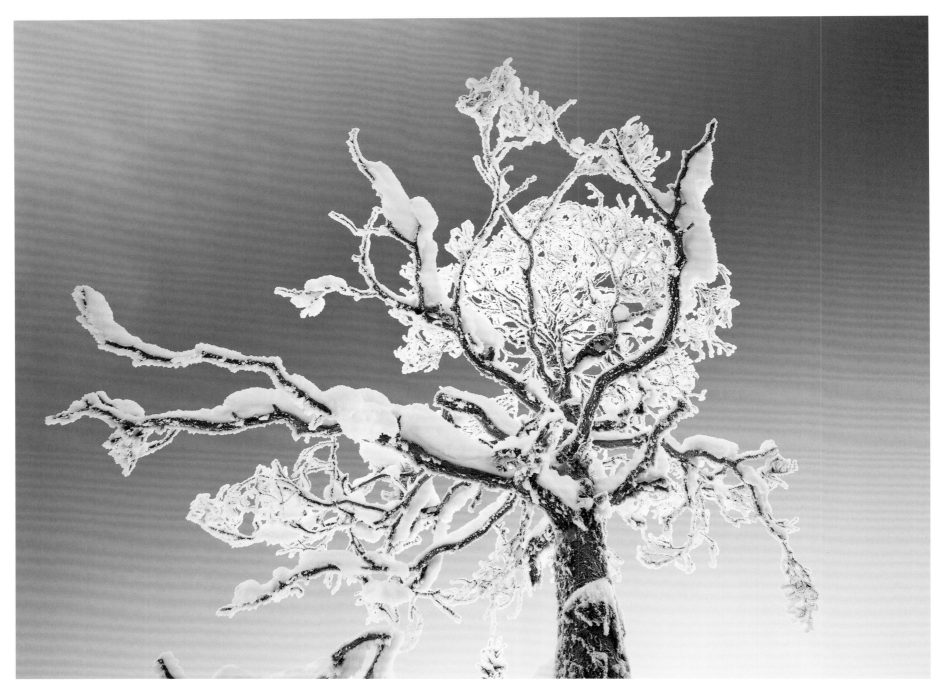

Riisitunturi National Park

Helsinki

During cold winters the Gulf of Bothnia and the Gulf of Finland can freeze over, and then maritime navigation is only possible using ice-breaking vessels. Life in the Finnish capital Helsinki is not affected, the Finns are used to icy temperatures. This metropolis with its 650,000 inhabitants has a large harbor, and a visit to the market directly beside South Harbor in the city centre is well worthwhile. From here, the cathedral and the orthodox Uspenski Cathedral are quickly reached. For architecture and music lovers, the city is definitely worth a visit.

Helsinki

Au cours des hivers froids, il arrive aux golfes de Botnie et de Finlande de geler. Dans ce cas, la circulation maritime n'est possible que pour les bateaux polaires ou accompagnés d'un brise-glace. Néanmoins la vie suit son cours à Helsinki, la capitale finlandaise. Les Finlandais sont coutumiers des températures glaciales. La métropole, qui compte 650 000 habitants, dispose d'un grand port doté d'un marché qui vaut le détour, situé directement au port sud, dans le centre-ville. De là, la cathédrale luthérienne et la cathédrale Uspenski ne sont qu'à deux pas. Helsinki est un incontournable pour les amateurs d'architecture et de musique.

Helsinki

In kalten Wintern können der Bottnische und der Finnische Meerbusen zufrieren, dann ist Schiffsverkehr nur mit eisgängigen Schiffen oder mithilfe von Eisbrechern möglich. Dem Leben in der finnischen Hauptstadt Helsinki tut das keinen Abbruch; die Finnen sind eisige Temperaturen gewohnt. Die 650 000 Einwohner zählende Metropole verfügt über einen großen Hafen, sehenswert ist ein Besuch auf dem Markt direkt am Südhafen in der Innenstadt. Von hier aus sind der Dom und die orthodoxe Uspenski-Kathedrale schnell erreicht. Für Architektur- und Musikliebhaber ist die Stadt unbedingt lohnenswert.

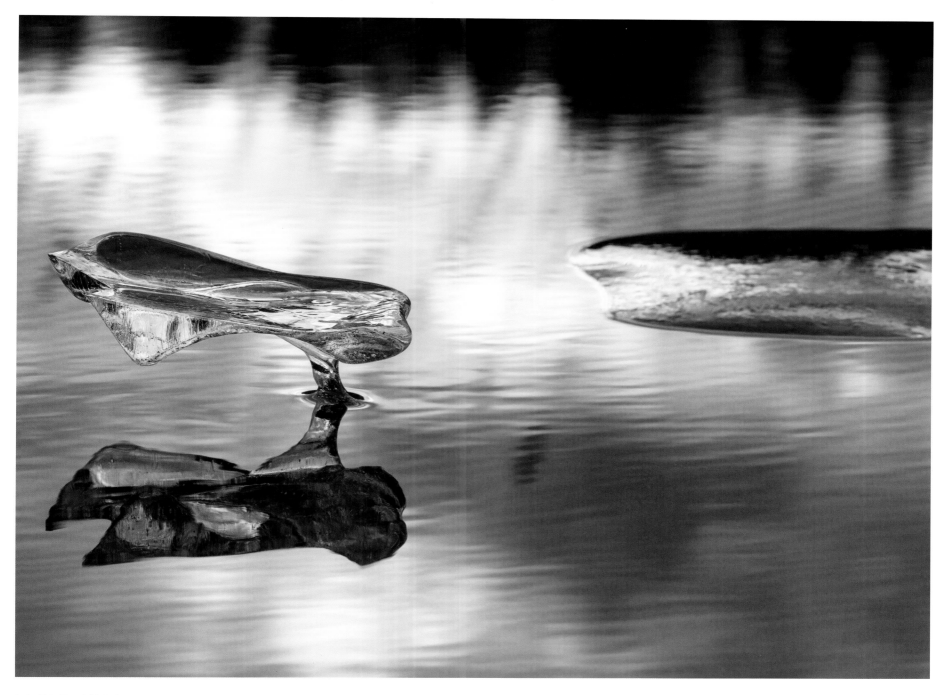

Lake Takajävari, Hattula

Helsinki

En los inviernos fríos, el Golfo de Botnia y el Golfo de Finlandia pueden congelarse, y el transporte marítimo solo es posible con barcos que atrapan el hielo o con rompehielos. La vida en la capital finlandesa, Helsinki, no se ve afectada; los finlandeses están acostumbrados a las temperaturas heladas. La metrópoli de 650 000 habitantes tiene un gran puerto y merece la pena visitar el mercado directamente en el puerto sur del centro de la ciudad. Desde aquí se llega rápidamente a la catedral y a la catedral ortodoxa de Uspenski. Para los amantes de la arquitectura y la música, vale la pena visitar la ciudad.

Helsínquia

Nos invernos frios, o Golfo de Bótnia e o Golfo da Finlândia podem congelar, e o transporte marítimo só é possível com navios apropriados para o gelo ou com quebra-gelos. A vida na capital finlandesa Helsínquia não é afetada; os finlandeses estão habituados a temperaturas geladas. A metrópole com 650.000 habitantes tem um grande porto, vale a pena visitar o mercado diretamente no porto do sul, no centro da cidade. A partir daqui, a catedral de Helsínquia e a catedral ortodoxa Uspenski são rapidamente alcançadas. Para os amantes da arquitetura e da música, é uma cidade que vale absolutamente a pena ser vista.

Helsinki

In koude winters kunnen de Botnische Golf en de Finse Golf bevriezen, de scheepvaart is dan alleen mogelijk met behulp van ijsbrekers. Het doet geen afbreuk aan het leven in de Finse hoofdstad Helsinki; de Finnen zijn gewend aan ijzige temperaturen. De metropool met 650.000 inwoners heeft een grote haven en een bezoek aan de markt direct aan de zuidelijke haven in het centrum van de stad is de moeite waard. Van hieruit zijn de kathedraal en de orthodoxe Oespenski-kathedraal snel bereikt. Voor architectuur- en muziekliefhebbers is de stad absoluut de moeite waard.

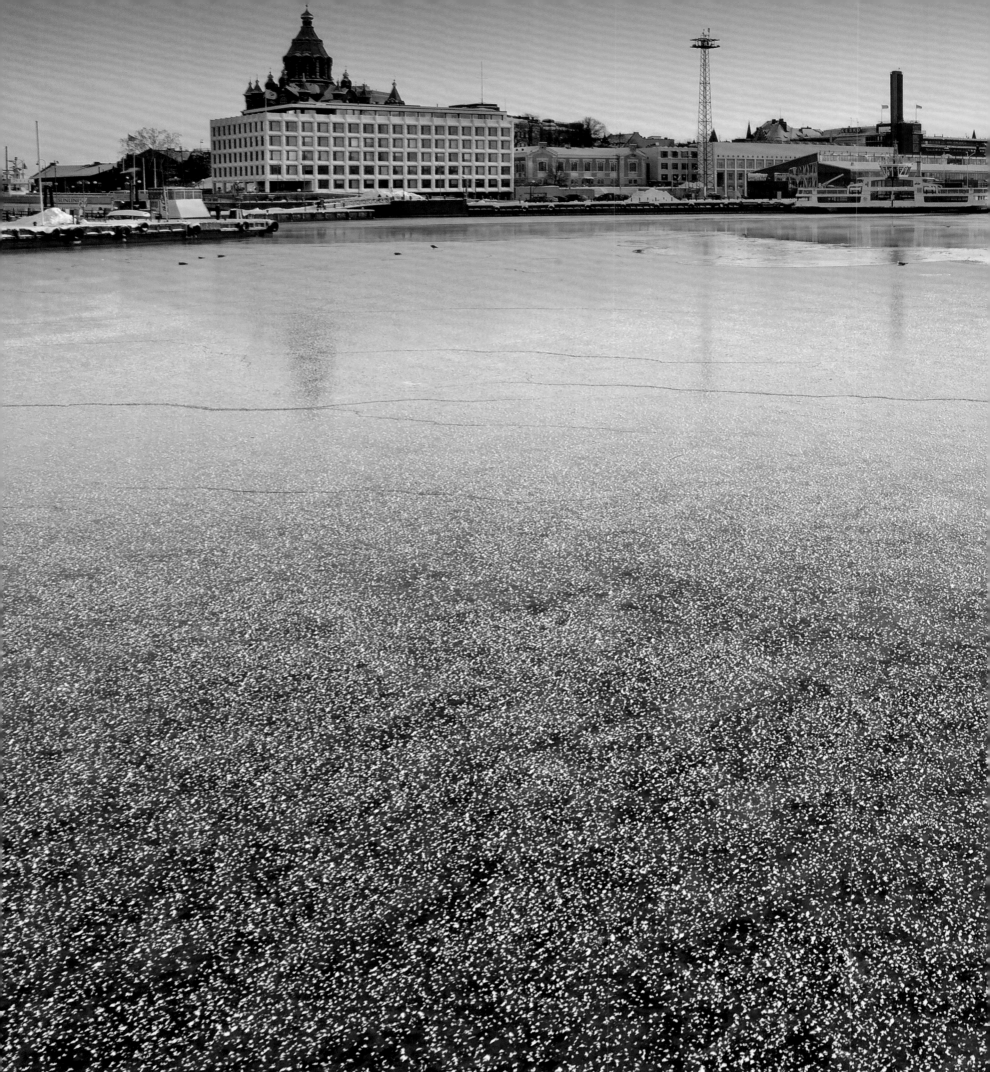

Helsinki Bay

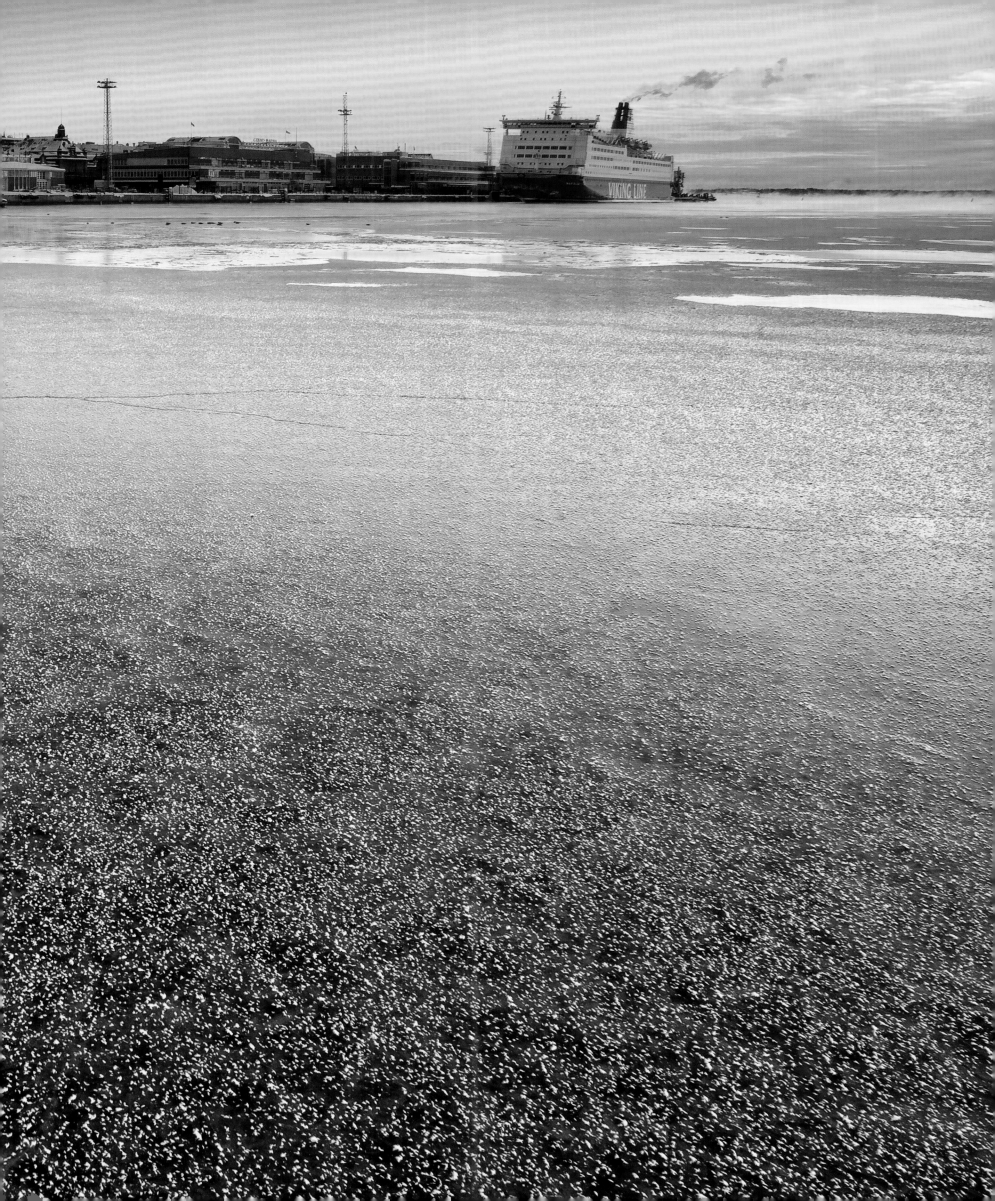

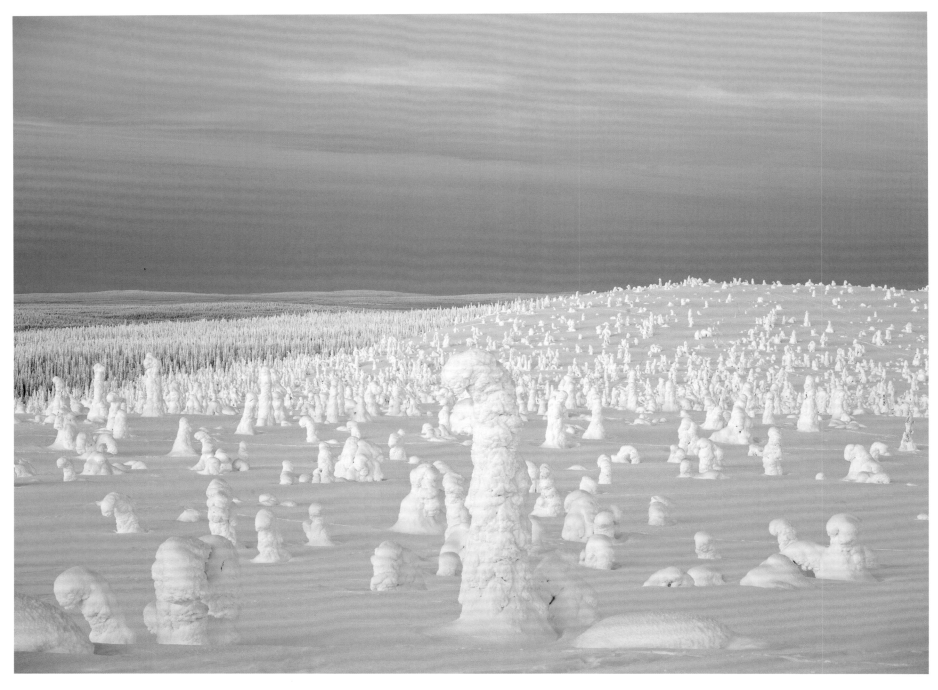

Riisitunturi National Park

Riisitunturi National Park

In winter there is absolutely no lack of snow in this 77 km² (30 sq mi) national park in southern Lapland. What fascinates both nature lovers and photographers are the bizarre sculptures which the snow forms in the trees. They look like an assembly of masked figures with pointed caps, or like silent trolls or strangely bent candles. The explanation is simple: the high humidity condenses and becomes hard snow on the treetops, often bending the tops to the ground. Not all trees survive this, some collapse under the weight of the snow.

Parc national de Riisitunturi

Ce parc national de seulement 77 km² situé dans le sud de la Laponie ne manque jamais de neige en hiver. Les arbres sont transformés en étranges sculptures, qui ressemblent à des silhouettes aux chapeaux pointus enveloppées de neige, à des trolls silencieux ou encore à des bougies singulièrement déformées, fascinant les amoureux de la nature tout autant que les photographes. L'explication à ce phénomène est simple : l'importante humidité de l'air se condense et se transforme en neige compacte à la cime des arbres, faisant ployer celle-ci jusqu'au sol. Tous les arbres n'y survivent pas. Régulièrement, certains d'entre eux cassent sous le poids de ce lourd manteau blanc.

Riisitunturi Nationalpark

Im Winter herrscht in dem nur 77 km² großen Nationalpark im südlichen Lappland absolut kein Mangel an Schnee. Was Naturliebhaber wie Fotografen fasziniert, sind die bizarren Skulpturen, zu denen der Schnee die Bäume formt: Wie eine Versammlung vermummter Gestalten mit Zipfelmützen wirken sie, oder wie schweigende Trolle oder seltsam verbogene Kerzen. Die Erklärung ist einfach: Die hohe Luftfeuchtigkeit kondensiert und wird an den Baumkronen zu hartem Schnee, der die Wipfel oft bis zum Boden beugt. Nicht alle Bäume überleben das, immer wieder brechen einige unter der Schneelast zusammen.

Ice formations

Parque Nacional Riisitunturi

En invierno jamás falta nieve en este parque nacional de 77 km² situado en el sur de Laponia. Lo que fascina a los amantes de la naturaleza (como a los fotógrafos) son las extrañas esculturas en las que la nieve forma los árboles: parecen un conjunto de figuras enmascaradas con tapas puntiagudas, o como trolls silenciosos o velas extrañamente dobladas. La explicación es simple: la alta humedad se condensa y se convierte en nieve dura en las copas de los árboles, que a menudo dobla las copas hacia el suelo. No todos los árboles sobreviven a esto; algunos se descomponen una y otra vez bajo la carga de nieve.

Parque Nacional de Riisitunturi

No inverno, não há absolutamente nenhuma falta de neve no Parque Nacional de 77 km² no sul da Lapônia. O que fascina tanto os amantes da natureza como os fotógrafos são as esculturas bizarras, formadas pela neve nas árvores: Parecem um conjunto de figuras mascaradas com gorros com borlas, ou como ogros silenciosos ou velas estranhamente dobradas. A explicação é simples: a alta umidade se condensa e se torna neve dura nas copas das árvores, muitas vezes as inclinando para o chão. Nem todas as árvores sobrevivem a isto repetidamente, e algumas quebram sob a carga de neve.

Nationaal park Riisitunturi

In de winter is er absoluut geen gebrek aan sneeuw in het 77 km² grote nationale park in het zuiden van Lapland. Wat zowel natuurliefhebbers als fotografen fascineert zijn de bizarre sculpturen waar de sneeuw de bomen vormt: Ze zien uit als een verzameling gemaskerde figuren met puntmutsen, of als stille trollen of vreemd gebogen kaarsen. De verklaring is eenvoudig: de hoge luchtvochtigheid condenseert en veroorzaakt harde sneeuw op de boomtoppen, waardoor de toppen vaak naar de grond worden gebogen. Niet alle bomen overleven dit, sommige breken steeds weer onder de sneeuwlast af.

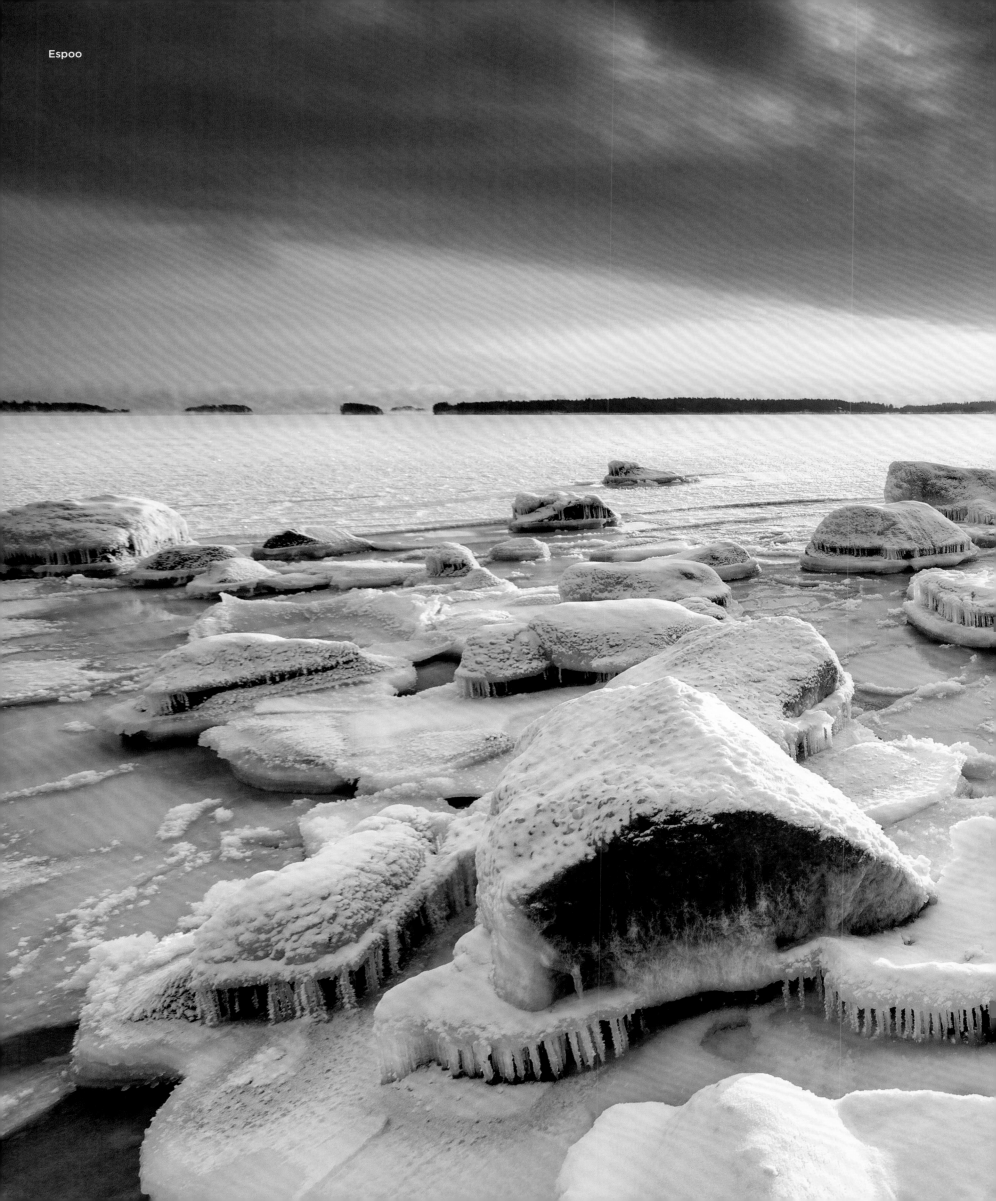

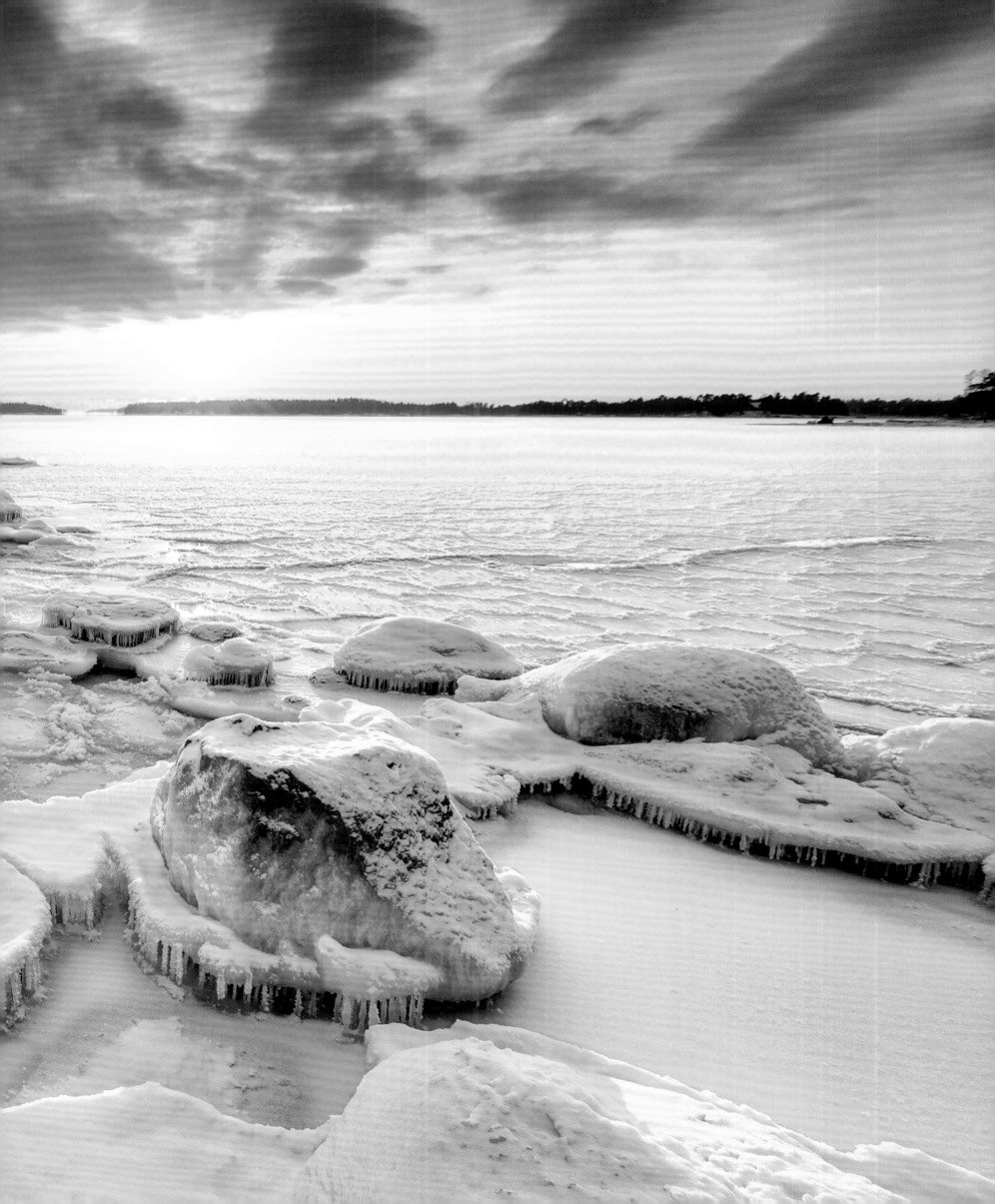

Ice hotel, Sinettä, Lapland

Ice Hotels

There are now many temporary hotels made of ice and snow in Scandinavia. The ice hotel in Sinettä, Finland, by a lake about 30 km (18 mi) from the Arctic Circle, is built every year in December and melts again in spring. While humans can only survive for a short time on ice without protection, they enjoy a healthy night in the icy rooms and suites at a constant temperature of minus 5 °C (23 °F). The beds, formed from blocks of ice, are covered with animal skins, and high-tech sleeping bags guarantee cosy warmth. You can also thoroughly warm yourself in Scandinavia's only snow sauna.

Hôtel de glace

Il existe désormais toute une série d'hôtels éphémères faits de glace et de neige en Scandinavie. L'hôtel de glace de Sinettä, au bord d'un lac à une trentaine de kilomètres du cercle polaire, est bâti chaque année au mois de décembre et fond de nouveau au printemps. Alors que l'homme ne peut survivre que peu de temps sans protection dans la glace, il peut sereinement passer une nuit par une température constante de -5° C dans les chambres et les suites de glace de l'hôtel. Les lits sculptés dans des blocs de glace sont couverts de fourrures et des sacs de couchage haute technologie garantissent une agréable chaleur. Et pour se réchauffer en profondeur, il suffit de se rendre dans l'unique sauna de neige de Scandinavie.

Eishotel

Mittlerweile gibt es in Skandinavien eine ganze Reihe temporärer Hotels aus Eis und Schnee. Das Eishotel im finnischen Sinettä, etwa 30 km vom Polarkreis entfernt an einem See gelegen, wird jedes Jahr im Dezember errichtet, im Frühjahr schmilzt es wieder. Während der Mensch im Eis ungeschützt nur kurz überleben kann, genießt er in den eisigen Zimmern und Suiten bei konstant minus 5 °C eine gesunde Nacht. Die aus einem Eisblock geformten Betten sind mit Fellen bedeckt, Hightech-Schlafsäcke garantieren wohlige Wärme. Gründlich aufwärmen kann man sich in der einzigen Schneesauna Skandinaviens.

Ice hotel, Sinettä, Lapland

Hotel de hielo

Hoy en día, en Escandinavia hay muchos hoteles temporales hechos de hielo y nieve. El hotel de hielo en Sinettä, Finlandia, a unos 30 km del Círculo Polar Ártico sobre un lago, se construye cada año en diciembre y se derrite de nuevo en primavera. Aunque los seres humanos solo pueden sobrevivir durante un corto periodo de tiempo en el hielo sin protección, disfrutan de una noche saludable en las habitaciones y suites heladas a una temperatura constante de -5 °C. Las camas, formadas por un bloque de hielo, están cubiertas de pieles, los sacos de dormir de alta tecnología garantizan un calor acogedor. En la única sauna de nieve de Escandinavia se puede calentar a fondo.

Hotel de gelo

Atualmente, existem vários hotéis temporários feitos de gelo e neve na Escandinávia. O hotel de gelo em Sinettä, Finlândia, a cerca de 30 km do Círculo Polar Ártico em um lago, é construído todos os anos em dezembro e derrete novamente na primavera. Enquanto os seres humanos só conseguem sobreviver desprotegido no gelo por pouco tempo, pode-se neste hotel desfrutar de uma noite saudável nos quartos e suites gelados a uma temperatura constante de menos 5 °C. As camas, formadas a partir de um bloco de gelo, são cobertas com peles e sacos de dormir de alta tecnologia garantem um calor aconchegante. Você pode se aquecer completamente na única sauna de neve da Escandinávia.

IJshotel

Inmiddels zijn er in Scandinavië veel tijdelijke hotels van ijs en sneeuw. Het ijshotel in Sinettä, Finland, ongeveer 30 km van de poolcirkel liggend aan een meer, wordt elk jaar in december gebouwd en smelt in het voorjaar weer. Terwijl de mens slechts korte tijd zonder bescherming in het ijs kan overleven, geniet hij van een rustgevende nacht in de ijskamers en suites bij een constante temperatuur van min 5 °C. De bedden, gevormd uit een blok ijs, zijn bedekt met huiden, high-tech slaapzakken garanderen een behaaglijke warmte. In de enige sneeuwsauna van Scandinavië kunt u zich goed opwarmen.

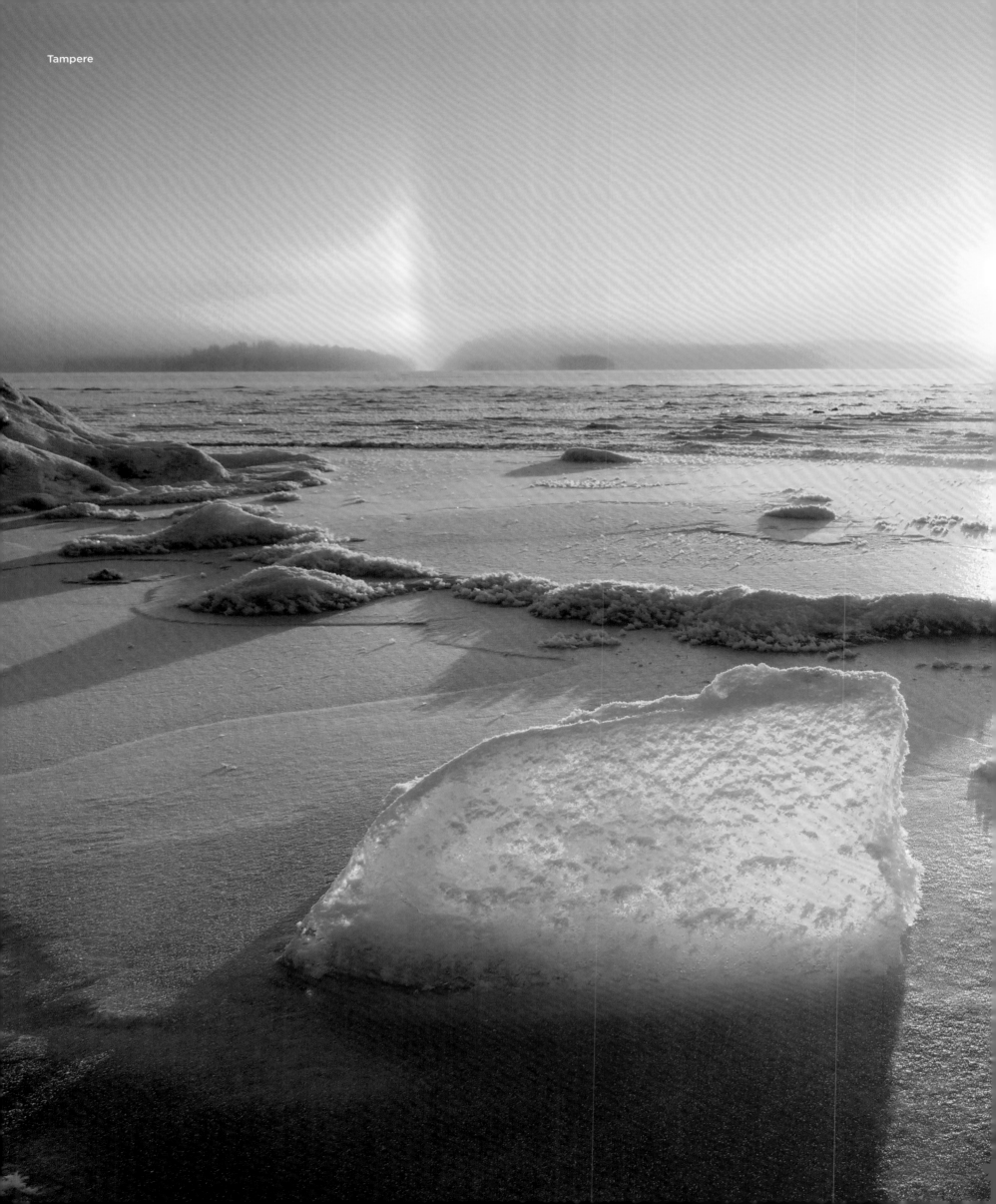

Tampere

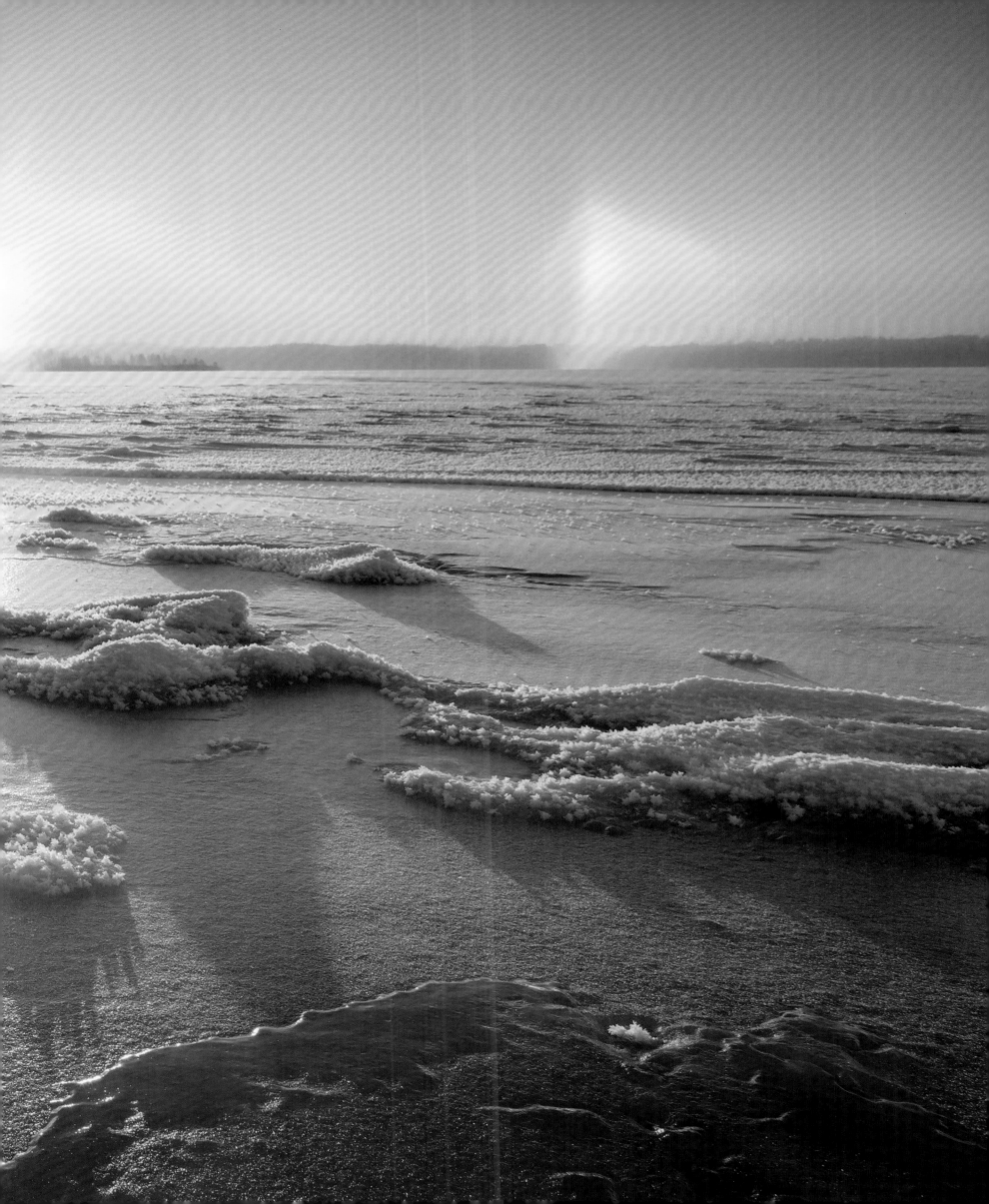

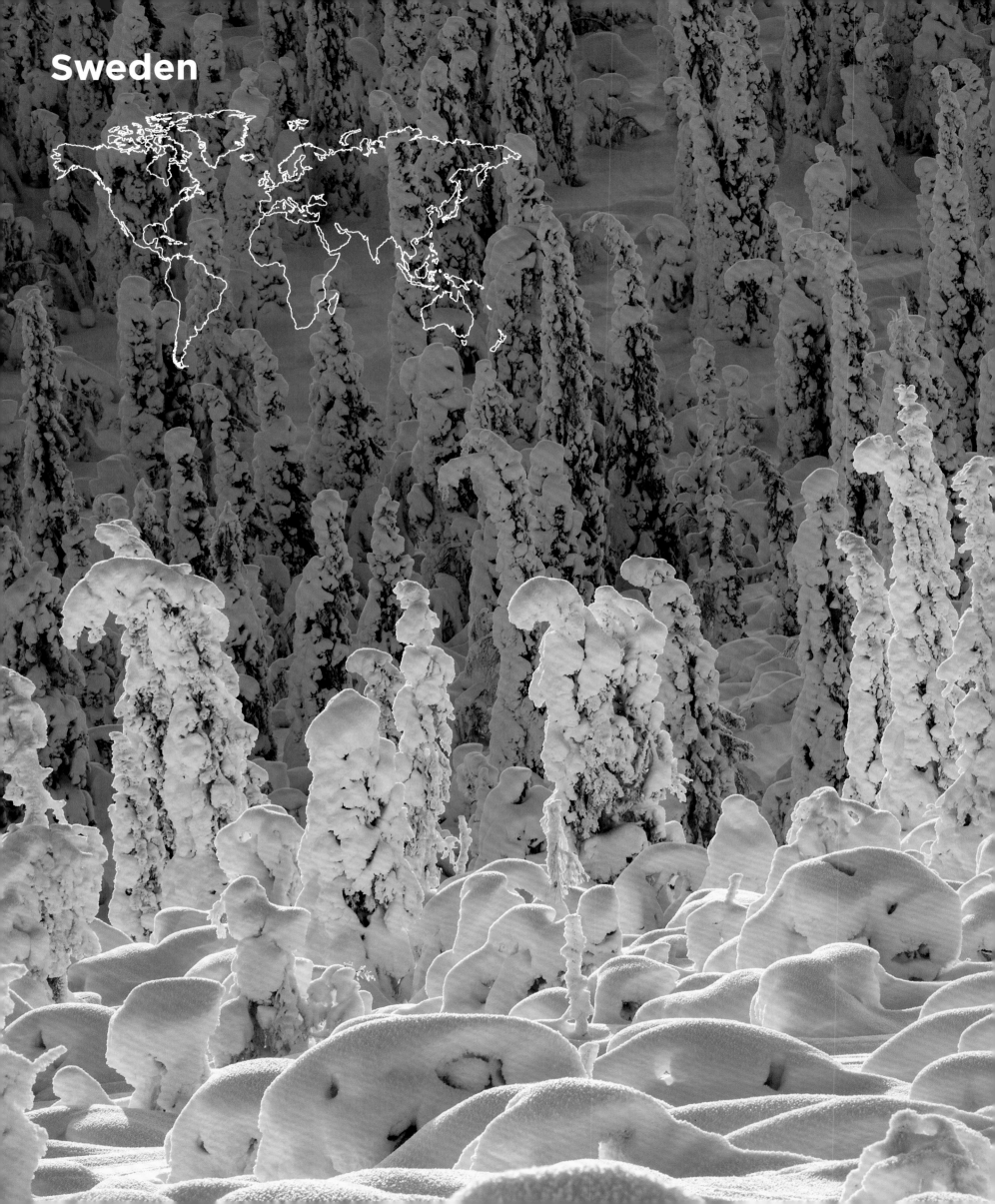

Sweden

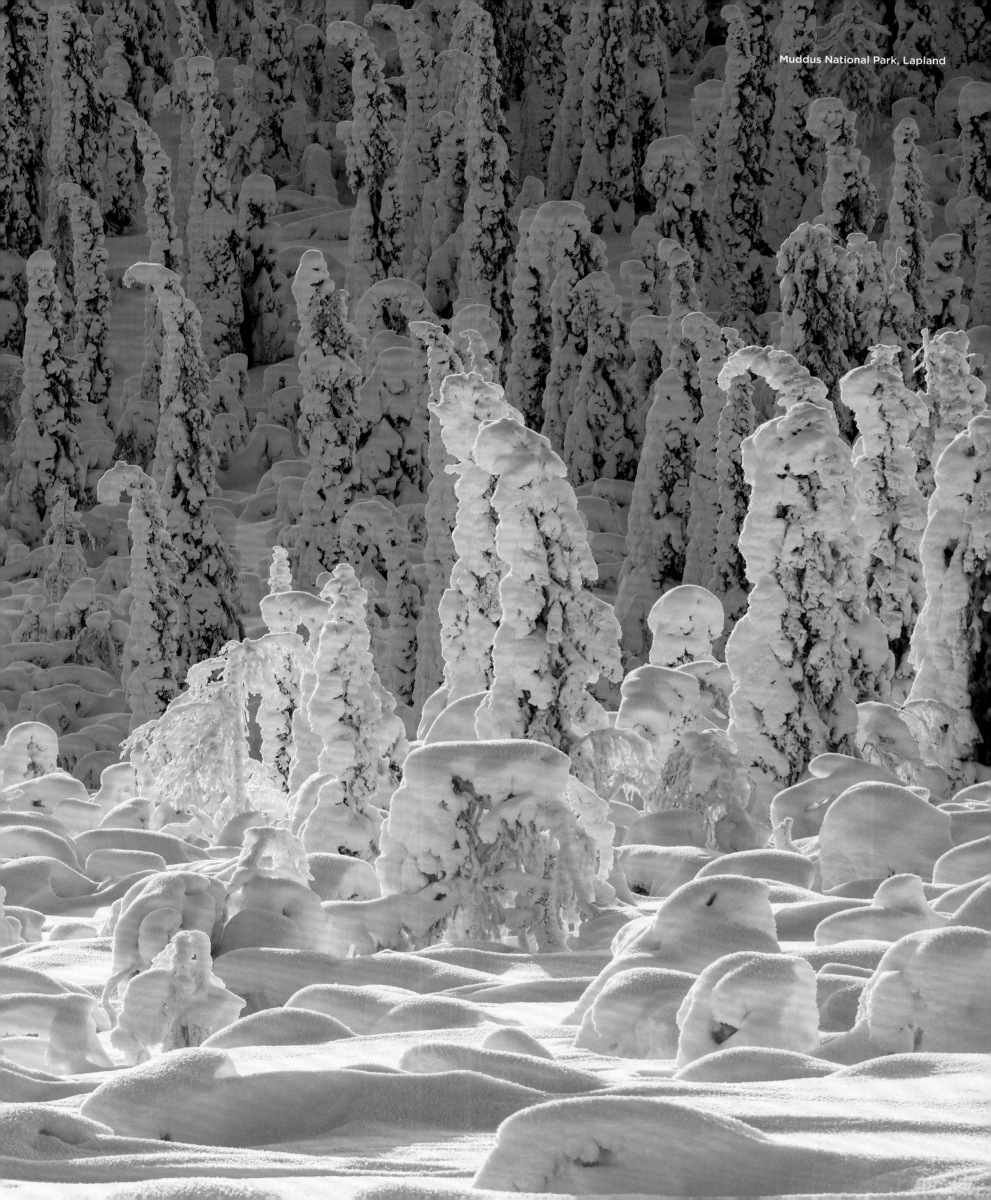

Muddus National Park, Lapland

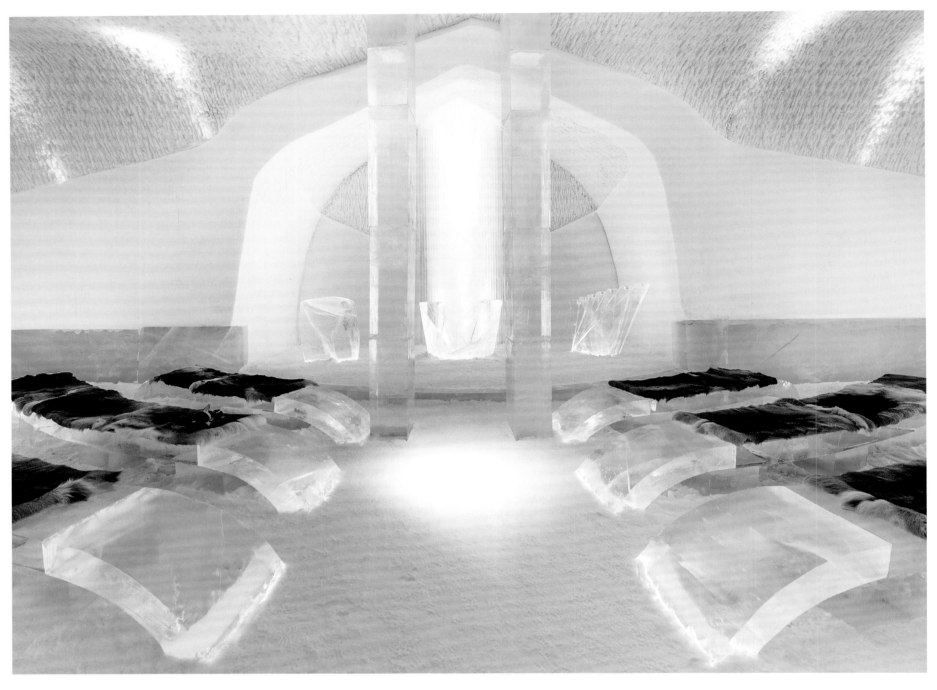

Ice hotel, Jukkasjärvi, Lapland

Sweden

The fourth largest country in Europe (apart from Russia) stretches over more than 1500 km (932 mi) from north to south. In the north, which partly lies north of the Arctic Circle, temperatures often drop to minus 15 ° (5 °F) or minus 20 °C (-4 °F)in winter; occasionally temperatures of minus 50 °C (-58 °F) have been measured. The indigenous Sami population, of whom about 20,000 live in Sweden, are best adapted to life in sub-Arctic or Arctic conditions; some of them are still semi-nomadic with their reindeer herds. Most of the population lives in the south of the country, where the climate is relatively mild.

Suède

Le quatrième plus grand pays d'Europe (sans compter la Russie) s'étend sur plus de 1 500 km du nord au sud. Au nord de la Suède, qui se trouve en partie au nord du cercle polaire, les températures hivernales descendent souvent en dessous de -15° C ou -20° C. Des températures isolées de -50° C furent déjà mesurées. Le peuple autochtone des Samis, dont environ 20 000 membres vivent en Suède, est parfaitement adapté aux conditions de vie subarctiques et arctiques. Certains d'entre eux, accompagnés de leurs troupeaux de rennes, sont encore semi-nomades. La majorité de la population suédoise vit dans le sud du pays, où règne un climat plus doux.

Schweden

Das viertgrößte Land Europas (außer Russland) erstreckt sich über mehr als 1500 km von Nord nach Süd. Im Norden, der teilweise nördlich des Polarkreises liegt, sinken die Temperaturen im Winter oft auf minus 15 ° oder minus 20 °C; vereinzelt wurden Temperaturen von minus 50 °C gemessen. Dem Leben in subarktischen oder arktischen Verhältnissen am besten angepasst ist die Urbevölkerung der Samen, von denen etwa 20 000 in Schweden leben, einige von ihnen noch als Halbnomaden mit ihren Rentierherden. Der größte Teil der Bevölkerung lebt im Süden des Landes; hier herrscht ein recht mildes Klima.

Ice bar, Jukkasjärvi, Lapland

Suecia

El cuarto país más grande de Europa (exceptuando Rusia) se extiende a lo largo de más de 1500 km de norte a sur. En el norte, que en parte se encuentra al norte del Círculo Polar Ártico, las temperaturas descienden a menudo a -15 °C o -20 °C en invierno, aunque se han llegado a medir temperaturas de -50 °C. La población nativa de los samis, de los cuales unos 20 000 viven en Suecia, se adapta mejor a la vida en condiciones subárticas o árticas. Algunos de ellos siguen siendo seminómadas con sus rebaños de renos. La mayor parte de la población vive en el sur del país, donde el clima es bastante suave.

Suécia

O quarto maior país da Europa (com exceção da Rússia) estende-se por mais de 1500 km de norte a sul. No norte, que fica parcialmente ao norte do Círculo Ártico, as temperaturas caem frequentemente para menos 15 ° ou menos 20 °C no inverno; ocasionalmente, foram medidas temperaturas de menos 50 °C. A população nativa dos Sami, dos quais cerca de 20.000 vivem na Suécia, foi a que mais se adaptou à vida em condições sub-árticas ou árticas; alguns deles são ainda semi-nómadas com os seus rebanhos de renas. A maioria da população vive no sul do país, onde o clima é bastante ameno.

Zweden

De op drie na grootste land van Europa (buiten Rusland) strekt zich uit over meer dan 1500 km van noord naar zuid. In het noorden, dat deels ten noorden van de poolcirkel ligt, dalen de temperaturen in de winter vaak tot -15° of -20°C; soms zijn er temperaturen van -50°C gemeten. De inheemse bevolking van de Sami, waarvan er ongeveer 20.000 in Zweden wonen, is goed aangepast aan het leven in sub-Arctische of Arctische omstandigheden; sommigen van hen zijn nog steeds semi-nomaden met rendierkuddes. Het grootste deel van de bevolking woont in het zuiden van het land, waar het klimaat vrij mild is.

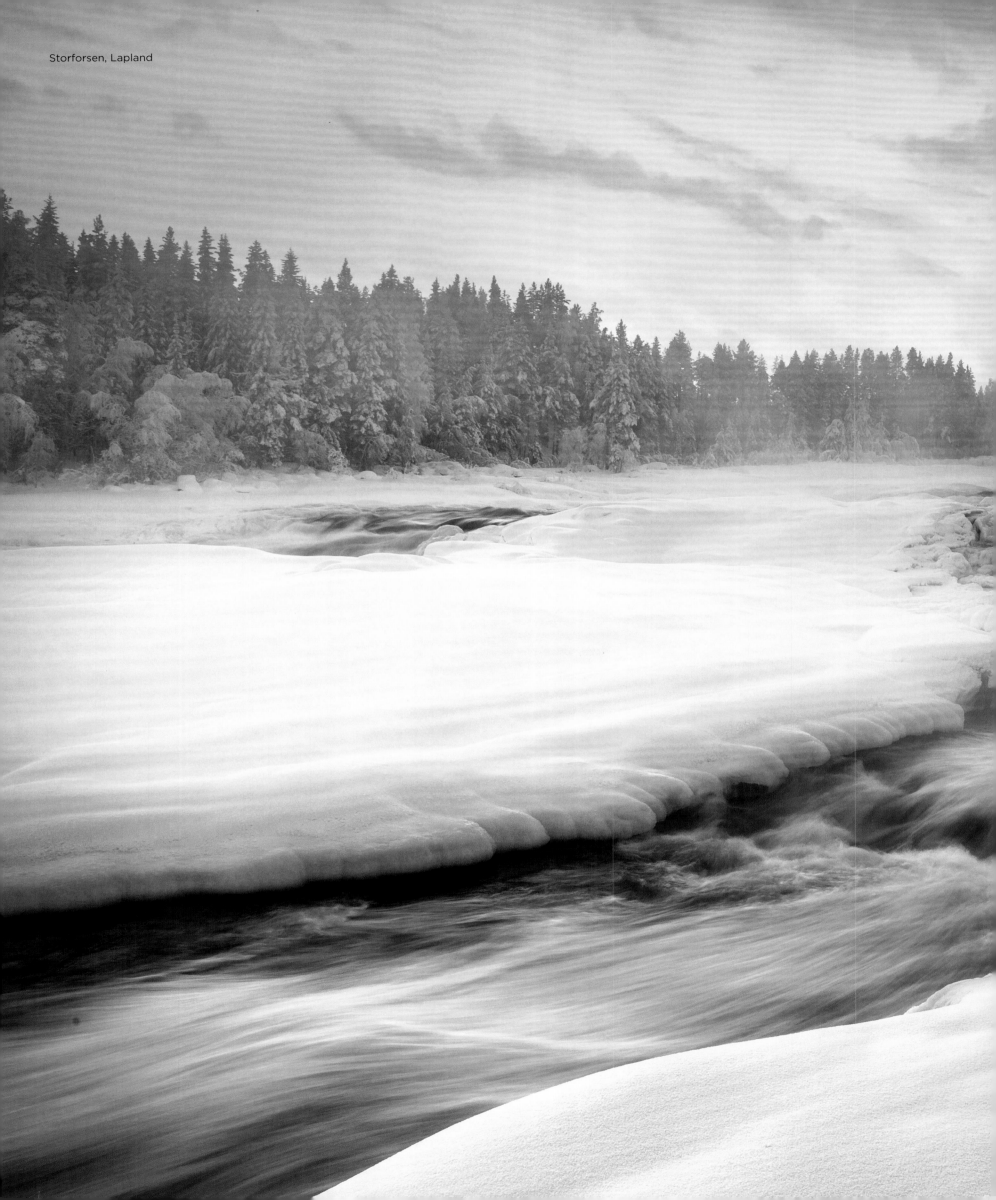

Storforsen, Lapland

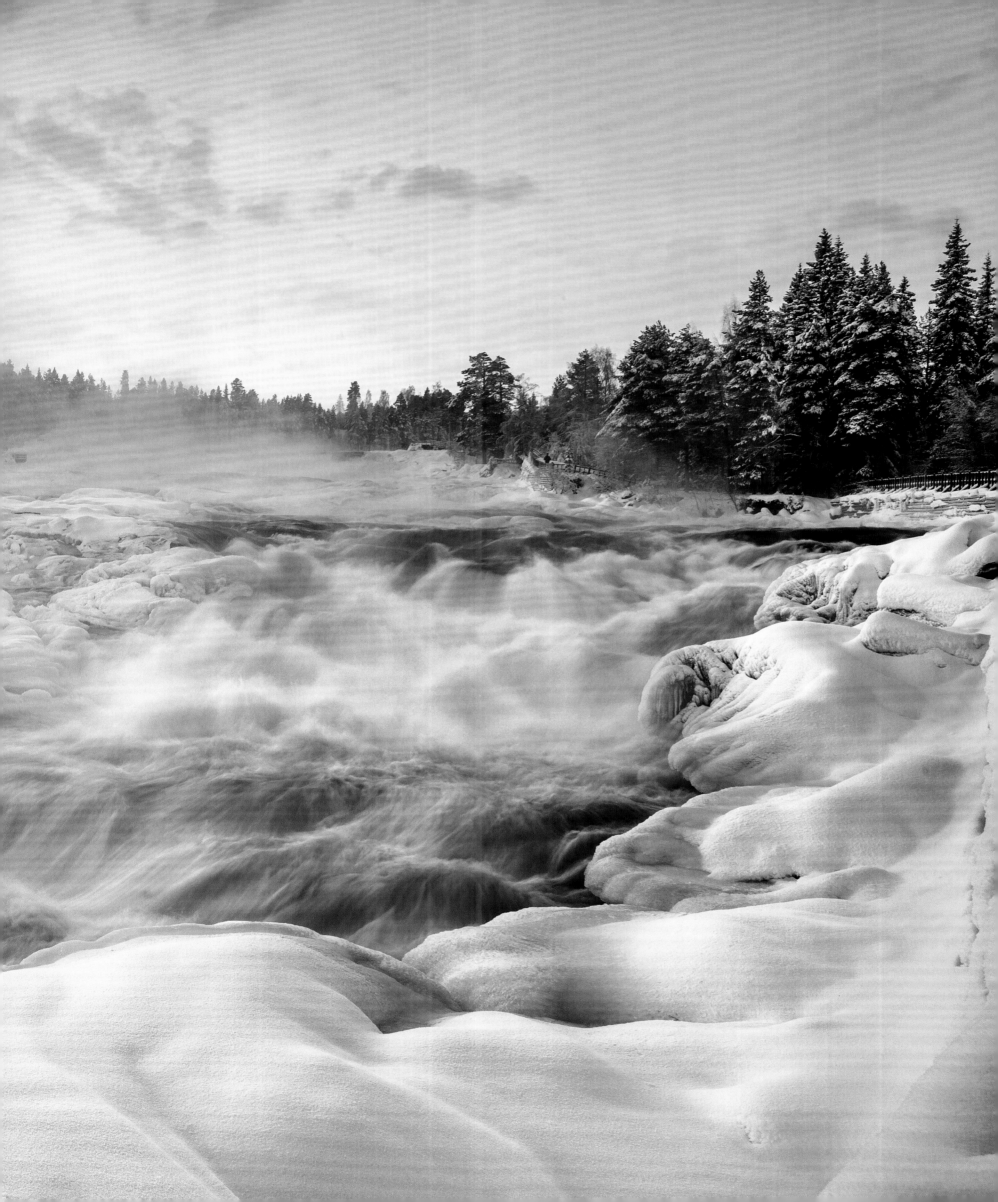

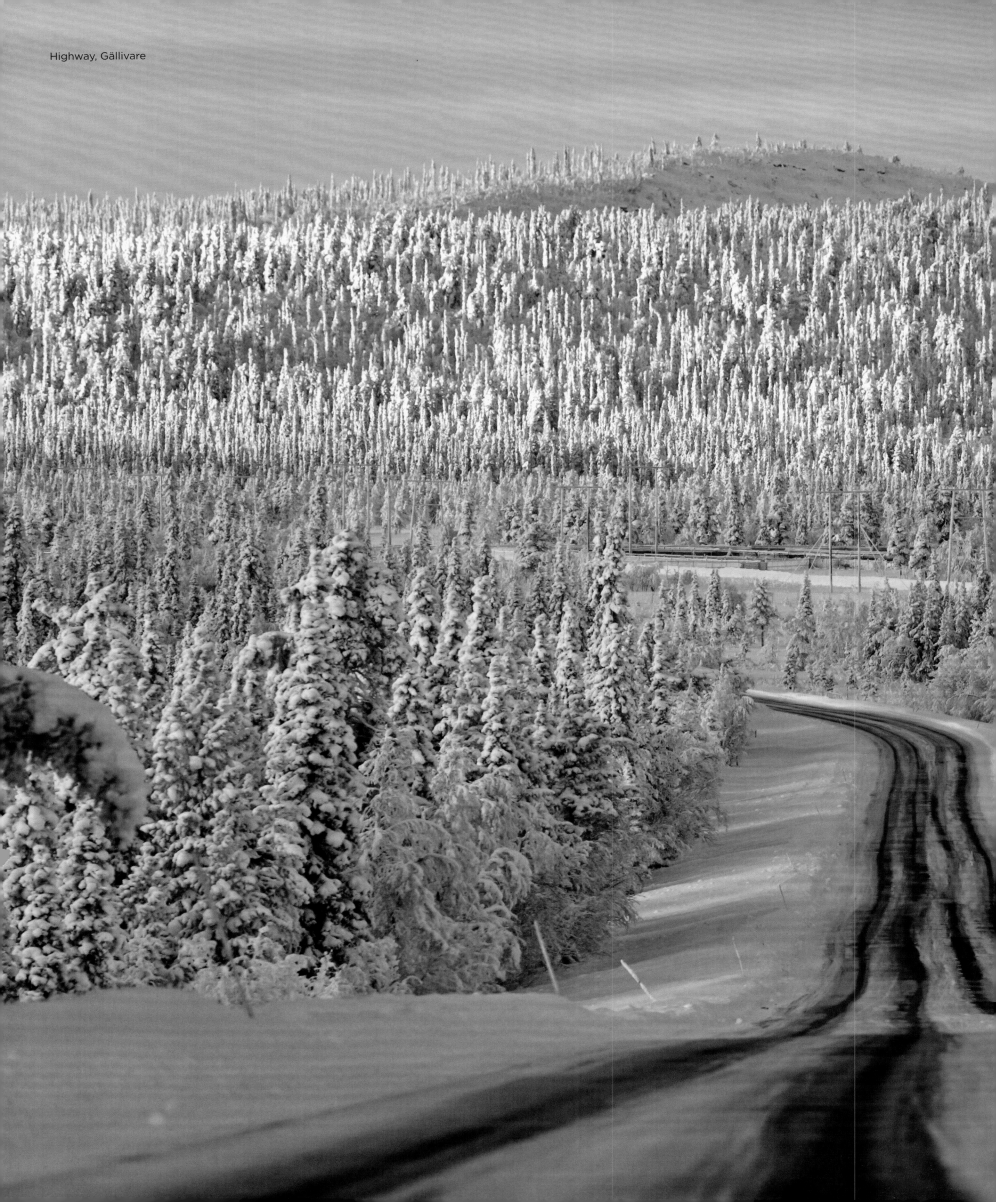

Highway, Gällivare

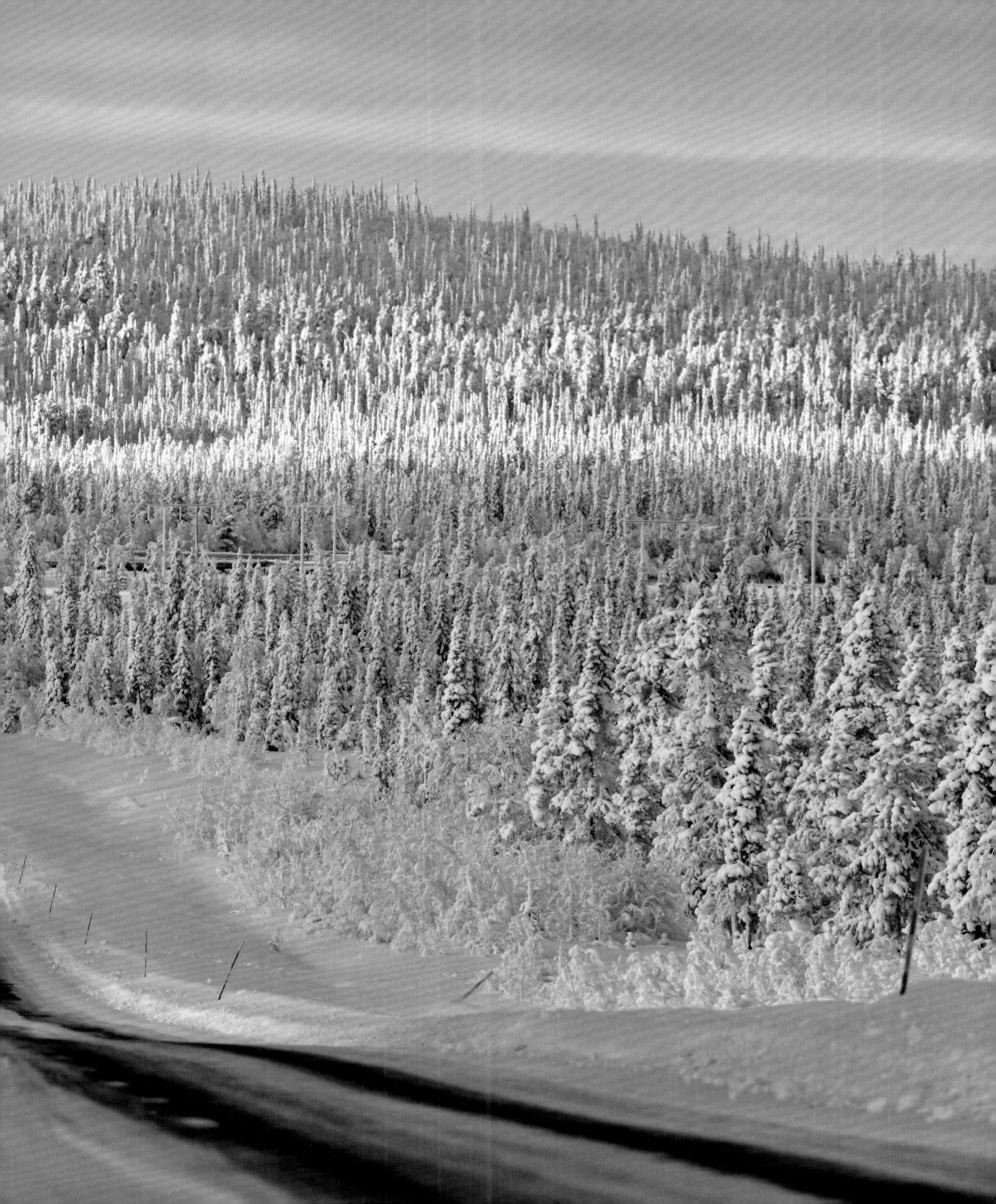

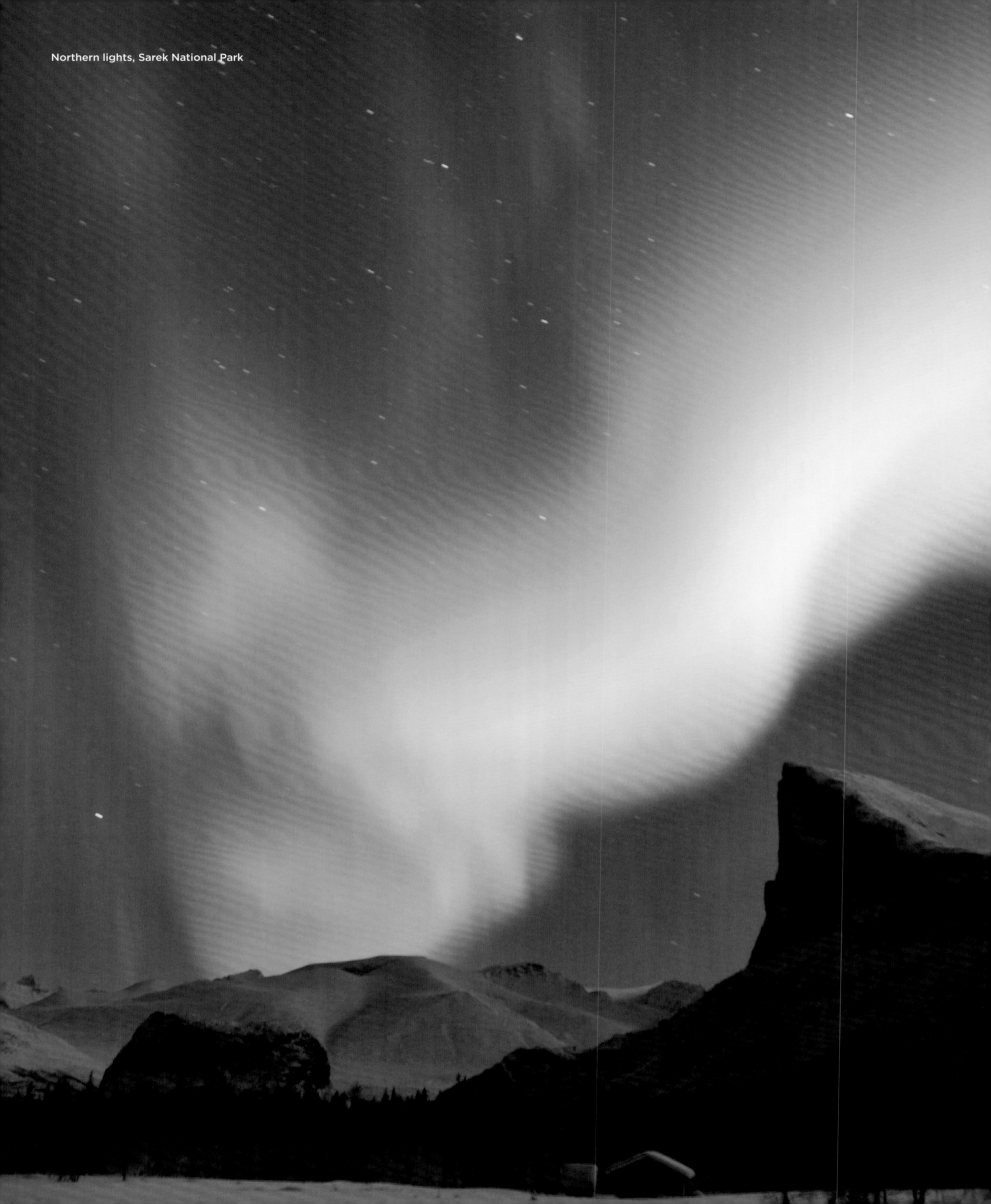

Northern lights, Sarek National Park

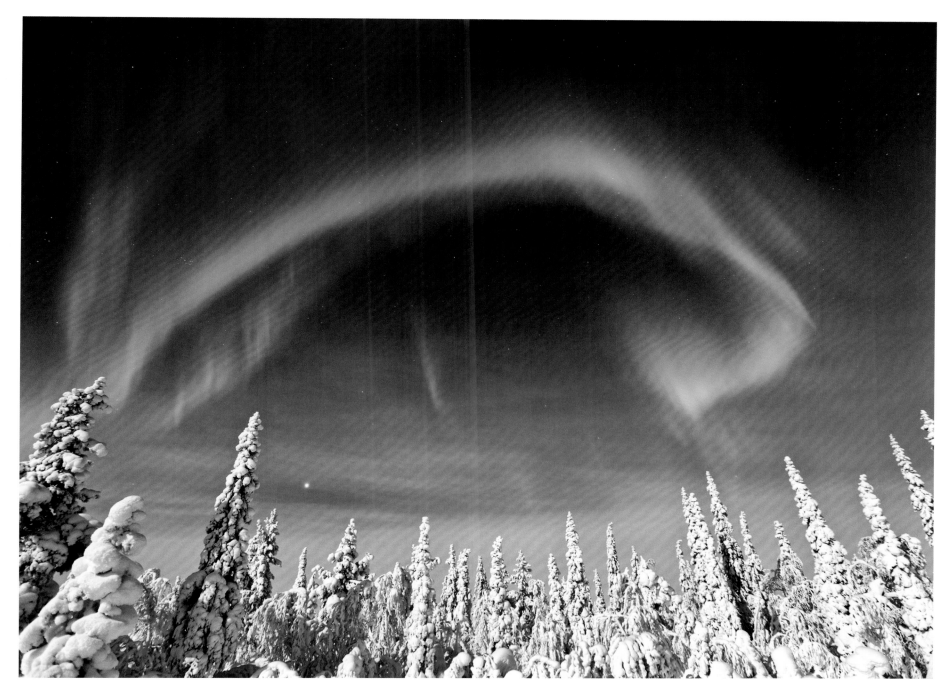

Northern lights, Norbotten County

Northern Lights

In Lapland in the far north of Sweden, the chances of observing the northern lights are particularly good. The proximity to the magnetic North Pole and the clear air favor this fascinating spectacle, which attracts visitors and nature photographers between September and March. The experience cannot be planned, you will need luck and patience.

Aurores boréales

Au nord de la Suède, en Laponie, les chances de voir des aurores boréales sont particulièrement propices. La proximité du pôle Nord magnétique et l'air pur favorisent ce spectacle fascinant qui attire aussi bien les visiteurs que les photographes, de septembre à mars. Les aurores boréales ne sont cependant pas prévisibles, il faut donc de la chance et s'armer de patience.

Nordlichter

Im hohen Norden Schwedens, in Lappland, sind die Chancen, Nordlichter zu beobachten, besonders gut. Die Nähe zum magnetischen Nordpol und die klare Luft begünstigen das faszinierende Schauspiel, das von September bis März Besucher wie Naturfotografen anzieht. Planbar ist das Ereignis nicht, man braucht Glück und Geduld.

Aurora boreal

En el extremo norte de Suecia, en Laponia, las posibilidades de observar la aurora boreal son particularmente buenas. La proximidad al Polo Norte magnético y el aire puro favorecen el fascinante espectáculo, que atrae a visitantes y fotógrafos de naturaleza de septiembre a marzo. El evento no se puede planear; se necesita suerte y paciencia.

Luzes do norte

No extremo norte da Suécia, na Lapónia, as possibilidades de observar as luzes do norte são excelentes. A proximidade do Pólo Norte magnético e o ar puro favorecem o espectáculo fascinante, que atrai visitantes e fotógrafos da natureza de setembro a março. O evento não pode ser previsível, é preciso ter sorte e paciência.

Noorderlicht

In het uiterste noorden van Zweden, in Lapland, zijn de kansen om het noorderlicht te observeren bijzonder goed. De nabijheid van de magnetische Noordpool en de heldere lucht bevorderen het fascinerende schouwspel, dat van september tot maart bezoekers en natuurfotografen aantrekt. Het evenement kan niet gepland worden, men heeft geluk en geduld nodig.

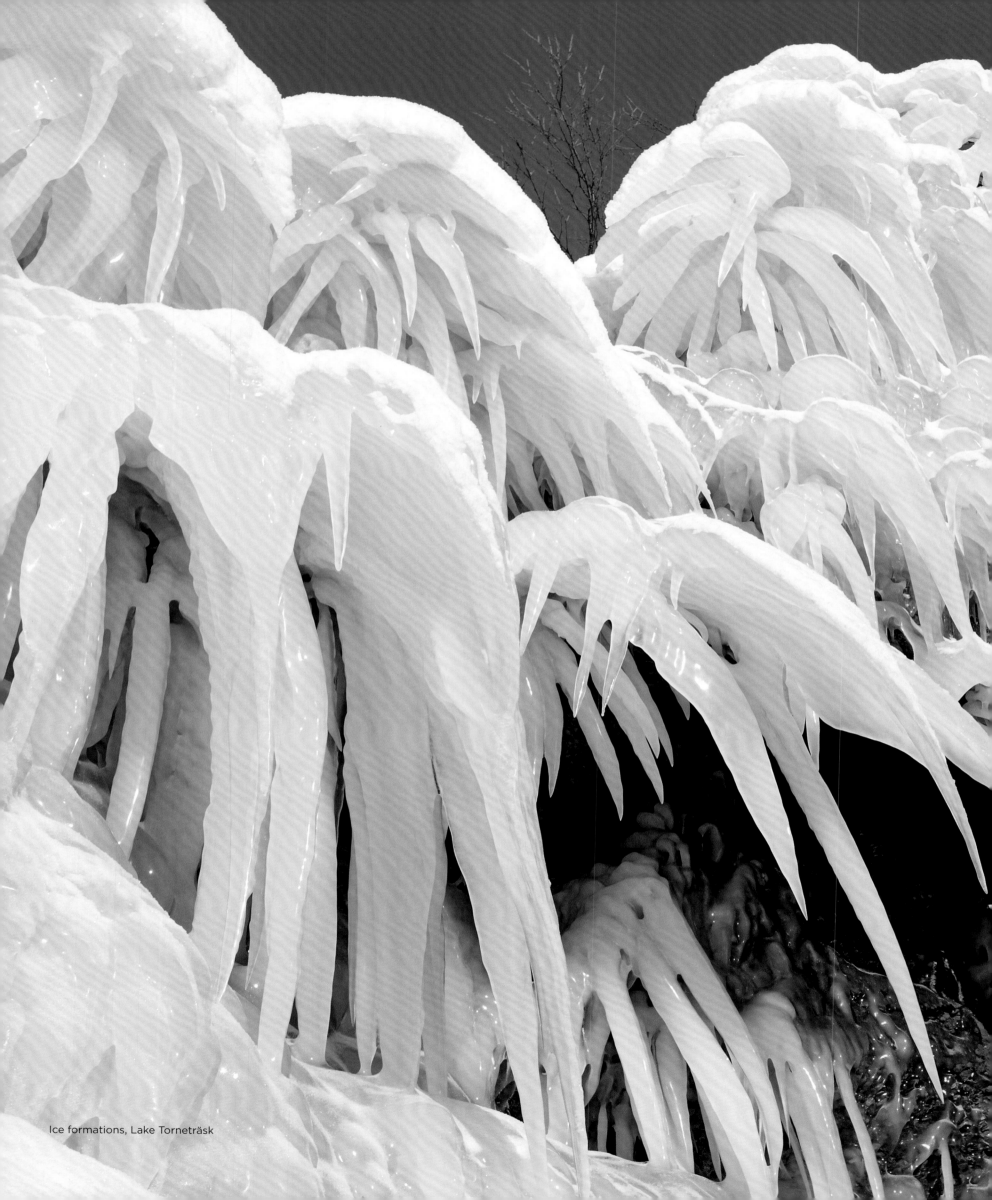

Ice formations, Lake Torneträsk

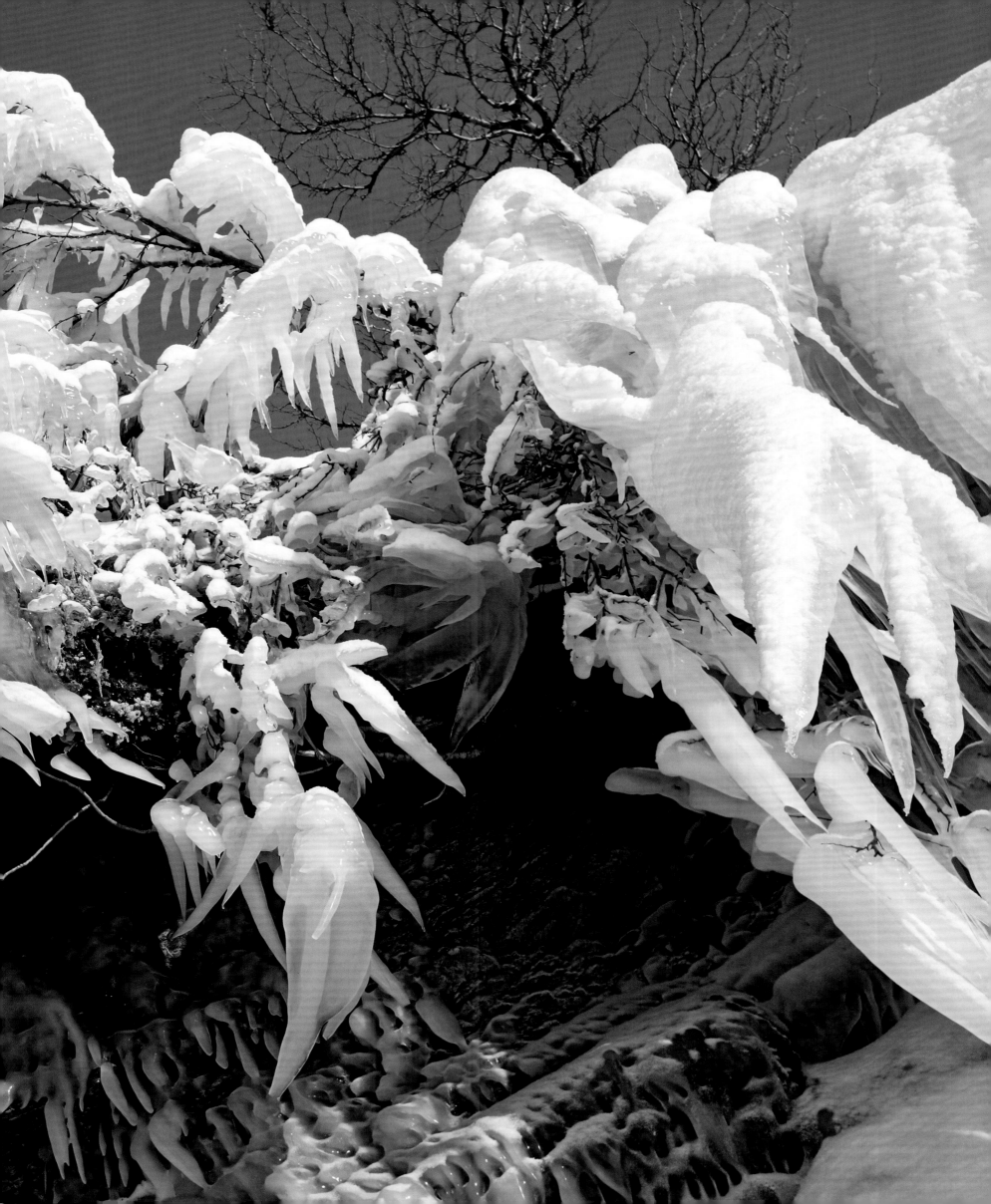

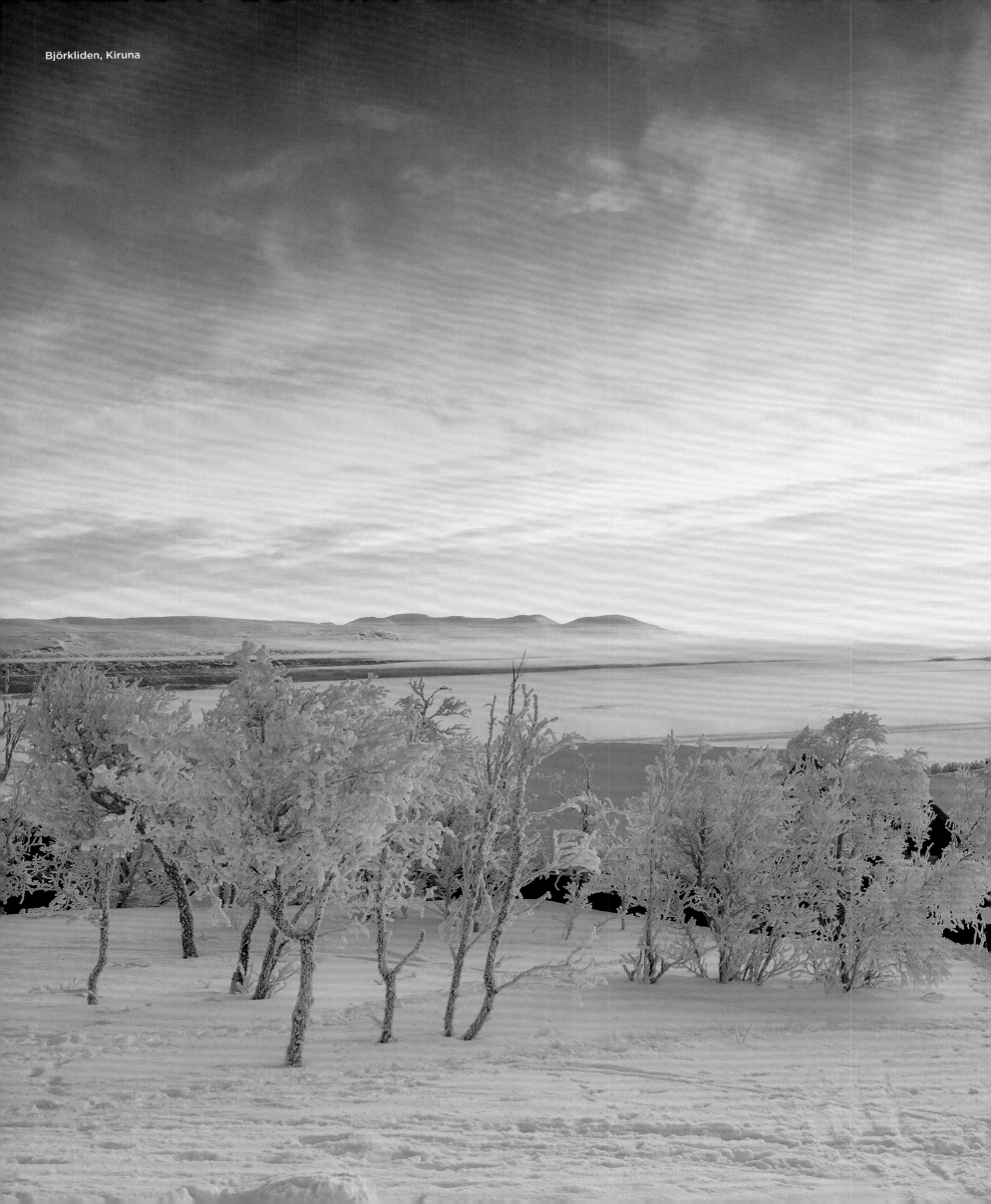

Björkliden, Kiruna

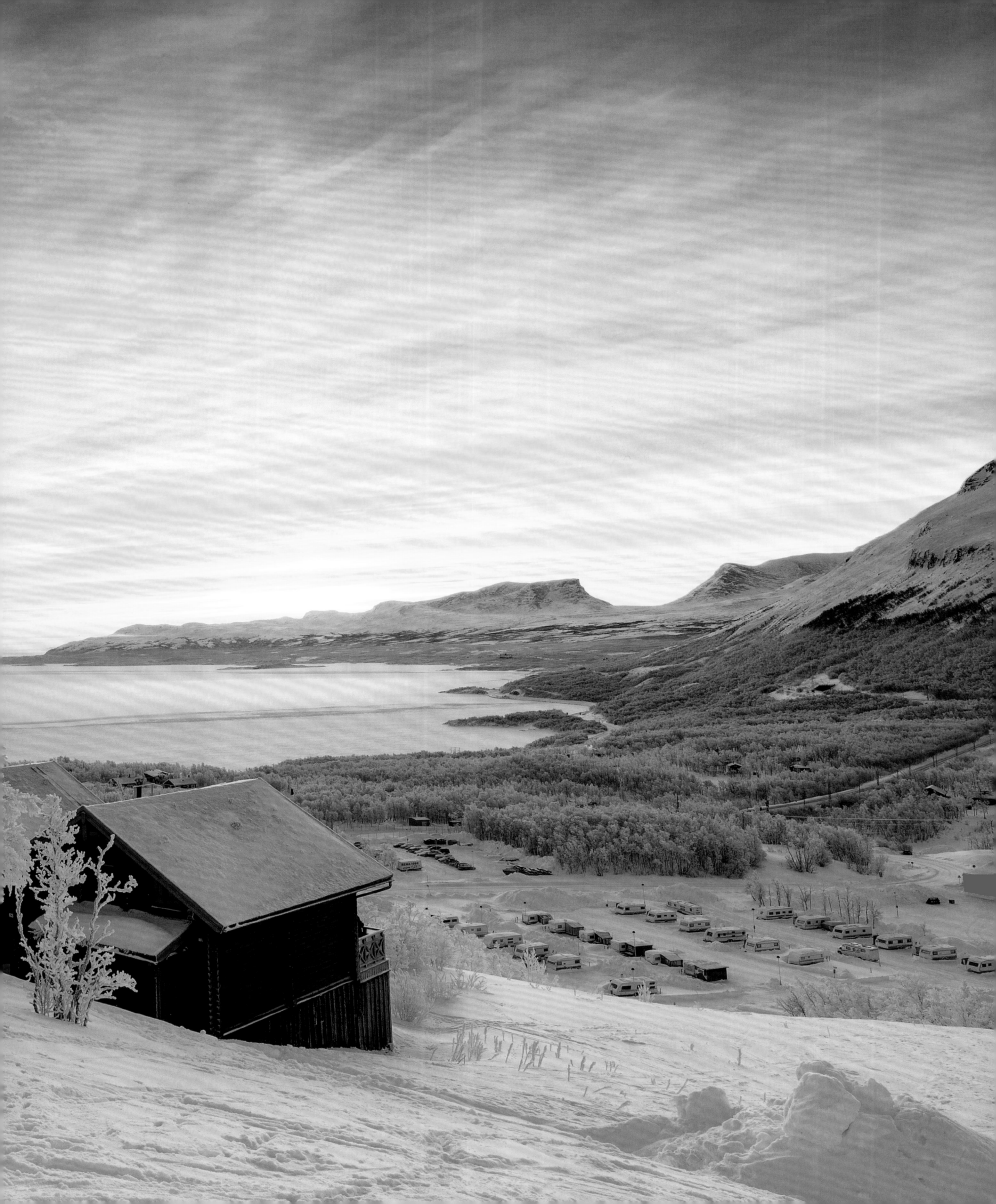

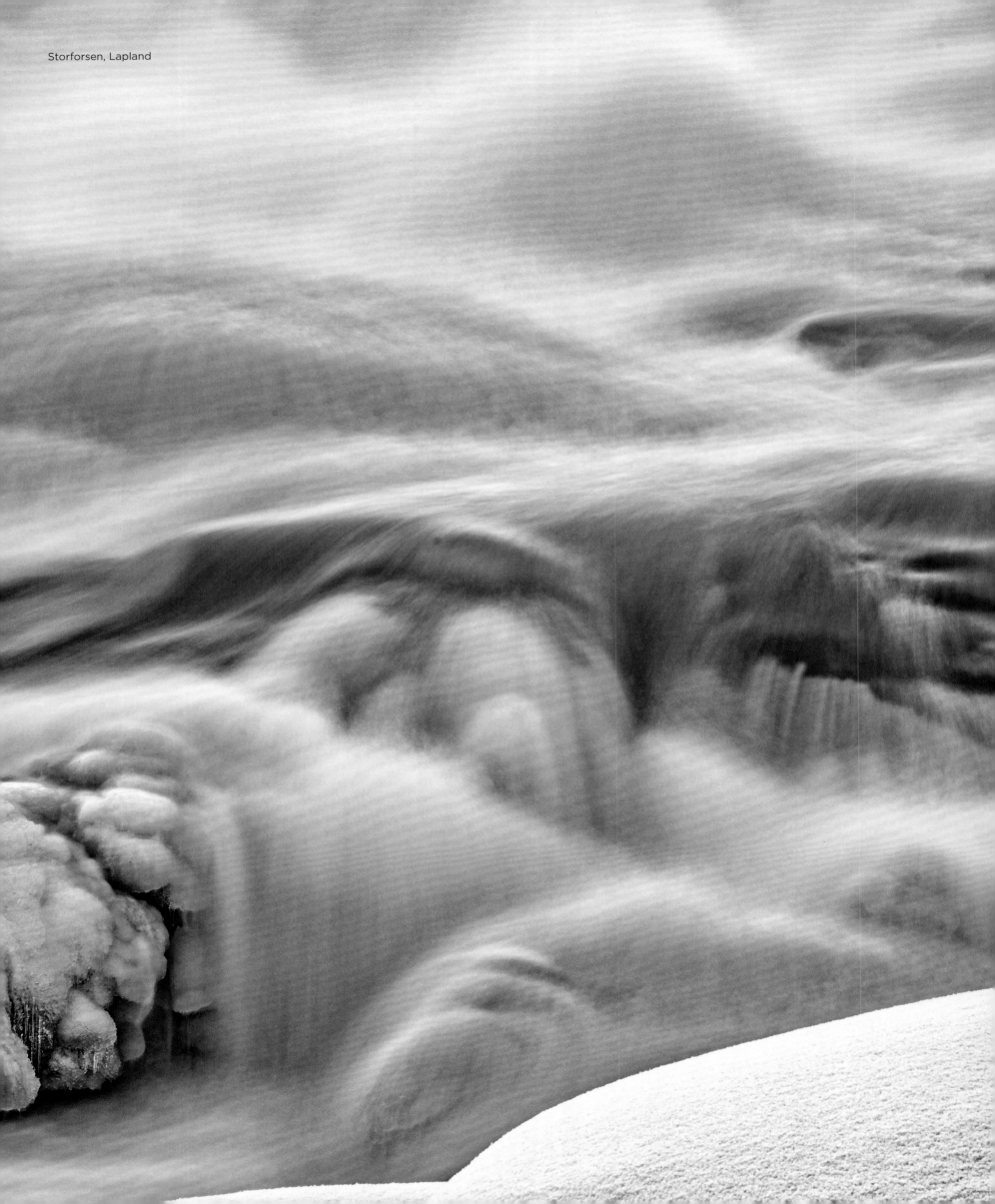

Storforsen, Lapland

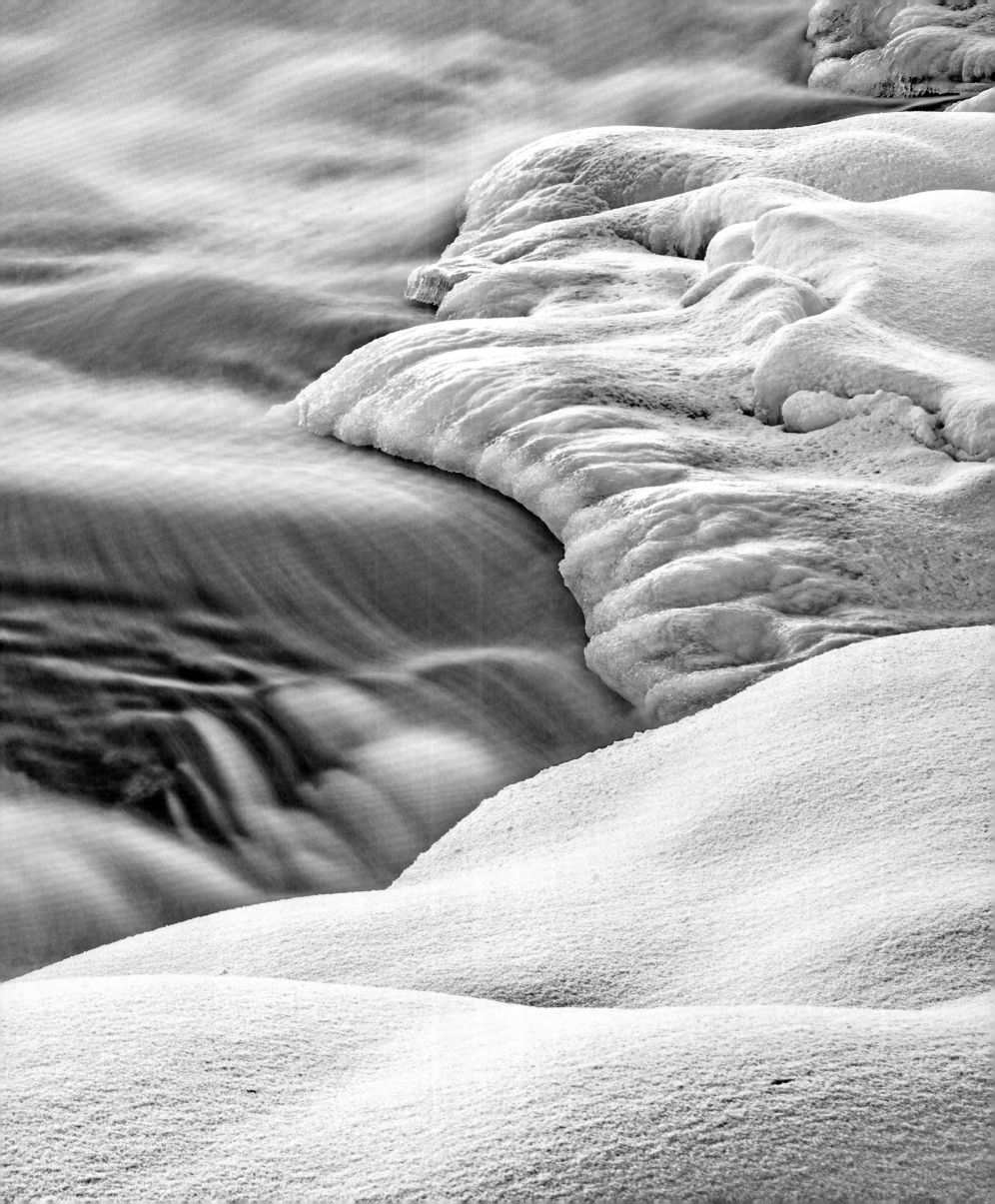

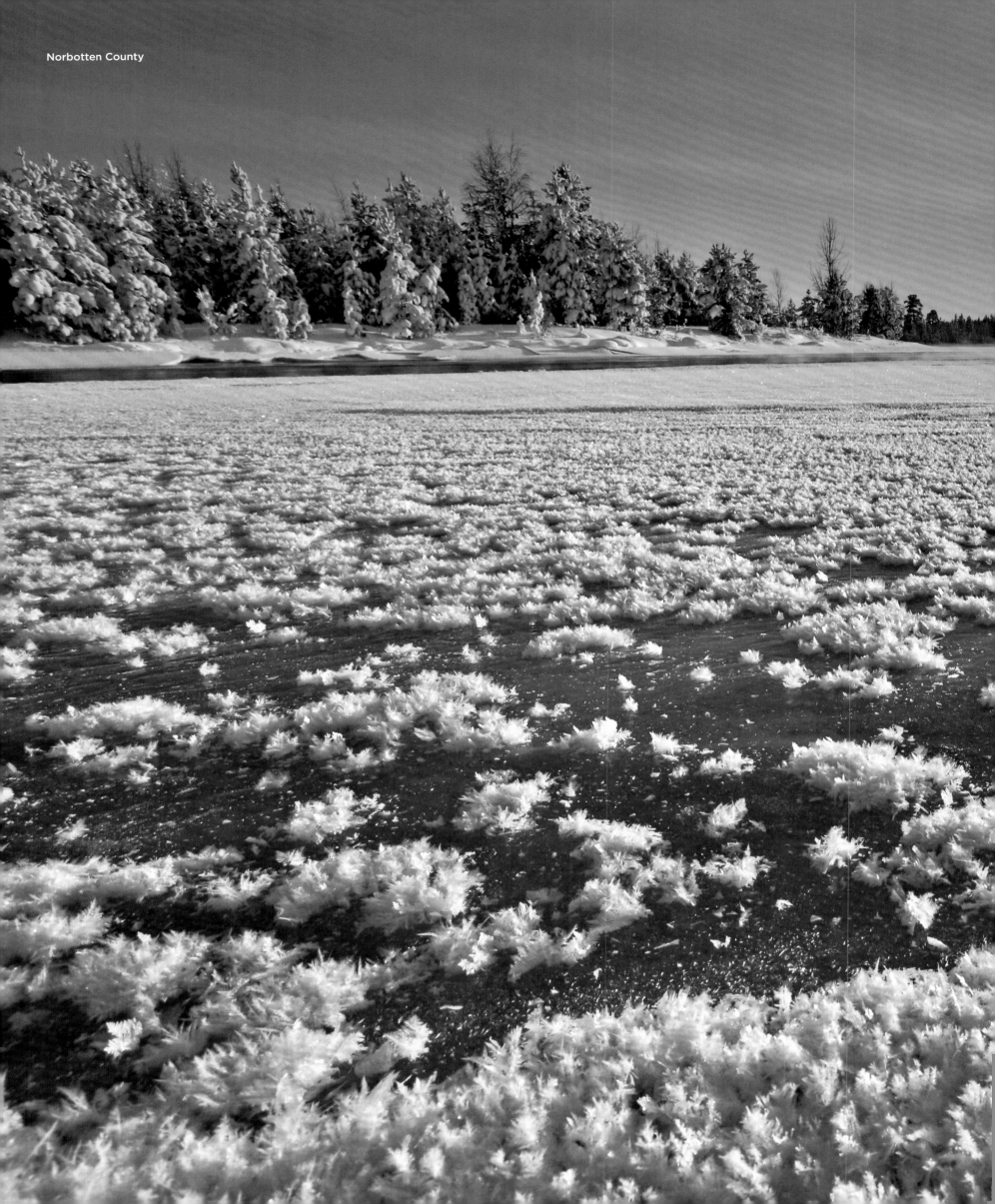

Norbotten County

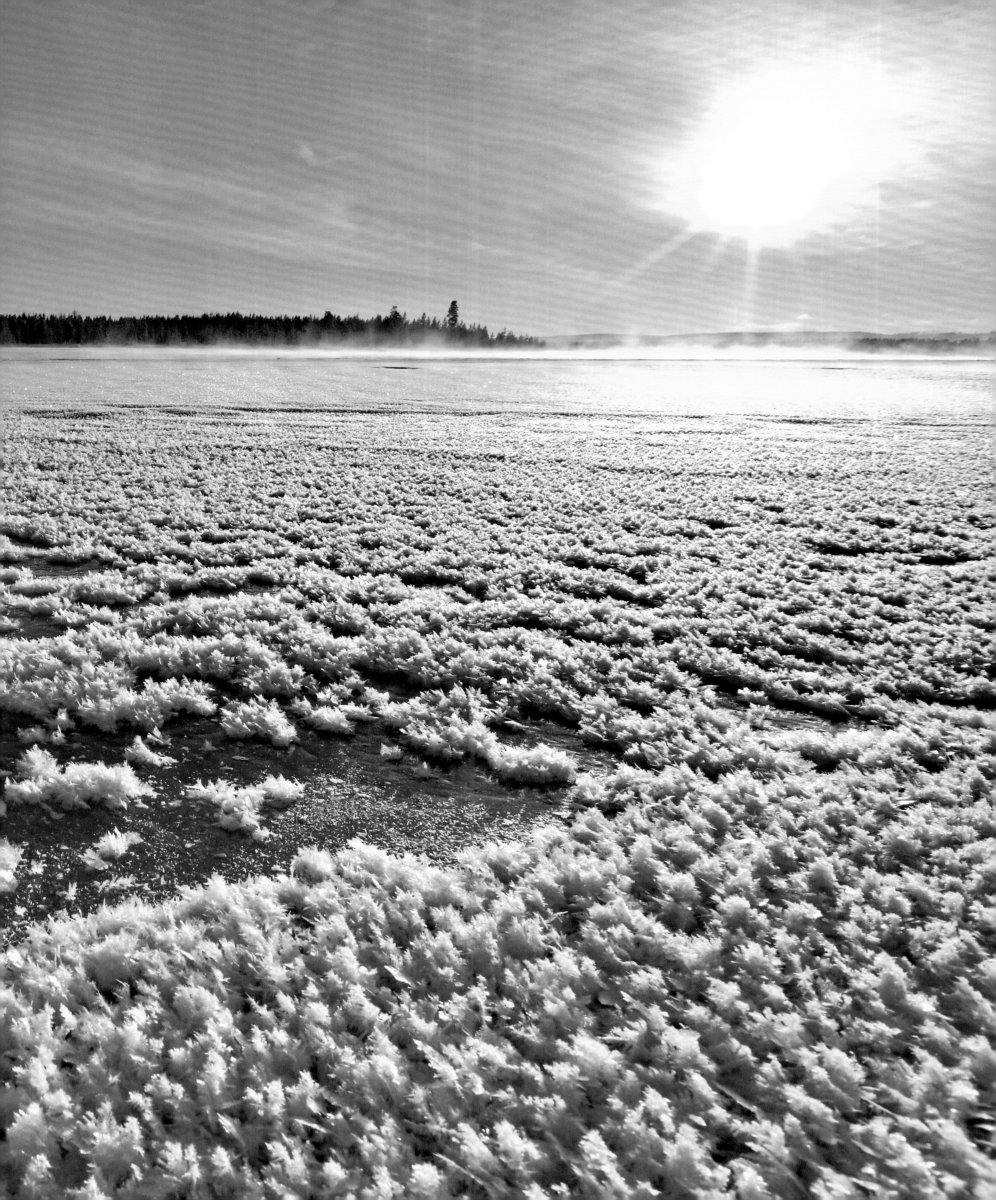

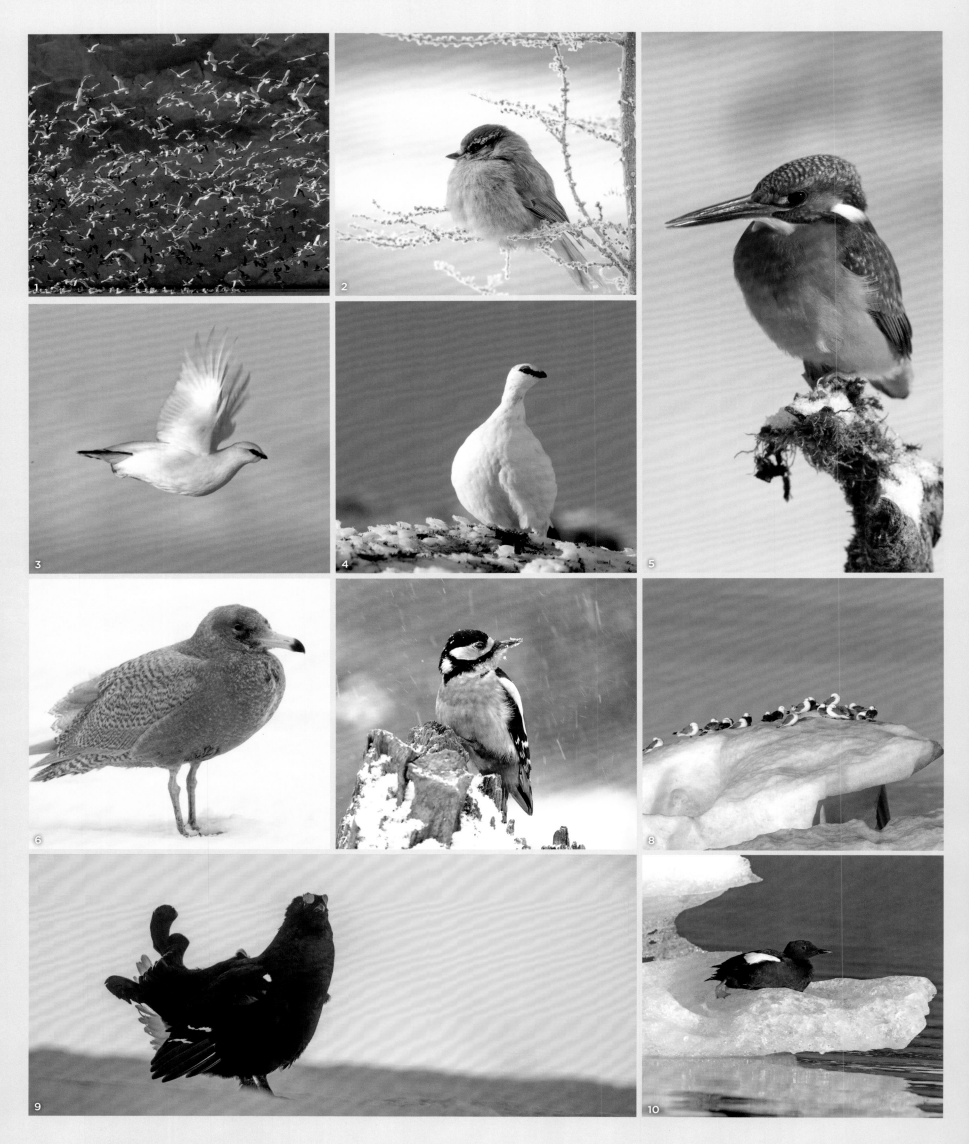

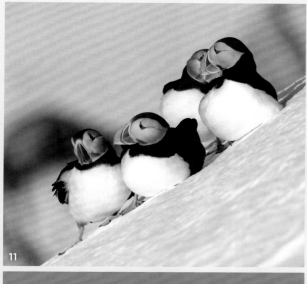

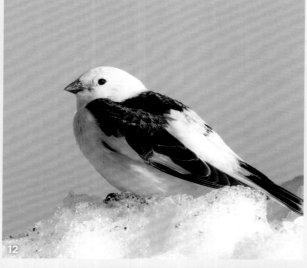

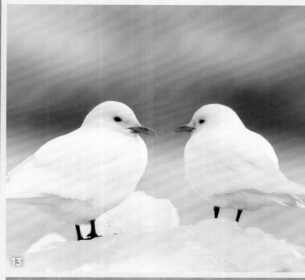

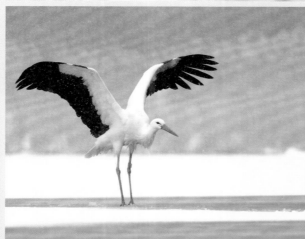

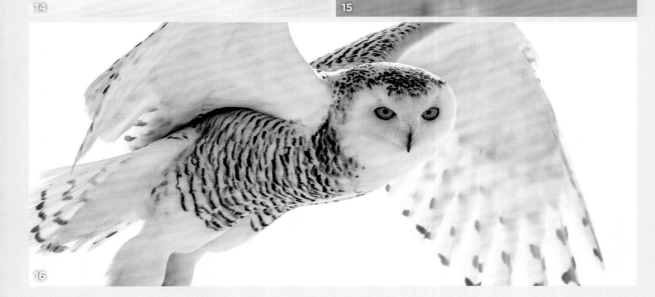

Birds

1, 8 Black-legged kittiwakes, Mouette tridactyle, Dreizehenmöwen, Gaviotas tridáctilas, Gaivota tridáctila, Drieteenmeeuwen

2 Siberian jay, Mésangeai imitateur, Unglückshäher, Arrendajo siberiano, Gaio-siberiano, Taigagaai

3 Willow ptarmigan, Lagopède des saules, Moorschneehuhn, Lagópodo escandinavo, Lagópode-escocês, Moerassneeuwhoen

4 Snow grouse, Lagopède, Schneehuhn, Lagópodo, Perdiz branca polar, Lagopus

5 Kingfisher, Martin-pêcheur d'Europe, Eisvogel, Martín pescador común, Martim-pescador, IJsvogel

6 Glaucous gull, Goéland bourgmestre, Eismöwe, Gaviota hiperbórea, Grote burgemeester

7 Great spotted woodpecker, Pic épeiche, Buntspecht, Pico picapinos, Pica-pau-malhado-grande, Grote bonte specht

9 Black grouse, Tétras lyre, Birkhuhn, Gallo lira común, Galo-lira, Korhoen

10 Black guillemot, Guillemot à miroir, Gryllteiste, Arao aliblanco, Arau-d´asa-branca, Zwarte zeekoet

11 Puffins, Macareux moine, Papageitaucher, Frailecillos atlánticos, Papagaio-do-mar, Papegaaiduiker

12 Snow bunting, Plectrophane des neiges, Schneeammer, Escribano nival, Escrevedeira-das-neves, Sneeuwgorsen

13 Ivory gulls, Mouette blanche, Elfenbeinmöwen, Gaviotas marfileñas, Gaivotas-marfim, Ivoormeeuwen

14 Snowfinch, Niverolle alpine, Schneesperling, Gorrión nival, Pardal-das-neves, Sneeuwvink

15 White stork, Cigogne blanche, Weißstorch, Cigüeña blanca, Cegonha-branca, Ooievaar

16 Snowy owl, Chouette harfang, Schnee-Eule, Búho nival, Coruja-das-neves, Sneeuwuil

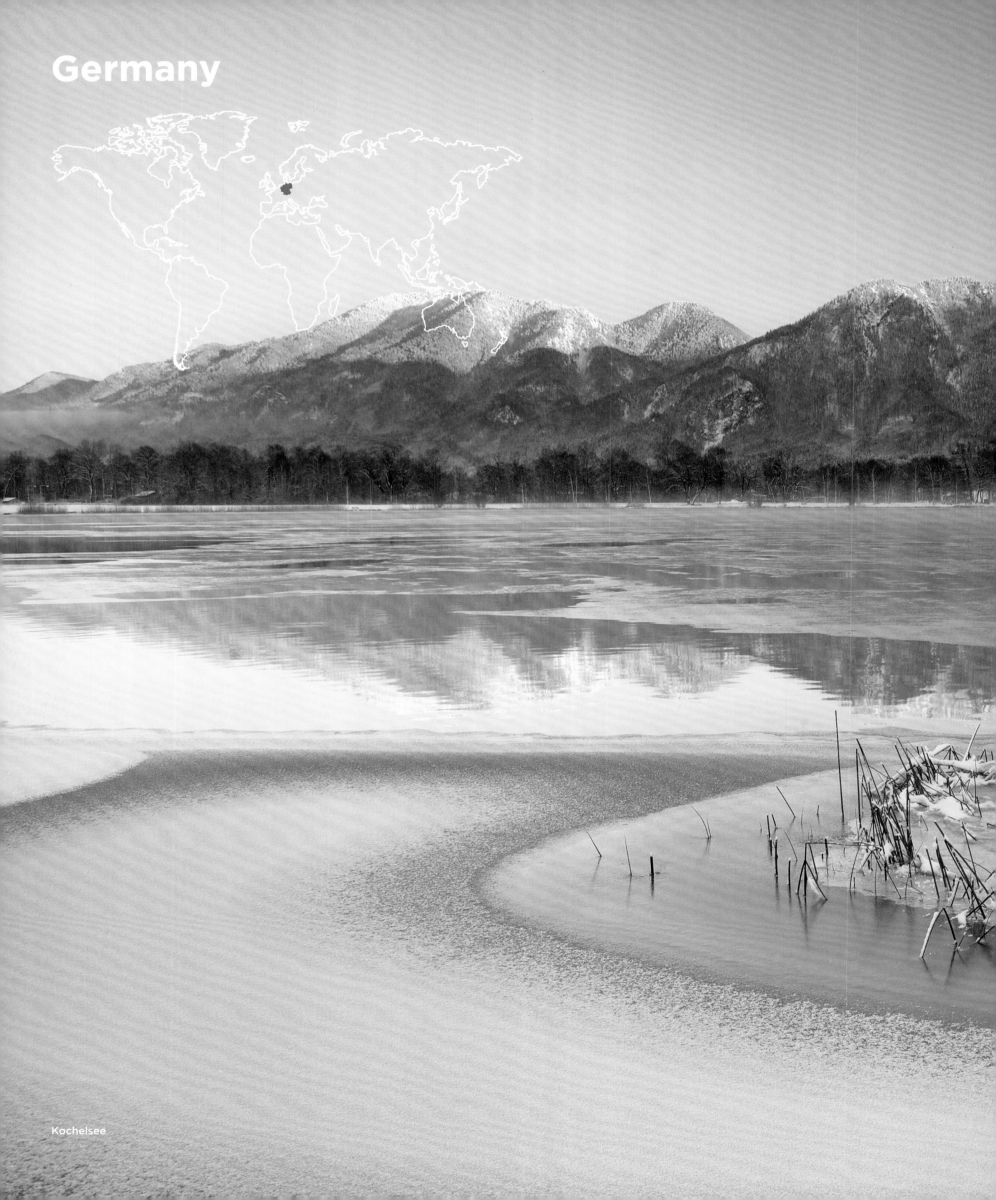

Germany

Kochelsee

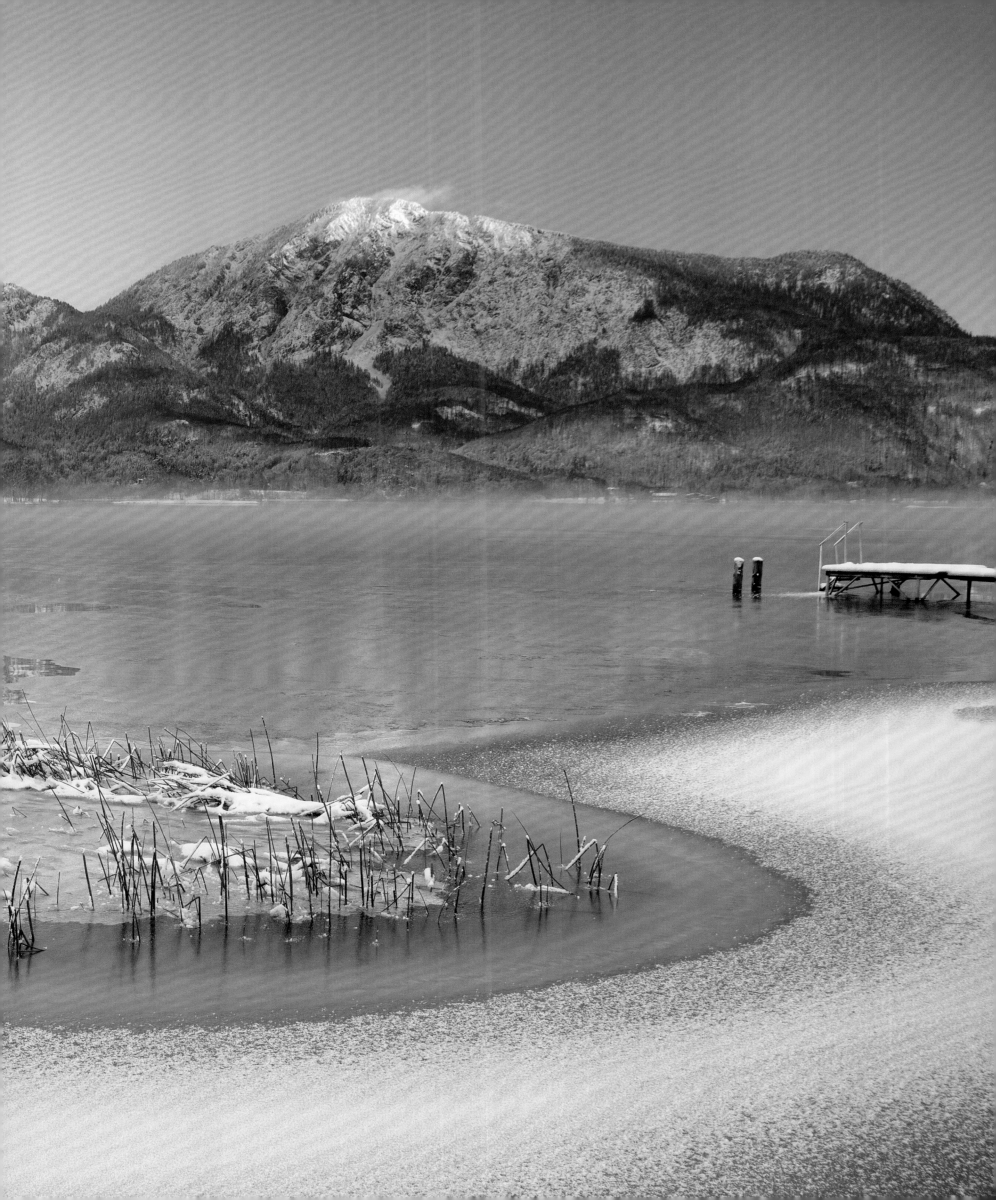

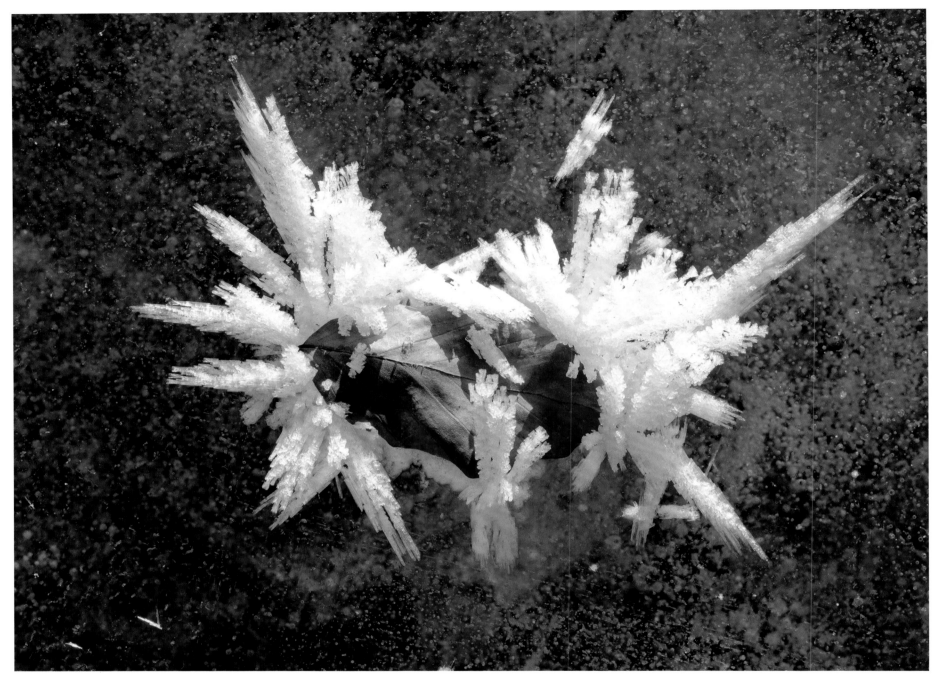

Isarauen, Bavaria

Germany

Europe's most populous state has a temperate climate. It is only in the Alps, of which Germany has a small portion, that are there some glaciers located around the Zugspitze massif, which reaches its highest on the Zugspitze, Germany's highest mountain at 2962 m (9718 ft). Cold winters with abundant snow can also occur in the low mountain ranges, but climate change is making itself felt everywhere with higher average temperatures. Germany is a much visited tourist destination, and the capital Berlin is a major attraction. However, winter idylls with snow-covered mountains and the Christmas markets are particularly popular.

Allemagne

L'état le plus peuplé d'Europe a un climat tempéré. Il n'y a que dans les Alpes, dont une petite part se trouve en Allemagne, que l'on trouve quelques glaciers aux alentours du massif du Wetterstein. Son sommet le plus haut, la Zugspitze, culminant à 2 962 m d'altitude, est aussi la plus haute montagne du pays. En moyenne montagne également, les hivers peuvent être froids et enneigés mais le réchauffement climatique se fait toutefois sentir avec des températures moyennes plus élevées. L'Allemagne est un pays prisé de nombreux voyageurs et sa capitale, Berlin, est un important pôle d'attraction. Cependant, sont particulièrement appréciées les idylles hivernales au cœur des paysages montagneux enneigés et dans les allées des marchés de Noël.

Deutschland

Der bevölkerungsreichste Staat Europas hat ein gemäßigtes Klima. Lediglich in den Alpen, an denen Deutschland einen kleinen Anteil hat, gibt es einige Gletscher rund um das Zugspitzmassiv, das in der Zugspitze gipfelt, mit 2962 m Deutschlands höchster Berg. Kalte Winter mit viel Schnee kann es auch in den Mittelgebirgen geben, doch macht sich der Klimawandel überall mit höheren Durchschnittstemperaturen bemerkbar. Deutschland ist ein viel besuchtes Reiseland, die Hauptstadt Berlin ein Anziehungspunkt. Besonders beliebt sind aber winterliche Idyllen mit verschneiten Bergwelten und Weihnachtsmärkten.

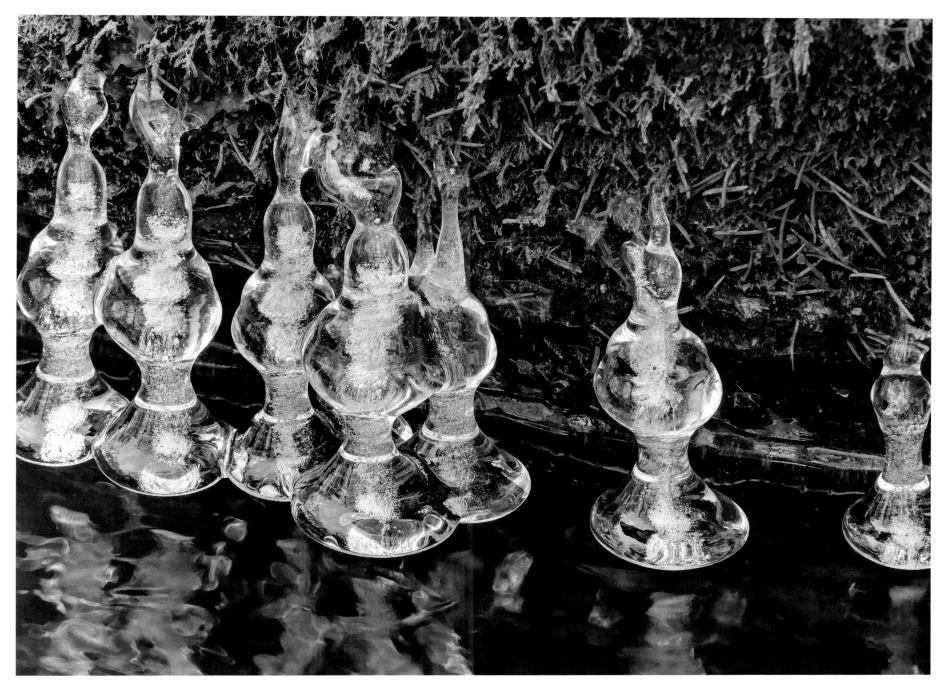

Wenichbach, Tabener Urwald

Alemania

El estado más poblado de Europa tiene un clima templado. Solo en los Alpes, en los que Alemania tiene una pequeña parte, hay algunos glaciares alrededor del macizo del Zugspitze, que culmina en el Zugspitze, la montaña más alta de Alemania con 2962 m. En las cordilleras bajas también puede haber inviernos fríos con mucha nieve, pero el cambio climático se está haciendo sentir en todas partes con temperaturas medias más altas. Alemania es un destino turístico muy visitado y su capital, Berlín, es un gran centro de atracción. Pero lo que es particularmente popular son los idílicos inviernos con montañas nevadas y mercadillos navideños.

Alemanha

O país mais populoso da Europa tem um clima temperado. Apenas nos Alpes, nos quais a Alemanha tem uma pequena parte, existem algumas geleiras ao redor do maciço de Zugspitze, que culminam no cume principal Zugspitze, a montanha mais alta da Alemanha com 2962 m. Invernos frios com muita neve também podem ocorrer nas montanhas baixas, mas pode-se sentir a mudança climática em todos os lugares com temperaturas médias mais altas. A Alemanha é um destino turístico muito visitado, a capital Berlim uma atração. No entanto, os idílios de inverno com montanhas cobertas de neve e mercados de Natal são particularmente populares.

Duitsland

De dichtstbevolkte staat van Europa heeft een gematigd klimaat. Alleen in de Alpen, waar Duitsland een klein aandeel in heeft, zijn er enkele gletsjers rond het Zugspitze-massief, dat uitmondt in de Zugspitze, de hoogste berg van Duitsland met 2962 m. Koude winters met veel sneeuw kunnen ook in de middelgebergten voorkomen, maar met hogere gemiddelde temperaturen is de klimaatverandering overal voelbaar. Duitsland is een veel bezochte toeristische bestemming, de hoofdstad Berlijn een attractie. Vooral winteridylles met besneeuwde bergen en kerstmarkten zijn erg populair.

Kesselbachfälle, Kochel am See

Ilse, Harz National Park

Harz National Park

In cold winters, the heights of the Harz low mountain range are often covered in snow and ice. This is due to the harsh climate, the abundant rainfall to the west and the low 1000 m (3280 ft) tree line. This is when the idyllic course of the 50 km (321 mi) long Ilse freezes over. On the highest mountain, the 1141 m (3743 ft) Brocken, temperatures of minus 28 °C (-18 °F) have been measured.

Parc national du Harz

Lorsque les hivers sont froids, les hauteurs de la région semi-montagneuse du Harz se retrouvent souvent ensevelies sous la neige et la glace. Cela est dû à la rudesse du climat, aux importantes précipitations sur le versant ouest et à la faible hauteur de la limite de la zone arborée (1 000 m). Il arrive alors que les 50 km du cours bucolique de la rivière Ilse gèlent. Sur le plus haut sommet, le Brocken (1 141 m), des températures allant jusqu'à -28° C ont déjà été relevées.

Nationalpark Harz

In kalten Wintern versinken die Höhen des Mittelgebirges Harz häufig unter Schnee- und Eislasten. Grund sind das raue Klima, die reichlichen Niederschläge auf der Westseite und die niedrige Baumgrenze (1000 m). Dann passiert es, dass der idyllische Lauf der 50 km langen Ilse zufriert. Auf dem höchsten Berg, dem Brocken (1141 m), wurden schon minus 28 °C gemessen.

Parque Nacional de Harz

En inviernos fríos, las alturas de la cordillera baja de Harz a menudo se hunden bajo las cargas de nieve y hielo. Esto se debe a la dureza del clima, a las abundantes lluvias en el lado oeste y a la baja arboleda (1000 m). Entonces sucede que el idílico curso de los 50 km de largo de Ilse se congela. En la montaña más alta, el Brocken (1141 m), ya se han medido -28 °C.

Parque Nacional de Harz

Nos invernos frios, os pontos mais altos da cordilheira baixa de Harz afundam-se muitas vezes sob cargas de neve e gelo. Isto é devido ao clima rigoroso, à abundância de chuvas no lado oeste e à baixa linha de árvores (1000 m). Então acontece o congelamento do curso idílico dos 50 km do rio Ilse. Na montaña mais alta, o Brocken (1141 m), já foram medidos menos 28 °C .

Nationaal Park Harz

In koude winters verzinken de hoogten van de Harz in het middelgebergte vaak onder sneeuw en ijs. Dit komt door het harde klimaat, de overvloedige regenval aan de westkant en de lage boomgrens (1000 m). Dan komt het voor dat het idyllische verloop van de 50 km lange Ilse bevriest. Op de hoogste berg, de Brocken (1141 m), werd al een temperatuur van -28 °C gemeten.

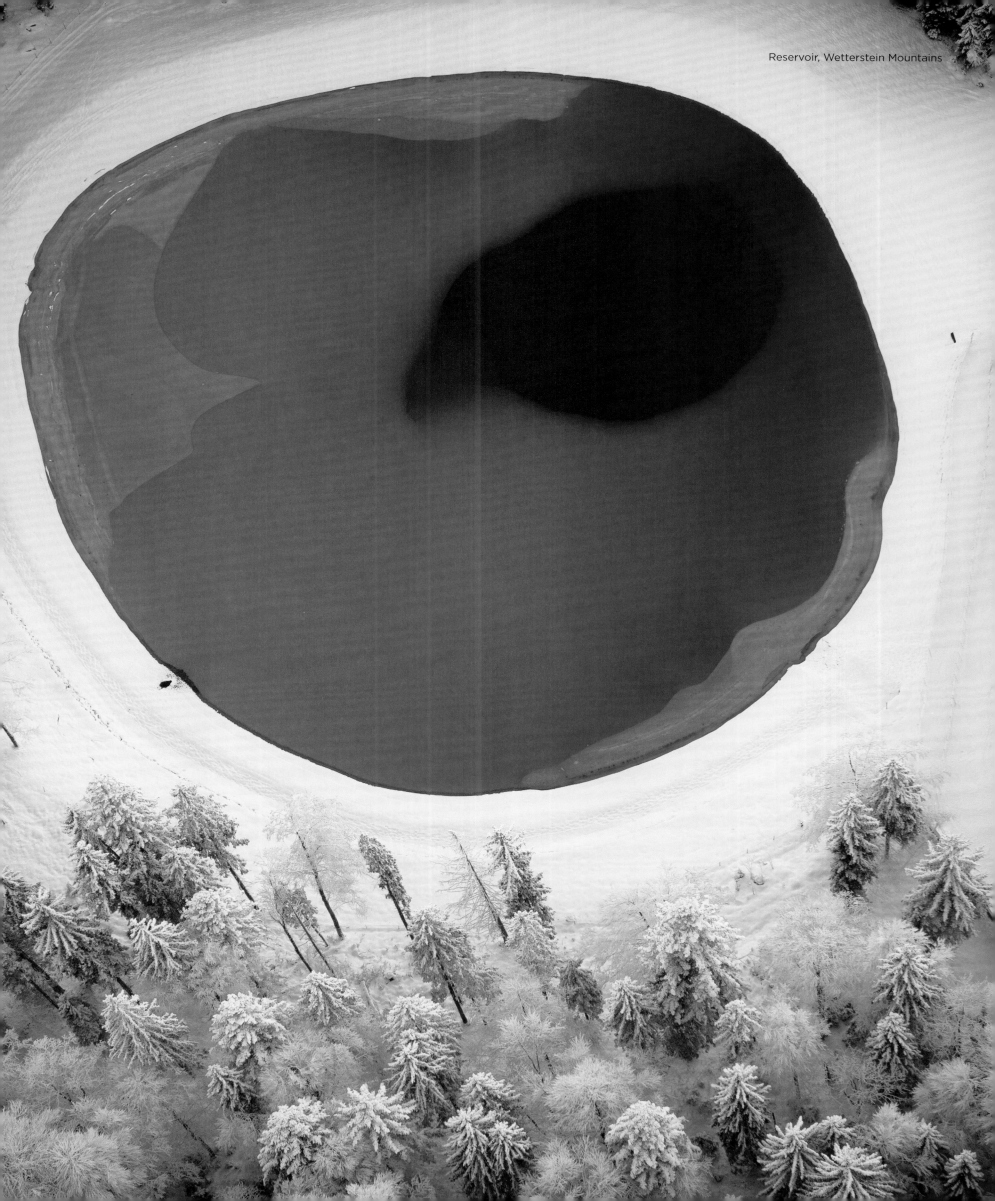

Reservoir, Wetterstein Mountains

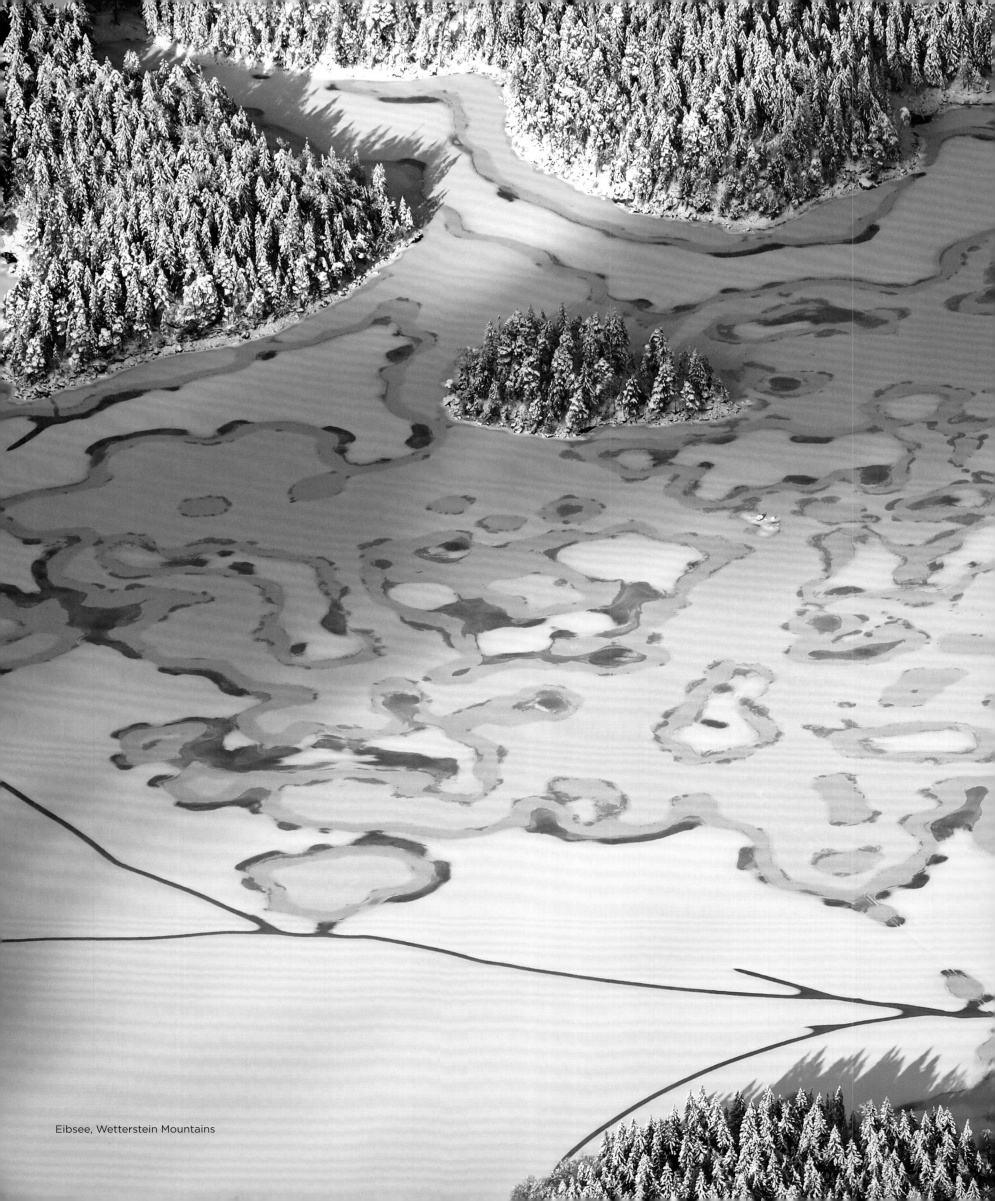

Eibsee, Wetterstein Mountains

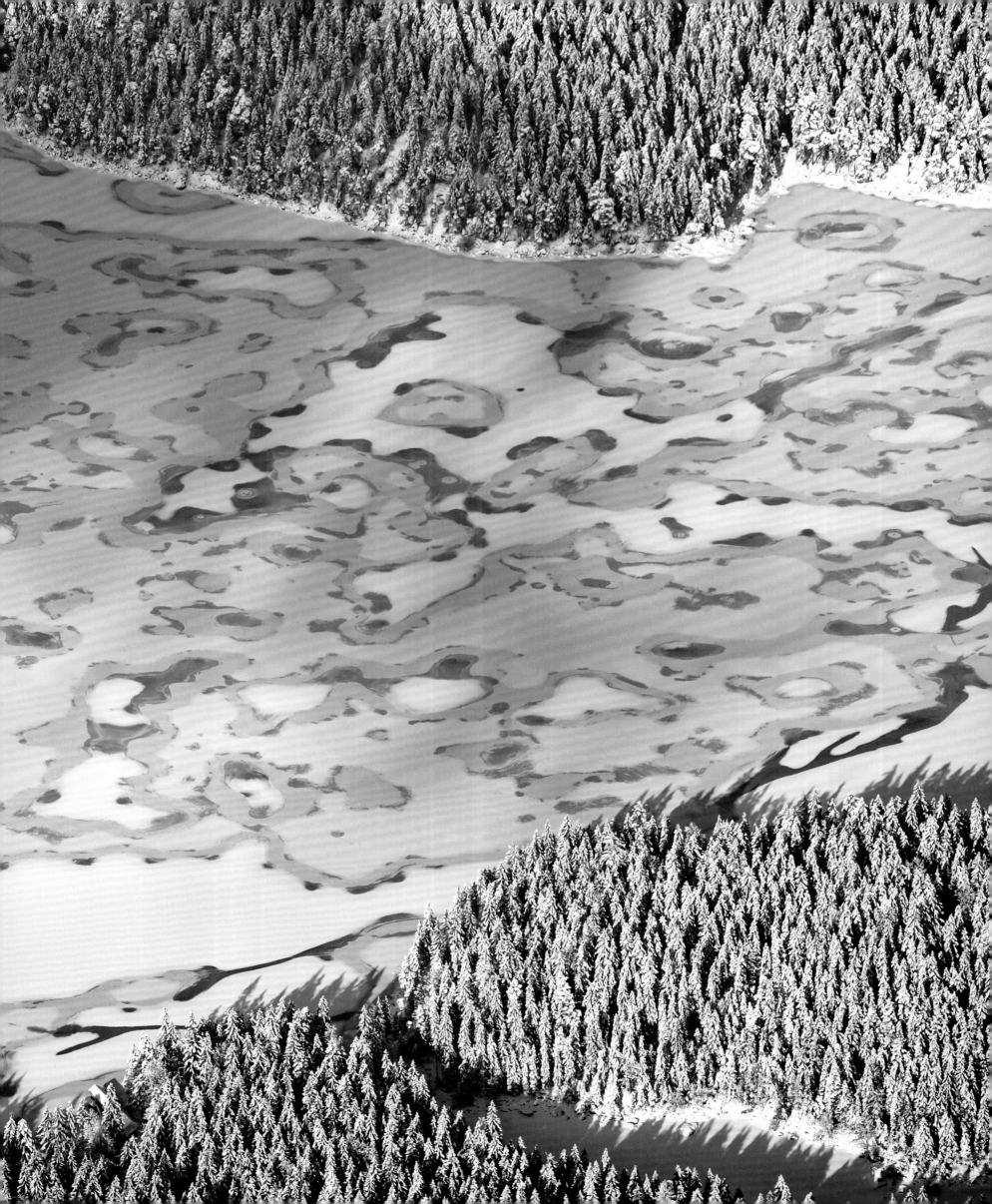

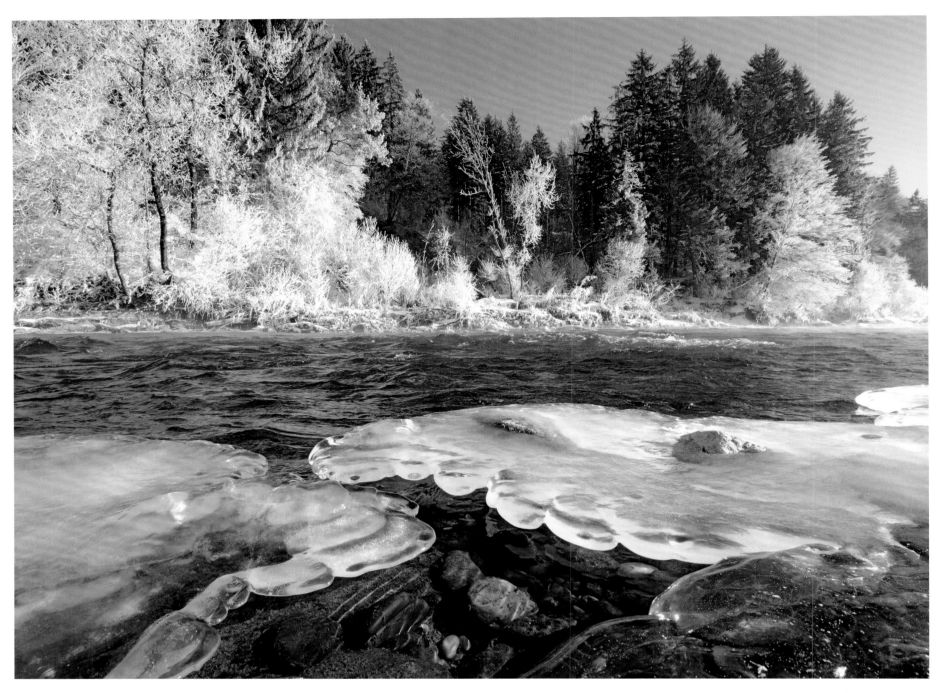

Isarauen, Geretsried

Isar

In the Austrian Karwendelgebirge, the 290 km
(180 mi) long Isar River rises at an altitude of 1160 m
(3806 ft) and flows into the Danube. Along the
way it passes the Bavarian capital Munich, where
it has high recreational value for the inhabitants.
It is also utilized economically, for example by a
number of hydroelectric power stations. Above all,
the significance of the river and its catchment area
for tourism is increasing. The upper reaches of the
river are particularly attractive when it freezes over in
cold winters and beautiful views of the snow-covered
Wetterstein mountains and the Zugspitze open up.

L'Isar

L'Isar prend sa source à 1 160 m d'altitude, dans la
partie autrichienne du massif des Karwendel et se
jette dans le Danube 290 km plus loin. Au passage,
elle traverse la capitale bavaroise, Munich, où elle a
une valeur récréative très appréciée des citadins. Elle
est également exploitée économiquement par le biais
de centrales hydroélectriques, mais ce sont surtout
son attrait touristique et ses nombreuses activités
autour de son bassin qui, pour les Munichois, prennent
de l'importance. Le cours supérieur de la rivière est
particulièrement charmant lorsque, en hiver, ses eaux
gèlent et de magnifiques perspectives s'ouvrent sur le
massif du Wetterstein et sur la Zugspitze enneigés.

Isar

Im österreichischen Karwendelgebirge entspringt
in 1160 m Höhe die Isar, die nach 290 km in
die Donau mündet. Unterwegs passiert sie die
bayerische Landeshauptstadt München, wo sie
großen Erholungswert für die Städter hat. Sie wird
wirtschaftlich genutzt, etwa durch eine Reihe von
Wasserkraftwerken. Aber vor allem die touristische
Bedeutung des Flusses und seines Einzugsbereichs
etwa als Naherholungsgebiet für die Münchner nimmt
zu. Reizvoll ist besonders der Oberlauf, wenn in
kalten Wintern das Gewässer zufriert und sich schöne
Ausblicke auf das verschneite Wettersteingebirge mit
der Zugspitze eröffnen.

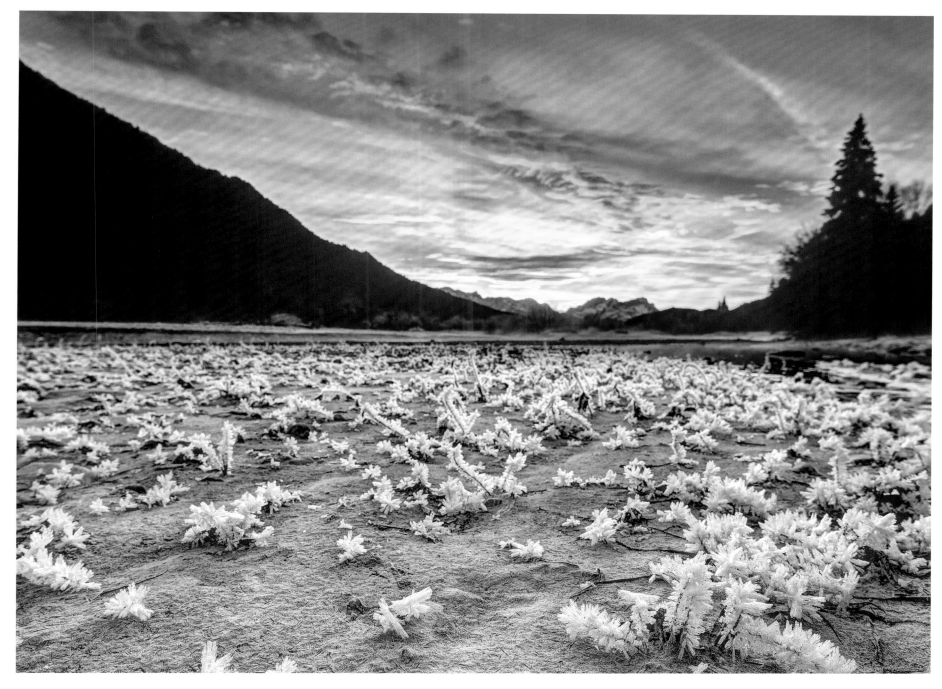

Isarauen, Wallgau

Isar

En los montes austríacos del Karwendel, el río Isar nace a 1160 m de altitud y desemboca en el Danubio después de 290 km de recorrido. En el camino pasa por la capital bávara, Múnich, donde tiene un gran valor recreativo para los habitantes de la ciudad. Se utiliza de forma económica, por ejemplo, en varias centrales hidroeléctricas. Pero sobre todo la importancia turística del río y de su cuenca, por ejemplo como zona de recreo para los habitantes de Múnich, va en aumento. Los tramos superiores del río son especialmente atractivos cuando el agua se congela en los inviernos fríos y se abren hermosas vistas de las montañas nevadas de Wetterstein y del Zugspitze.

Isar

Na cordilheira de Karwendel austríaca, o rio Isar sobe a uma altitude de 1160 m e deságua no Danúbio após 290 km. No caminho passa pela capital da Baviera, Munique, onde tem grande valor recreativo para os habitantes da cidade. É utilizado economicamente, por exemplo, por várias centrais hidroelétricas. Mas, acima de tudo, a importância turística do rio e da sua bacia hidrográfica, por exemplo, como área de lazer local para os habitantes de Munique, está a aumentar. As partes superiores do rio são particularmente atraentes, quando a água congela nos invernos frios e abrem-se belas vistas das montanhas nevadas de Wetterstein com o Zugspitze.

Isar

In het Oostenrijkse Karwendelgebergte stijgt de Isar op een hoogte van 1160 m en mondt na 290 km uit in de Donau. Onderweg passeert het de Beierse hoofdstad München, waar het voor de stadsbewoners een grote recreatieve waarde heeft. Het wordt economisch gebruikt, bijvoorbeeld door een aantal waterkrachtcentrales. Maar bovenal neemt de toeristische betekenis van de rivier en zijn stroomgebied, bijvoorbeeld als lokaal recreatiegebied voor de inwoners van München, toe. De bovenloop van de rivier is vooral aantrekkelijk wanneer het water in koude winters bevriest en het prachtige uitzicht op de besneeuwde Wettersteinbergen en de Zugspitze zich opent.

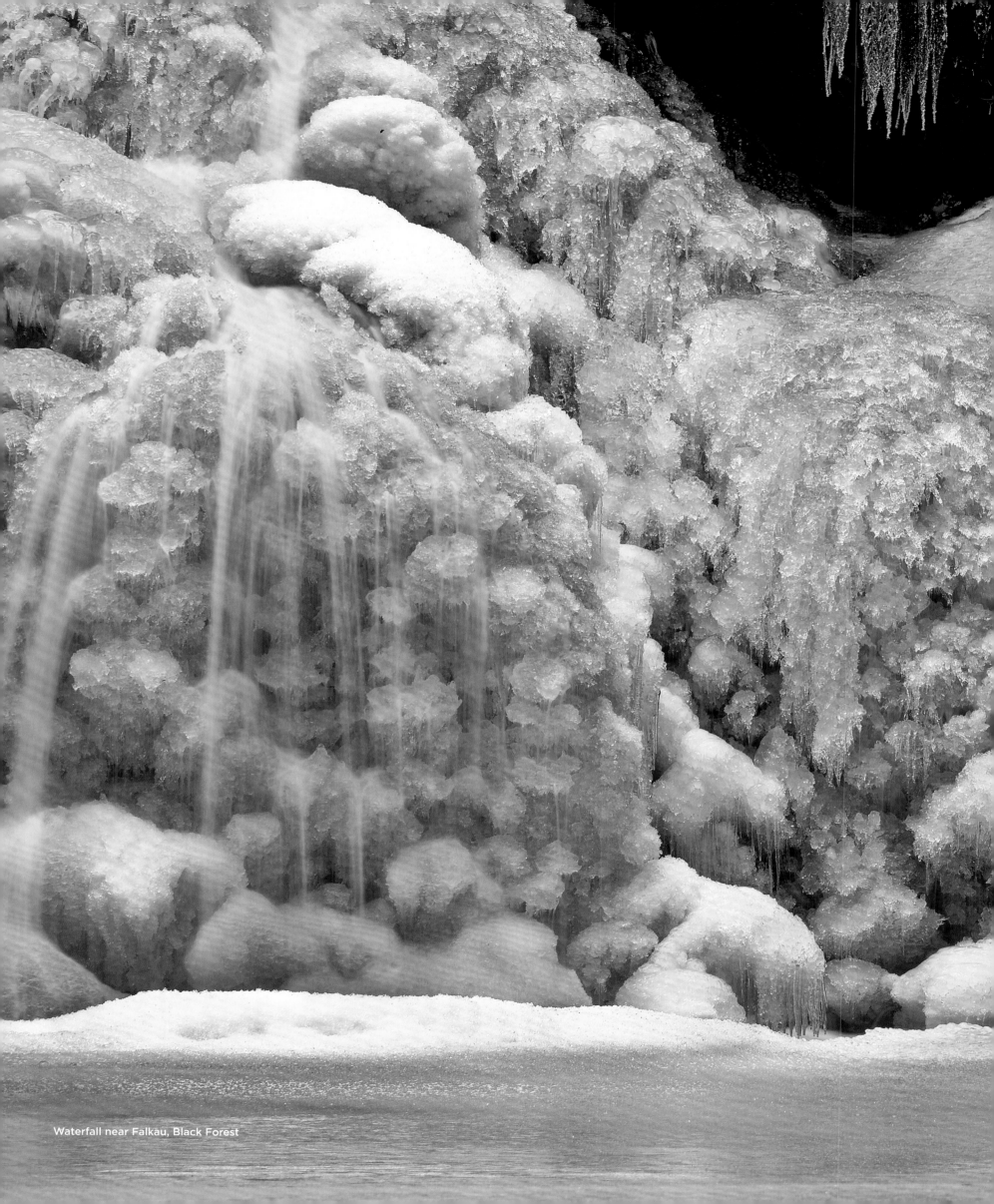
Waterfall near Falkau, Black Forest

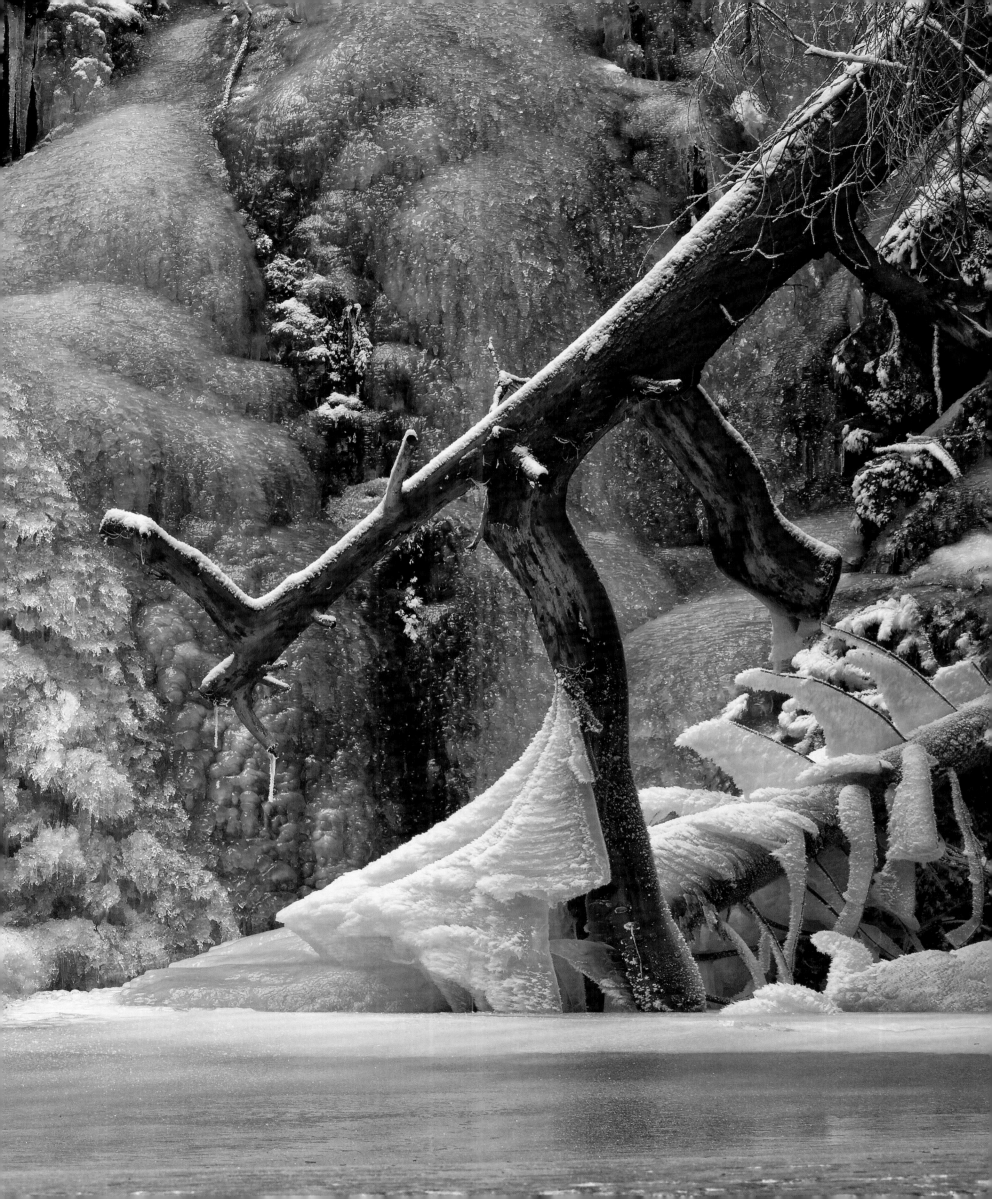

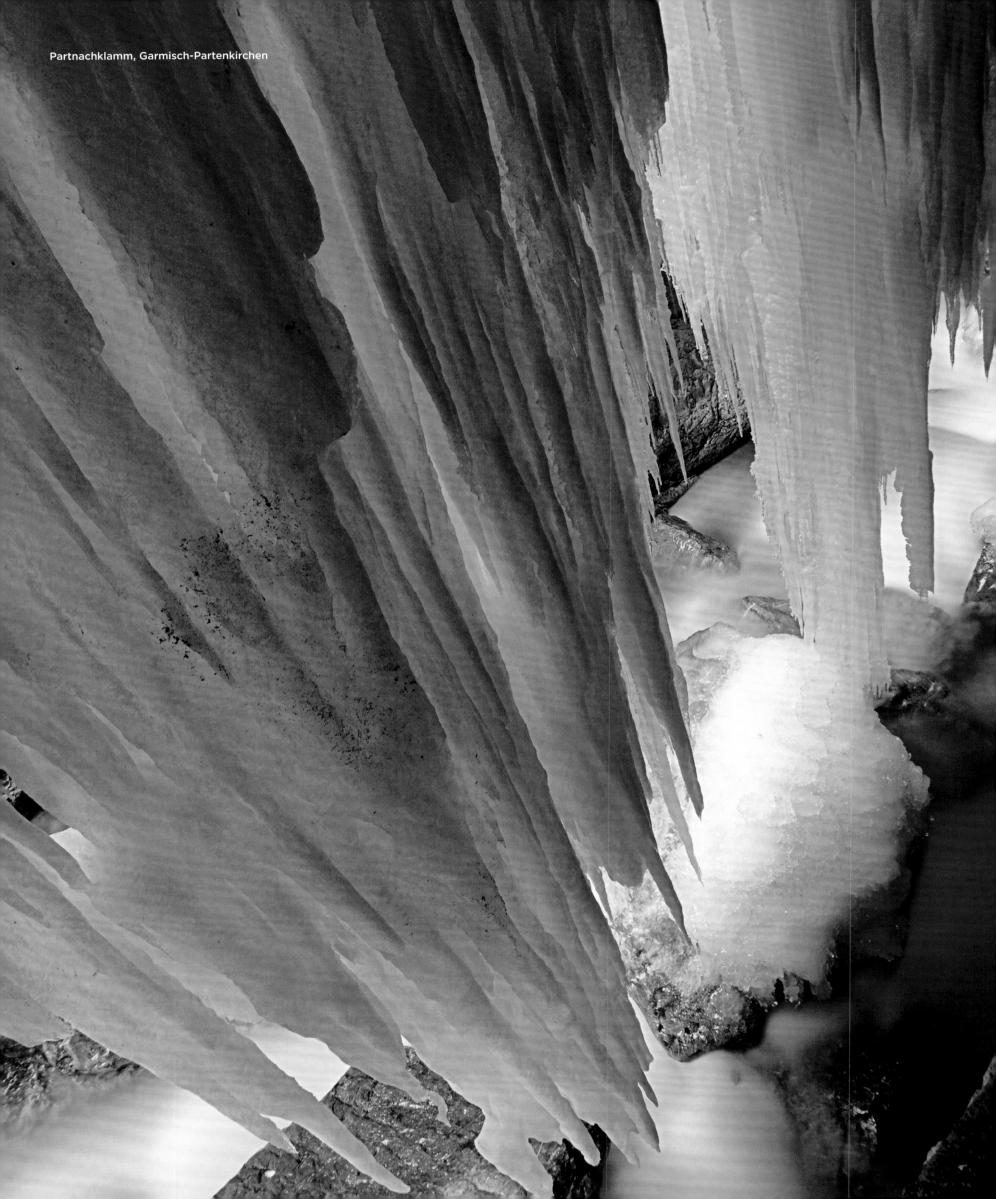

Partnachklamm, Garmisch-Partenkirchen

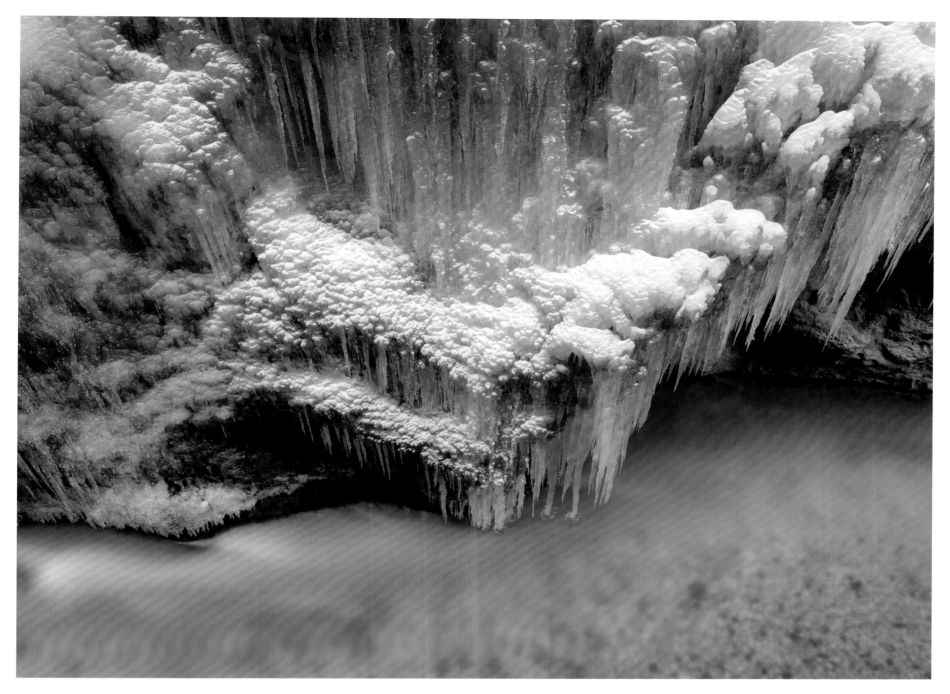

Partnachklamm, Garmisch-Partenkirchen

Partnach Gorge

The mountain river Partnach rises in the Zugspitze massif and flows into the Loisach after only 18 km (11mi.). On its way, it forms several very narrow and deeply cut gorges. The location in the mountains, the lack of sunlight and the icy water from the Schneeferner glacier ensure that Partnach Gorge freezes over spectacularly in winter.

La gorge de la Partnach

La rivière de montagne Partnach prend sa source dans le massif du Wetterstein et se jette, après 18 km seulement, dans la Loisach. Elle creuse plusieurs gorges sur son sillage, des canyons de quelques mètres de largeur profondément taillés dans la roche. Son emplacement dans les montagnes, l'absence de rayons de soleil et l'eau glaciale arrivant du Schneeferner font que la gorge de la Partnach gèle de manière spectaculaire en hiver.

Partnachklamm

Im Zugspitzmassiv entspringt der Gebirgsfluss Partnach, der nach nur 18 km in die Loisach mündet. Auf seinem Weg bildet er mehrere Klammen, wenige Meter breite, tief eingeschnittene Schluchten. Die Lage im Gebirge, die fehlende Sonneneinstrahlung und das eisige Gletscherwasser des Schneeferner sorgen dafür, dass die Partnachklamm im Winter spektakulär zufriert.

Garganta de Partnach

El río de montaña Partnach nace en el macizo de Zugspitze y desemboca en el Loisach después de solo 18 km. En su camino, forma varias gargantas, de unos pocos metros de ancho, con profundos desfiladeros. La ubicación en las montañas, la falta de luz solar y el agua helada de los glaciares del Schneeferner hacen que el la garganta de Partnach se congele en invierno, lo cual resulta espectacular a la vista.

Garganta do Partnach

O rio de montanha Partnach sobe no maciço de Zugspitze e deságua no Loisach após apenas 18 km. No seu caminho, forma vários desfiladeiros, com alguns metros de largura, desfiladeiros profundamente incisos. A localização nas montanhas, a falta de luz solar e a água gelada da geleira "Schneeferner" garantem que a Garganta do Partnach o "Partnachklamm" congele espetacularmente no inverno.

Partnachklamm

De bergstroom Partnach ontspringt in het Zugspitzemassief en mondt na slechts 18 km uit in de Loisach. Onderweg vormt het verschillende paar meter diepe ingesneden kloven. De ligging in de bergen, zorgt door een gebrek aan zonlicht en het ijzige gletsjerwater van de Schneeferner ervoor dat de Partnachklamm in de winter spectaculair bevriest.

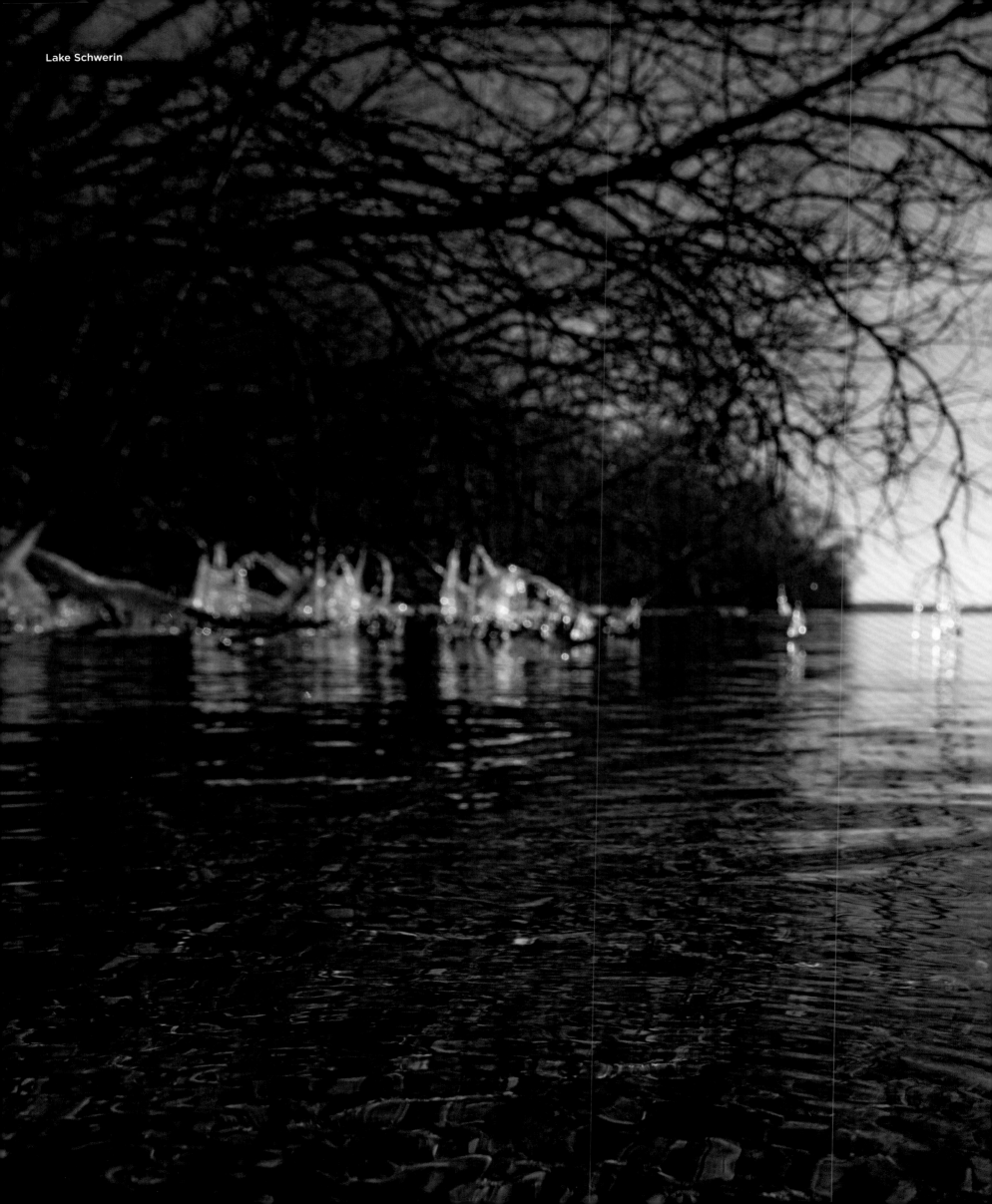
Lake Schwerin

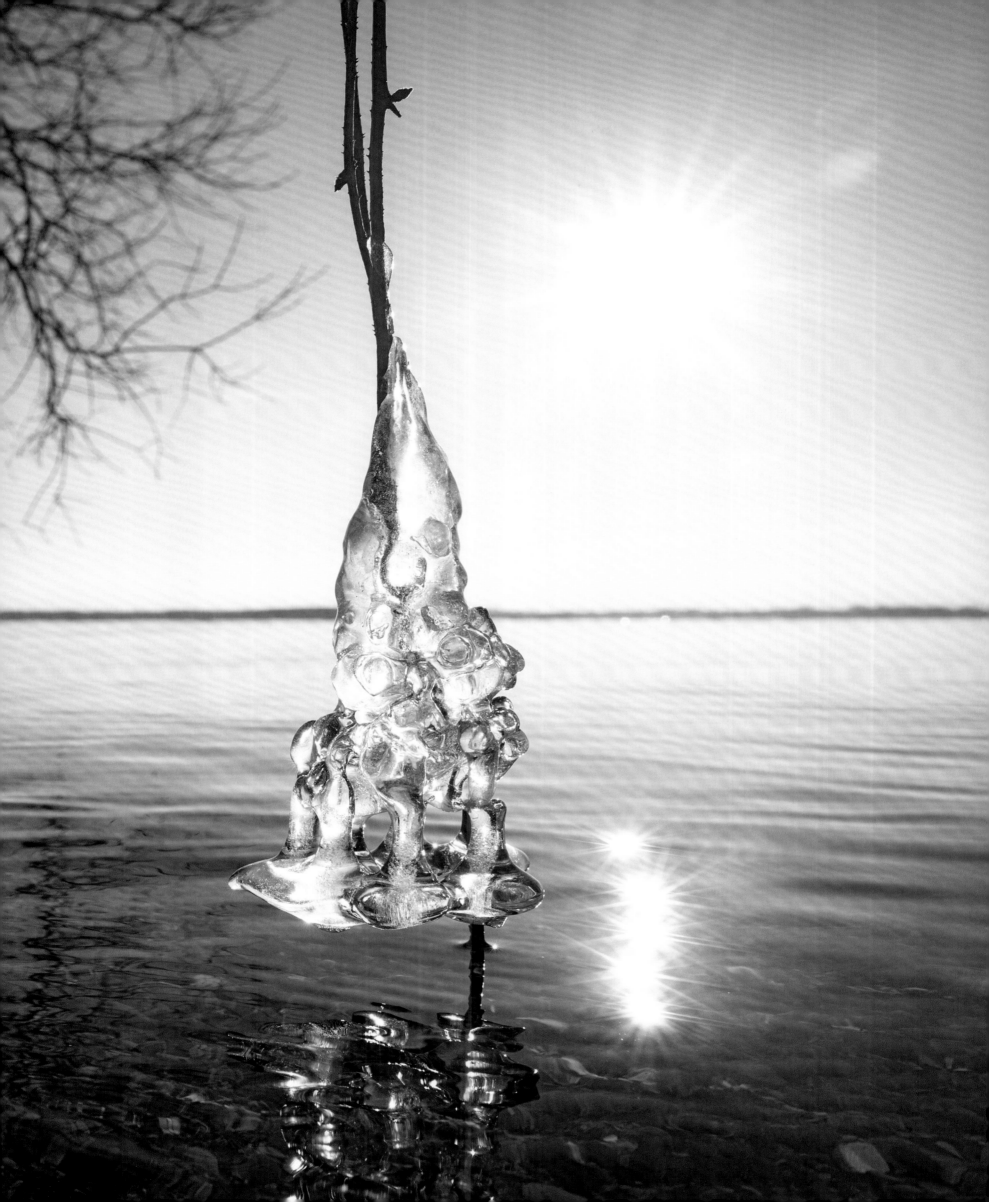

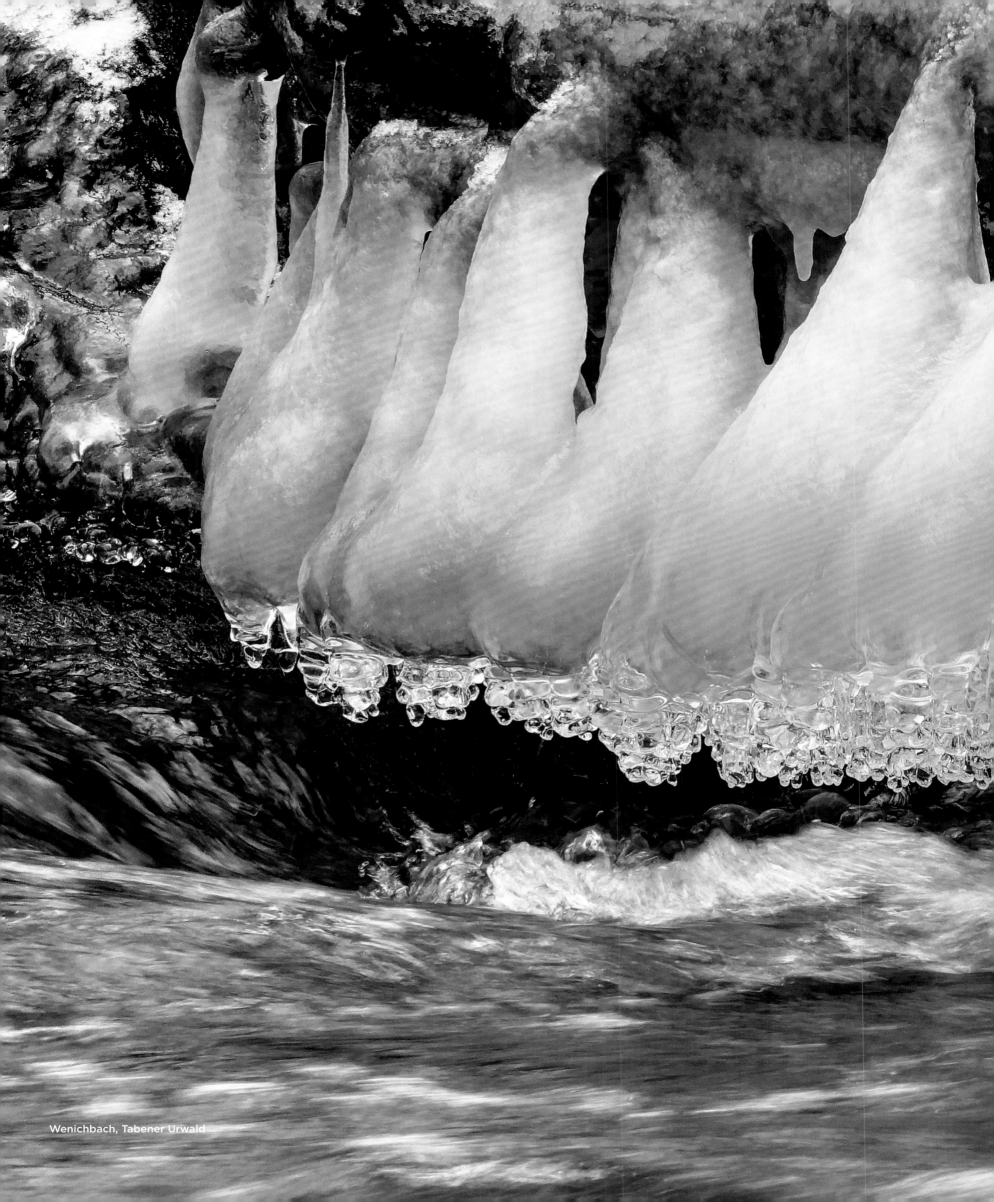

Wenichbach, Tabener Urwald

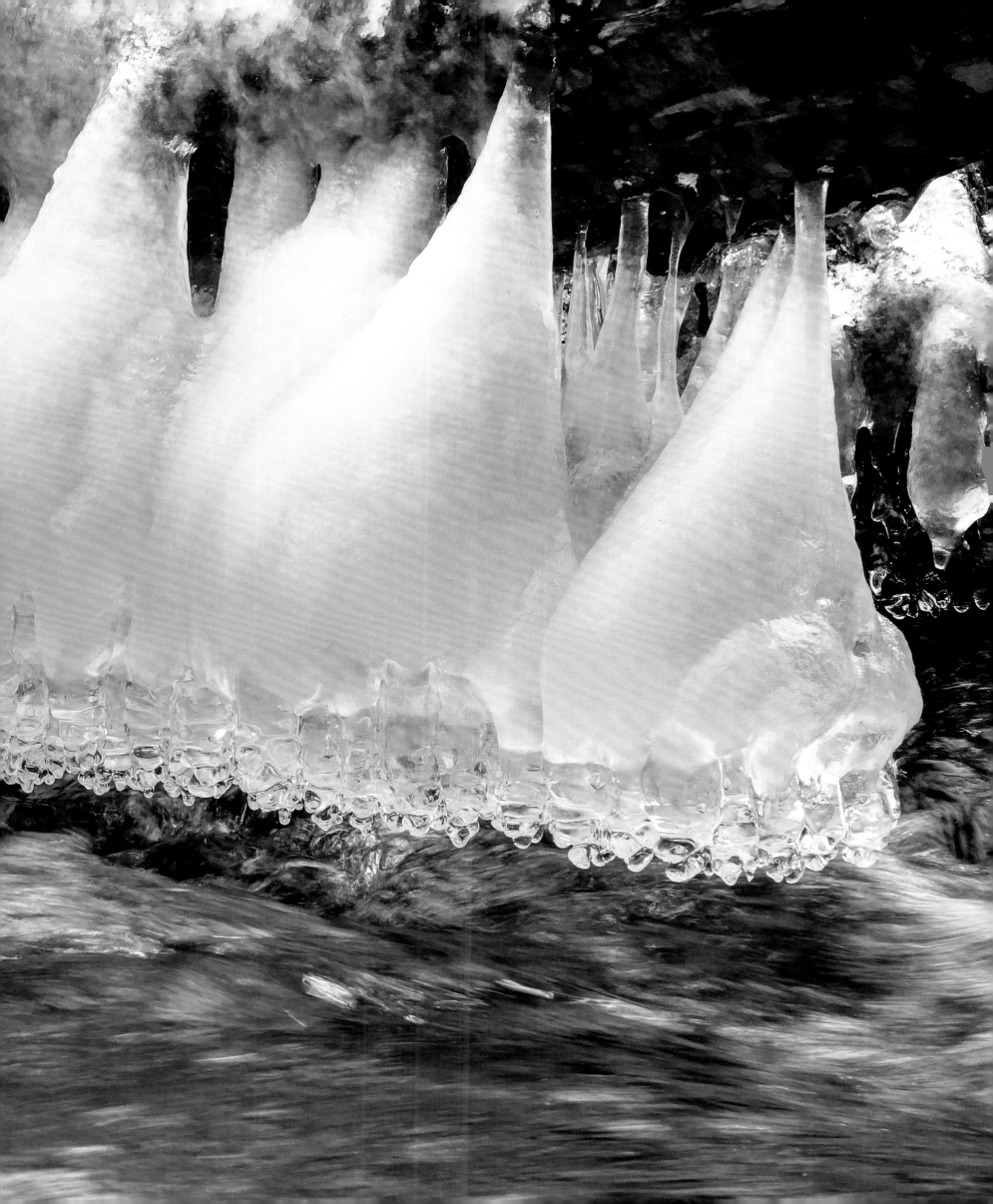

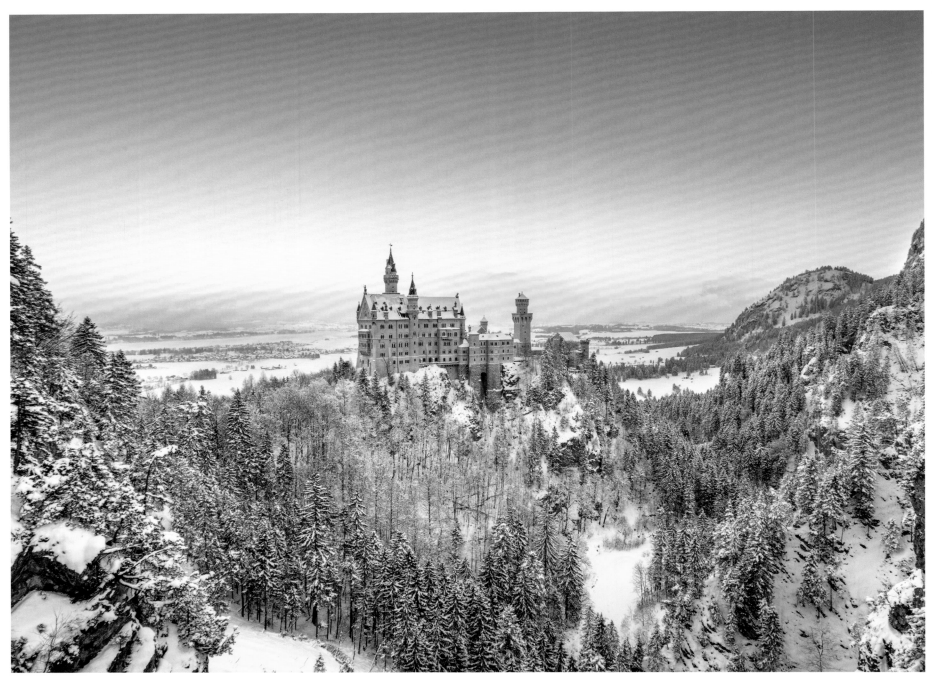

Neuschwanstein Castle

Neuschwanstein Castle

One of the most visited attractions in Germany is Neuschwanstein Castle, which was built from 1869 on by King Ludwig II of Bavaria against a picturesque mountain backdrop near Füssen in the Allgäu region. The "Fairytale King" lived in a dream world at times, and the castle is also a reflection of his romantic dream of a Middle Ages that never actually existed in this form. Neuschwanstein has been fulfilling the classic image of German knightly romanticism for tourists from all over the world since 1886. The castle, built in historicism style before a snow-covered Alpine panorama, is particularly attractive.

Le château de Neuschwanstein

Le château de Neuschwanstein est l'un des sites touristiques les plus visités d'Allemagne. Le roi Louis II de Bavière le fit construire dès 1869 dans un décor de montagnes pittoresques, proche de la ville de Füssen, dans l'Allgäu. Le « roi des contes de fées » vécut dans le carcan d'un monde imaginaire et le château de Neuschwanstein est à l'image de ses rêveries romantiques d'un Moyen Âge n'ayant jamais existé de la sorte. Depuis 1886, le château représente pour les touristes du monde entier l'image-cliché du romantisme chevaleresque allemand. Bâti dans le style de l'historicisme, il est particulièrement charmant lorsque les Alpes derrière lui sont couvertes de neige.

Schloss Neuschwanstein

Eine der meistbesuchten Sehenswürdigkeiten Deutschlands ist Schloss Neuschwanstein, das der bayerische König Ludwig II. ab 1869 vor malerischer Bergkulisse in der Nähe von Füssen im Allgäu errichten ließ. Der „Märchenkönig" lebte zeitweise in einer Traumwelt, und auch das Schloss ist Abbild seiner romantisierenden Traumvorstellung von einem Mittelalter, das es so nie gegeben hat. Seit 1886 bedient Neuschwanstein für Touristen aus aller Welt die Klischeevorstellung von deutscher Ritterromantik, besonders attraktiv wirkt die im Stil des Historismus errichtete Burg vor verschneitem Alpenpanorama.

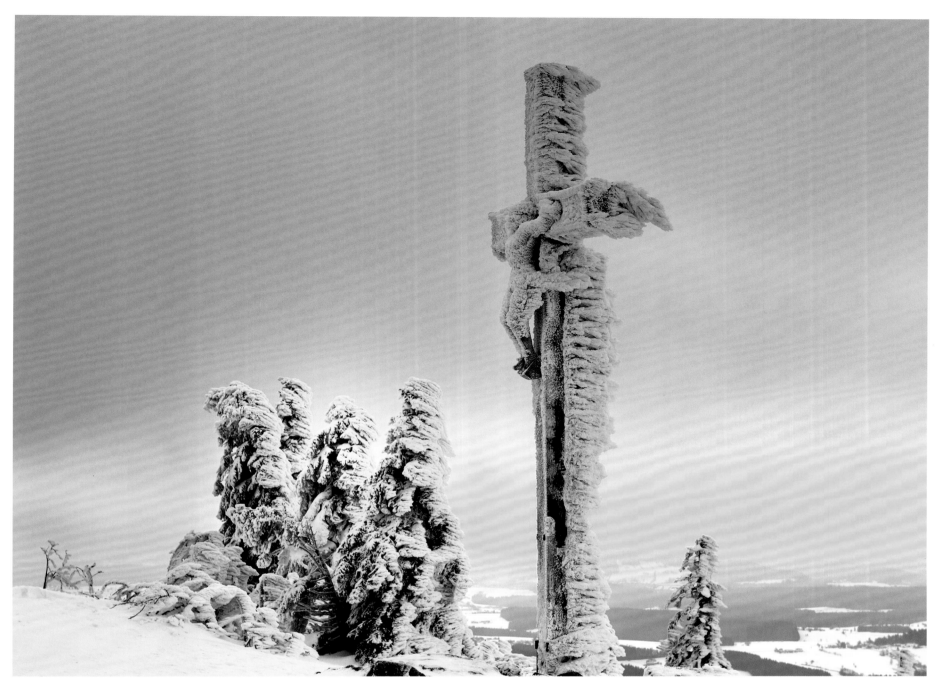

Mount Lusen, Bavarian Forest National Park

Castillo de Neuschwanstein

Uno de los monumentos más visitados de Alemania es el castillo de Neuschwanstein, que fue construido desde 1869 por el rey Luis II de Baviera en un pintoresco entorno montañoso cerca de Füssen, en la región de Allgäu. El «Rey de los cuentos de hadas» vivió en un mundo de ensueño, y el castillo es también un reflejo de su sueño romántico de una Edad Media que nunca existió en esta forma. Desde 1886, Neuschwanstein ha estado sirviendo al cliché de los caballeros románticos alemanes para los turistas de todo el mundo. El castillo construido al estilo del historicismo frente a un panorama alpino cubierto de nieve es especialmente atractivo.

Castelo de Neuschwanstein

Um dos pontos turísticos mais visitados na Alemanha é o Castelo de Neuschwanstein, construído em 1869 pelo rei Ludwig II da Baviera em um pitoresco cenário montanhoso perto de Füssen, na região de Allgäu. O "Rei dos Contos de Fadas" viveu por vezes num mundo de sonho, e o castelo é também um reflexo do seu sonho romântico de uma Idade Média que nunca existiu nesta forma. Desde 1886 Neuschwanstein serve o clichê dos cavaleiros românticos alemães para turistas de todo o mundo. O castelo construído no estilo neoromanesco historicista parece particularmente atraente em frente a um panorama alpino coberto de neve.

Slot Neuschwanstein

Een van de meest bezochte bezienswaardigheden in Duitsland is slot Neuschwanstein, dat in 1869 door koning Ludwig II van Beieren tegen een schilderachtige bergachtige achtergrond in de buurt van Füssen in de Allgäu regio werd gebouwd. De „Sprookjeskoning" leefde soms in een droomwereld en het slot is ook een weerspiegeling van zijn romantiserende droom van een Middeleeuwen die nooit in deze vorm heeft bestaan. Sinds 1886 dient Neuschwanstein voor toeristen uit de hele wereld als cliché van de Duitse romantische ridders. Vooral het slot, gebouwd in de stijl van het historisme voor een besneeuwd Alpenpanorama, is bijzonder aantrekkelijk.

Landungsbrücken, Hamburg

Piers, Hamburg

Ice floes on the Elbe have rarity value. The port of Hamburg lies on the lower reaches of the Elbe, and is about 100 km (62 mi) from the sea. Nevertheless, it is considered an international port; it is Germany's most important and Europe's third largest. The cultural life of the city often takes place at the water, and the Elbe Philharmonic Hall is an icon of modern architecture.

Les jetées de Hambourg

Sur l'Elbe, les blocs de glace sont rares. Le port de Hambourg est situé sur le cours inférieur de ce fleuve, à une centaine de kilomètres de la mer. Pourtant, il a valeur de grand port maritime, le plus important d'Allemagne et le troisième plus grand d'Europe. La vie culturelle de la ville se joue souvent près de l'eau et la Philharmonie de l'Elbe est d'ailleurs une icône de l'architecture moderne.

Landungsbrücken, Hamburg

Eisschollen auf der Elbe haben Seltenheitswert. Der Hamburger Hafen liegt am Unterlauf der Elbe und ist rund 100 km vom Meer entfernt. Dennoch gilt er als Überseehafen, er ist Deutschlands bedeutendster und Europas drittgrößter Hafen. Das Kulturleben der Stadt spielt sich häufig am Wasser ab. Eine Ikone der modernen Architektur ist die Elbphilharmonie.

Embarcaderos, Hamburgo

Los témpanos de hielo en el Elba tienen un valor de rareza. El puerto de Hamburgo se encuentra en la parte baja del Elba y está a unos 100 km del mar. Sin embargo, se considera un puerto de ultramar. Es el puerto más importante de Alemania y el tercero más grande de Europa. La vida cultural de la ciudad a menudo tiene lugar en el agua. La Sala Filarmónica del Elba es un icono de la arquitectura moderna.

Embarcadouros, Hamburgo

Os blocos de gelo no Elba têm valor de raridade. O porto de Hamburgo fica na parte inferior do rio Elba e fica a cerca de 100 km do mar. No entanto, é considerado um porto ultramarino, é o mais importante da Alemanha e o terceiro maior porto da Europa. A vida cultural da cidade acontece muitas vezes à beira d'água. O Salão Filarmônico do Elba é um ícone da arquitetura moderna.

Landungsbrücken, Hamburg

De ijsschotsen op de Elbe hebben zijn zeldzaam. De haven van Hamburg ligt aan de benedenloop van de Elbe en ligt op ongeveer 100 km van de zee. Toch wordt het beschouwd als een overzeese haven, het is de belangrijkste en op twee na grootste haven van Duitsland en Europa's grootste haven. Het culturele leven van de stad vindt vaak plaats op het water. De Elbe Philharmonic Hall is een icoon van de moderne architectuur.

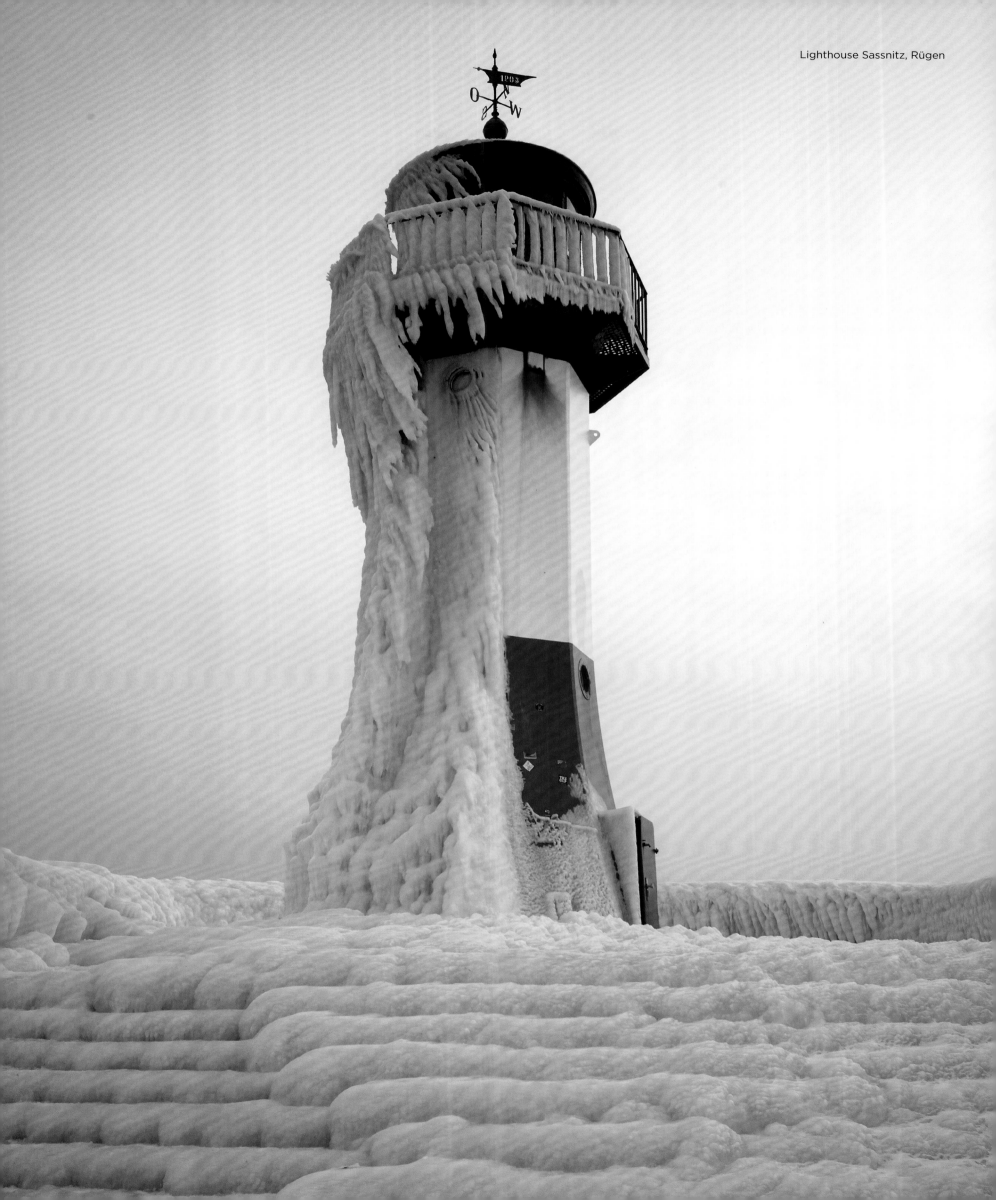

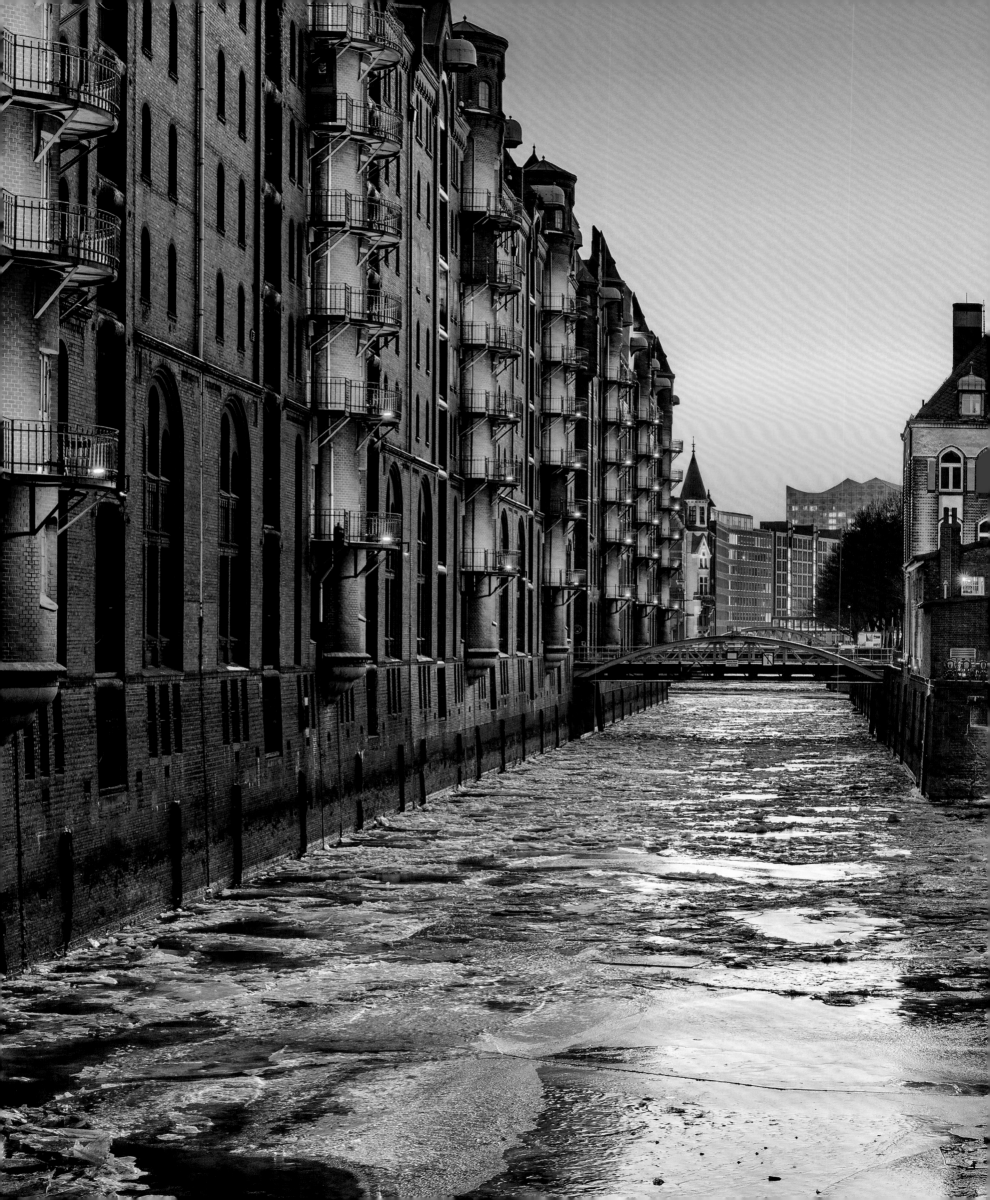

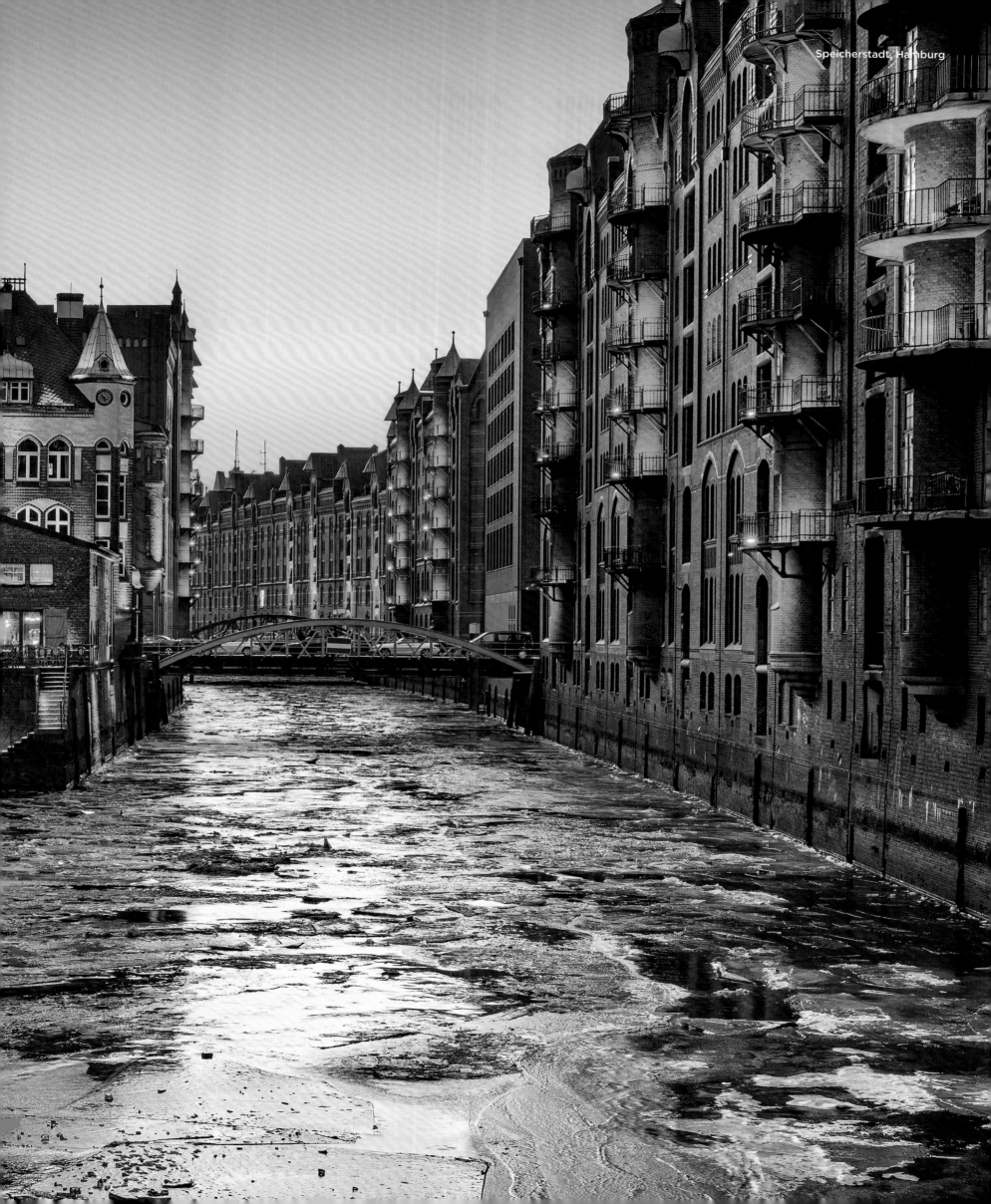
Speicherstadt, Hamburg

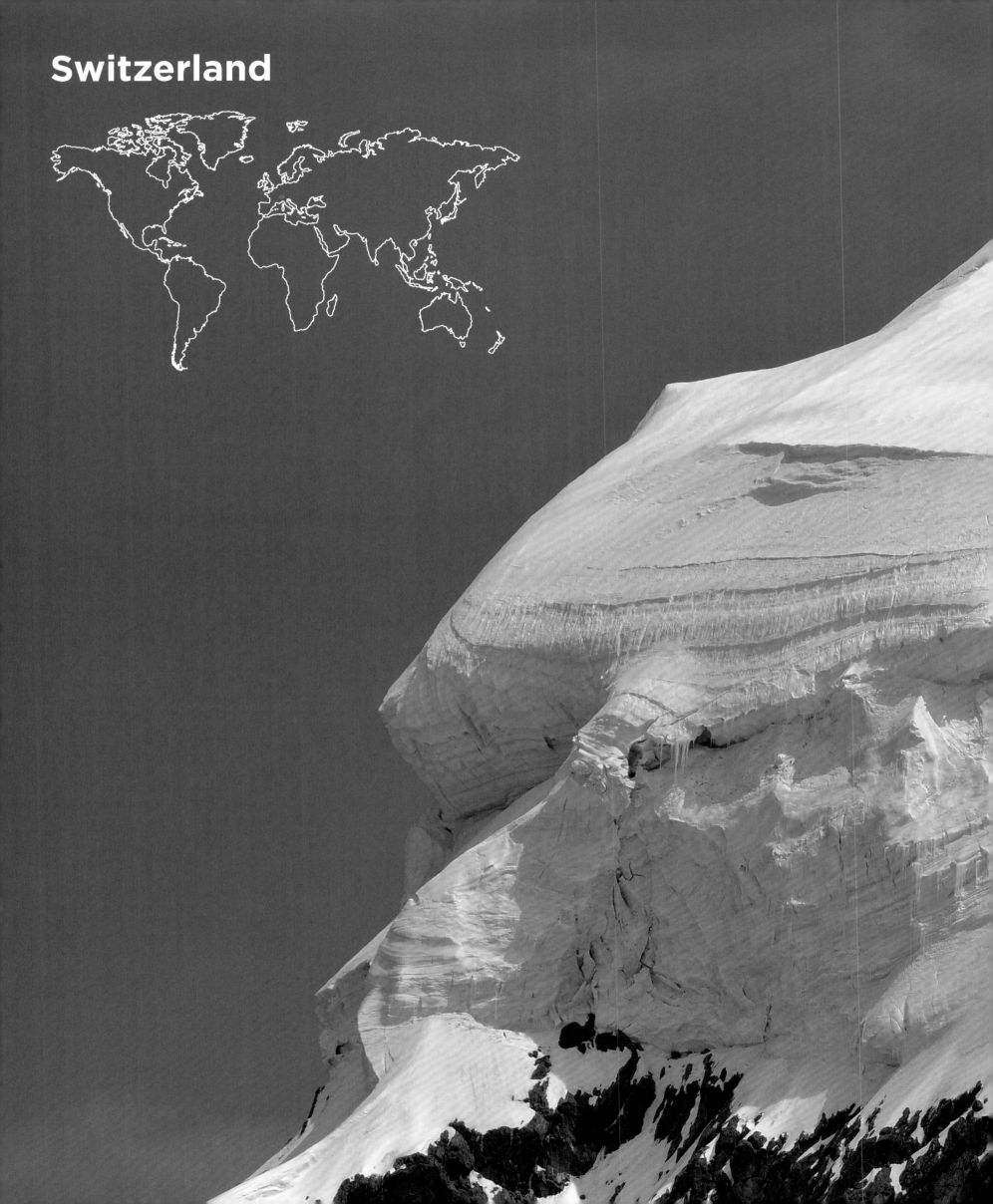

Switzerland

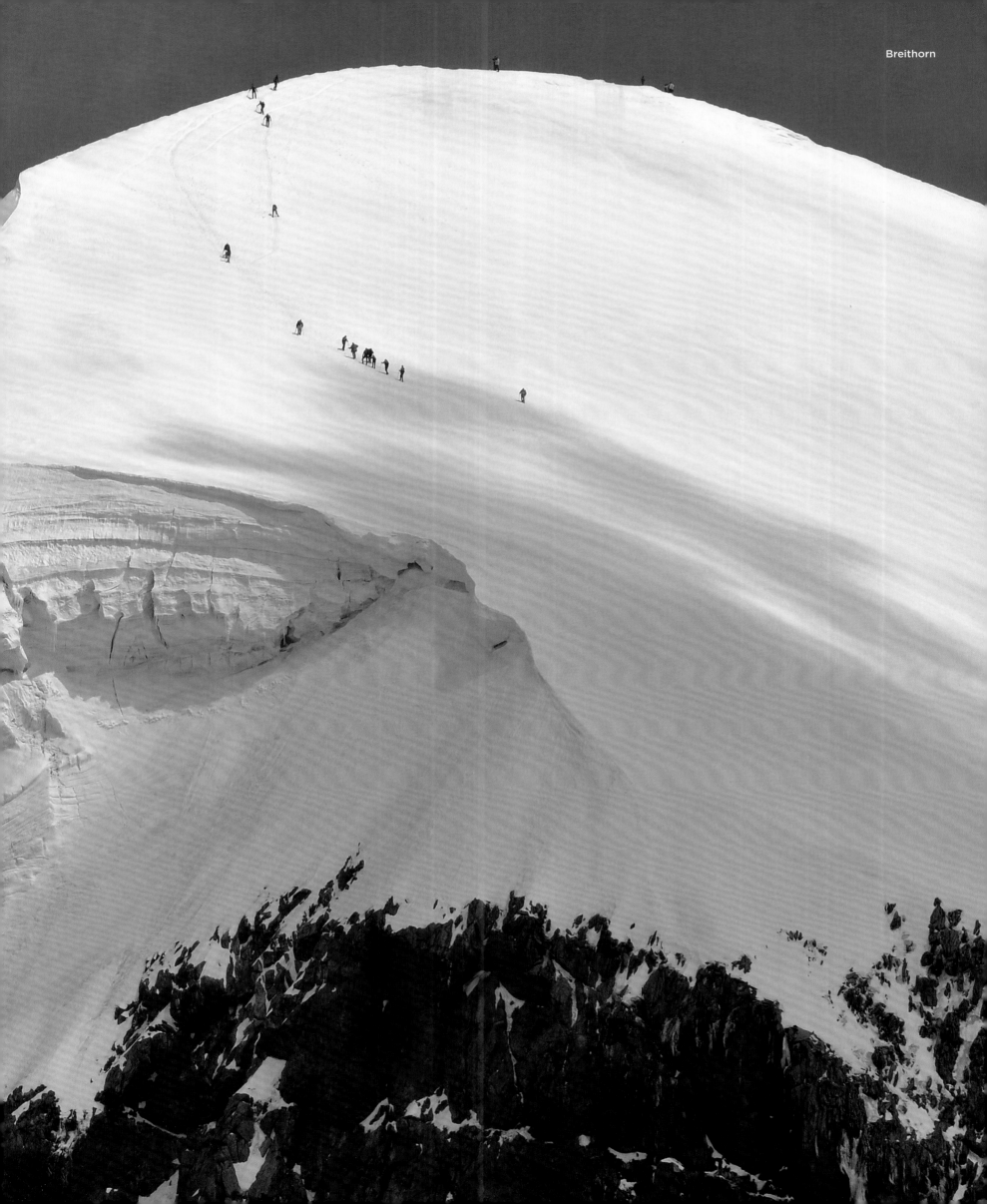

Glacier Palace, Matterhorn Glacier Paradise

Switzerland

The Swiss Confederation is a mountain country. About 30 percent of the total area of around 41,000 km² (1583 sq mi) is suitable for use for agricultural purposes or urban areas, 30 percent is forested, and the remainder is made up of lakes, mountain areas, meadows and alpine pastures—and ice, as the Swiss glaciers cover almost 1,000 km² (386 sq mi). The largest of them is the Great Aletsch Glacier with a length of about 20 km (13 mi) and an area of about 80 km² (31 sq mi). However, it must still be said that as everywhere, the glaciers are rapidly receding. This economically strong country offers a very high standard of living and is a popular tourist destination.

Suisse

La Confédération helvétique est un état montagnard. Quelque 30 % de sa superficie de 41 000 km² environ sont cultivables ou occupés par des communes, 30 % encore sont boisés et le reste est constitué de lacs, de montagnes, de prairies et d'alpages. Mais c'est aussi une terre de glace, car les glaciers suisses représentent près de 1 000 km². Le plus grand d'entre eux est le glacier d'Aletsch, d'une longueur de plus de 20 km et d'une surface d'environ 80 km². Du moins pour le moment car, comme partout ailleurs, les glaciers reculent rapidement. La Suisse, économiquement forte, offre un niveau de vie élevé et reste une destination touristique prisée.

Schweiz

Die Schweizerische Eidgenossenschaft ist ein Gebirgsstaat. Etwa 30 Prozent der Fläche von insgesamt rund 41 000 km² sind landwirtschaftlich nutzbar bzw. Ortschaften, ebenfalls 30 Prozent sind bewaldet, der Rest sind Seen, Gebirgsflächen, Wiesen und Almen – und Eis, denn fast 1000 km² umfassen die Schweizer Gletscher. Der größte von ihnen ist der Große Aletschgletscher mit einer Länge von gut 20 km und einer Fläche von etwa 80 km². Noch, muss man sagen, denn wie überall gehen die Gletscher rapide zurück. Die wirtschaftlich starke Schweiz bietet einen sehr hohen Lebensstandard und ist ein beliebtes Reiseziel.

Matterhorn Glacier Paradise

Suiza

La Confederación Suiza es un país montañoso. Aproximadamente el 30 por ciento de la superficie total de unos 41 000 km² se puede utilizar para fines agrícolas o son pueblos, otro 30 por ciento son bosques y el resto son lagos, zonas montañosas, praderas y pastos alpinos... Y hielo, ya que los glaciares suizos cubren casi 1000 km². El más grande de ellos es el Gran Glaciar Aletsch, con una longitud de unos 20 km y una superficie de unos 80 km². Sin embargo, hay que decir que, como en todas partes, que los glaciares están retrocediendo rápidamente. La Suiza económicamente fuerte ofrece un nivel de vida muy alto y es un destino turístico muy popular.

Suíça

A Confederação Suíça é um país de montanha. Cerca de 30 por cento da área total de aproximadamente 41.000 km² podem ser usados para fins agrícolas ou como vilarejos, da mesma forma 30 por cento são florestas, o restante são lagos, áreas montanhosas, prados e pastagens alpinas - e gelo, pois as geleiras suíças cobrem quase 1.000 km². A maior delas é a grande geleira de Aletsch, com um comprimento de cerca de 20 km e uma área de cerca de 80 km². Ainda assim, é preciso dizer, que assim como em toda parte, que os glaciares estão a recuar rapidamente. A Suíça, economicamente forte, oferece um alto padrão de vida e é um destino turístico popular.

Zwitserland

De Zwitserse Bondsstaat is een bergland. Ongeveer 30 procent van de totale oppervlakte van ongeveer 41.000 km² kan worden gebruikt voor landbouwdoeleinden of als dorpen, 30 procent is bebost, de rest zijn meren, berggebieden, weiden en alpenweiden - en ijs, aangezien de Zwitserse gletsjers bijna 1.000 km² beslaan. De grootste daarvan is de Grote Aletschgletsjer met een lengte van ongeveer 20 km en een oppervlakte van ongeveer 80 km². Toch moet men zeggen, zoals overal, dat de gletsjers zich snel terugtrekken. Het economisch sterke Zwitserland biedt een zeer hoge levensstandaard en is een populaire toeristische bestemming.

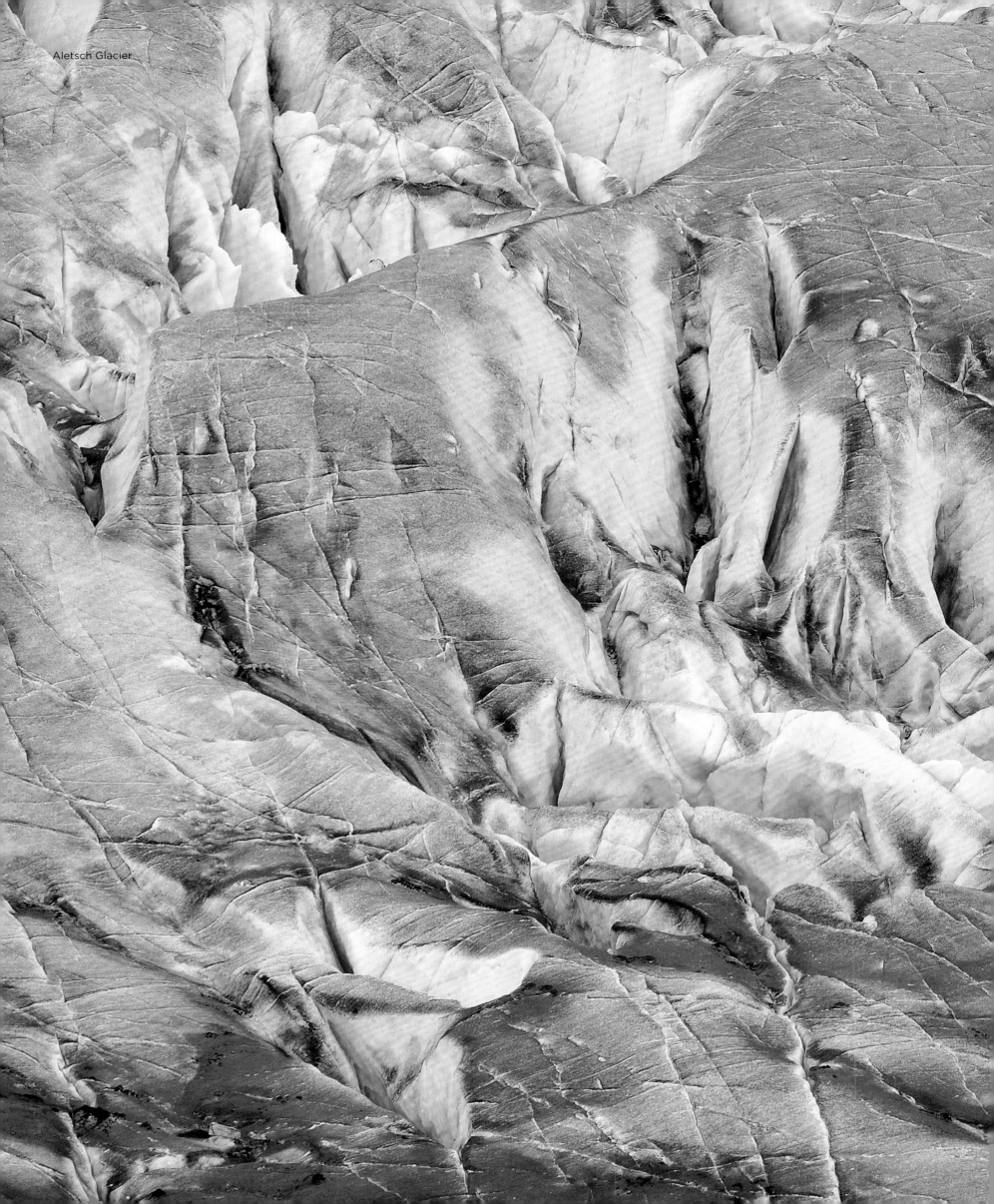

Aletsch Glacier

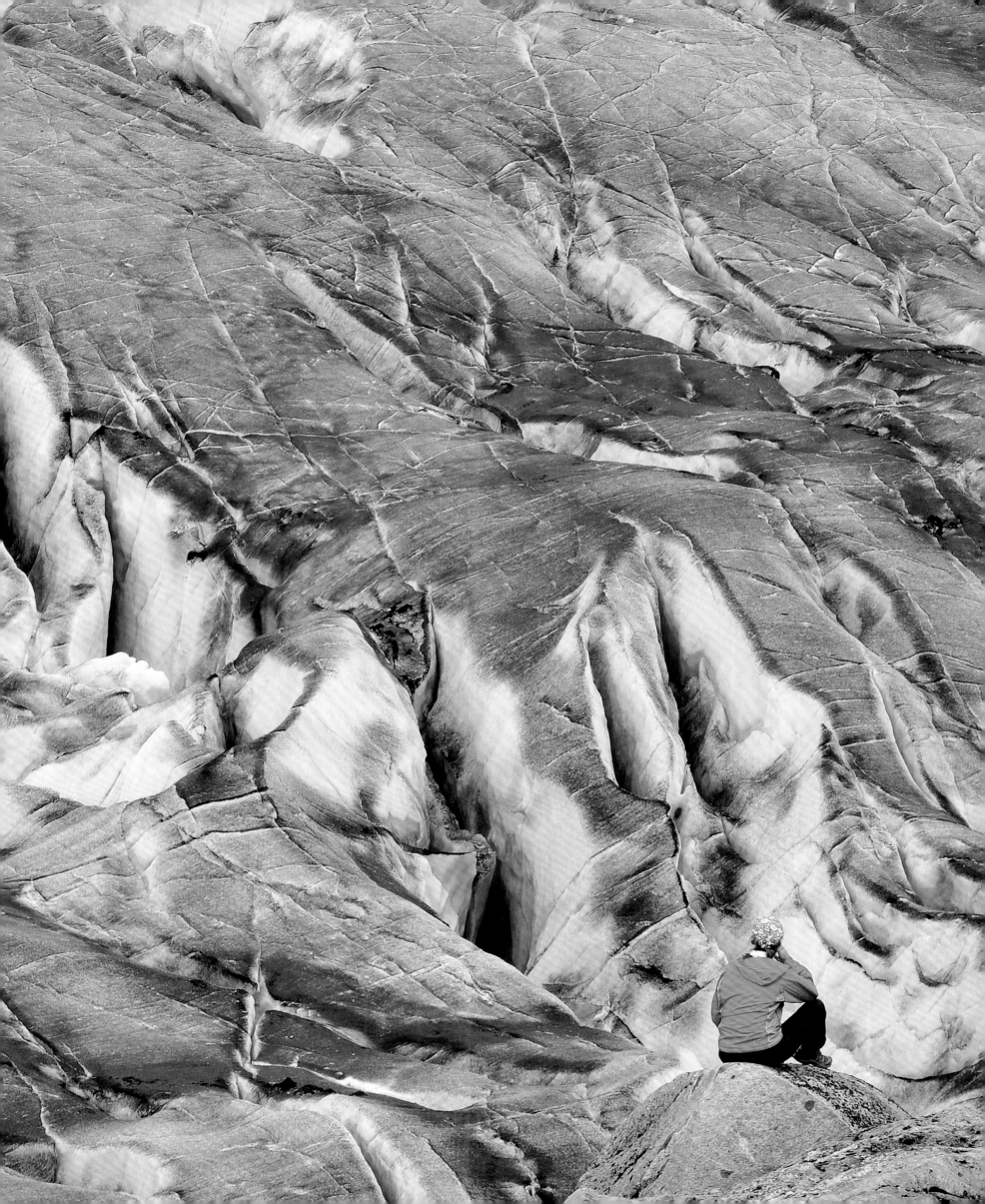

Sphinx, Jungfraujoch

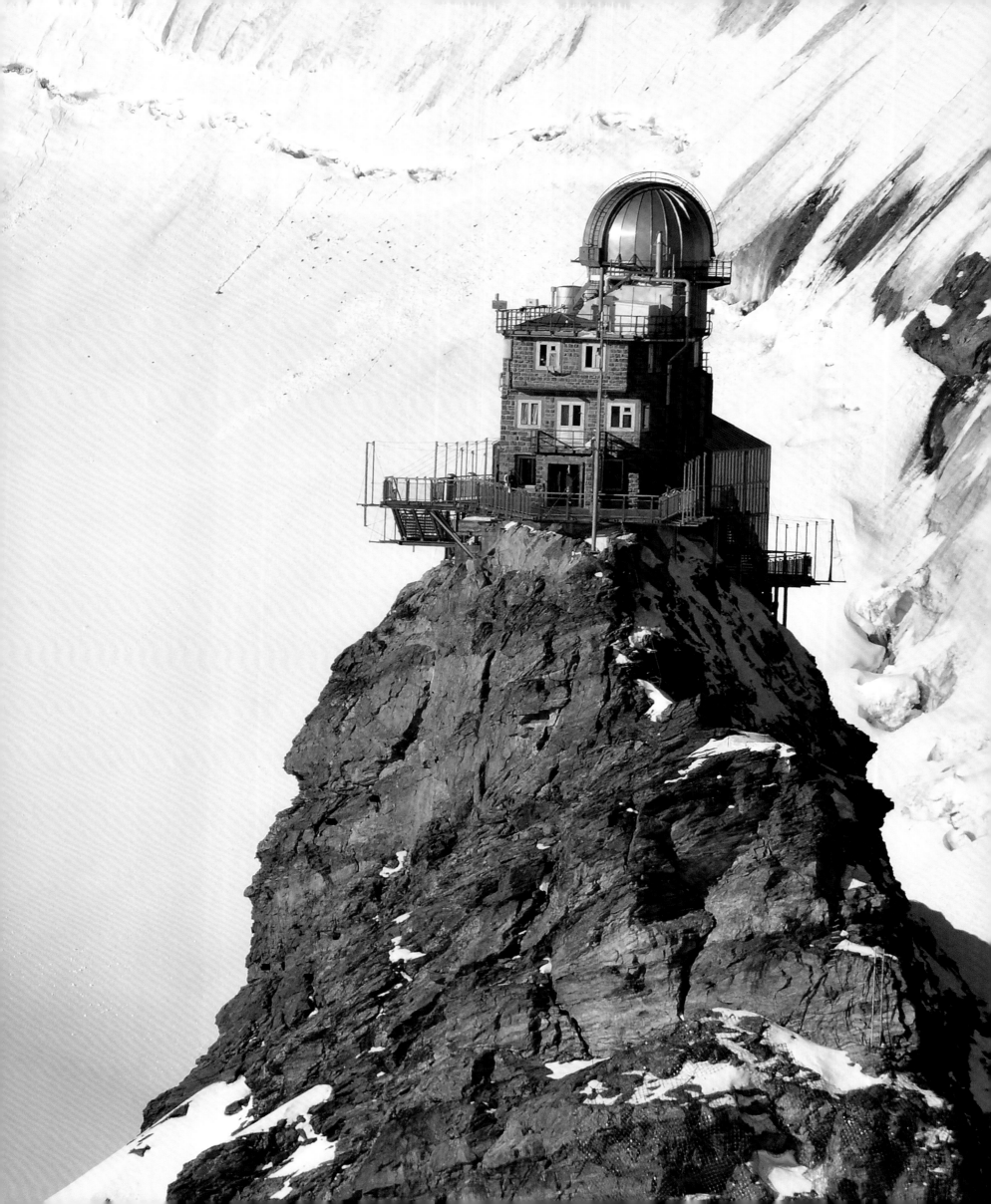

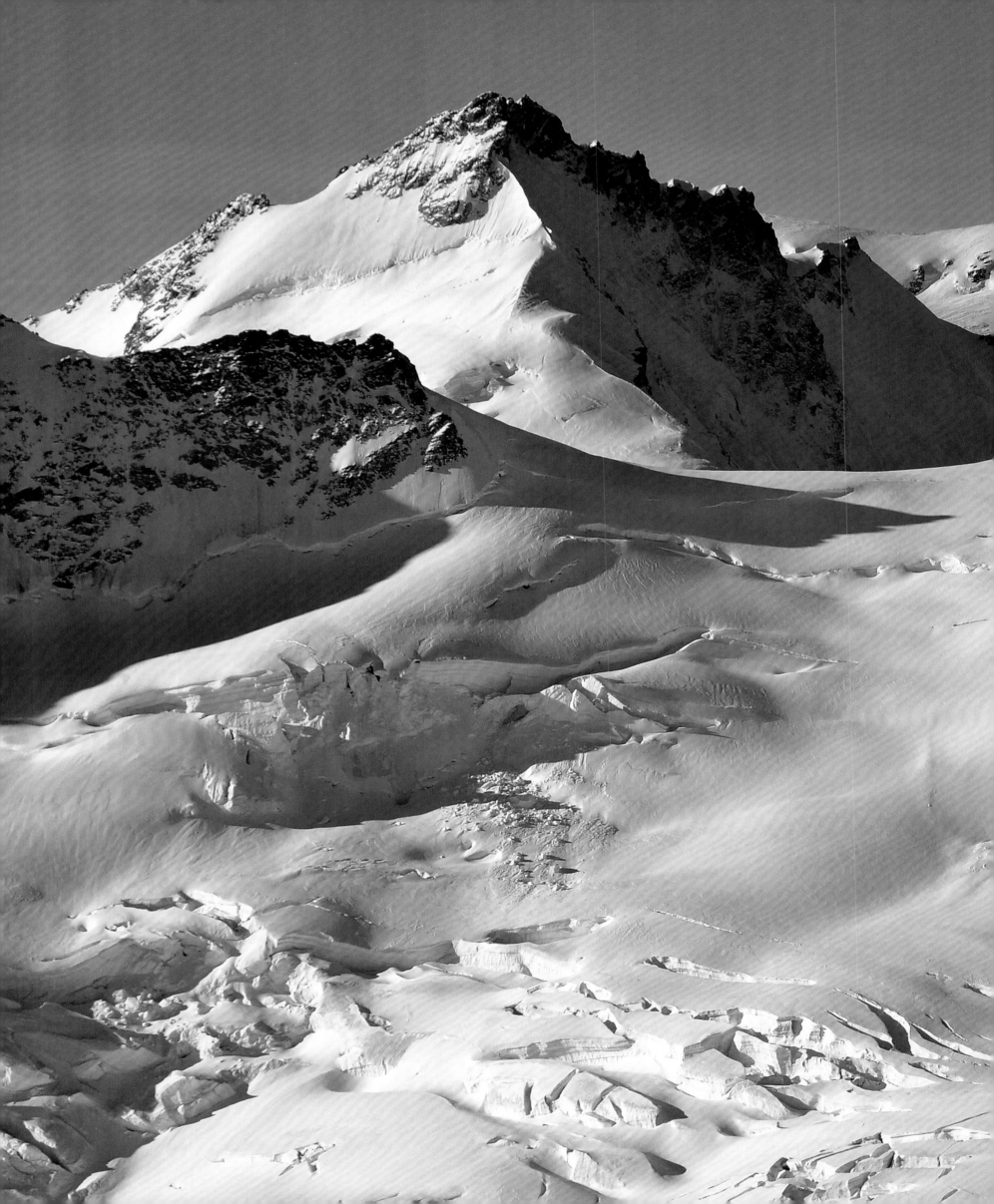

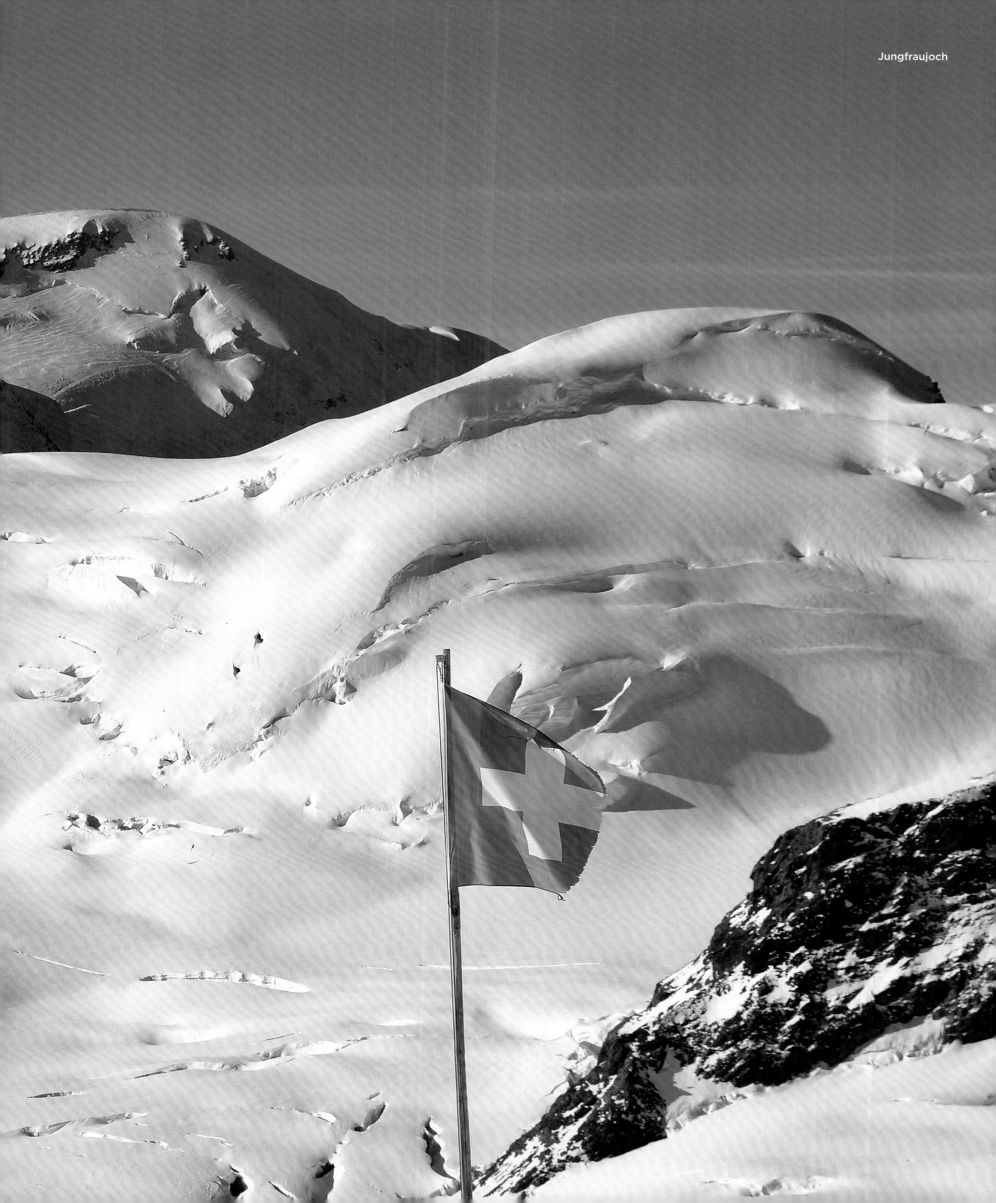

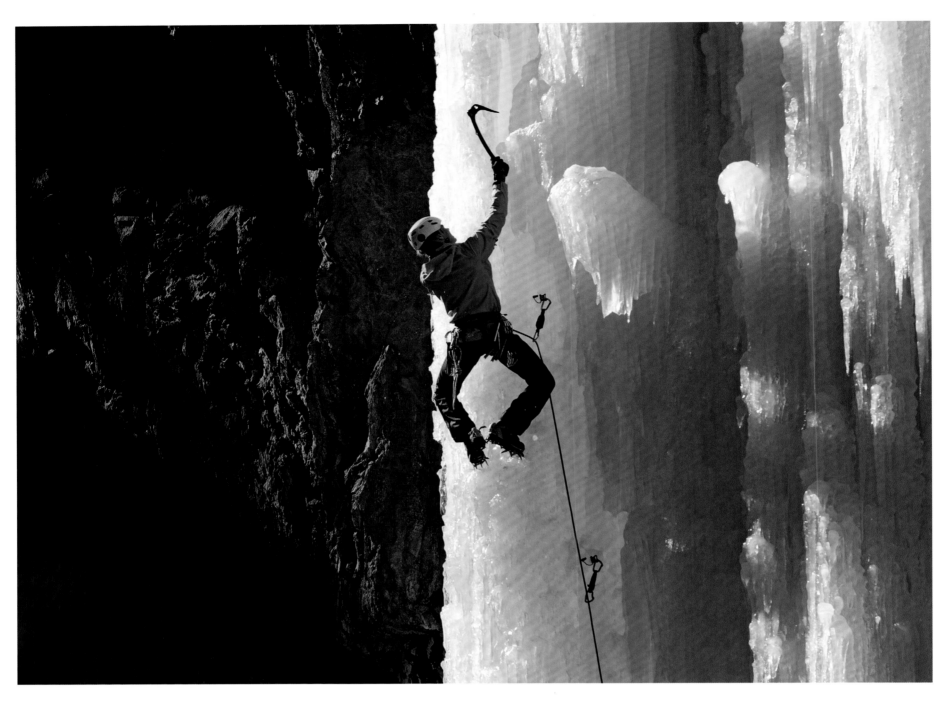

Ice climbing, Pontresina, Engadin

Ice Climbing

Ice climbing is related to alpine climbing. Just as a mountaineer or climber needs to know the exact nature of rock, ice climbers must have a comprehensive knowledge of the properties of the ice. Ice axes are used to climb ice walls, in most cases frozen waterfalls. Crampons on the boot are mandatory, and ice screws serve as temporary fixings for the belay rope. Ice climbing is a high-risk sport; ice is a fragile element, and liquid water may also flow behind the curtain of frozen water.

Escalade glaciaire

L'escalade glaciaire est apparentée à l'alpinisme. Tout comme l'alpiniste ou le grimpeur qui doit parfaitement connaître la structure de la roche, le glaciairiste doit avoir des connaissances approfondies sur les propriétés de la glace. Pour escalader les murs glacés, le plus souvent des chutes d'eau gelées, on utilise des piolets ainsi que des crampons, obligatoires. Les broches à glace servent de points d'ancrage temporaires pour la corde de sécurité. L'escalade glaciaire est un sport à risque car la glace est un élément fragile et il se peut que derrière le rideau d'eau gelée ruisselle de l'eau encore liquide.

Eisklettern

Eisklettern ist mit dem alpinen Klettern verwandt. So wie der Bergsteiger oder Kletterer genau über die Beschaffenheit des Gesteins Bescheid wissen muss, braucht der Eiskletterer umfassende Kenntnisse über die Eigenschaften des Eises. Mithilfe von Eisäxten werden die Eiswände erklettert, in den meisten Fällen gefrorene Wasserfälle. Steigeisen an den Schuhen sind obligatorisch. Als temporäre Befestigungen für das sichernde Seil dienen Eisschrauben. Das Eisklettern ist eine Risikosportart: Eis ist ein fragiles Element, eventuell fließt hinter dem Vorhang aus gefrorenem Wasser auch noch flüssiges Wasser.

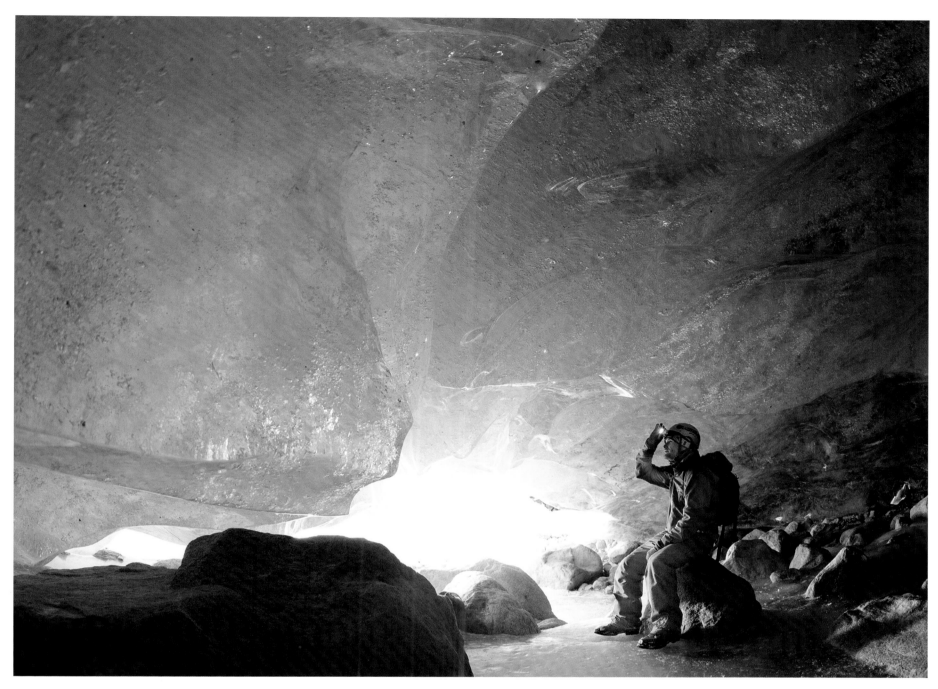

Ice cave, Morteratsch Glacier

Escalada en hielo

La escalada en hielo está emparentada con la escalada alpina. Así como el alpinista o escalador necesita saber exactamente cómo es la roca, el escalador de hielo necesita saber todo acerca de las propiedades del hielo. Los piolets se utilizan para escalar las paredes de hielo, en la mayoría de los casos, cascadas congeladas. Es obligatorio que el calzado tenga crampones. Los tornillos de hielo sirven como fijación temporal para la cuerda de sujeción. La escalada en hielo es un deporte de alto riesgo: el hielo es un elemento frágil, y detrás de la cortina de agua congelada también puede fluir agua líquida.

Escalada no gelo

A escalada no gelo está relacionada com a escalada alpina. Assim como o montanhista ou escalador precisa saber exatamente como é a rocha, o escalador de gelo precisa saber tudo sobre as propriedades do gelo. Os machados de gelo são usados para escalar as paredes de gelo, na maioria dos casos cachoeiras congeladas. Os grampos nos sapatos são obrigatórios. Os parafusos de gelo servem como fixações temporárias para a corda de segurança. A escalada no gelo é um esporte de alto risco: o gelo é um elemento frágil, e eventualmente atrás da cortina de água congelada ainda pode também fluir água líquida.

IJsklimmen

IJsklimmen is verwant aan alpine klimmen. Net zoals bergbeklimmers moet weten hoe de rots er precies uitziet, zo moet de ijsklimmer alles weten over de eigenschappen van het ijs. IJsbijlen worden gebruikt om de ijsmuren te beklimmen, in de meeste gevallen bevroren watervallen. De stijgijzers op de schoenen zijn verplicht. IJsschroeven dienen als tijdelijke bevestigingen voor het bevestigingskoord. IJsklimmen is een sport met een hoog risico: ijs is een kwetsbaar element, en ook vloeibaar water kan achter het gordijn van bevroren water stromen.

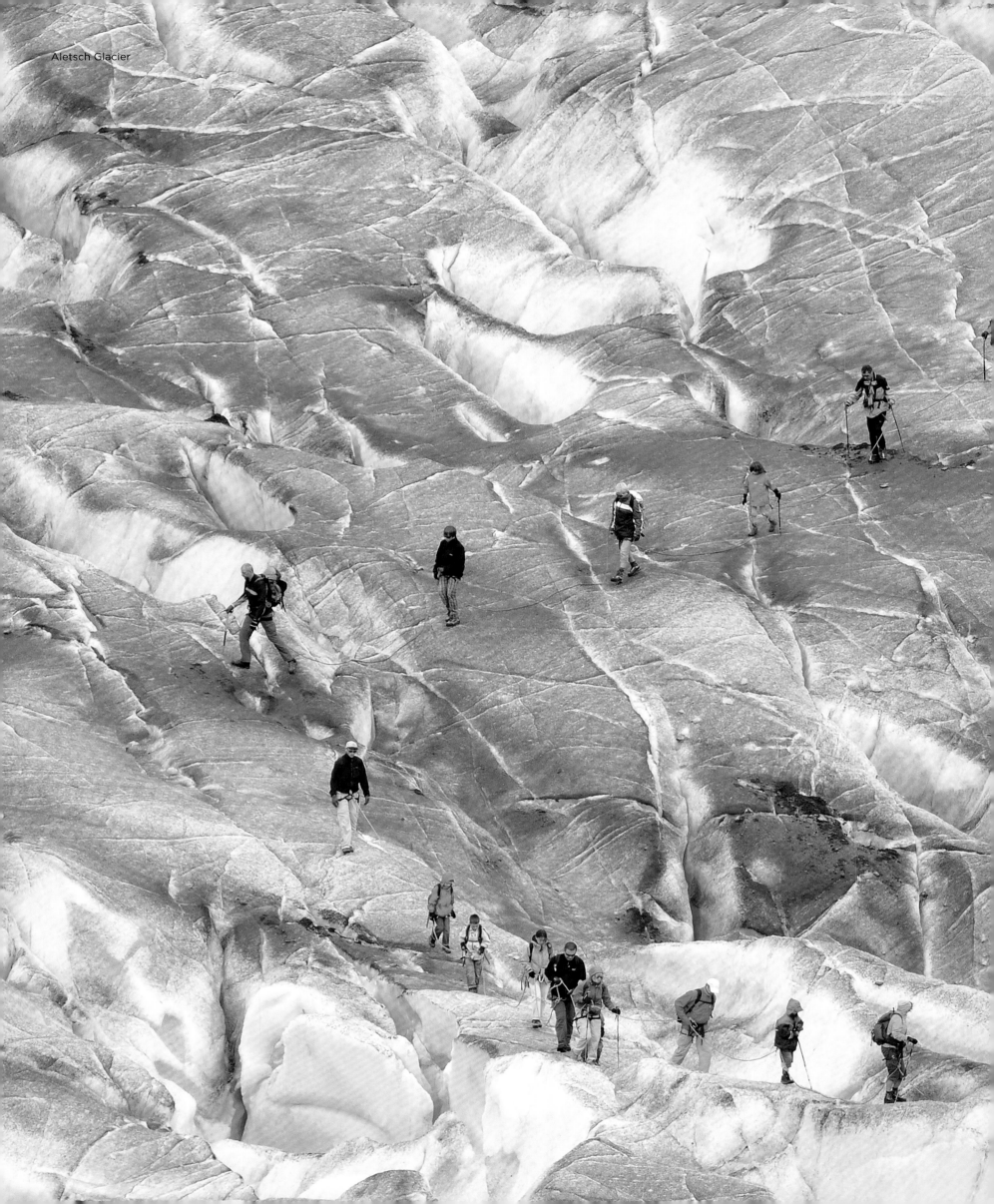
Aletsch Glacier

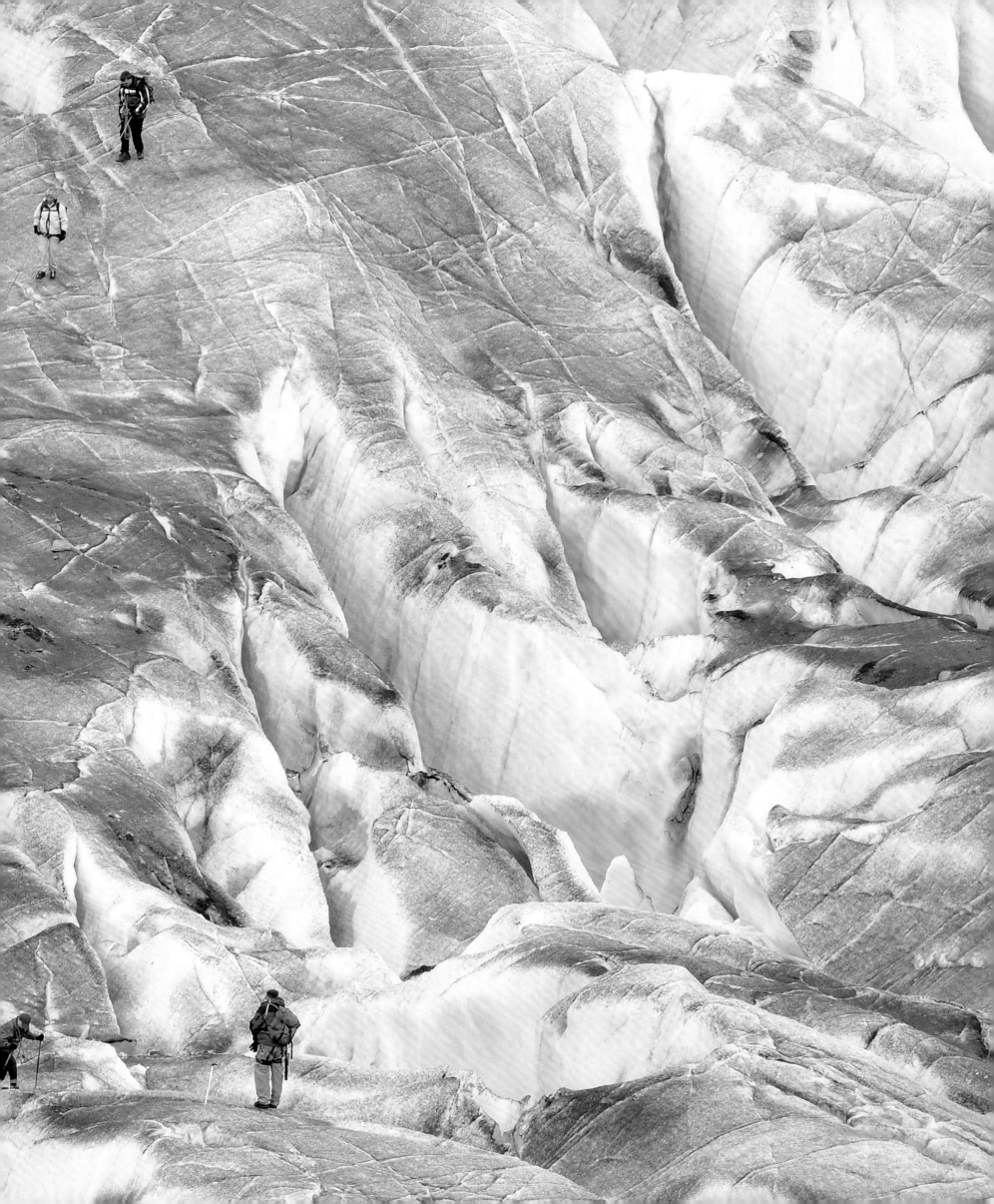

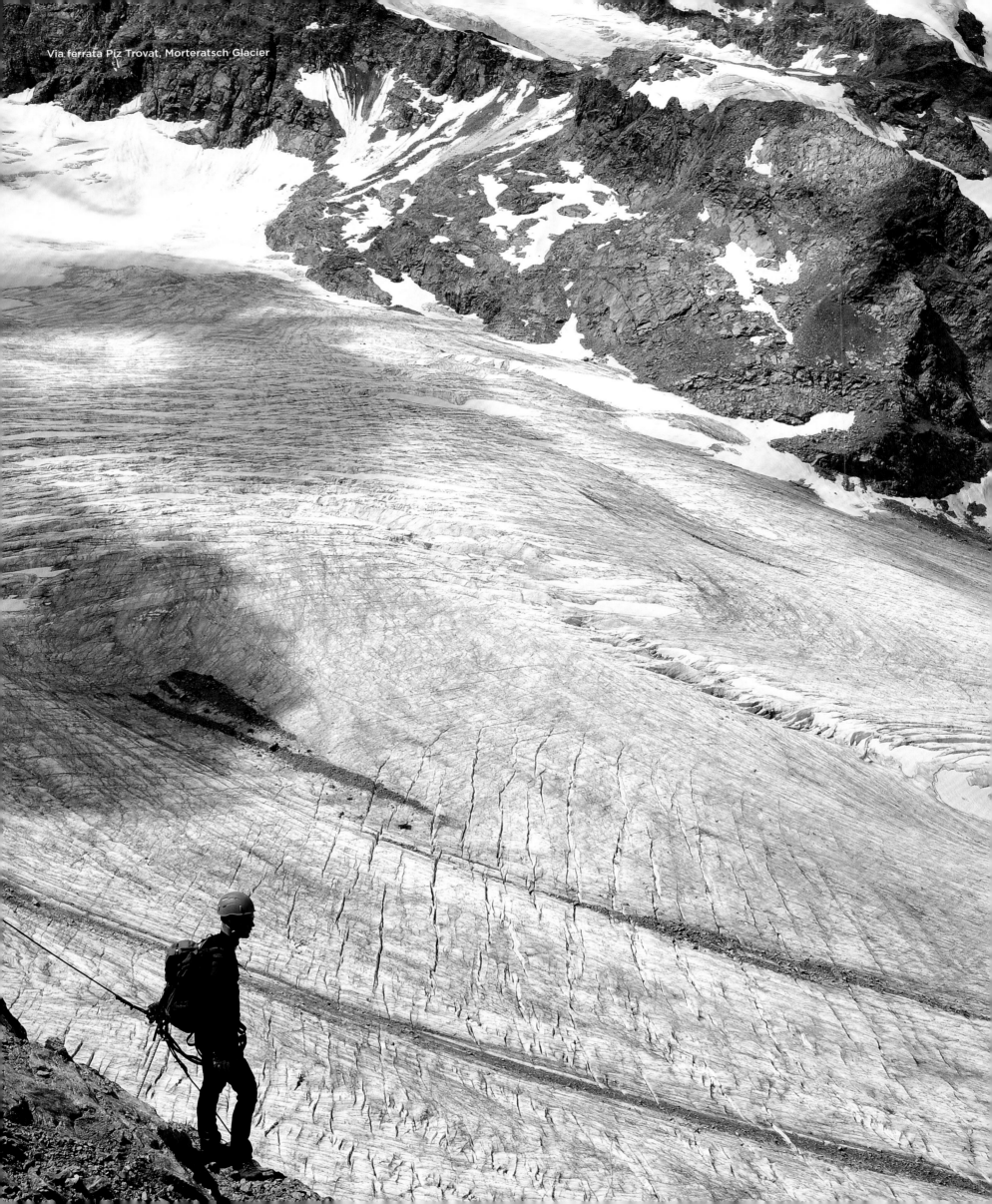

Via ferrata Piz Trovat, Morteratsch Glacier

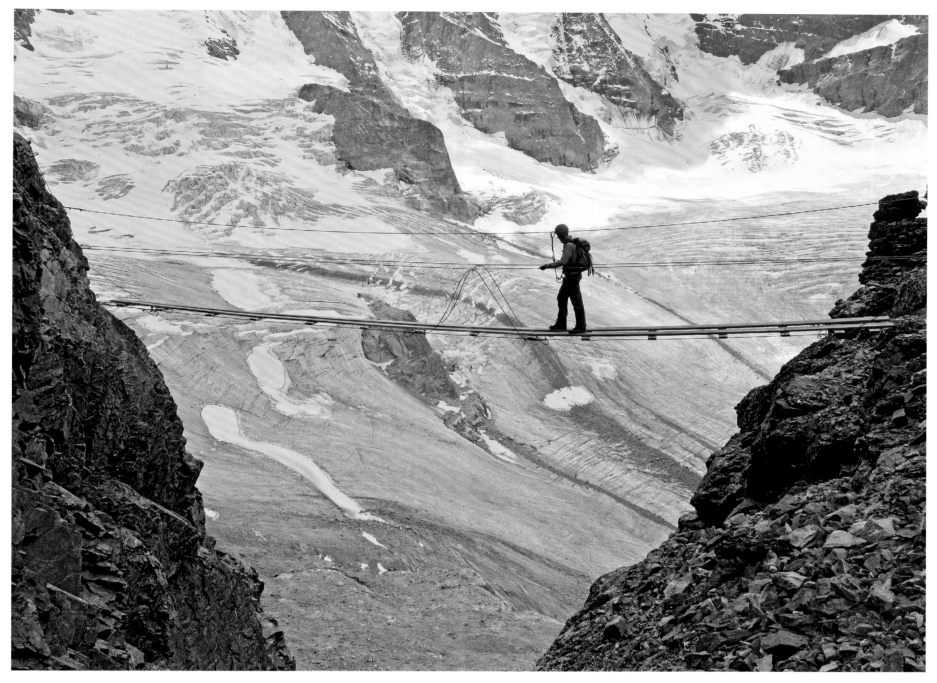

Via ferrata Piz Trovat, Morteratsch Glacier

Via Ferrata Piz Trovat

The via ferrata at Piz Trovat offers breathtaking views of the Morteratsch glacier and the mountain world of the Engadine. The via ferrata (iron path) is well secured with iron clamps and ropes, the spectacular highlight being a suspension bridge. Even though the via ferrata is considered suitable for beginners, you must be sure-footed and free of vertigo.

Via ferrata du Piz Trovat

La via ferrata du Piz Trovat offre des panoramas hors du commun sur le glacier Morteratsch et sur les montagnes de l'Engadine. La via ferrata (« voie ferrée ») est sécurisée par des câbles métalliques et des cordes. Son pont suspendu est une étape fort spectaculaire. Bien que la via ferrata soit dite adaptée aux débutants, mieux vaut avoir le pied sûr et ne pas être sujet au vertige.

Via ferrata Piz Trovat

Der Klettersteig am Piz Trovat bietet atemberaubende Ausblicke auf den Morteratsch-Gletscher und die Bergwelt des Engadin. Die Via ferrata (Eisenweg) ist mit Eisenklammern und Seilen gut gesichert, spektakulärer Höhepunkt ist eine Hängebrücke. Auch wenn der Klettersteig als für Einsteiger geeignet gilt: Trittsicher und schwindelfrei sollte man schon sein.

Vía ferrata del Piz Trovat

La vía ferrata del Piz Trovat ofrece unas vistas impresionantes del glaciar Morteratsch y del mundo montañoso de la Engadina. La vía ferrata está bien asegurada con abrazaderas de hierro y cuerdas, y su punto culminante más espectacular es un puente colgante. Aunque la vía ferrata se considera apta para principiantes, hay que tener cuidado y no tener vértigo.

Via ferrata Piz Trovat

A via ferrata no Piz Trovat oferece vistas deslumbrantes da geleira Morteratsch e do mundo montanhoso do Engadine. A via ferrata (caminho de ferro) é bem fixada com braçadeiras e cordas de ferro, sendo o destaque espetacular uma ponte suspensa. Mesmo que a via ferrata seja considerada adequada para iniciantes, você deve estar bem firme e livre de vertigens.

Via ferrata Piz Trovat

De klettersteig bij Piz Trovat biedt een adembenemend uitzicht op de Morteratschgletsjer en de bergdalen van het Engadin. Het Via ferrata (ijzeren pad) is goed beveiligd met ijzeren klemmen en touwen, met als spectaculair hoogtepunt een hangbrug. Ook al wordt de klettersteig geschikt geacht voor beginners, moet je zeker en vrij van hoogtevrees zijn.

Great St Bernard Hospice

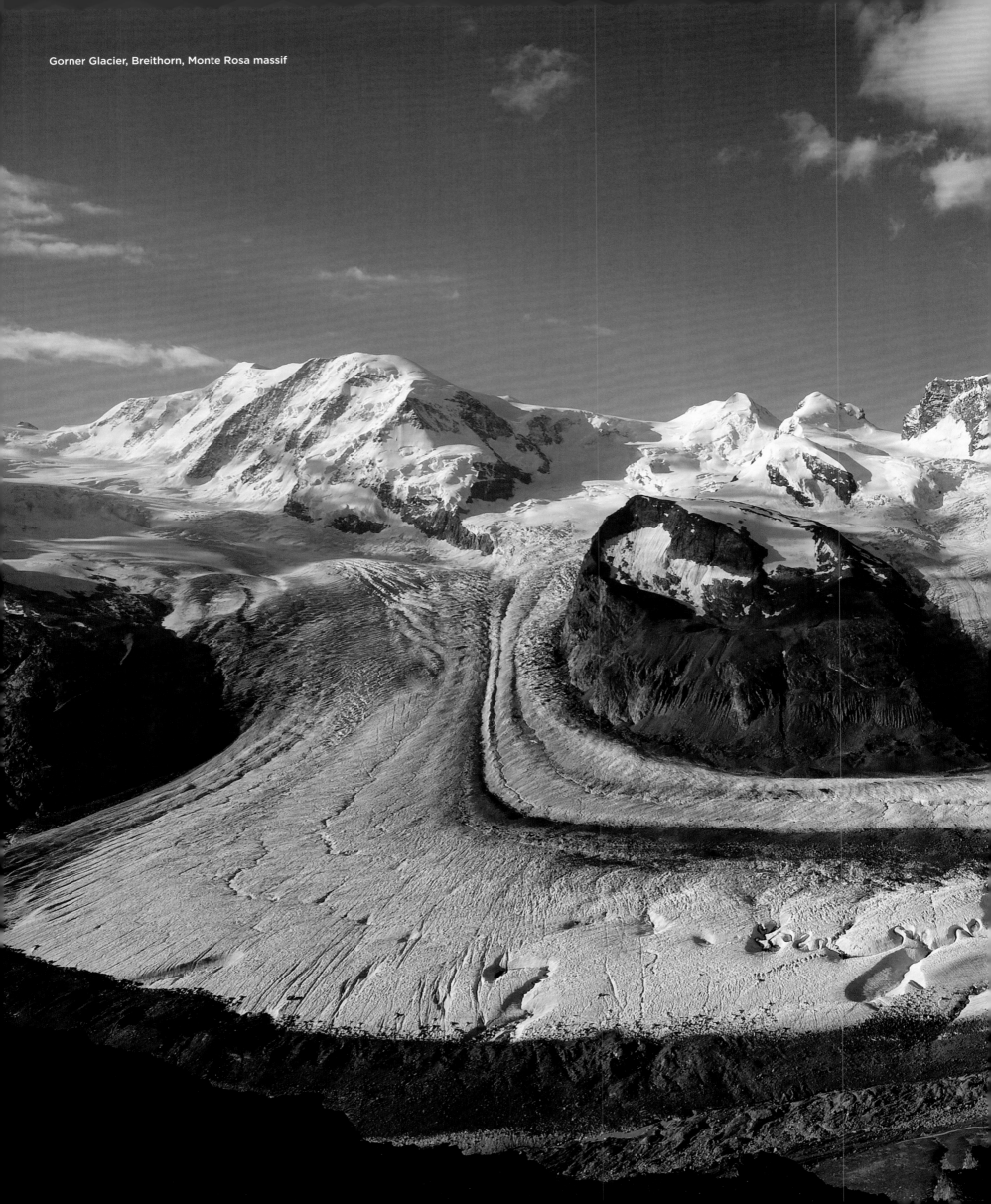

Gorner Glacier, Breithorn, Monte Rosa massif

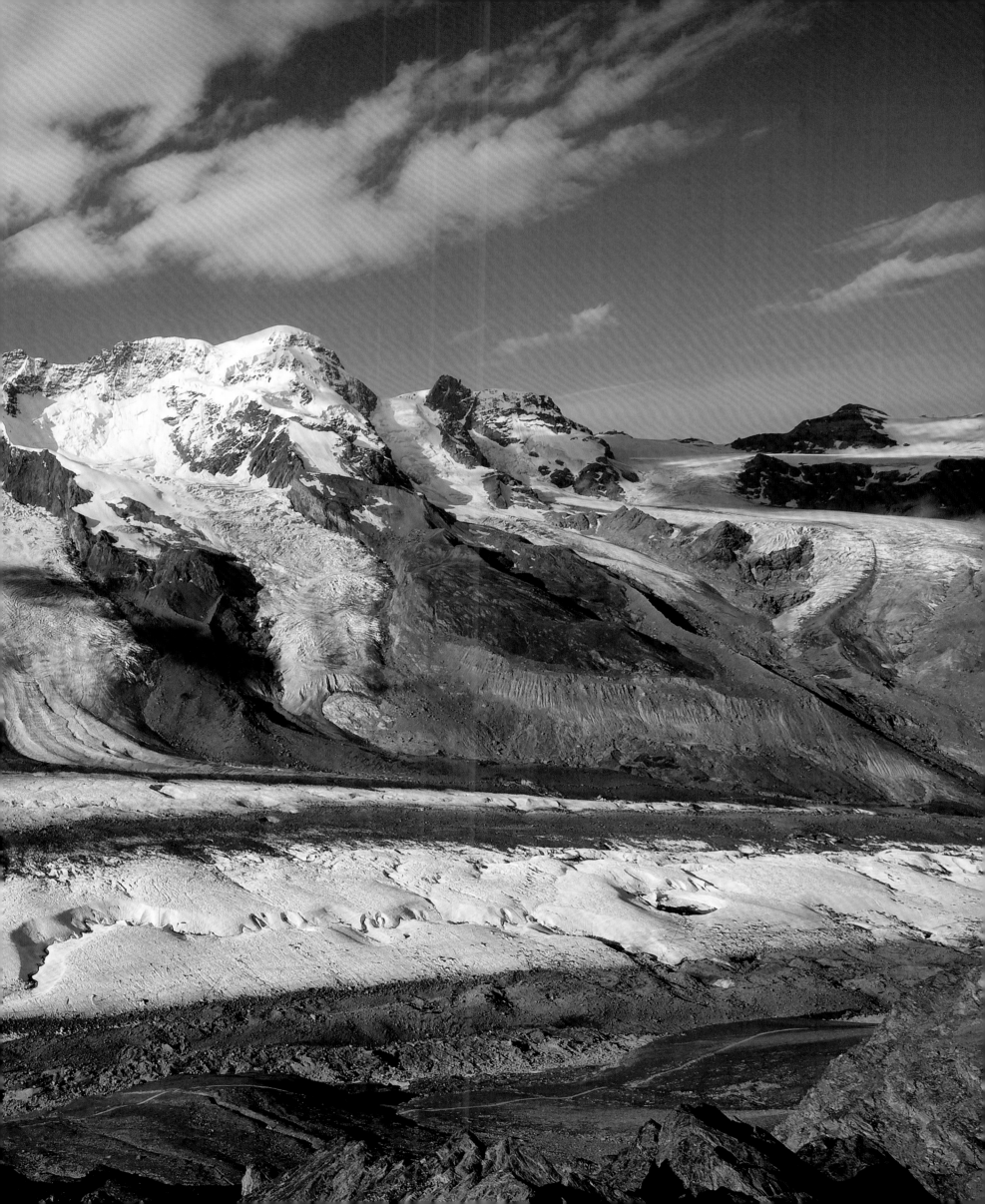

Ice palace, Jungfraujoch

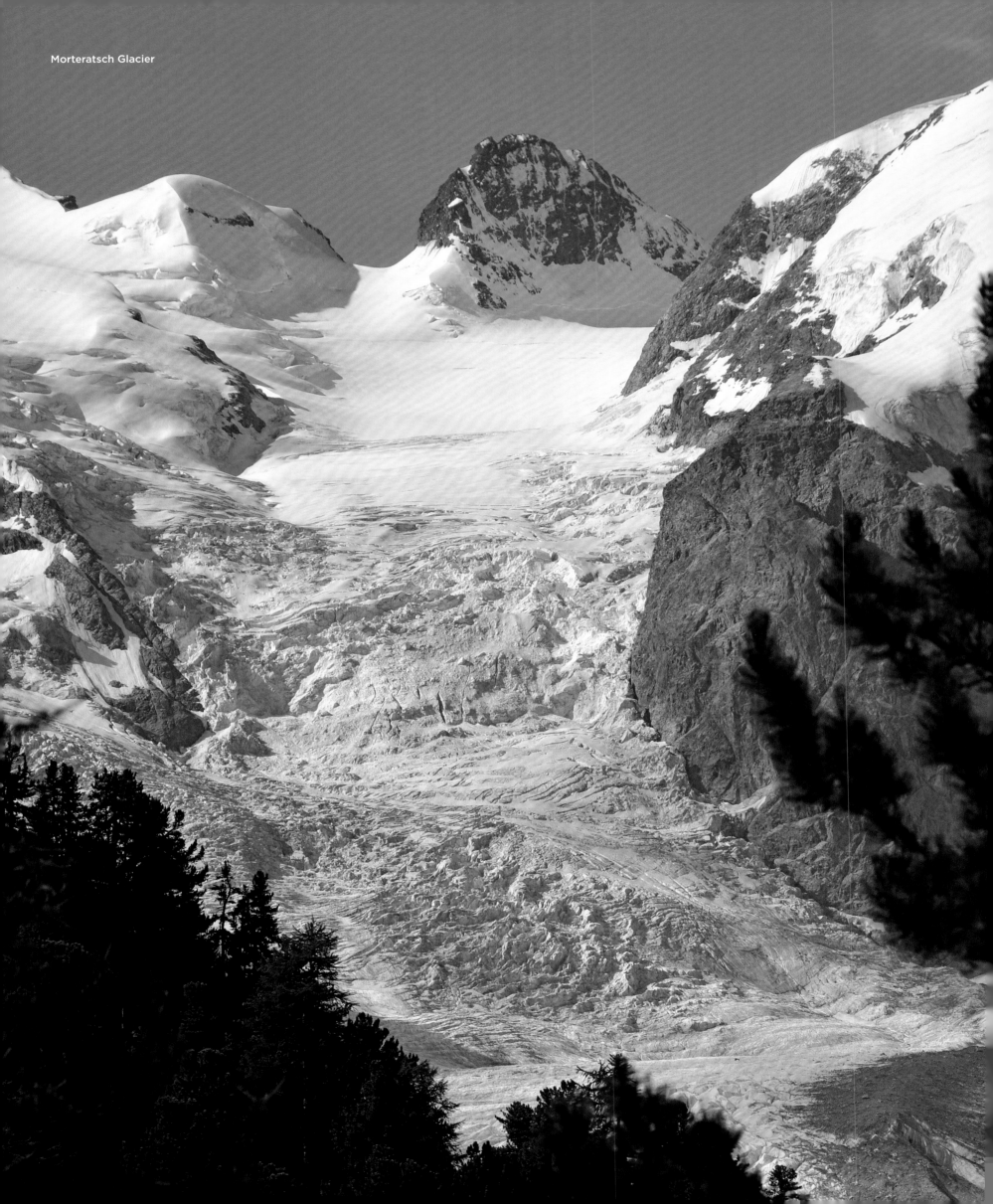

Morteratsch Glacier

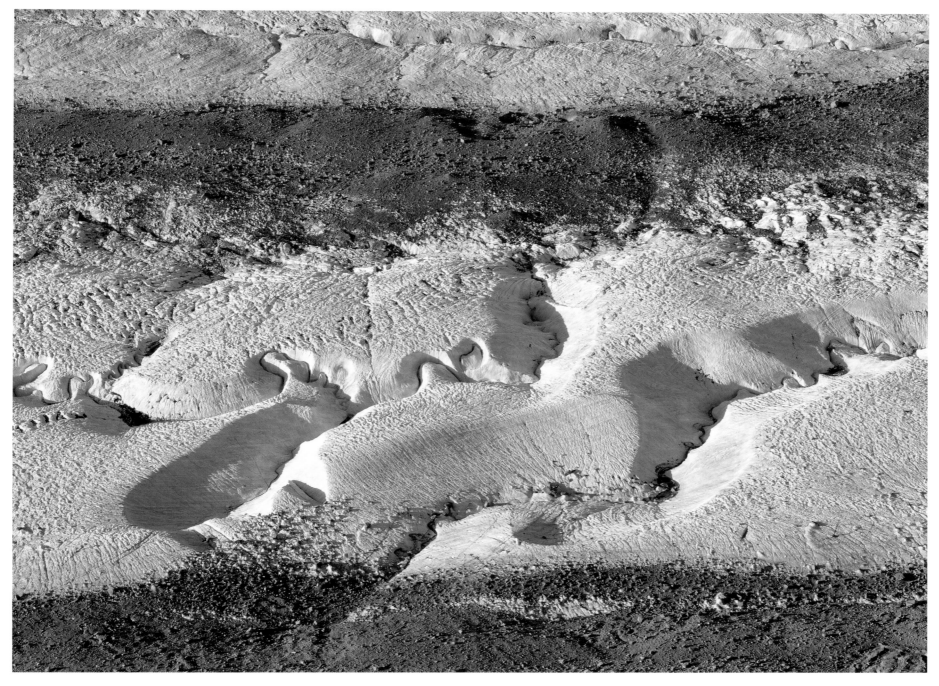

Gorner Glacier

Morteratsch Glacier

The Morteratsch glacier in the Swiss canton of Graubünden is one of the longest glaciers in the Alps. It measures about 6.5 km (4 mi), but has lost 2.5 km (1.5 mi) in length in the last 120 years. Climate change is causing it to shrink faster and faster. The glacier is a popular destination for tourists. Hiking is possible in summer and ski tours in winter.

Glacier Morteratsch

Le glacier Morteratsch, situé dans le massif de la Bernina dans le canton des Grisons, fait partie des plus longs glaciers alpins. Il mesure environ 6,5 km de long mais a perdu 2,5 km de glace au cours des cent vingt dernières années. Le changement climatique accélère de plus en plus son rétrécissement. Ce glacier est une destination appréciée des touristes, qui peuvent y randonner en été et y skier en hiver.

Morteratsch-Gletscher

Der Morteratsch-Gletscher im Schweizer Kanton Graubünden gehört zu den längsten Gletschern in den Alpen. Er misst etwa 6,5 km, hat aber in den letzten 120 Jahren 2,5 km an Länge eingebüßt. Der Klimawandel lässt ihn immer schneller schrumpfen. Für Touristen ist der Gletscher ein beliebtes Ziel, im Sommer sind Wanderungen, im Winter Skitouren möglich.

Glaciar Morteratsch

El glaciar Morteratsch en el cantón suizo de los Grisones es uno de los glaciares más largos de los Alpes. Mide unos 6,5 km, pero ha perdido 2,5 km de longitud en los últimos 120 años. El cambio climático hace que se reduzca cada vez más rápido. El glaciar es un destino popular entre los turistas, en verano se puede hacer senderismo y en invierno excursiones de esquí.

Glaciar Morteratsch

A geleira Morteratsch no cantão suíço de Graubünden pertence a uma das geleiras mais longas dos Alpes. Mede cerca de 6,5 km, mas nos últimos 120 anos perdeu 2,5 km de comprimento. A mudança climática está fazendo com que ela encolha cada vez mais rápido. A geleira é um destino popular para os turistas, no verão são possíveis caminhadas e no inverno passeios de esqui.

Morteratsch gletsjer

De Morteratschgletsjer in het Zwitserse kanton Graubünden is een van de langste gletsjers in de Alpen. Het is ongeveer 6,5 km lang, maar heeft de afgelopen 120 jaar 2,5 km aan lengte verloren. Klimaatverandering zorgt ervoor dat het steeds sneller krimpt. De gletsjer is een populaire bestemming voor toeristen, wandelen is mogelijk in de zomer en skitochten in de winter.

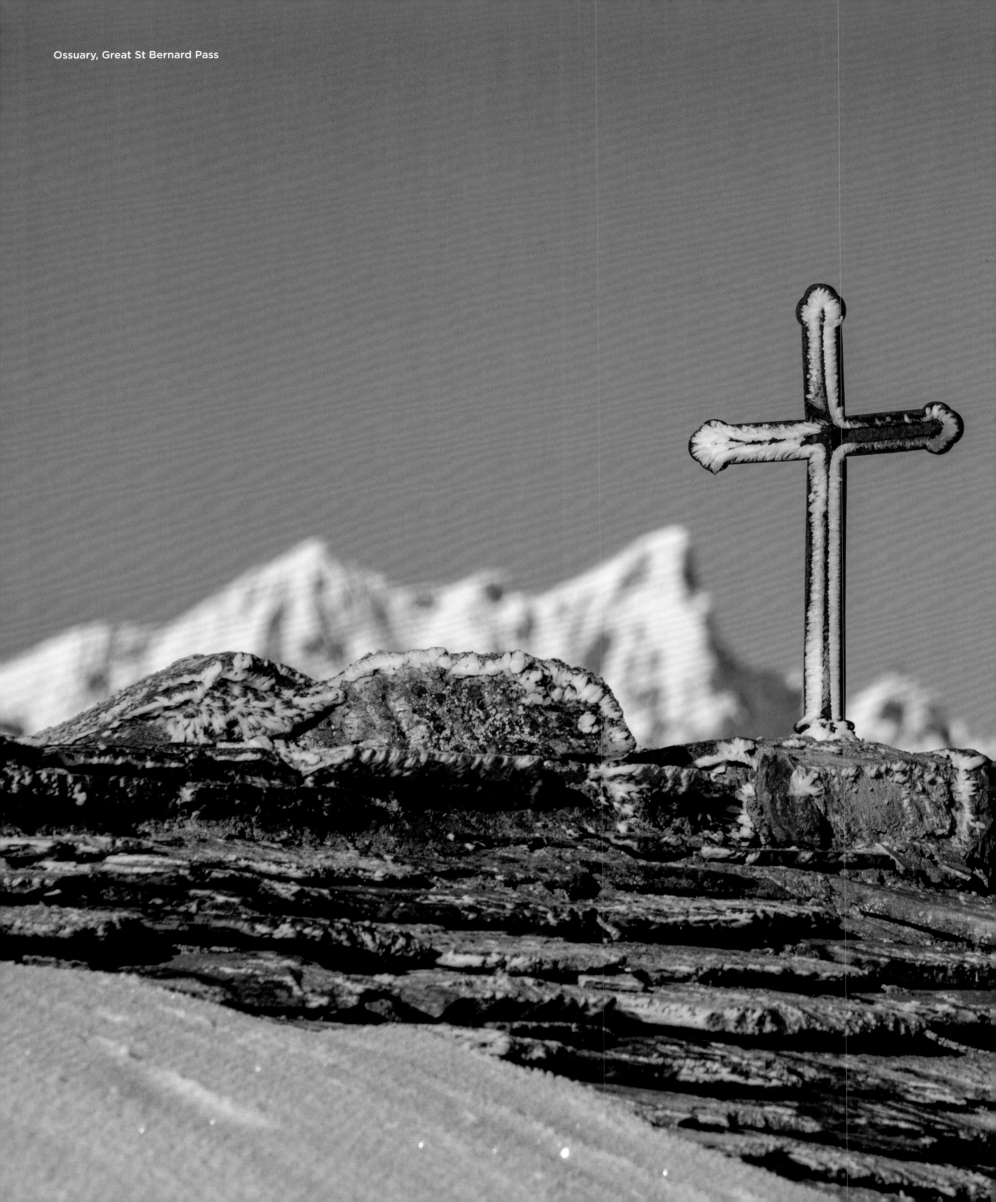

Ossuary, Great St Bernard Pass

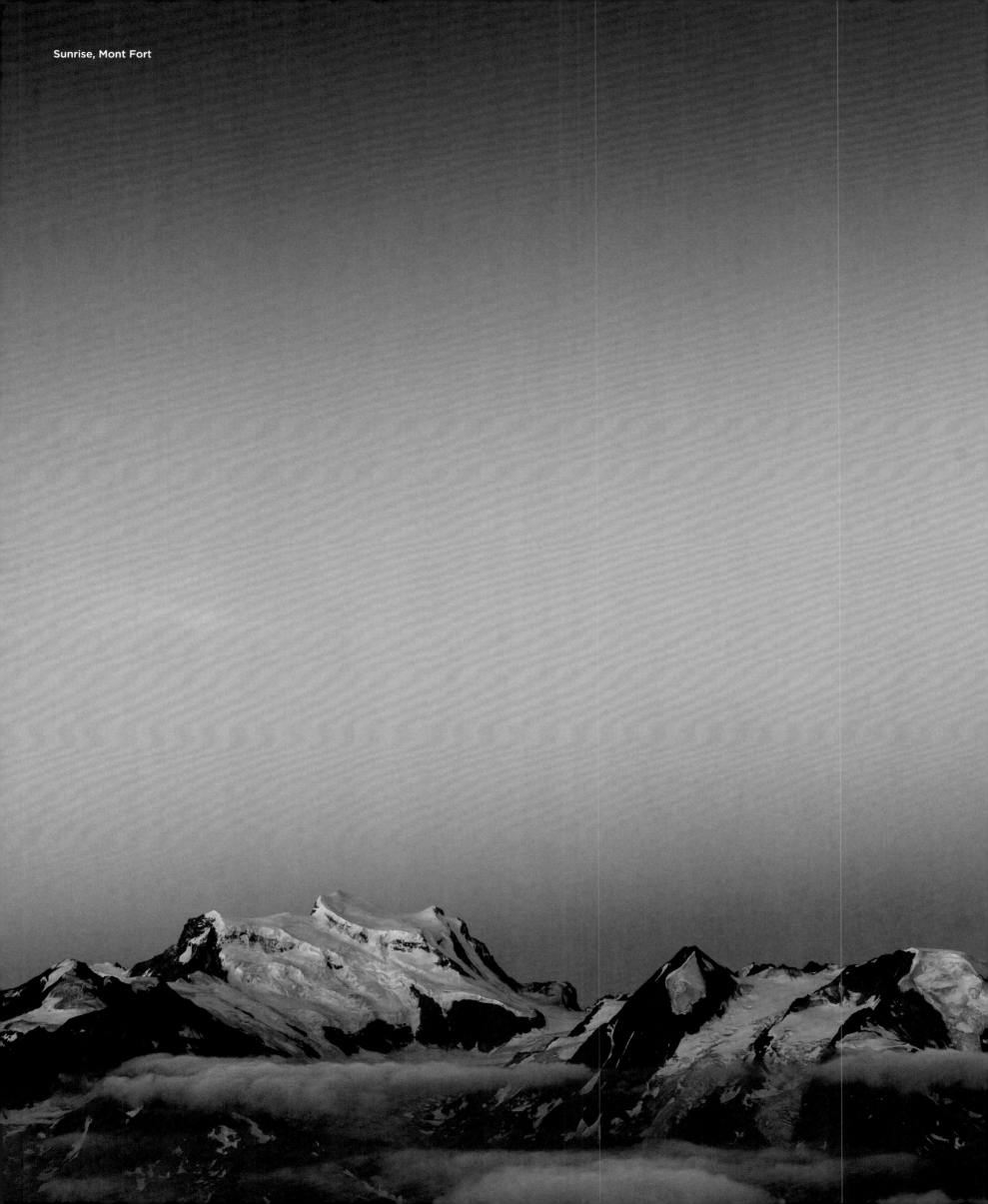

Sunrise, Mont Fort

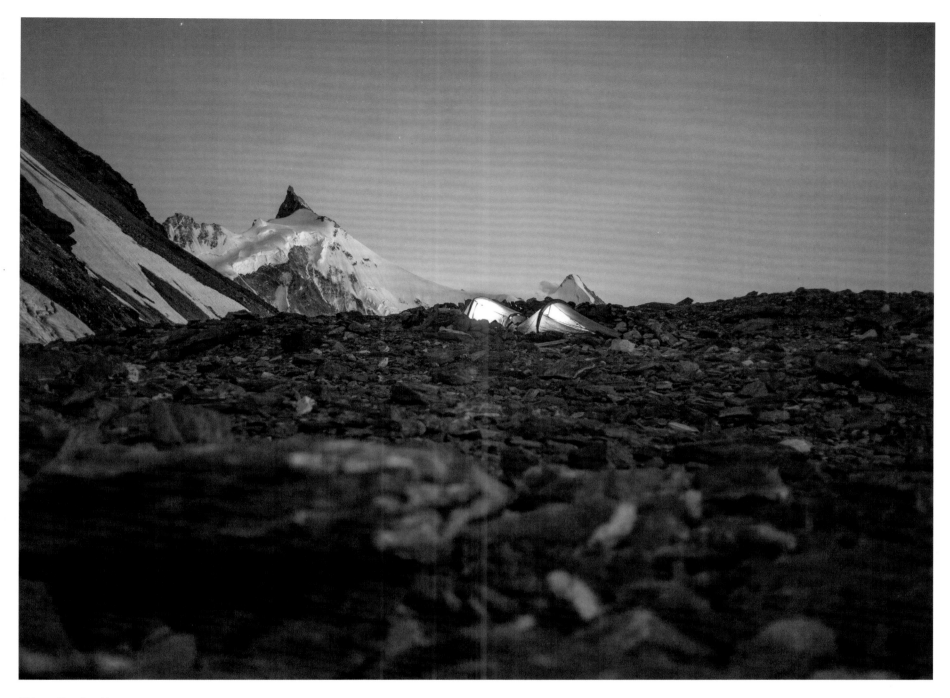

Bishorn, Pennine Alps

Mountain Bivouac

People can adapt to heights and a life amongst ice and snow. However, good physical condition and training are required, for example when embarking on mountain tours that involve bivouacking at great heights. High-tech equipment such as suitable clothing and tents also make this possible for non-athletes. The reward is a unique experience of nature.

Bivouac d'altitude

Les hommes sont capables de s'adapter à l'altitude et à la vie au milieu de la glace et de la neige. Une bonne condition physique et de l'entraînement sont toutefois nécessaires pour, par exemple, effectuer des randonnées en montagne prévoyant de bivouaquer en altitude. Des équipements haute technologie tels que des vêtements et une tente adaptés rendent également cela possible pour les non-sportifs, qui seront récompensés par des expériences exceptionnelles en pleine nature.

Höhenbiwak

Menschen können sich an Höhen und ein Leben in Eis und Schnee anpassen. Doch gute Konstitution und Training sind erforderlich, um beispielsweise Touren im Gebirge zu gehen, die Biwakieren in großer Höhe vorsehen. Hightech-Ausrüstung wie geeignete Kleidung und Zelte machen es auch für Nicht-Sportler möglich. Belohnung sind einzigartige Naturerlebnisse.

Vivac a gran altitud

La gente puede adaptarse a las alturas y a una vida en el hielo y la nieve. Sin embargo, se requiere una buena condición física y entrenamiento, por ejemplo, para realizar excursiones de montaña que impliquen acampar a grandes alturas. Los equipos de alta tecnología, como la ropa adecuada y las tiendas de campaña, también lo hacen posible para los no deportistas. La recompensa es una experiencia única en la naturaleza.

Bivaque de montanha

As pessoas podem adaptar-se às alturas e a uma vida no gelo e na neve. No entanto, são necessárias boas condições físicas e treinamento, por exemplo, para ir em passeios de montanha que envolvem "bivouacking" em grandes alturas. Equipamentos de alta tecnologia, como roupas e tendas adequadas, também possibilitam a participação de não-atletas. A recompensa é uma experiência única da natureza.

Hoogte bivak

Mensen kunnen zich aanpassen aan hoogtes en een leven in ijs en sneeuw. Een goede fysieke conditie en training zijn echter vereist, bijvoorbeeld om bergtochten te maken met bivakkeren op grote hoogte. Hoogtechnologische apparatuur zoals geschikte kleding en tenten maken het ook mogelijk voor niet-atleten. De beloning is een unieke natuurervaring.

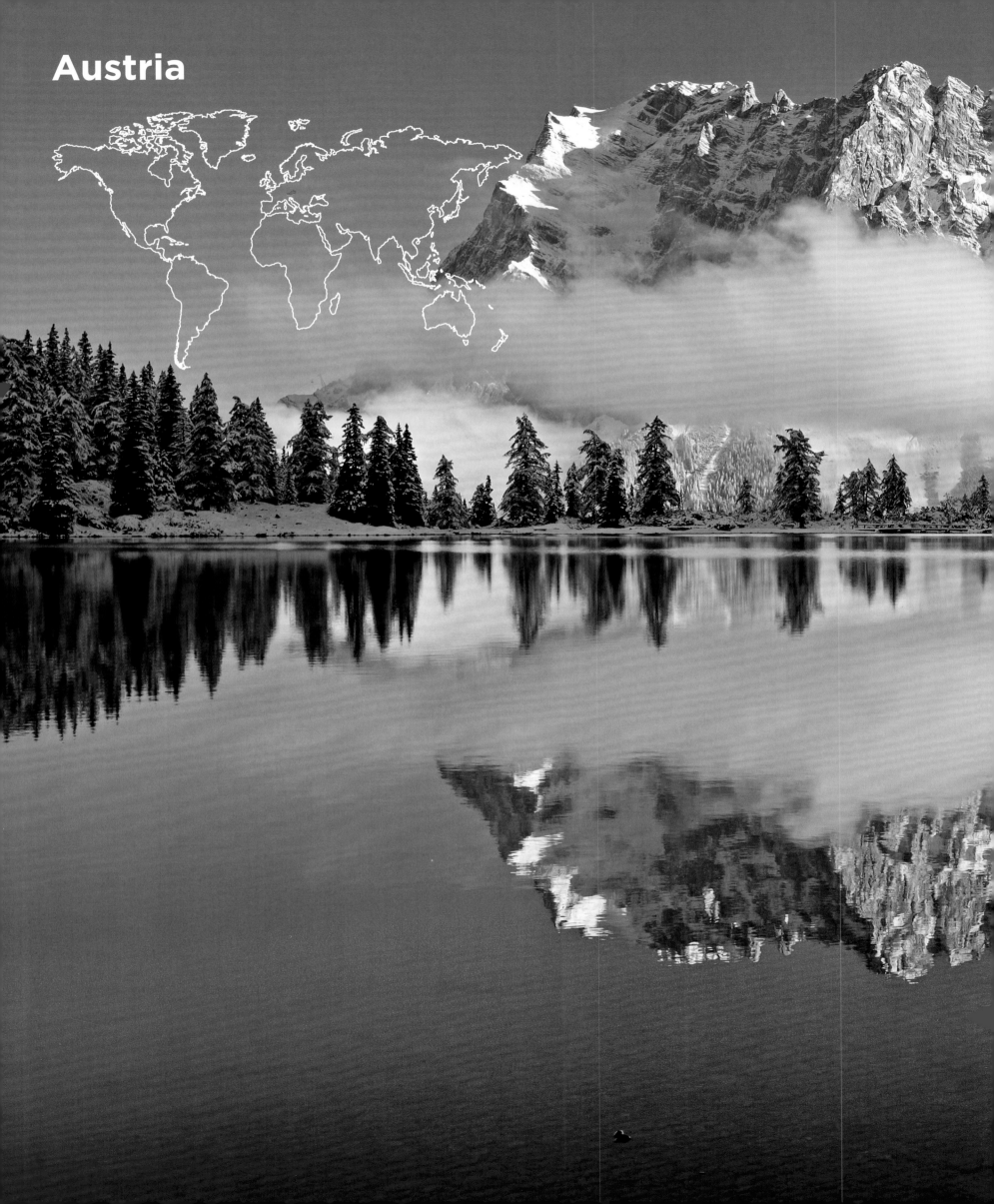

Austria

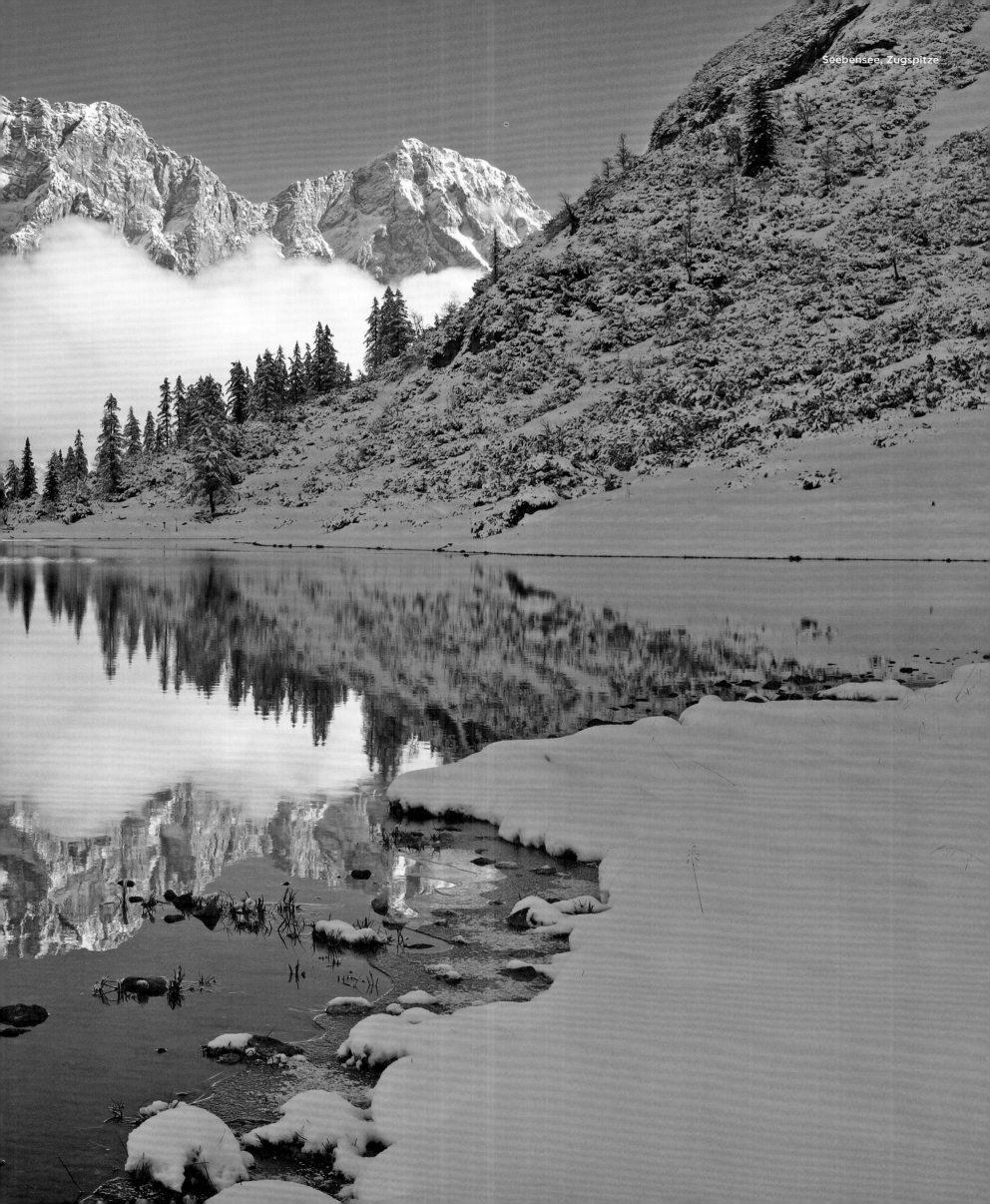

Seebensee, Zugspitze

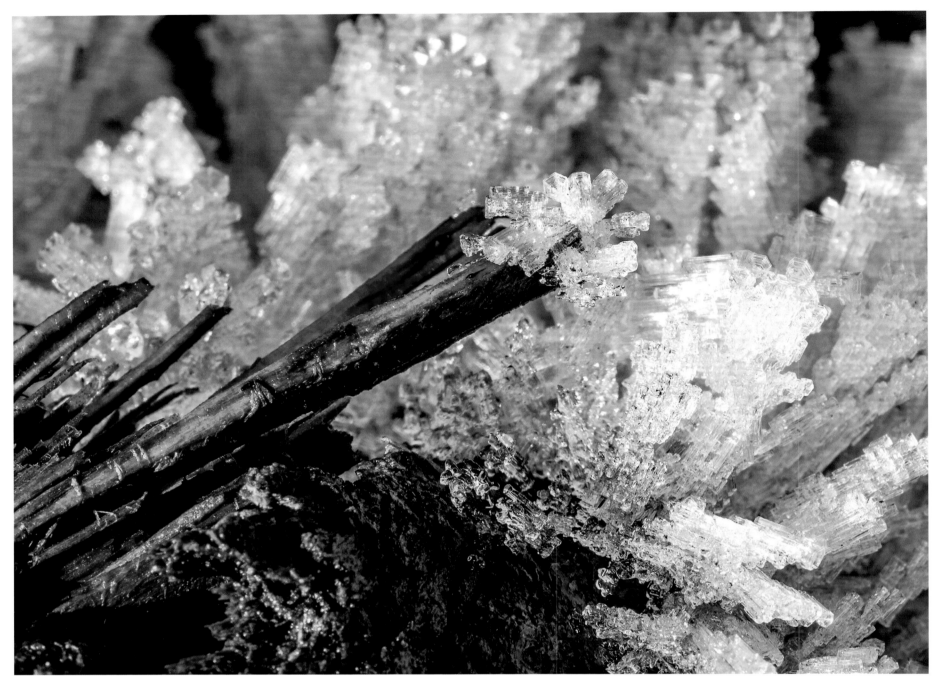

Ice crystals, Hinterriß, Karwendel

Austria

In the north, east and southeast of Austria there are extensive plains, but about 60 percent of the country is mountainous. The Alpine chain with its numerous three thousand meter (9842 ft.) peaks reaches its highest altitude at 3798 m (12460 ft) in the Großglockner. Climate change has dramatic effects on the many glaciers in Austria, which are shrinking faster and faster. It also affects the important economic factor of tourism, as winter sports play a major role. However, Austria is still considered a paradise for skiers. In addition to the metropolis of Vienna, it is above all the small holiday resorts set against a picturesque mountain backdrop that attract visitors to the country.

Autriche

Au nord, à l'est et au sud-est de l'Autriche s'étendent de vastes plaines alors qu'environ 60 % du pays est constitué de montagnes. La chaîne des Alpes, qui abonde en sommets dépassant les 3 000 m, a son point culminant au Grossglockner à 3 798 m d'altitude. Le changement climatique a des effets dramatiques sur les nombreux glaciers autrichiens, qui fondent à grande vitesse. Ceci a également un impact sur le tourisme, important facteur économique, car les sports d'hiver jouent un rôle majeur en Autriche. Même si toutefois le pays reste encore un paradis pour les skieurs. En dehors de la métropole de Vienne, les petits villages de vacances nichés au cœur de décors de montagnes pittoresques attirent particulièrement les visiteurs.

Österreich

Im Norden, Osten und Südosten Österreichs erstrecken sich ausgedehnte Ebenen, aber rund 60 Prozent des Landes sind gebirgig. Die Alpenkette mit zahlreichen Dreitausendern erreicht im Großglockner mit 3798 m ihre größte Höhe. Der Klimawandel hat dramatische Auswirkungen auf die vielen Gletscher in Österreich, die immer schneller schrumpfen. Er betrifft auch den wichtigen Wirtschaftsfaktor Tourismus, denn Wintersport spielt eine große Rolle. Noch gilt Österreich aber als Paradies für Skifahrer. Neben der Metropole Wien locken vor allem kleine Urlaubsorte vor malerischer Bergkulisse Besucher ins Land.

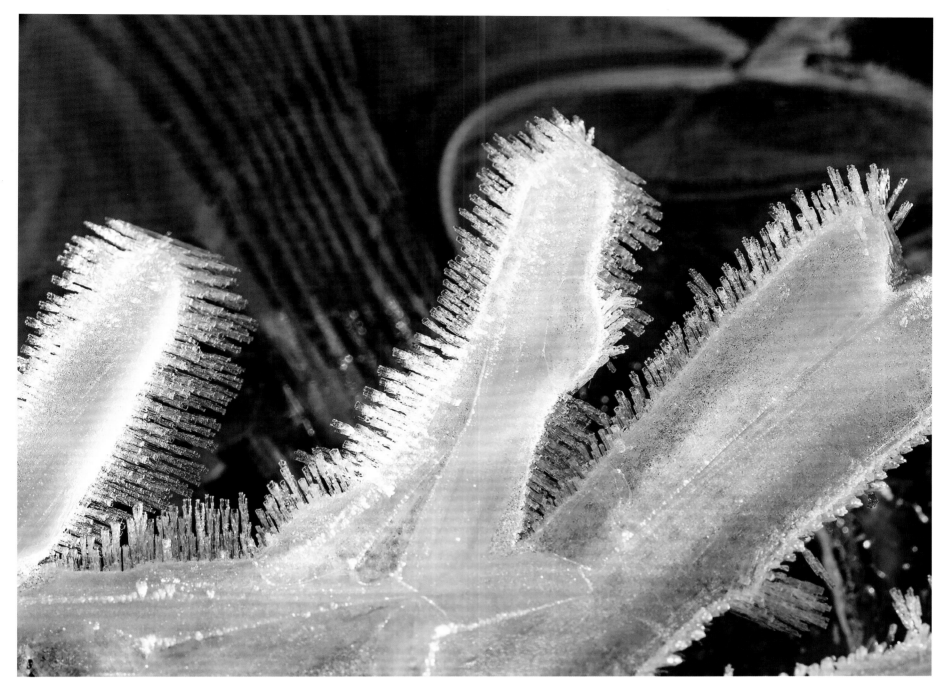

Ice crystals, Hinterriß, Karwendel

Austria

En el norte, este y sureste de Austria hay extensas llanuras, pero alrededor del 60 por ciento del país es montañoso. La cadena alpina, con sus numerosos picos de tres mil metros de altura, alcanza su altura máxima de 3798 m en el Großglockner. El cambio climático tiene efectos dramáticos en los numerosos glaciares de Austria, que se están reduciendo cada vez con mayor rapidez. También afecta al importante factor económico del turismo, ya que los deportes de invierno desempeñan un papel fundamental. Pero Austria sigue siendo un paraíso para los esquiadores. Además de la metrópoli de Viena, son sobre todo los pequeños complejos turísticos situados en un pintoresco entorno montañoso los que atraen a los visitantes al país.

Áustria

No norte, leste e sudeste da Áustria existem extensas planícies, mas cerca de 60 por cento do país é montanhoso. A cadeia alpina, com os seus numerosos picos de três mil metros, atinge a sua altitude máxima, com 3798 metros, no "Großglockner". As alterações climáticas têm efeitos dramáticos nos muitos glaciares da Áustria, que estão a diminuir cada vez mais rapidamente. Ele afeta igualmente o turismo, considerado um importante fator económico, uma vez que os desportos de inverno desempenham um papel importante. Mas a Áustria ainda é considerada um paraíso para os esquiadores. Além da metrópole de Viena, são sobretudo pequenas estâncias de férias situadas num cenário pitoresco de montanha, que atraem visitantes ao país.

Oostenrijk

In het noorden, oosten en zuidoosten van Oostenrijk zijn uitgestrekte vlakten, ongeveer 60 procent van het land is bergachtig. De Alpenketen met talrijke drieduizender bereikt op Großglockner met 3798 m zijn hoogste punt. De klimaatverandering heeft dramatische gevolgen voor de vele gletsjers in Oostenrijk, die steeds sneller krimpen. Het is ook van invloed op de belangrijke economische factor van het toerisme, aangezien de wintersport een belangrijke rol speelt. Maar Oostenrijk wordt nog steeds beschouwd als een paradijs voor skiërs. Naast de metropool Wenen is het vooral de kleine vakantieoorden tegen een schilderachtige bergachtige achtergrond die bezoekers naar het land trekken.

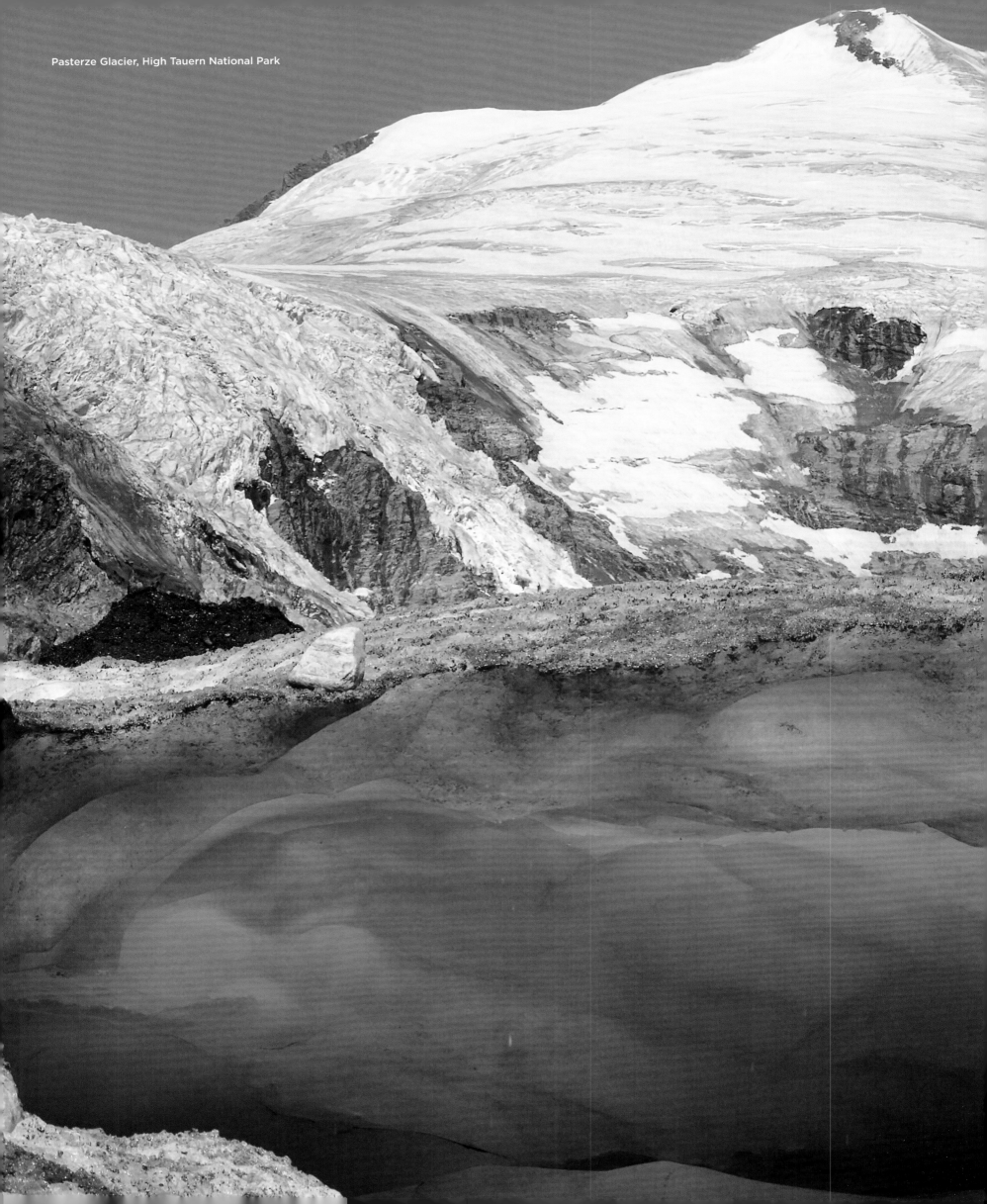

Pasterze Glacier, High Tauern National Park

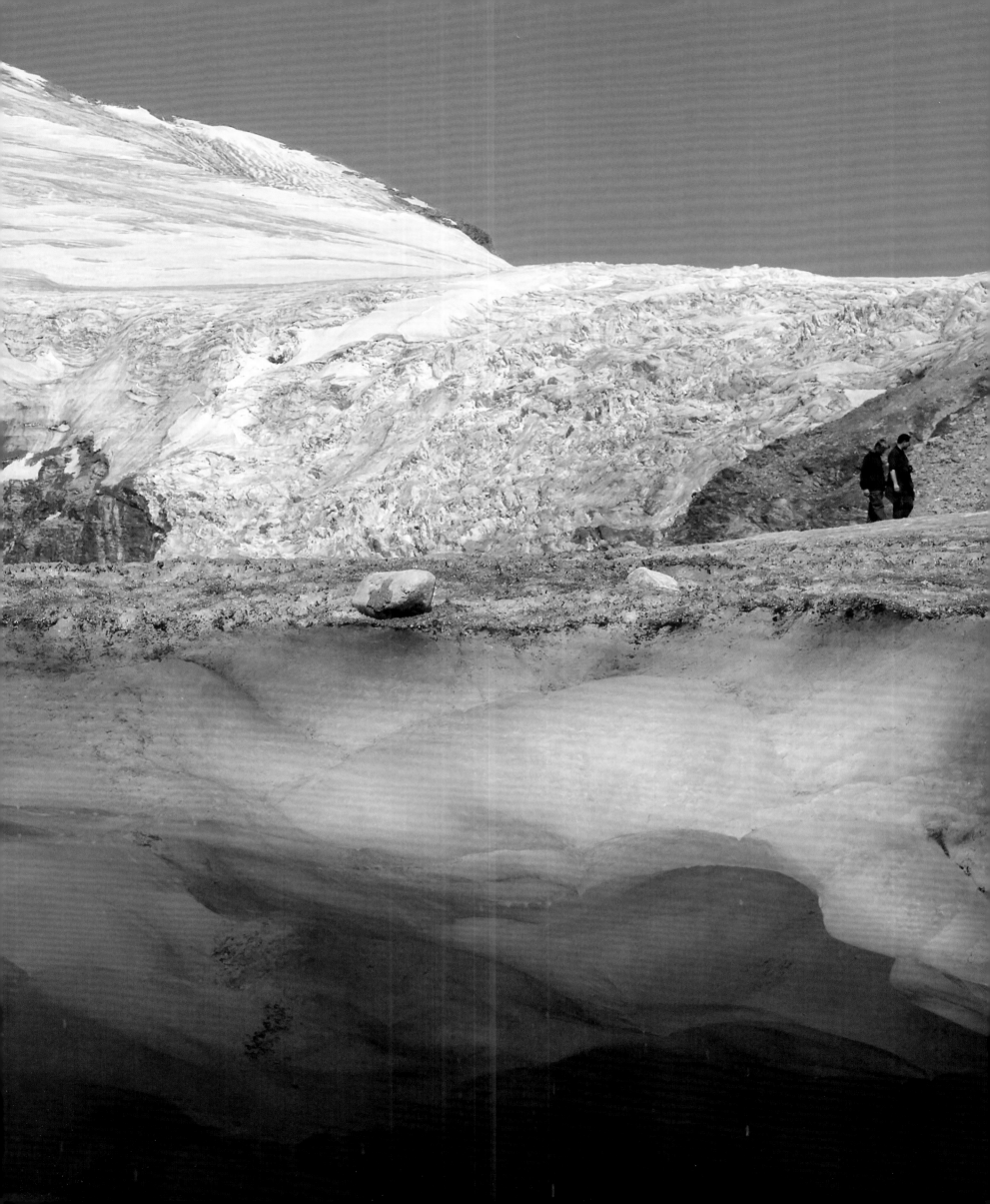

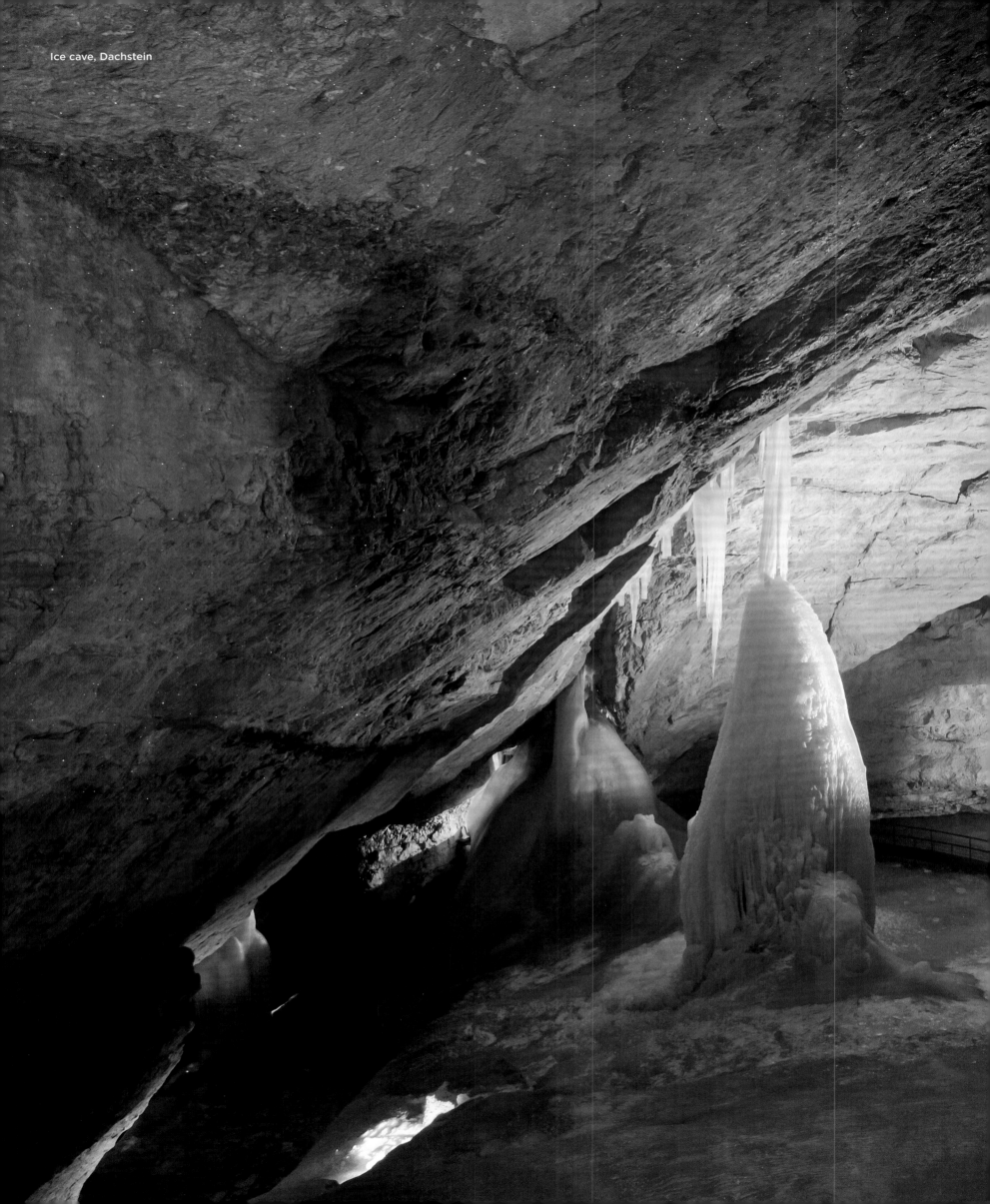

Ice cave, Dachstein

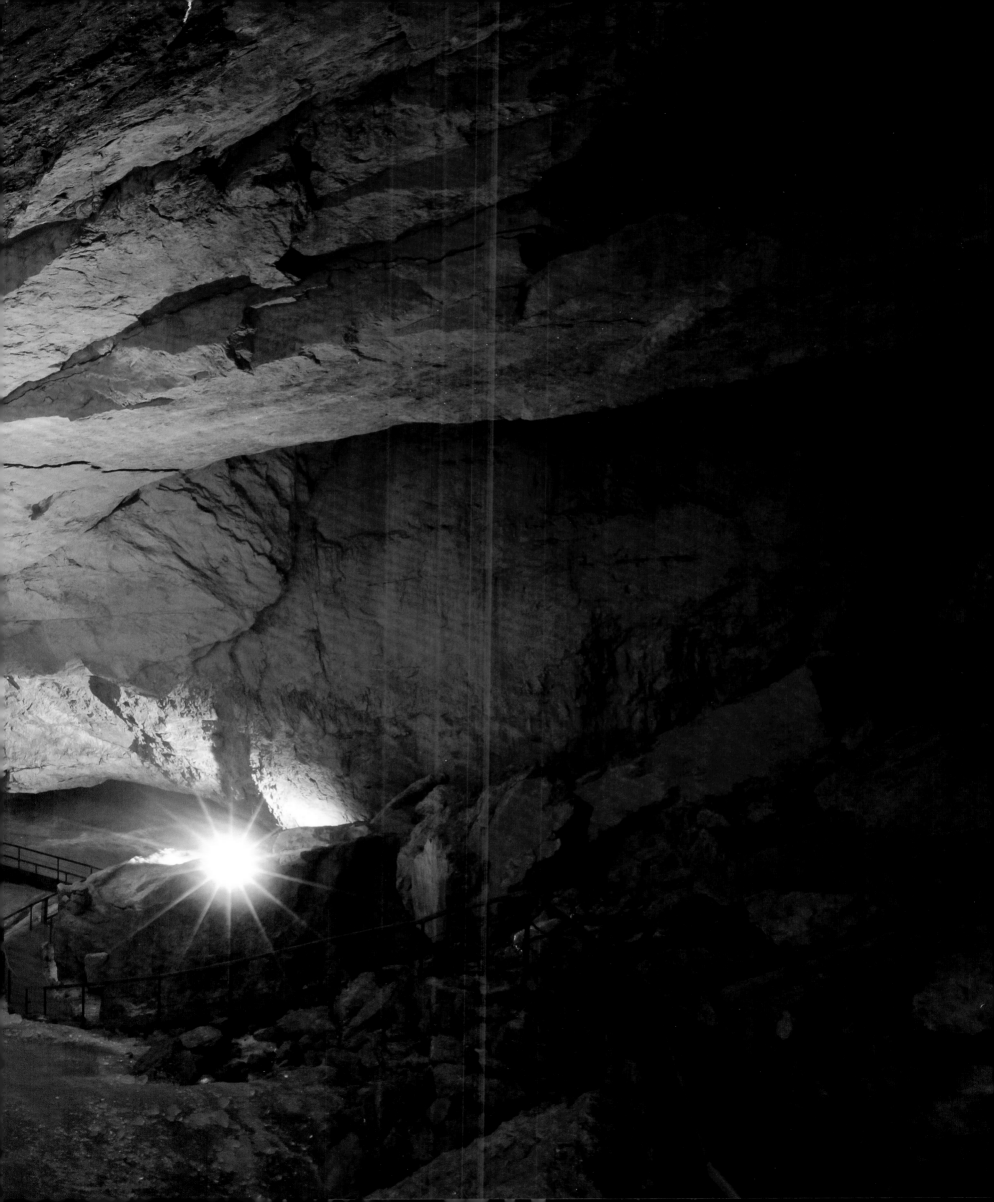

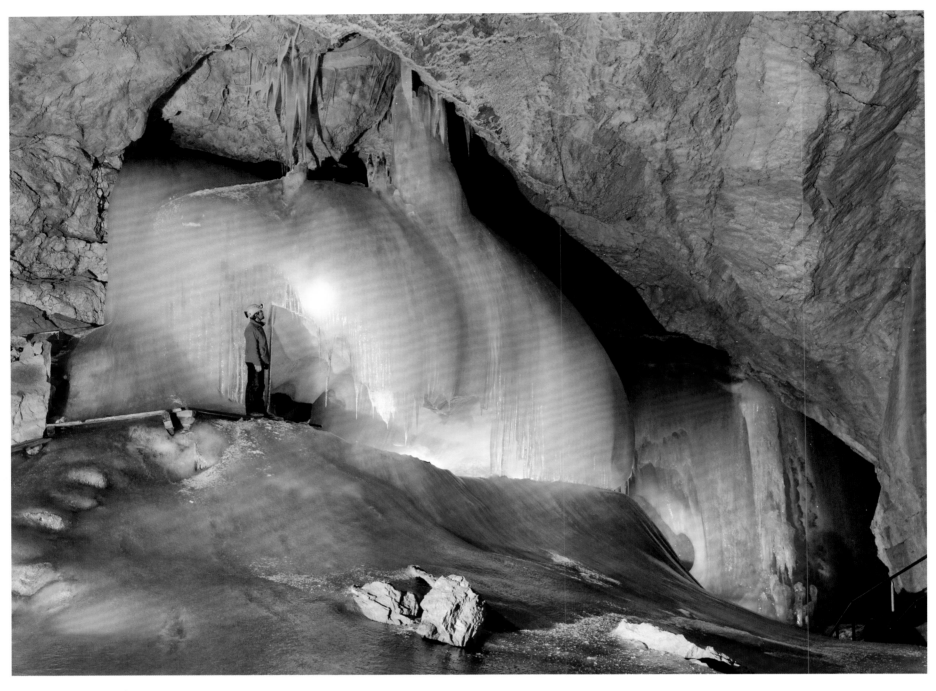

Ice Cave, Eisriesenwelt, Werfen

Eisriesenwelt

The Eisriesenwelt in Salzburger Land advertises itself with a superlative: the largest ice cave in the world. The cave was discovered in 1879 and is about 40 km (25 mi) long. A small part of it can be visited on guided tours during the summer months. The fantastic ice formations inside are formed by freezing melt water. The formation of these rare ice caves depends on the underground temperatures, which never rise above 0 °C (32 °F) due to the constant draught of air. The extensive development of the cave for tourism provides a good insight into the complex icy underworld.

Eisriesenwelt

Le nom de l'Eisriesenwelt (« le monde des géants de glace »), dans le land de Salzbourg, parle pour lui : il s'agit de la plus grande grotte de glace du monde. Découverte en 1879, elle est longue d'une quarantaine de kilomètres et ne peut être que très partiellement visitée avec un guide, durant les mois d'été. Les formidables formations de glace à l'intérieur de la grotte sont formées d'eau de fonte gelée. Des températures ne dépassant jamais 0° C dans les profondeurs de la terre, en raison d'un renouvellement de l'air constant (courant d'air), sont une des conditions nécessaires à la naissance des rares grottes de glace. L'aménagement de la grotte pour les touristes permet d'obtenir un bon aperçu de ce monde de glace souterrain.

Eisriesenwelt

Mit einem Superlativ wirbt die Eisriesenwelt im Salzburger Land für sich: größte Eishöhle der Welt. Rund 40 km Länge weist die 1879 entdeckte Höhle auf, ein kleiner Teil davon ist in den Sommermonaten bei Führungen begehbar. Die fantastischen Eisgebilde im Innern entstehen durch gefrierendes Schmelzwasser. Voraussetzung für die Entstehung der – seltenen – Eishöhlen sind die Temperaturen im Erdinnern, die durch ständigen Luftaustausch (Zugluft) nie über 0 °C steigen. Durch die umfassende touristische Erschließung der Höhle lässt sich ein guter Einblick in die komplexe eisige Unterwelt gewinnen.

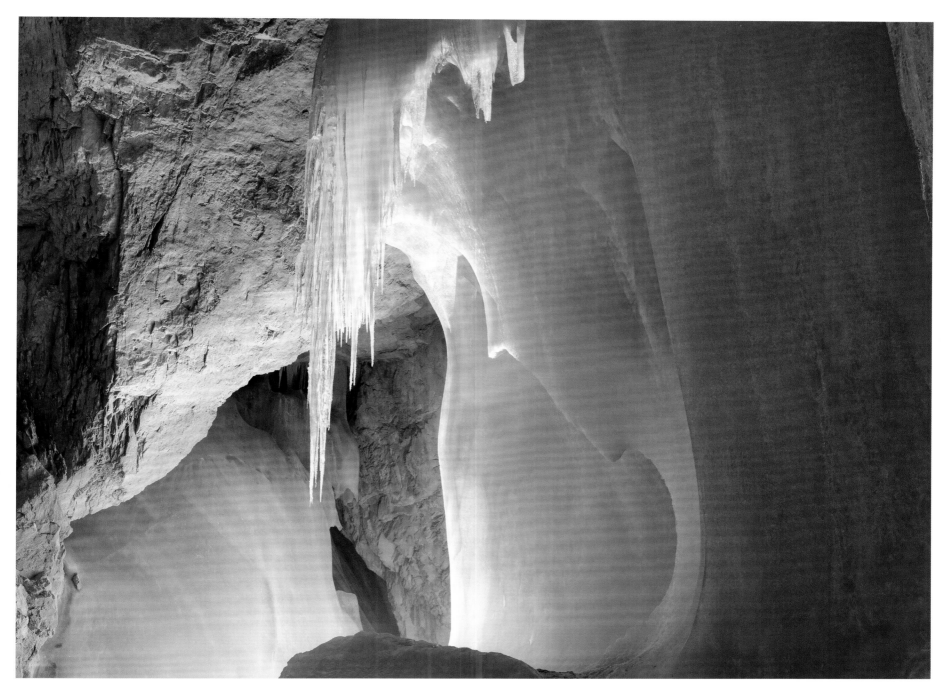

Ice cave, Eisriesenwelt, Werfen

Eisriesenwelt

La Eisriesenwelt (mundo gigante de hielo) en Salzburgo se anuncia con un superlativo: la mayor cueva de hielo del mundo. La cueva se descubrió en 1879 y tiene unos 40 km de longitud, una pequeña parte de la cual se puede visitar durante las visitas guiadas durante los meses de verano. Las fantásticas formaciones de hielo en su interior están formadas por agua helada derretida. La formación de las extrañas cuevas de hielo depende de las temperaturas en el interior de la tierra, que nunca superan los 0 °C debido al constante intercambio de aire (corriente de aire). El extenso desarrollo turístico de la cueva proporciona una buena perspectiva del complejo inframundo helado.

Mundo gigante do gelo

O mundo das cavernas de gelo na região de Salzburg promete um superlativo: a maior caverna de gelo do mundo. A caverna foi descoberta em 1879 e tem cerca de 40 km de extensão. Uma pequena parte dela pode ser visitada durante as visitas guiadas durante os meses de verão. As fantásticas formações de gelo no interior são formadas pelo congelamento da água de fusão. A formação das - raras - cavernas de gelo depende das temperaturas no interior da Terra, que nunca sobem acima de 0 °C devido à constante troca de ar (correntes de ar). Através do extenso desenvolvimento turístico da caverna, é possível obter uma boa visão do complexo submundo gelado.

Eisriesenwelt

De Eisriesenwelt in het Salzburger Land adverteert zichzelf met een superlatief: de grootste ijsgrot ter wereld. De grot werd ontdekt in 1879 en is ongeveer 40 km lang. Een klein deel ervan kan tijdens de zomermaanden d.m.v. een rondleiding bezocht worden. De fantastische ijsformaties binnenin worden gevormd door bevroren smeltwater. De vorming van de - zeldzame - ijsgrotten is afhankelijk van de temperaturen in de aarde, die door de constante luchtuitwisseling (tocht) nooit boven 0 °C stijgen. De uitgebreide toeristische ontwikkeling van de grot geeft een goed inzicht in de complexe ijzige onderwereld.

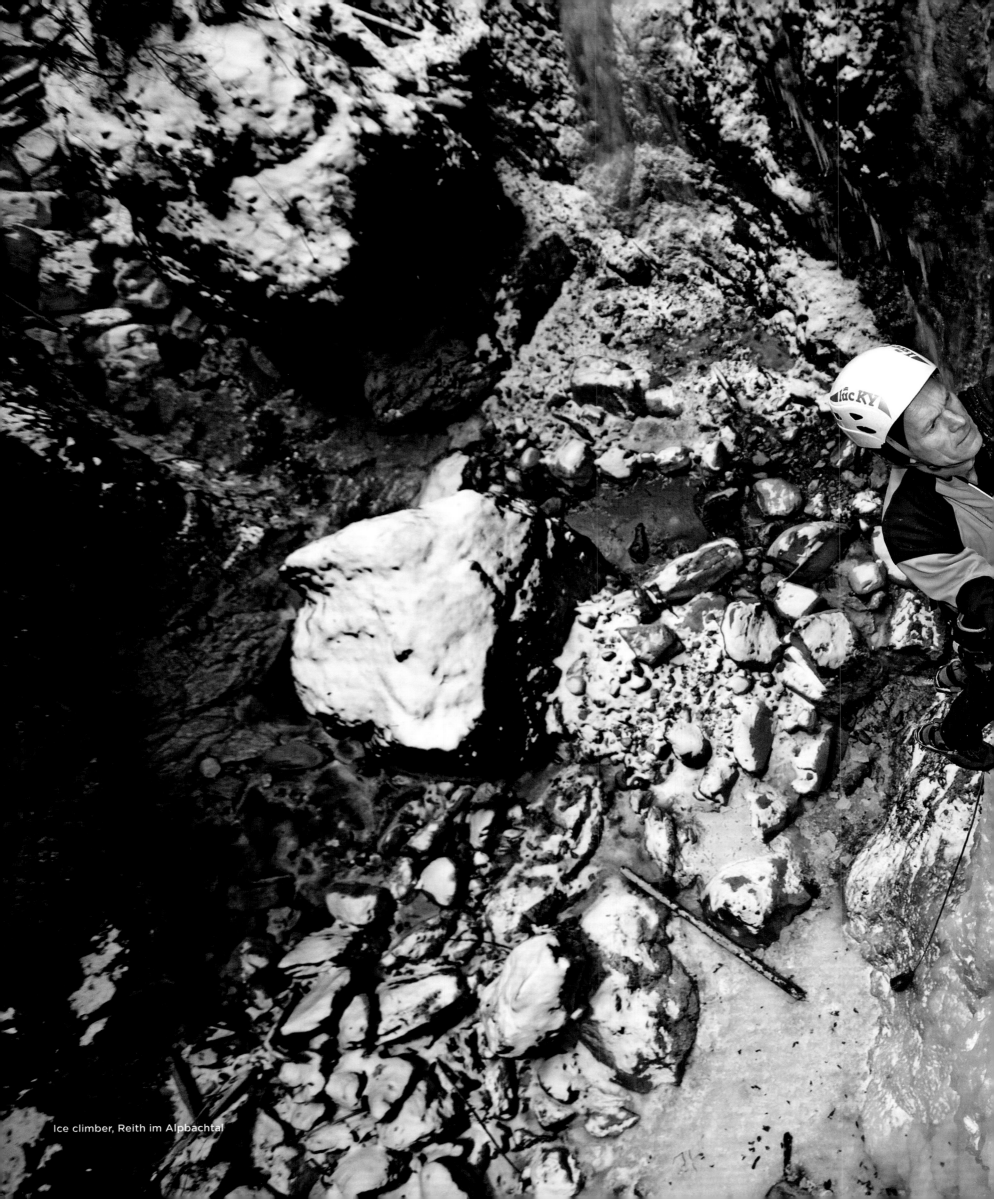

Ice climber, Reith im Alpbachtal

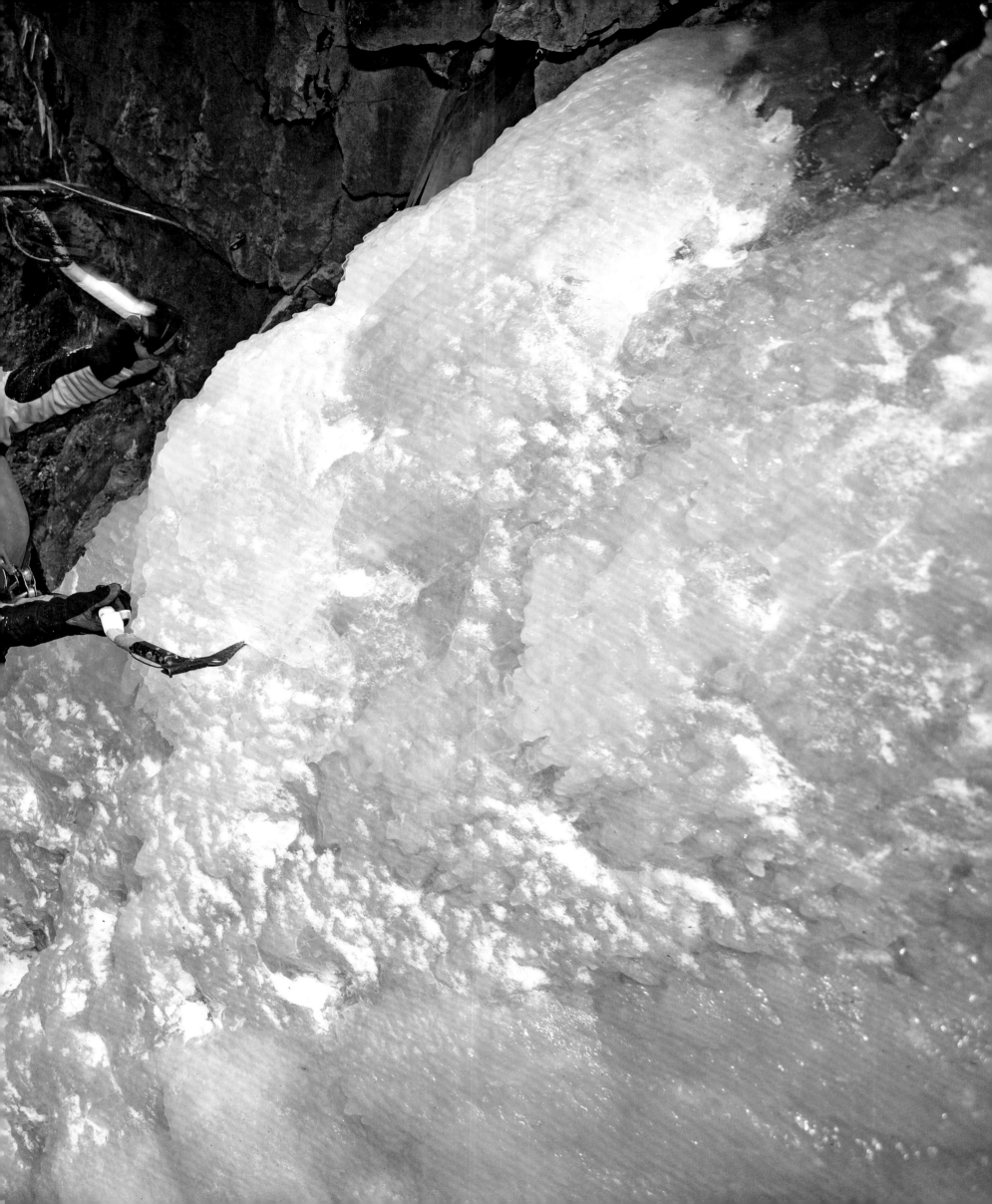

Iced apple tree, Wechsel

Plansee

The Plansee lies at an altitude of almost 1000 m (3280 ft) on the edge of the Wetterstein Mountains. This second largest lake in Tyrol is connected to Lake Heiterwang by a canal and has excellent water quality, although it is used commercially, including as a reservoir. In summer it is a popular bathing lake with boat traffic. Plansee is particularly attractive in winter when it freezes over, and it offers winter sports enthusiasts such as ice skaters a beautiful mountain setting. In the early morning and in the evening it belongs to nature lovers who are fascinated by ice flowers.

Plansee

Le lac du Plansee se trouve à presque 1 000 m d'altitude en bordure du massif du Wetterstein. Deuxième plus grand lac du Tyrol, il est relié au lac de Heiterwang par un canal et contient une eau d'excellente qualité, bien qu'il soit notamment exploité comme bassin de rétention. L'été, les visiteurs aiment à s'y baigner et des bateaux l'empruntent. Le véritable attrait du Plansee se dévoile cependant en hiver, lorsqu'il gèle. Le lac offre alors aux amateurs de sports d'hiver et particulièrement aux patineurs sur glace, un magnifique décor de montagne pour pratiquer leur discipline. Tôt le matin ainsi que le soir, il appartient aux amoureux de la nature venus admirer les fleurs de givre.

Plansee

In fast 1000 m Höhe liegt am Rand des Wettersteingebirges der Plansee. Der zweitgrößte See Tirols, der durch einen Kanal mit dem Heiterwanger See verbunden ist, verfügt über eine ausgezeichnete Wasserqualität, obwohl er wirtschaftlich genutzt wird, u. a. als Speichersee. Im Sommer ist er ein beliebter Badesee mit Schiffsverkehr. Besonderen Reiz entfaltet der Plansee aber im Winter, wenn er zufriert. Dann bietet er Wintersportlern wie etwa Eisläufern einen Ort vor schöner Bergkulisse. Am frühen Morgen und am Abend gehört er den Naturliebhabern, die sich von Eisblumen faszinieren lassen.

Ice crystals

Plansee

El Plansee se encuentra a una altitud de casi 1000 m en el borde de las montañas Wetterstein. El segundo lago más grande del Tirol, que está conectado con el lago Heiterwang por un canal, tiene una excelente calidad de agua, aunque se utiliza como recurso económico (como embalse, entre otros). En verano es un lago de baño popular con tráfico de barcos. Pero Plansee es particularmente atractivo en invierno cuando se congela, ya que ofrece a los entusiastas de los deportes de invierno, como los patinadores de hielo, un lugar con un hermoso telón de fondo montañoso. Por la mañana temprano y por la tarde pertenece a los amantes de la naturaleza que se quedan fascinados por las flores de hielo.

Plansee

O lago Plansee fica a uma altitude de quase 1000 m à beira das montanhas Wetterstein. O segundo maior lago do Tirol, que está ligado ao lago Heiterwang por um canal, tem uma excelente qualidade de água, embora seja utilizado economicamente, inclusive como reservatório. No verão é um popular lago de águas balneares com tráfego de barcos. Mas o Plansee é particularmente atraente no inverno, quando congela. Nesta altura, oferece aos entusiastas dos esportes de inverno, como patinadores de gelo, um lugar perante a um belo cenário de montanha. De manhã cedo e à noite, ele pertence aos amantes da natureza, fascinados pelas flores de gelo.

Plansee

De Plansee ligt op een hoogte van bijna 1000 m aan de rand van het Wettersteingebergte. Het op een na grootste meer van Tirol, dat via een kanaal met het Heiterwanger See is verbonden. Het heeft een uitstekende waterkwaliteit, hoewel het economisch wordt gebruikt onder andere als reservoir. In de zomer is het een populair zwemmeer met bootverkeer. Maar de Plansee is vooral aantrekkelijk in de winter wanneer het vriest. Dan biedt het wintersporters zoals schaatsers een plek tegen een prachtige bergachtige achtergrond. In de vroege ochtend en in de avond behoort het tot de natuurliefhebbers die gefascineerd zijn door ijsbloemen.

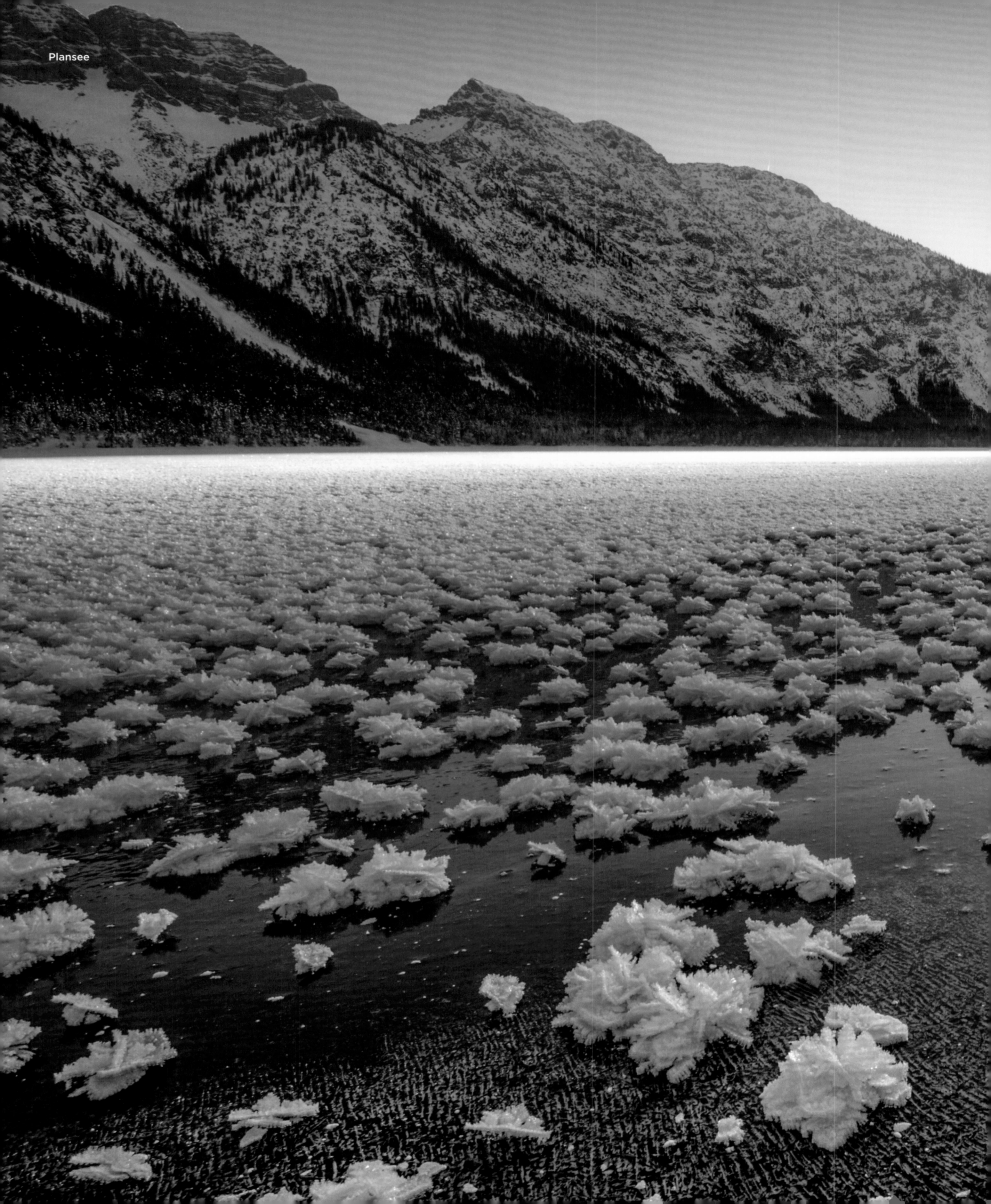

Plansee

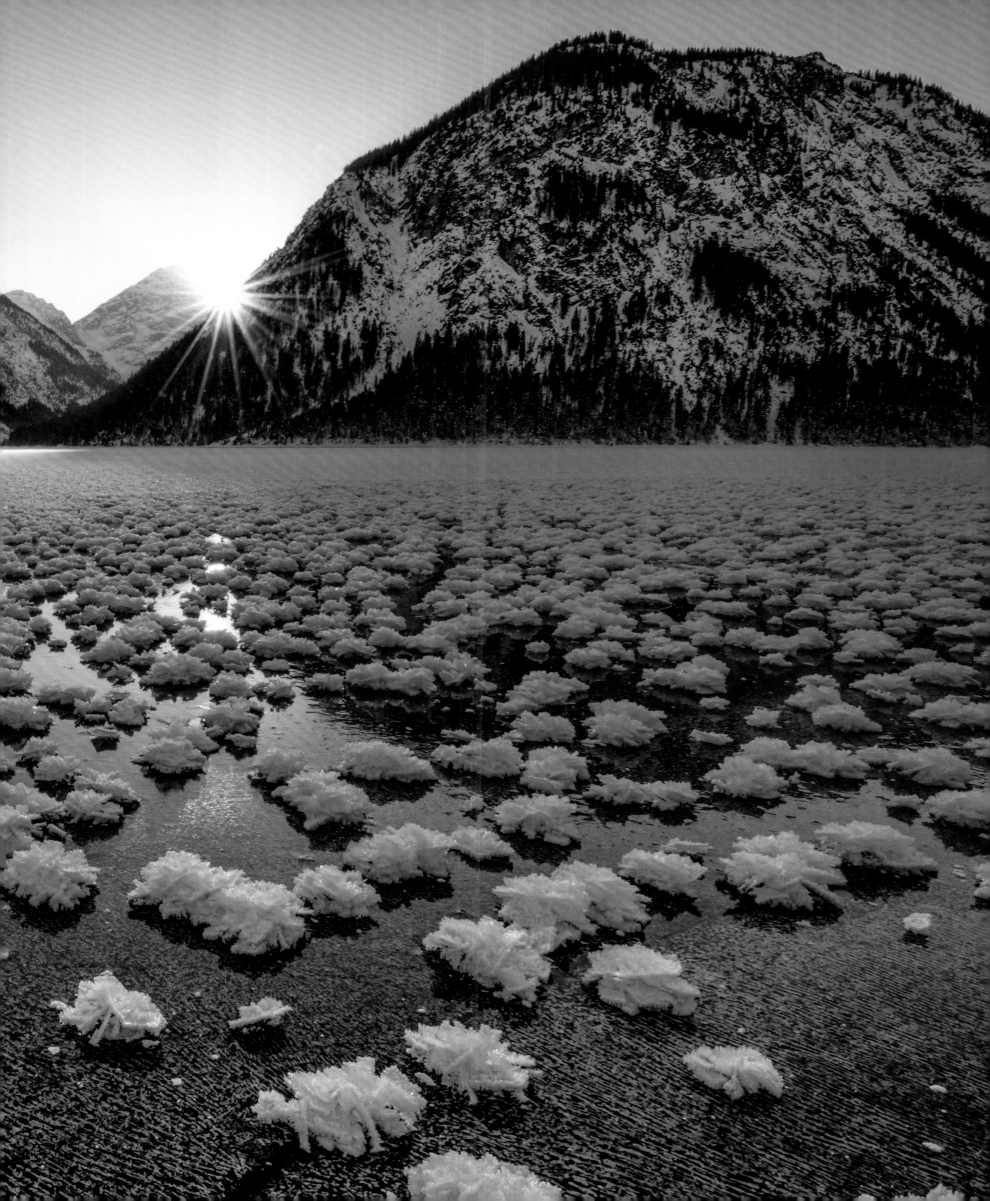

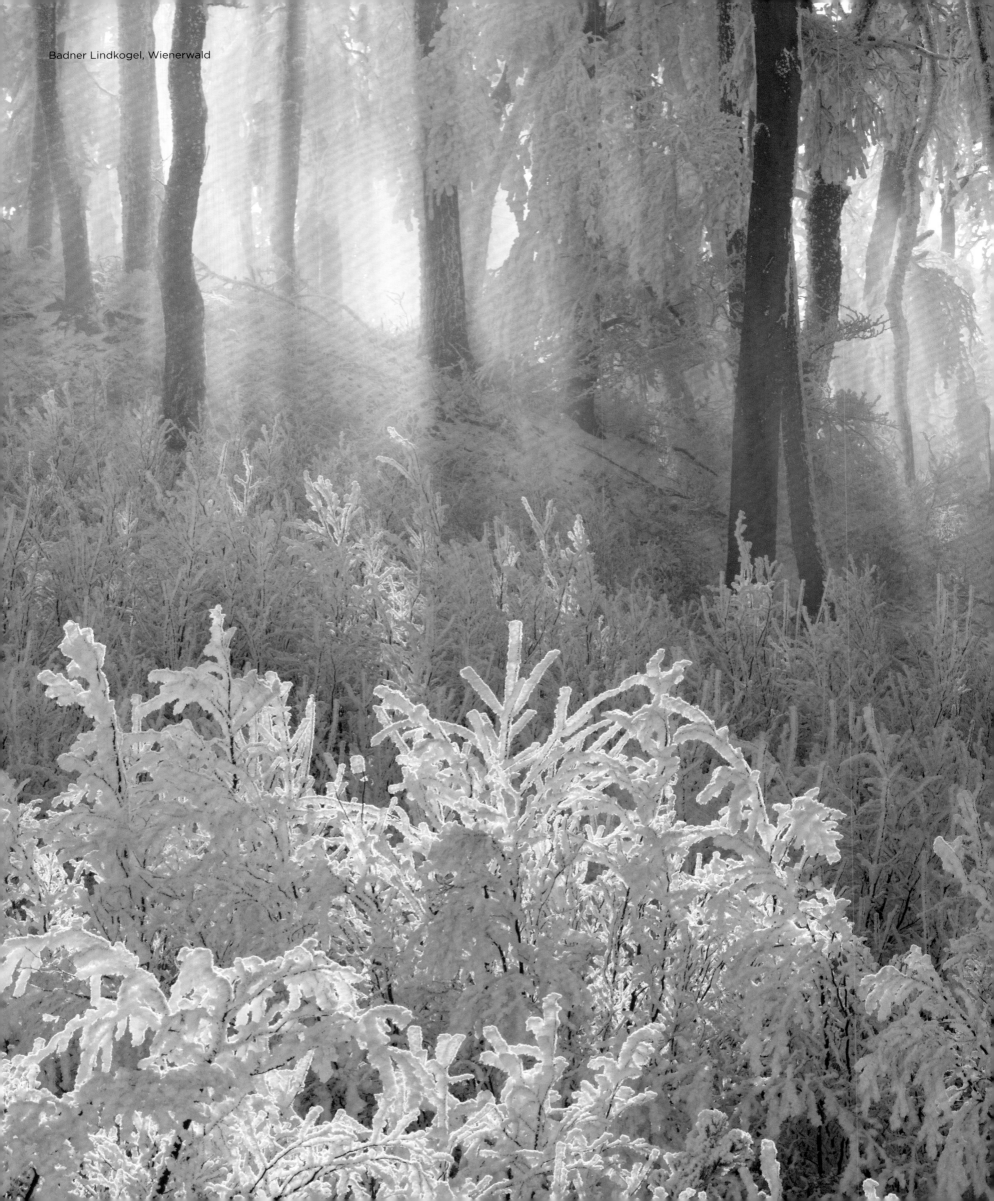

Badner Lindkogel, Wienerwald

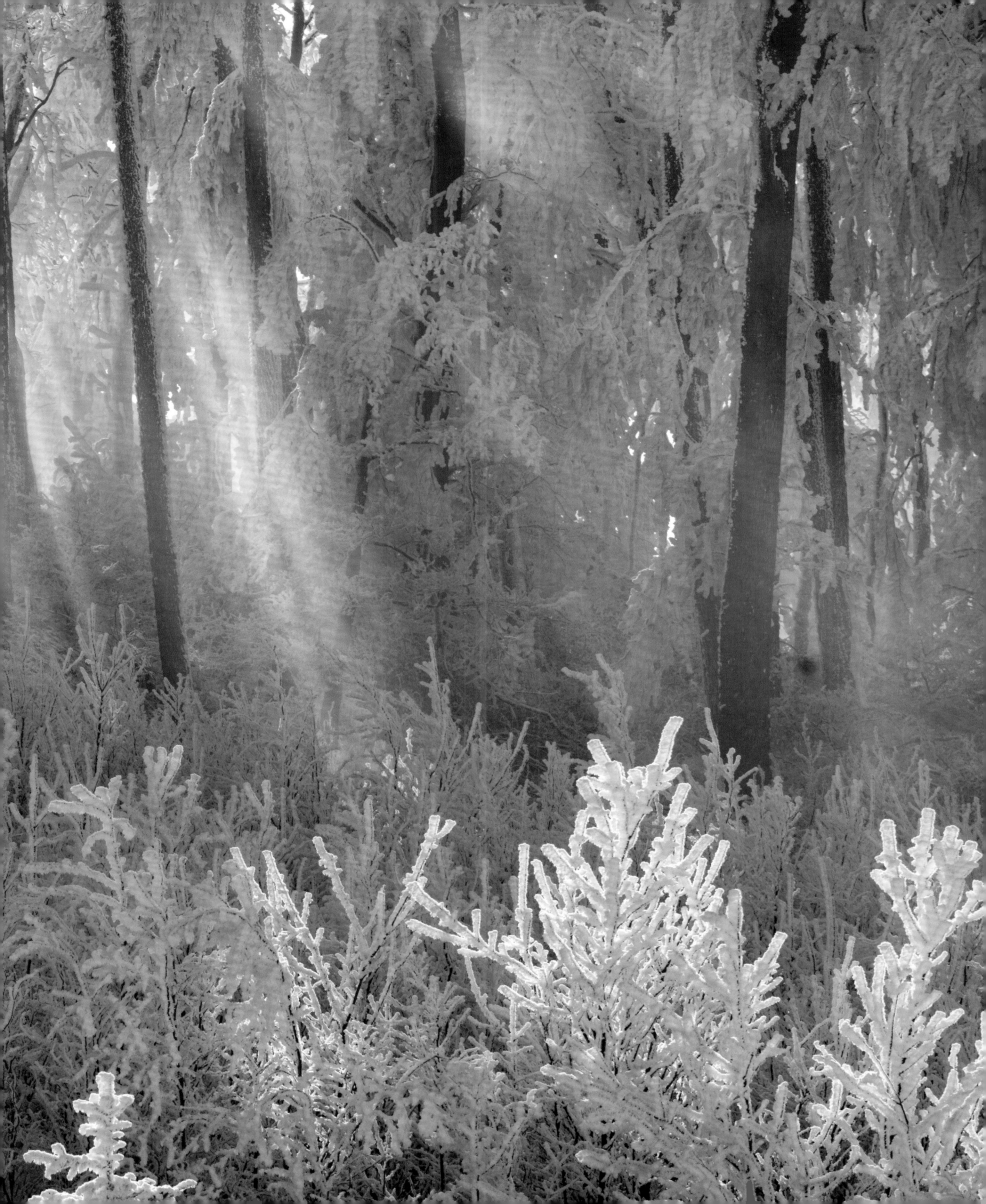

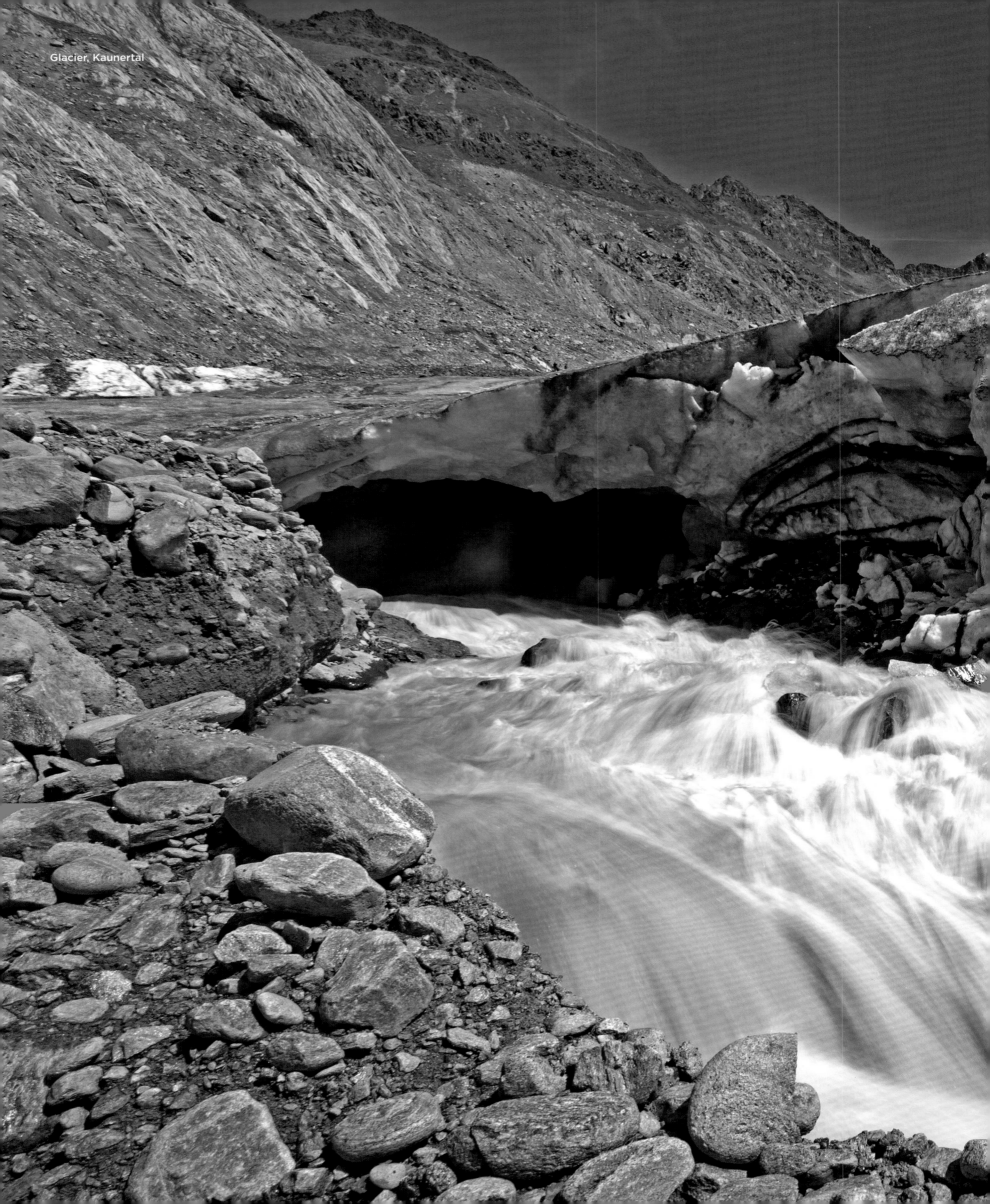

Glacier, Kaunertal

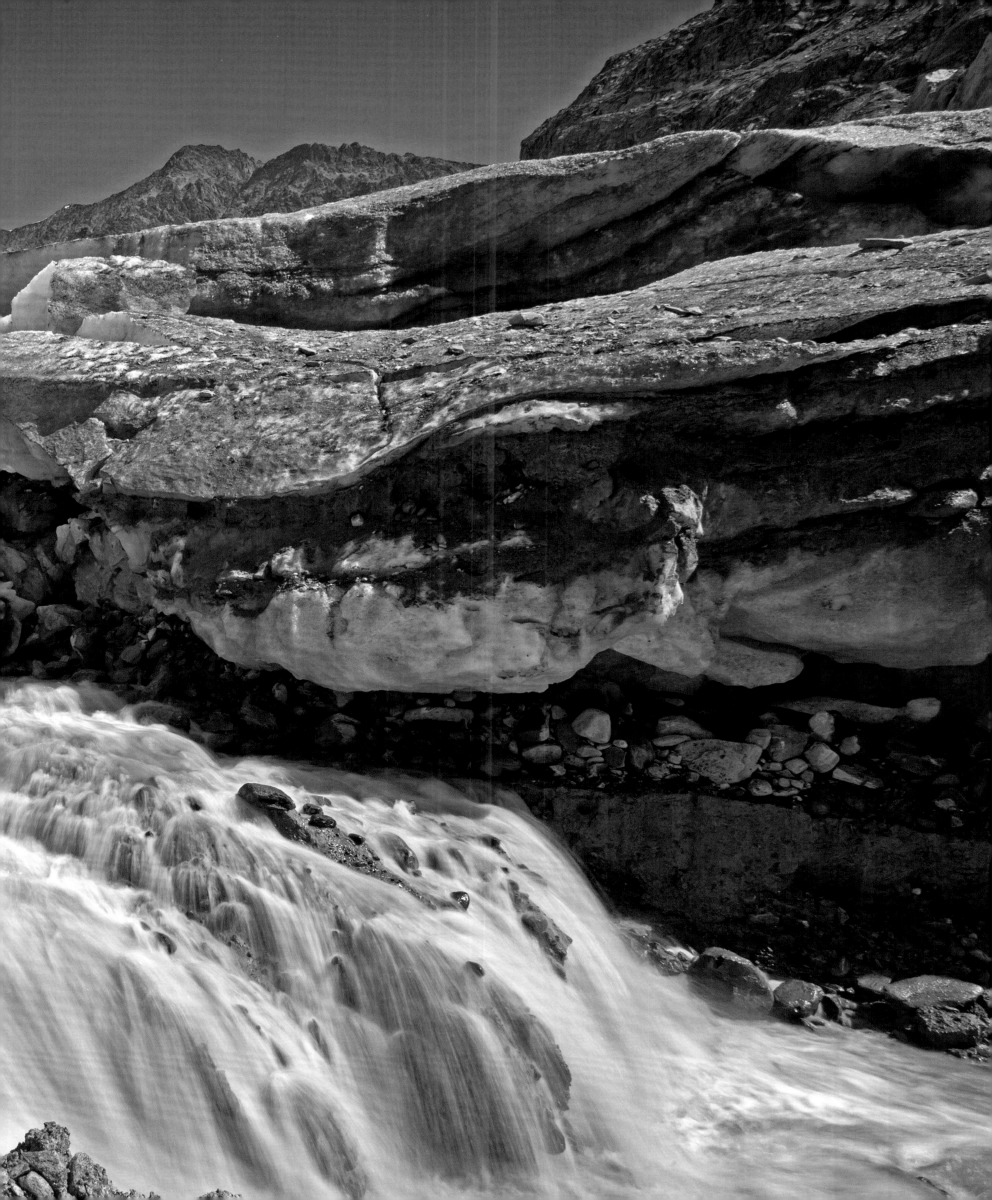

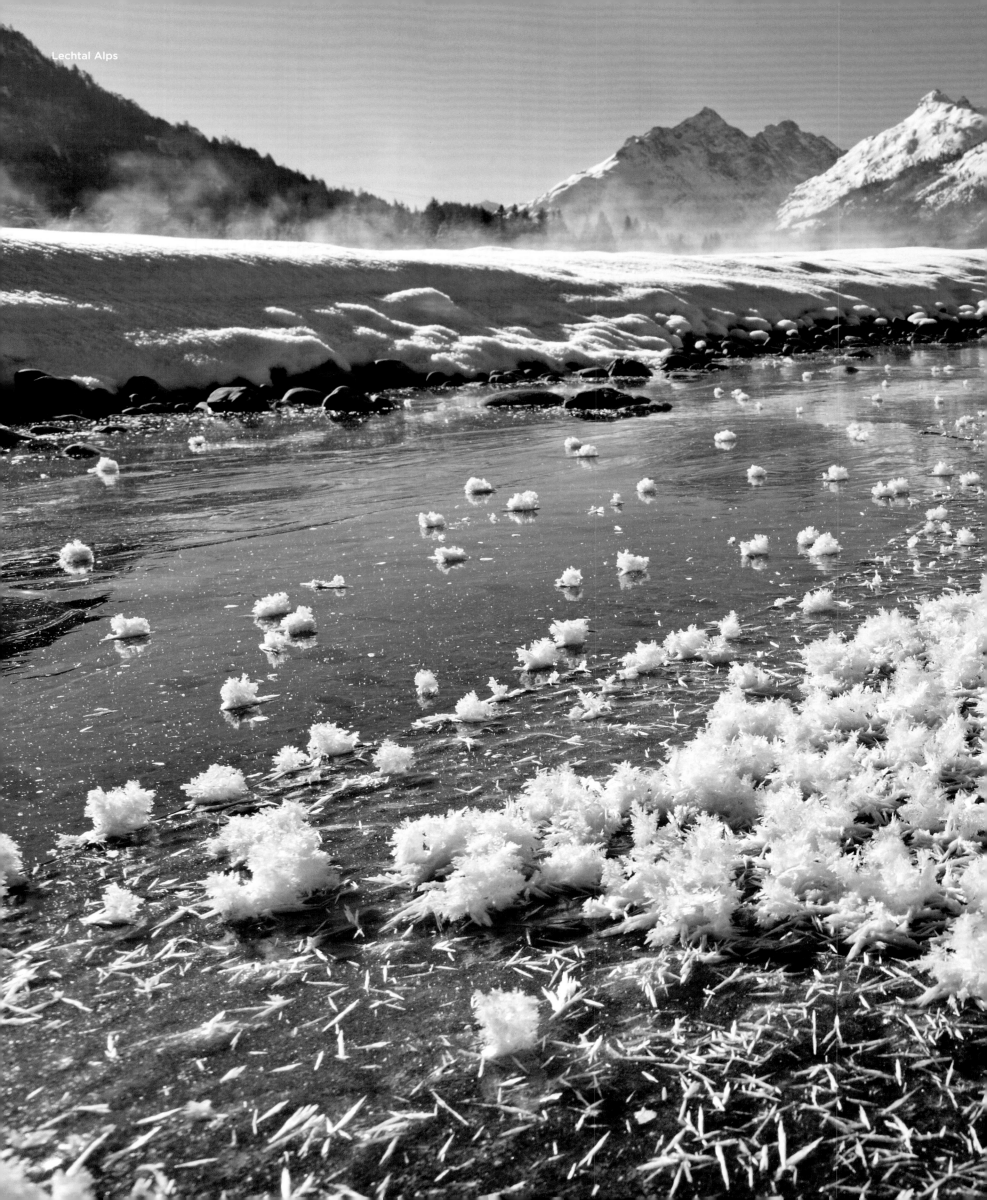

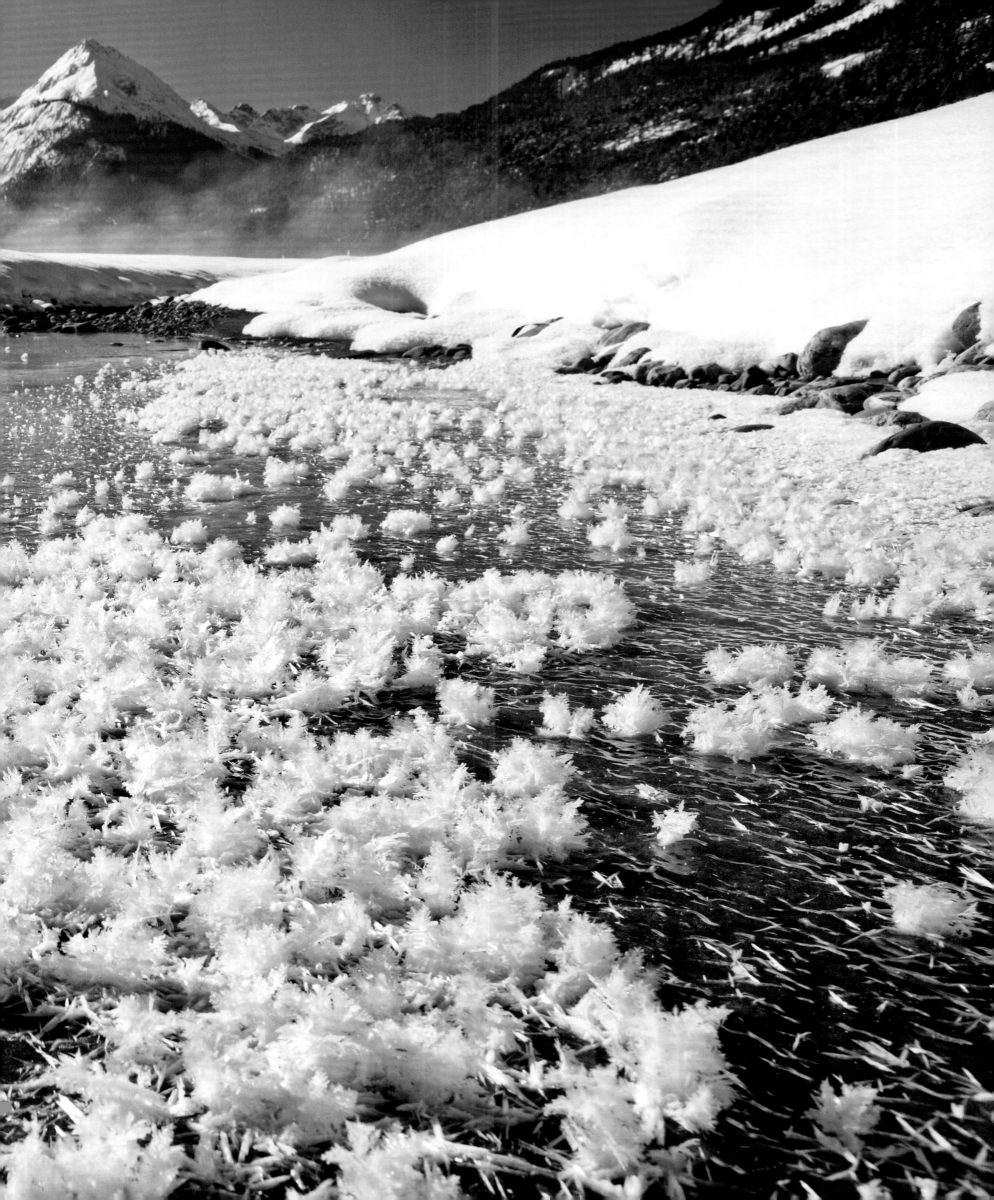

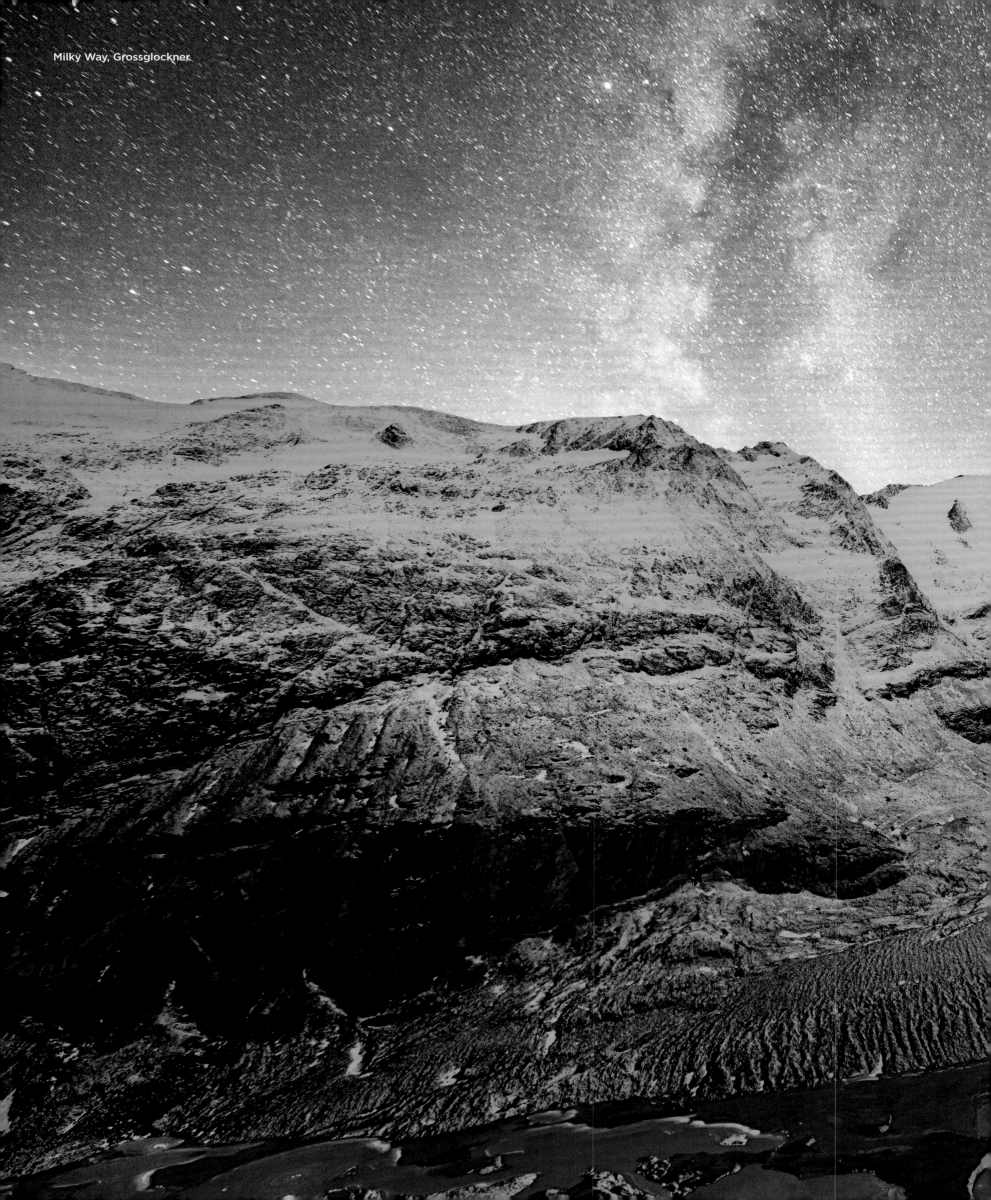

Milky Way, Grossglockner

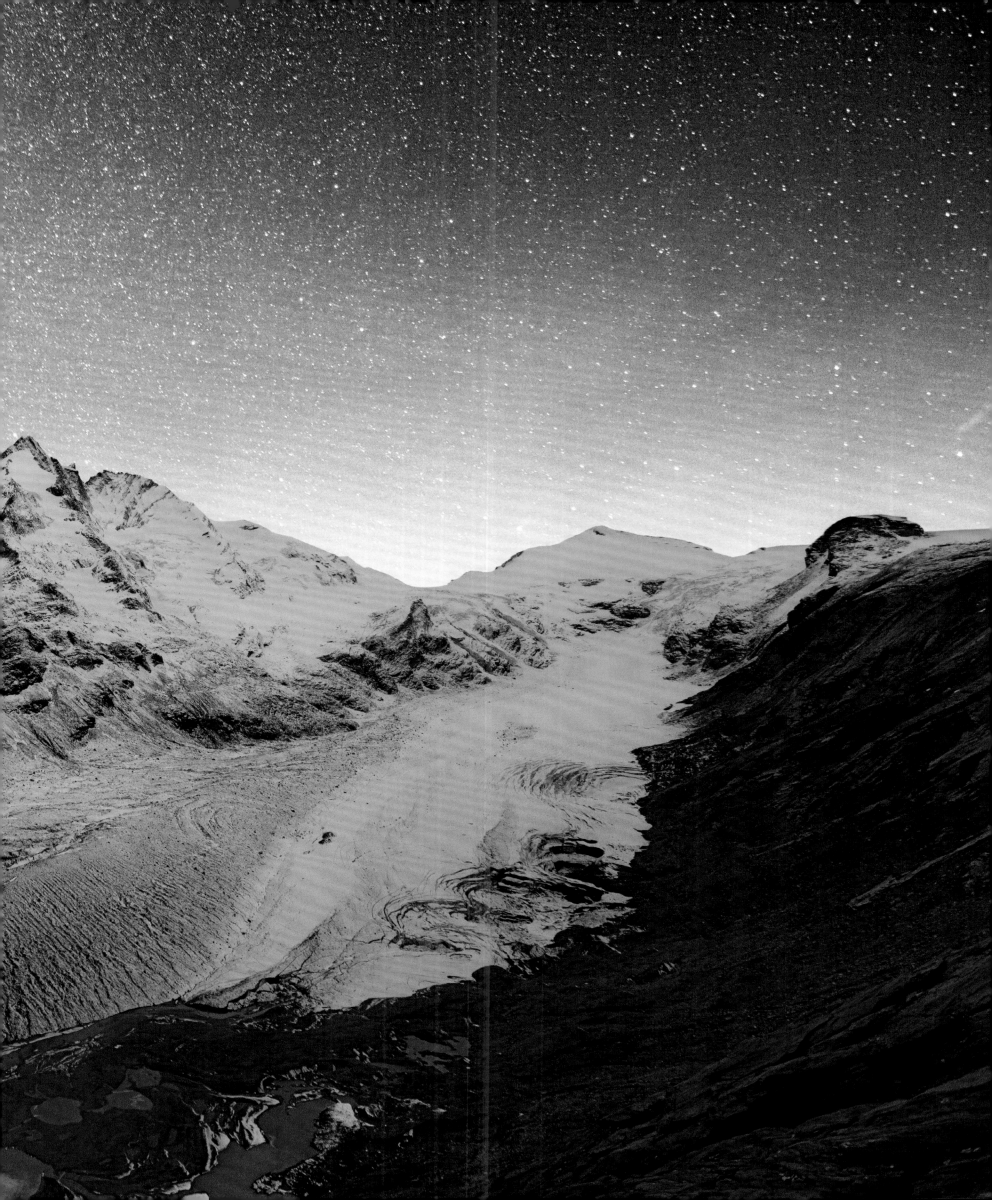

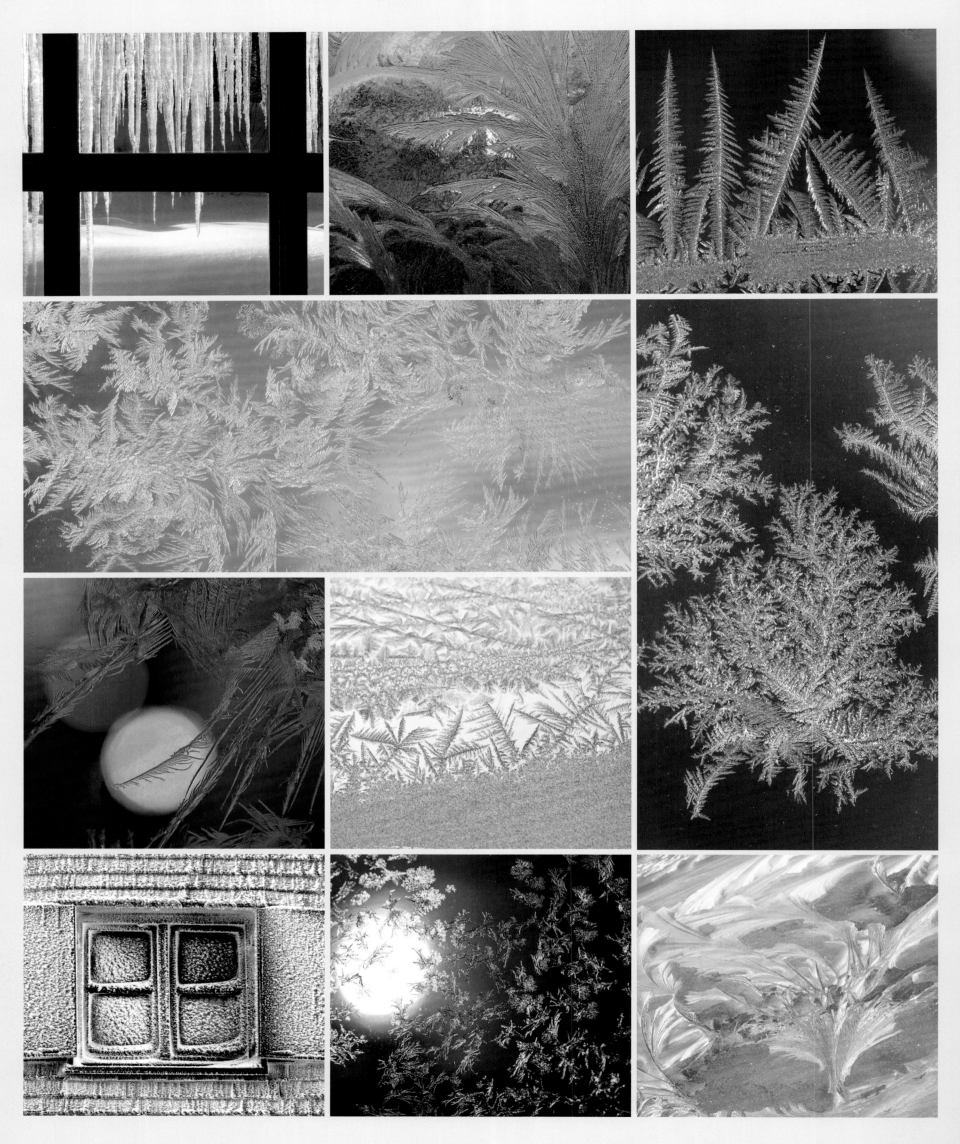

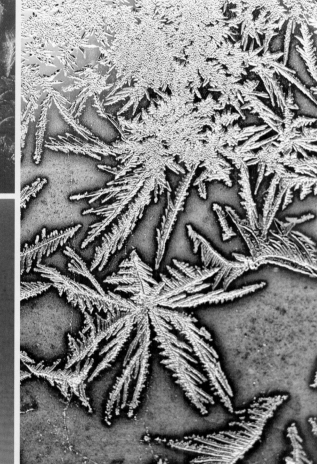

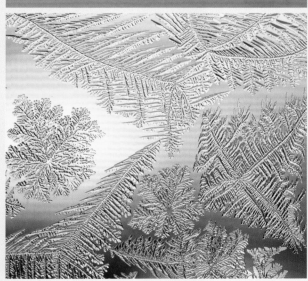

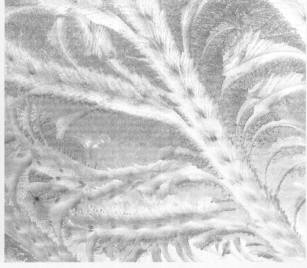

Ice Crystals

The successful Danish author Peter Høeg gave his protagonist Miss Smilla a feeling for snow. She should also know something about the amazing variety of shapes and the pronounced symmetry of snow crystals. As a rule, these filigree structures have a diameter of 5 mm (0.2 inches) and a weight of 4 mg (0.000141 oz). At around freezing point, the crystals cling together to form large flakes.

Cristaux de glace

Le Danois et auteur à succès Peter Høeg a donné à son personnage principal, Smilla, l'amour de la neige. Elle devait ainsi avoir des connaissances sur l'incroyable diversité des formes et sur la symétrie marquée des cristaux de glace. En règle générale, ces formes délicates ont un diamètre de 5 mm et un poids de 4 mg. Aux alentours de 0° C, les cristaux se collent les uns aux autres pour former de gros flocons.

Eiskristalle

Der dänische Erfolgsautor Peter Høeg gab seiner Protagonistin Fräulein Smilla ein Gespür für Schnee. Damit sollte sie auch etwas über die verblüffende Formenvielfalt und die ausgeprägte Symmetrie von Schneekristallen wissen. In der Regel haben die filigranen Gebilde einen Durchmesser von 5 mm und ein Gewicht von 4 mg. Um den Gefrierpunkt verkleben die Kristalle zu großen Flocken.

Cristales de hielo

El exitoso escritor danés Peter Høeg le dio a su protagonista, la señorita Smilla, un sentimiento por la nieve. También debía saber algo sobre la asombrosa variedad de formas y la pronunciada simetría de los cristales de nieve. Por regla general, las estructuras de filigrana tienen un diámetro de 5 mm y un peso de 4 mg. Alrededor del punto de congelación, los cristales se pegan para formar grandes escamas.

Cristais de gelo

O bem sucedido autor dinamarquês Peter Høeg deu à sua protagonista Miss Smilla uma sensibilidade para a neve. Assim ela também deveria saber algo sobre a incrível variedade de formas e a simetria acentuada dos cristais de neve. Geralmente, as estruturas feita de filigranas têm um diâmetro de 5 mm e um peso de 4 mg. Ao redor do ponto de congelamento, os cristais se unem para formar grandes flocos.

IJskristallen

De succesvolle Deense auteur Peter Høeg gaf zijn hoofdpersoon, Miss Smilla, een gevoel voor sneeuw. Ze moest zo ook iets weten over de verbazingwekkende variatie aan vormen en de uitgesproken symmetrie van sneeuwkristallen. In de regel hebben de filigraanstructuren een diameter van 5 mm en een gewicht van 4 mg. Rond het vriespunt kleven de kristallen aan elkaar tot grote vlokken.

313

France

Great egret, Lac de Kruth-Wildenstein
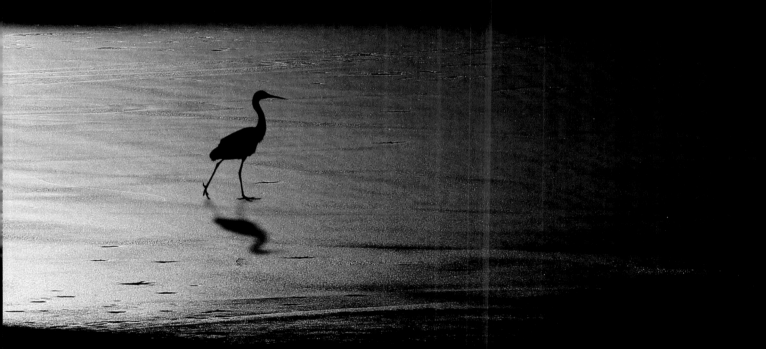

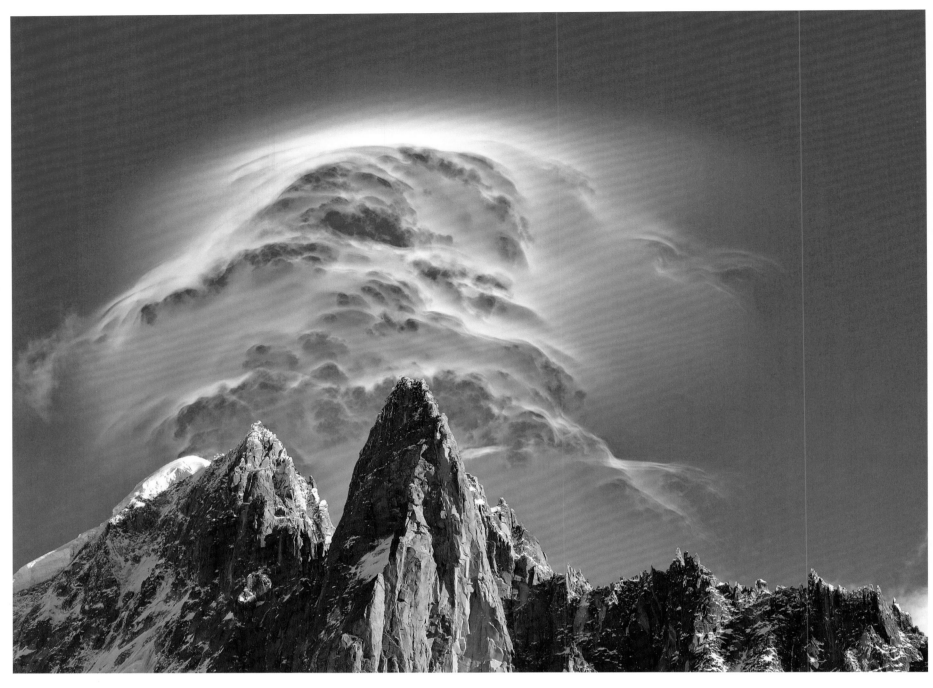

Aiguille Verte, Aiguille du Dru, Mont Blanc massif

France

The landscape of the French Republic is extraordinarily diverse: seashores, hills and high mountains, vineyards and farmland, partly untamed rivers, cities steeped in history and the metropolis of Paris - no other country in the world attracts more visitors. It is only a short distance from life on the Mediterranean coast to areas of permanent ice. The alpine regions are breathtaking, and the 4810 m (15780 ft) high Mont Blanc on the border to Italy is the highest mountain in Europe. Several mountain massifs are glaciated, and the largest glacier in France is the 12 km (7 mi) long Mer de Glace in the Mont Blanc massif.

France

Les paysages français sont exceptionnellement variés : côtes, régions vallonnées et haute montagne, vignobles et terres cultivables, rivières partiellement sauvages et pour couronner le tout, des villes chargées d'histoires ainsi que leur capitale, Paris. Aucun autre pays au monde n'accueille autant de touristes. De la vie méditerranéenne en bord de mer aux glaces éternelles, il n'y a qu'un pas. Les régions alpines sont d'une beauté fascinante, le mont Blanc (4 810 m), à la frontière italienne, est la plus haute montagne d'Europe. Plusieurs massifs montagneux comportent des glaciers, le plus grand d'entre eux étant la Mer de Glace, mesurant 12 km de long et située dans le massif du Mont-Blanc.

Frankreich

Das Landschaftsbild der Französischen Republik ist außerordentlich vielfältig: Meeresküsten, Hügelland und Hochgebirge, Weinberge und Ackerland, teils ungezähmte Flüsse, dazu geschichtsträchtige Städte und die Metropole Paris – in kein Land weltweit kommen mehr Besucher. Vom mediterranen Leben am Mittelmeer bis ins ewige Eis ist es nur ein kurzer Weg. Atemberaubend sind die alpinen Regionen, der Mont Blanc (4810 m) auf der Grenze zu Italien ist der höchste Berg Europas. Mehrere Bergmassive sind vergletschert, der größte Gletscher Frankreichs ist das 12 km lange Mer de Glace im Mont-Blanc-Massiv.

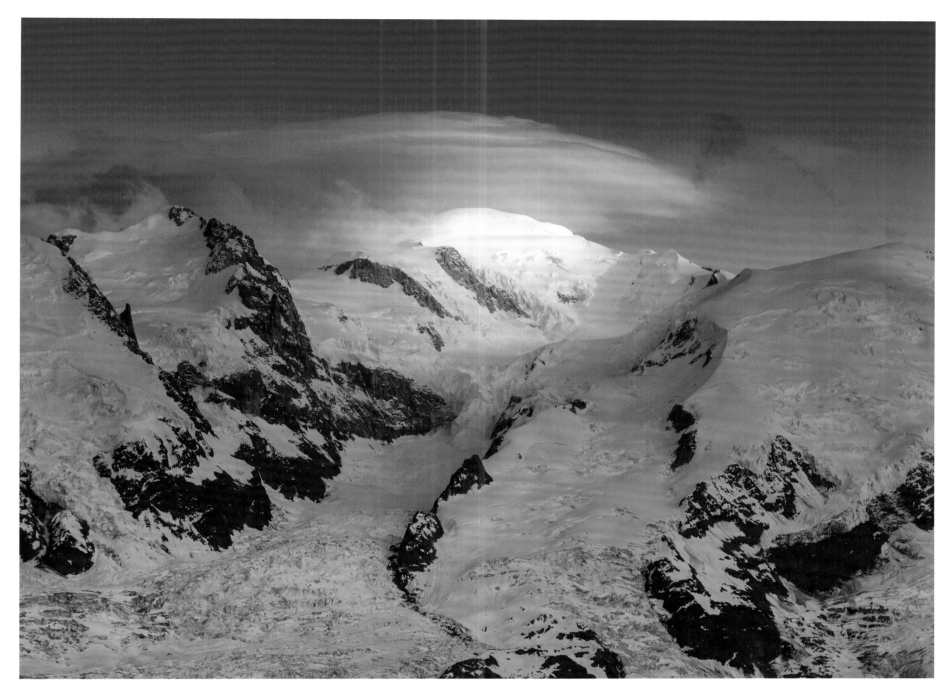

Mont Blanc, Dome du Goûter, Mont Maudit

Francia

El paisaje de la República Francesa es extraordinariamente diverso: costas, colinas y altas montañas, viñedos y tierras de cultivo, ríos en parte indómitos, ciudades cargadas de historia y la metrópoli de París; ningún otro país del mundo atrae a más visitantes. Está a poca distancia de la vida mediterránea en la costa mediterránea y de los hielos eternos. Las regiones alpinas son impresionantes, el Mont Blanc (4810 m), en la frontera con Italia, es la montaña más alta de Europa. Varios macizos montañosos son glaciares. El glaciar más grande de Francia es el Mer de Glace de 12 km de longitud en el macizo del Mont Blanc.

França

A paisagem da República Francesa é extraordinariamente diversificada: praias, colinas e altas montanhas, vinhedos e terras agrícolas, rios parcialmente indomados, além disso cidades repletas de história e a metrópole de Paris - nenhum outro país do mundo atrai mais visitantes. O caminho é pequeno entre a vida mediterrânea na costa do Mediterrâneo até ao gelo eterno. As regiões alpinas são de tirar o fôlego, o Monte Branco (4810 m), na fronteira com a Itália, é a montanha mais alta da Europa. Vários maciços montanhosos são glaciares, o maior glaciar da França é o Mer de Glace, de 12 km de comprimento, no maciço do Monte Branco.

Frankrijk

Het landschap van de Franse Republiek is buitengewoon divers: kusten, heuvels en hoge bergen, wijngaarden en landbouwgrond, deels ongetemde rivieren, steden met een rijke geschiedenis en de metropool Parijs - geen enkel ander land in de wereld trekt meer bezoekers. Het is slechts een korte afstand van het mediterrane leven aan de Middellandse Zeekust tot het eeuwige ijs. De Alpengebieden zijn adembenemend, de Mont Blanc (4810 m) op de grens met Italië is de hoogste berg van Europa. Verschillende bergmassieven zijn gletsjers, de grootste gletsjer van Frankrijk is de 12 km lange Mer de Glace in het Mont Blancmassief.

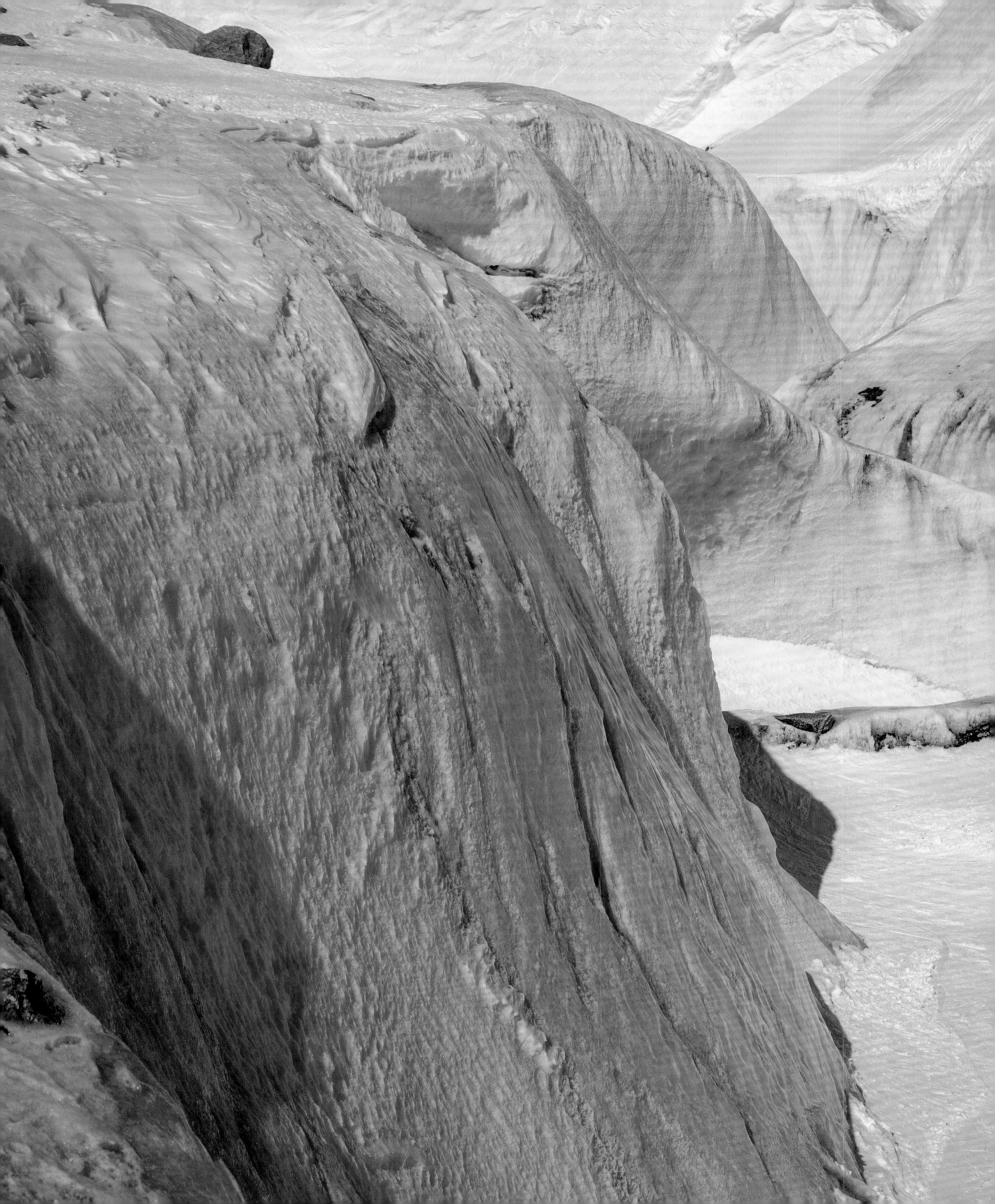

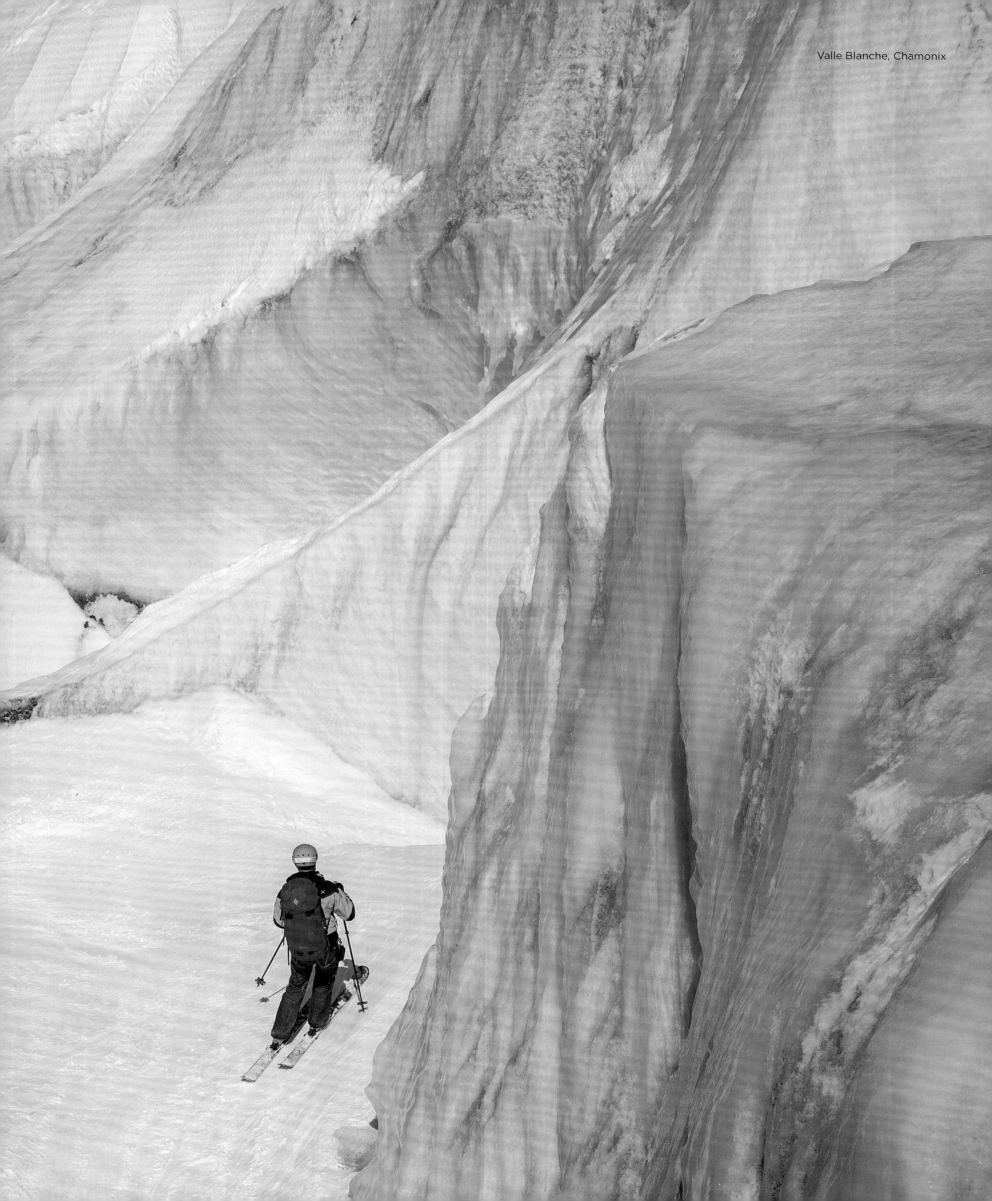

Valle Blanche, Chamonix

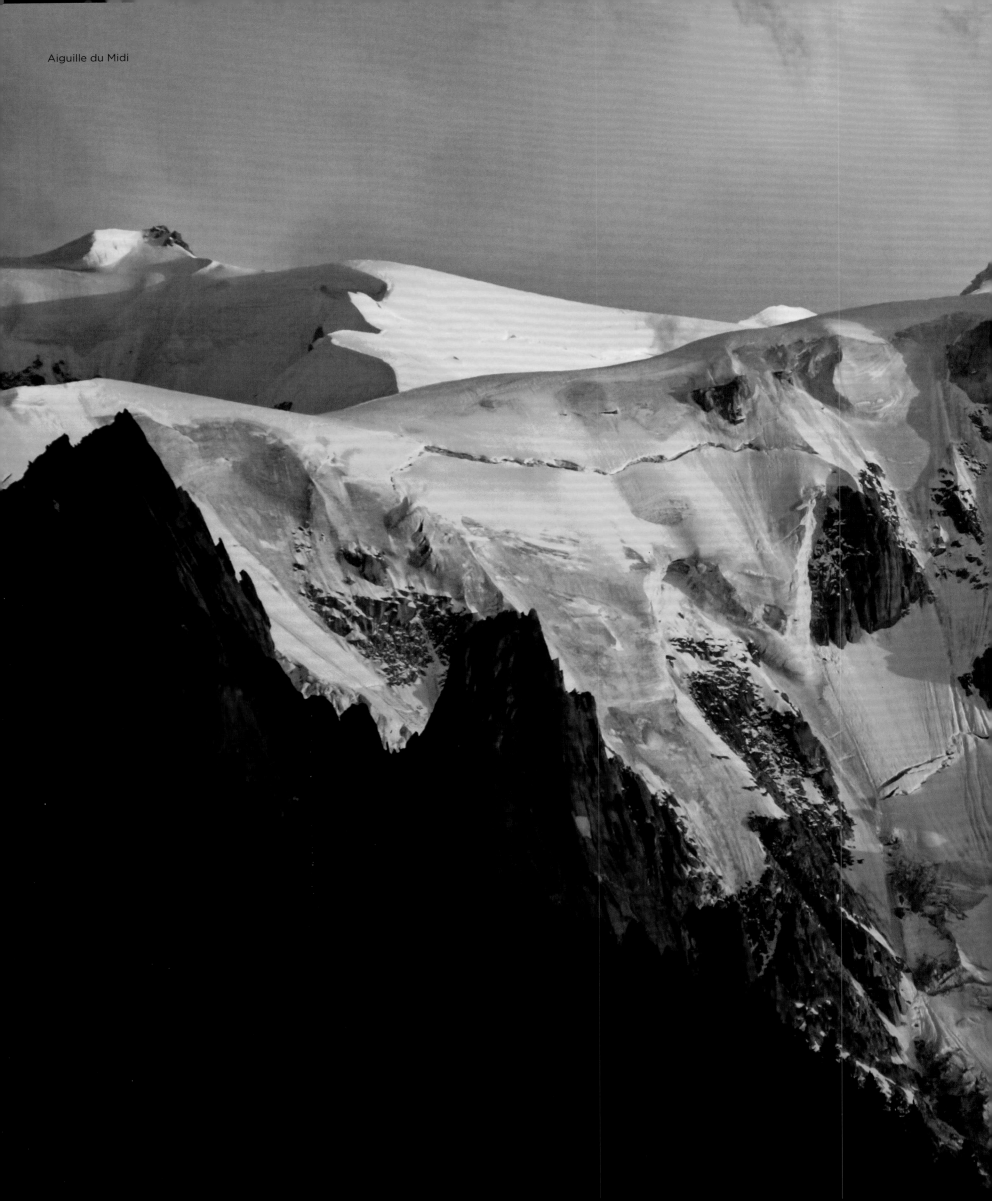

Aiguille du Midi

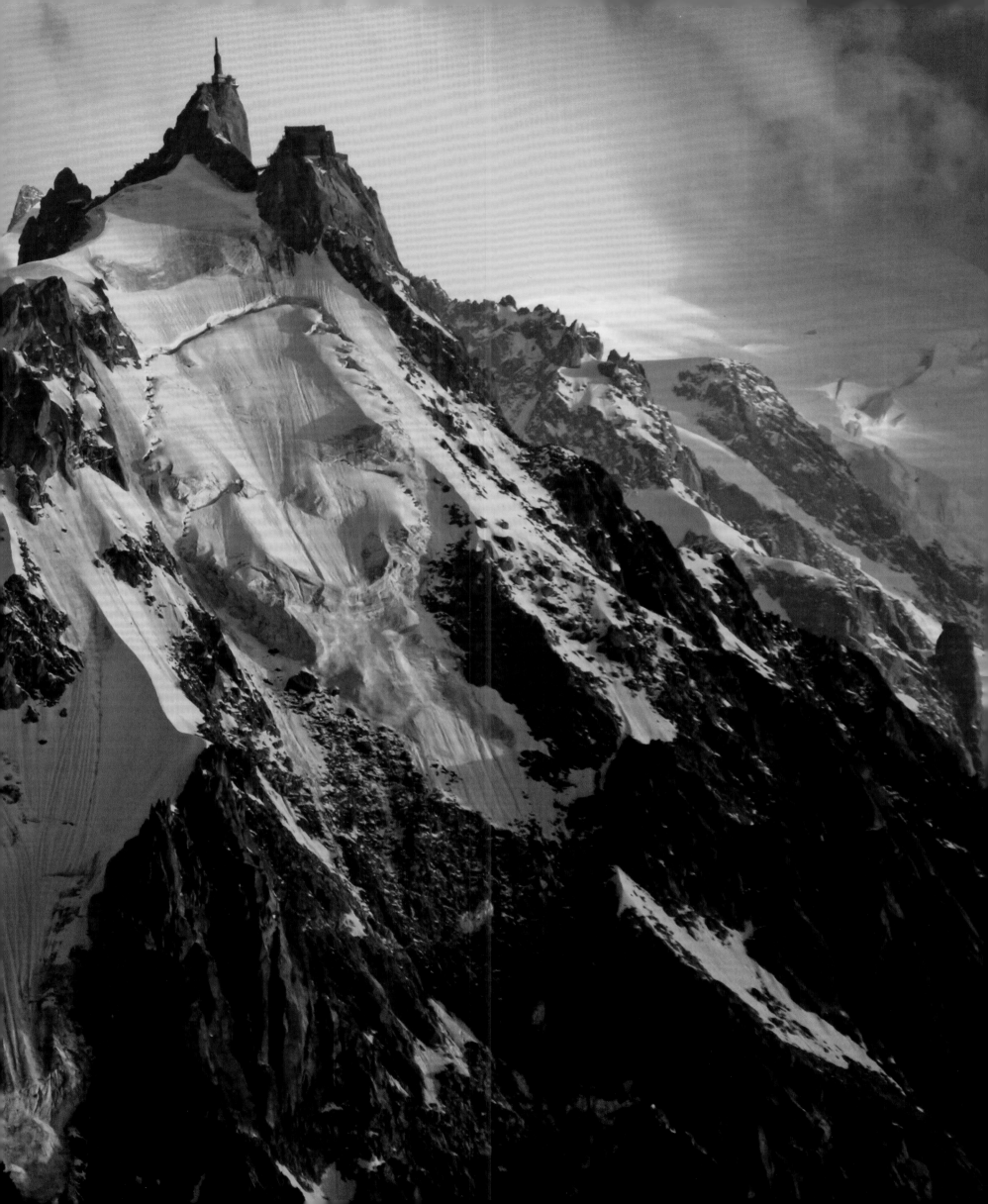

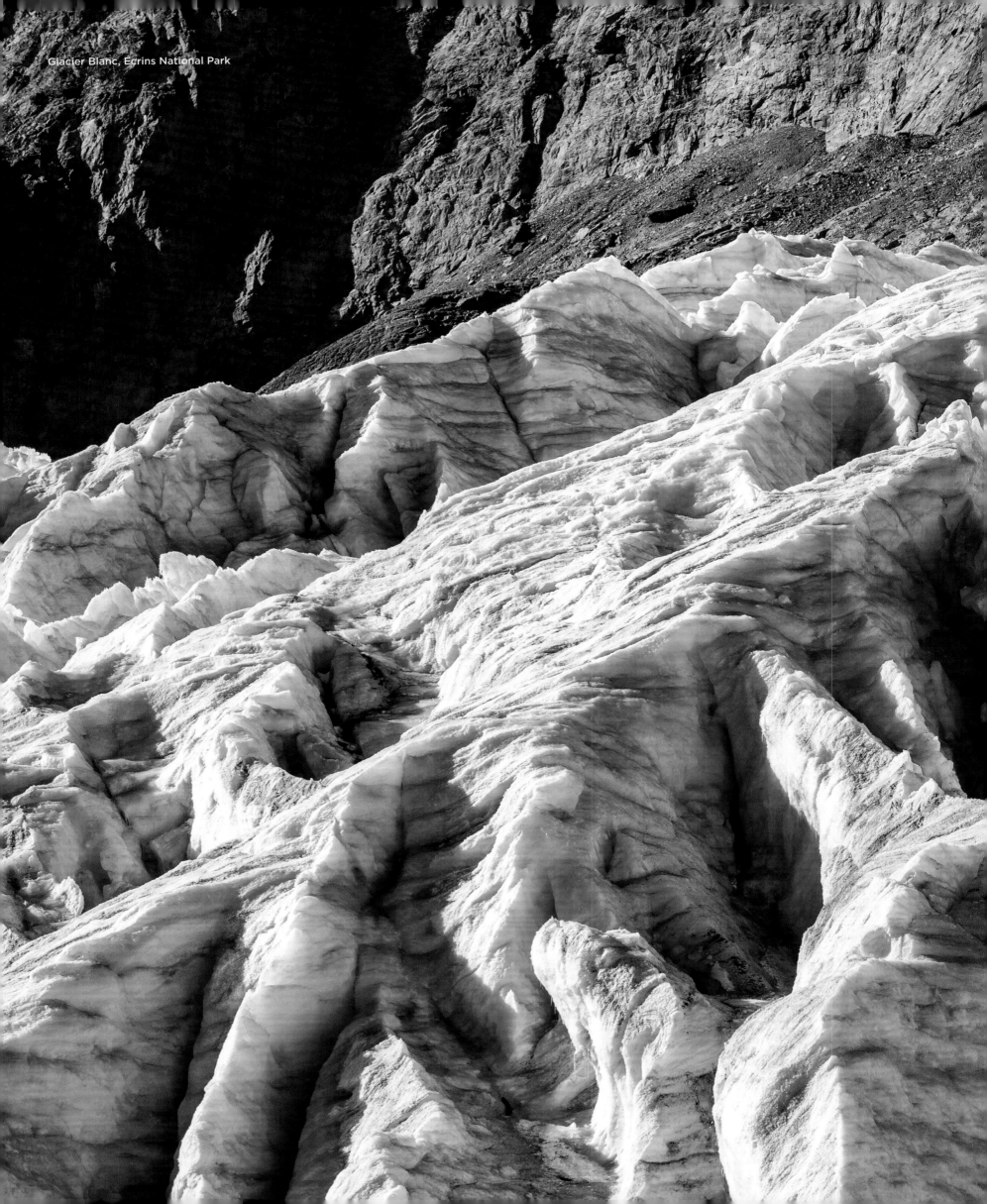

Glacier Blanc, Ecrins National Park

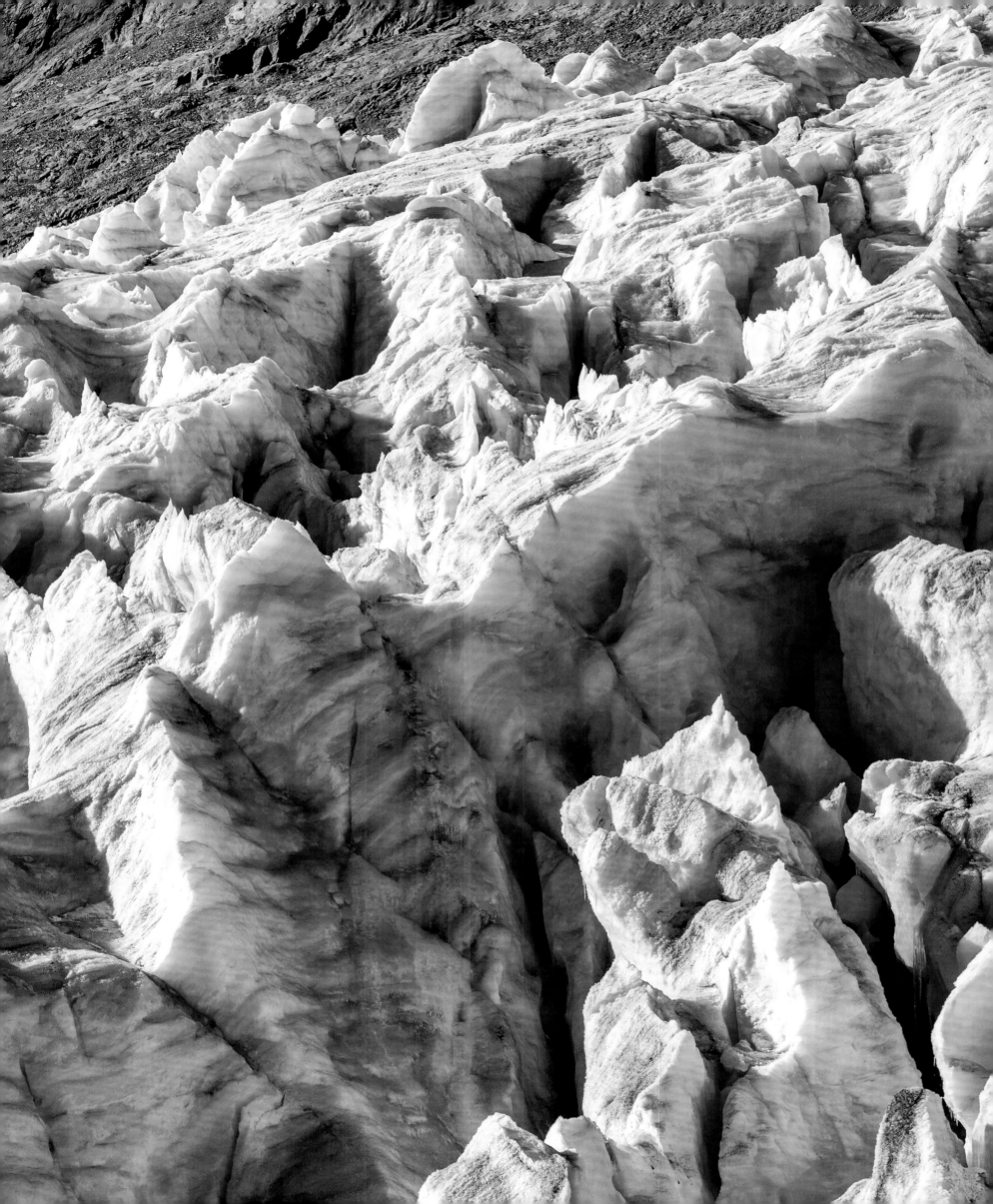

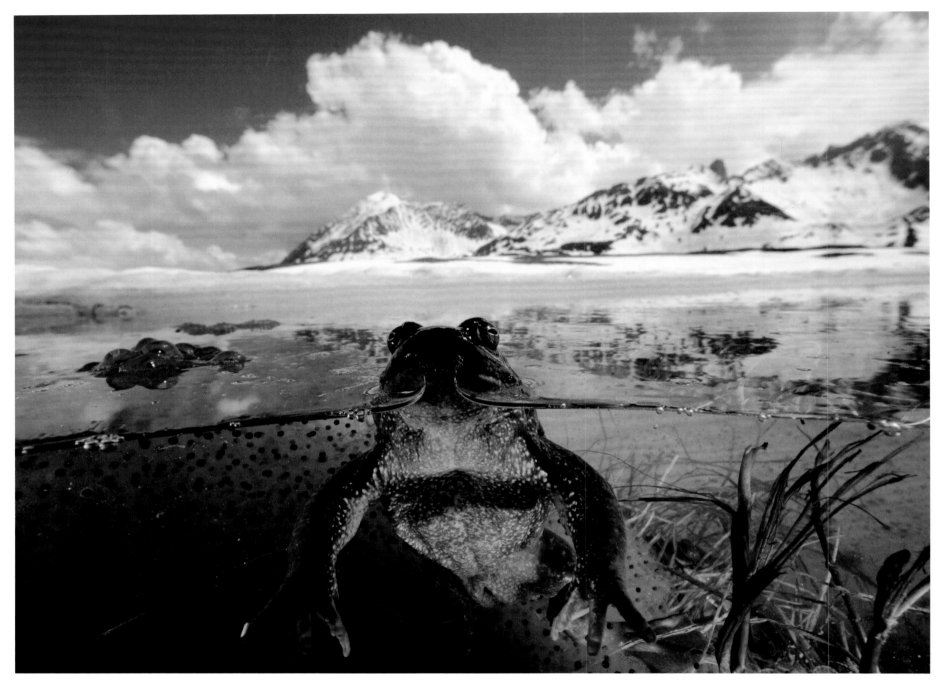

Common frog

Mer de Glace

One of the most beautiful ways to enjoy the mountain panorama at Mont Blanc is a ride on the rack railway from Chamonix to Montenvers, covering a distance of 5 km (3 mi) and almost 900 meters (2953 ft) in altitude. Since 1909 there has been a railway that travels up the mountain at a maximum speed of 20 km/h (12mph), where you can visit a small museum dedicated to alpine flora. From here there is a beautiful view of the largest glacier in France, the Mer de Glace, which has been a constant inspiration for poets and painters. For over 250 years the Mer de Glace has been painted and photographed.

La Mer de Glace

L'une des plus belles façons de profiter des paysages du mont Blanc est d'effectuer le trajet à bord du train Chamonix-Mont-Blanc qui mène à Montenvers. Ce train à crémaillère parcourt presque 900 m de dénivelé sur 5 km. Il existe depuis 1909 et avance à une vitesse maximale de 20 km/h jusqu'au sommet de la montagne, où il est possible de visiter un petit musée sur la flore alpine. De là-haut, la vue sur la Mer de Glace, plus gros glacier de France, est imprenable. Depuis plus de deux cent cinquante ans, la Mer de Glace, qui a inspiré de nombreux poètes et peintres, continue d'être peinte, photographiée et poétisée.

Mer de Glace

Eine der schönsten Arten, das Bergpanorama am Mont Blanc zu genießen, ist eine Fahrt mit der Zahnradbahn von Chamonix bis auf den Montenvers, wobei auf einer Strecke von 5 km fast 900 Höhenmeter überwunden werden. Seit 1909 gibt es die Bahn, die mit maximal 20 km/h auf den Berg fährt, wo man ein kleines Museum über die alpine Pflanzenwelt besuchen kann. Von hier oben gibt es einen schönen Blick auf den größten Gletscher Frankreichs, das Mer de Glace (Eismeer), der immer schon Dichter und Maler inspiriert hat. Seit über 250 Jahren wird das Eismeer gemalt, fotografiert und bedichtet.

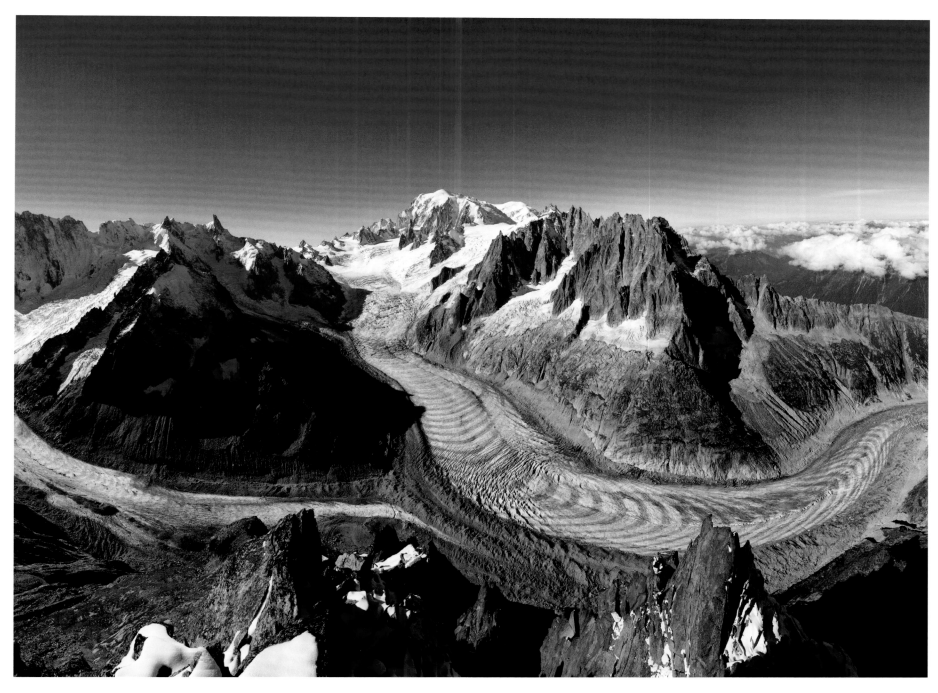

Mer de Glace, Mont Blanc massif

Mer de Glace

Una de las formas más bellas de disfrutar del panorama montañoso del Mont Blanc es dando un paseo en el ferrocarril de cremallera de Chamonix a Montenvers, que cubre una distancia de 5 km y casi 900 m de altitud. Desde 1909 existe un ferrocarril que sube la montaña a una velocidad máxima de 20 km/h, donde se puede visitar un pequeño museo sobre la flora alpina. Desde aquí arriba, hay una hermosa vista del glaciar más grande de Francia, el Mer de Glace (Océano Ártico), que siempre ha inspirado a poetas y pintores. Durante más de 250 años, el Océano Ártico ha sido pintado, fotografiado y sellado.

Mer de Glace

Uma das mais belas formas de apreciar o panorama montanhoso do Monte Branco é um passeio de trem de cremalheira, que liga a estação de Chamonix com Montenvers, cobrindo uma distância de 5 km a quase 900 metros de altitude. Desde 1909, existe a ferrovia que sobe a montanha a uma velocidade máxima de 20 km/h, onde se pode visitar um pequeno museu sobre a flora alpina. Daqui de cima, há uma bela vista da maior geleira da França, o Mer de Glace (Mar de Gelo), que sempre inspirou poetas e pintores. Há mais de 250 anos que o Mar de Gelo é pintado, fotografado e vangloriado em poemas.

Mer de Glace

Een van de beste manieren om van het bergpanorama op de Mont Blanc te genieten, is een rit met de tandradbaan van Chamonix naar Montenvers, waarbij een afstand van 5 km op bijna 900 meter hoogte wordt afgelegd. Sinds 1909 is er een spoorlijn die met een maximumsnelheid van 20 km/u de berg op rijdt, waar je een klein museum over de alpenflora kunt bezoeken. Vanaf hier heb je een prachtig uitzicht op de grootste gletsjer van Frankrijk, de Mer de Glace (Zee van IJs), die altijd al een inspiratiebron is geweest voor dichters en schilders. Al meer dan 250 jaar wordt de Zee van IJs geschilderd, gefotografeerd en gedichten over geschreven.

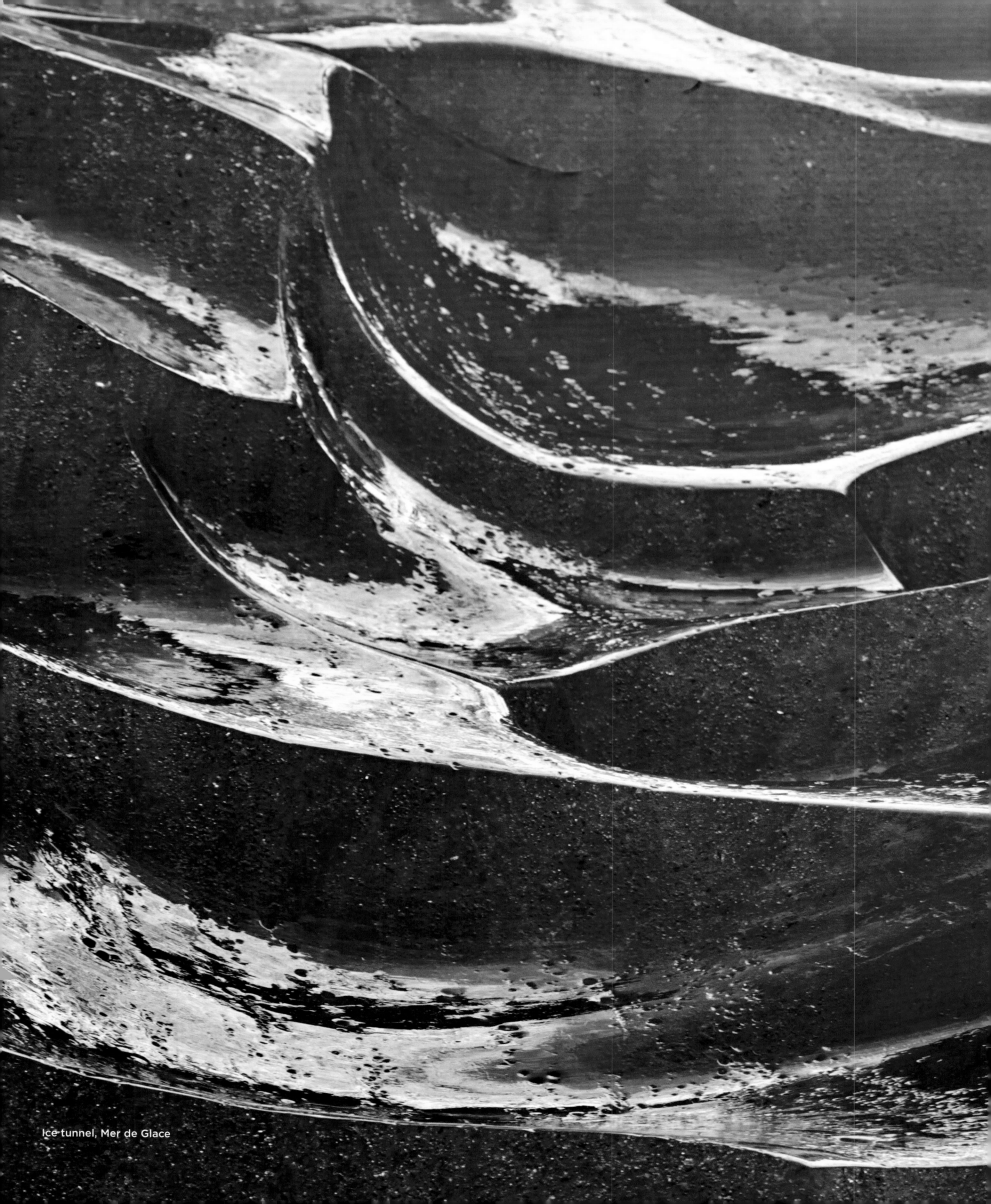

Ice tunnel, Mer de Glace

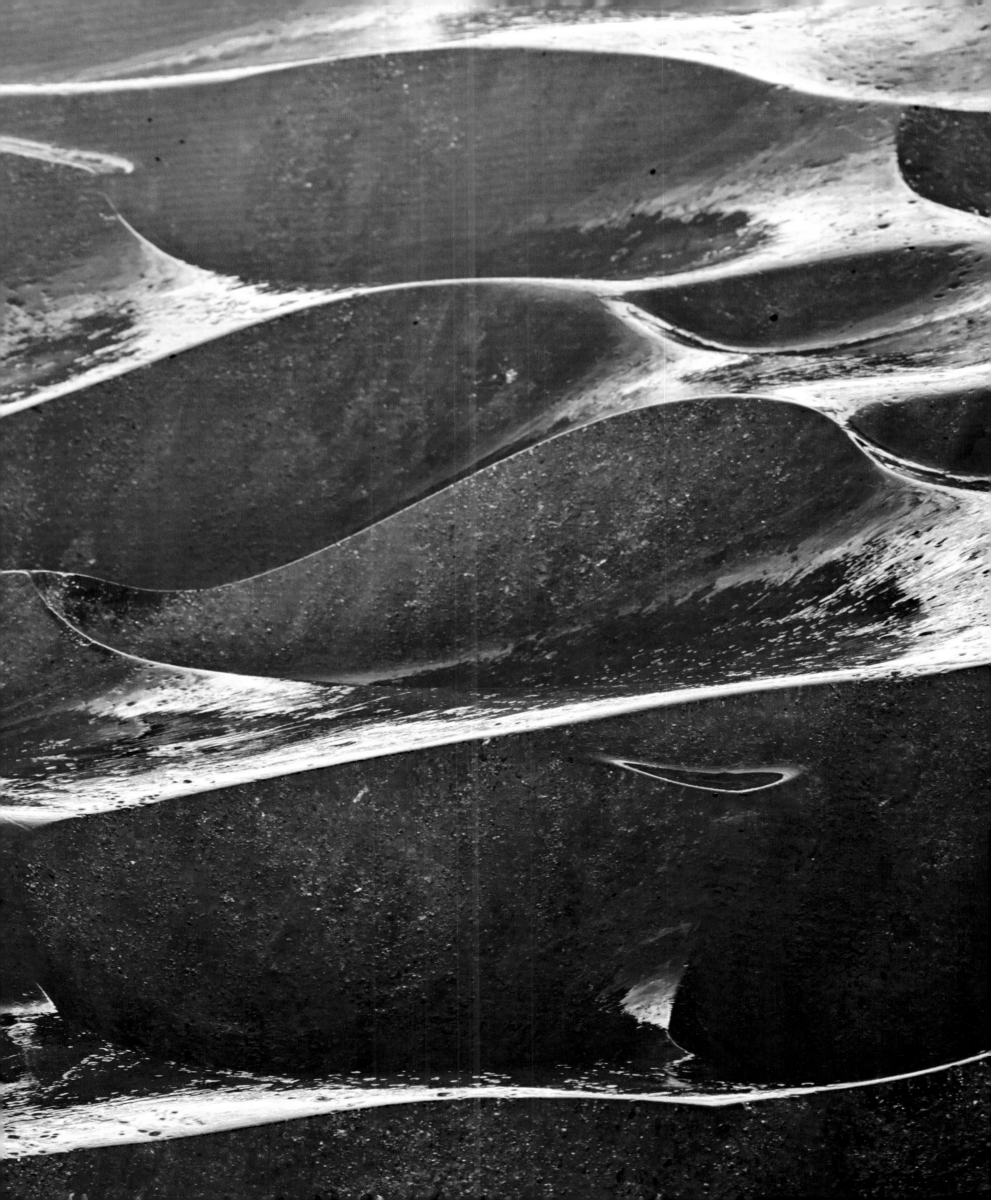

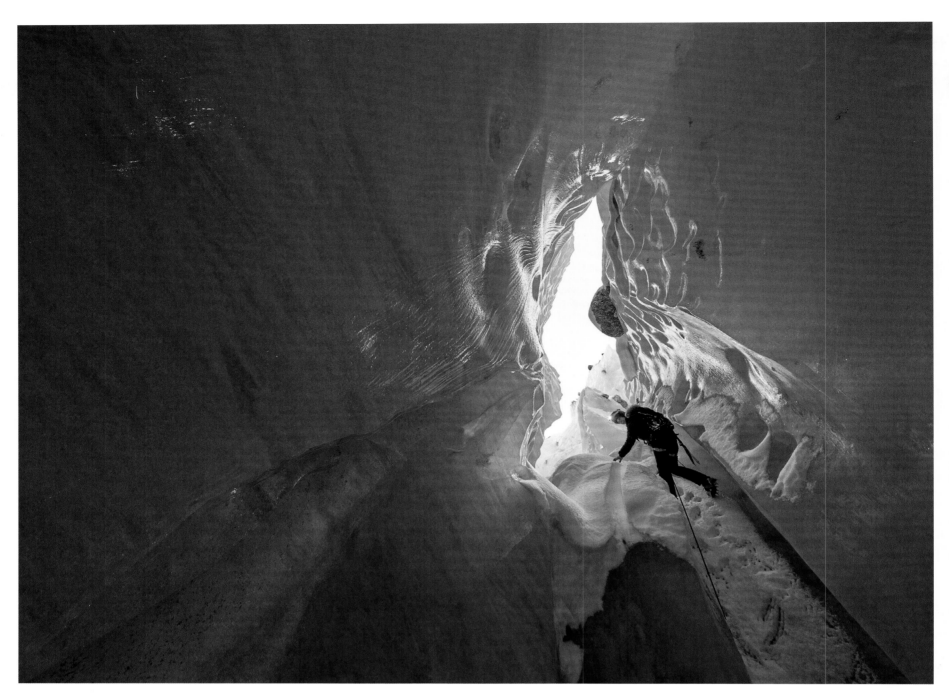

Ice cave, Mer de Glace

Abseiling

The magic of otherwise inaccessible ice caves and glacier ice, can be experienced by abseiling. In contrast to climbing with an ice axe and crampons, you can lower yourself on a rope and enter the ice through even the narrowest crevasses. Some ice caves are open to visitors, others are only accessible to experienced sportsmen.

Rapel

La magia de las cuevas de hielo, que de otro modo serían inaccesibles, como el hielo de los glaciares, se puede experimentar haciendo rapel. A diferencia de escalar con piolet y crampones, te dejas caer sobre una cuerda y te metes en el hielo a través de las grietas más estrechas. Algunas cuevas de hielo están abiertas a los visitantes, otras solo son accesibles para atletas experimentados.

Descente en rappel

Grâce à la descente en rappel, il est possible de se laisser envoûter par la beauté des grottes de glace, autrement inaccessibles. Contrairement à l'escalade avec piolet et crampons, la descente en rappel consiste à se laisser glisser le long d'une corde, ce qui permet d'accéder également à l'intérieur de la glace par les crevasses les plus étroites. Certaines grottes de glace sont aménagées pour les visiteurs de passage, d'autres ne sont accessibles qu'aux sportifs expérimentés.

Rapel

A magia de cavernas de gelo inacessíveis, como o gelo glacial, pode ser experimentada pelo rapel. Ao contrário de escalar com um machado de gelo e grampos, você se deixa levar por uma corda e entra no gelo através das fendas mais estreitas. Algumas cavernas de gelo estão abertas a visitantes, outras são acessíveis apenas a atletas experientes.

Abseilen

Die Magie von sonst unzugänglichen Eishöhlen, etwa im Gletschereis, lässt sich beim Abseilen erleben. Im Gegensatz zum Klettern mit Eisaxt und Steigeisen lässt man sich selbst an einem Seil hinab und gelangt auch durch schmalste Spalten ins Innere des Eises. Manche Eishöhlen sind für Besucher erschlossen, andere nur erfahrenen Sportlern zugänglich.

Abseilen

De magie van anders ontoegankelijke ijsgrotten, zoals gletsjerijs, kan worden ervaren door abseilen. In tegenstelling tot het klimmen met een ijsbijl en stijgijzers, laat je je aan een touw zakken en kom je door de smalste spleten het ijs in. Sommige ijsgrotten zijn open voor bezoekers, andere zijn alleen toegankelijk voor ervaren sporters.

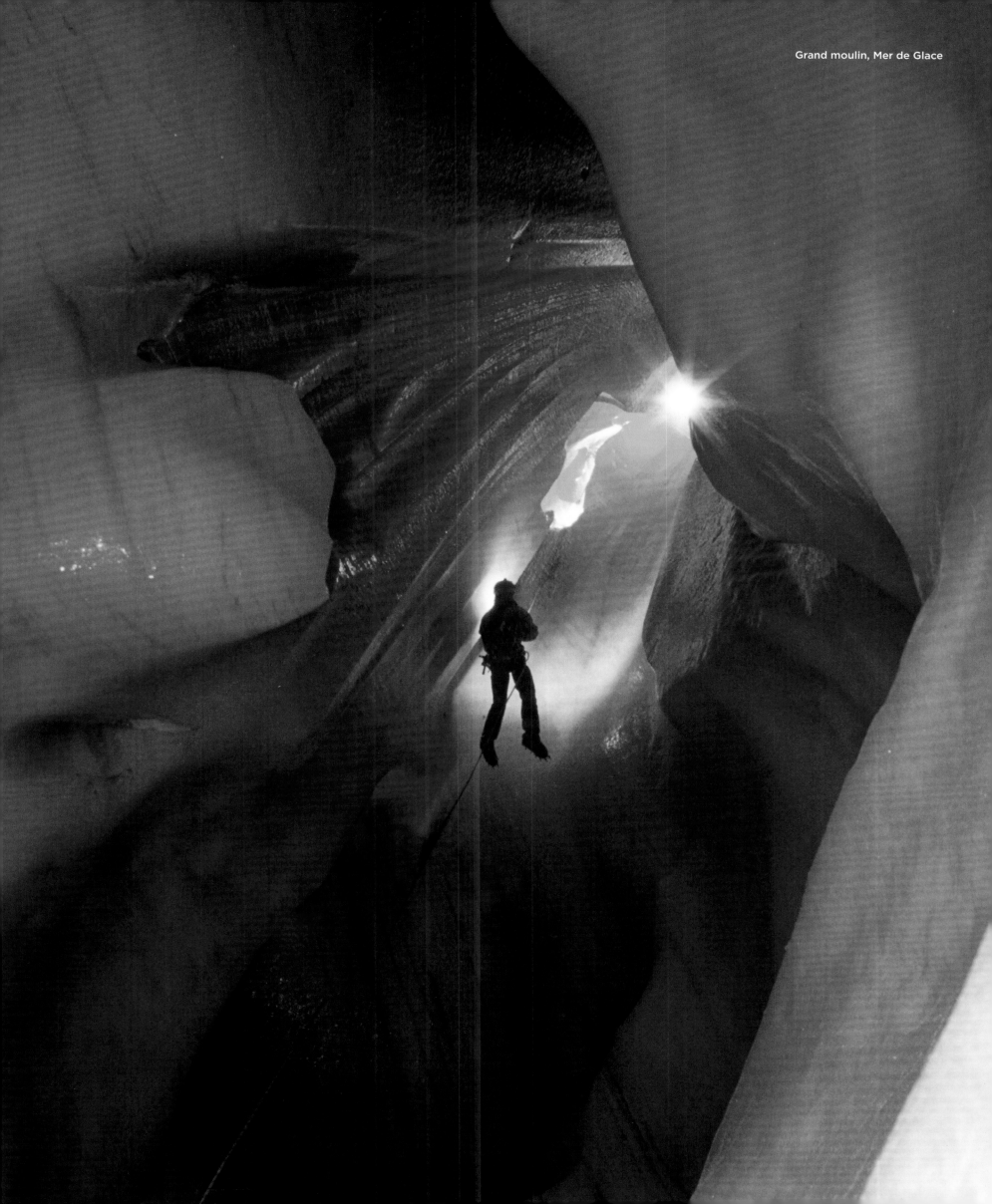

Grand moulin, Mer de Glace

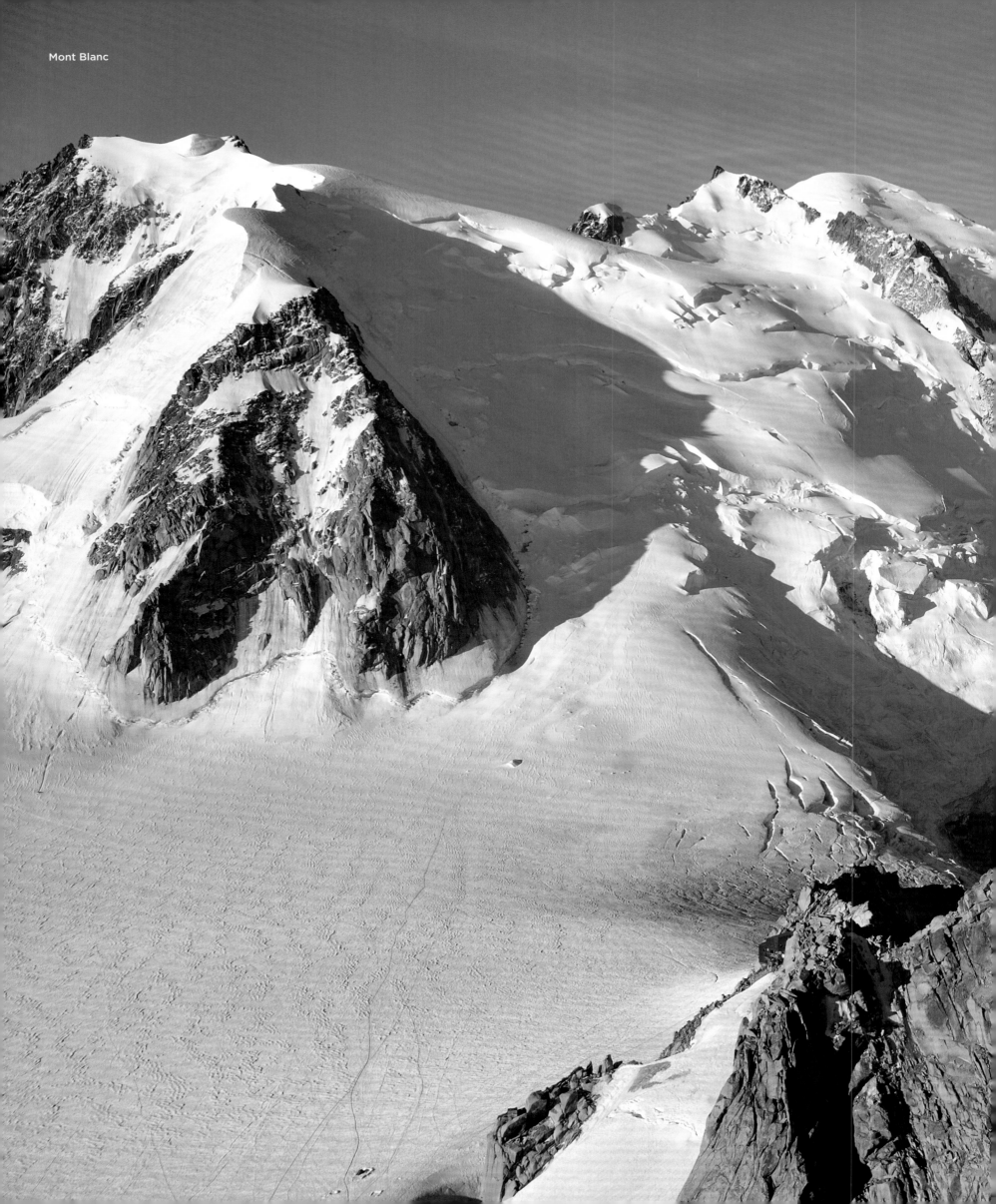

Mont Blanc

Fountain, Aix-en-Provence

Bossons Glacier

Like all alpine glaciers, Bossons Glacier on the northern edge of the Mont Blanc massif has retreated significantly in recent decades; it has already lost around 350 meters (1148 ft) of its length. The glacier became tragically famous when airplanes collided with the mountain twice, in 1950 and 1966. In total, more than 150 passengers of the two Air India aircraft were killed in the catastrophes. As it flows slowly down into the valley, the glacier carries not only boulders but also objects; remains of the plane crashes are still being found today.

Le glacier des Bossons

Comme tous les glaciers alpins, le glacier des Bossons, situé sur la bordure nord du massif du Mont-Blanc, a nettement reculé au cours des dernières décennies. Il a déjà perdu environ 350 m de longueur. Le glacier des Bossons devint tristement célèbre pour une autre raison car à deux reprises, en 1950 et en 1966, un avion le percuta. La totalité des passagers des deux vols d'Air India de plus de 150 personnes, perdirent la vie dans ces accidents. Dans sa lente descente vers la vallée, le glacier ne transporte pas uniquement des éboulis, mais aussi des objets. Aujourd'hui encore, on retrouve des restes de ces catastrophes aériennes.

Glacier des Bossons

Wie alle Alpengletscher hat sich der Glacier des Bossons am Nordrand des Mont-Blanc-Massivs in den letzten Jahrzehnten deutlich zurückzogen; rund 350 m seiner Länge hat er bereits verloren. Traurige Berühmtheit erlangte der Glacier des Bossons, weil hier gleich zweimal, 1950 und 1966, Flugzeuge gegen den Berg prallten. Alle insgesamt mehr als 150 Insassen der beiden Air-India-Maschinen kamen bei den Katastrophen ums Leben. Bei seinem langsamen Fluss hinunter ins Tal transportiert der Gletscher nicht nur Geröll, sondern auch Gegenstände; bis heute werden Überreste der Flugzeugunglücke gefunden.

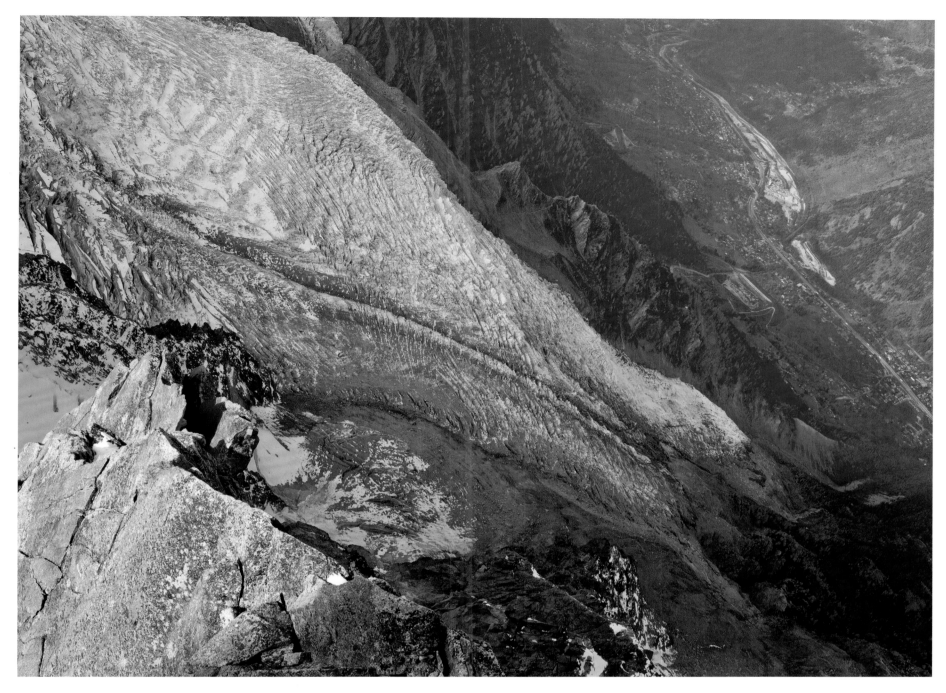

Bossons Glacier

Glaciar de Bossons

Como todos los glaciares alpinos, el glaciar de Bossons, en el borde norte del macizo del Mont Blanc, ha retrocedido considerablemente en las últimas décadas: ya ha perdido unos 350 metros de su longitud. El glaciar de Bossons se hizo famoso por un motivo muy triste: porque dos aviones chocaron con la montaña dos veces, en 1950 y 1966. En total, más de 150 pasajeros de los dos aviones de Air India murieron en las catástrofes. A medida que desciende lentamente hacia el valle, el glaciar transporta no solo cantos rodados, sino también objetos; todavía se siguen encontrando restos de los accidentes aéreos.

Glaciar dos Bossons

Como todos os glaciares alpinos, o Glaciar dos Bossons, no limite norte do maciço do Monte Branco, recuou significativamente nas últimas décadas; já perdeu cerca de 350 metros de comprimento. O Glaciar dos Bossons tornou-se tristemente famoso porque aqui, já por duas vezes, aviões colidiram com a montanha, em 1950 e 1966. Ao todo, mais de 150 passageiros dos ambos aviões da companhia Air-India foram mortos nas catástrofes. À medida que desce lentamente para o vale, a geleira transporta não só pedras, mas também objetos; restos dos acidentes aéreos ainda estão sendo encontrados até nos dias de hoje.

Gletsjer van de Bosson

Zoals alle Alpengletsjers heeft de Bosson-gletsjer aan de noordelijke rand van het Mont Blanc-massief zich in de afgelopen decennia aanzienlijk teruggetrokken; hij is al ongeveer 350 meter van zijn lengte kwijt. De Glacier des Bossons werd helaas beroemd omdat 2 vliegtuigen, een keer in 1950 en een keer in 1966 met de berg in botsing kwamen. Al met al zijn er meer dan 150 passagiers van de twee vliegtuigen van Air-India omgekomen bij de rampen. De gletsjer stroomt langzaam het dal in en vervoert niet alleen keien, maar ook voorwerpen; resten van de vliegtuigcrash worden vandaag de dag nog steeds gevonden.

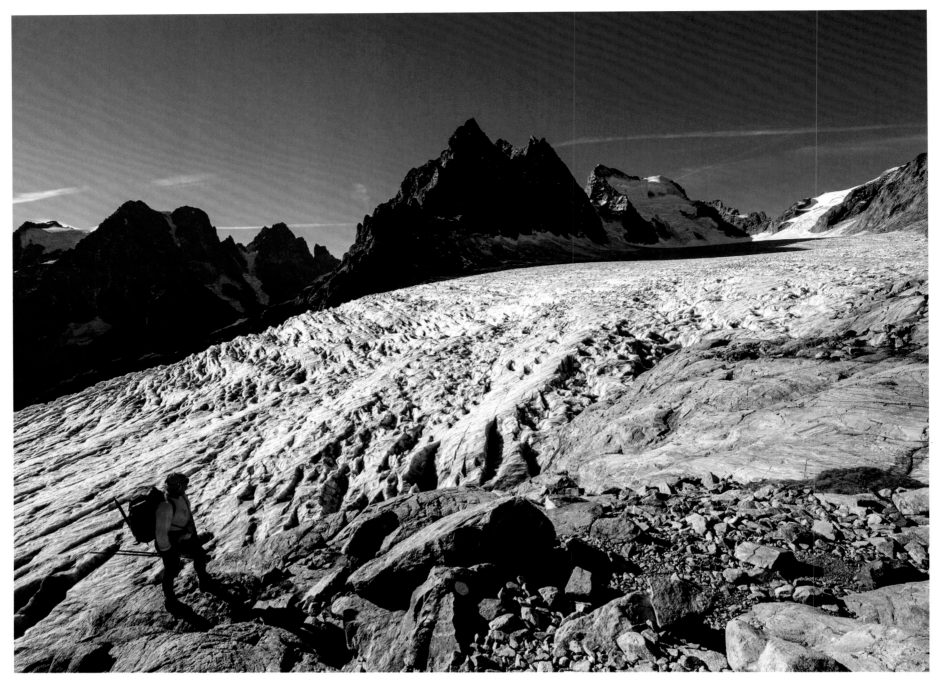

Glacier Blanc, Écrins National Park

Glacial Melting

The melting of glaciers caused by rising temperatures can often be clearly observed on the surface. Melt water forms small rivers or lakes and seeps into the subsurface, and can thus help to soften the soil under the ice and make it unstable. A paradoxical consequence of this melting is often a lack of water: many rivers that originate in the high mountains feed on glacier water, which accounts for a large proportion of freshwater reserves. If the glaciers recede, the amount of water also sinks, which can lead to drought.

Fonte des glaciers

La fonte due à l'augmentation des températures peut souvent être observée à la surface des glaciers : l'eau de fonte y creuse de petites rivières ou lacs, s'infiltre dans les sols et ramollit ainsi le terrain sous la glace, le rendant instable. Une conséquence de la fonte des glaciers pouvant paraître paradoxale est souvent une pénurie d'eau. De nombreuses rivières prenant leur source dans les hautes montagnes se nourrissent de l'eau des glaciers, qui constituent une grande partie des réserves d'eau douce mondiales. Si les glaciers reculent, les quantités d'eau diminuent également, pouvant entraîner la sécheresse.

Gletscherschmelze

Das durch steigende Temperaturen verursachte Abschmelzen von Gletschern lässt sich häufig gut an der Oberfläche beobachten: Schmelzwasser bildet kleine Flüsse oder Seen, es versickert im Untergrund und kann so dazu beitragen, dass der Boden unter dem Eis aufweicht und instabil wird. Eine paradox anmutende Folge des Abschmelzens ist oftmals Wassermangel: Viele Flüsse, die im Hochgebirge entspringen, speisen sich durch Gletscherwasser, das einen großen Teil der Süßwasserreserven ausmacht. Gehen die Gletscher zurück, sinken aber auch die Wassermengen, was zu Trockenheit führen kann.

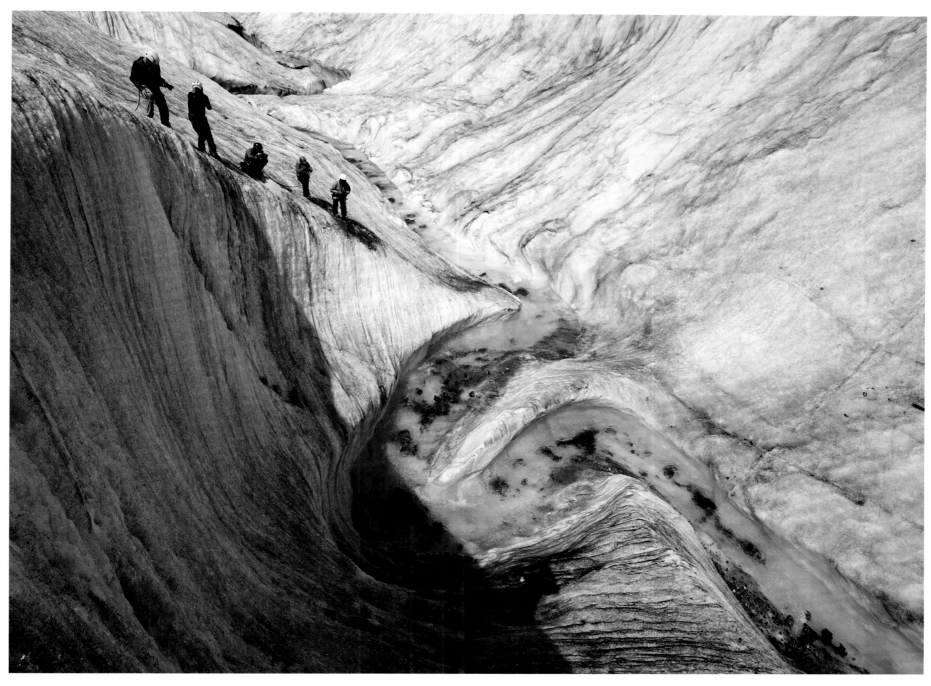

Mer de Glace

Derretimiento glacial

El derretimiento de los glaciares causado por el aumento de las temperaturas a menudo se puede observar bien en la superficie: el agua derretida forma pequeños ríos o lagos, se filtra en el subsuelo y puede así ayudar a ablandar el suelo bajo el hielo y hacerlo inestable. Una consecuencia paradójica del deshielo es a menudo la falta de agua: muchos ríos que nacen en las altas montañas se alimentan de agua de los glaciares, lo que representa una gran proporción de las reservas de agua dulce. Si los glaciares retroceden, la cantidad de agua también se reduce, lo que puede llevar a la sequía.

Fusão glacial

O derretimento das geleiras causado pelo aumento da temperatura pode ser frequentemente observado bem na superfície: A água de fusão forma pequenos rios ou lagos, infiltra-se na subsuperfície e com isso pode contribuir para que o solo sob o gelo amoleça e torne instável. Uma consequência paradoxal do derretimento é muitas vezes a falta de água: muitos rios que nascem nas altas montanhas alimentam-se de água da geleira, o que representa uma grande proporção das reservas de água doce. Se as geleiras diminuírem, a quantidade de água também diminui, o que pode levar à seca.

IJssmelten

Het smelten van gletsjers als gevolg van stijgende temperaturen kan vaak goed aan het oppervlak worden waargenomen: Smeltwater vormt kleine rivieren of meren, sijpelt in de ondergrond en kan zo helpen om de bodem onder het ijs te verzachten en instabiel te maken. Een paradoxaal gevolg van het smelten is vaak een gebrek aan water: veel rivieren die hun oorsprong vinden in het hooggebergte voeden zich met gletsjerwater, dat een groot deel van de zoetwaterreserves uitmaakt. Als de gletsjers teruglopen, zinkt ook de hoeveelheid water, wat tot droogte kan leiden.

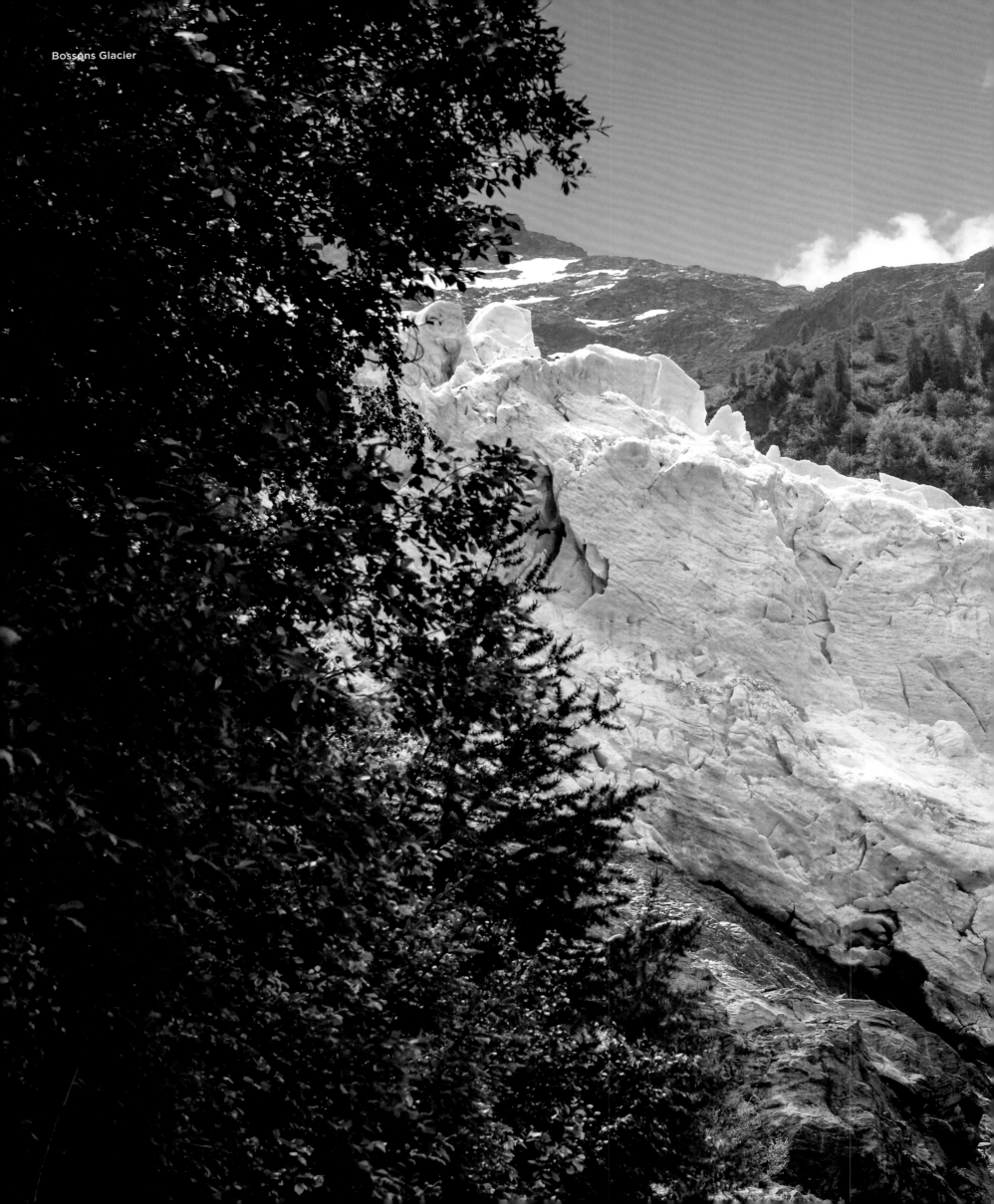

Bossons Glacier

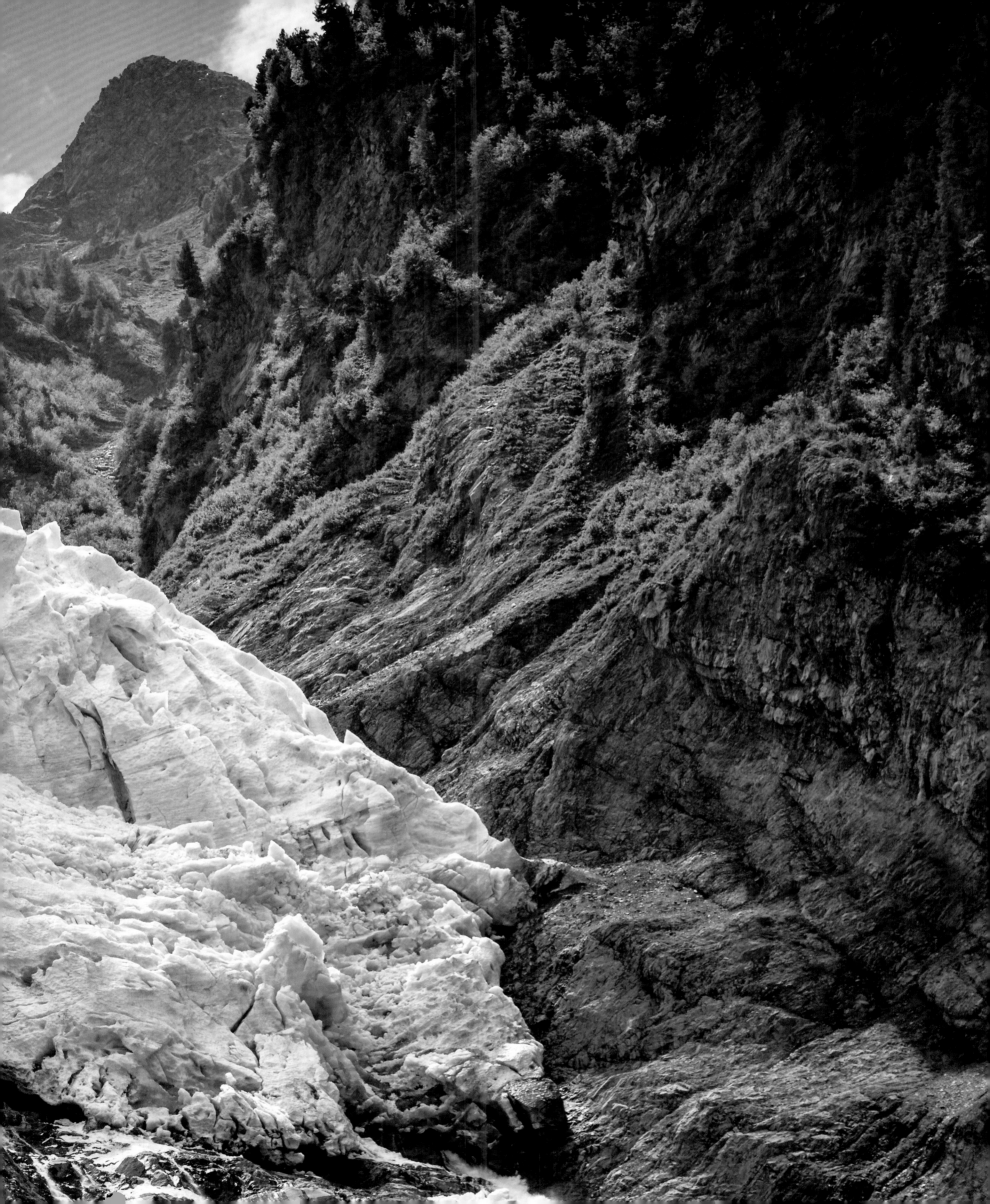

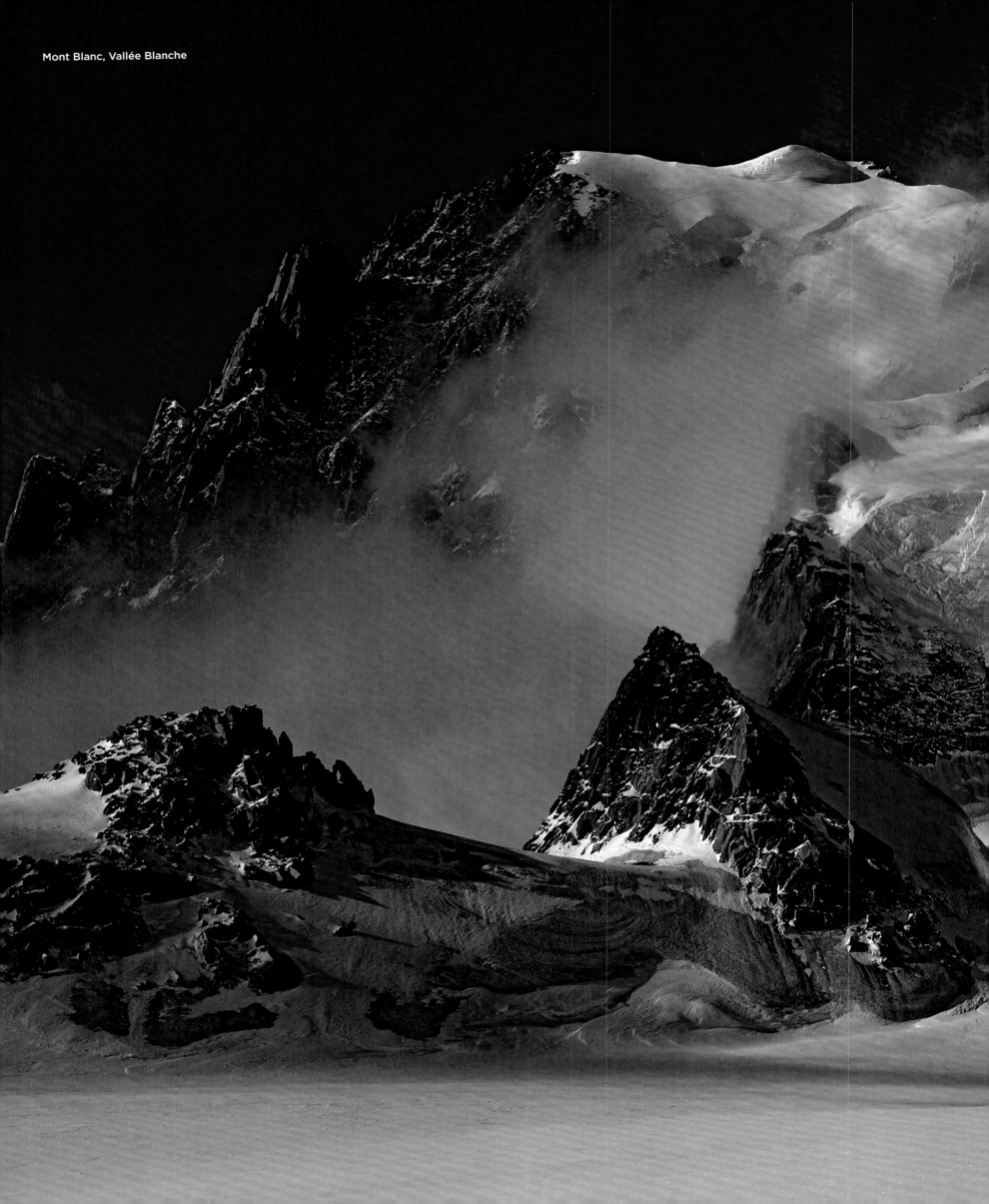

Mont Blanc, Vallée Blanche

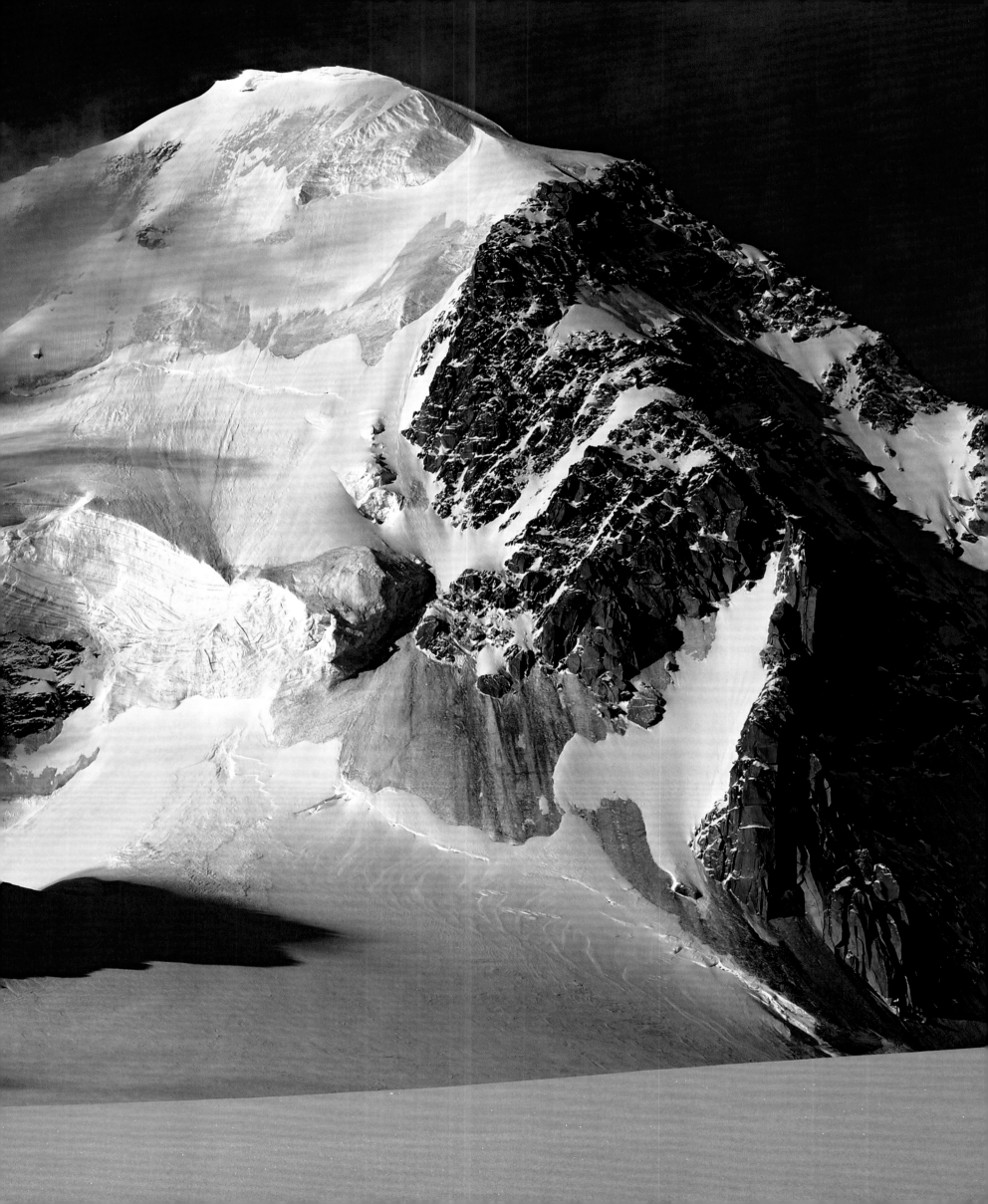

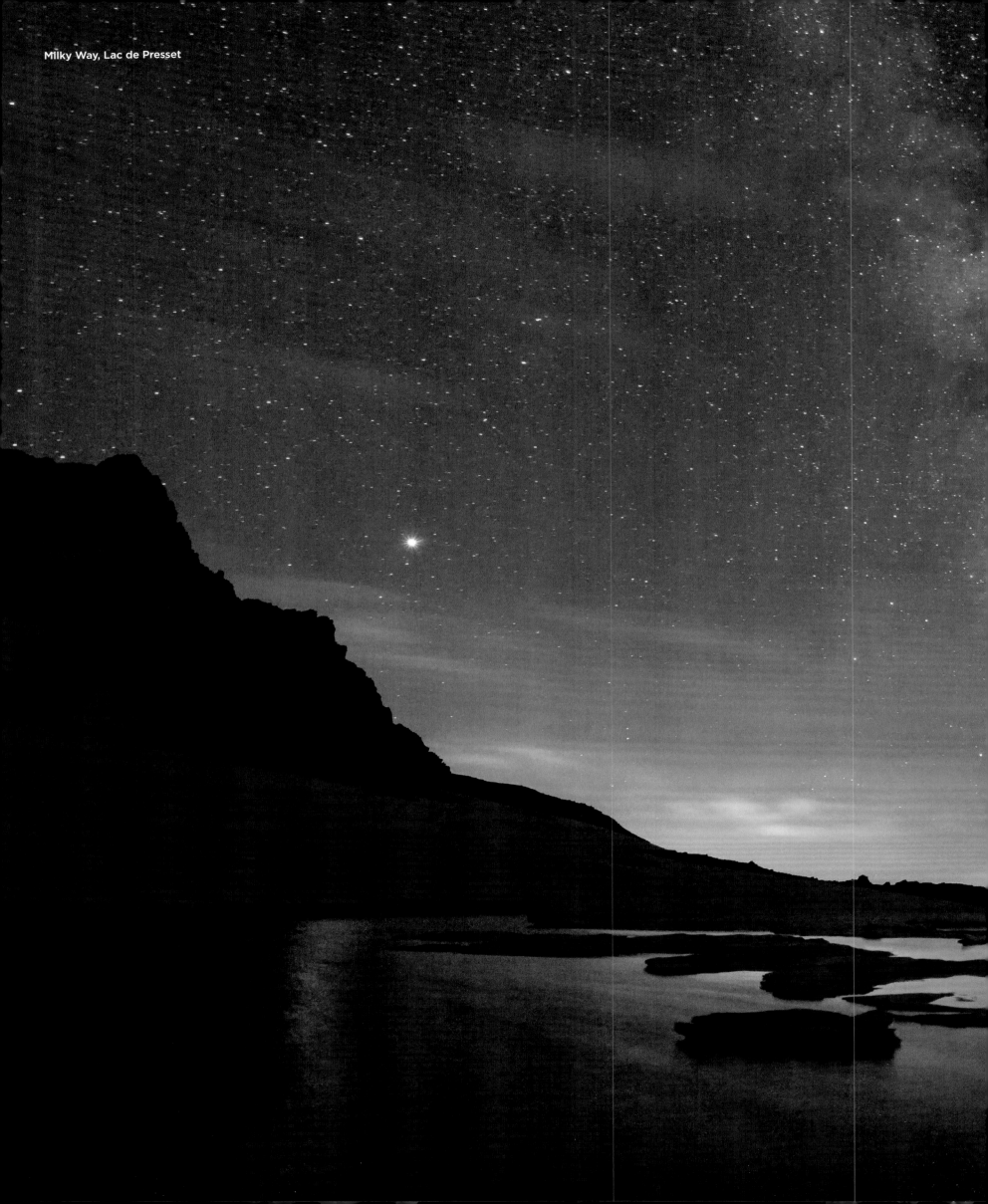

Milky Way, Lac de Presset

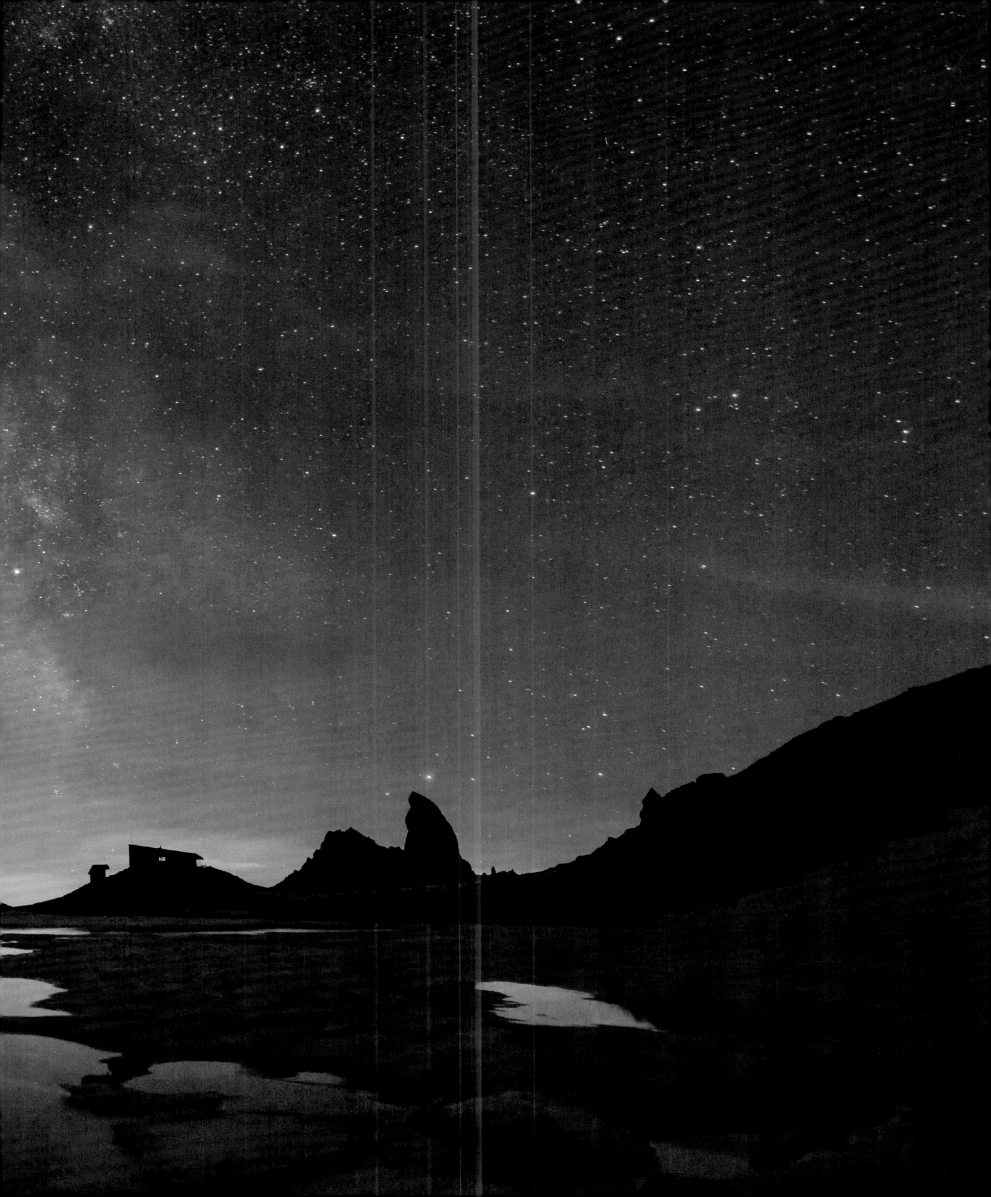

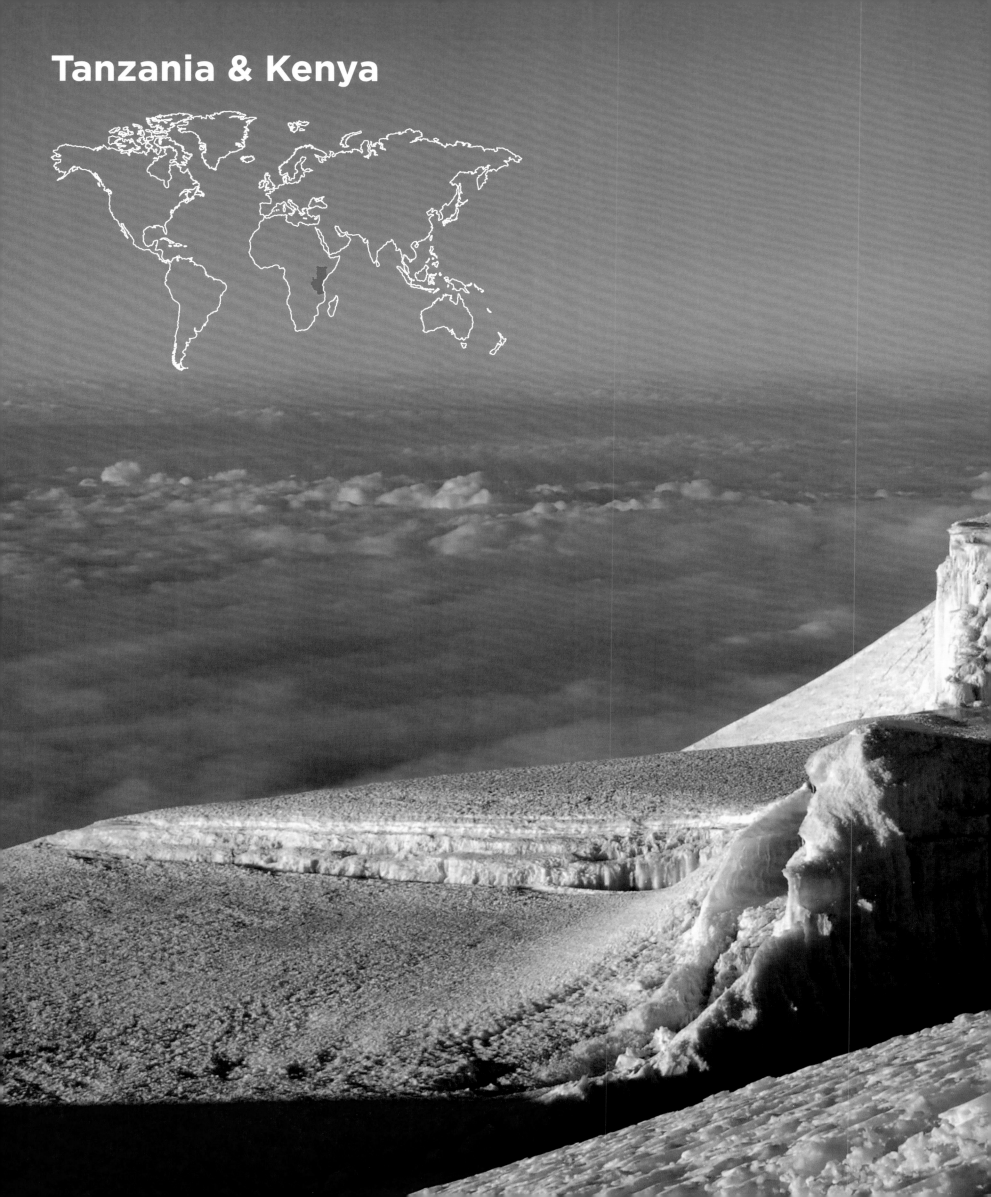

Tanzania & Kenya

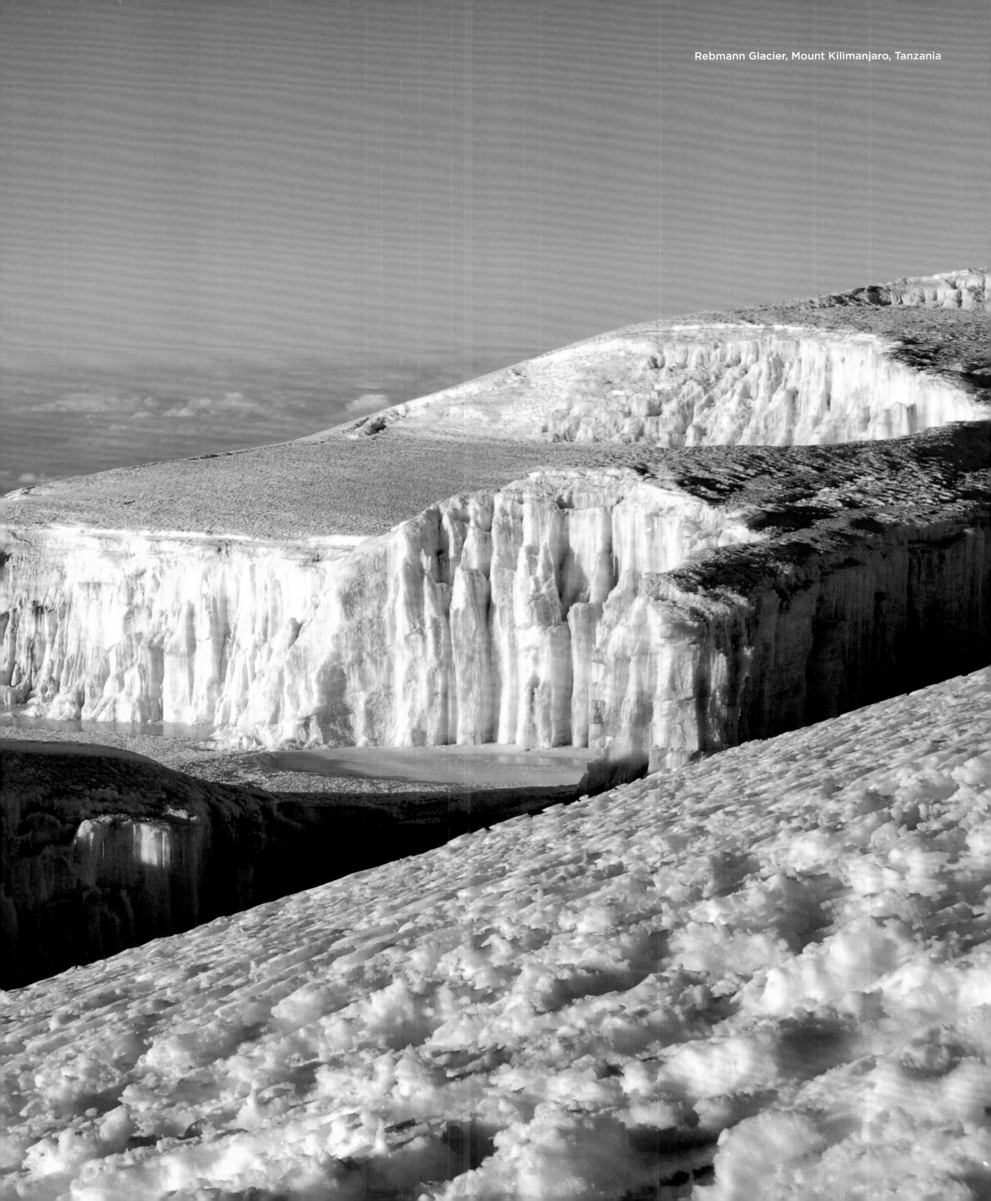

Rebmann Glacier, Mount Kilimanjaro, Tanzania

Heavy frost

Tanzania and Kenya

After Australia, Africa is the hottest continent on earth. Nevertheless, there are mountain regions near the equator whose peaks are covered with ice and which even show glaciations. In Kenya, the Mount Kenya massif rises almost exactly on the equator, with the 5199 m (17057 ft) high Batian as the highest peak. Further east, on the border of Uganda and the Democratic Republic of Congo lies the Ruwenzori mountain range, which reaches a height of up to 5109 m (16761 ft). The best known of the mountain massifs is Kilimanjaro in Tanzania, 350 km (217 mi) south of the equator. Kilimanjaro is 5895 m (19340 ft) high and is the highest mountain in Africa.

Tanzanie et Kenya

L'Afrique est, derrière l'Australie, le continent le plus chaud de la planète. Pourtant, il y a à proximité de l'équateur des régions de montagne dont les sommets sont couverts de glace et révèlent des zones de glaciation. Au Kenya, le massif du Mont-Kenya, avec pour point le plus haut le Batian, à 5 199 m d'altitude, s'élève presque exactement sur l'équateur. Plus à l'est, à la frontière de l'Ouganda et de la République démocratique du Congo, se trouve la chaîne du Rwenzori, culminant à 5 109 m. Le massif montagneux le plus célèbre est le Kilimandjaro, situé à 350 km au sud de l'équateur, en Tanzanie et dont le Kibo est la plus haute montagne d'Afrique, culminant à 5 895 m d'altitude.

Tansania und Kenia

Afrika ist nach Australien der heißeste Kontinent der Erde. Dennoch gibt es in der Nähe des Äquators Bergregionen, deren Gipfel mit Eis bedeckt sind und die sogar Vergletscherungen aufweisen. In Kenia, fast genau auf dem Äquator, erhebt sich das Mount-Kenya-Massiv mit dem 5199 m hohen Batian als höchstem Gipfel. Weiter östlich liegt an der Grenze von Uganda und der Demokratischen Republik Kongo das bis zu 5109 m hohe Ruwenzori-Gebirge. Das bekannteste der Gebirgsmassive ist der 350 km südlich des Äquators gelegene Kilimandscharo in Tansania, der mit dem 5895 m hohen Kibo den höchsten Berg Afrikas aufweist.

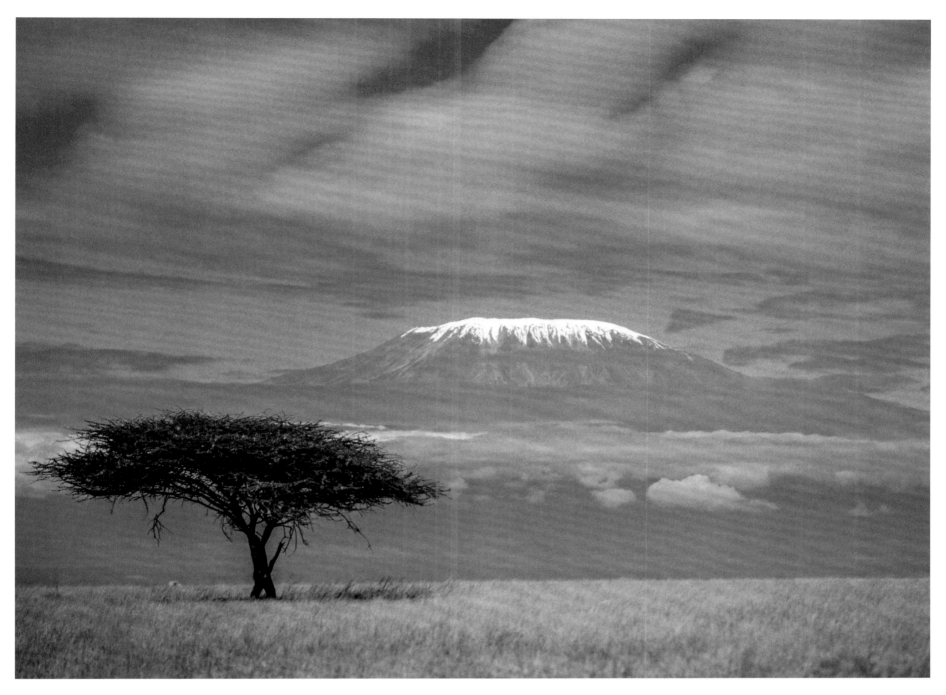

Mount Kilimanjaro, Tanzania

Tanzania y Kenia

Después de Australia, África es el continente más cálido del mundo. Sin embargo, hay regiones montañosas cercanas al ecuador cuyos picos están cubiertos de hielo y que incluso muestran glaciaciones. En Kenia, casi exactamente en el ecuador, el macizo montañoso Kenia se eleva con el Batian de 5199 m de altura como el pico más alto. Más al este, en la frontera de Uganda y la República Democrática del Congo, se encuentran las montañas Ruwenzori, de hasta 5109 m de altura. El más conocido de los macizos montañosos es el Kilimanjaro en Tanzania, a 350 km al sur del ecuador y que, con sus 5895 m de altura, es la montaña más alta de África.

Tanzânia e Quénia

Depois da Austrália, a África é o continente mais quente do mundo. No entanto, existem regiões montanhosas perto da linha do Equador, cujos picos estão cobertos de gelo e que apresentam até glaciações. No Quénia, quase exatamente no equador, ergue-se o maciço do Monte Quénia com o pico de Batian de 5199 m de altura como o pico mais alto. Mais a leste, na fronteira entre o Uganda e a República Democrática do Congo, encontra-se a cadeia montanhosa Ruwenzori, com até 5109 m de altura. O mais conhecido dos maciços montanhosos é o Kilimanjaro na Tanzânia, 350 km ao sul da linha do Equador. O pico principal Kibo do Kilimanjaro de 5895 m de altura é a montanha mais alta da África.

Tanzania en Kenia

Na Australië is Afrika het heetste continent op aarde. Toch zijn er in de buurt van de evenaar berggebieden waarvan de toppen bedekt zijn met ijs en die zelfs gletsjers vertonen. In Kenia, bijna precies op de evenaar, rijst het Mount-Kenya-massief op met de 5199 m hoge Batian als hoogste top. Verder naar het oosten, op de grens van Oeganda en de Democratische Republiek Congo, ligt het Ruwenzori gebergte, dat tot 5109 m hoog is. De bekendste van de bergmassieven is de Kilimanjaro in Tanzania, 350 km ten zuiden van de evenaar. De Kilimanjaro is 5895 m hoog en de hoogste berg van Afrika.

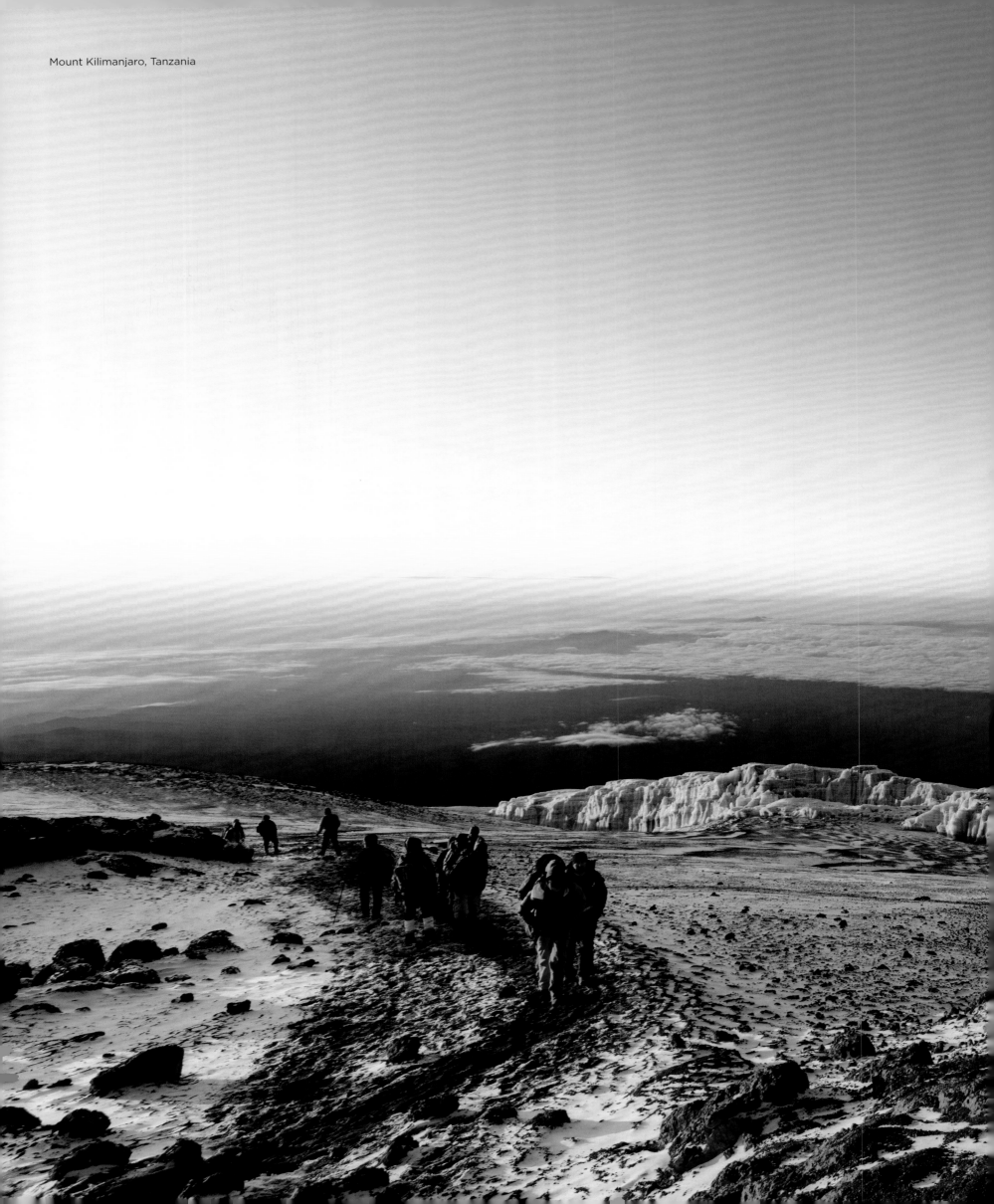

Mount Kilimanjaro, Tanzania

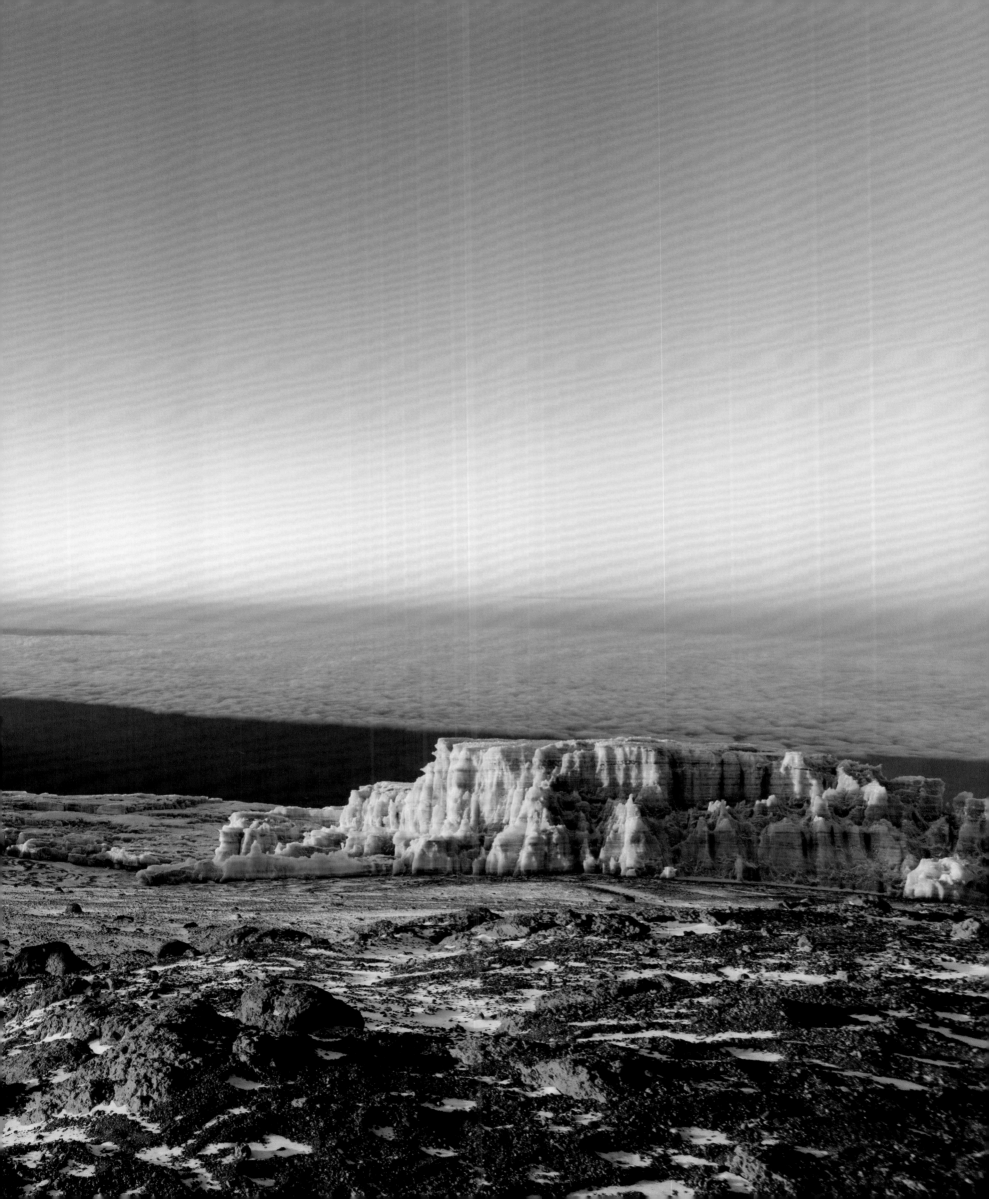

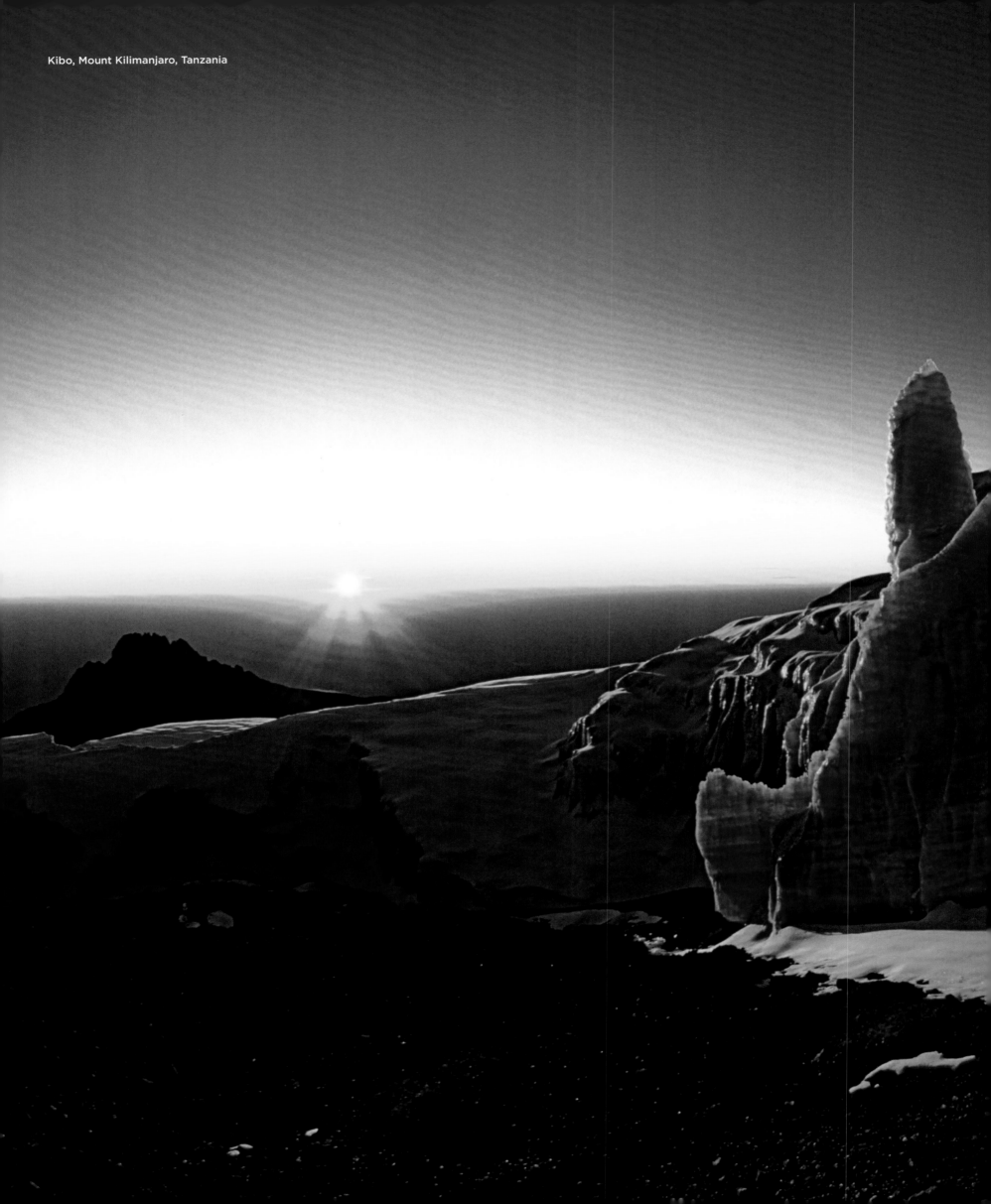

Kibo, Mount Kilimanjaro, Tanzania

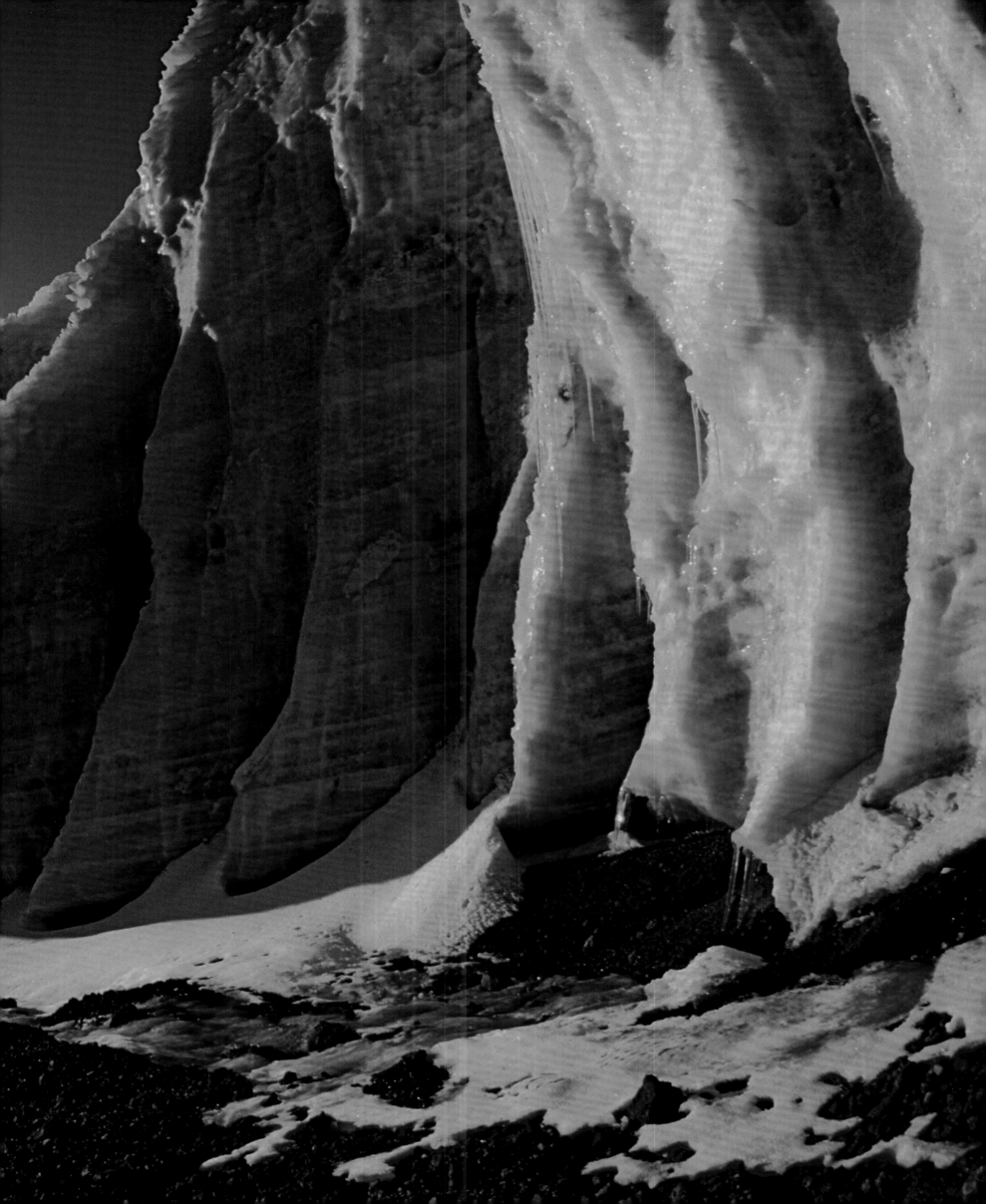

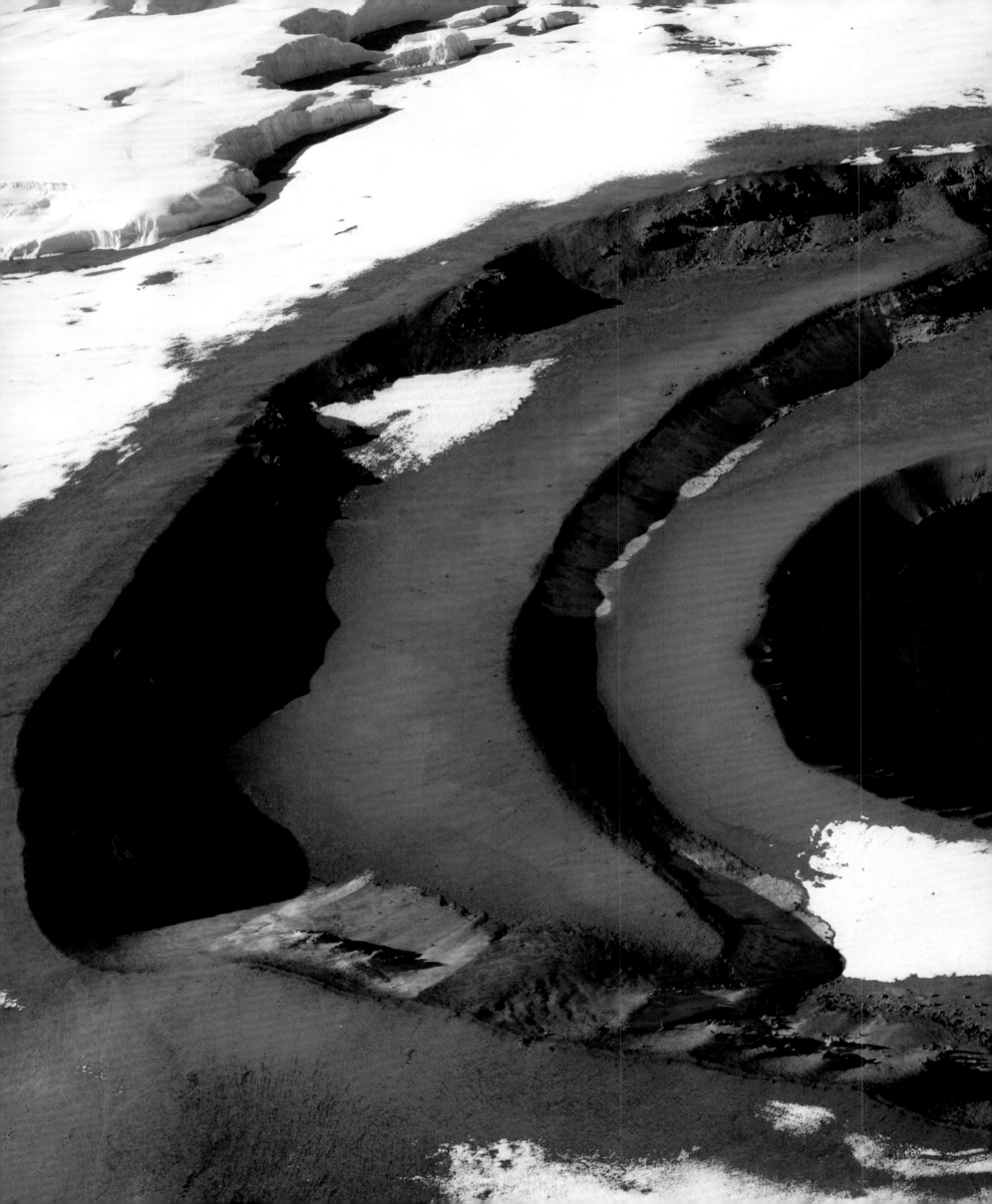

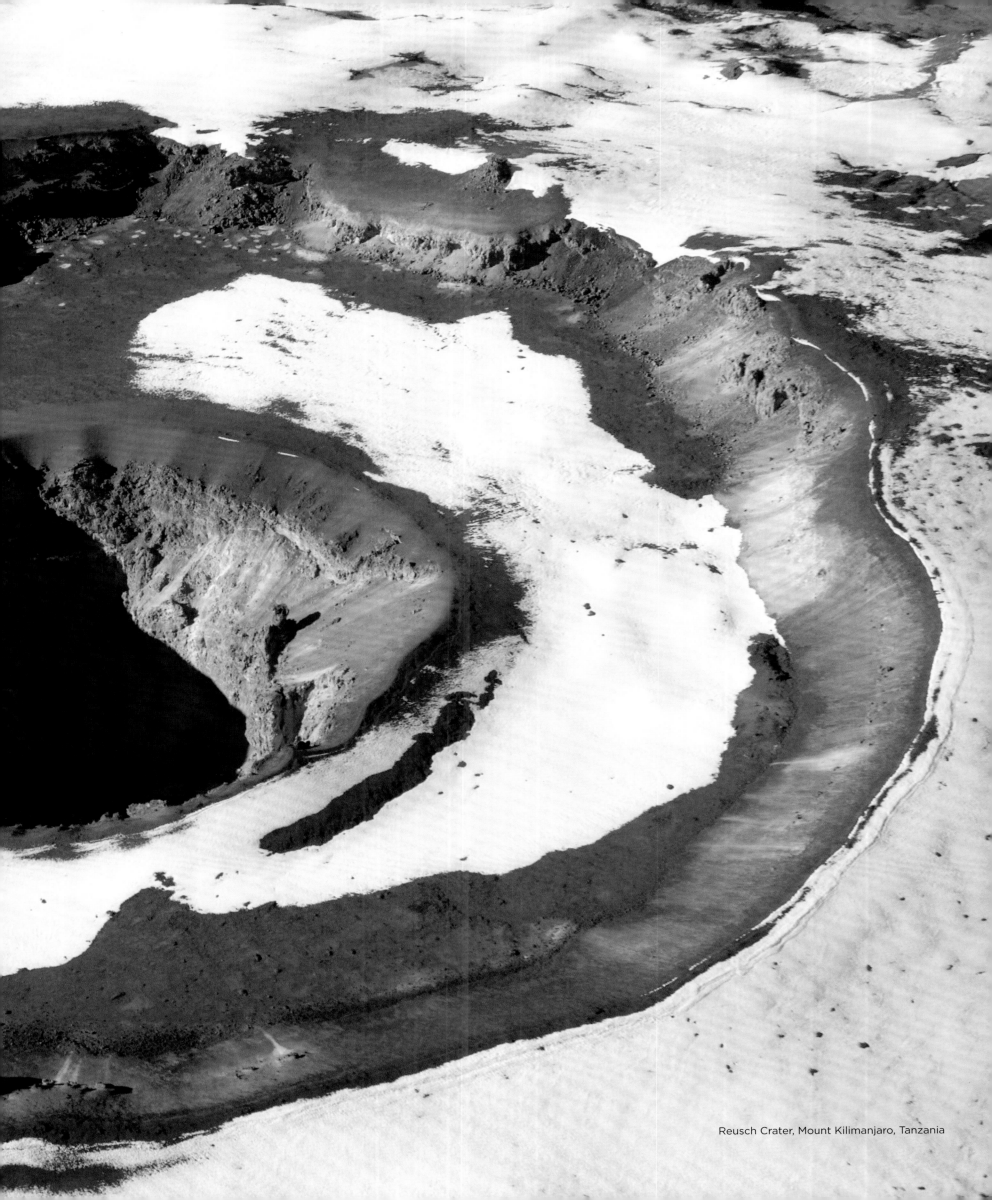

Reusch Crater, Mount Kilimanjaro, Tanzania

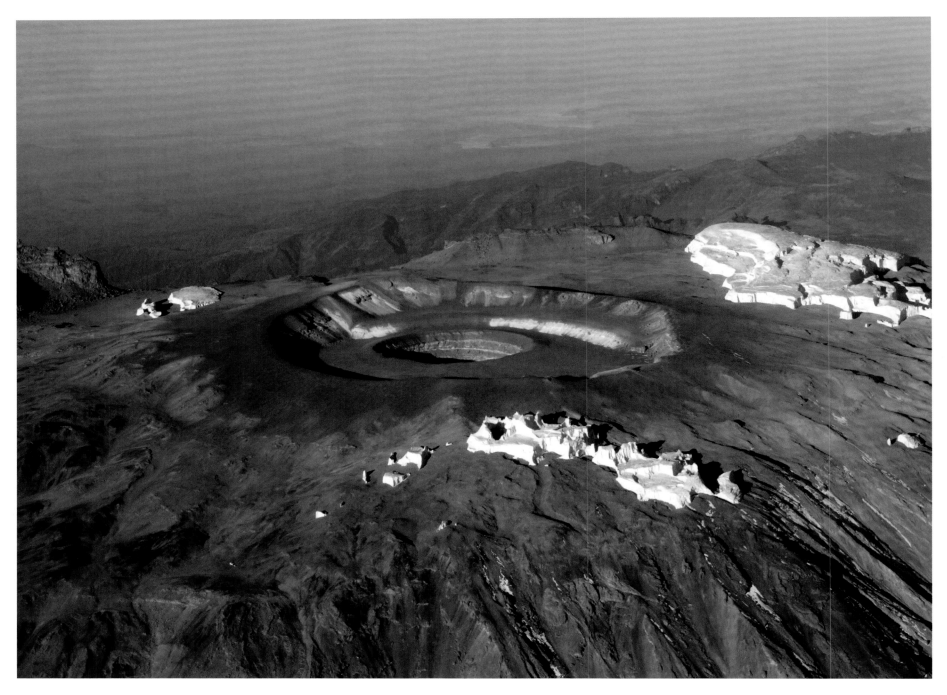

Mount Kilimanjaro, Tanzania

Kilimanjaro

The existence of a snow-covered mountain in the middle of Africa had long appeared to non-Africans as a mere rumor. The first serious reports were made in the middle of the 19th century, and 40 years later Europeans climbed the summit for the first time. German colonial rulers gave it the name Kaiser-Wilhelm-Spitze, and only after the end of colonial times was the highest peak renamed Uhuru (Swahili for "freedom"). The mass of snow described by former travelers has shrunk enormously in the course of only 150 years, and only the bare remains of the glaciers that once covered it can now be seen.

Le Kilimandjaro

L'existence d'une montagne couverte de neige en plein cœur de l'Afrique est longtemps restée une rumeur pour les non-Africains. Les premiers rapports sérieux à ce sujet apparurent au milieu du XIXᵉ siècle. Quarante ans plus tard, des Européens escaladèrent pour la première fois son sommet. Les colonisateurs allemands lui donnèrent le nom de Kaiser-Wilhelm-Spitze, en l'honneur de l'empereur Guillaume II d'Allemagne. Ce n'est qu'après la fin de l'époque coloniale que le plus haut pic fut renommé Uhuru (qui signifie « liberté » en swahili). Les quantités de neige décrites par les voyageurs d'autrefois ne sont plus les mêmes qu'aujourd'hui, après à peine cent cinquante ans il ne reste que de timides vestiges des glaciers qui le recouvraient jadis.

Kilimandscharo

Die Existenz eines schneebedeckten Berges mitten in Afrika war Nicht-Afrikanern lange als Gerücht erschienen. Erste seriöse Berichte gab es in der Mitte des 19. Jahrhunderts. 40 Jahre später bestiegen Europäer erstmals den Gipfel. Deutsche Kolonialherren gaben ihm den Namen Kaiser-Wilhelm-Spitze, erst nach dem Ende der Kolonialzeit wurde der höchste Gipfel in Uhuru (Suaheli für „Freiheit") umbenannt. Die Schneemassen, die frühere Reisende beschrieben, sind im Lauf von nur 150 Jahren gewaltig eschrumpft, und von den Gletschern, die ihn einst bedeckten, sind nur noch kümmerliche Reste zu sehen.

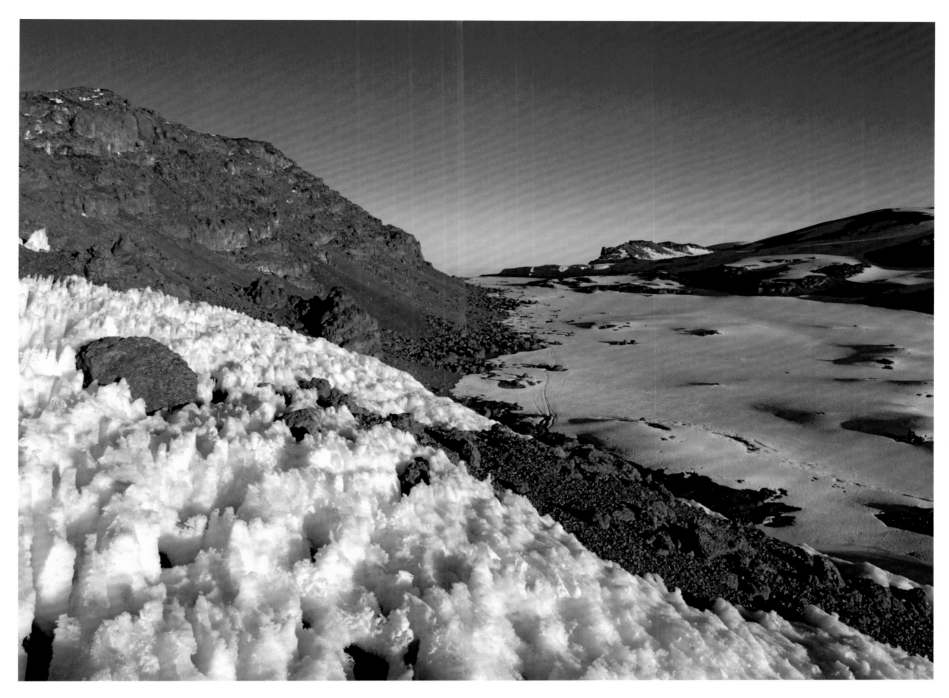

Uhuru Peak, Kibo, Mount Kilimanjaro, Tanzania

Kilimanjaro

La existencia de una montaña cubierta de nieve en el medio de África pareció un rumor durante mucho tiempo a los no africanos. Los primeros informes serios se realizaron a mediados del siglo XIX. 40 años después, los europeos escalaron la cumbre por primera vez. Los gobernantes coloniales alemanes le dieron el nombre de Kaiser-Wilhelm-Spitze. Solo después del final de la época colonial fue el pico más alto rebautizado como Uhuru (que en swahili significa «libertad»). Las masas de nieve descritas por los antiguos viajeros se han reducido mucho en el transcurso de tan solo 150 años, y de los glaciares que una vez la cubrieron, solo se pueden ver pobres restos.

Kilimanjaro

Para os não-africanos a existência de uma montanha coberta de neve no meio da África, há muito tempo não passava de um boato. Os primeiros relatos sérios foram feitos em meados do século XIX. 40 anos depois, os europeus escalaram o cume pela primeira vez. Os governantes coloniais alemães deram-lhe o nome de Kaiser-Wilhelm-Spitze, só depois do fim dos tempos coloniais é que o pico mais alto foi renomeado para Uhuru (em Swahili que dizer "liberdade"). As massas de neve descritas pelos antigos viajantes diminuíram enormemente ao longo de apenas 150 anos, e podem ser vistos apenas alguns remanescentes das geleiras que uma vez a cobriam.

Kilimanjaro

De aanwezigheid van een besneeuwde berg in het midden van Afrika was voor niet-Afrikanen al lang een gerucht. De eerste serieuze rapporten werden gemaakt in het midden van de 19e eeuw. 40 jaar later beklommen de Europeanen voor het eerst de top. Duitse koloniale heersers gaven het de naam Kaiser-Wilhelm-Spitze, pas na het einde van de koloniale tijd werd de hoogste piek omgedoopt tot Uhuru (Swahili voor „vrijheid"). De sneeuwmassa's die door voormalige reizigers zijn beschreven, zijn in de loop van slechts 150 jaar enorm gekrompen, en van de gletsjers die het ooit bedekten, zijn alleen nog maar resten te zien.

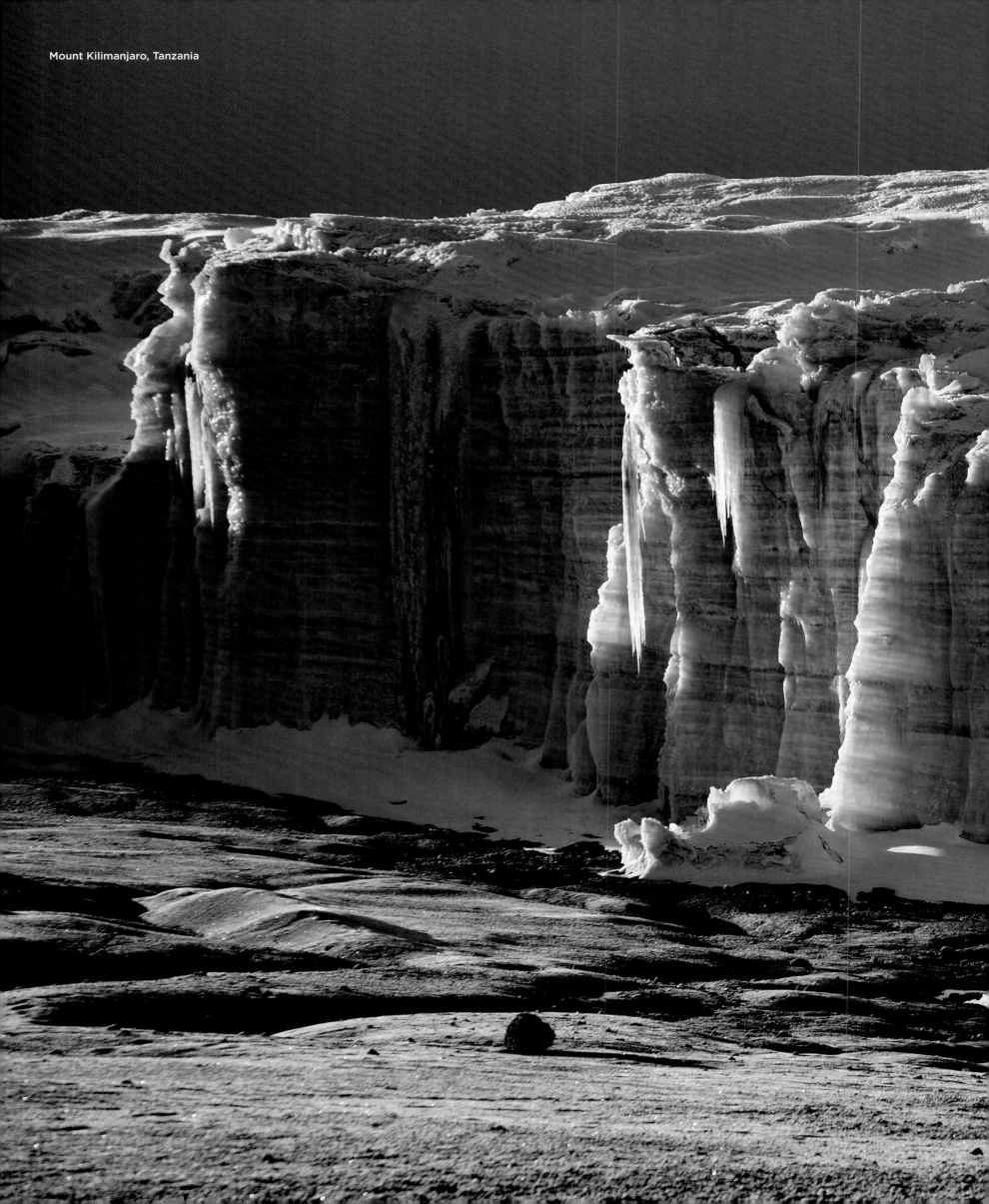

Mount Kilimanjaro, Tanzania

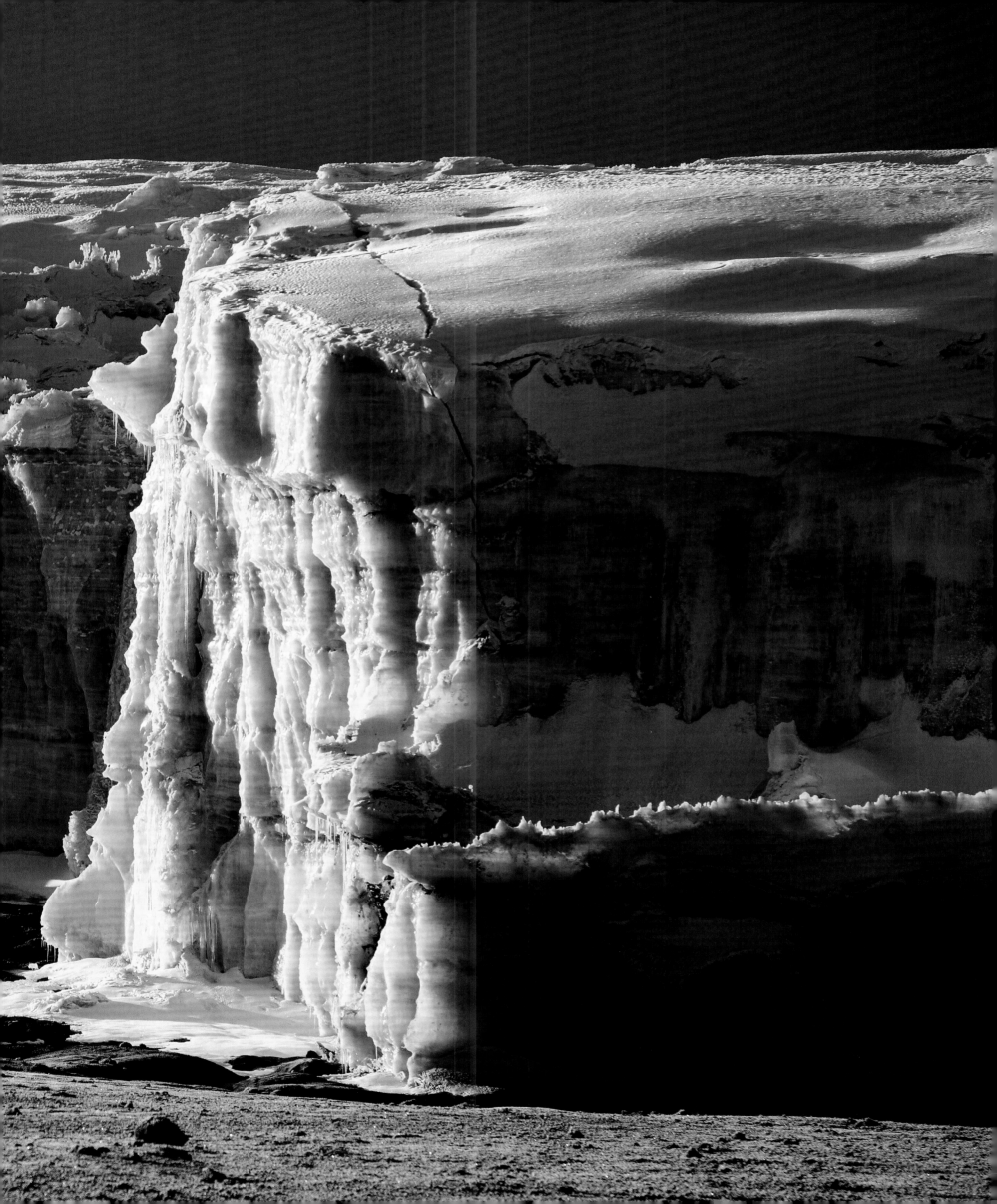

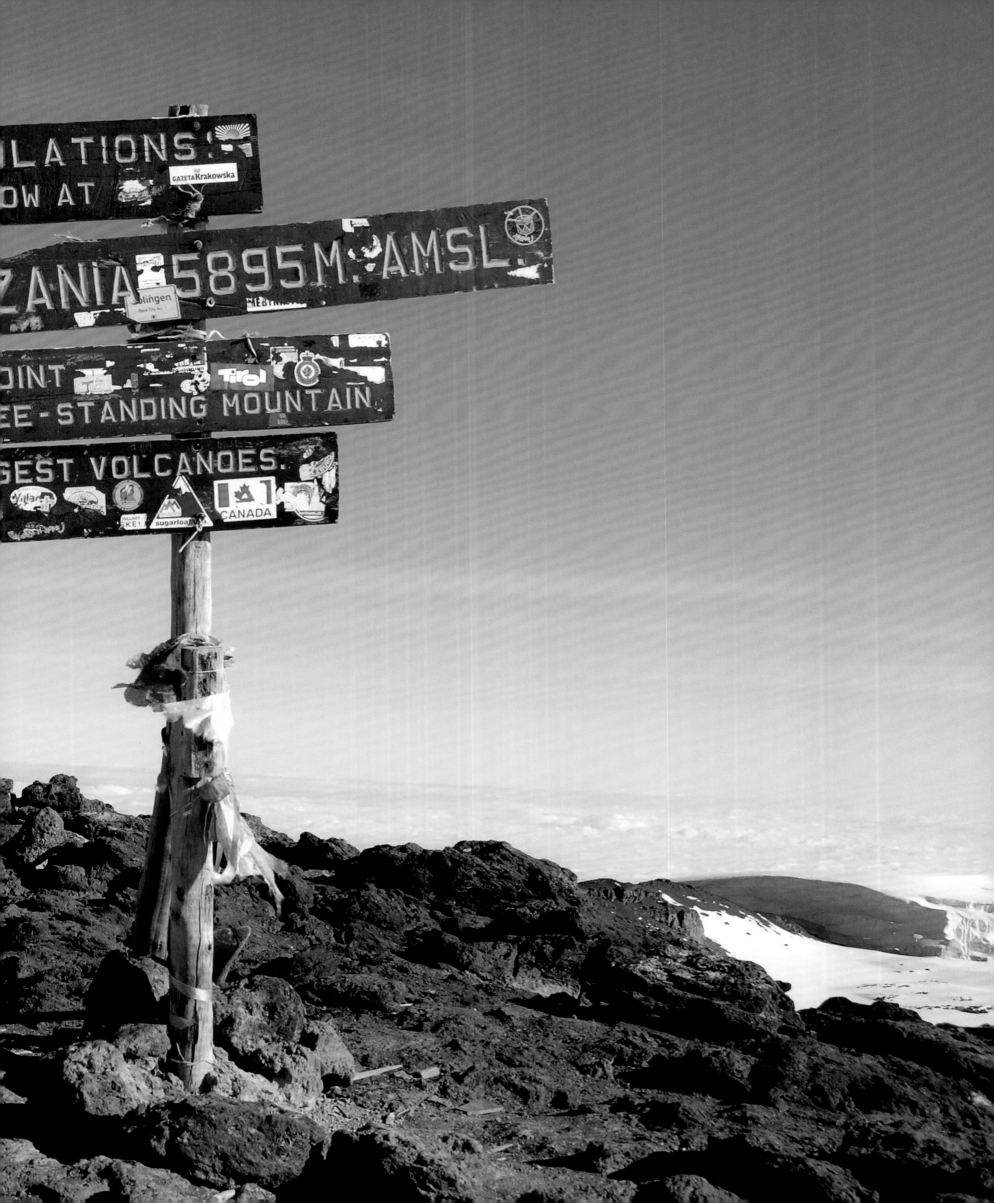

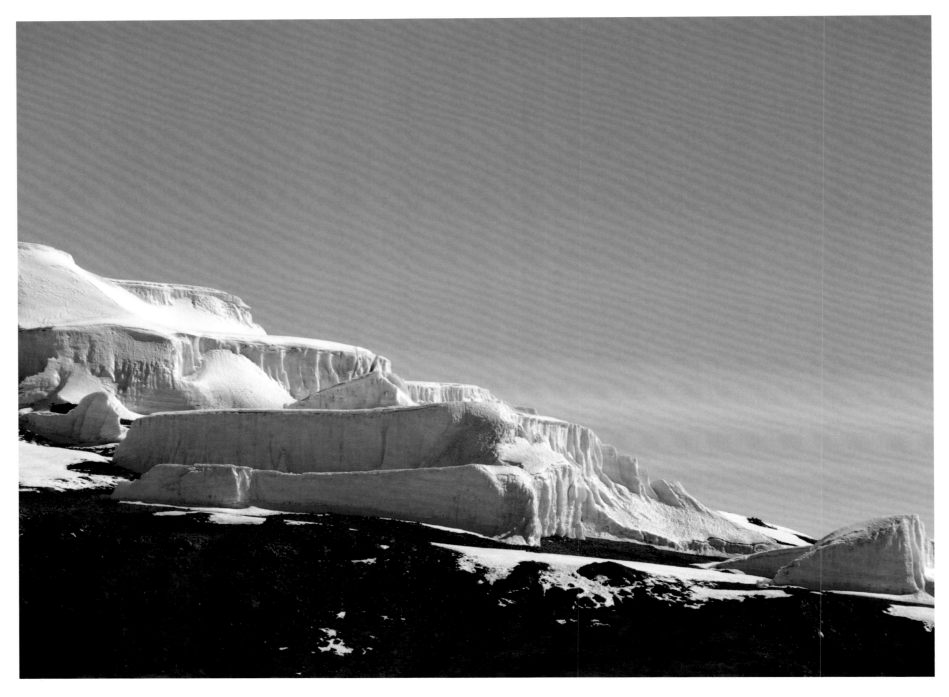

Mount Kilimanjaro, Tanzania

The Ice Disappears

The rise in global temperatures plays a role in the melting of the glaciers on the Kilimanjaro Massif, but has also had a part to play in the drier climate of recent decades, which has caused less precipitation. The remains of glaciers such as the stepped glacier at the crater edge of Uhuru or the Furtwängler glacier are in constant retreat, and in a few decades Kilimanjaro will be ice-free. However, the temperatures at the summit are still below freezing, and so the tropical vegetation at the foot of the mountain at the summit is transformed into a barren, dry high mountain landscape.

La glace disparaît

La hausse mondiale des températures mais aussi la sécheresse du climat au cours des dernières décennies et en conséquence, la baisse des précipitations, jouent un rôle dans la fonte des glaciers du massif du Kilimandjaro. Ainsi, les restes des glaciers tels que la cascade de glace en bordure du cratère de l'Uhuru ou le glacier Furtwängler sont en recul constant si bien que dans quelques décennies, le Kilimandjaro sera complètement dépourvu de glace. Les températures au sommet restent toutefois encore en dessous de 0° C et la végétation tropicale trouvée au pied de la montagne laisse place à un paysage rude et sec de haute montagne lorsque l'on s'approche du point culminant.

Das Eis verschwindet

Der globale Temperaturanstieg spielt eine Rolle beim Abschmelzen der Gletscher am Kilimandscharo-Massiv, aber auch das trockenere Klima der letzten Jahrzehnte, das geringere Niederschläge bedingt. So sind die Reste der Gletscher wie etwa des Stufengletschers am Kraterrand des Uhuru oder des Furtwängler-Gletschers im stetigen Rückzug begriffen, und in wenigen Jahrzehnten wird der Kilimandscharo eisfrei sein. Noch liegen die Temperaturen am Gipfel aber unter dem Gefrierpunkt, und so verwandelt sich die tropische Vegetation am Fuß des Berges am Gipfel in eine karge, trockene Hochgebirgslandschaft.

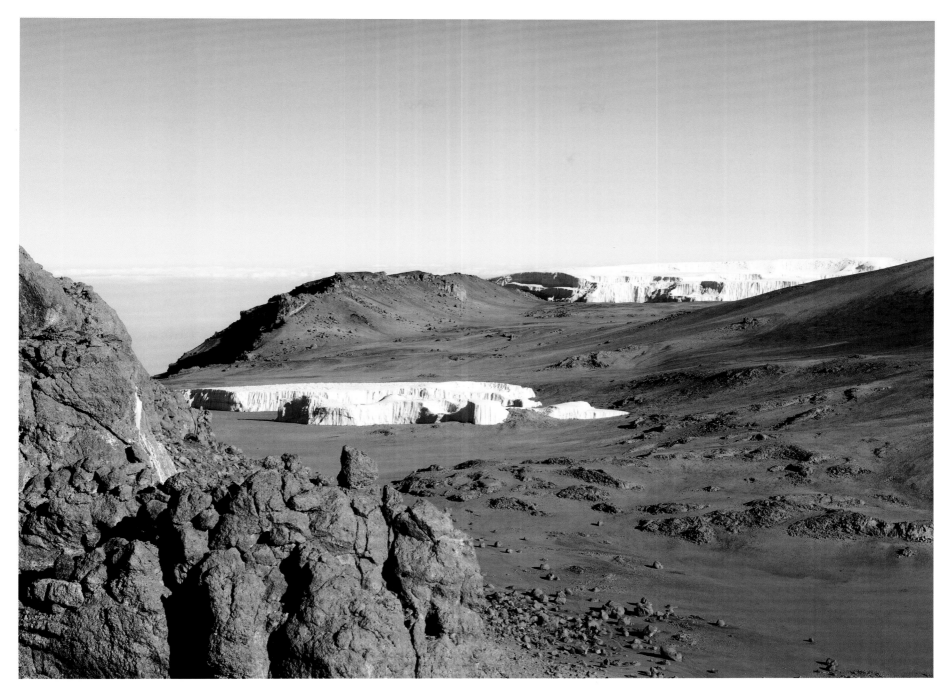

Kibo, Mount Kilimanjaro, Tanzania

El hielo desaparece

El aumento de la temperatura global juega un papel importante en el derretimiento de los glaciares del macizo del Kilimanjaro, pero también en el clima más seco de las últimas décadas, que ha causado menos precipitaciones. Los restos de los glaciares, como el glaciar escalonado en el borde del cráter de Uhuru o el glaciar Furtwängler, están en constante retroceso, y en unas pocas décadas el Kilimanjaro estará libre de hielo. Sin embargo, las temperaturas en la cima todavía están bajo cero, por lo que la vegetación tropical al pie de la montaña en la cima se transforma en un paisaje árido y seco de alta montaña.

O gelo desaparece

O aumento global da temperatura desempenha um papel importante no derretimento das geleiras no maciço do Kilimanjaro, mas também no clima mais seco das últimas décadas, o que tem causado menos precipitação. Os remanescentes dos glaciares, como o vasto glaciar na borda da cratera de Uhuru ou o glaciar Furtwängler, estão em constante recuo, e em poucas décadas não será possível encontrar gelo no Kilimanjaro. No entanto, as temperaturas no cume ainda estão abaixo de zero, e assim a vegetação tropical no sopé da montanha no cume se transforma em uma paisagem seca e árida de alta montanha.

Het ijs verdwijnt

De wereldwijde temperatuurstijging speelt een rol bij het smelten van de gletsjers in het Kilimanjaro-massief, maar ook bij het drogere klimaat van de afgelopen decennia, dat minder neerslag heeft veroorzaakt. De overblijfselen van de gletsjers, zoals de getrapte gletsjer aan de kraterrand van Uhuru of de Furtwängler gletsjer, trekken zich voortdurend terug en over een paar decennia zal de Kilimanjaro ijsvrij zijn. De temperaturen op de top zijn echter nog steeds onder het vriespunt, waardoor de tropische vegetatie aan de voet van de berg aan de top verandert in een kaal en droog hooggebergte.

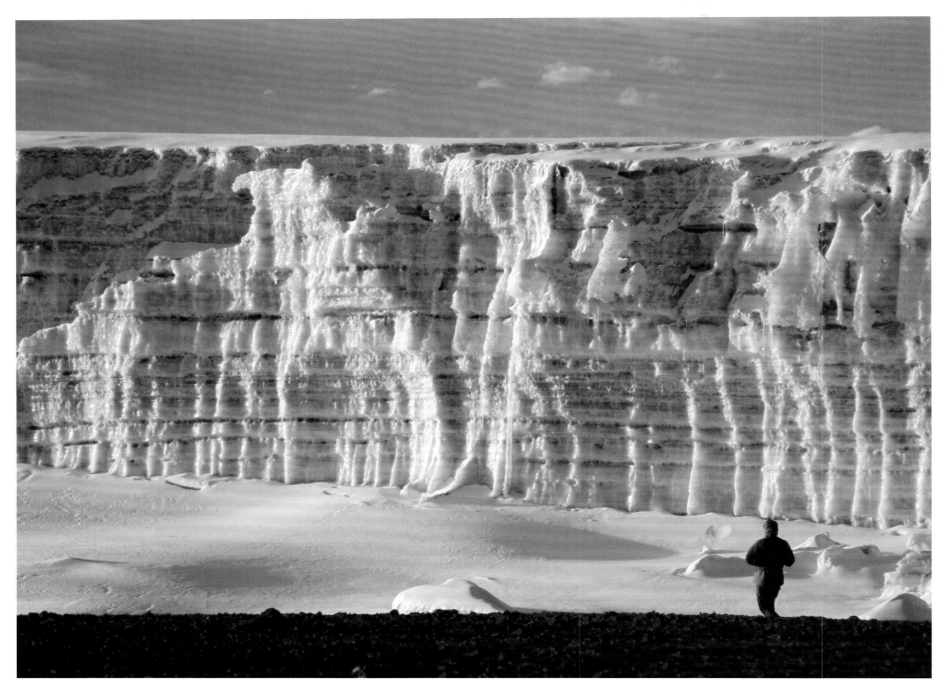

Mount Kilimanjaro, Tanzania

Summit Storm

Kilimanjaro attracts winter sports enthusiasts and tourists who can reach Uhuru Peak on five different routes. Perhaps it is due to the special exoticism of an ice-covered peak on the equator that more and more people attempt the climb; more than 20,000 people do so every year. Although Kilimanjaro is considered to be relatively easy to climb, many inexperienced mountaineers underestimate the dangers of altitude sickness. Slow acclimatization is essential, and every year tourists die on the mountain.

À l'assaut du sommet

Le Kilimandjaro attire les amateurs de sports d'hiver et les touristes, qui ont la possibilité d'atteindre le pic Uhuru par 5 chemins différents. Peut-être est-ce le côté exotique d'un sommet enneigé au niveau de l'équateur qui pousse de plus en plus de monde, plus de 20 000 personnes par an, à tenter l'ascension. Le Kilimandjaro est certes réputé pour être facile à escalader, mais nombreux sont les alpinistes inexpérimentés qui sous-estiment les dangers du mal aigu des montagnes. Une acclimatation lente est indispensable. C'est pourquoi, chaque année, des touristes perdent la vie sur ce sommet par manque de préparation.

Gipfelsturm

Der Kilimandscharo lockt Wintersportler und Touristen an, die auf fünf verschiedenen Routen den Uhuru Peak erreichen können. Vielleicht ist es der besonderen Exotik eines eisbedeckten Gipfels am Äquator geschuldet, dass immer mehr Menschen sich an einer Besteigung versuchen; mehr als 20 000 sind es im Jahr. Zwar gilt der Kilimandscharo als relativ einfach zu besteigen, doch viele im Höhenbergsteigen Unerfahrene unterschätzen die Gefahren der Höhenkrankheit. Eine langsame Akklimatisierung ist zwingend erforderlich. Und so kommt es, dass jährlich immer wieder Touristen am Berg sterben.

Mount Kilimanjaro, Tanzania

Asalto a cumbre

El Kilimanjaro atrae a los entusiastas de los deportes de invierno y a los turistas que pueden llegar al pico Uhuru por cinco rutas diferentes. Quizás sea debido al especial exotismo de un pico cubierto de hielo en el ecuador que cada vez más personas intentan escalar; más de 20 000 lo hacen cada año. Aunque se considera que el Kilimanjaro es relativamente fácil de escalar, muchos montañeros sin experiencia subestiman los peligros del mal de altura. Una aclimatación lenta es esencial. Y por este motivo, todos los años mueren turistas en la montaña.

Expedição ao cume da montanha

O Kilimanjaro atrai entusiastas dos esportes de inverno e turistas que podem chegar ao pico Uhuru em cinco rotas diferentes. Talvez seja devido ao exotismo especial de um pico coberto de gelo na linha do Equador que mais e mais pessoas tentam escalá-lo; mais de 20.000 o fazem todos os anos. Embora o Kilimanjaro seja considerado relativamente fácil de escalar, muitos alpinistas inexperientes subestimam os perigos da doença da altitude elevada. A aclimatação lenta é essencial. E acontece que todos os anos turistas morrem na montanha.

Berg beklimmen

De Kilimanjaro trekt wintersportliefhebbers en toeristen aan die via vijf verschillende routes de Uhuru Peak kunnen bereiken. Misschien is het te wijten aan het bijzondere exotisme van een met ijs bedekte piek op de evenaar dat steeds meer mensen het proberen te beklimmen; meer dan 20.000 mensen proberen het elk jaar. Hoewel de Kilimanjaro als relatief gemakkelijk te beklimmen wordt beschouwd, onderschatten veel onervaren bergbeklimmers de gevaren van hoogteziekte. Een langzame acclimatisatie is essentieel. En zo gebeurt het dat elk jaar weer toeristen op de berg sterven.

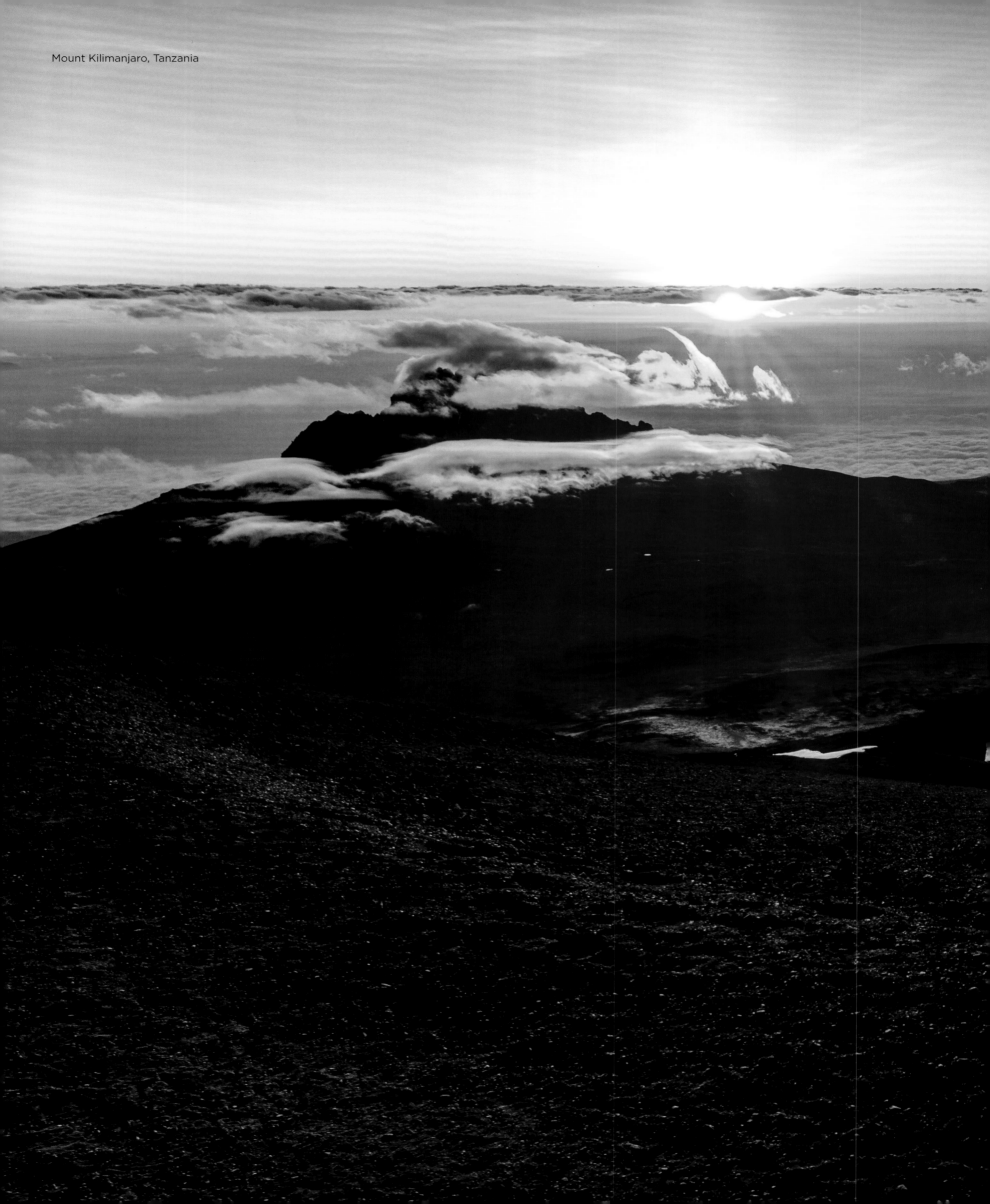

Mount Kilimanjaro, Tanzania

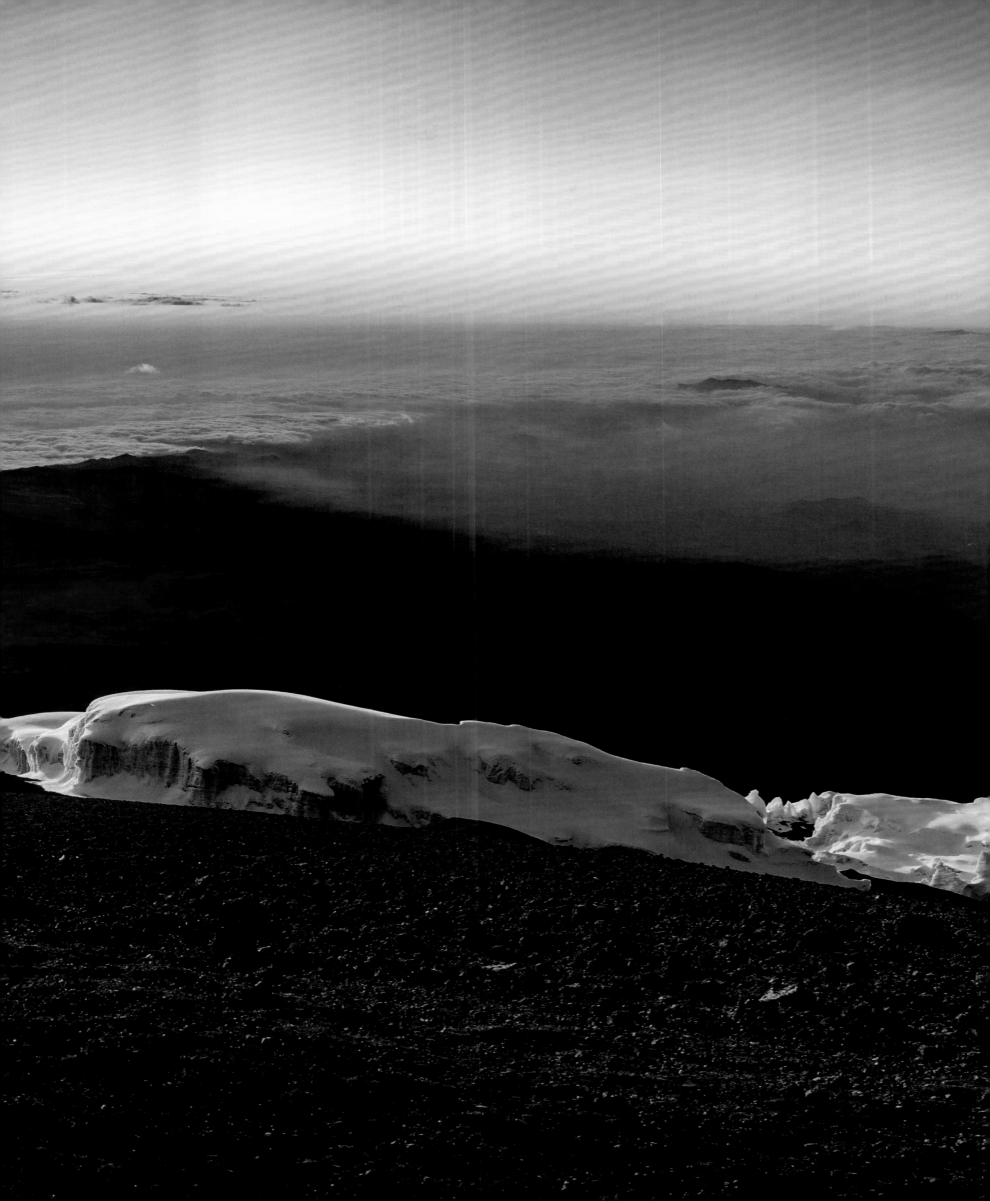

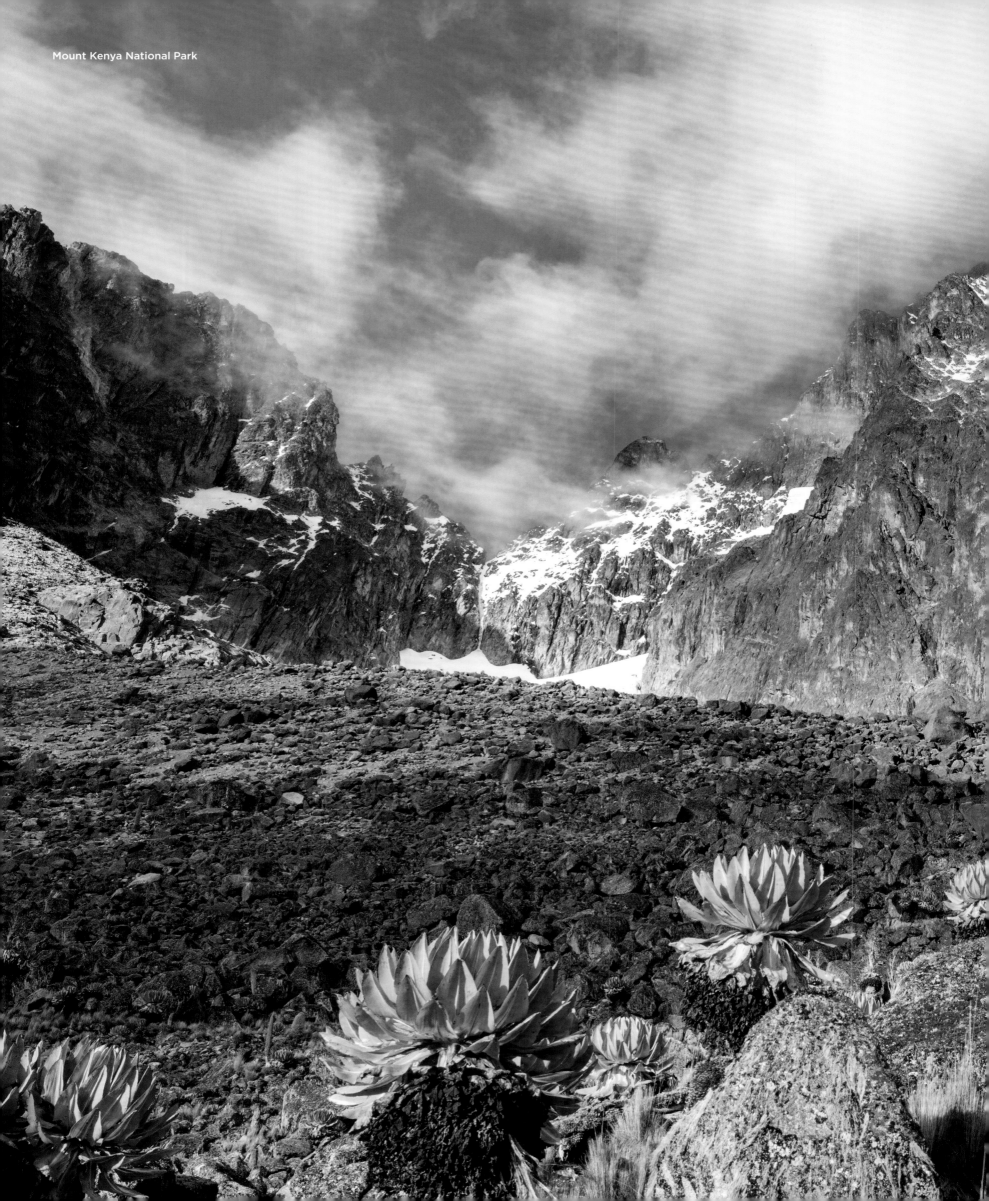

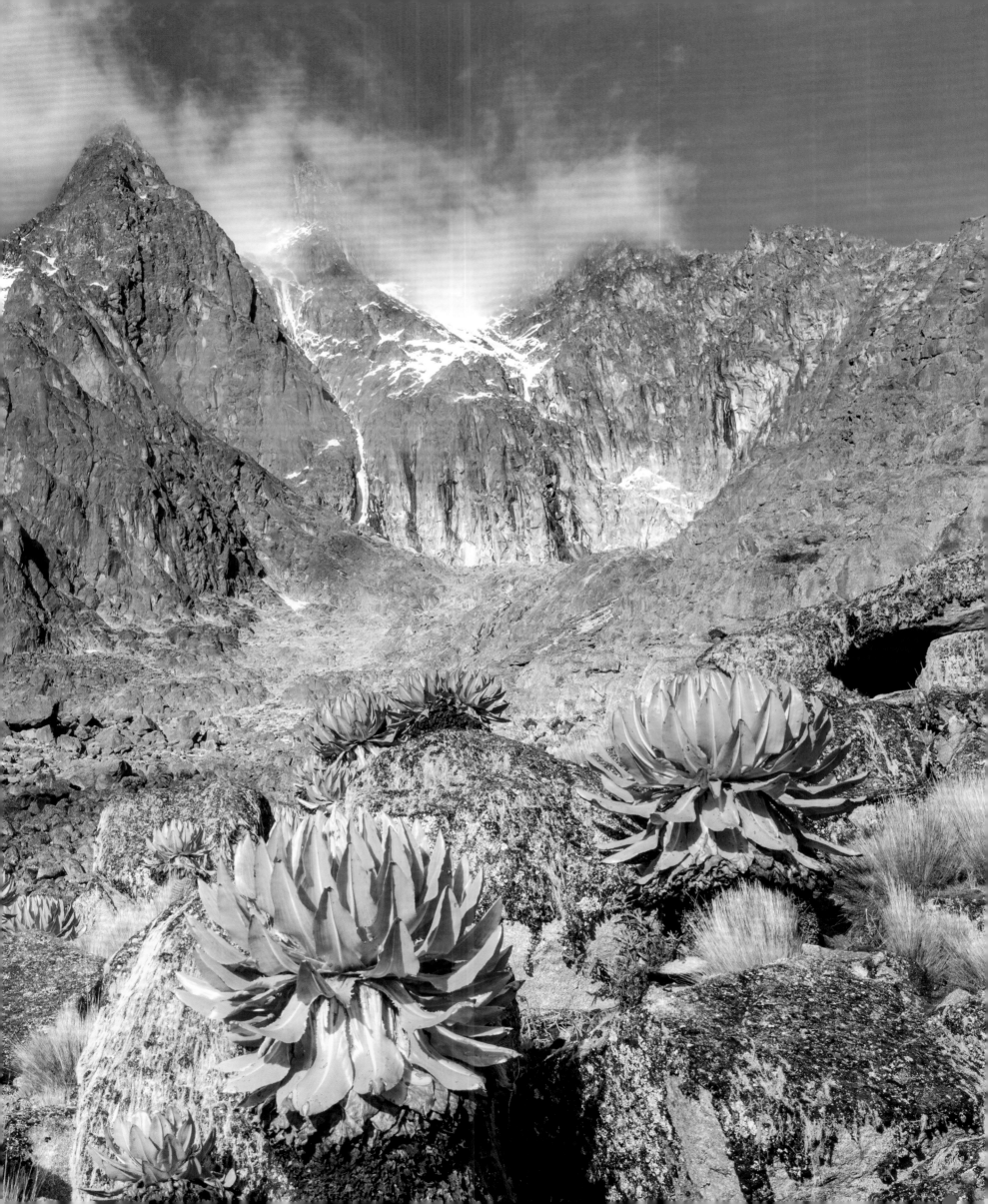

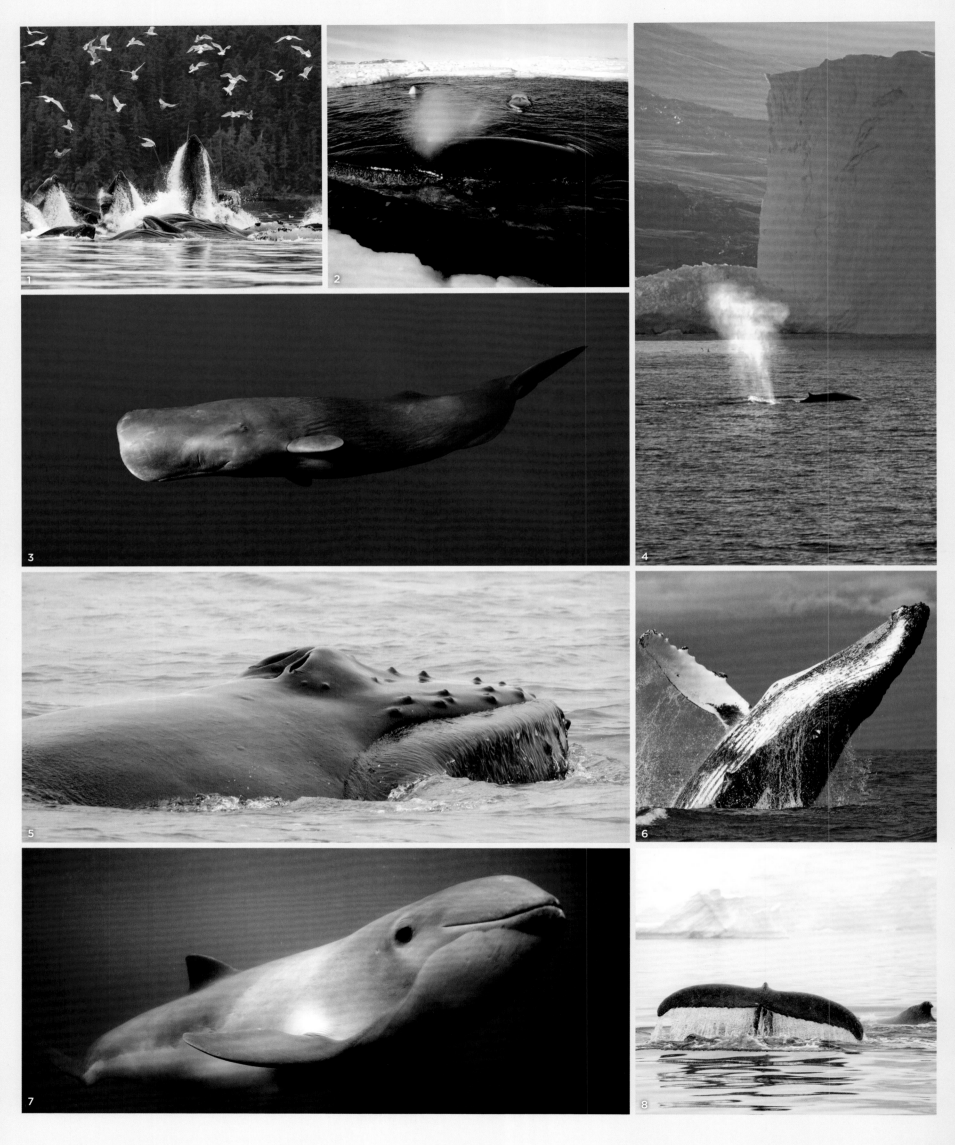

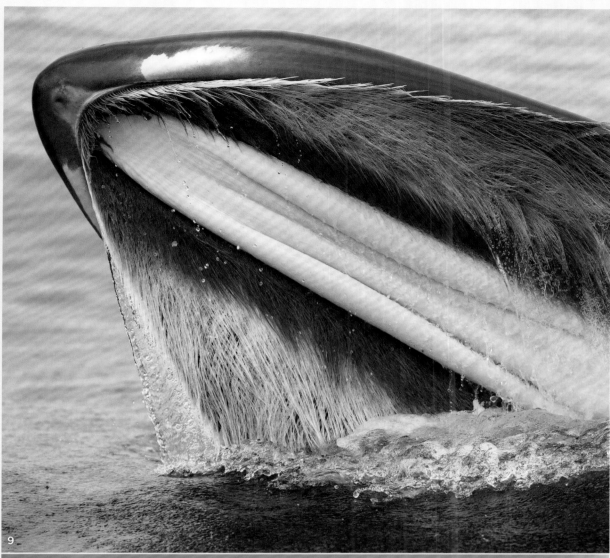

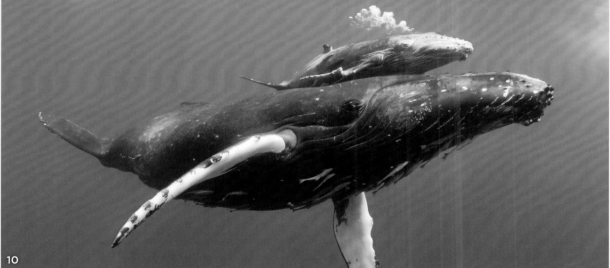

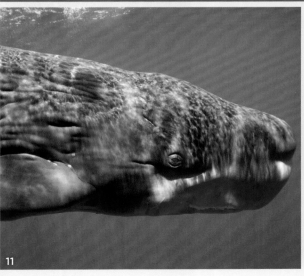

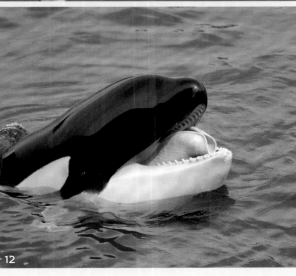

Whales

1, 5, 6, 8, 9, 10 Humpbacked whale, Baleine à bosse, Buckelwal, Ballena jorobada, Baleia-jubarte, Bultrugwalvis

2 Minke whale, Baleine de Minke, Zwergwal, Ballena enana, Baleia-anã, Dwergvinvis

3, 11 Sperm whale, Grand cachalot, Pottwal, Cachalote, Potvis

4 Fin whale, Rorqual commun, Finnwal, Ballena de aleta, Baleia-comum, Gewone vinvis

7 Porpoise, Marsouin, Schweinswal, Marsopa, Toninha, Bruinvis

12 Orca, Orque, Orka

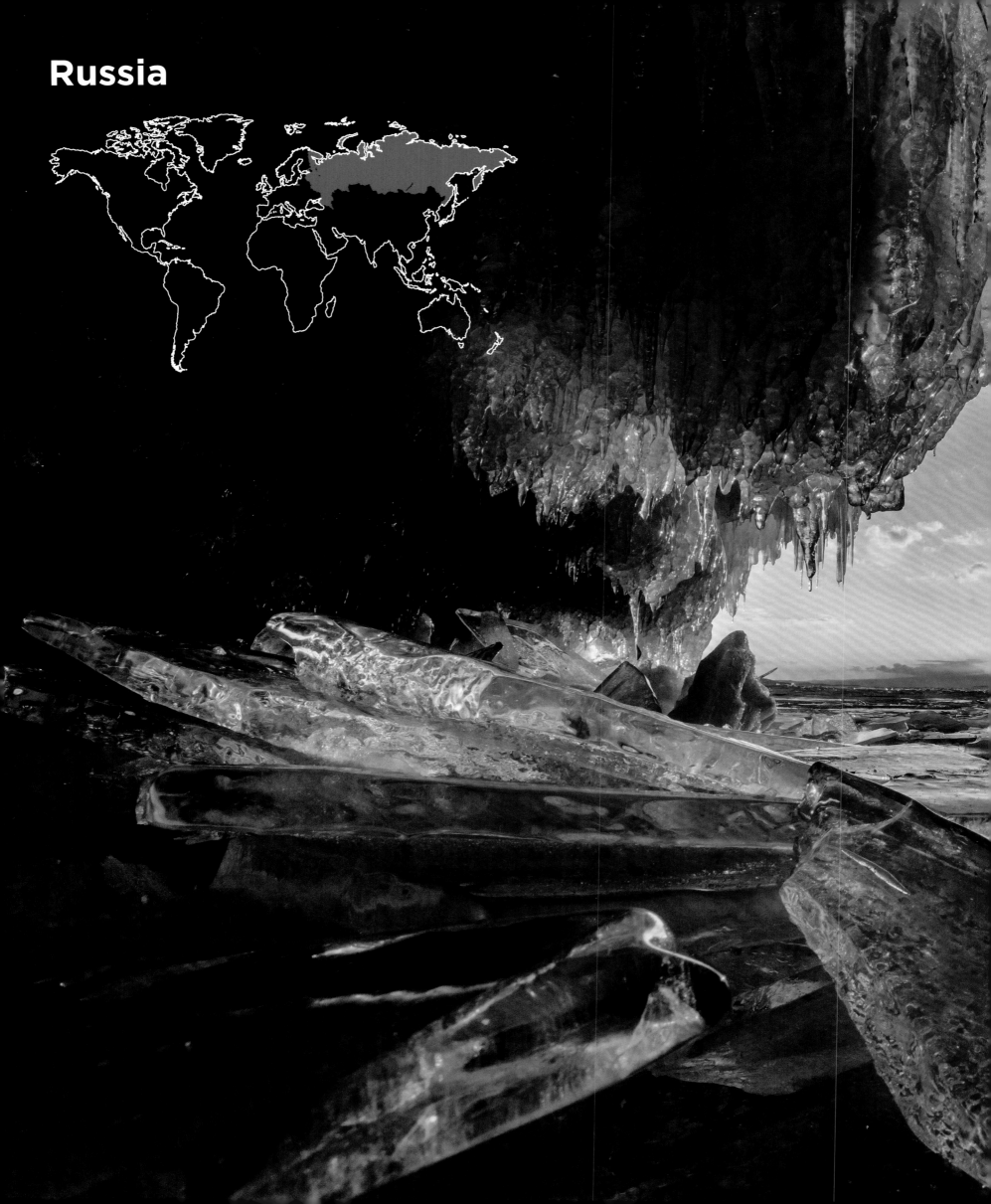

Russia

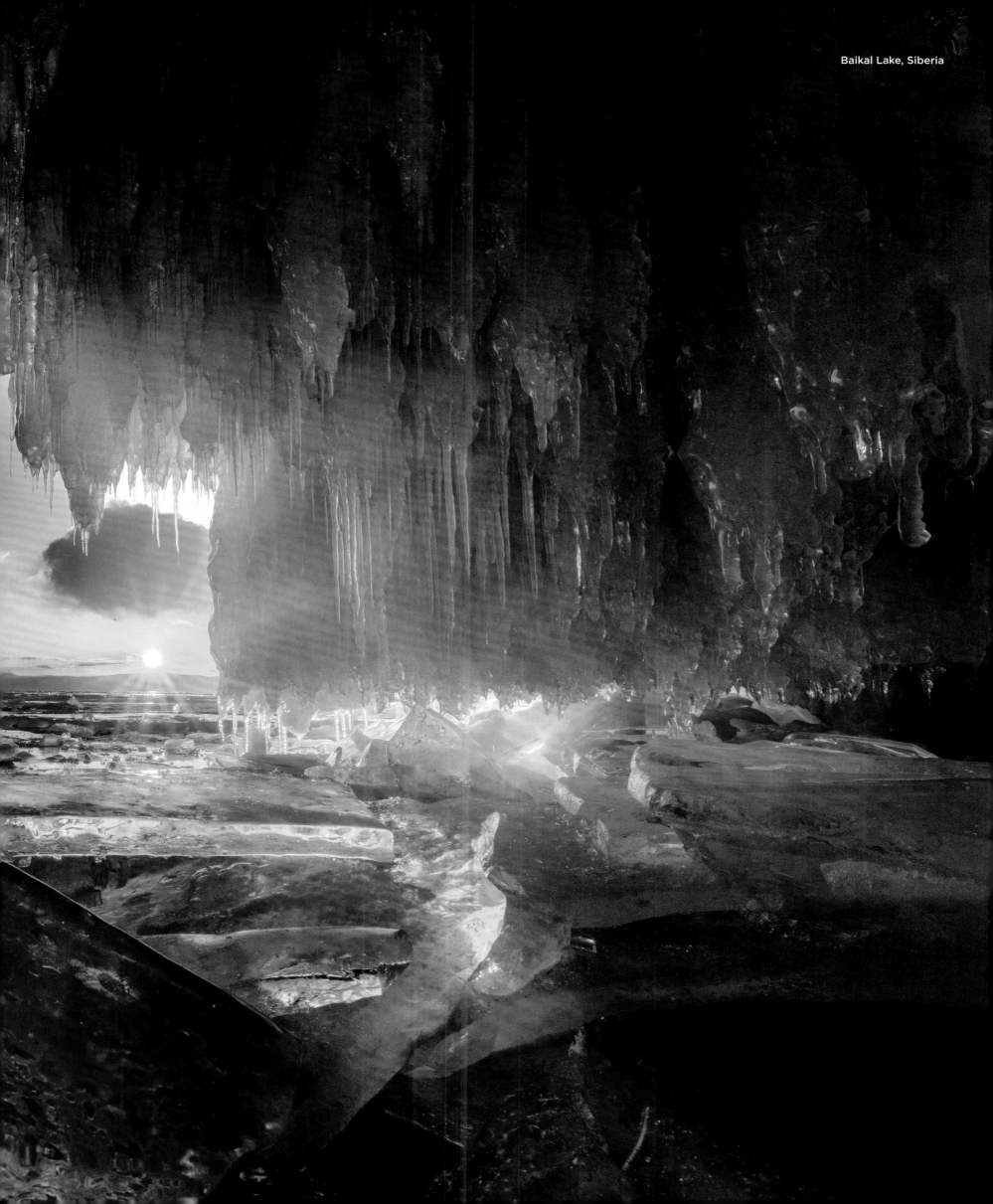
Baikal Lake, Siberia

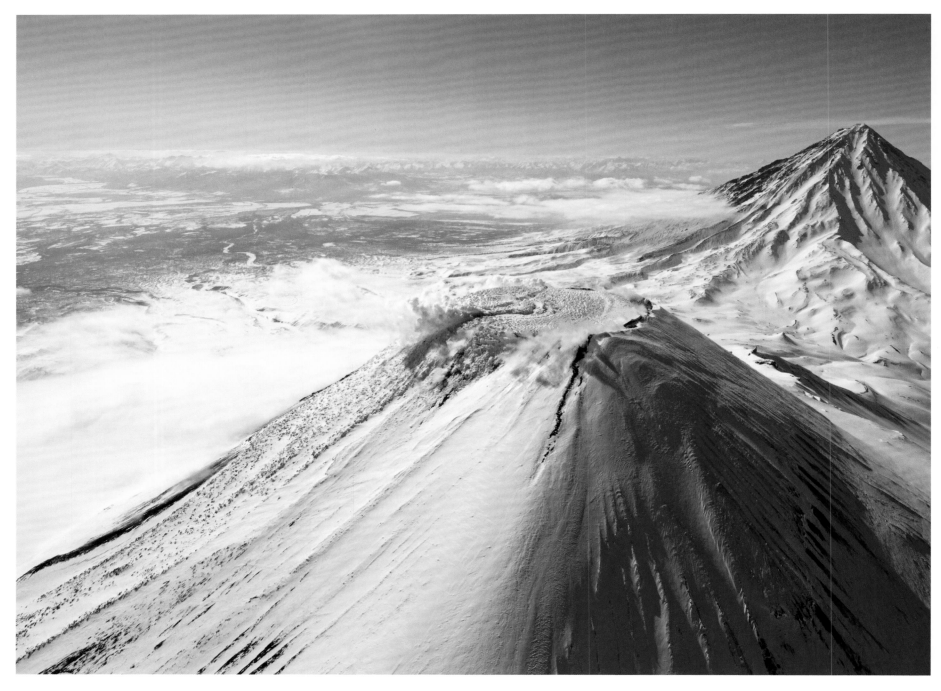

Avacha Volcano, Koryaksky Volcano, Kamchatka

Russia

The world's largest country in terms of surface area, stretching from the Atlantic to the Pacific, is home to some 145 million people, around three quarters of whom live west of the Urals. Almost 80 percent are Russians and the remaining 20 percent are made up of 100 other peoples, almost half of whom are indigenous. In no other country are the differences in temperature greater. In many areas there is a continental climate with hot summers and cold winters. The further east you go, the colder the winters become. In Siberia, temperatures have been measured as low as minus 70 °C (-94 °F). In the arctic regions treeless tundra prevails.

Russie

Le plus grand pays de la terre en termes de superficie, s'étendant de l'Atlantique au Pacifique, est habité par environ 145 millions de personnes, dont les trois quarts vivent à l'ouest de l'Oural. Presque 80 % d'entre elles sont russes, les 20 % restant appartiennent à une centaine d'autres peuples, dont près de la moitié sont des populations autochtones. Dans aucun autre pays les différences de températures ne sont aussi importantes. Un climat continental avec des étés chauds et des hivers froids prédomine sur de grandes parties du territoire. Plus l'on s'éloigne à l'est, plus les hivers sont froids. En Sibérie, les températures peuvent descendre jusqu'à -70° C. Les régions arctiques du pays présentent des paysages de toundra non arborés.

Russland

Im flächenmäßig größten Land der Erde, das sich vom Atlantik bis zum Pazifik erstreckt, leben rund 145 Millionen Menschen, rund drei Viertel davon westlich des Urals. Fast 80 Prozent sind Russen, die restlichen 20 Prozent verteilen sich auf 100 weitere Völker, wovon knapp die Hälfte zu den Indigenen gehören. In keinem anderen Land sind die Temperaturunterschiede größer: In großen Teilen herrscht Kontinentalklima mit heißen Sommern und kalten Wintern. Je weiter man nach Osten kommt, desto kälter werden die Winter, in Sibirien wurden schon bis zu minus 70 °C gemessen. In den arktischen Regionen herrscht baumlose Tundra vor.

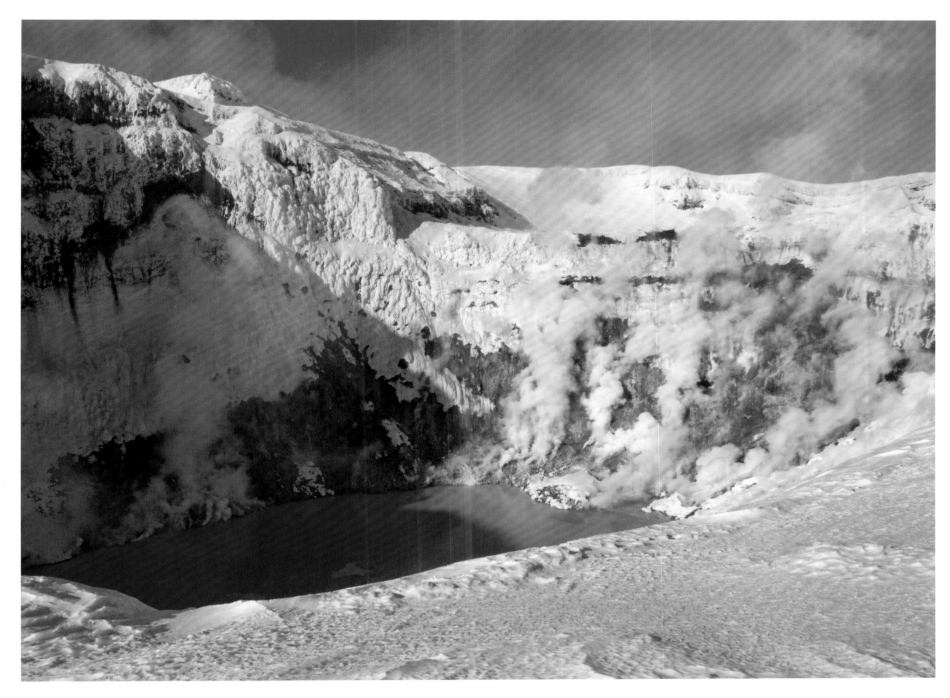

Crater lake, Gorelaya Volcano, Kamchatka

Rusia

Rusia es el país más grande del mundo en términos de superficie, que se extiende desde el Atlántico hasta el Pacífico y cuenta con unos 145 millones de habitantes, de los cuales unas tres cuartas partes viven al oeste de los Urales. Casi el 80 por ciento son rusos, y el 20 por ciento restante se distribuye entre otros 100 pueblos, casi la mitad de los cuales son indígenas. En ningún otro país las diferencias de temperatura son mayores: en gran parte es el clima continental con veranos calurosos e inviernos fríos. Cuanto más al este se va, más fríos se vuelven los inviernos; en Siberia, se han llegado a medir temperaturas de hasta -70 °C. En las regiones árticas prevalece la tundra sin árboles.

Rússia

O maior país do mundo em termos de superfície, que se estende do Atlântico ao Pacífico, abriga cerca de 145 milhões de pessoas, cerca de três quartos das quais vivem a oeste dos Urais. Quase 80 por cento são russos, os 20 por cento restantes estão distribuídos entre 100 outros povos, dos quais quase metade é indígena. Em nenhum outro país as diferenças de temperatura são tão grandes: em grande parte predomina o clima continental com verões quentes e invernos frios. Quanto mais a leste se for, mais frios se tornam os invernos; na Sibéria, foram medidas temperaturas de até menos 70 °C. Nas regiões árticas prevalece a tundra sem árvores.

Rusland

Het geografisch grootste land ter wereld, wat zich uitstrekt van de Atlantische Oceaan tot de Stille Oceaan, is de thuisbasis van ongeveer 145 miljoen mensen, van wie ongeveer driekwart ten westen van de Oeral woont. Bijna 80 procent zijn Russen, de overige 20 procent is verdeeld over 100 andere volkeren, waarvan bijna de helft inheems is. In geen enkel ander land zijn de temperatuurverschillen groter: in grote delen is het continentale klimaat met warme zomers en koude winters. Hoe verder je naar het oosten gaat, hoe kouder de winters worden; in Siberië zijn de temperaturen tot min 70 °C gemeten. In de arctische regio's heerst een boomloze toendra.

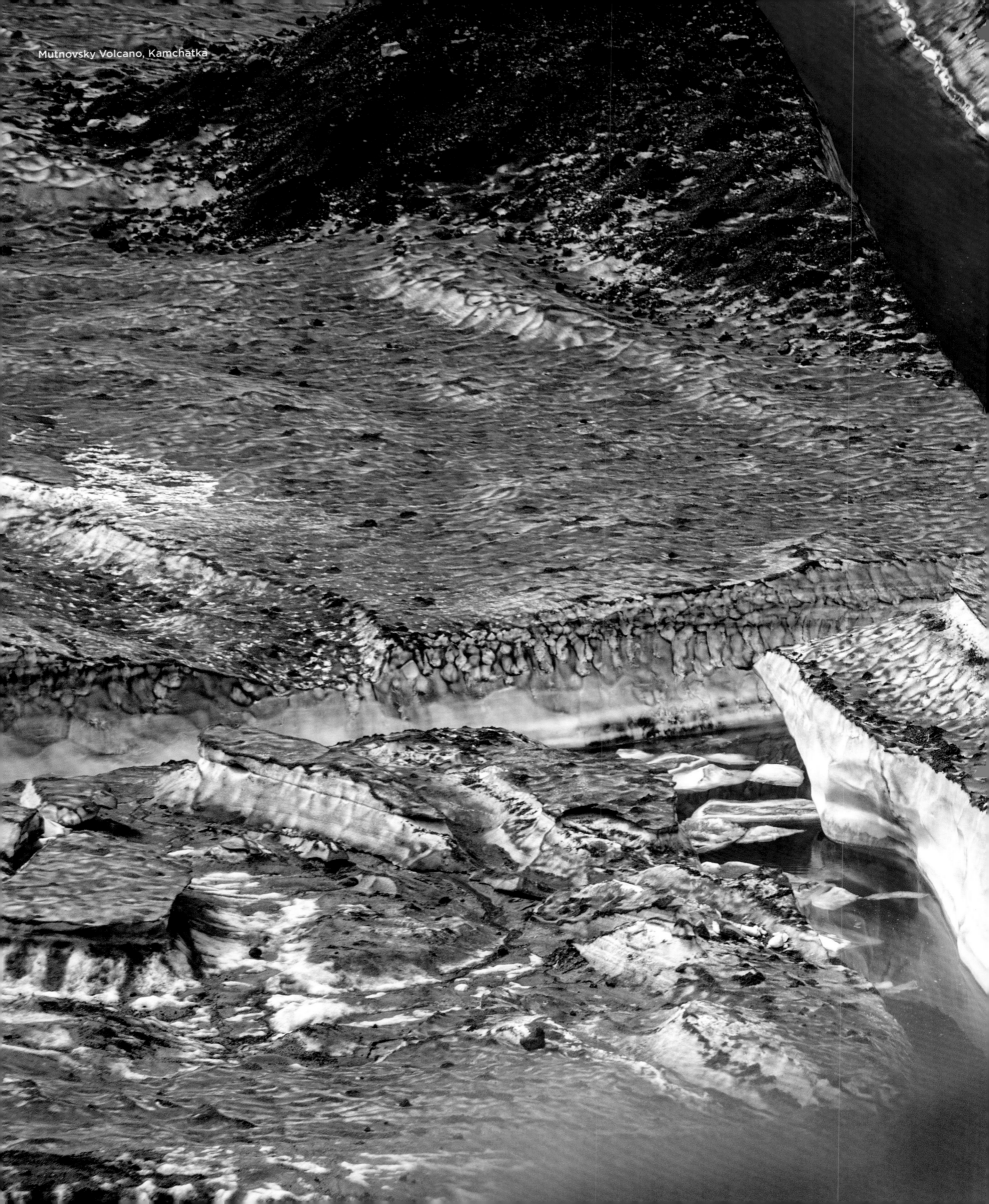

Mutnovsky Volcano, Kamchatka

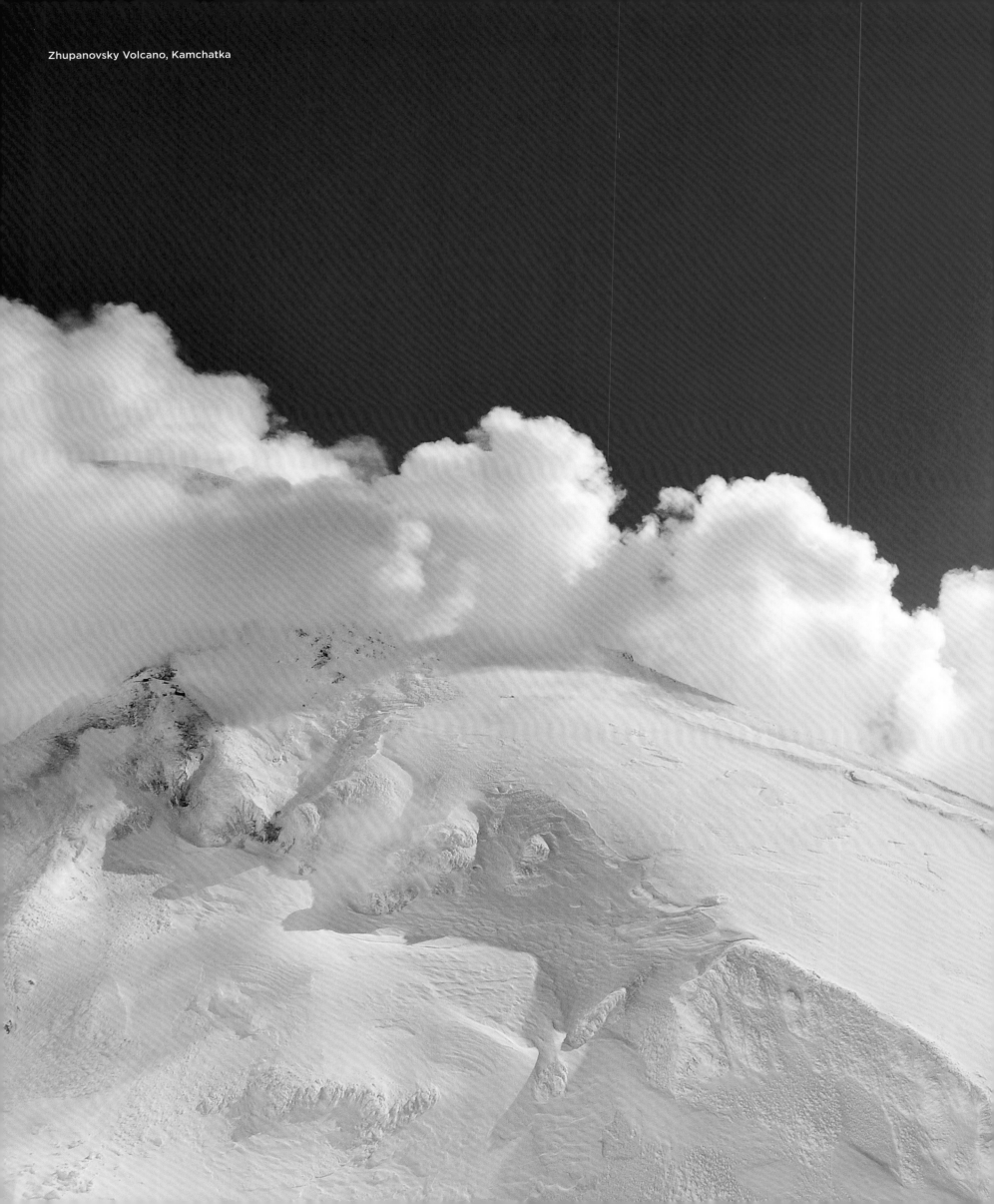

Zhupanovsky Volcano, Kamchatka

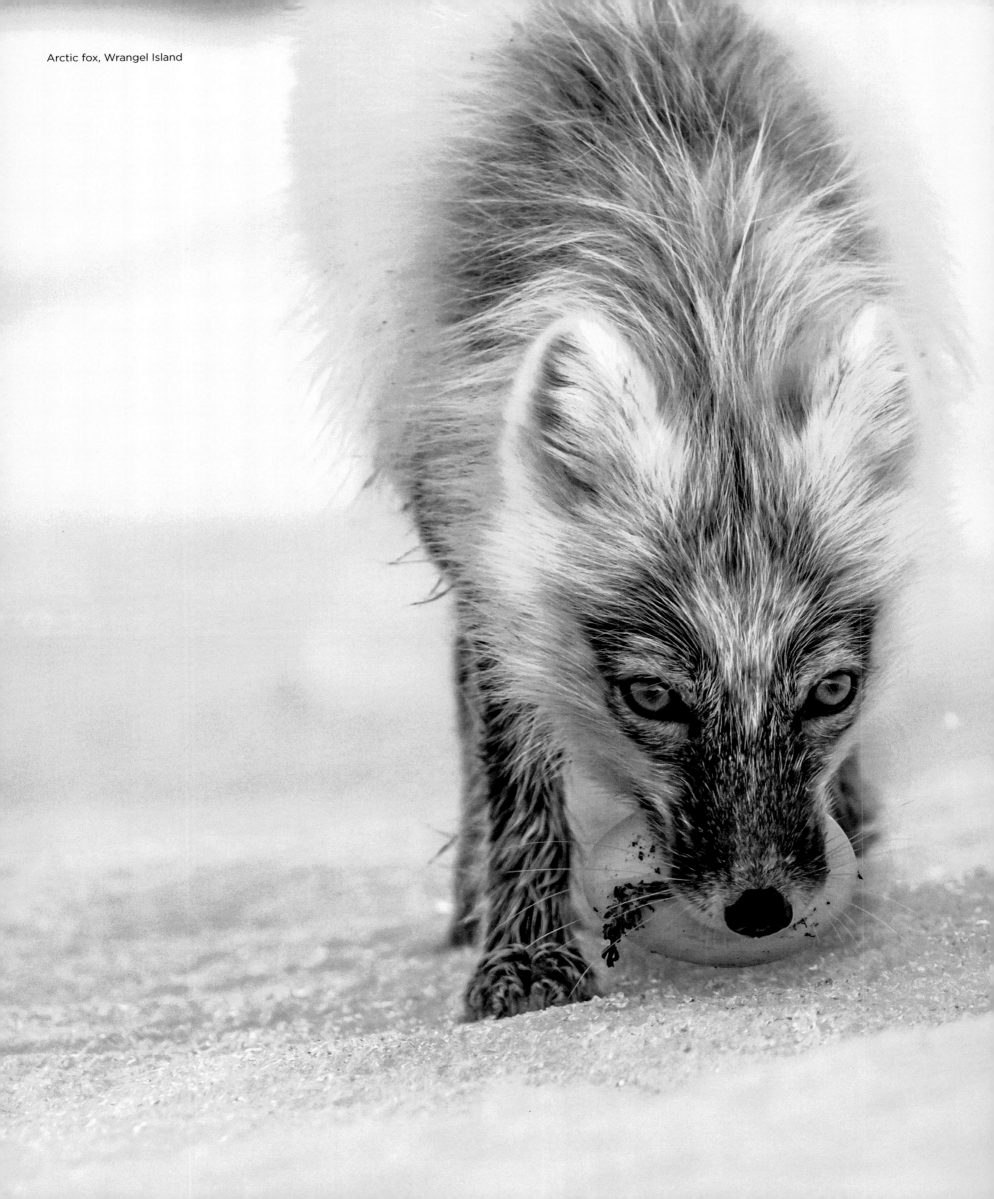

Arctic fox, Wrangel Island

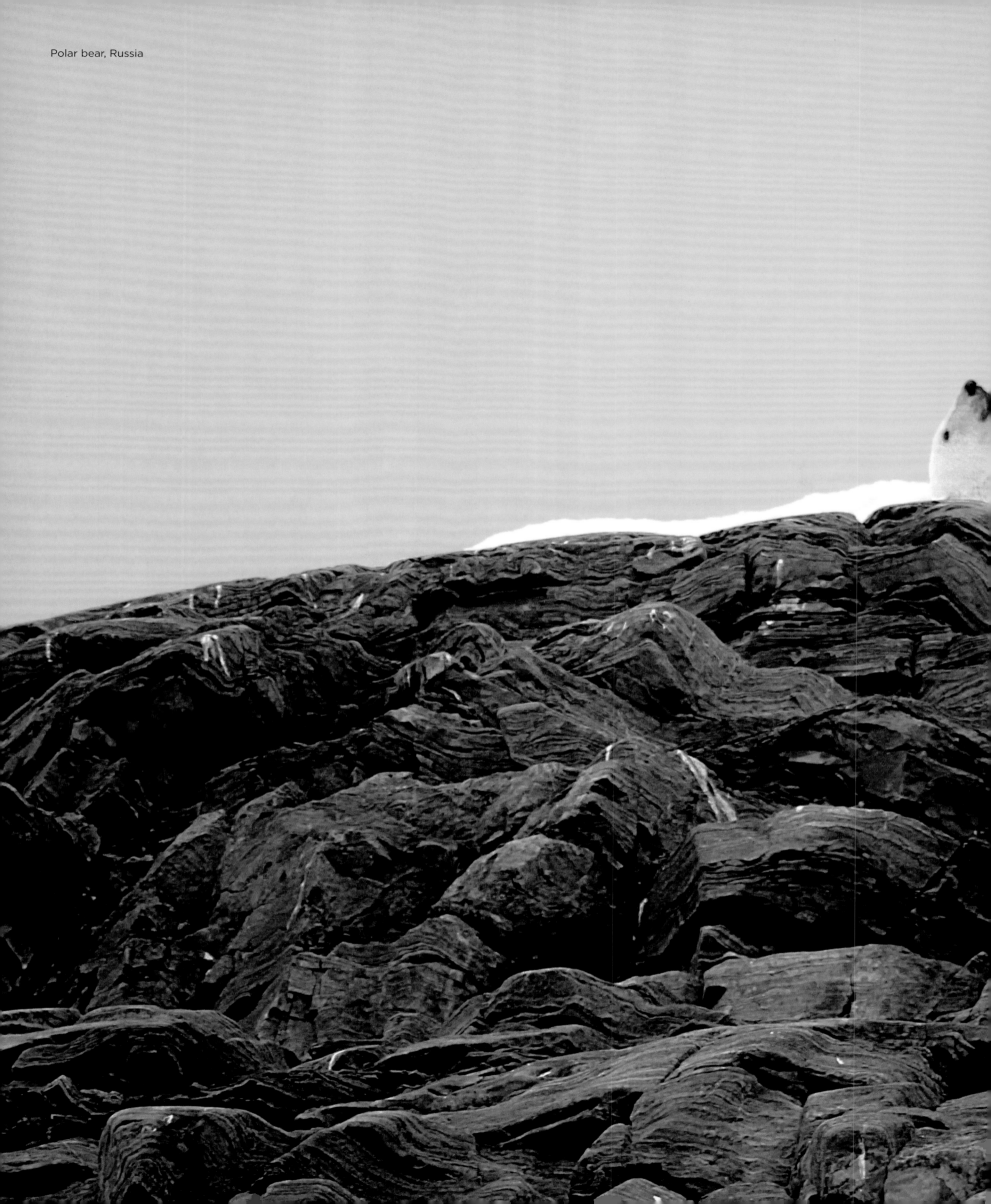
Polar bear, Russia

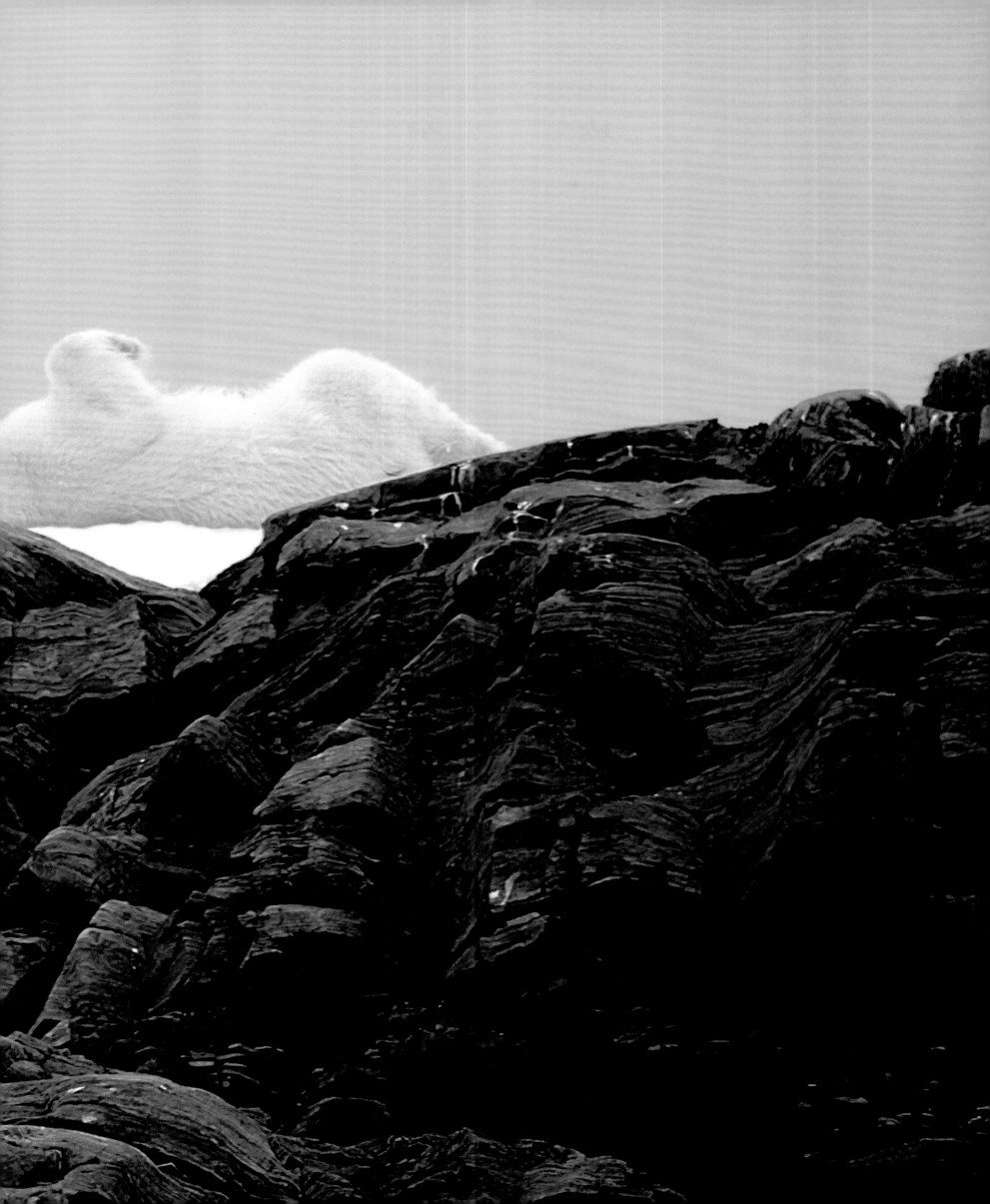

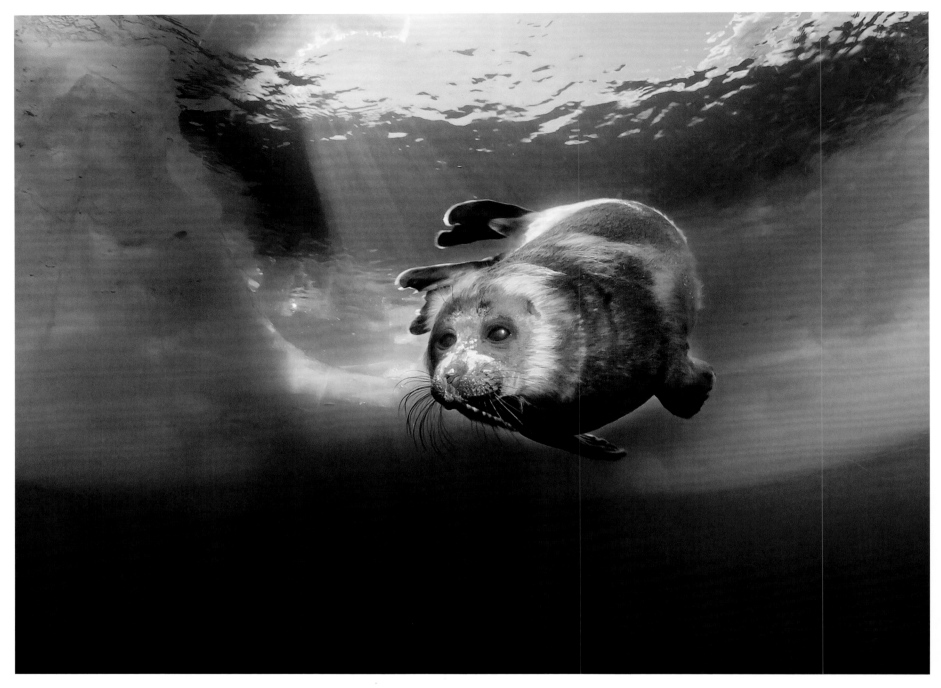

Baikal seal, Lake Baikal

Baikal Seals

Baikal seals are considered the symbol of Lake Baikal. They occur only in this lake and are the only seal species that lives exclusively in fresh water. With a length of 130 cm (51 inches), they are one of the small seal species. Their fur is grey-brown, and on the stomach often somewhat lighter. Their closest relatives are the ringed seals, from which they split off 400,000 to 500,000 years ago. Until today it is not clear how the Baikal seal became established in a lake so far from the sea. During mating season, they form colonies of up to 500; otherwise they live as a solitary life.

Phoques de Sibérie

Les phoques de Sibérie sont considérés comme étant le symbole du lac Baïkal. Ils ne se trouvent que dans ce dernier et sont la seule espèce de phoques à vivre uniquement en eau douce. Grands de 130 cm, ils font partie des petites espèces de phoques. Leur pelage est gris-brun et souvent plus clair sur le ventre. Leurs parents les plus proches sont les phoques annelés, dont ils se sont séparés il y a quatre cent mille à cinq cent mille ans. Aujourd'hui encore, la manière dont les phoques de Sibérie sont arrivés dans ce lac si éloigné de la mer reste un mystère. Hormis à la saison des amours, où ils forment des colonies pouvant atteindre 500 animaux, les phoques de Sibérie vivent en solitaire.

Baikalrobben

Baikalrobben gelten als Wahrzeichen des Baikalsees. Sie kommen nur in diesem See vor und sind die einzige Robbenart, die ausschließlich im Süßwasser lebt. Mit einer Körperlänge von 130 cm zählen sie zu den kleinen Robbenarten, ihr Fell ist graubraun, am Bauch oft etwas heller. Ihre nächsten Verwandten sind die Ringelrobben, von denen sie sich vor 400 000 bis 500 000 Jahren abgespalten haben. Bis heute ist nicht klar, wie die Baikalrobbe in den weit vom Meer entfernten See gelangt ist. Zur Paarungszeit bilden die Tiere Kolonien mit bis zu 500 Tieren, ansonsten leben sie als Einzelgänger.

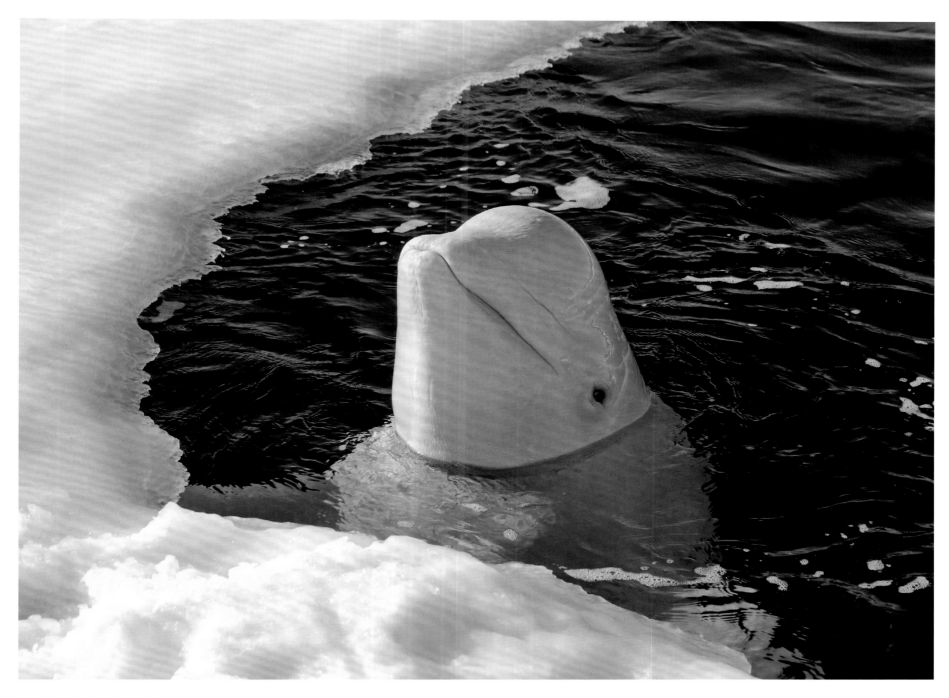

White whale, Kareliya, White Sea

Nerpas

Las nerpas son consideradas el punto de referencia del lago Baikal. Solo se encuentran en este lago y son la única especie de foca que vive exclusivamente en agua dulce. Con una longitud de 130 cm, son un tipo de foca pequeña, cuyo pelaje es pardo, a menudo algo más ligero en el estómago. Sus parientes más cercanos son las focas anilladas, de las que se separaron hace 400 000 a 500 000 años. Hasta hoy no está claro cómo se introdujo la nerpa en el lago, tan lejos del mar. En la época de apareamiento, estos animales forman colonias de hasta 500 nerpas. El resto del tiempo, viven en soledad.

Foca-de-baikal

As focas-de-baikal ou focas-da-sibéria são consideradas marcos históricos do lago Baikal. Elas aparecem apenas neste lago e são as únicas espécies de focas que vivem exclusivamente em água doce. Com um comprimento de corpo de 130 cm, eles pertencem às pequenas espécies de foca, seu pêlo é marrom-acinzentado, na barriga geralmente um pouco mais claro. Os seus familiares mais próximos são as focas aneladas, das quais se separaram há 400 000 a 500 000 anos atrás. Até hoje não se está claro como a foca-de-baikal chegou a este lago longe do mar. Na época de acasalamento, os animais formam colónias com até 500 animais, por outro lado vivem como solitários.

Baikalrobben

Baikalrobben worden beschouwd als het herkenningspunt van het Baikalmeer. Ze komen alleen in dit meer voor en zijn de enige zeehondensoort die uitsluitend in zoet water leeft. Met een lengte van 130 cm behoren ze tot de kleine zeehondensoorten, de vacht is grijs-bruin, de buik vaak wat lichter. Hun naaste verwanten zijn de ringelrobben, waarvan zij 400 000 tot 500 000 jaar geleden zijn afgesplitst. Tot op de dag van vandaag is het niet duidelijk hoe de Baikalrob ver weg van de zee in het meer is gekomen. In de paartijd vormen de dieren kolonies met maximaal 500 dieren, anders leven ze als eenling.

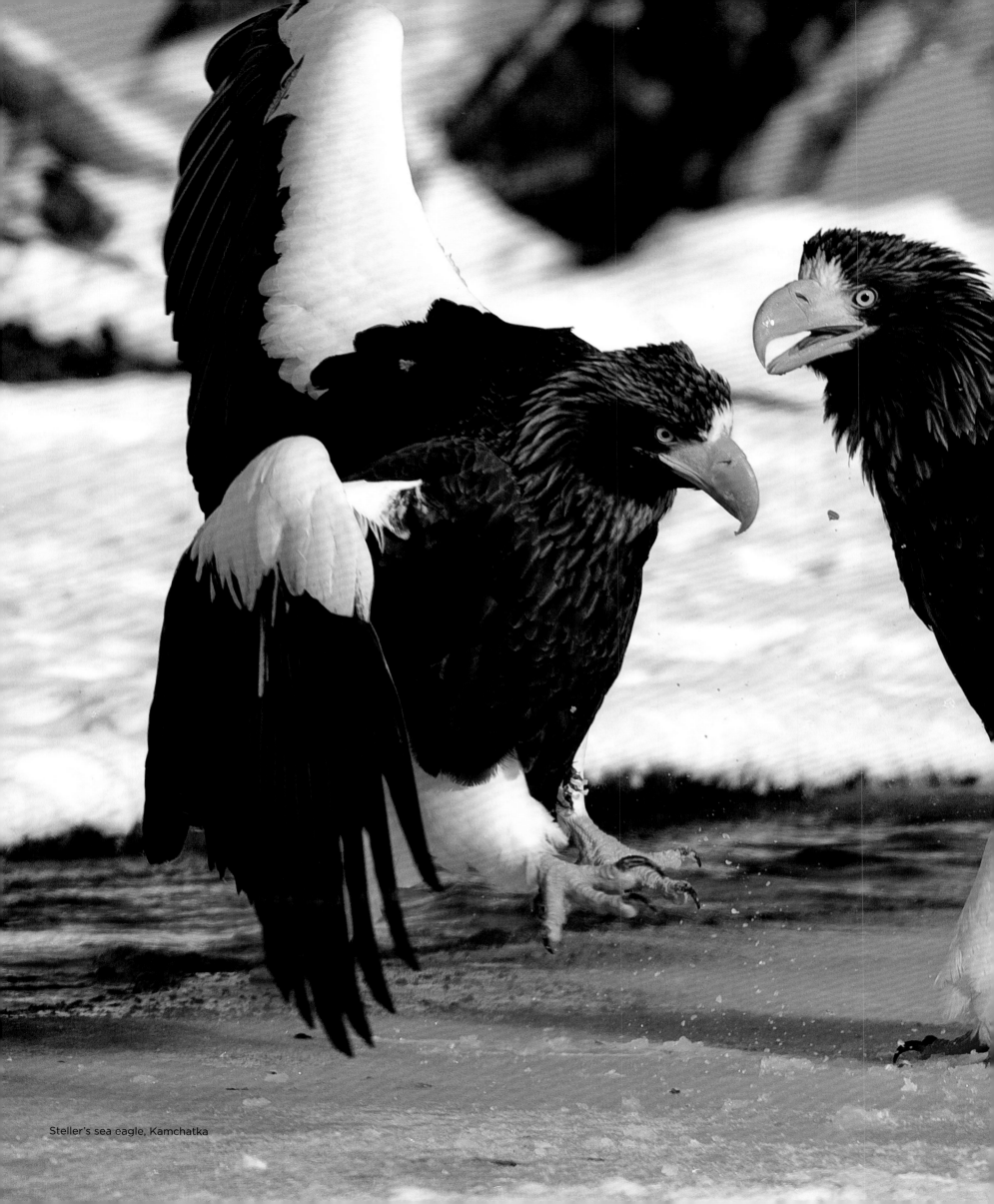

Steller's sea eagle, Kamchatka

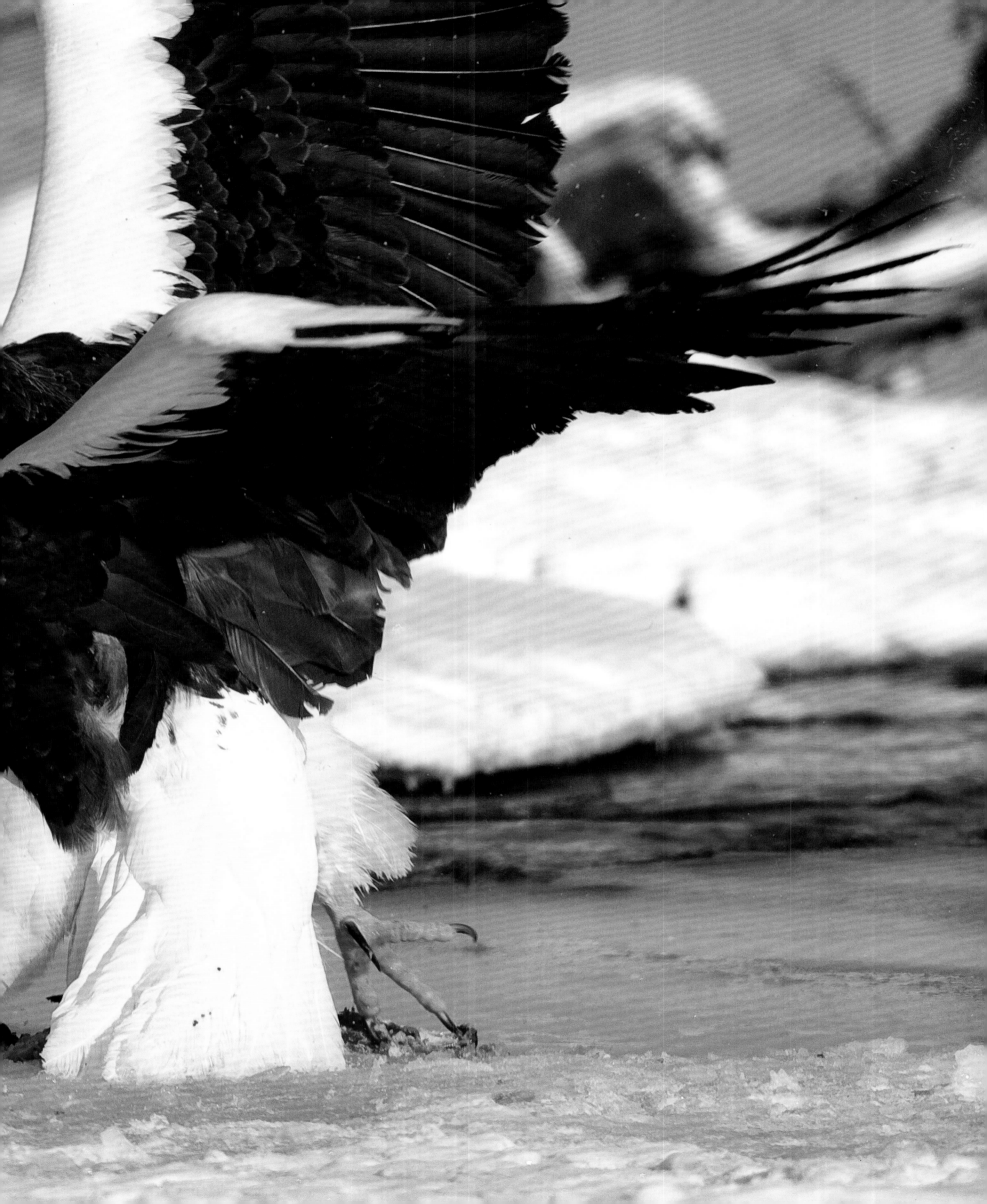

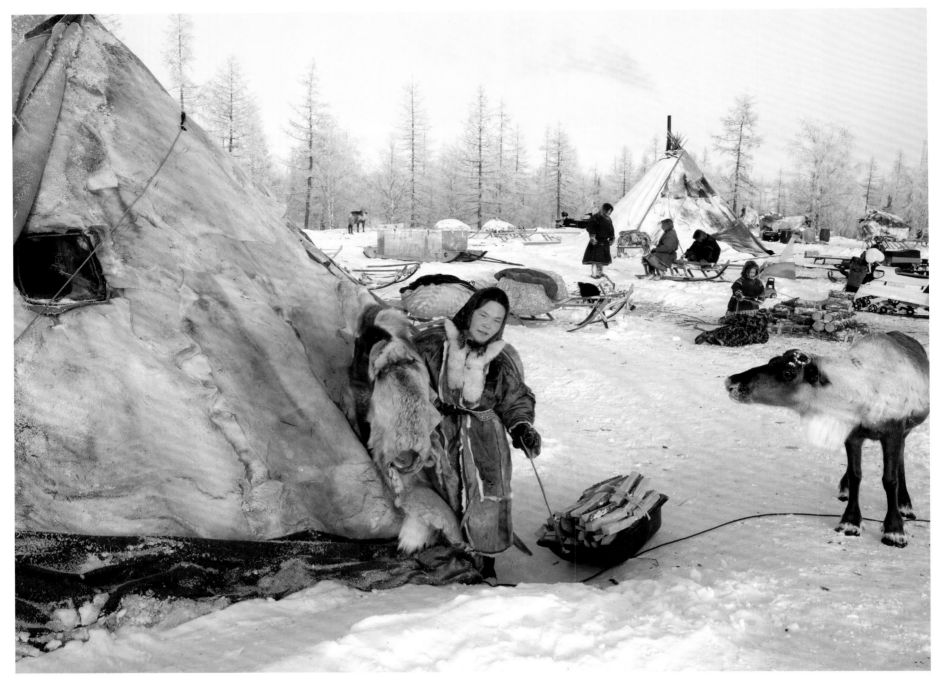

Winter camp, Jamal-Nenzen, Siberia

The Nenet people

The Jamal Peninsula lies beyond the Arctic Circle, and winding rivers meander through this remote, stormy region with its permafrost soil. In the language of the Nenets, an indigenous people with around 40,000 people, "Jamal" means "the end of the world". The Nenets have been nomadic reindeer herders, fishermen and hunters for at least 1000 years. Many have now settled because the increasingly intensive oil and gas production and climate change is turning their land into a huge swamp and is threatening their traditional way of life.

Les Nénètses

La péninsule de Yamal se situe de l'autre côté du cercle polaire arctique. Le pergélisol de cette région lointaine et orageuse est sillonné de rivières sinueuses. « Yamal » signifie « le bout du monde » dans la langue des Nénètses, un peuple autochtone comptant environ 40 000 individus. Depuis au moins mille ans, les Nénètses sont nomades et vivent de l'élevage de rennes, de la pêche et de la chasse. Par la suite, nombre d'entre eux sont devenus sédentaires car l'extraction de plus en plus intensive de gaz et de pétrole ainsi que le changement climatique transforment leurs terres en un immense marécage, mettant en danger leur style de vie traditionnel.

Die Nenzen

Die Jamal-Halbinsel liegt jenseits des nördlichen Polarkreises, verschlungene Flüsse mäandern durch diese abgelegene, stürmische Region mit Permafrostboden. „Jamal" bedeutet in der Sprache der Nenzen, einem indigenen Volk mit rund 40 000 Angehörigen, „Ende der Welt". Seit mindestens 1000 Jahren ziehen die Nenzen als nomadische Rentierhirten, Fischer und Jäger durch ihr Land. Mittlerweile sind viele sesshaft geworden, weil die immer intensiver betriebene Öl- und Gasförderung und der Klimawandel, der ihr Land in einen riesigen Sumpf verwandelt, ihre traditionelle Lebensweise bedroht.

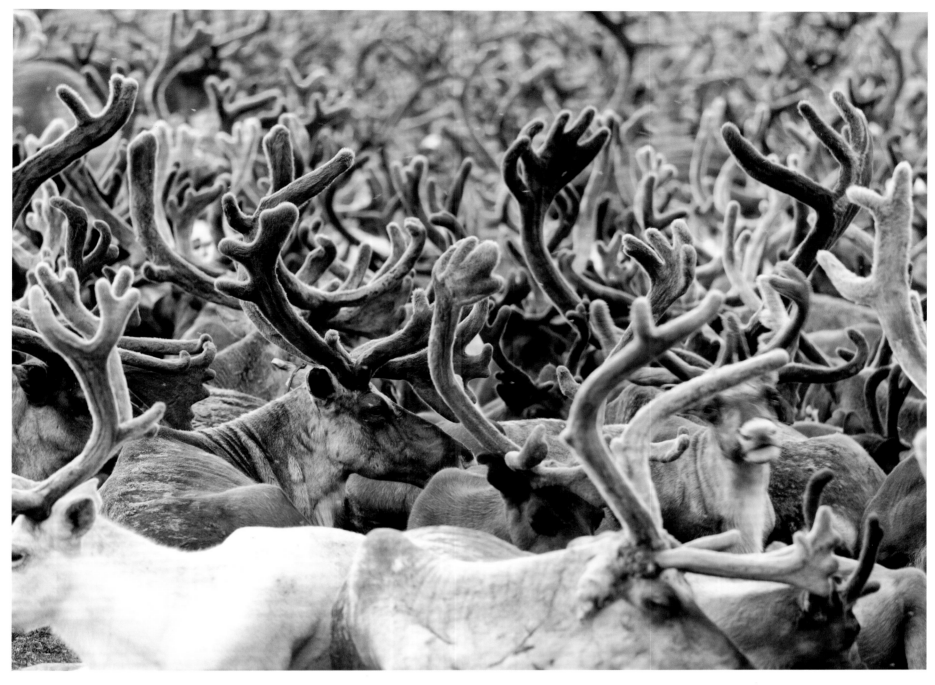

Reindeer herd, Taimyr Peninsula, Siberia

Los Nénets

La Península de Yamalia se encuentra más allá del Círculo Polar Ártico, y sus sinuosos ríos serpentean a través de esta remota y tormentosa región con suelo de permafrost. En la lengua de los nénets, un pueblo indígena de unos 40 000 habitantes, «Jamal» significa «el fin del mundo». Los nénets han sido pastores nómadas de renos, pescadores y cazadores durante al menos 1000 años. Muchos se han asentado porque la producción cada vez más intensiva de petróleo y gas y el cambio climático, que está convirtiendo su tierra en un enorme pantano, están amenazando su modo de vida tradicional.

Os Nenets

A Península de Jamal está situada além do Círculo Ártico, rios sinuosos serpenteiam por esta região remota e tempestuosa com solo permafrost. Na língua dos Nenets, um povo indígena com cerca de 40.000 habitantes, "Jamal" significa "o fim do mundo". Os Nenets são criadores nómades de renas , pescadores e caçadores há pelo menos 1000 anos. Muitos já se instalaram porque a produção cada vez mais intensiva de petróleo e gás e as alterações climáticas, que estão a transformar as suas terras num enorme pântano, estão a ameaçar o seu modo de vida tradicional.

De Nenetsen

Het Jamal-schiereinland ligt voorbij de poolcirkel en kronkelt zich door dit afgelegen, stormachtige gebied en bestaat uit permafrost. In het Nenets, een inheemse bevolking met ongeveer 40.000 inwoners, betekent „Jamal" zoiets als „einde van de wereld". De Nenets zijn al minstens 1000 jaar nomadische rendierhoeders, vissers en jagers. Velen hebben zich nu gevestigd omdat de steeds intensievere olie- en gaswinning en de klimaatverandering, die hun land in een groot moeras veranderen, hun traditionele manier van leven bedreigen.

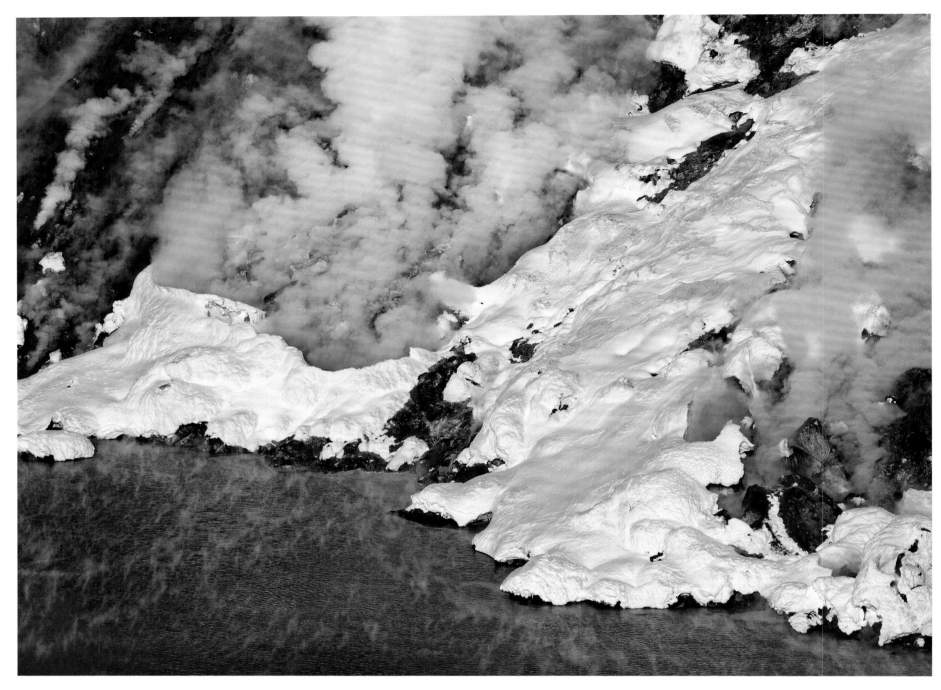

Gorelaya Volcano, crater lake, Kamchatka

Kamchatka

The Kamchatka peninsula, which is about the size of Germany, was a restricted military area until 1990. Today it is still so isolated that many destinations can only be reached by helicopter. Kamchatka is known as the land of volcanoes, and rightly so, because from a total of 160, around 30 are active. Far above all others, the active volcano Kljutschewskaja is 4750 m (15884 ft) high. It is part of the Pacific Ring of Fire , and impresses with its perfect cone. Volcanic cones, glaciers, steaming fumaroles and colorful lava fields are the highlights of the wide, almost completely untouched tundra.

Kamtchatka

Jusqu'en 1990, la péninsule de Kamtchatka, presque aussi vaste que l'Allemagne, fut une zone militaire interdite d'accès et reste aujourd'hui encore si reculée que nombre d'endroits ne sont accessibles que par hélicoptère. La Kamtchatka est appelée « terre des volcans » à raison, car elle en compte 160, dont une trentaine sont actifs. Le Klioutchevskoï, particulièrement actif, dépasse de loin tous les autres sommets avec ses 4 750 m d'altitude. Il fait partie de la ceinture de feu du Pacifique et impressionne par la forme parfaite de sa coupole. Dômes volcaniques, glaciers, fumerolles et champs de lave colorés sont les caractéristiques marquantes de cette lointaine toundra encore presque vierge.

Kamtschatka

Bis 1990 war die Halbinsel Kamtschatka, die in etwa die Größe Deutschlands hat, militärisches Sperrgebiet, bis heute ist sie so abgeschieden, dass viele Ziele nur mit dem Hubschrauber zu erreichen sind. „Land der Vulkane" wird Kamtschatka genannt, zu Recht, denn rund 30 sind aktiv, insgesamt gibt es 160. Der aktive Kljutschewskaja überragt mit 4750 m alle anderen bei Weitem, er zählt zum Pazifischen Feuerring und beeindruckt mit seinem perfekten Kegel. Vulkankegel, Gletscher, dampfende Fumarolen und bunte Lavafelder bilden die Höhepunkte in der weiten, von Menschen fast gänzlich unberührten Tundra.

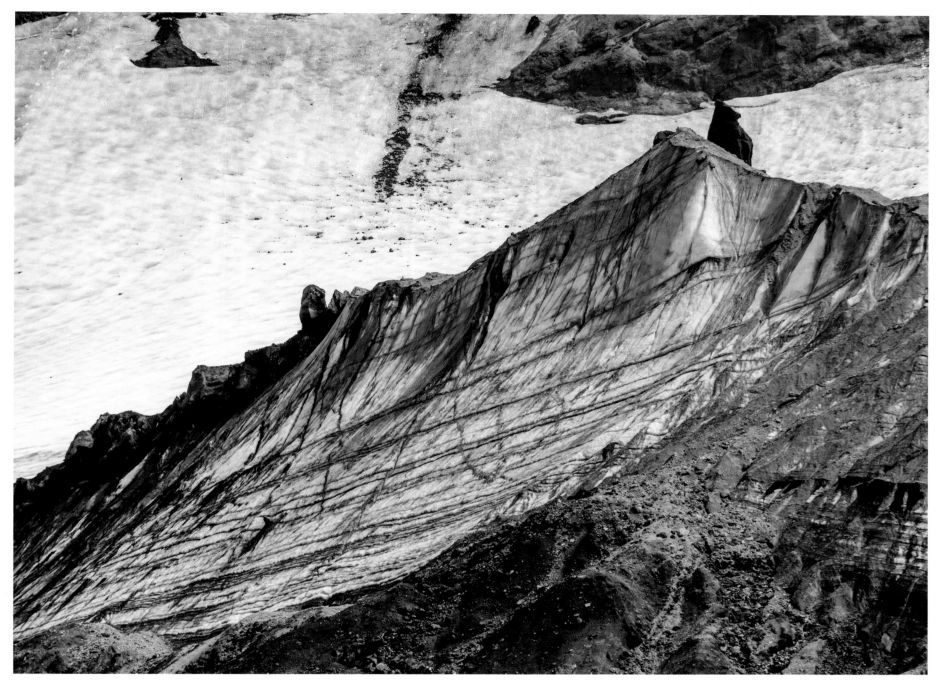

Mutnovsky Volcano, main crater

Kamchatka

Hasta 1990, la península de Kamchatka, del tamaño de Alemania, era una zona militar restringida, hasta hoy tan aislada que a muchos destinos solo se puede llegar en helicóptero. La «tierra de los volcanes» se llama Kamchatka, y con razón, porque hay unos 30 volcanes activos (en total, hay 160 volcanes en la península). El Kljutschewskaja está activo y tiene 4750 m de altura, mucho más que todos los demás. Además, es parte del Cinturón de Fuego del Pacífico e impresiona con su cono perfecto. Conos volcánicos, glaciares, fumarolas humeantes y coloridos campos de lava son los puntos culminantes de la amplia y casi intacta tundra.

Kamchatka

Até 1990, a península de Kamchatka, que tem aproximadamente o tamanho da Alemanha, era uma área militar restrita, até hoje é tão isolada que muitos destinos só podem ser alcançados por helicóptero. A "Terra dos Vulcões" é chamada Kamchatka, e com razão, porque cerca de 30 são ativos, de um total de 160. O Kljutschewskaja eleva-se a 4750 m de altura, muito acima de todos os outros, faz parte do Anel de Fogo do Pacífico e impressiona com seu cone perfeito. Cones vulcânicos, glaciares, fumarolas de enxofre fumegantes e campos de lava coloridos são os destaques da ampla tundra, quase completamente intocada pelo homem.

Kamtsjatka

Tot 1990 was het schiereiland Kamtsjatka, dat ongeveer even groot is als Duitsland, een militair beperkt gebied, tot op heden is het zo geïsoleerd dat veel bestemmingen alleen met een helikopter bereikbaar zijn. Kamtsjatka wordt het "Land van Vulkanen" genoemd, en terecht, want er zijn er ongeveer 30 actief, in totaal zijn er 160. De actieve Kljoetsjevska Sopka is 4750 m hoog, ver boven alle andere, maakt het deel uit van de Pacific Ring of Fire en maakt indruk met zijn perfecte top. Vulkanische kegels, gletsjers, dampende fumarolen en kleurrijke lavavelden zijn de hoogtepunten van de brede, bijna volledig ongerepte toendra.

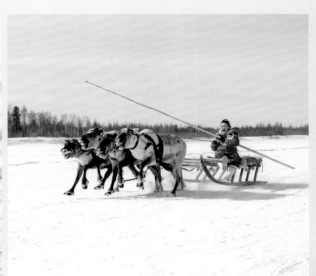
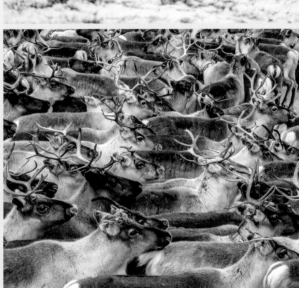
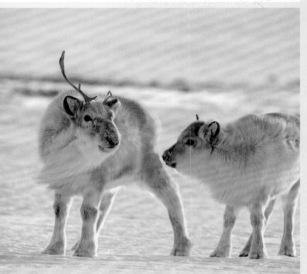
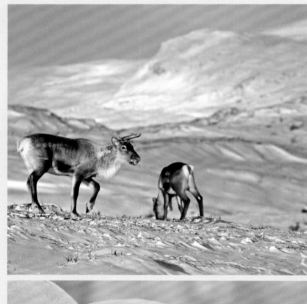
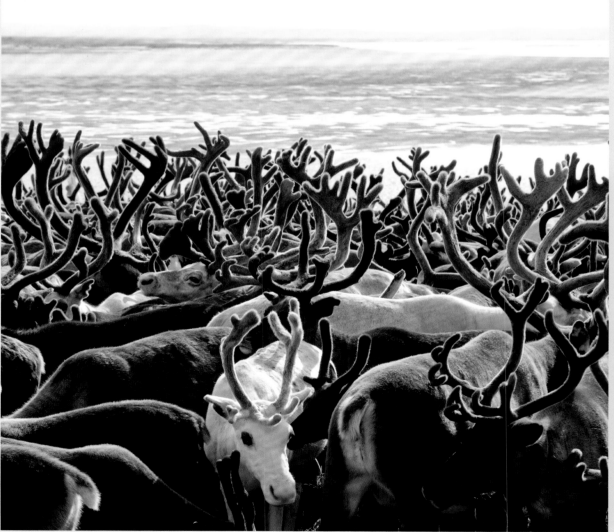
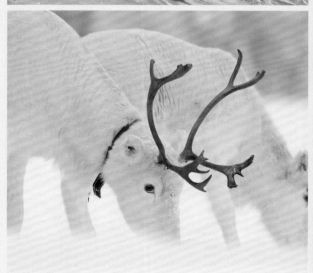

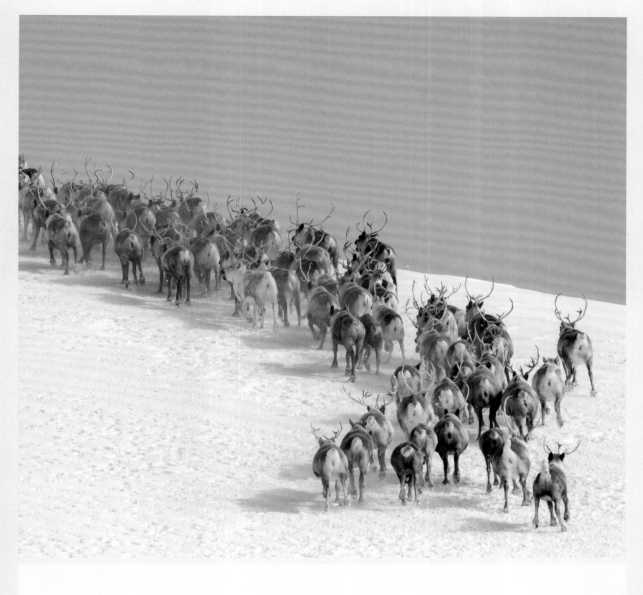

Reindeer

Reindeer are among the largest mammals in the far north, and even live on high arctic islands such as Spitsbergen and Greenland. However, in winter they migrate south on long hikes if possible. Reindeer live in a circumpolar range, and in North America they are called caribous. In this unique deer species the female reindeer also carries antlers, but these are smaller than those of the males.

Élans

Les élans sont d'imposants mammifères vivant en plein nord; on les trouve même sur les îles du Haut-Arctique telles que Spitzberg ou au Groenland. En hiver cependant, ils se mettent en route pour de longues marches vers le sud, bien qu'ils vivent toujours autour du pôle. En Amérique du Nord, ils portent le nom de caribous. Ce sont les seuls cervidés chez qui les femelles ont également des bois, toutefois plus petits que ceux des mâles.

Rentiere

Rentiere gehören zu den am weitesten im Norden lebenden großen Säugetieren, selbst auf hocharktischen Inseln wie Spitzbergen und Grönland kommen sie vor. Im Winter jedoch begeben sie sich, wenn möglich, auf lange Wanderungen in Richtung Süden. Rentiere leben zirkumpolar; in Nordamerika werden sie als Karibus bezeichnet. Als einzige Hirschart trägt auch das Rentier-Weibchen ein – allerdings kleineres – Geweih.

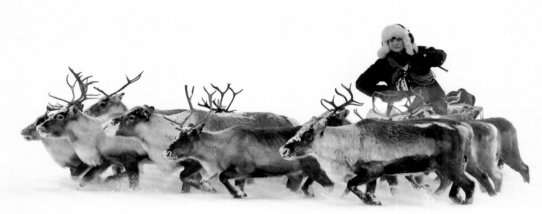

Renos

Los renos se encuentran entre los mamíferos más grandes que viven más al norte, incluso en las islas árticas altas como Spitsbergen y Groenlandia. En invierno, sin embargo, si es posible, se dirigen al sur en largas caminatas. Los renos viven circumpolarmente; en Norteamérica, se les llama caribús. Es el único tipo de ciervo cuya hembra también tiene cuernos, aunque más pequeños que los del macho.

Rena

As renas estão entre os maiores mamíferos que vivem mais a norte, mesmo nas altas ilhas árticas, como Spitsbergen e Gronelândia. No inverno, no entanto, se possível, eles vão para o sul em longas caminhadas. As renas vivem circumpolarmente; na América do Norte, são chamadas de caribu. Como uma única espécie de veado, também a rena-fêmea transporta chifres, ainda que mais pequenos.

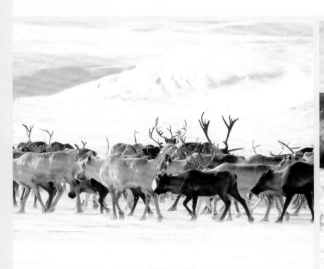
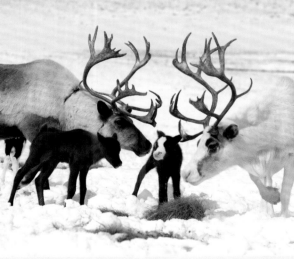

Rendieren

Rendieren behoren tot de grootste zoogdieren die verder naar het noorden leven, zelfs op hoge arctische eilanden zoals Spitsbergen en Groenland komen ze voor. In de winter gaan ze echter, indien mogelijk, tijdens lange wandelingen naar het zuiden. Rendieren leven circumpolair; in Noord-Amerika worden ze kariboes genoemd. Als enkelvoudig hertengewei draagt ook het rendier-vrouwtje - hoe kleiner ook - een gewei.

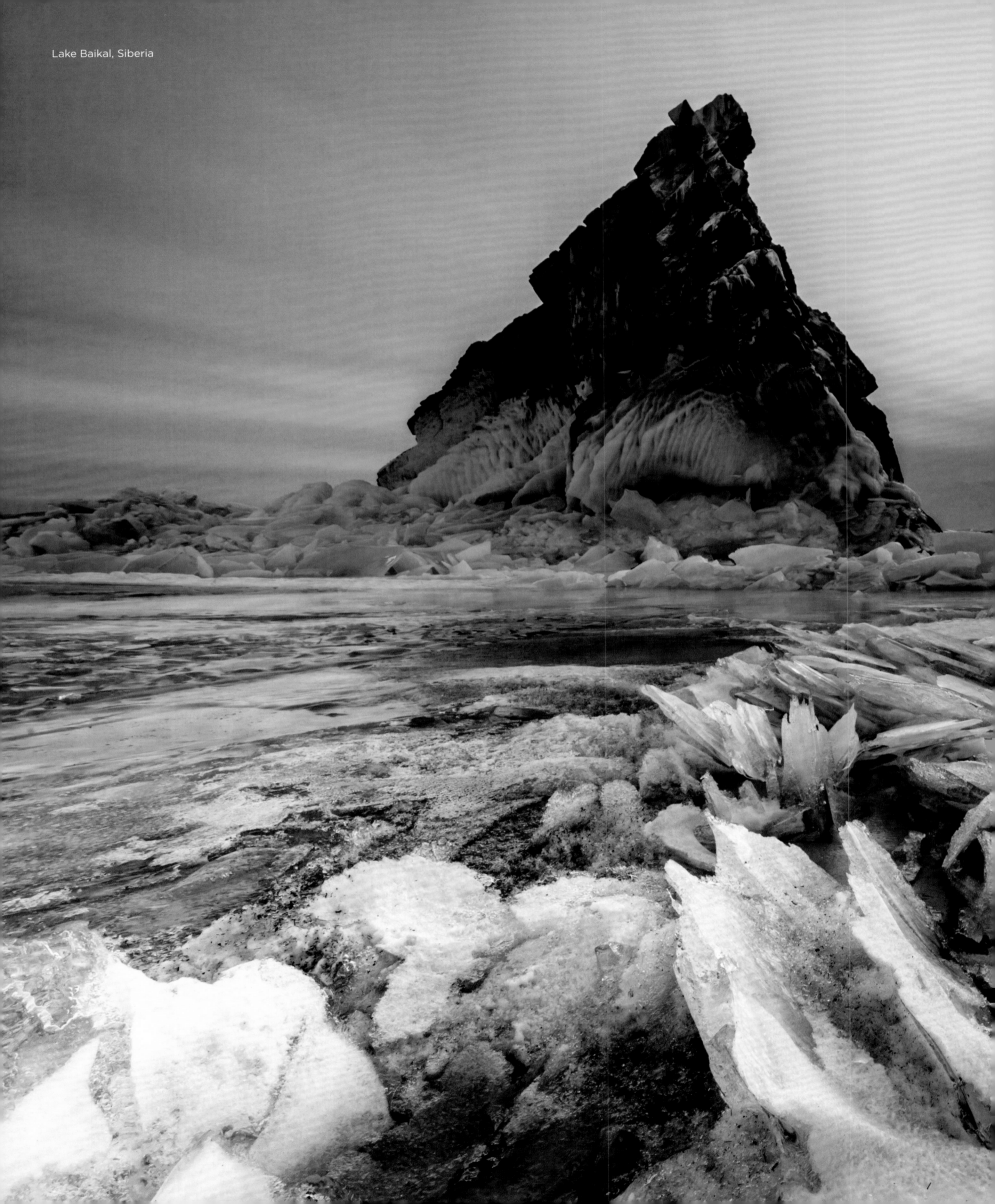

Lake Baikal, Siberia

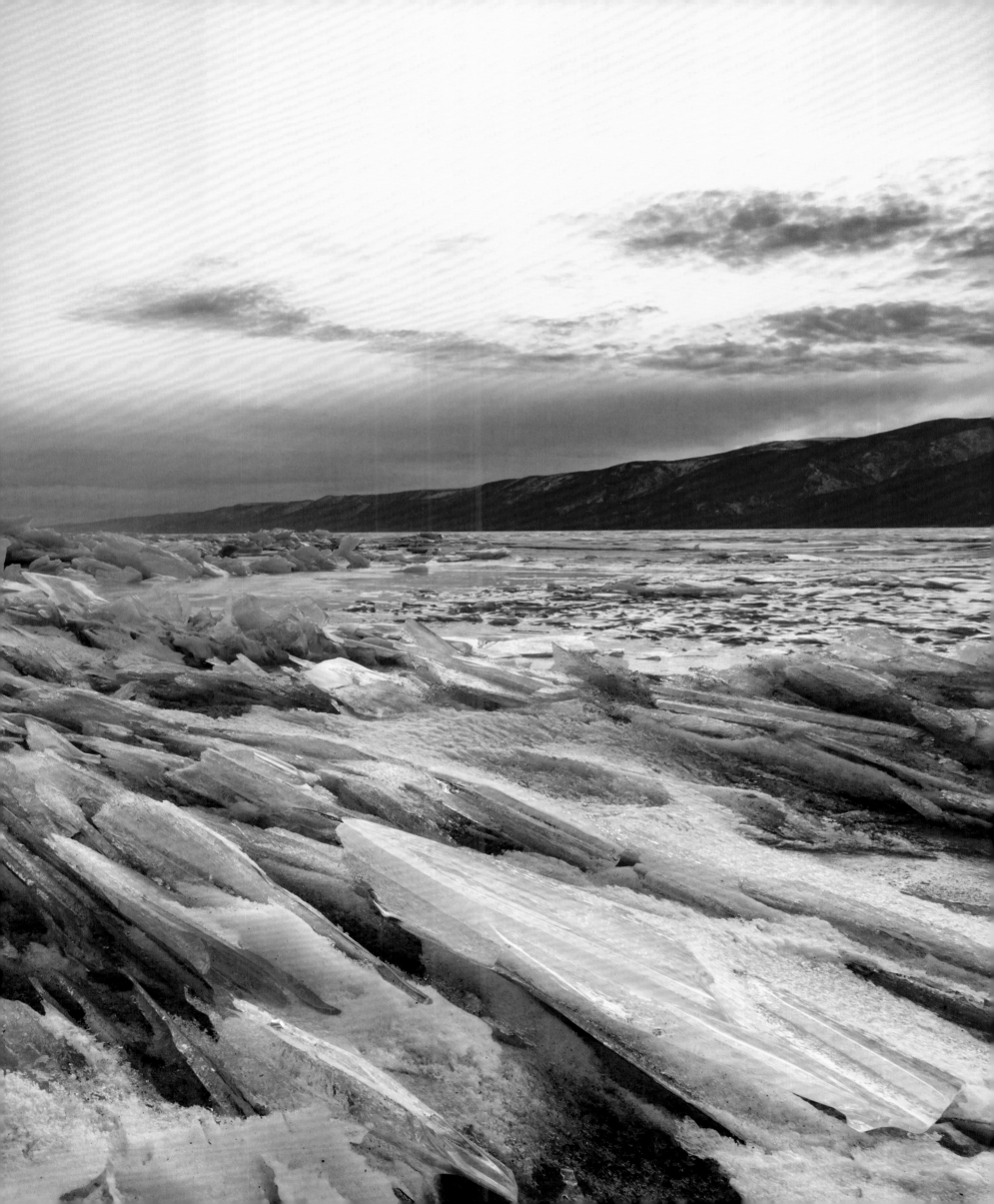

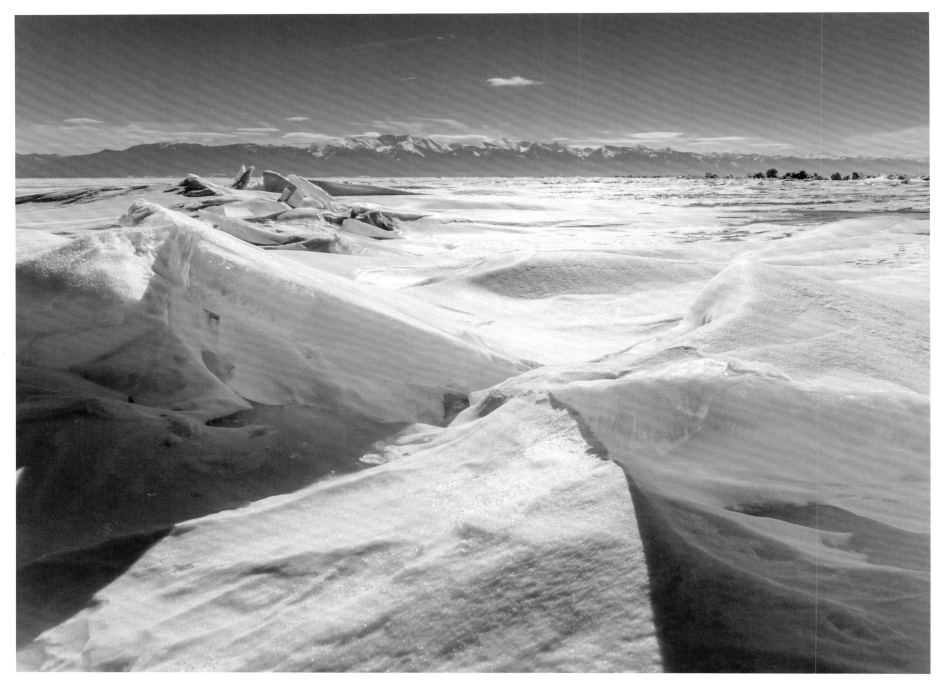

Lake Baikal, Siberia

Lake Baikal

Lake Baikal in southern Siberia combines several superlatives: at 25 million years it is the oldest freshwater lake in the world, and at 1642 m (5387 ft) it is the deepest inland lake in the world and also the largest reservoir of liquid fresh water. Since 1996 the Baikal region has been listed by Unesco as a World Natural Heritage Site, but scientists see its unique ecosystem increasingly threatened by industry, environmental pollution, tourism and forest fires. Between November and the end of April, an ice layer up to 2 m (6 ft) thick forms on the surface of Baikal, often with filigree structures.

Le lac Baïkal

Le lac Baïkal, au sud de la Sibérie, cumule les superlatifs : à plus de vingt-cinq millions d'années, il est le plus vieux lac d'eau douce au monde ; ses 1 642 m de profondeur font de lui le lac intérieur le plus profond de la terre ; enfin, il représente la plus grande réserve d'eau douce de la planète sous forme liquide. Depuis 1996, la région du Baïkal est classée au patrimoine mondial naturel de l'Unesco. Les scientifiques voient cependant son écosystème unique de plus en plus menacé en raison de l'industrie, de la pollution environnementale, du tourisme et des incendies de forêt. De novembre à avril, la surface du lac Baïkal se recouvre d'une couche de glace pouvant atteindre 2 m d'épaisseur, souvent parcourue de motifs délicats.

Baikalsee

Der Baikalsee in Südsibirien vereint mehrere Superlative: Mit 25 Millionen Jahren ist er der weltweit älteste Süßwassersee, mit 1642 m ist er der tiefste Binnensee der Erde, zudem bildet er den größten Speicher flüssigen Süßwassers. Seit 1996 wird die Baikalregion von der Unesco als Weltnaturerbe geführt. Doch Wissenschaftler sehen sein einzigartiges Ökosystem durch Industrie, Umweltverschmutzung, Tourismus und Waldbrände zunehmend bedroht. Zwischen November und Ende April bildet sich auf der Oberfläche des Baikal eine bis zu 2 m dicke Eisschicht mit oft filigranen Strukturen.

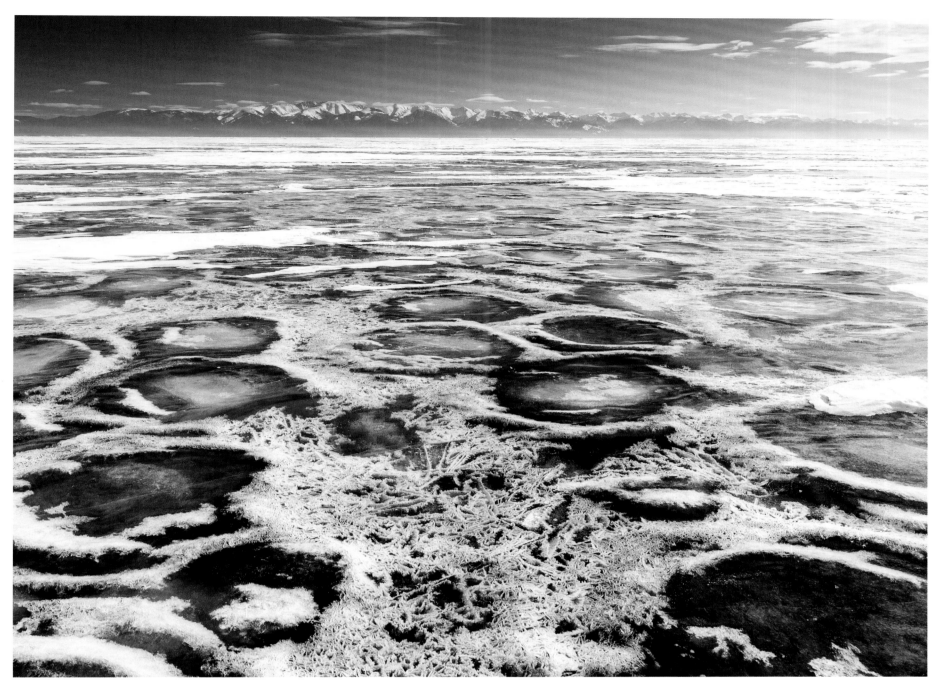

Irkutsk Oblast, Lake Baikal, Siberia

Lago Baikal

El lago Baikal, en el sur de Siberia, combina varios superlativos: con 25 millones de años, es el lago de agua dulce más antiguo del mundo; con 1642 m, es el lago interior más profundo del mundo y también el mayor reservorio de agua dulce líquida. Desde 1996, la región del Baikal ha sido declarada por la Unesco Patrimonio Natural de la Humanidad. Pero los científicos ven su ecosistema único cada vez más amenazado por la industria, la contaminación ambiental, el turismo y los incendios forestales. Entre noviembre y finales de abril se forma en la superficie del Baikal una capa de hielo de hasta 2 m de espesor con estructuras a menudo filigranas.

Lago Baikal

O Lago Baikal no sul da Sibéria combina vários superlativos: com 25 milhões de anos é o lago de água doce mais antigo do mundo, com 1642 m é o lago mais profundo do mundo e também o maior reservatório de água doce líquida. Desde 1996, a região de Baikal foi classificada pela Unesco como Patrimônio Natural da Humanidade. Mas os cientistas vêem o seu ecossistema único cada vez mais ameaçado pela indústria, pela poluição ambiental, pelo turismo e pelos incêndios florestais. Entre novembro e finais de abril, forma-se na superfície do Baikal uma camada de gelo de até 2 m de espessura com estruturas frequentemente de filigranas.

Baikalmeer

Het Baikalmeer in het zuiden van Siberië combineert meerdere superlatieven: met 25 miljoen jaar is dit het oudste zoetwatermeer ter wereld, met 1642 m is dit het diepste binnenmeer ter wereld en tevens het grootste reservoir van vloeibaar zoet water. Sinds 1996 is de Baikal-regio door de Unesco opgenomen op de lijst van het natuurlijk werelderfgoed. Wetenschappers zien het unieke ecosysteem van dit gebied steeds meer door de industrie, milieuvervuiling, toerisme en bosbranden worden bedreigd. Tussen november en eind april vormt zich op het oppervlak van het Baikal een ijslaag tot 2 m dik met vaak filigraanstructuren.

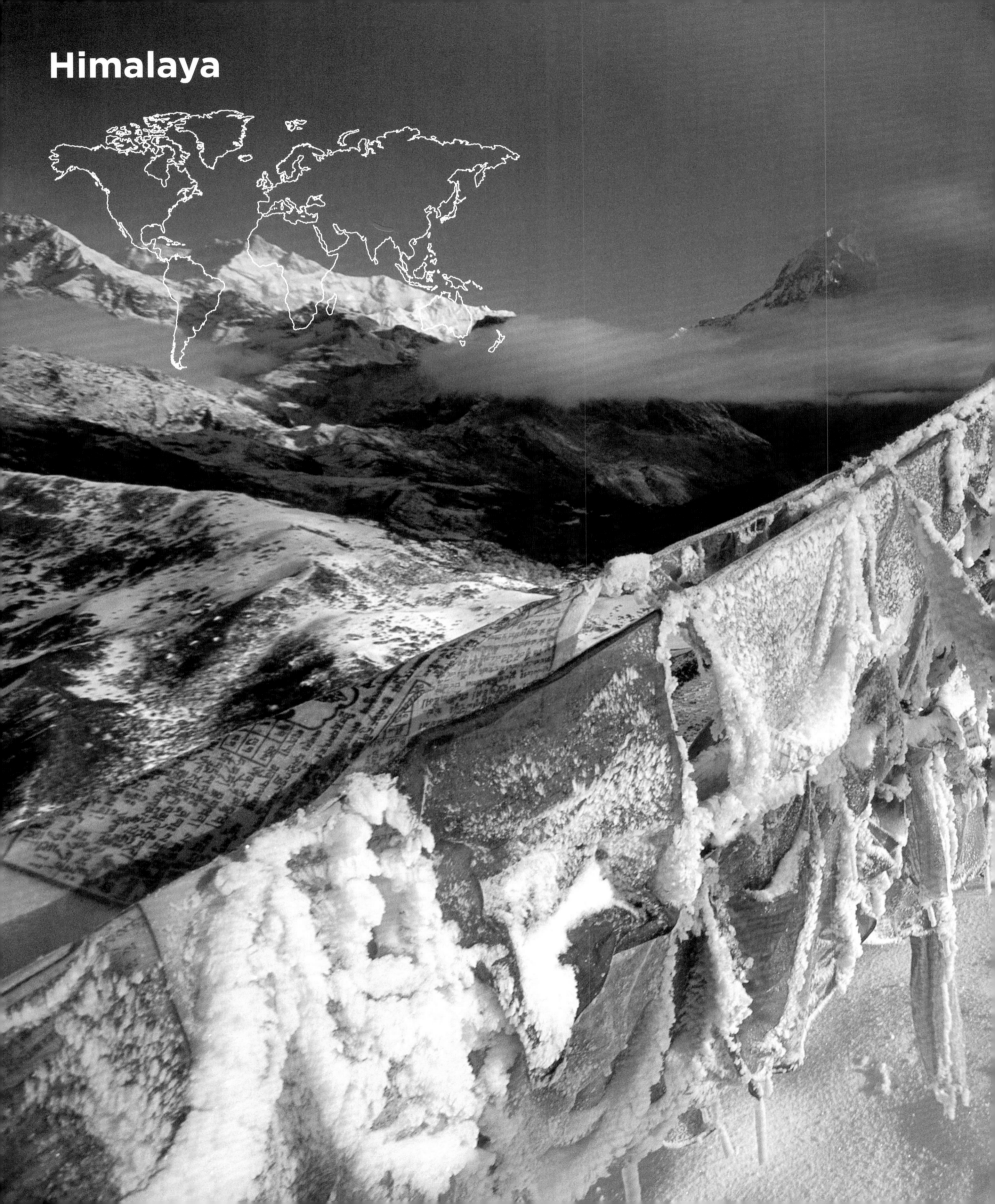

Himalaya

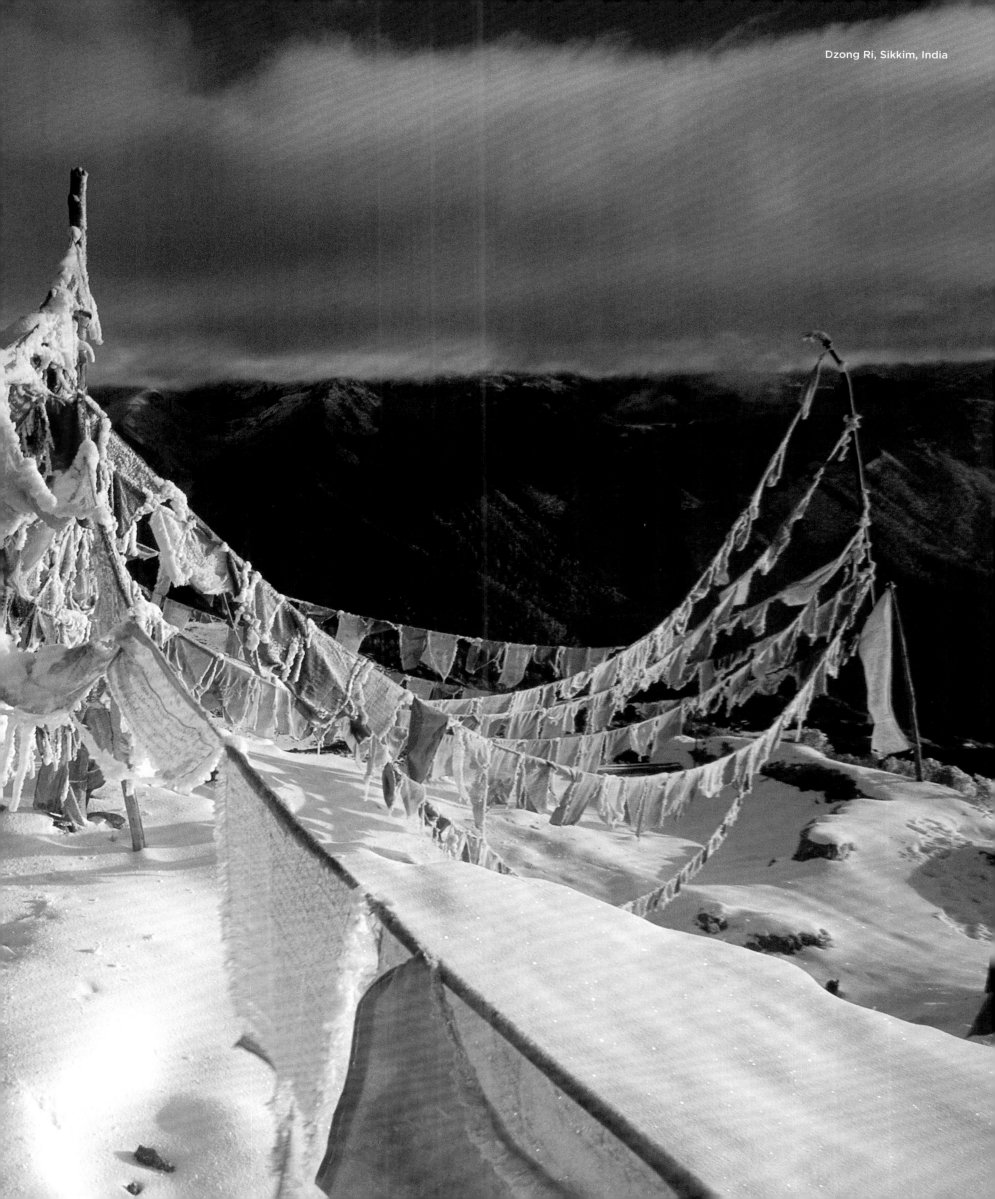

Dzong Ri, Sikkim, India

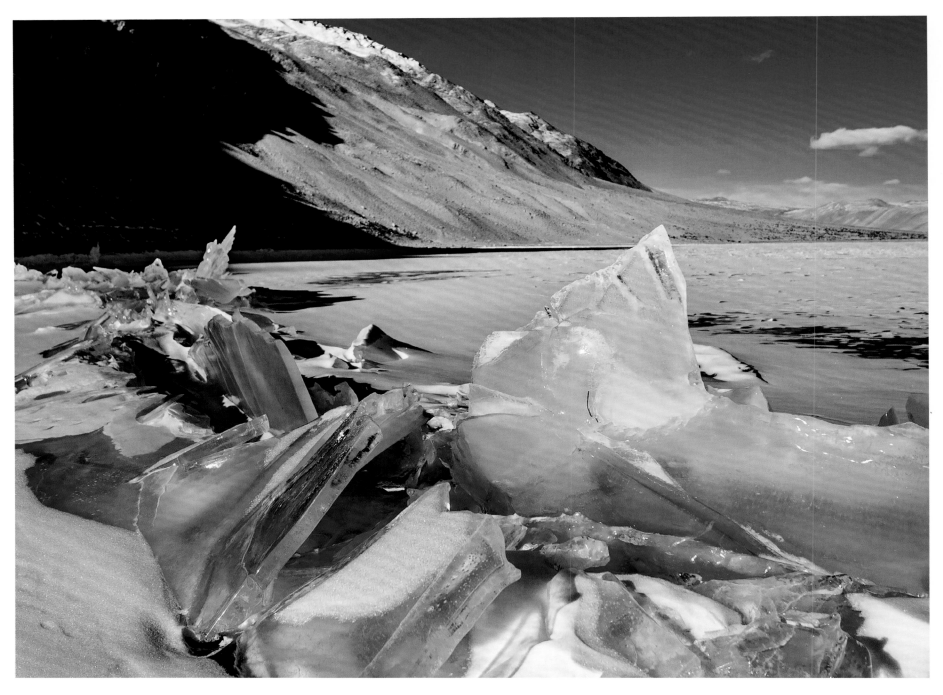

Lake Moriri, Ladakh, India

Himalaya

The term Himalaya comes from Sanskrit and means "place of snow, frost and cold". The mountains of the Himalayas are considered by many inhabitants of the region to be the seat of the gods. The 3000 km (1864 mi) long mountain range is the highest in the world. It stretches from Pakistan to Myanmar, and lies between the Indian subcontinent in the south and the Tibetan highlands in the north. In some regions the border between the neighboring states Pakistan, India, Nepal, Bhutan and China is disputed. The youngest and highest mountain range in the world has risen from the earth due to the meeting of two continental plates.

L'Himalaya

Le terme d'Himalaya vient du sanskrit et signifie « territoire de la neige, du gel et du froid ». Les montagnes de l'Himalaya sont considérées par de nombreux habitants de la région comme la demeure des dieux. Cette chaîne montagneuse longue d'environ 3 000 km est la plus haute du monde. Elle s'étend du Pakistan au Myanmar et se trouve à la fois sur le sous-continent indien au sud et sur les hauts plateaux tibétains au nord. Dans certaines régions, la délimitation des frontières entre les états limitrophes du Pakistan, de l'Inde, du Népal, du Bhoutan et de la Chine est controversée. L'Himalaya, à la fois la plus jeune et la plus haute montagne de la planète, est née de la collision entre deux plaques continentales.

Himalaya

Der Begriff Himalaya stammt aus dem Sanskrit und bedeutet „Ort des Schnees, des Frostes und der Kälte". Die Berge des Himalaya gelten vielen Bewohnern der Region als Sitz der Götter. Das rund 3000 km lange Gebirge ist das höchste der Erde; es erstreckt sich von Pakistan bis Myanmar und liegt zwischen dem indischen Subkontinent im Süden und dem Tibetischen Hochland im Norden. In einigen Regionen ist der Grenzverlauf zwischen den Anrainerstaaten Pakistan, Indien, Nepal, Bhutan und China umstritten. Das jüngste und höchste Gebirge der Erde hat sich durch das Aufeinandertreffen zweier Kontinentalplatten aufgetürmt.

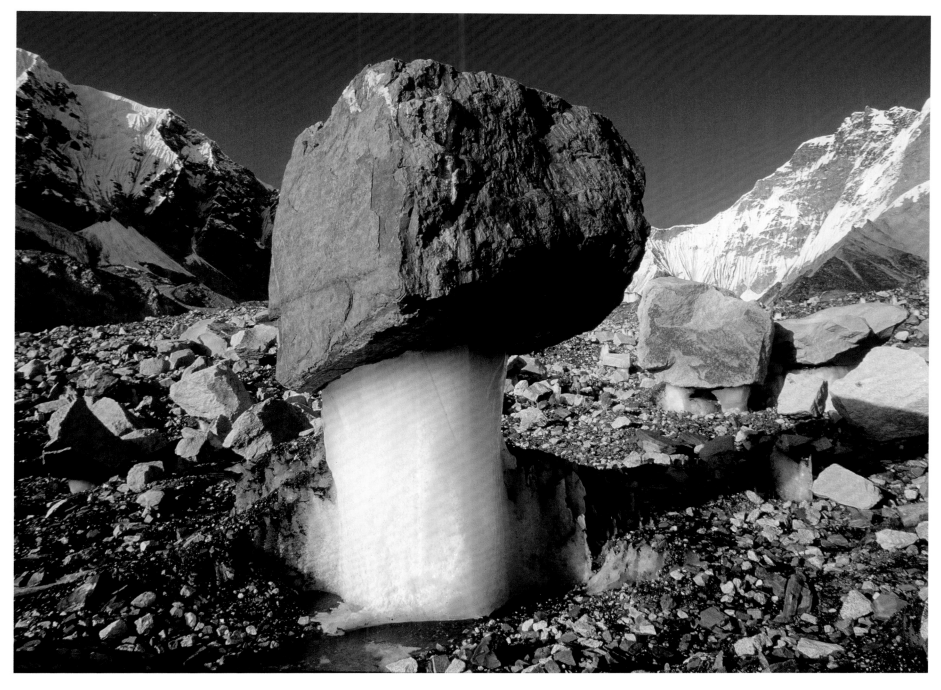

Nuptse Glacier, Khumbu, Nepal

Himalaya

El término Himalaya viene del sánscrito y significa «lugar de nieve, escarcha y frío». Muchos habitantes de la región consideran que las montañas del Himalaya son el asiento de los dioses. La cadena montañosa de 3000 km de longitud es la más alta del mundo; se extiende desde Pakistán hasta Myanmar y se encuentra entre el subcontinente indio en el sur y las tierras altas tibetanas en el norte. En algunas regiones, la frontera entre los estados vecinos Pakistán, India, Nepal, Bután y China está en disputa. La cordillera más joven y alta del mundo se ha amontonado debido al encuentro de dos placas continentales.

Himalaia

O termo Himalaia vem do sânscrito e significa "lugar de neve, geada e frio". As montanhas dos Himalaias são consideradas por muitos habitantes da região como a sede dos deuses. A cordilheira de 3000 km de extensão é a mais alta do mundo; estende-se do Paquistão até Myanmar e fica entre o subcontinente indiano no sul e as terras altas tibetanas no norte. Em algumas regiões, a fronteira entre os Estados vizinhos Paquistão, Índia, Nepal, Butão e China é disputada. A mais jovem e mais alta cadeia de montanhas do mundo se formou devido ao encontro de duas placas continentais.

Himalaya

De term Himalaya komt uit het Sanskriet en betekent „woonplaats in de sneeuw". De bergen van de Himalaya worden door veel inwoners van de regio beschouwd als de zetel van de goden. De 3000 km lange bergketen is de hoogste ter wereld; het strekt zich uit van Pakistan tot Myanmar en ligt tussen het Indiase subcontinent in het zuiden en de Tibetaanse hooglanden in het noorden. In sommige regio's wordt de grens tussen de buurlanden Pakistan, India, Nepal, Bhutan en China betwist. Het jongste en hoogste gebergte ter wereld heeft zich opgestapeld door de ontmoeting van twee continentale platen.

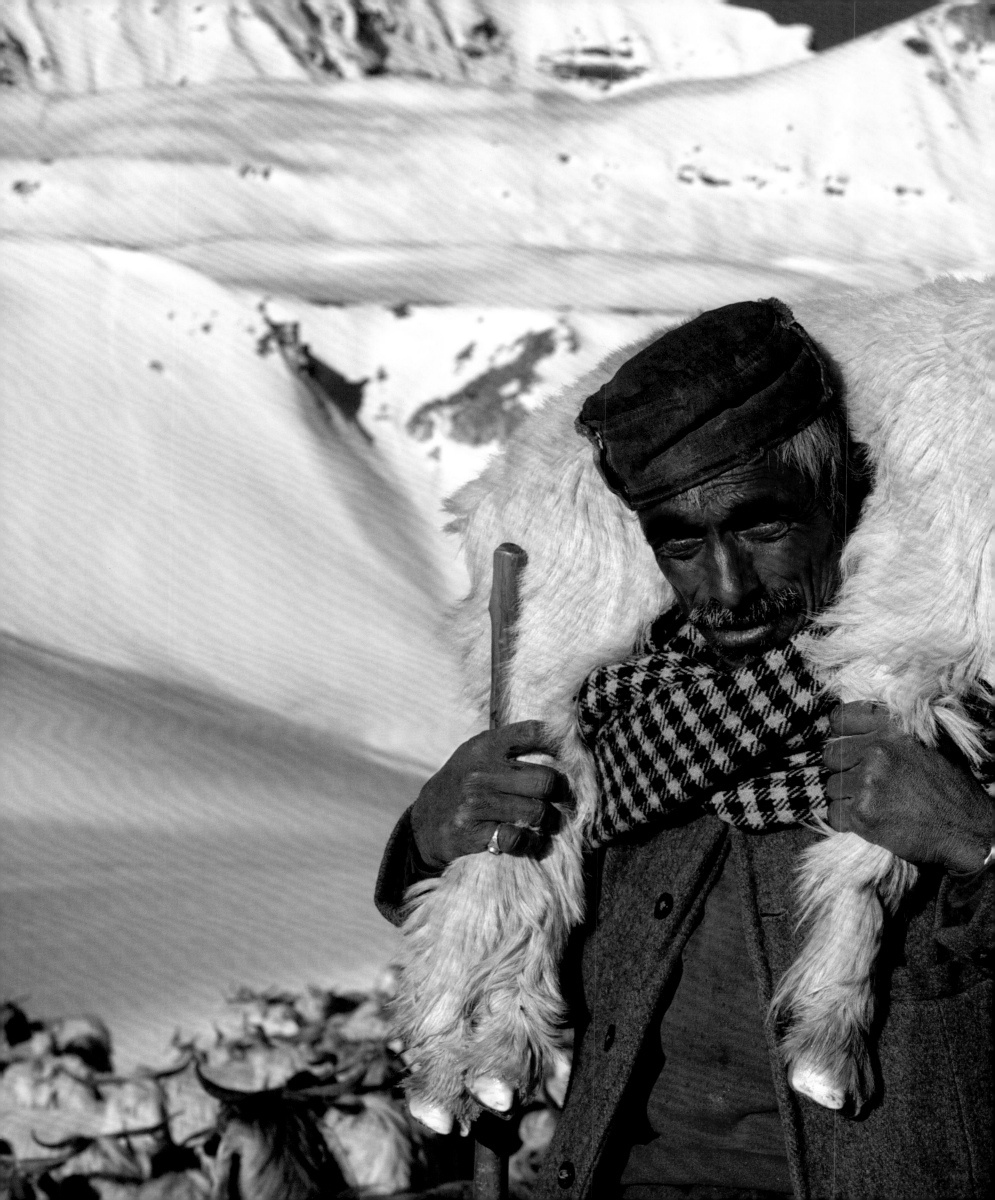

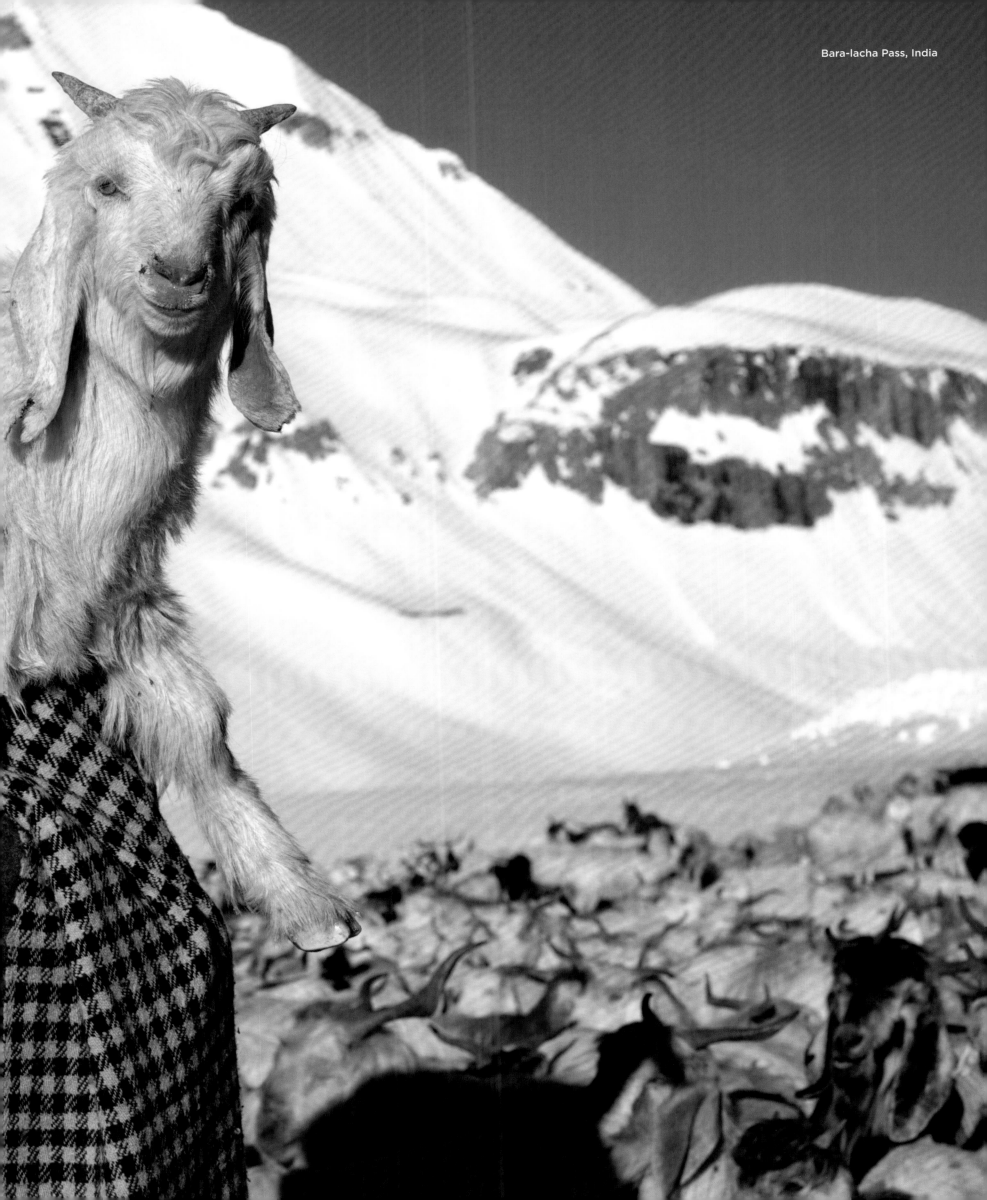

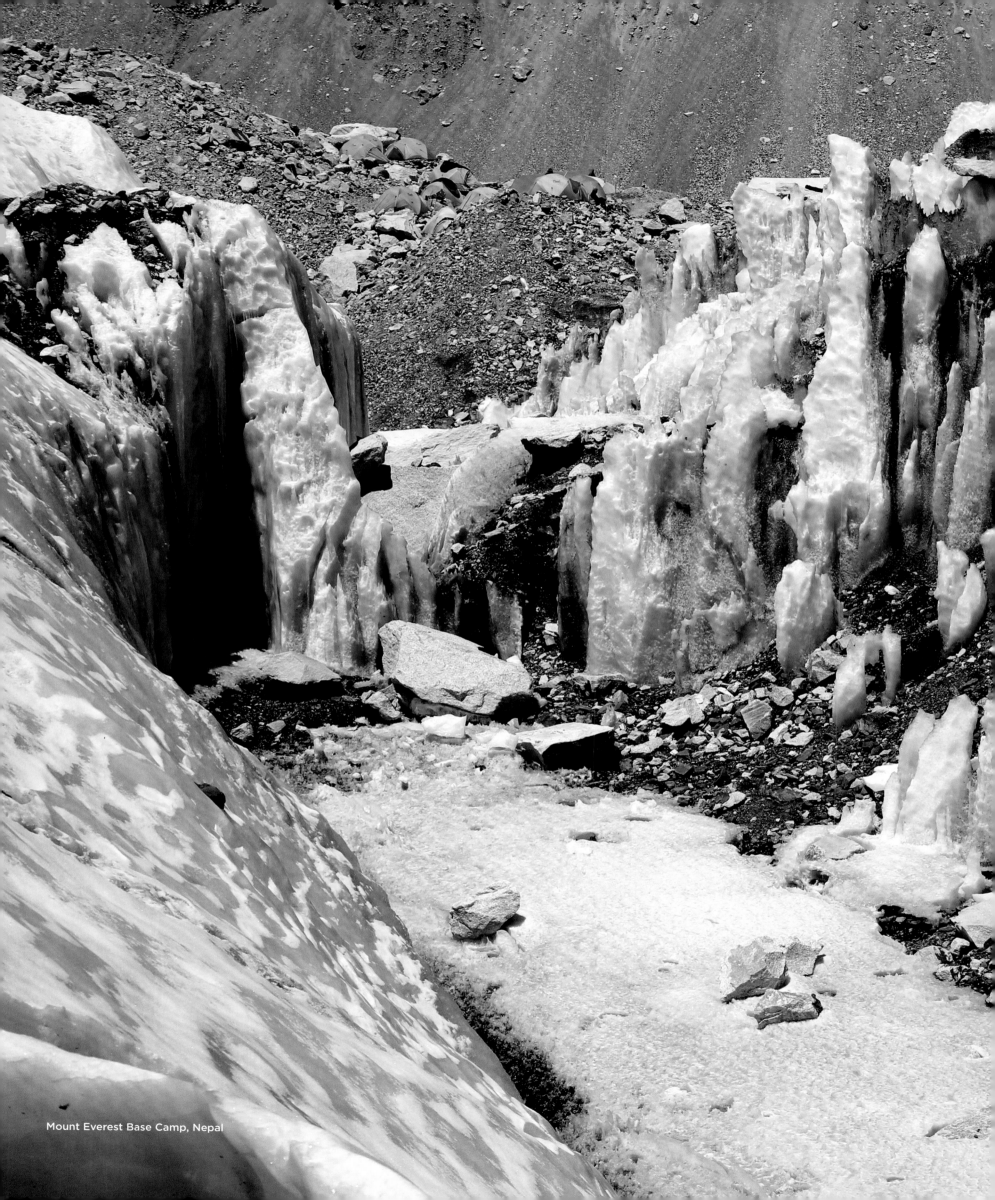

Mount Everest Base Camp, Nepal

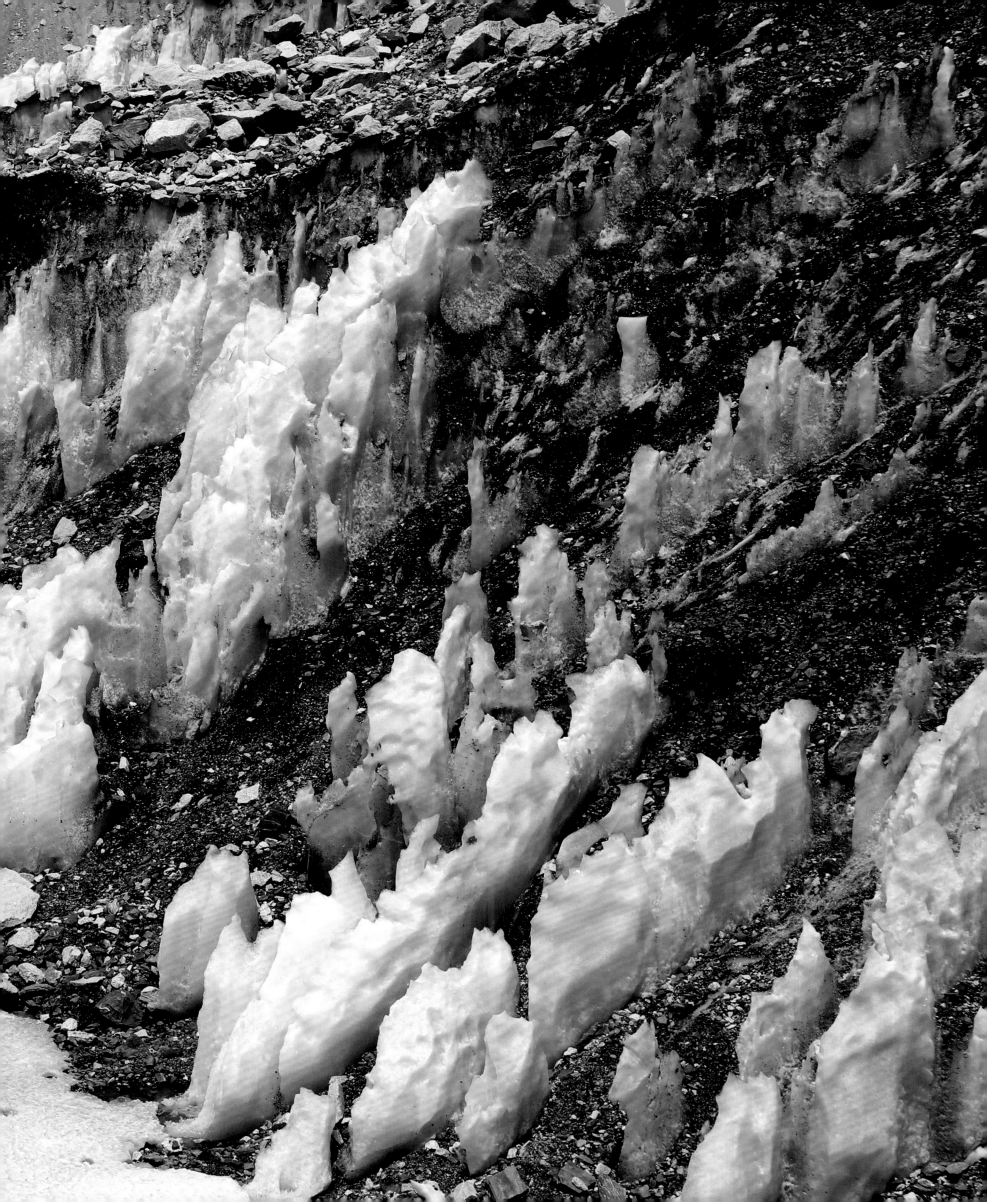

Chukar partridge, Hemis National Park, Ladakh, India

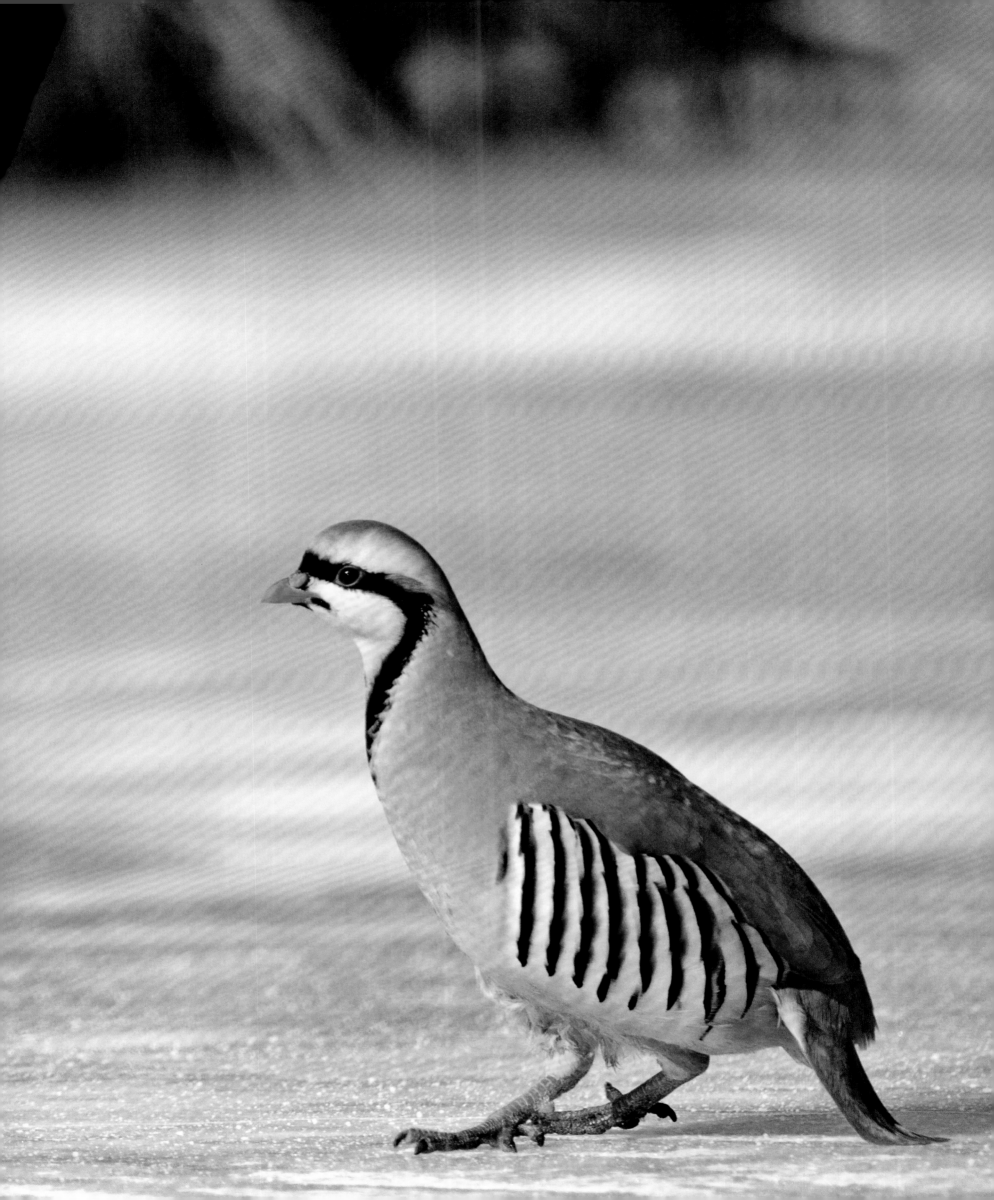

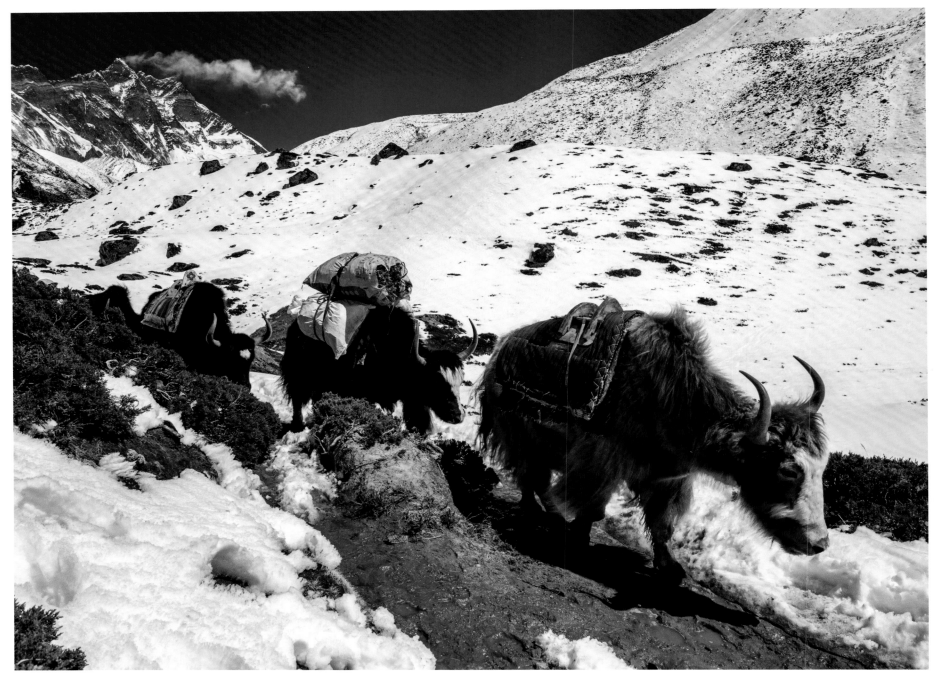

Dzos

Yaks

The yak is a domesticated cattle species which is kept in large numbers in Mongolia, the Himalayas and Siberia. Yaks are also called "Tibetan grunt oxen" because of their grunt-like sounds. The animals provide meat, milk, leather, hair and wool, and are ideal as pack animals as they are sure-footed on narrow paths. Due to their compact body and dense coat, they are perfectly adapted to the extreme cold of life in the mountains. They don't mind temperatures of minus 40°C (-40°F), but in summer the average temperature should not exceed 13°C (55°F) for them to feel comfortable.

Yaks

Les yaks sont une race de bœufs domestiqués dont la population reste élevée en Mongolie, dans l'Himalaya et en Sibérie. Les sons qu'ils émettent ressemblent à des grognements, ce qui leur vaut le surnom de « bœufs grognant ». Ces animaux procurent de la viande, du lait, du cuir, des poils et de la laine et font d'excellentes bêtes de somme grâce à leur stabilité même sur des sentiers étroits. Leur constitution physique compacte et leur pelage dense sont parfaitement adaptés à la montagne et au froid extrême, même par -40° C. En été, en revanche, il est préférable pour eux que les températures moyennes n'excèdent pas 13° C.

Yaks

Der Yak ist eine domestizierte Rinderart, die in der Mongolei, im Himalaya und in Sibirien in großer Zahl gehalten wird. Wegen ihrer grunzähnlichen Laute werden Yaks auch Tibetische Grunzochsen genannt. Die Tiere liefern Fleisch, Milch, Leder, Haar und Wolle und eignen sich hervorragend als Lasttiere, da sie trittsicher auch schmale Pfade bewältigen. Durch den kompakten Körperbau und das dichte Fell sind sie perfekt an das Leben im Gebirge mit extremer Kälte angepasst. Auch minus 40 °C machen ihnen nichts aus, im Sommer sollte jedoch die Durchschnittstemperatur 13 °C nicht überschreiten, damit sie sich wohlfühlen.

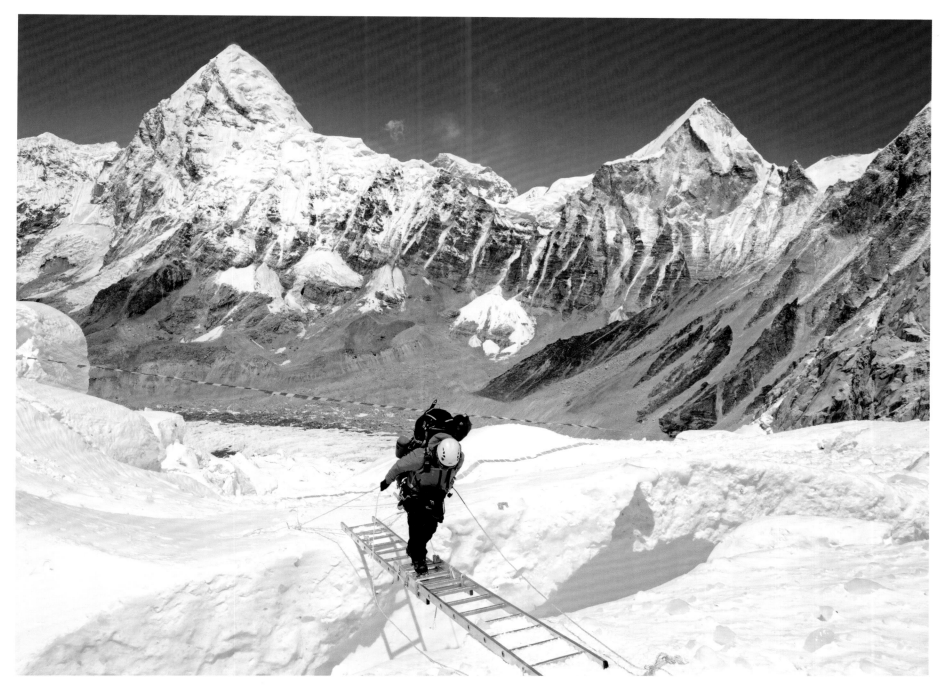

Khumbu Icefall, Mount Everest, Nepal

Yaks

El yak es una especie bovina domesticada que se mantiene en gran número en Mongolia, el Himalaya y Siberia. De estos animales se saca carne, leche, cuero, pelo y lana y son ideales como animales de carga, ya que son seguros para los caminos estrechos. Gracias a su cuerpo compacto y a su denso pelaje, se adaptan perfectamente a la vida en las montañas con frío extremo. No tienen ningún problema con temperaturas de -40 °C, pero en verano la temperatura media no debe superar los 13 °C para que se sientan cómodos.

Iaques

O iaque é uma espécie bovina domesticada que é mantida em grande número na Mongólia, nos Himalaias e na Sibéria. Os iaques também são chamados de Bos grunniens tibetanos por causa de seus sons grunhidos. Os animais fornecem carne, leite, couro, pêlo e lã e são ideais como animais de carga, pois têm pés seguros em caminhos estreitos. Devido ao seu corpo compacto e pelagem densa, adaptam-se perfeitamente à vida nas montanhas com frio extremo. Não se importam com os menos 40°C, mas no verão a temperatura média não deve exceder os 13°C para que se sintam bem.

Jakken

De Jak is een gedomesticeerde veesoort die in grote aantallen in Mongolië, de Himalaya en Siberië wordt gehouden. Ze zorgen voor vlees, melk, leer, haar en wol en zijn ideaal als lastdieren, omdat ze stabiel de smalle paden bewandelen. Door hun compacte lichaam en dichte vacht zijn ze perfect aangepast aan het leven in de bergen met extreme kou, zelfs -40°C stoort ze niet, maar in de zomer mag de gemiddelde temperatuur niet hoger zijn dan 13°C om zich comfortabel te voelen.

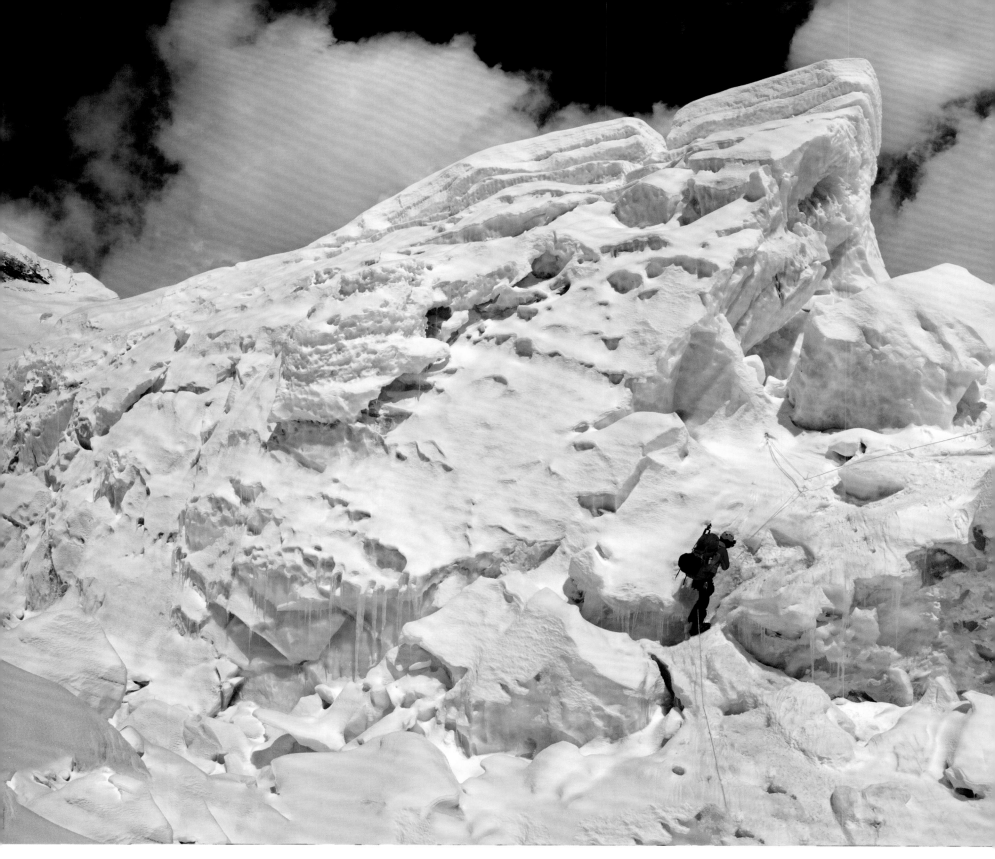

Khumbu Icefall, Mount Everest, Nepal

Khumbu Icefall

To stand once on the summit of Mount Everest, at 8848 m (29028 ft) the highest mountain on earth, is the dream of many extreme mountaineers. After an easy trekking tour to the base camp at an altitude of 5300 m (17388 ft), the Khumbu Glacier forms the first life-threatening obstacle. The glacier tongue is constantly in motion and forms a "river of ice". Crevasses can open without warning, huge towers of glacial ice (so-called seracs), collapse and avalanches are a constant danger. Despite ladders and fixed ropes, to crossing the Khumbu Icefall is dicing with death.

La cascade de glace du Khumbu

Se tenir au sommet de l'Everest, qui du haut de ses 8 848 m est la plus haute montagne de la planète, est le rêve de nombreux alpinistes de l'extrême. Après un trek aisé jusqu'au camp de base, situé à 5 300 m, le glacier du Khumbu est le premier obstacle potentiellement mortel. La langue de glace est en mouvement constant et forme une « rivière de glace ». Des crevasses qui s'ouvrent soudainement dans le sol, d'énormes amas de glace, les séracs, qui s'effondrent ou encore des avalanches qui représentent un danger permanent. Malgré les échelles et les cordes fixes, la traversée de la cascade de glace du Khumbu est un jeu avec la mort.

Khumbu-Eisbruch

Einmal auf dem Gipfel des Mount Everest, dem mit 8848 m höchsten Berg der Erde, zu stehen, ist der Traum vieler Extrembergsteiger. Nach einer leichten Trekkingtour zum Basislager auf 5300 m Höhe bildet der Khumbu-Gletscher das erste lebensgefährliche Hindernis. Die Gletscherzunge ist ständig in Bewegung und bildet einen „Fluss aus Eis". Spalten öffnen sich ohne Vorwarnung, riesige Türme aus Gletschereis, die sogenannten Seracs, stürzen in sich zusammen und auch Lawinenabgänge bilden eine ständige Gefahr. Trotz Leitern und Fixseilen ist die Überwindung des Khumbu-Eisbruches ein Spiel mit dem Tod.

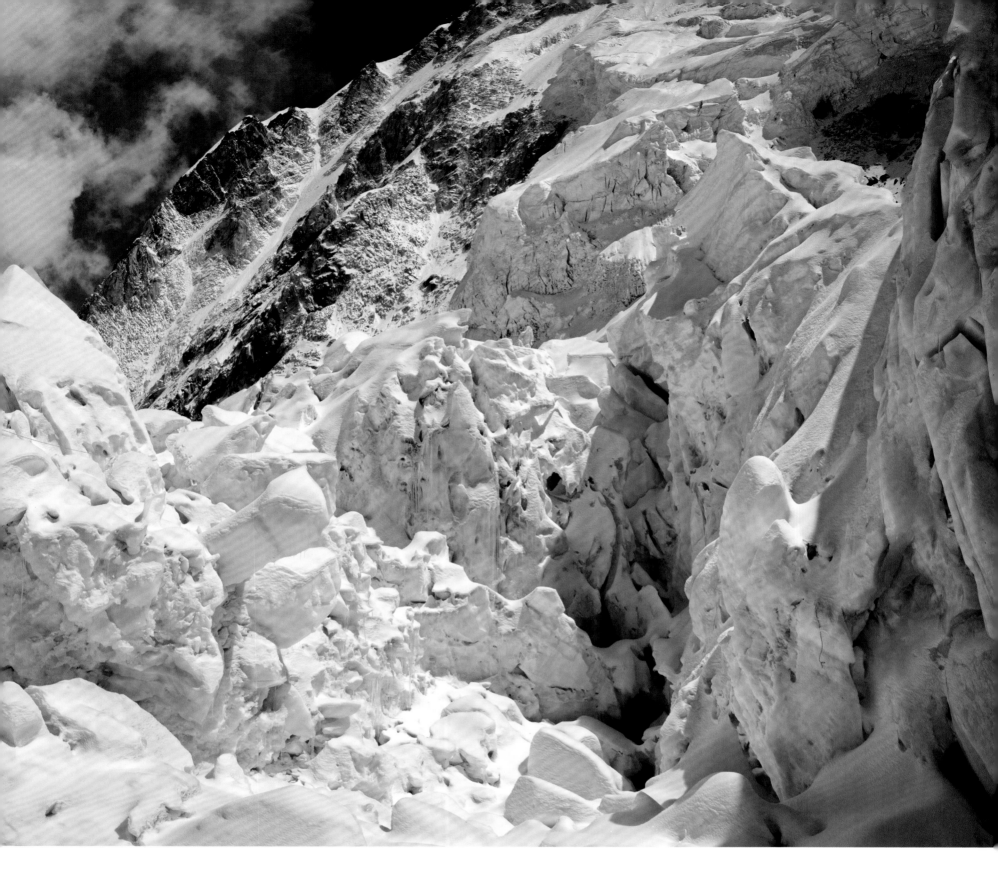

Cascada de hielo del Khumbu

Estar una vez en la cima del Monte Everest (con sus 8848 m, la montaña más alta del mundo) es el sueño de muchos montañeros extremos. Después de una sencilla ruta de trekking al campamento base a 5300 m de altitud, el glaciar Khumbu es el primer obstáculo que amenaza la vida. La lengua del glaciar se encuentra en constante movimiento y forma un «río de hielo». Las grietas se abren sin previo aviso, las enormes torres de hielo glaciar, los llamados seracs, el colapso y las avalanchas son un peligro constante. A pesar de las escaleras y las cuerdas fijas, para superar la cascada de hielo del Khumbu hay que jugarse la vida.

Cascada de Gelo do Khumbu

Estar uma vez no topo do Monte Everest, com 8848 m a montanha mais alta do mundo, é o sonho de muitos alpinistas extremos. Depois de um fácil passeio de trekking até o acampamento base a 5300 m de altitude, o Glaciar Khumbu forma o primeiro obstáculo com risco de vida. A língua glaciar está constantemente em movimento e forma um "rio de gelo". Fendas abertas sem aviso prévio, enormes torres de gelo glacial, os chamados seracs, colapso e avalanches são um perigo constante. Apesar de escadas e cordas fixas, superar a cascada de gelo do Khumbu é brincar com a morte.

Khumbu Icefall

De droom van veel extreme bergbeklimmers is eenmaal op de top van de Mount Everest te staan, wat met 8848 m de hoogste berg ter wereld is. Na een gemakkelijke trekking tour naar het basiskamp op 5300 m hoogte, vormt de Khumbu Gletsjer het eerste levensbedreigende obstakel. De gletsjertong is voortdurend in beweging en vormt een „rivier van ijs". Scheuren die zonder waarschuwing opengaan, grote torens van gletsjerijs, de zogenaamde Seracs storten in en lawines vormen een voortdurend gevaar. Ondanks ladders en vaste touwen is het overwinnen van de Khumbu Icefall een spel op leven en dood.

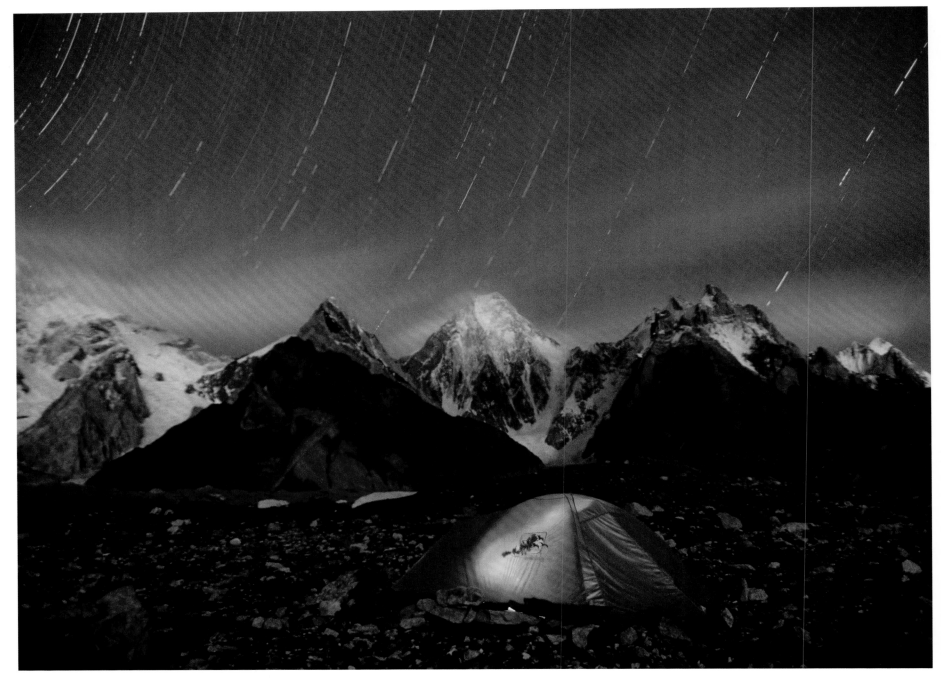

Masherbrum, Karakoram, Pakistan

The Highest Mountains in the World

All fourteen mountains of our planet which are higher than 8000 m (26246 ft) lie in the Himalayas. These are: Mount Everest, K 2, Kangchendzönga, Lhotse, Makalu, Cho Oyu, Dhaulagiri I, Manaslu, Nanga Parbat, Annapurna I, Gasherbrum I, Broad Peak, Gasherbrum II and Shishapangma. Mount Everest was first climbed by New Zealander Edmund Hillary and Sherpa Tenzing Norgay in 1953 as part of a major expedition. The first people to reach the summit of Mount Everest without bottled oxygen were South Tyrolean Reinhold Messner and Austrian Peter Habeler in 1978.

Les plus hauts sommets du monde

Les 14 sommets de notre planète dépassant les 8 000 m d'altitude se trouvent dans l'Himalaya. Il s'agit de l'Everest, du K2, du Kangchenjunga, du Lhotse, du Makalu, du Cho Oyu, du Dhaulagiri, du Manaslu, du Nanga Parbat, de l'Annapurna I, du Gasherbrum I, du Broad Peak, du Gasherbrum II et du Shishapangma. L'Everest fut escaladé pour la première fois par le Néo-Zélandais Edmund Hillary et le sherpa Tensing Norgay en 1953, dans le cadre d'une grande expédition. Les premiers hommes à avoir atteint le sommet de l'Everest sans l'aide de bouteilles d'oxygène furent le Tyrolien du Sud Reinhold Messner et l'Autrichien Peter Habeler en 1978.

Die höchsten Berge der Welt

Alle vierzehn Berge unseres Planeten, die höher als 8000 m sind, liegen im Himalaya. Dies sind: Mount Everest, K 2, Kangchendzönga, Lhotse, Makalu, Cho Oyu, Dhaulagiri I, Manaslu, Nanga Parbat, Annapurna I, Gasherbrum I, Broad Peak, Gasherbrum II und Shishapangma. Der Mount Everest wurde erstmals von dem Neuseeländer Edmund Hillary und dem Sherpa Tenzing Norgay 1953 im Rahmen einer großen Expedition bestiegen. Die ersten Menschen, die den Gipfel des Mount Everest ohne Hilfe von Flaschen-Sauerstoff erreichten, waren der Südtiroler Reinhold Messner und der Österreicher Peter Habeler 1978.

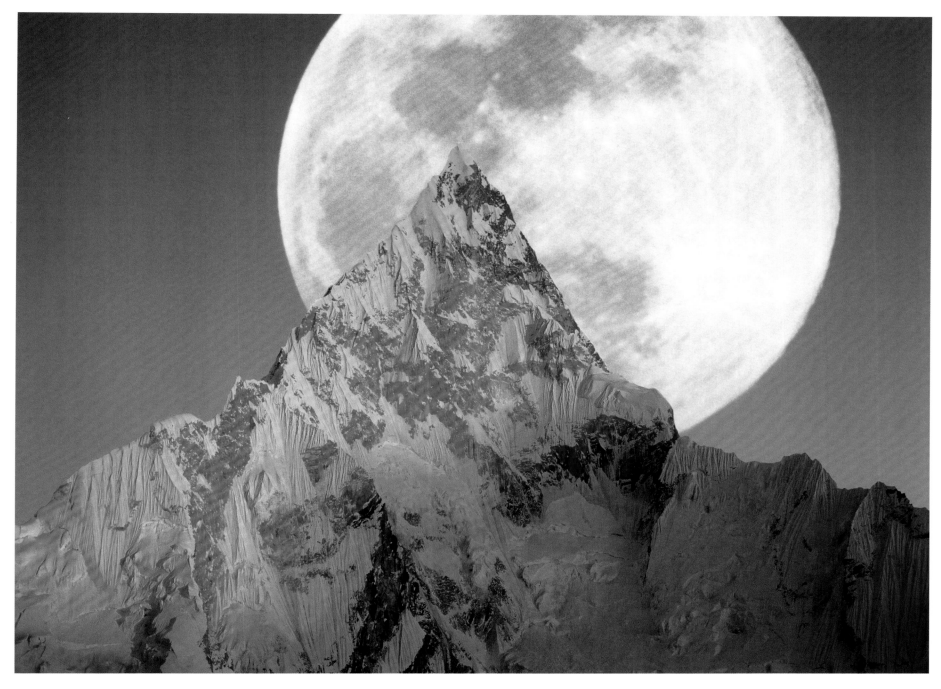

Moonrise, Himalaya

Las montañas más altas del mundo

Las catorce montañas de nuestro planeta que superan los 8000 m de altitud se encuentran en el Himalaya. Son el monte Everest, K 2, Kangchendzönga, Lhotse, Makalu, Cho Oyu, Dhaulagiri I, Manaslu, Nanga Parbat, Annapurna I, Gasherbrum I, Broad Peak, Gasherbrum II y Shishapangma. El monte Everest fue escalado por el neozelandés Edmund Hillary y el sherpa Tenzing Norgay en 1953 como parte de una gran expedición. Las primeras personas que llegaron a la cima del Everest sin oxígeno embotellado fueron Reinhold Messner del Tirol del Sur y el austríaco Peter Habeler en 1978.

As montanhas mais altas do mundo

Todas as quatorze montanhas do nosso planeta, com mais de 8000 m, estão localizadas no Himalaia. Estes são: Monte Everest, K 2, Kangchenjunga, Lhotse, Makalu, Cho Oyu, Dhaulagiri I, Manaslu, Nanga Parbat, Annapurna I, Gasherbrum I, Broad Peak, Gasherbrum II e Shishapangma. O Monte Everest foi escalado pela primeira vez pelo neozelandês Edmund Hillary e por Sherpa Tenzing Norgay em 1953 como parte de uma grande expedição. As primeiras pessoas a chegar ao cume do Monte Everest sem ajuda do oxigênio engarrafado foram Reinhold Messner, do Tirol do Sul, e o austríaco Peter Habeler em 1978.

De hoogste bergen ter wereld

Alle veertien bergen van onze planeet die hoger dan 8000 m zijn, liggen in de Himalaya. Deze zijn: Mount Everest, K2, Kangchenjunga, Lhotse, Makalu, Cho Oyu, Dhaulagiri I, Manaslu, Nanga Parbat, Annapurna I, Gasherbrum I, Broad Peak, Gasherbrum II en Shishapangma. De Mount Everest werd voor het eerst in 1953 beklommen door Nieuw-Zeelander Edmund Hillary en Sherpa Tenzing Norgay als onderdeel van een grote expeditie. De eerste mensen die de top van de Mount Everest zonder zuurstofflessen bereikten, waren de Zuid-Tiroolse Reinhold Messner en de Oostenrijker Peter Habeler in 1978.

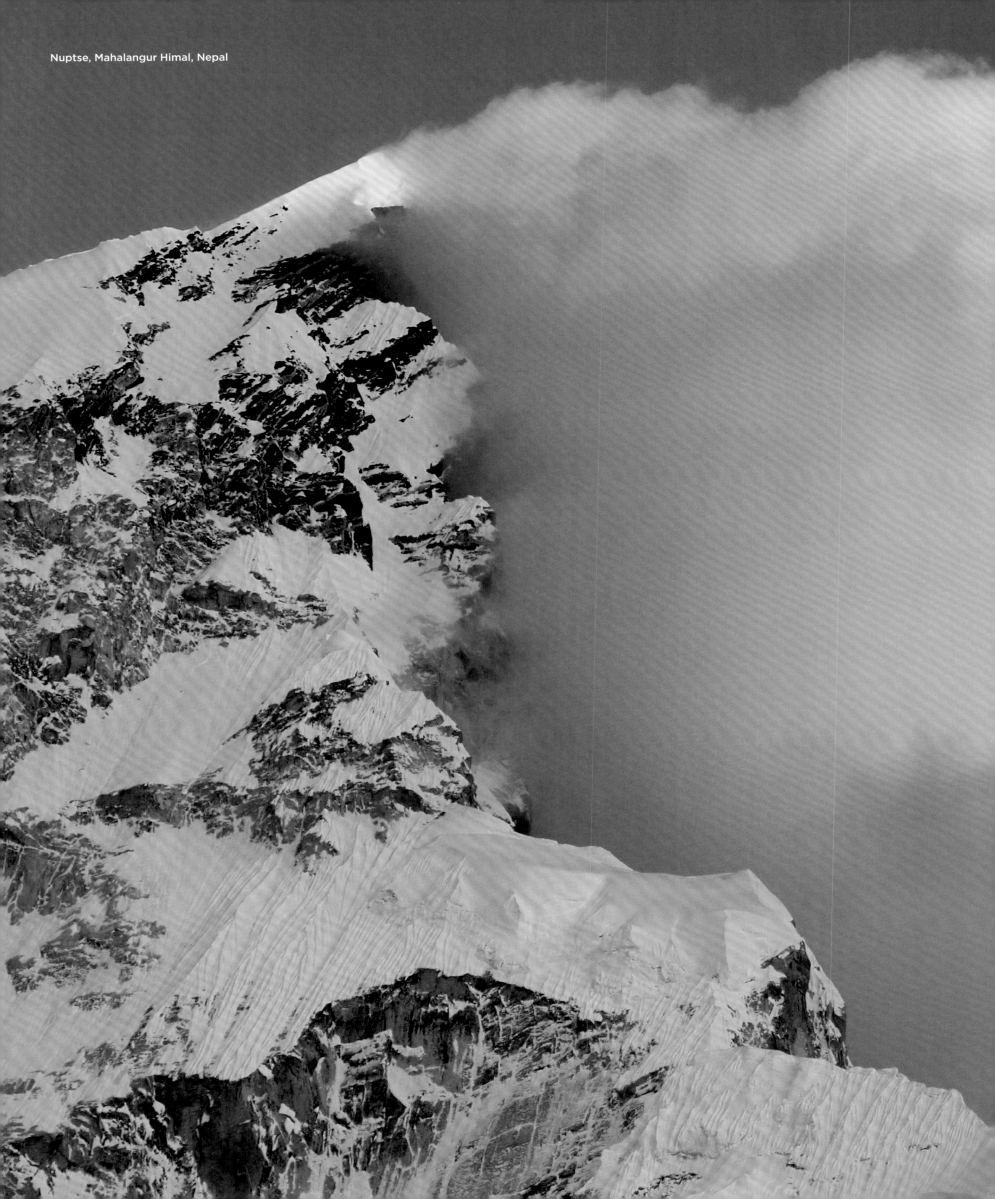

Nuptse, Mahalangur Himal, Nepal

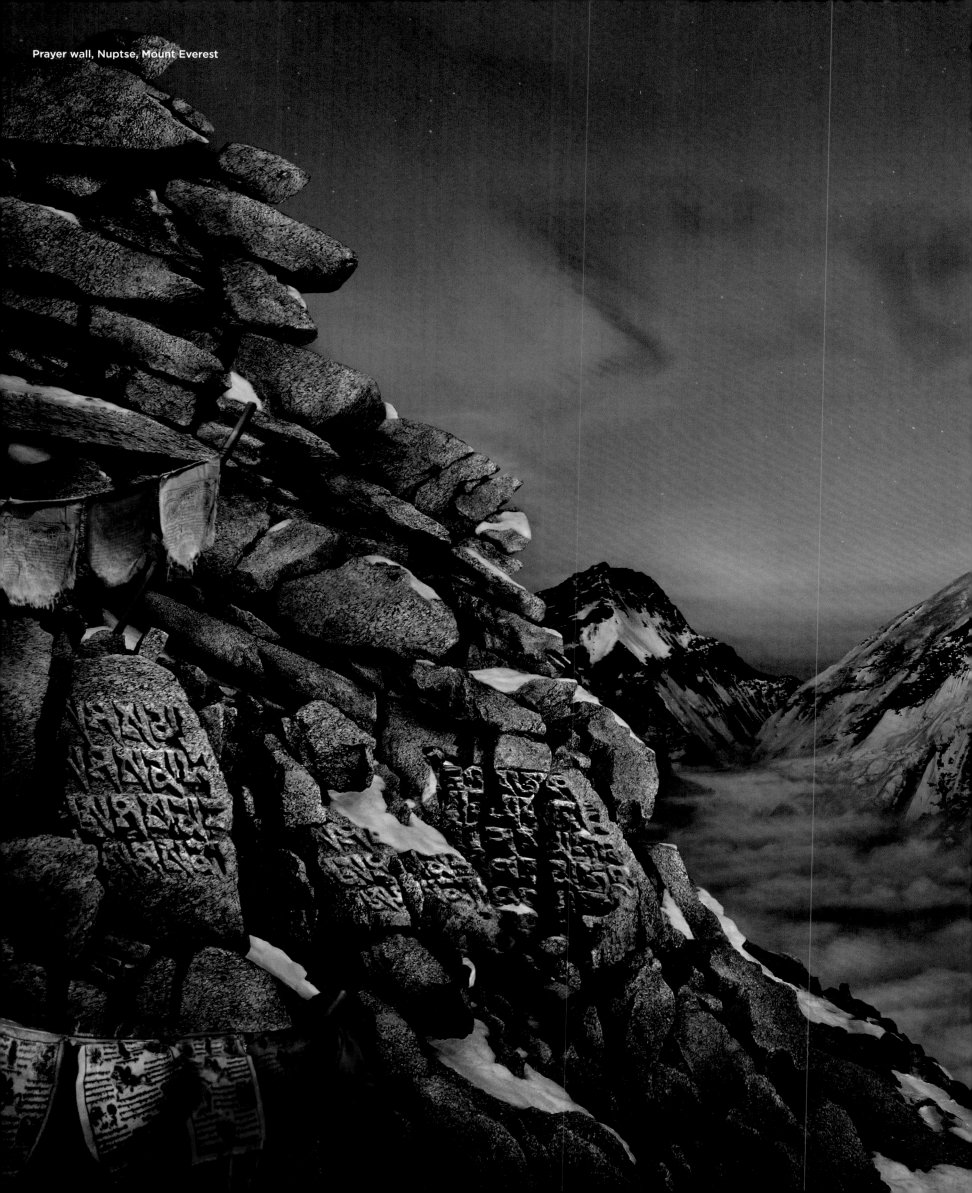

Prayer wall, Nuptse, Mount Everest

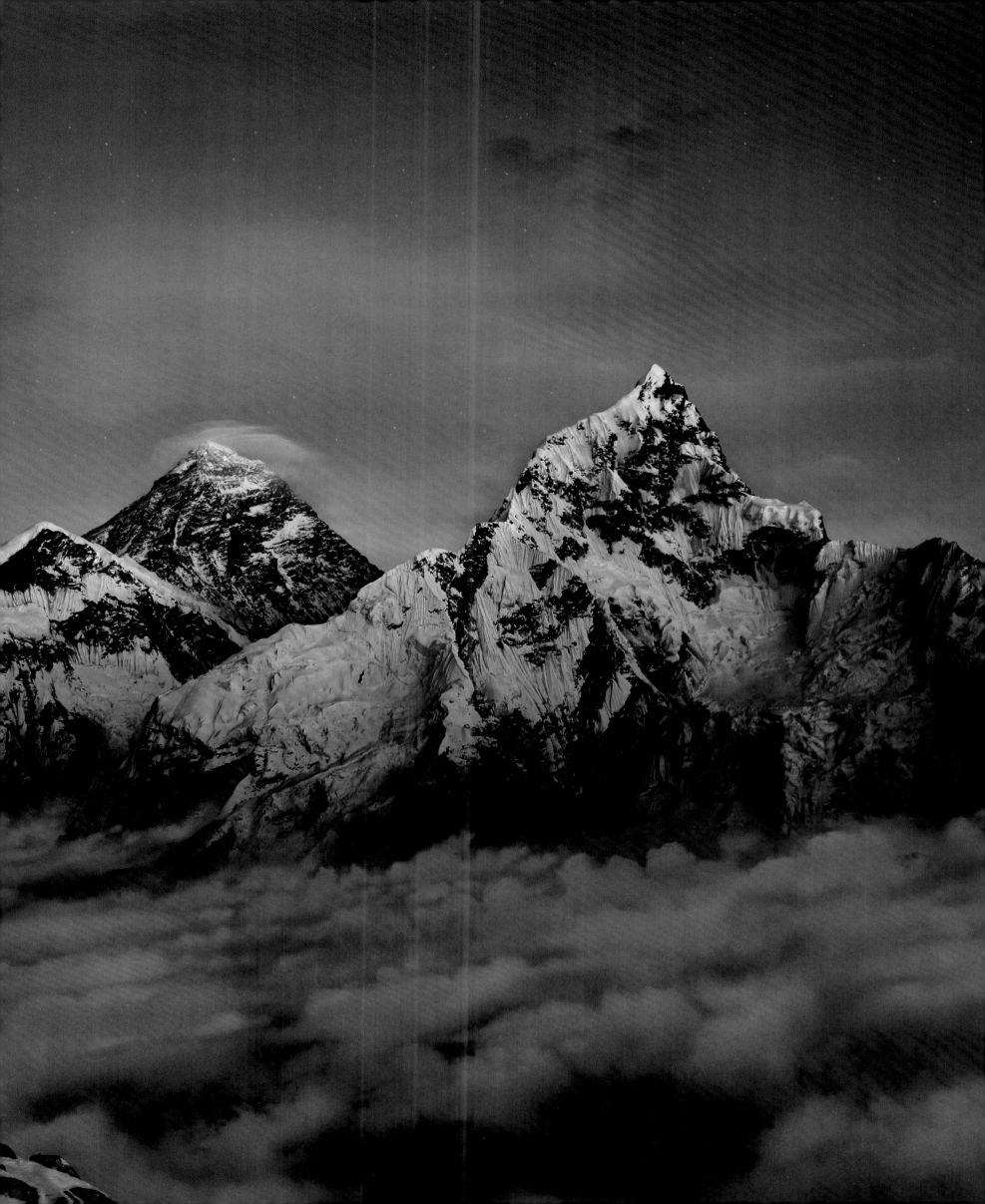

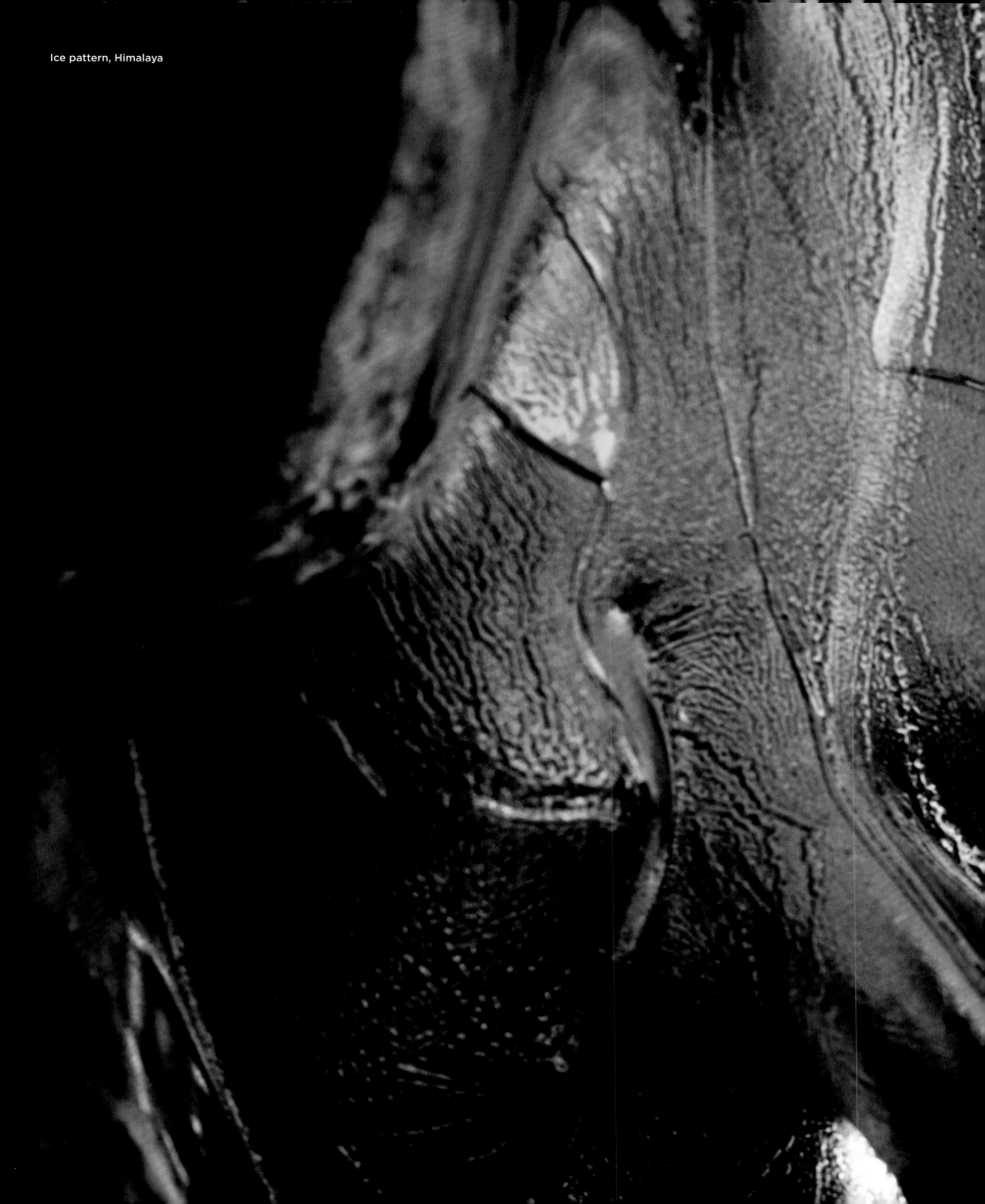

Ice pattern, Himalaya

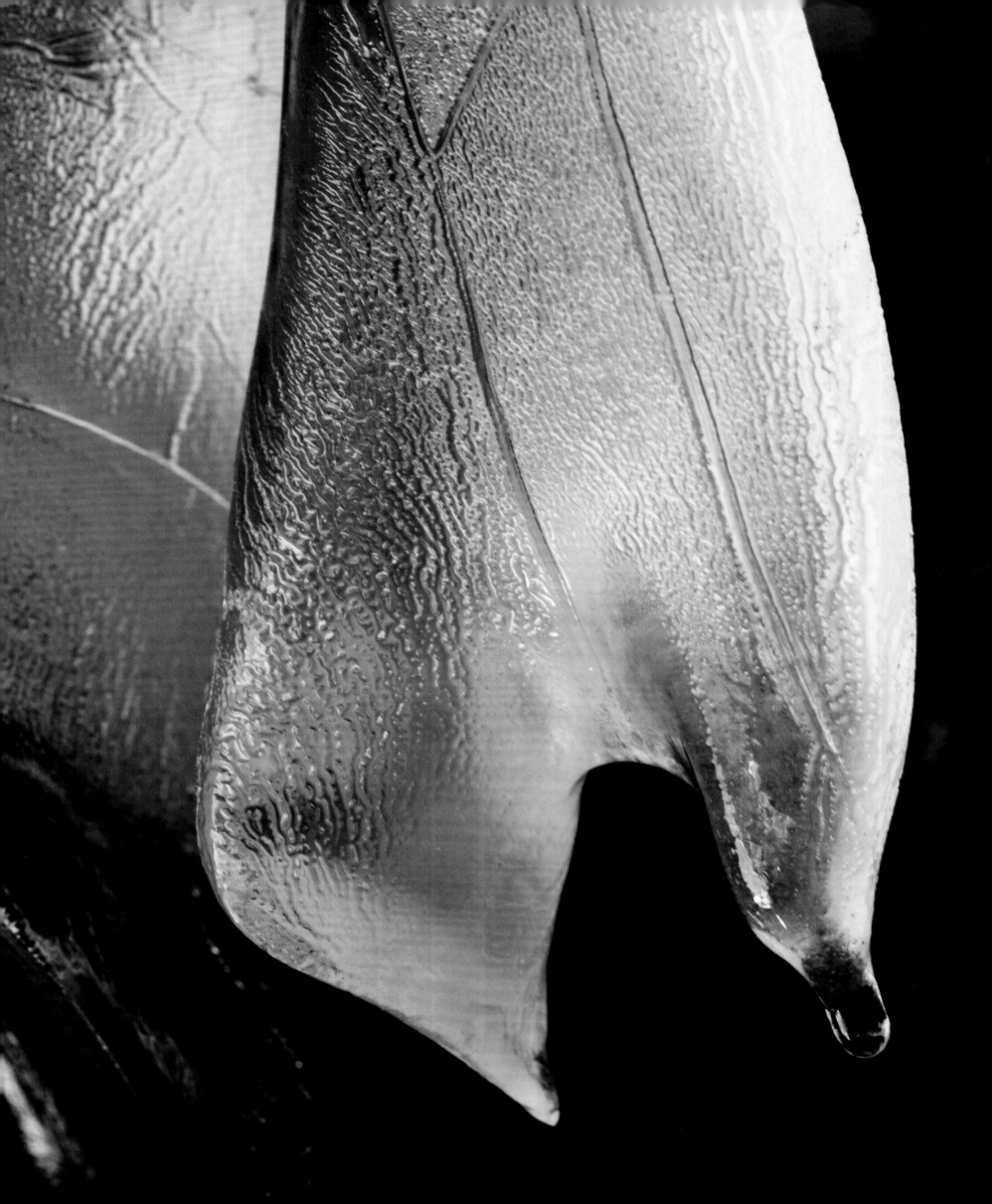

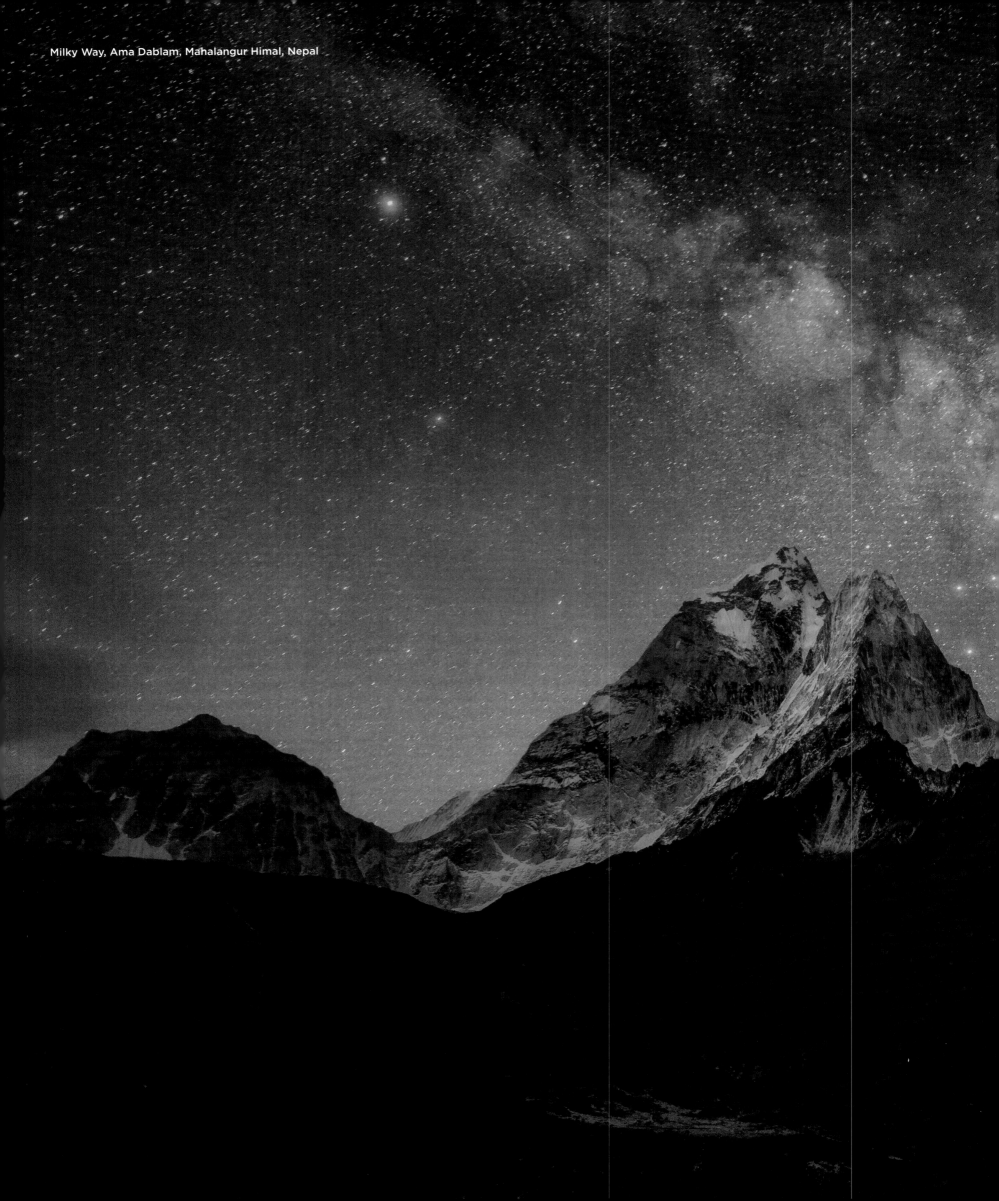

Milky Way, Ama Dablam, Mahalangur Himal, Nepal

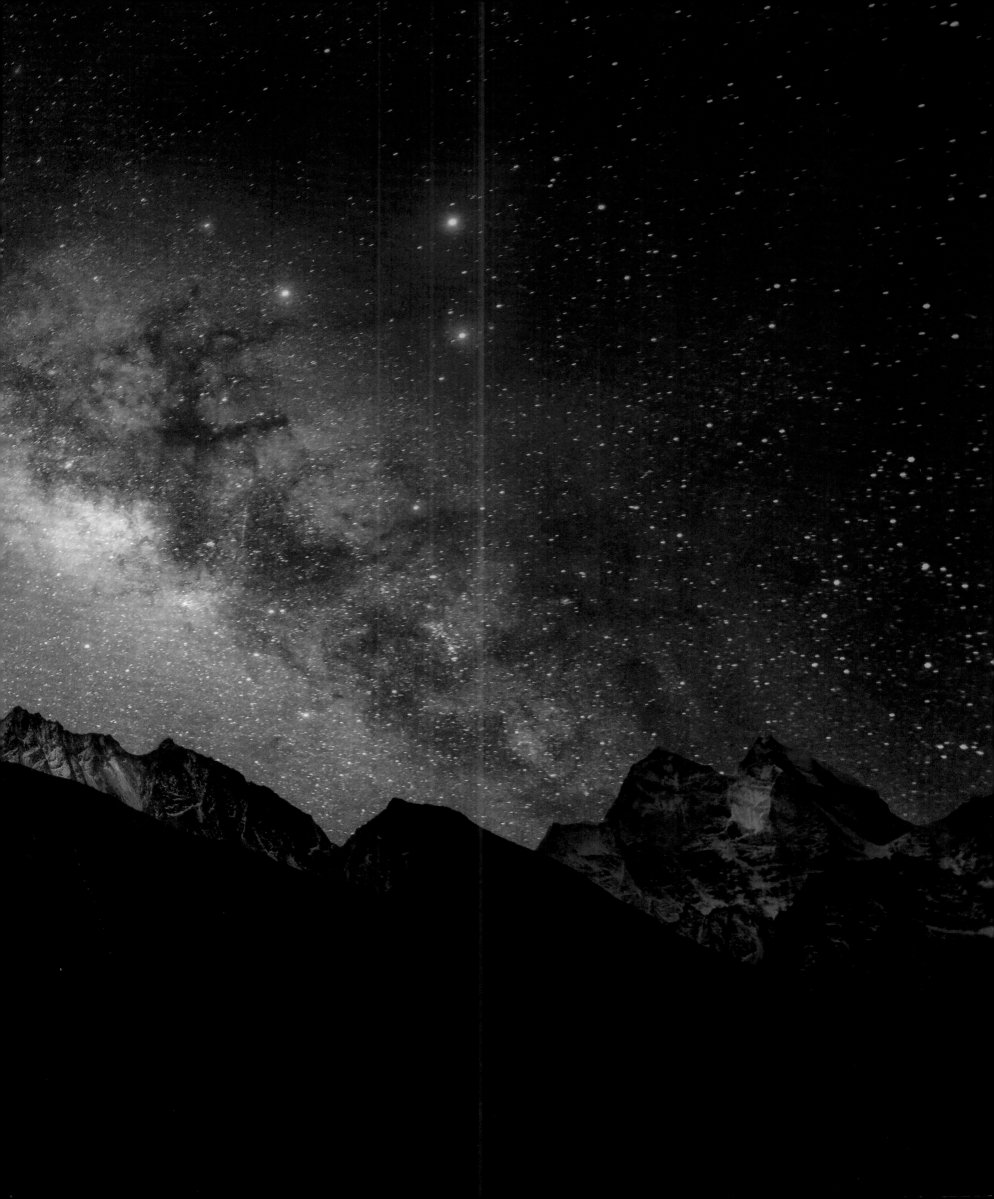

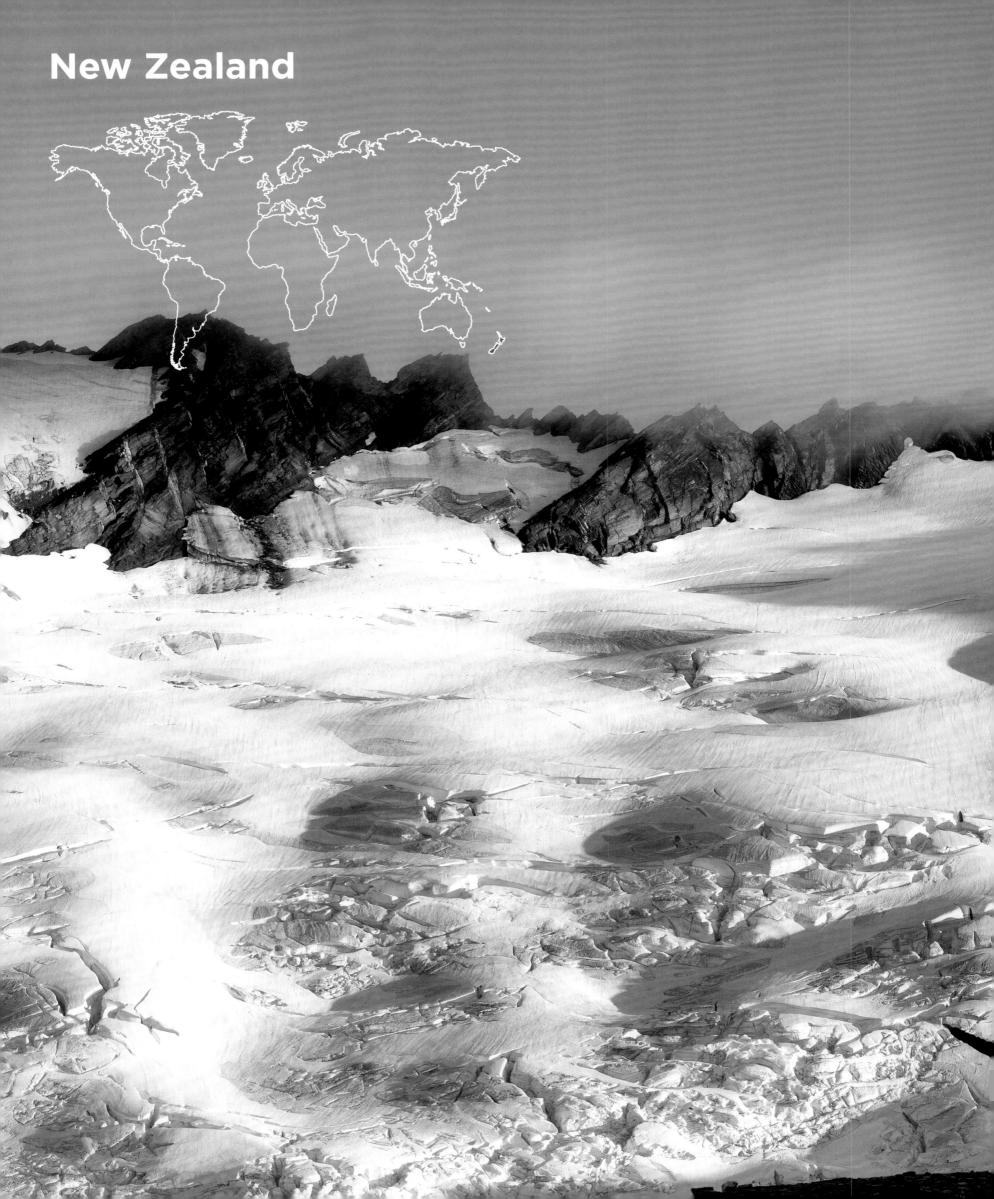

New Zealand

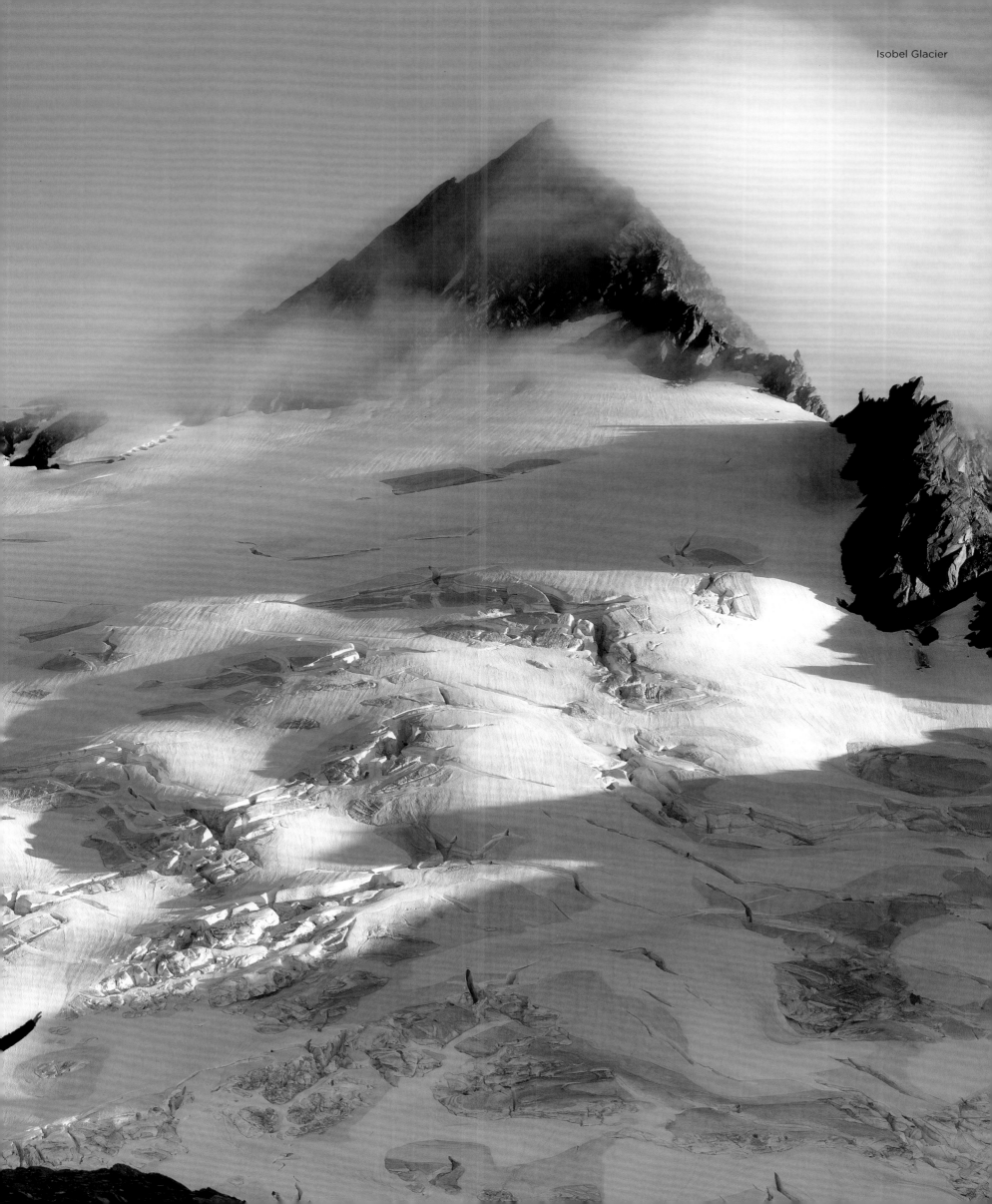

Isobel Glacier

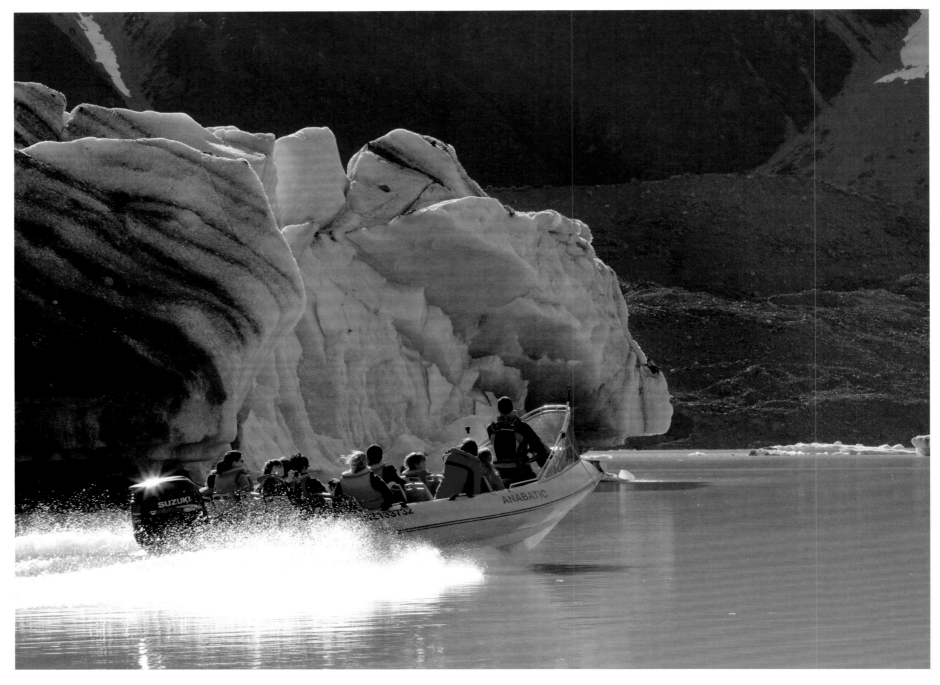

Tasman Glacier, Mount Cook National Park

New Zealand

From subtropical plains in the north to high alpine, glaciated mountain regions in the south, New Zealand has a wide range of climate zones. In the Southern Alps there are 17 peaks over 3000 m (9842 ft), the highest of which is Aoraki/Mount Cook at 3724 m (12217 ft). Fire and ice are typical components of these two islands which are located on the Pacific Ring of Fire: there are active volcanoes in the North Island, glaciers in the South Island. The film adaptation of the adventure epic "The Lord of the Rings" in New Zealand made the wild mountain landscape world famous, and this island nation is a desirable destination for numerous tourists.

Nouvelle-Zélande

Entre ses plaines subtropicales au nord et ses régions de hautes montagnes couvertes de glaciers au sud, la Nouvelle-Zélande est constituée d'un large spectre de zones climatiques. Dans les Alpes du Sud, plus de 17 sommets excèdent les 3 000 m d'altitude, le plus haut étant l'Aoraki ou le Mont Cook, à 3 724 m. Le feu et la glace sont des éléments représentatifs de ces deux îles situées sur la ceinture de feu du Pacifique : l'île du Nord abrite des volcans actifs, l'île du Sud, des glaciers. L'adaptation cinématographique de l'épopée du *Seigneur des anneaux*, tournée en Nouvelle-Zélande, rendit mondialement célèbre ces paysages montagneux sauvages, faisant de cet État insulaire une destination prisée de nombreux touristes.

Neuseeland

Von subtropischen Ebenen im Norden bis zu hochalpinen, vergletscherten Gebirgsregionen im Süden weist Neuseeland eine große Bandbreite von Klimazonen auf. In den Neuseeländischen Alpen gibt es 17 Gipfel über 3000 m, der höchste ist der Aoraki/Mount Cook mit 3724 m. Feuer und Eis sind typische Bestandteile der auf dem Pazifischen Feuerring gelegenen Doppelinsel: Aktive Vulkane gibt es auf der Nordinsel, Gletscher auf der Südinsel. Die Verfilmung des Abenteuer-Epos „Der Herr der Ringe" in Neuseeland machte die wilde Berglandschaft weltbekannt und den Inselstaat zu einem Sehnsuchtsziel zahlreicher Touristen.

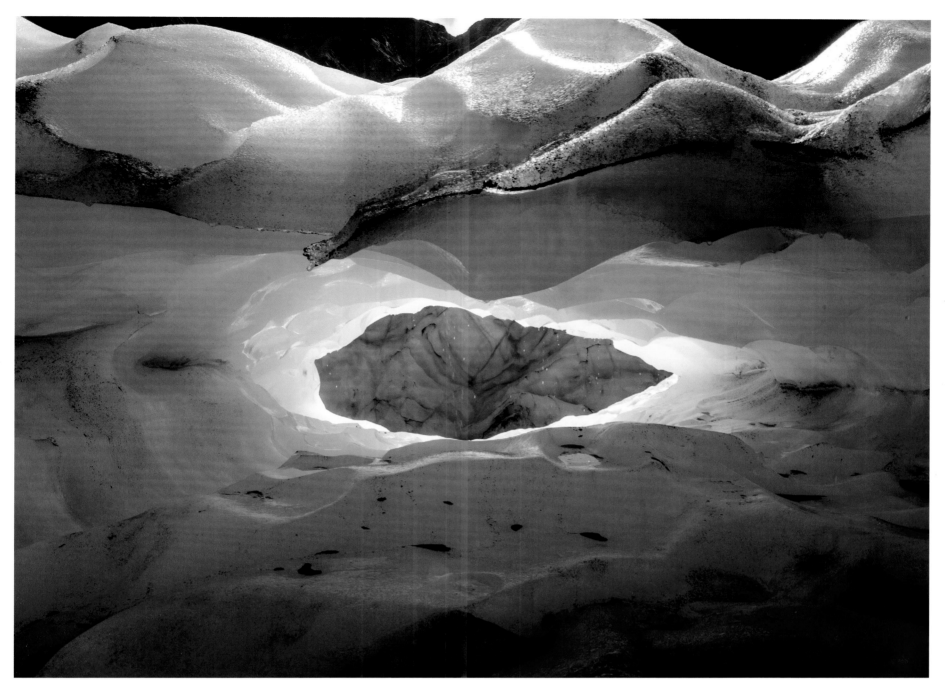
Ice cave, Fox Glacier

Nueva Zelanda

Desde las llanuras subtropicales en el norte hasta las regiones montañosas de alta montaña glaciada en el sur, Nueva Zelanda tiene una gran variedad de zonas climáticas. En los Alpes de Nueva Zelanda hay 17 picos de más de 3000 m (el más alto es Aoraki/monte Cook, con 3724 m). El fuego y el hielo son componentes típicos de la doble isla situada en el Cinturón de Fuego del Pacífico: hay volcanes activos en la Isla Norte y glaciares en la Isla Sur. La adaptación cinematográfica de la aventura épica «El Señor de los Anillos» en Nueva Zelanda hizo mundialmente famoso el paisaje montañoso salvaje y el estado insular un destino anhelado por numerosos turistas.

Nova Zelândia

Desde as planícies subtropicais no norte até as regiões montanhosas altas alpinas e glaciares no sul, a Nova Zelândia tem uma grande variedade de zonas climáticas. Nos Alpes da Nova Zelândia há 17 picos com mais de 3000 m, o mais alto é o Monte Cook/Aoraki com 3724 m. O fogo e o gelo são componentes típicos da ilha dupla localizada no Anel de Fogo do Pacífico: há vulcões ativos na Ilha Norte, geleiras na Ilha Sul. A adaptação cinematográfica do épico de aventura "O Senhor dos Anéis" na Nova Zelândia tornou a paisagem montanhosa selvagem mundialmente famosa e a nação insular um destino ansioso para inúmeros turistas.

Nieuw-Zeeland

Nieuw-Zeeland heeft een breed scala aan klimaatzones, van subtropische vlakten in het noorden tot hoogalpiene, vergletsjerde berggebieden in het zuiden. In de Nieuw-Zeelandse Alpen zijn 17 pieken van meer dan 3000 m, de hoogste is Aoraki/Mount Cook met 3724 m. Vuur en ijs zijn typische componenten van het dubbele eiland op de Pacific Ring of Fire: er zijn actieve vulkanen op het Noordereiland, gletsjers op het Zuidereiland. De verfilming van „The Lord of the Rings" in Nieuw-Zeeland maakte het wilde berglandschap wereldberoemd waardoor het eiland een populaire bestemming voor vele toeristen is geworden.

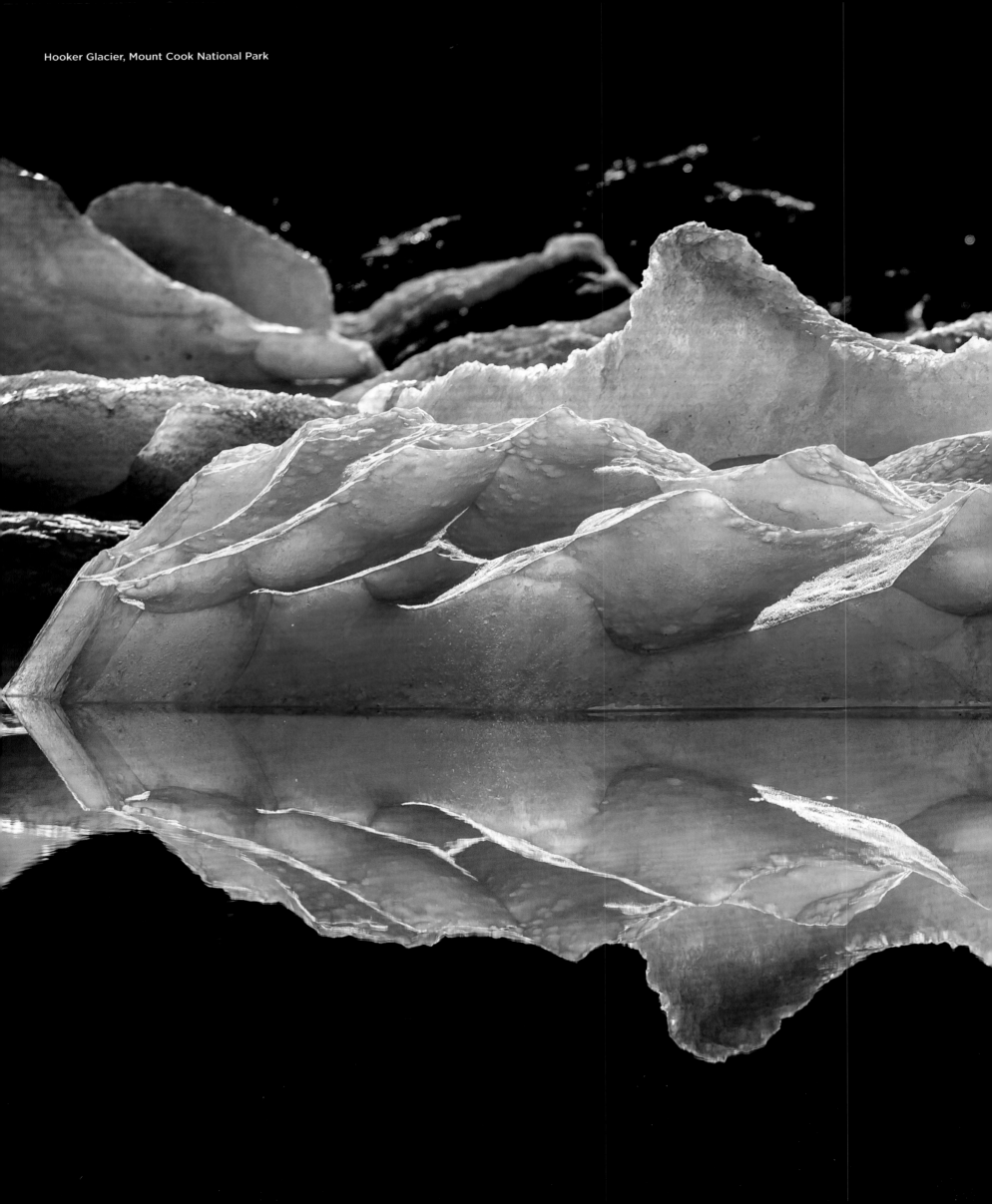

Hooker Glacier, Mount Cook National Park

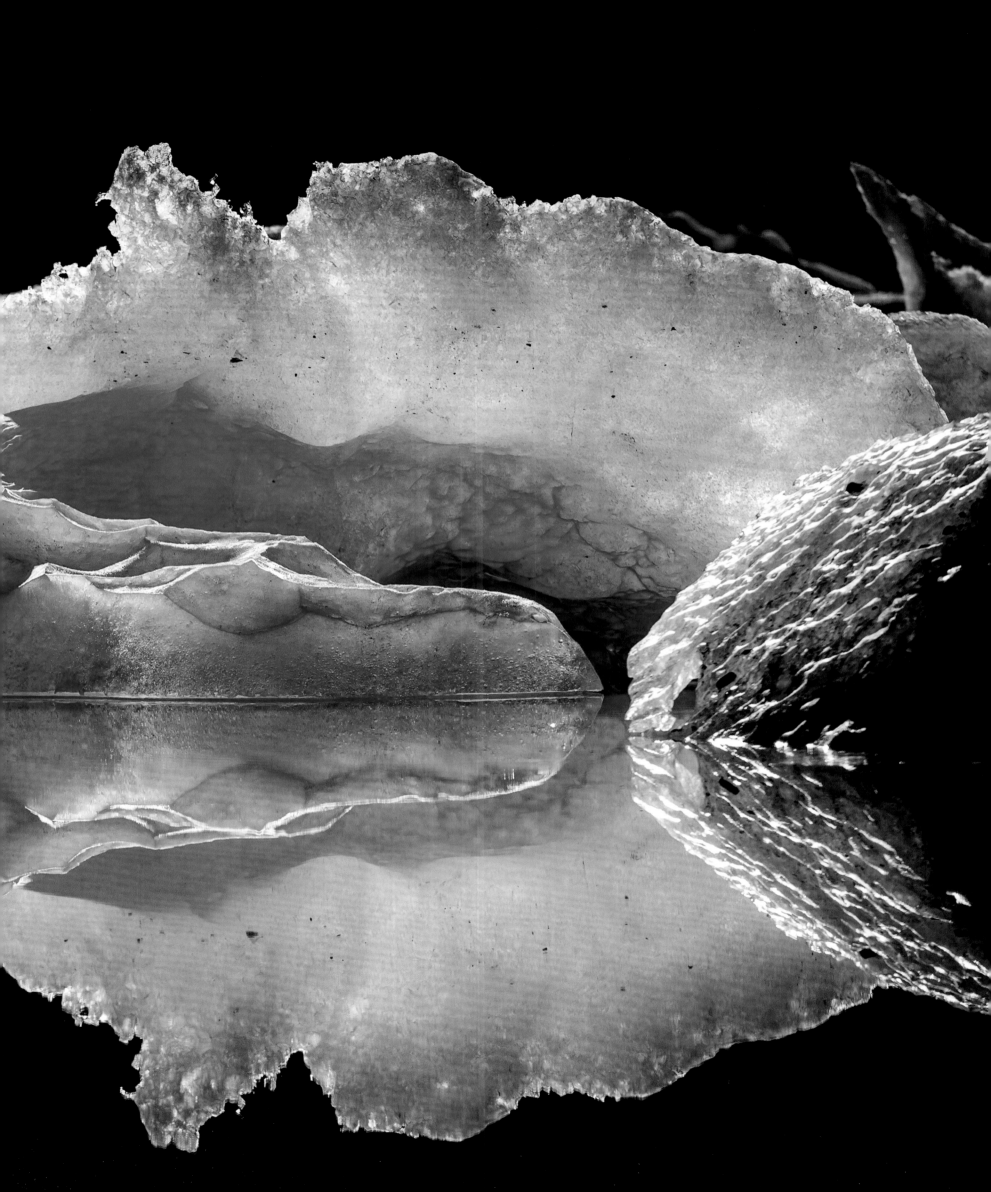

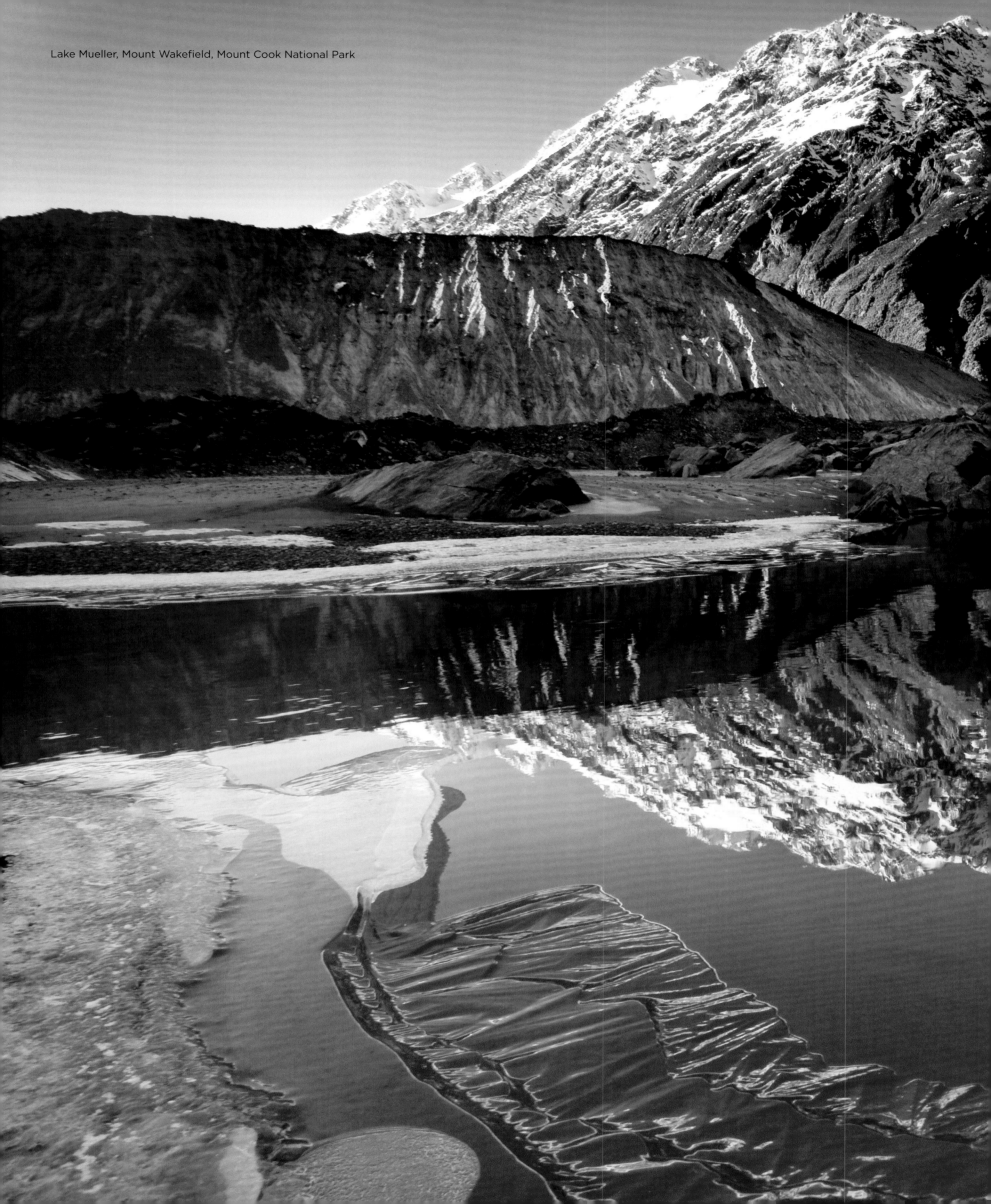

Lake Mueller, Mount Wakefield, Mount Cook National Park

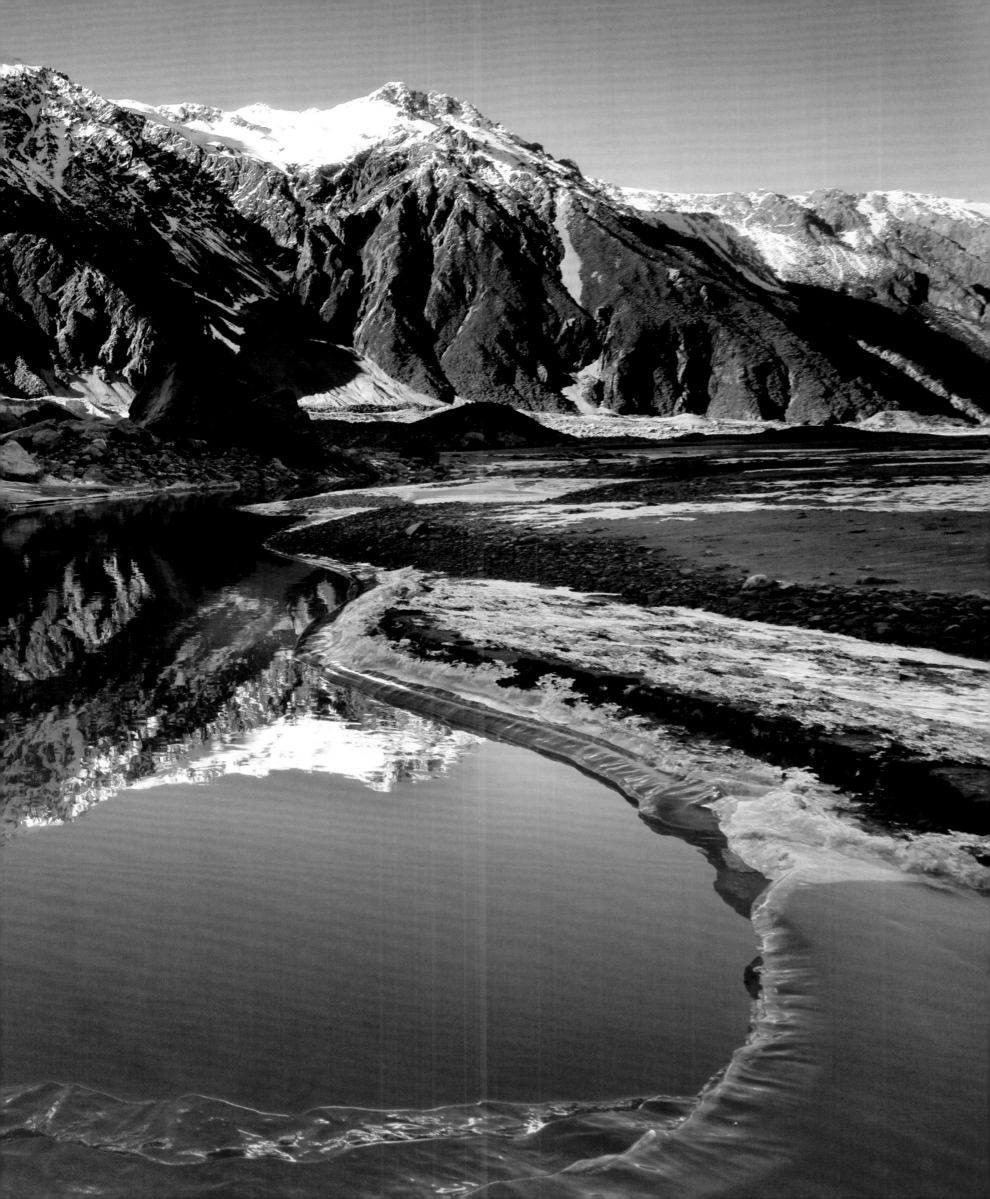

Syme Hut, Fanthams Peak, Mount Taranaki, Egmont National Park

National Parks

New Zealand's highest mountain has a double name: Mount Cook is named after the English navigator James Cook. The second name, Aoraki, comes from the Maori, the indigenous people of New Zealand whose cultural traditions are now more widely recognized in New Zealand society. Aoraki/Mount Cook gives its name to a 723 km² (279 sq mi) national park, one of ten national parks in the South Island, most of which are located in the Southern Alps. There are four national parks in the North Island, including Egmont National Park, which surrounds the 2518 m (8261 ft) volcano Mount Taranaki.

Parcs nationaux

Le plus haut sommet de Nouvelle-Zélande porte un double nom : il est appelé mont Cook en l'honneur de l'explorateur anglais James Cook, et Aoraki, un mot issu de la langue des Maoris, le peuple autochtone néo-zélandais, dont les traditions culturelles sont désormais bien ancrées au sein de la société néo-zélandaise. L'Aoraki/mont Cook est aussi le nom d'un parc national de 723 km², l'un des 10 parcs nationaux de l'île du Sud, dont la plupart sont dans les Alpes du Sud. Sur l'île du Nord il existe 4 parcs nationaux, dont le parc national d'Egmont autour du volcan du mont Taranaki/Egmont , qui mesure 2 518 m.

Nationalparks

Der höchste Berg Neuseelands trägt einen Doppelnamen: Mount Cook heißt er nach dem englischen Seefahrer James Cook. Der zweite Name Aoraki stammt aus der Sprache der Maori, der neuseeländischen Ureinwohner, deren kulturelle Traditionen in der neuseeländischen Gesellschaft inzwischen mehr anerkannt werden. Der Aoraki/Mount Cook ist Namensgeber des 723 km² großen Nationalparks, einer der zehn Nationalparks auf der Südinsel, von denen die meisten in den Neuseeländischen Alpen liegen. Auf der Nordinsel gibt es vier Nationalparks, darunter den Egmont-Nationalpark um den 2518 m hohen Vulkan Mount Taranaki.

Hawkdun Range, Central Otago

Parques nacionales

La montaña más alta de Nueva Zelanda tiene un doble nombre: monte Cook, que lleva el nombre del navegante inglés James Cook; y Aoraki, que proviene de la lengua maorí, el pueblo indígena de Nueva Zelanda, cuyas tradiciones culturales están ahora más ampliamente reconocidas en la sociedad neozelandesa. El Aoraki/monte Cook da nombre al Parque Nacional de 723 km², uno de los diez parques nacionales de la Isla Sur, la mayoría de los cuales se encuentran en los Alpes de Nueva Zelanda. Hay cuatro parques nacionales en la Isla Norte, incluido el Parque Nacional de Egmont alrededor del volcán Taranaki, de 2518 metros de altura.

Parques nacionais

A montanha mais alta da Nova Zelândia tem um nome duplo: Monte Cook, em homenagem ao navegador inglês James Cook. O segundo nome, Aoraki, vem da língua Maori, o povo indígena da Nova Zelândia, cujas tradições culturais são agora mais reconhecidas na sociedade da Nova Zelândia. O Monte Cook/Aoraki dá o nome ao Parque Nacional de 723 km², um dos dez parques nacionais da Ilha do Sul, a maioria dos quais estão localizados nos Alpes da Nova Zelândia. Existem quatro parques nacionais na Ilha Norte, incluindo o Parque Nacional Egmont em torno do vulcão também conhecido como Monte Taranaki de 2518 m de altura.

Nationale parken

De hoogste berg van Nieuw-Zeeland heeft twee namen: Mount Cook vernoemd naar de Engelse navigator James Cook en Aorak (Maori), de inheemse bevolking van Nieuw-Zeeland, waarvan de culturele tradities nu meer erkend worden in de Nieuw-Zeelandse samenleving. De Aoraki/Mount Cook geeft zijn naam aan het 723 km² grote Nationaal Park, een van de tien nationale parken op het Zuidereiland, waarvan de meeste zich in de Nieuw-Zeelandse Alpen bevinden. Er zijn vier nationale parken op het Noordereiland, waaronder het Egmont National Park rond de 2518 m hoge vulkaan Mount Taranaki.

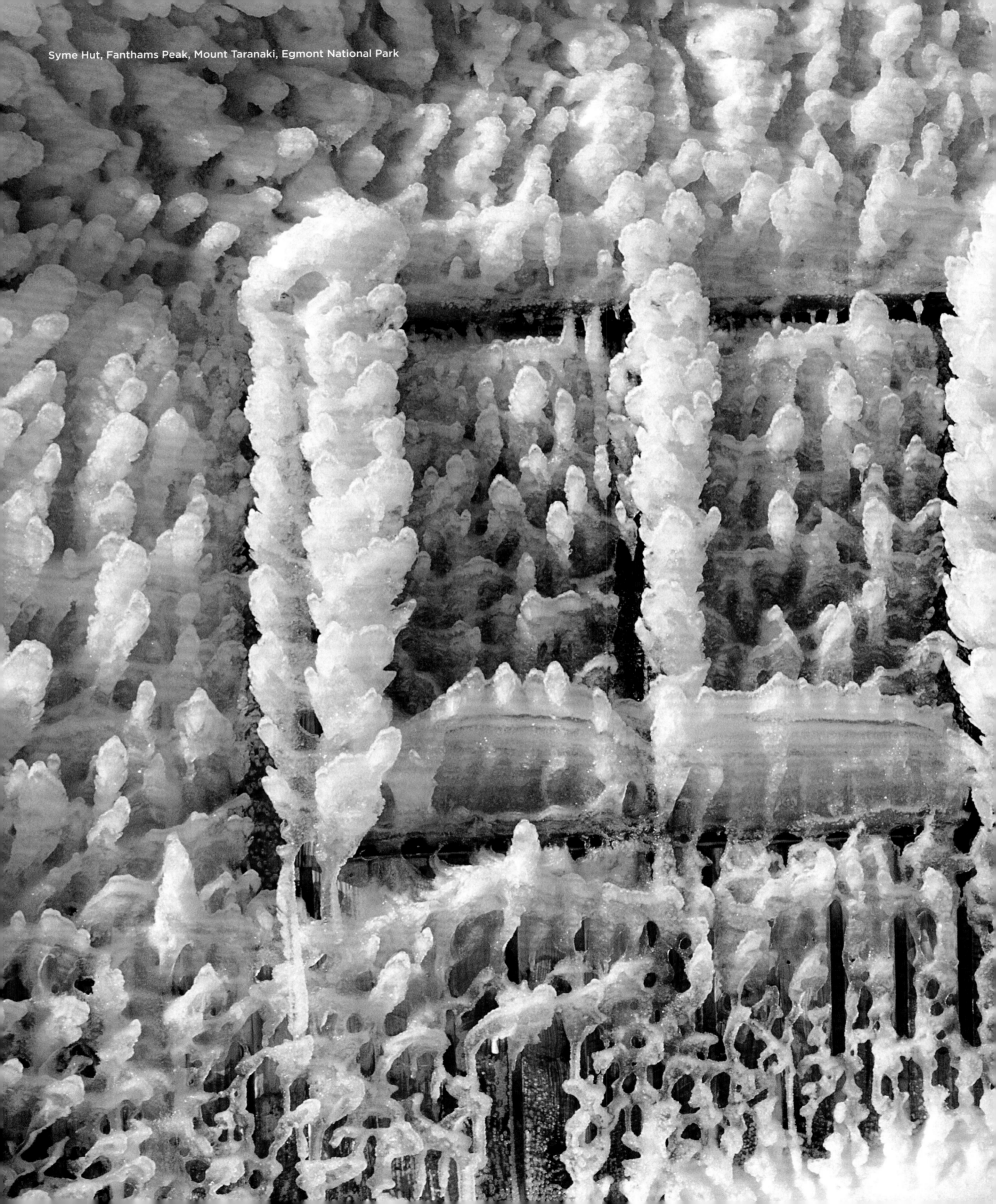

Syme Hut, Fanthams Peak, Mount Taranaki, Egmont National Park

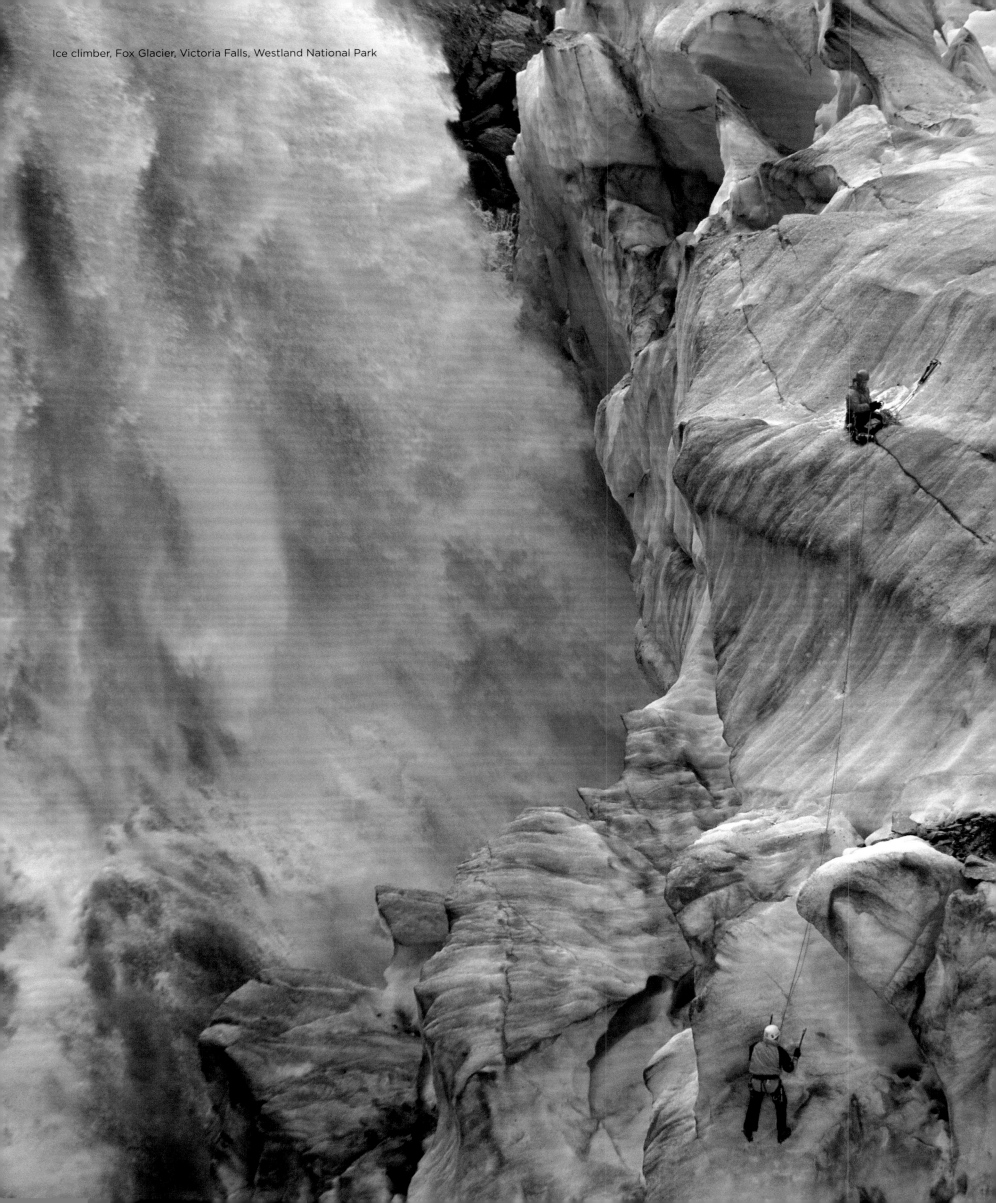

Ice climber, Fox Glacier, Victoria Falls, Westland National Park

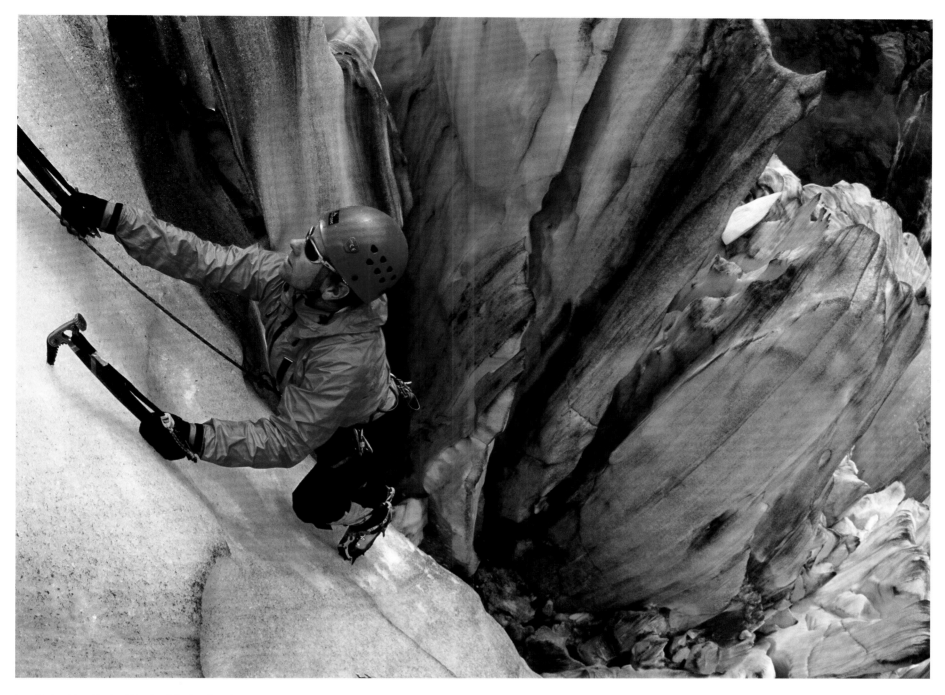

Ice climber, Fox Glacier, Westland National Park

Glacial Ice

Ice climbers will find a paradise in Westland National Park, which stretches from New Zealand's second highest mountain, Mount Tasman (3498 m or 11476 ft), down to the coast. Several glaciers, including Fox Glacier and Franz-Josef Glacier, flow almost to sea level. They are fed by the high precipitation on the coast, but are also shrinking.

Glace de glaciers

Les alpinistes trouvent leur paradis dans le parc national de Westland Tai Poutini, qui s'étend du deuxième plus haut sommet de la Nouvelle-Zélande, le mont Tasman (3 498 m) à la côte. Plusieurs glaciers, dont le glacier Fox et le glacier François-Joseph, s'écoulent presque jusqu'au niveau de la mer. Ils sont alimentés par les importantes précipitations qui tombent sur la côte, bien qu'eux aussi reculent.

Gletschereis

Eiskletterer finden ihr Paradies im Westland-Nationalpark, der von Neuseelands zweithöchstem Berg, dem Mount Tasman (3498 m), bis an die Küste hinunterreicht. Mehrere Gletscher, darunter der Fox-Gletscher und der Franz-Josef-Gletscher, fließen fast bis auf Meereshöhe. Sie werden von den hohen Niederschlägen an der Küste gespeist, aber auch sie schrumpfen.

Hielo glaciar

Los escaladores de hielo encontrarán su paraíso en el Parque Nacional Westland, que se extiende desde la segunda montaña más alta de Nueva Zelanda, el monte Tasman (3498 m), hasta la costa. Varios glaciares, incluido el glaciar Fox y el glaciar Franz-Josef, fluyen casi hasta el nivel del mar. Se alimentan de las altas precipitaciones de la costa, pero también se encogen.

Gelo glacial

Os alpinistas no gelo encontram seu paraíso no Parque Nacional Westland, que se estende da segunda montanha mais alta da Nova Zelândia, o Monte Tasman (3498 m), até a costa. Vários glaciares, incluindo a geleira Fox e a geleira Franz-Josef, fluem quase até o nível do mar. Elas são alimentadas pela alta precipitação na costa, mas elas também estão iminuindo.

Gletsjerijs

Voor IJsklimmers is het Westland National Park een paradijs, dat zich uitstrekt van de op een na hoogste berg van Nieuw-Zeeland, Mount Tasman (3498 m), tot aan de kust. Verschillende gletsjers, waaronder de vossengletsjer en de Franz-Josef gletsjer, stromen bijna tot op zeeniveau. Ze worden gevoed door de hoge neerslag aan de kust, maar ze krimpen ook.

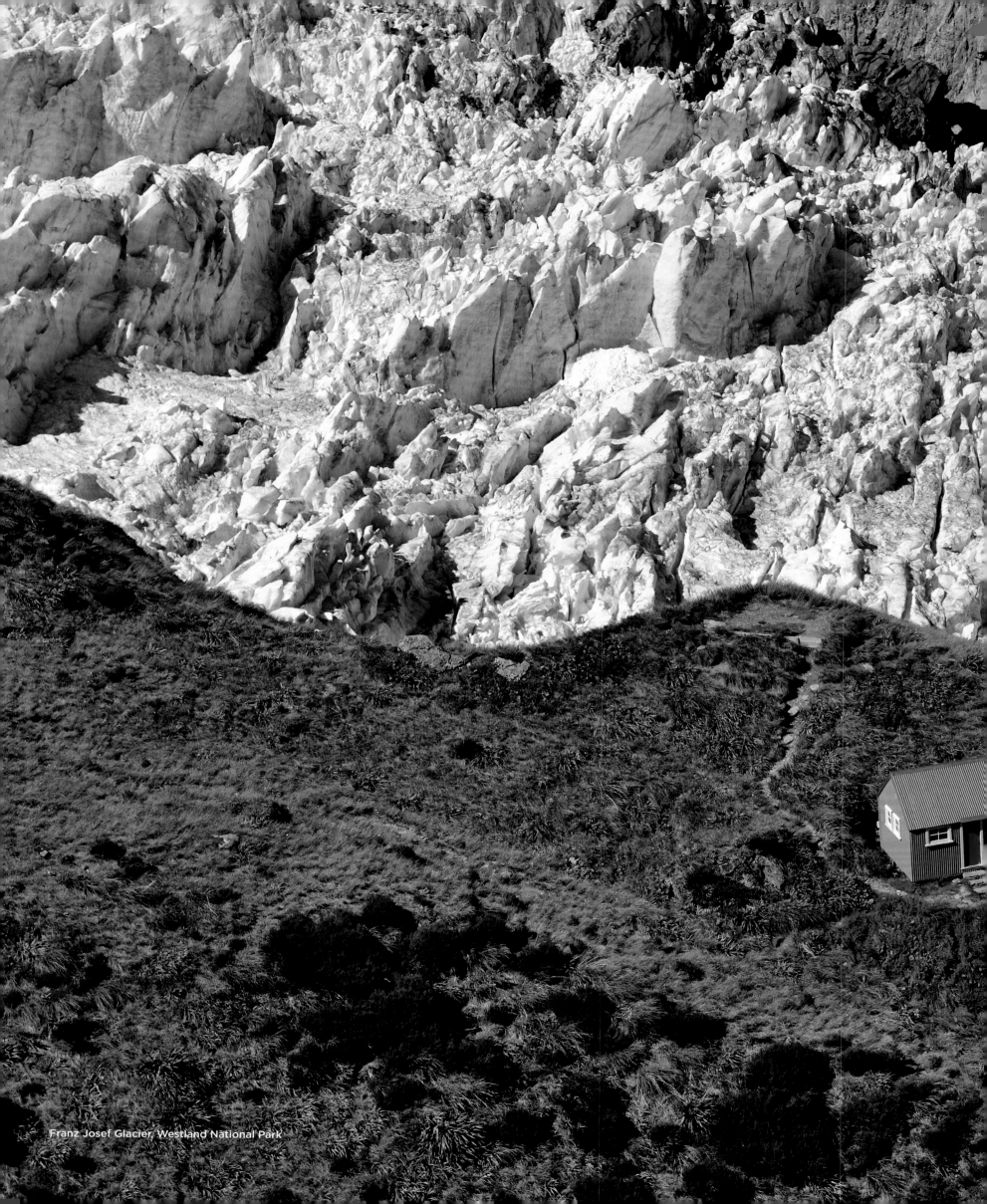

Franz Josef Glacier, Westland National Park

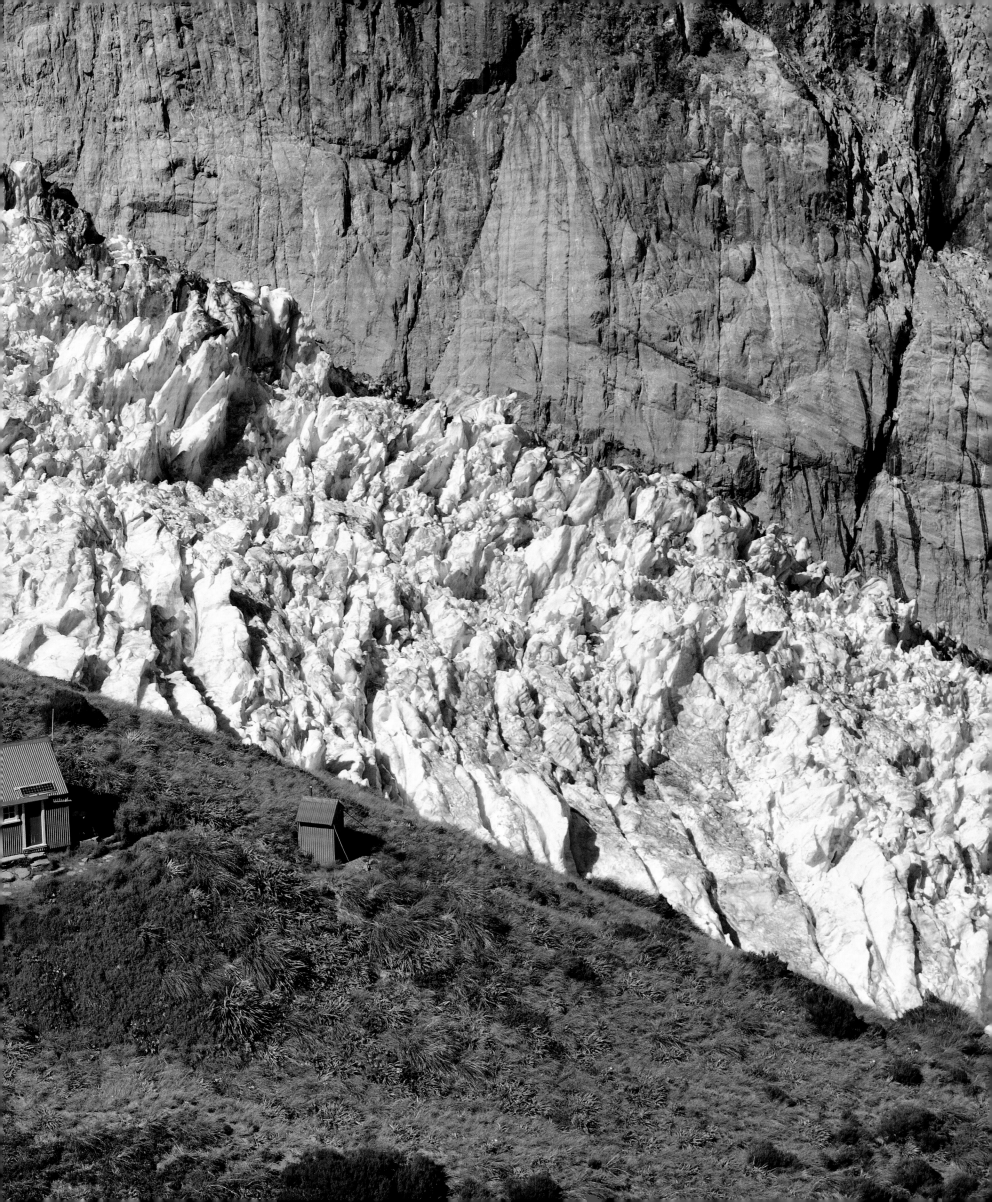

Great crested grebe, Lake Alexandrina

Lac Hooker

Le lac Hooker est un ajout récent aux lacs du parc national Aoraki/mont Cook. Ce lac glaciaire n'existe que depuis les années 1970 et sa taille augmente régulièrement. Il est nourri par le glacier Hooker, c'est pourquoi de petits icebergs flottent souvent sur ce lac qui affiche une température moyenne de 2° C seulement et gèle en hiver. En l'espace d'un siècle à peine, les glaciers néo-zélandais ont beaucoup perdu de leur longueur et de leur volume : leur surface de glace a perdu un quart à un tiers de leur superficie, tandis que plus de la moitié de leur volume total a disparu.

Lac Hooker

Le lac Hooker est un ajout récent aux lacs du parc national Aoraki/mont Cook. Ce lac glaciaire n'existe que depuis les années 1970 et sa taille augmente régulièrement. Il est nourri par le glacier Hooker, c'est pourquoi de petits icebergs flottent souvent sur ce lac qui affiche une température moyenne de 2° C seulement et gèle en hiver. En l'espace d'un siècle à peine, les glaciers néo-zélandais ont beaucoup perdu de leur longueur et de leur volume : leur surface de glace a perdu un quart à un tiers de leur superficie, tandis que plus de la moitié de leur volume total a disparu.

Hooker Lake

Der Hooker Lake ist ein Neuzugang unter den Seen im Mount-Cook-Nationalpark: Es gibt den Gletschersee erst seit den 1970er-Jahren, und seine Länge wächst beständig. Gespeist wird er vom Hooker-Gletscher. Auf dem mit einer Durchschnittstemperatur von nur 2 °C sehr kalten See, der im Winter zufriert, treiben häufig kleine Eisberge. Sie sind ein Produkt des Gletschers, der in den See kalbt. Die neuseeländischen Gletscher haben im Lauf von nur einem Jahrhundert massiv an Länge und Masse verloren: Um ein Viertel bis ein Drittel hat die Eisfläche abgenommen, das Gesamtvolumen um weit mehr als die Hälfte.

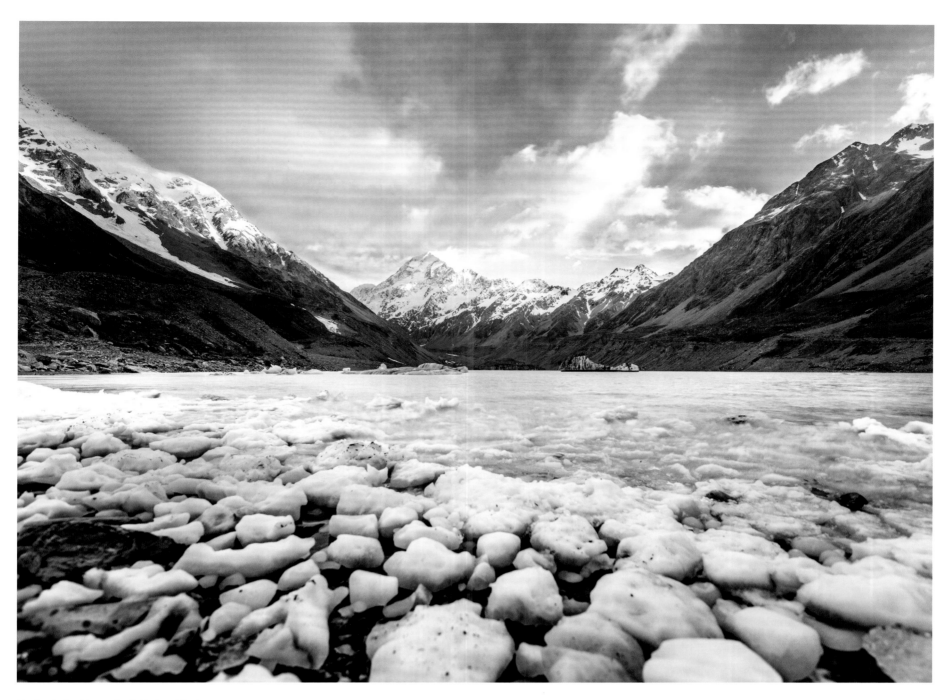

Hooker Lake, Mount Cook National Park

Lago Hooker

El lago Hooker es un recién llegado entre los lagos del Parque Nacional del monte Cook, ya que este lago glaciar solo existe desde los años 70, y su longitud crece constantemente. Se alimenta del glaciar Hooker. En el lago muy frío con una temperatura media de solo 2 °C, que se congela en invierno, a menudo flotan pequeños icebergs. Son un producto del glaciar que desemboca en el lago. Los glaciares neozelandeses han perdido gran parte de su longitud y masa en solo un siglo: la superficie de hielo ha disminuido entre un cuarto y un tercio, y el volumen total ha disminuido mucho más de la mitad.

Lago Hooker

O Lago Hooker é o mais recente entre os lagos do Parque Nacional do Monte Cook : o lago glacial existe apenas desde a década de 1970, e seu comprimento está em constante crescimento. É alimentado pelo Glaciar Hooker. No lago muito frio com uma temperatura média de apenas 2 °C, que congela no inverno, os pequenos icebergs flutuam frequentemente. Eles são um produto do glaciar que chega até o lago. Os glaciares da Nova Zelândia perderam uma grande parte do seu comprimento e da sua massa ao longo de apenas um século: a superfície de gelo diminuiu de um quarto para um terço e o volume total em mais da metade.

Hooker Lake

Hooker Lake is een nieuwkomer onder de meren in Mount Cook National Park: het gletsjermeer bestaat pas sinds de jaren zeventig en wordt steeds langer. Het wordt gevoed door de Hooker Glacier. Op het zeer koude meer met een gemiddelde temperatuur van slechts 2 °C, dat in de winter bevriest, drijven vaak kleine ijsbergen. Ze zijn een product van de gletsjer die in het meer kalft. De Nieuw-Zeelandse gletsjers hebben in de loop van een eeuw veel van hun lengte en massa verloren: het ijsoppervlak is met een kwart gedaald tot een derde, het totale volume met veel meer dan de helft.

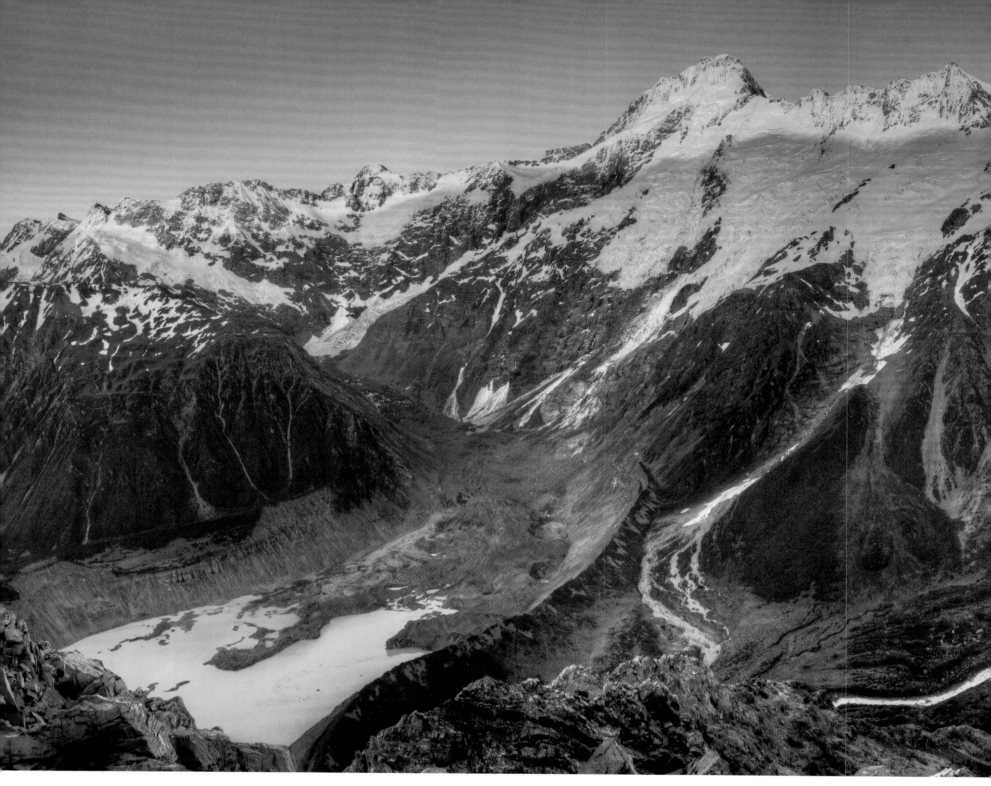

Mount Sefton, Mount Cook, Hooker Valley, Mount Cook National Park

World Heritage Site

The huge mountain panorama with Mount Sefton and Aoraki/Mount Cook shows an alpine world that is only seemingly untouched and original. Here too, the influence of man has brought about changes: first the indigenous people and later also the European settlers cleared the forests and introduced animals that damaged the flora. Nevertheless, the natural richness of the largely glaciated landscape was the reason that Unesco included Mount Cook National Park along with three other national parks in the southwest of the South Island (Te Waipounamu) on the World Heritage List in 1990.

Patrimoine mondial naturel

L'imposant panorama montagneux offert par le mont Sefton et par l'Aoraki/mont Cook n'est vierge et authentique qu'en apparence. Car là aussi, l'influence des hommes a provoqué des changements : les autochtones d'abord, les colons européens ensuite, ont abattu les forêts ; les animaux introduits par les humains ont mis à mal la flore. La richesse naturelle de ce paysage glaciaire a néanmoins incité l'Unesco à inscrire le site de Te Wāhipounamu au patrimoine mondial naturel en 1990, composé du parc national Aokari/mont Cook et de trois autres au sud-ouest de l'île du Sud.

Weltnaturerbe

Das gewaltige Bergpanorama mit dem Mount Sefton und dem Aoraki/Mount Cook zeigt eine alpine Welt, die nur scheinbar unberührt und ursprünglich ist. Denn auch hier hat der Einfluss des Menschen für Veränderungen gesorgt: Zunächst die Ureinwohner, später auch die europäischen Siedler holzten die Wälder ab, eingeführte Tiere setzten der Flora zu. Dennoch war der natürliche Reichtum der in weiten Teilen vergletscherten Landschaft Grund für die Unesco, den Mount-Cook-Nationalpark mit drei weiteren Nationalparks im Südwesten der Südinsel als Te Wahipounamu 1990 in die Liste des Weltnaturerbes aufzunehmen.

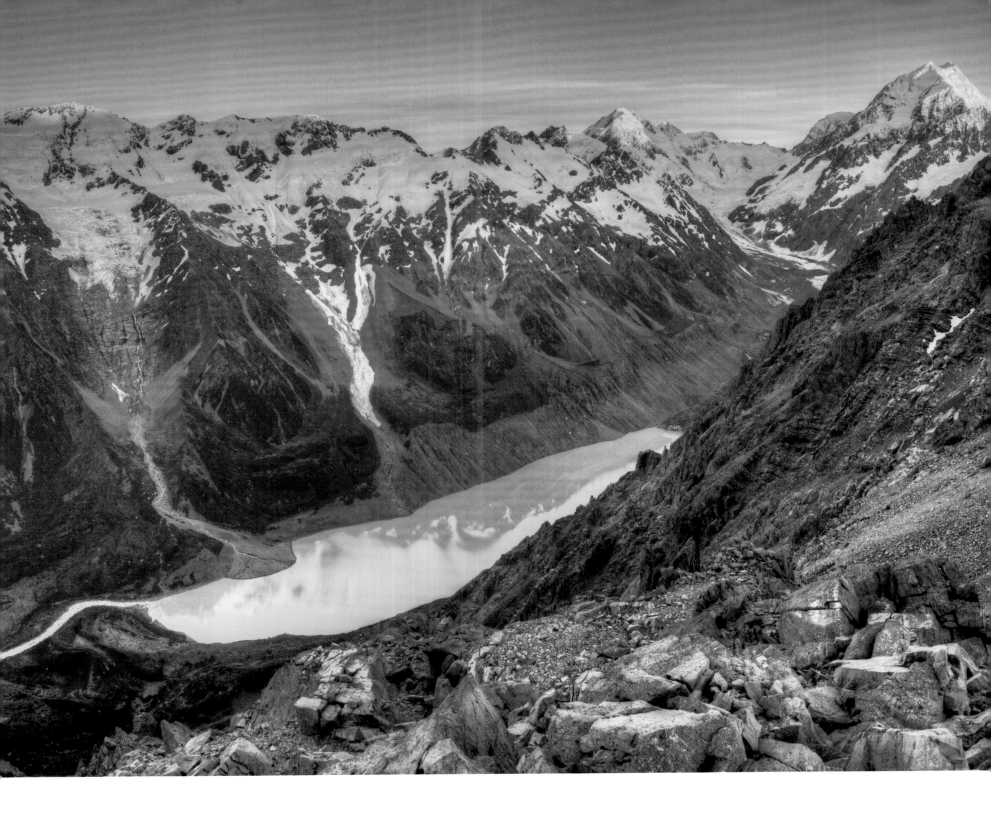

Sitio del patrimonio mundial

El enorme panorama de las montañas con el monte Sefton y Aoraki/monte Cook muestra un mundo alpino que solo se encuentra intacto y original de manera aparente. También en este caso, la influencia del hombre ha provocado cambios: primero los indígenas y luego también los colonos europeos limpiaron los bosques e introdujeron animales que infestaron la flora. Sin embargo, la riqueza natural del paisaje, en gran parte glaciado, fue la razón por la que la Unesco incluyó el Parque Nacional del monte Cook, junto con otros tres parques nacionales en el suroeste de la Isla del Sur, como Te Wahipounamu, en la Lista del Patrimonio Mundial en 1990.

Património Mundial Natural

O vasto panorama montanhoso com o Monte Sefton e o Monte Cook/Aoraki mostra um mundo alpino que é apenas aparentemente intocado e original. Também aqui a influência do homem provocou mudanças: primeiro os povos indígenas, depois também os colonos europeus desbravaram as florestas e introduziram animais que prejudicaram a flora. No entanto, a riqueza natural da paisagem amplamente glaciada foi a razão para a Unesco incluir o Parque Nacional Monte Cook com outros três parques nacionais no sudoeste da Ilha do Sul como o Te Wahipounamu na lista do Patrimônio Mundial em 1990.

Werelderfgoed

Het enorme bergpanorama met Mount Sefton en Aoraki/Mount Cook toont een alpenwereld die ongerept en origineel schijnt te zijn. Ook hier heeft de invloed van de mens veranderingen teweeggebracht: eerst de inheemse bevolking, later ook de Europese kolonisten die de bossen hebben gekapt en dieren hebben ingevoerd die de flora en fauna hebben aangetast. Toch was de natuurlijke rijkdom van het grotendeels vergletsjerde landschap de reden voor de Unesco om in 1990 het Mount-Cook National Park met drie andere nationale parken in het zuidwesten van het Zuidereiland op te nemen als Te Wahipounamu op de World Heritage List.

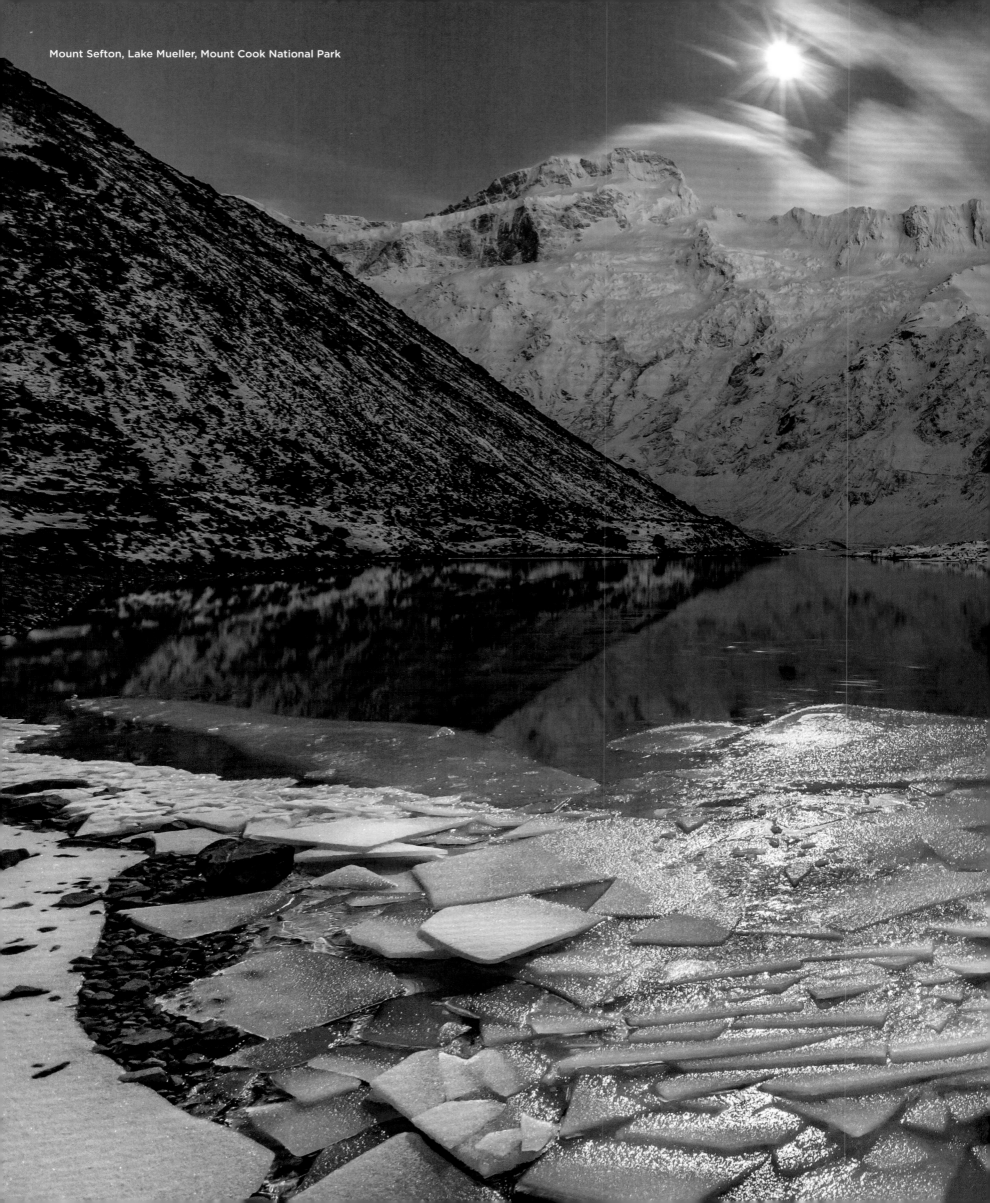
Mount Sefton, Lake Mueller, Mount Cook National Park

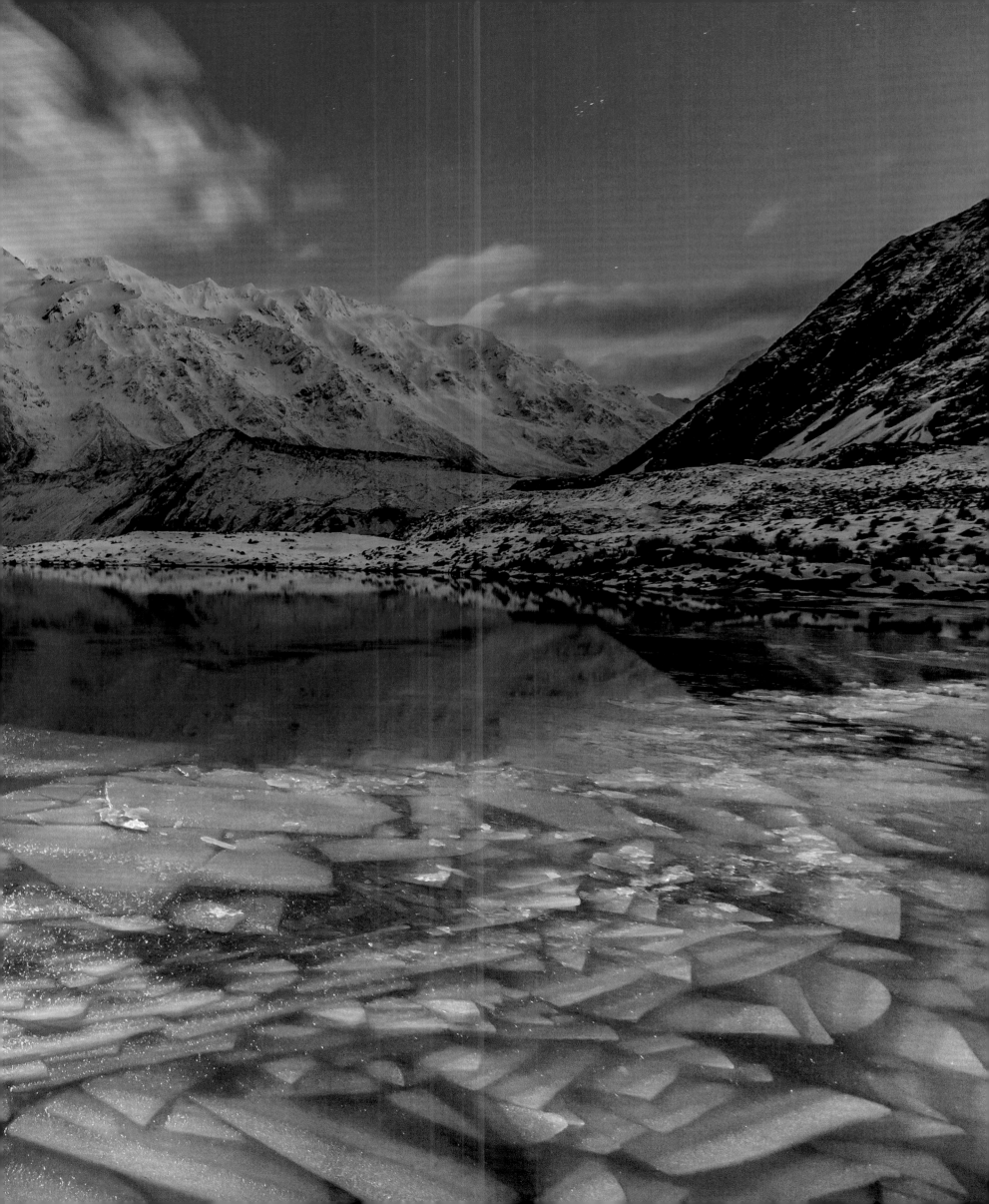

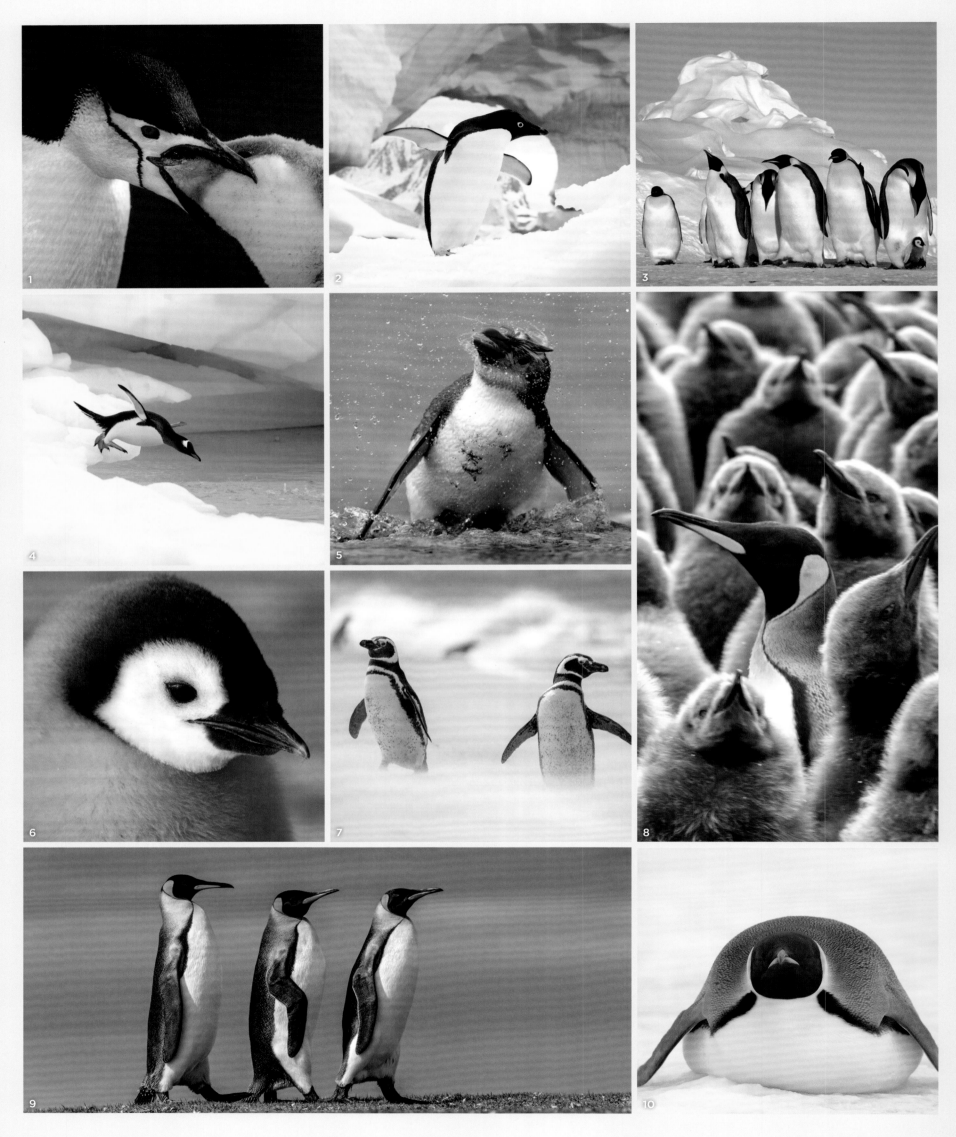

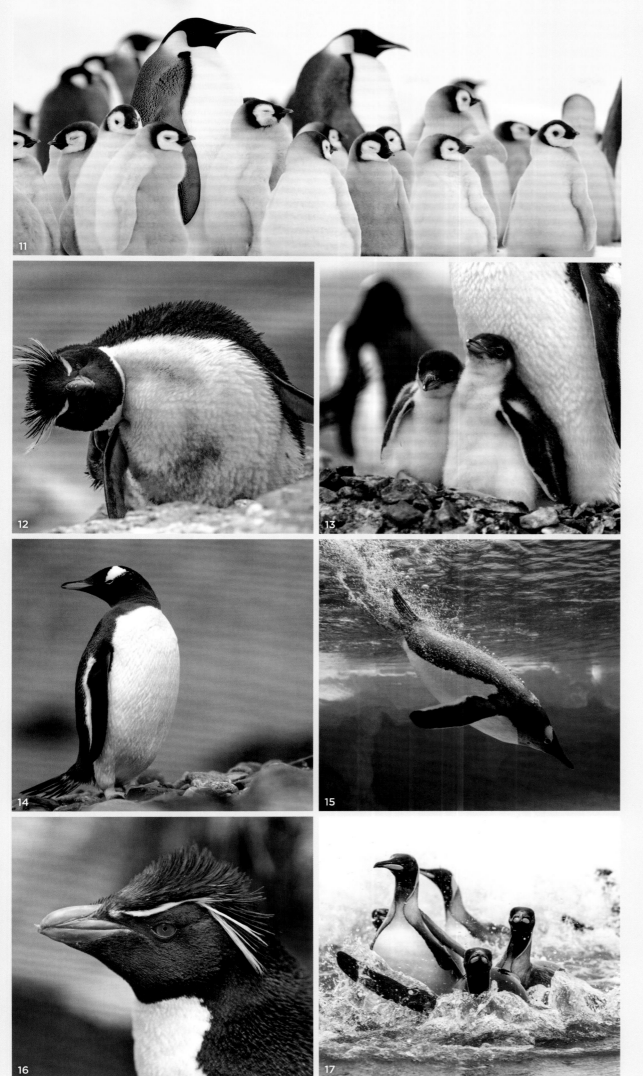

Penguins

1 Chinstrap penguin, Manchot à jugulaire, Zügelpinguin, Pingüino barbijo, Pinguim-de-barbicha, Stormbandpinguïn

2 Adelie penguin, Manchot Adélie, Adeliepinguin, Pingüino adelaida, Pinguim-de-adélia, Adeliepinguïn

3, 6, 10, 11 Emporer penguin, Manchot empereur, Kaiserpinguin, Pingüino emperador, Pinguim-imperador, Keizerspinguïn

4, 13, 14, 15 Gentoo penguin, Manchot papou, Eselspinguin, Pingüino papúa, Pinguim-gentoo, Ezelspinguïn

5 Royal penguin, Gorfou de Schlegel, Haubenpinguin, Pingüino real, Pinguim de crista, Schlegels pinguïn

7 Magellanic penguin, Manchot de Magellan, Magellan-Pinguin, Pingüino de Magallanes, Pinguim-de-magalhães, Magelhaenpinguïn

8, 9, 17 King penguin, Manchot royal, Königspinguin, Pingüino rey, Pinguim-real, Koningspinguïn

12, 16 Southern rockhopper penguin, Gorfou sauteur, Felsenpinguin, Pingüino saltarrocas, Pinguim-saltador-da-rocha, Zuidelijke rotspinguïn

441

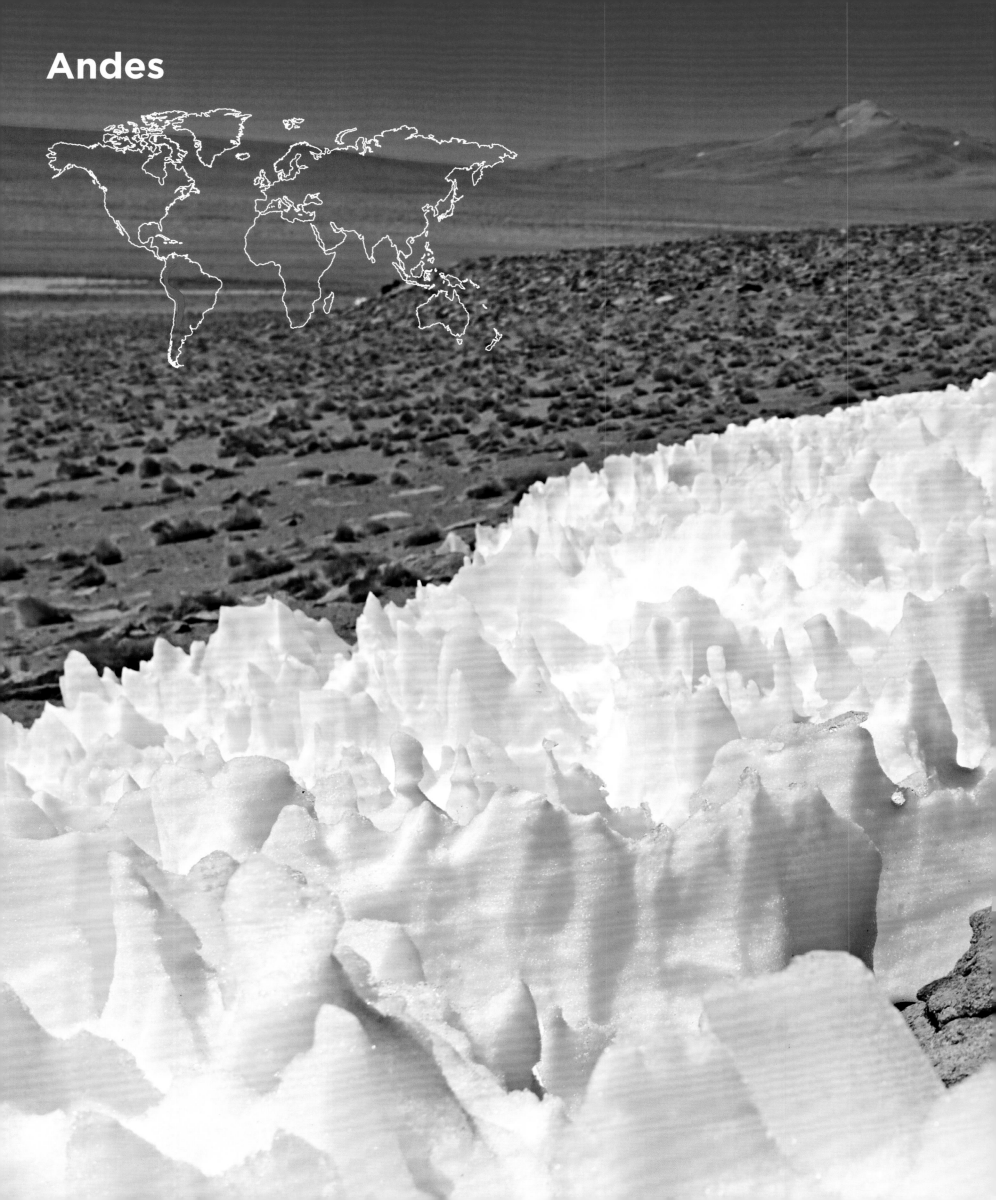

Andes

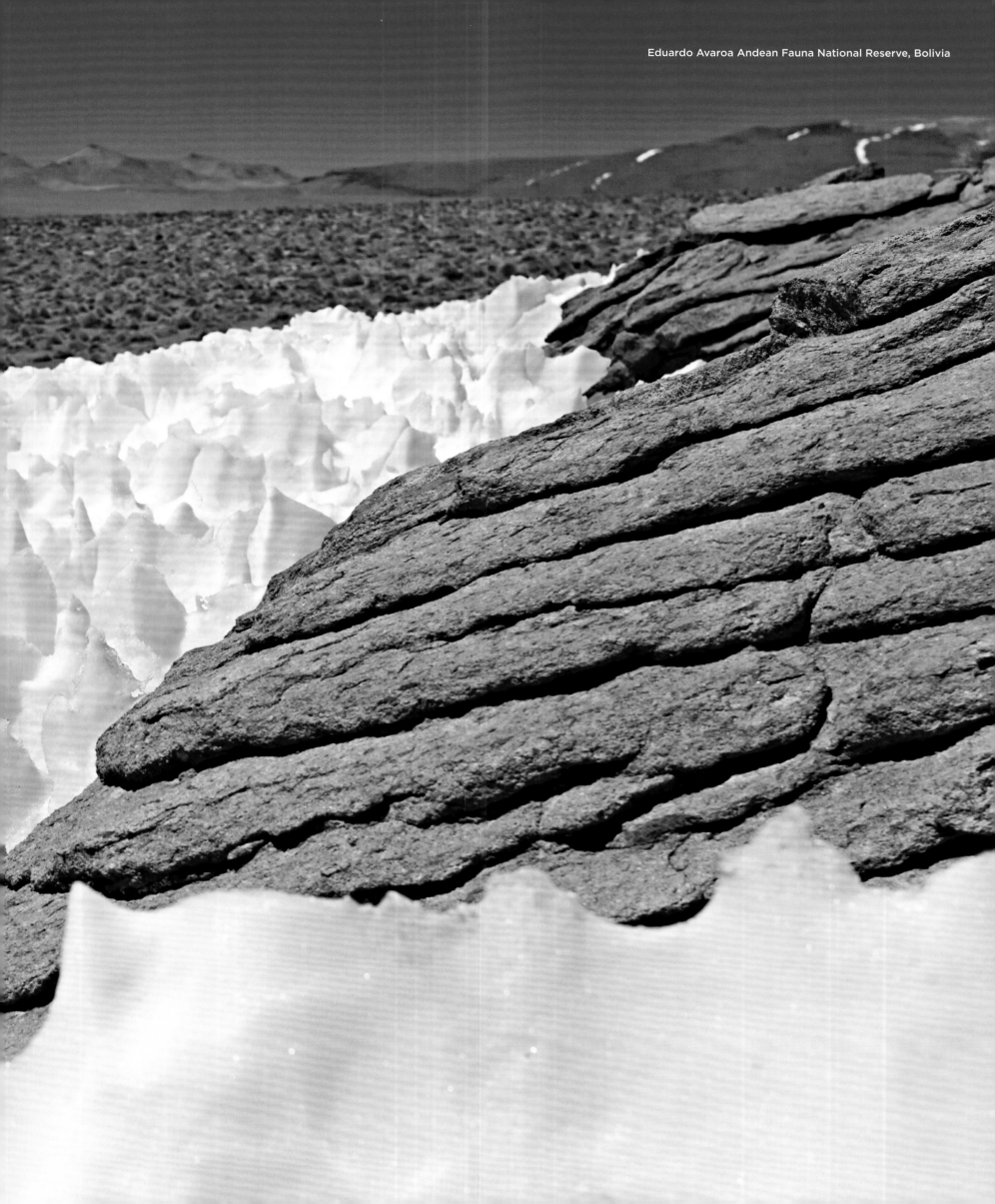

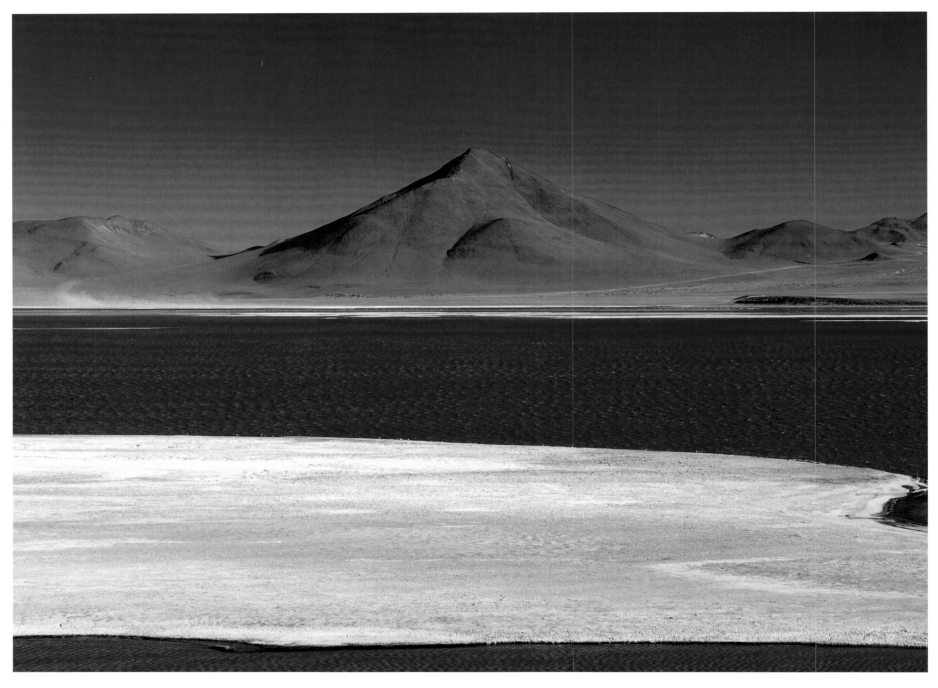

Andes, Bolivia

The Andes

The Cordillera mountain range stretches from Alaska to Tierra del Fuego along the western edge of the American double continent. With its numerous volcanoes, it belongs to the Pacific Ring of Fire. The Andes, the southern section from Venezuela to Chile, is 7500 km (4660 mi) long and up to 200 km (124 mi) wide. Around 100 peaks reach a height of more than 6000 m (19685 ft), the highest of which is Aconcagua in Argentina at 6961 m (22837 ft). Rugged peaks, huge glaciers, tropical volcanoes - the variety of landscapes is impressive. The mountains have always been a habitat for advanced civilizations such as the Incas in the central highlands.

Les Andes

La chaîne de montagnes constituant la cordillère américaine s'étend de l'Alaska à la Terre de Feu, le long de la côte ouest du double continent américain. Avec ses nombreux volcans, elle fait partie de la ceinture de feu du Pacifique. Les Andes, la partie sud de la cordillère allant du Venezuela au Chili, mesure 7 500 km de long et jusqu'à 200 km de large. Une centaine de sommets atteignent une hauteur de plus de 6 000 m, le plus élevé étant l'Aconcagua, en Argentine, à 6 961 m. Des cimes abruptes, d'imposants glaciers, des volcans tropicaux : la diversité des paysages est impressionnante. Ces montagnes ont toujours été l'habitat de civilisations avancées telle celle des Incas, notamment sur les hauts plateaux centraux.

Die Anden

Der Gebirgszug der Kordilleren zieht sich von Alaska bis Feuerland entlang des Westrandes des amerikanischen Doppelkontinents. Mit ihren zahlreichen Vulkanen gehört er zum Pazifischen Feuerring. Der südliche Teil von Venezuela bis Chile, die Anden, ist 7500 km lang und bis zu 200 km breit. Rund 100 Gipfel erreichen eine Höhe von über 6000 m, der höchste ist der Aconcagua in Argentinien mit 6961 m. Schroffe Gipfel, gewaltige Gletscher, tropische Vulkane – die Vielfalt der Landschaftsformen ist beeindruckend. Das Gebirge war immer schon Lebensraum für Hochkulturen, etwa der Inkas im zentralen Hochland.

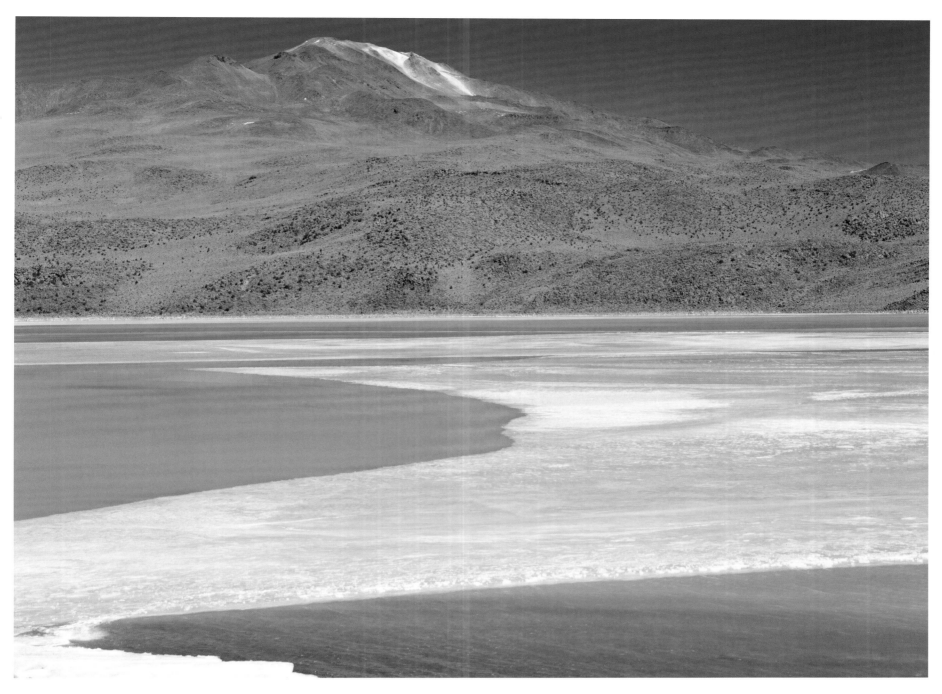

Laguna Celeste, Bolivia

Los Andes

La cordillera se extiende desde Alaska hasta Tierra
del Fuego a lo largo del borde occidental del doble
continente americano. Con sus numerosos volcanes
pertenece al Anillo de Fuego del Pacífico. La parte
sur de Venezuela a Chile, los Andes, tiene 7500 km
de largo y hasta 200 km de ancho. Cerca de 100
picos alcanzan una altura de más de 6000 m; el
más alto es el Aconcagua en Argentina con 6961 m.
Picos escarpados, enormes glaciares, volcanes
tropicales... La variedad de paisajes es impresionante.
Las montañas siempre han sido un hábitat para
civilizaciones avanzadas, como los incas en las tierras
altas centrales.

Os Andes

A Cordilheira se estende desde o Alasca até a Terra
do Fogo, ao longo da extremidade ocidental do
duplo continente americano. Com os seus numerosos
vulcões, pertence ao Anel de Fogo do Pacífico. Da
parte sul da Venezuela até ao Chile, os Andes, tem
7500 km de comprimento e até 200 km de largura.
Cerca de 100 picos atingem uma altura de mais
de 6000 m, o mais alto deles é o Aconcagua na
Argentina com 6961 m. Picos irregulares, enormes
glaciares, vulcões tropicais - a variedade de paisagens
é impressionante. As montanhas sempre foram um
habitat para civilizações avançadas, tais como os
incas, nos planaltos centrais.

De Andes

Het Cordillera gebergte strekt zich uit van Alaska
tot Tierra del Fuego langs de westelijke rand van
het Amerikaanse dubbele continent. Met zijn talrijke
vulkanen behoort het tot de Pacific Ring of Fire. Het
zuidelijke deel van Venezuela tot Chili, de Andes, is
7500 km lang en tot 200 km breed. Ongeveer 100
pieken bereiken een hoogte van meer dan 6000 m,
de hoogste is de Aconcagua in Argentinië met
6961 m. Ruige toppen, enorme gletsjers, tropische
vulkanen - de diversiteit aan landschappen is
indrukwekkend. De bergen zijn altijd een habitat
geweest voor geavanceerde beschavingen, zoals de
Inca's in de centrale hooglanden.

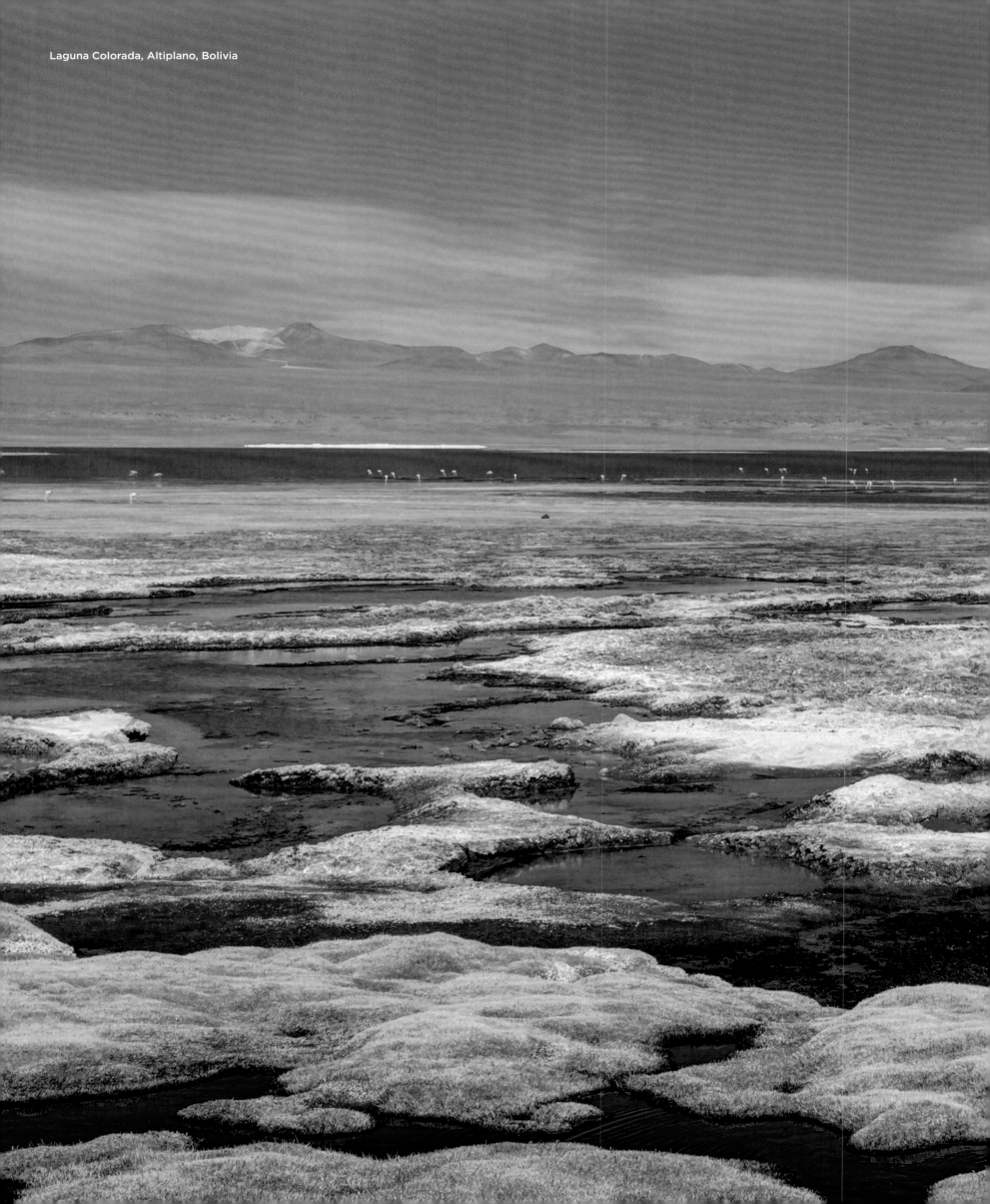

Laguna Colorada, Altiplano, Bolivia

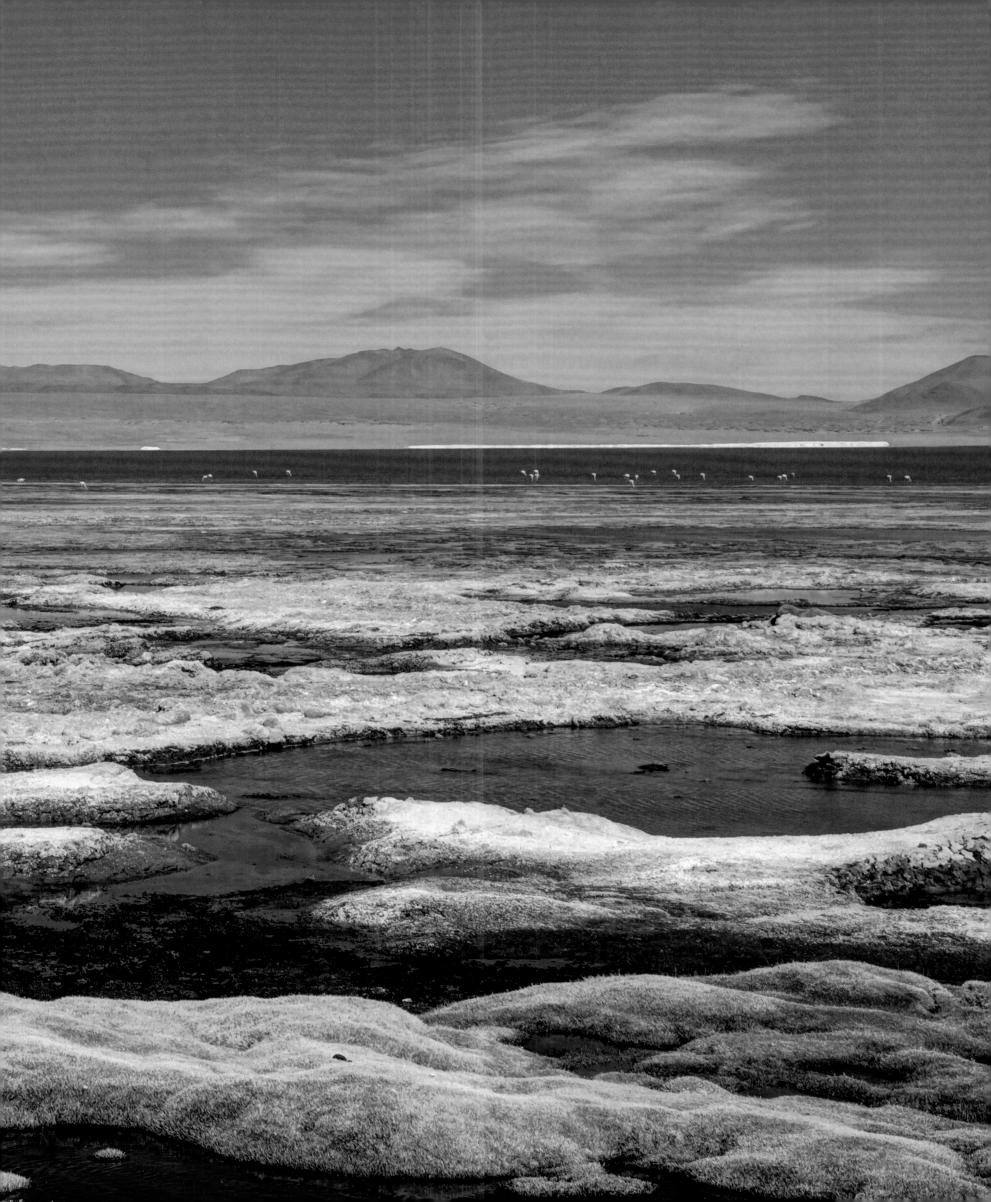

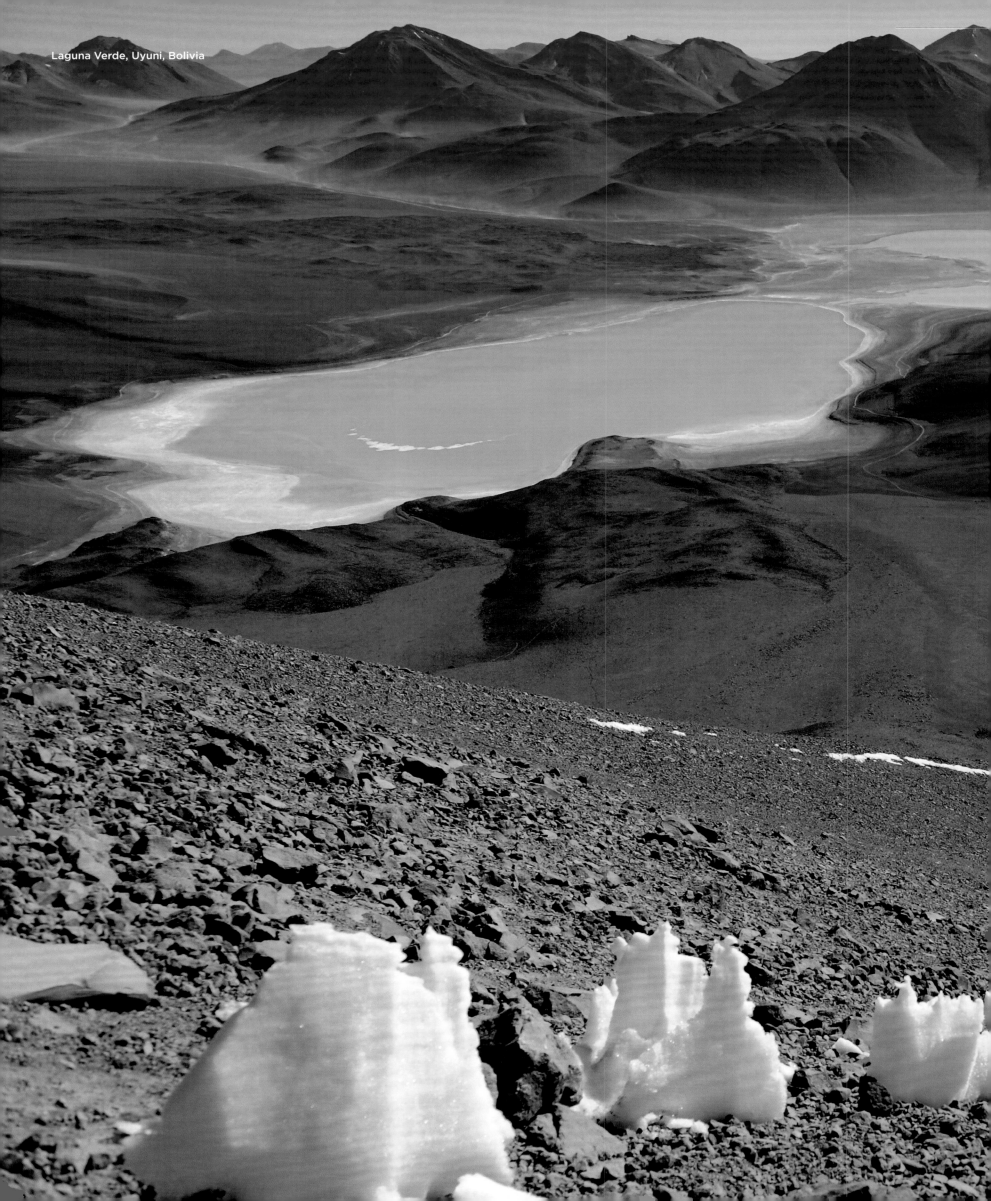

Laguna Verde, Uyuni, Bolivia

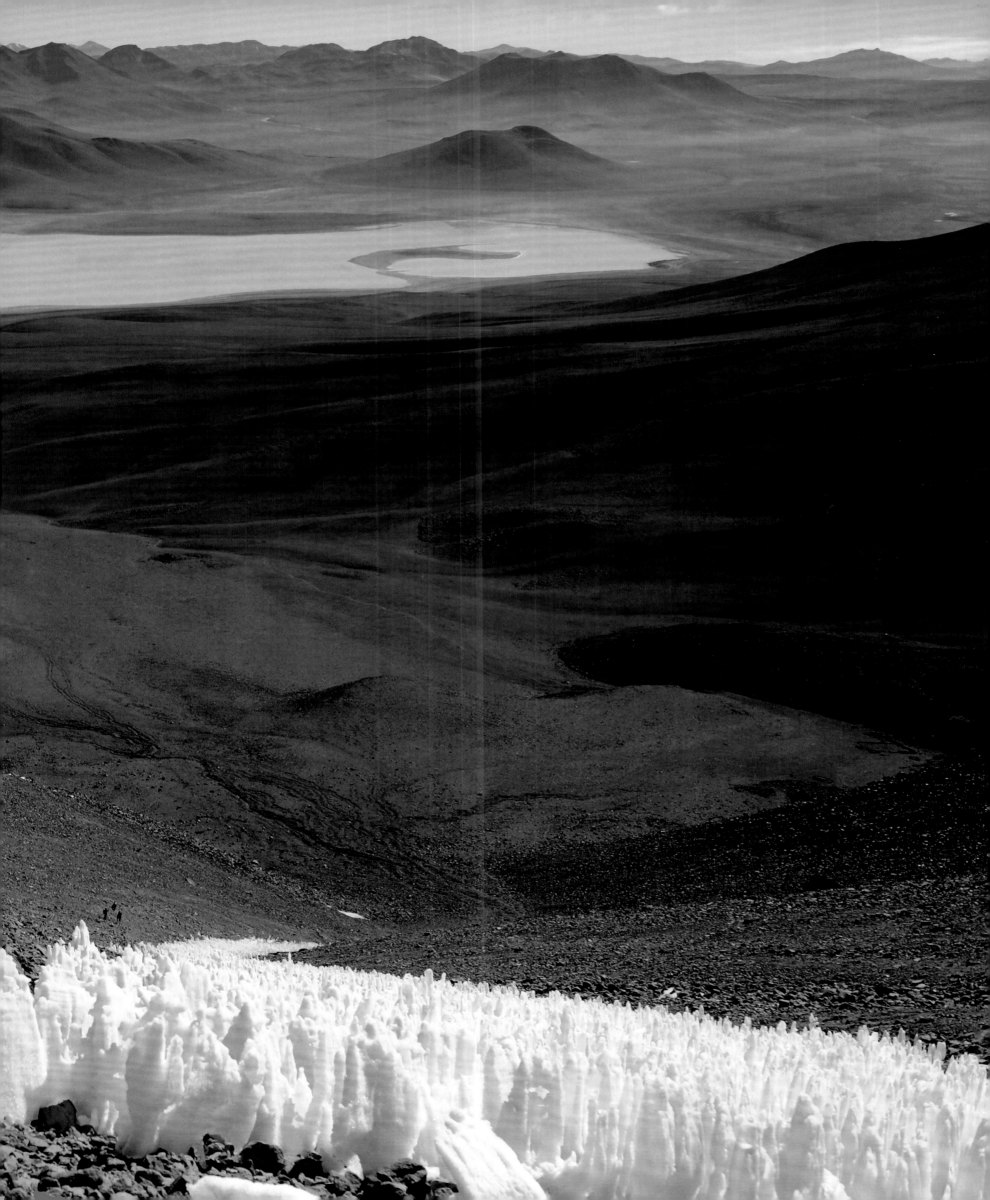

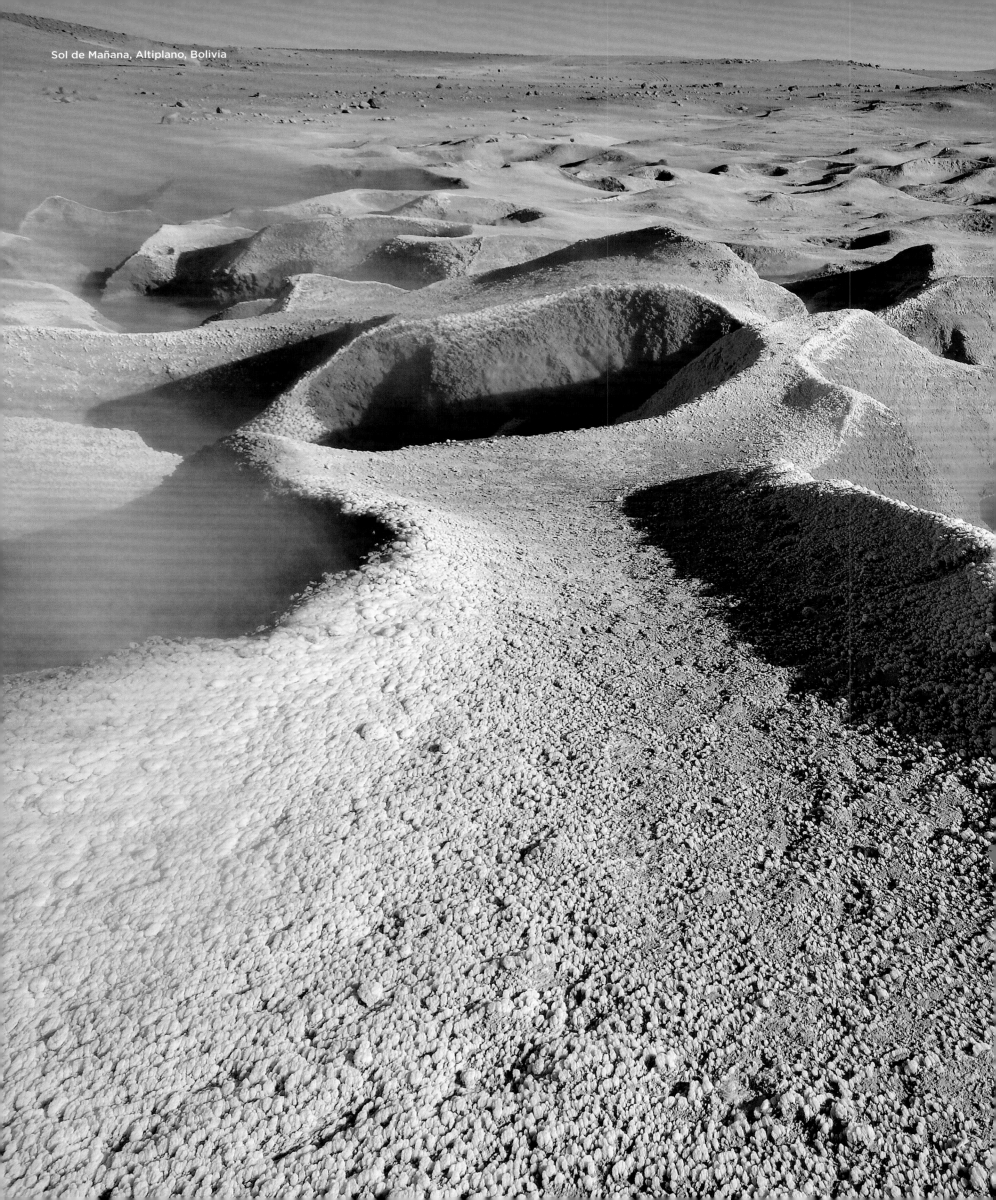

Sol de Mañana, Altiplano, Bolivia

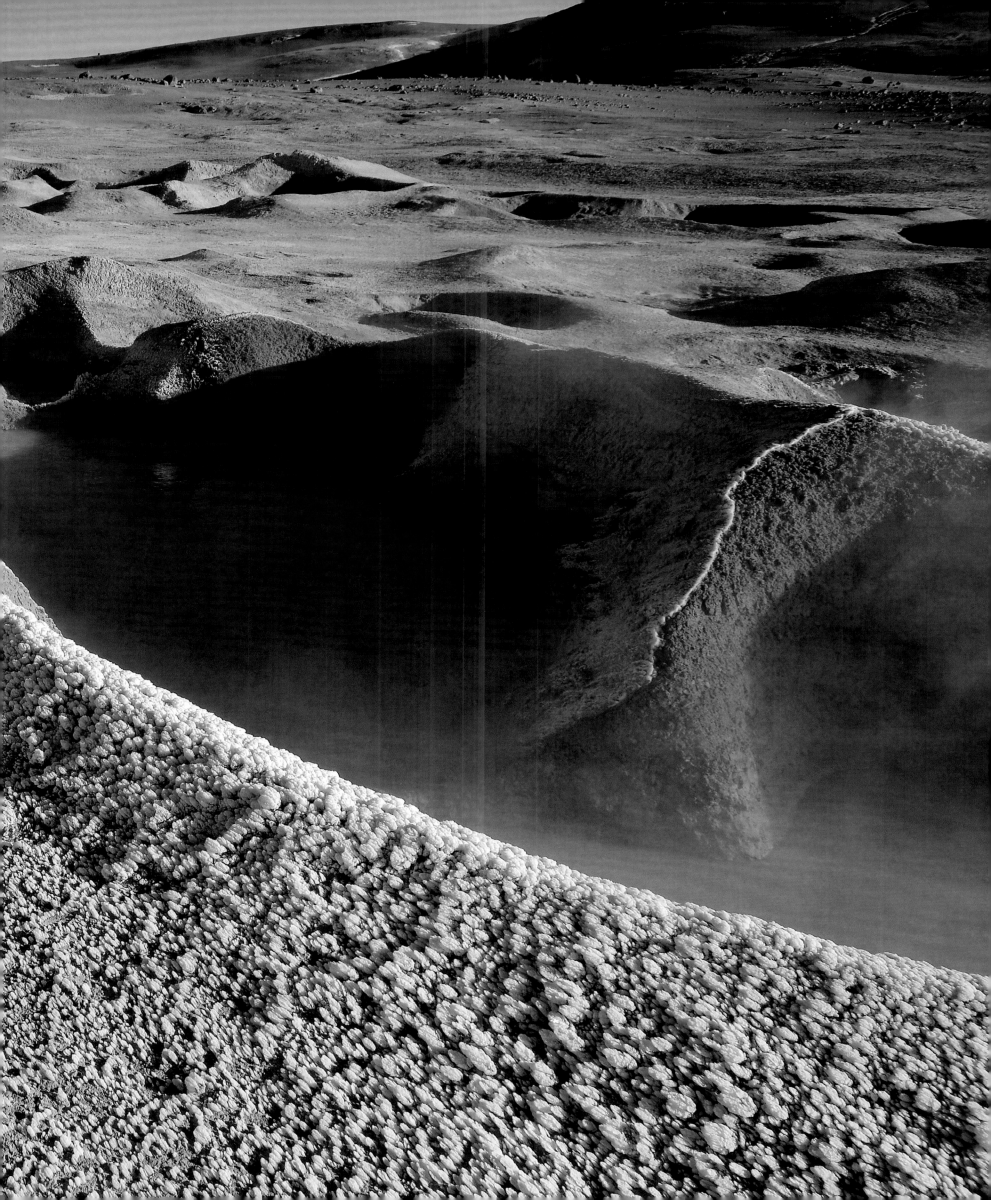

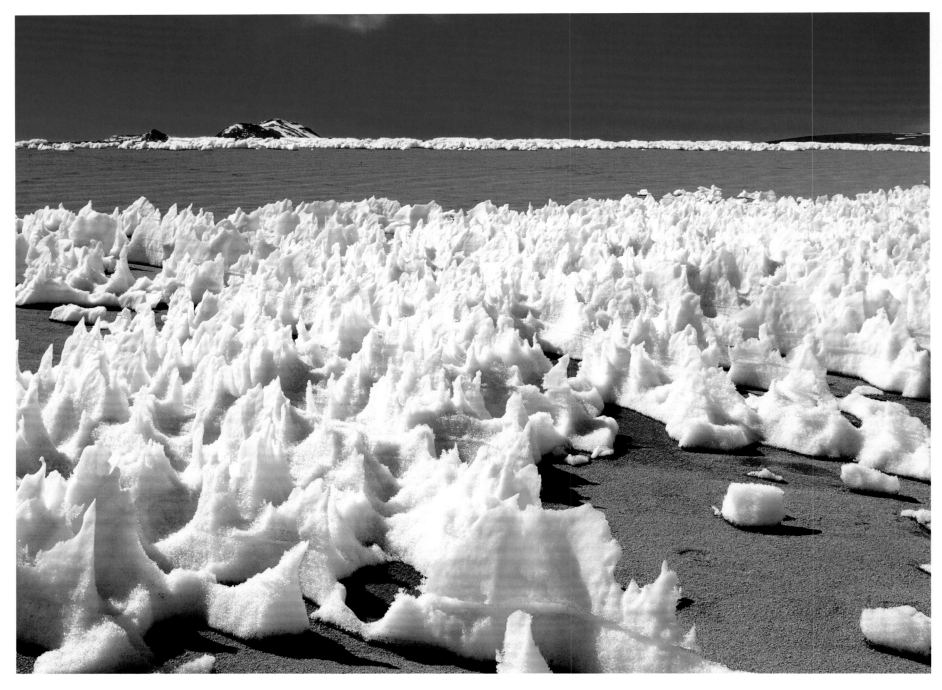

Snow Penitents, Bolivia

Penitentes

At high altitudes in the Andes, you can occasionally encounter bizarre ice formations that bear an equally bizarre name: penitent ice. These jagged ice needles probably reminded the Christian Spanish conquistadors of processions of penitents in white robes. Varying melting patterns and strong sunlight allow the structures to form.

Los penitentes

A grandes altitudes en los Andes, uno se encuentra ocasionalmente con extrañas formaciones de hielo que llevan un nombre igualmente extraño: penitentes. Las agujas de hielo dentadas probablemente recordaban a los conquistadores españoles (cristianos) las procesiones de los penitentes vestidos con túnicas blancas. El origen de estas estructuras radica en los diferentes comportamientos de fusión con fuerte irradiación solar.

Les pénitents de glace

Dans les hautes altitudes des Andes, on rencontre parfois d'étranges formations de glace, qui portent un nom tout aussi étrange : les pénitents de glace. Ces lames de glace rappelèrent probablement aux conquistadors espagnols (chrétiens) les processions des pénitents en robe blanche. Elles se forment par divers comportements de fonte sous le puissant rayonnement du soleil.

Penitentes de neve

Em altitudes elevadas nos Andes, ocasionalmente encontramos formações de gelo bizarras, com um nome igualmente bizarro: penitente de neve. As agulhas de gelo irregulares provavelmente lembravam aos conquistadores (cristãos) espanhóis de procissões de penitentes com vestes brancas. Diferentes comportamentos de fusão com forte irradiação solar permitem que as estruturas se originem.

Büßereis

In Höhenlagen der Anden trifft man gelegentlich auf bizarre Eisformationen, die einen ebenso bizarren Namen tragen: Büßereis. Vermutlich erinnerten die zackigen Eisnadeln die (christlichen) spanischen Konquistadoren an Prozessionen von Büßern in weißen Gewändern. Unterschiedliches Schmelzverhalten bei starker Sonneneinstrahlung lässt die Gebilde entstehen.

Boetelingensneeuw

Op grote hoogte in de Andes komt men soms bizarre ijsformaties tegen die een al even bizarre naam dragen: boetelingensneeuw. De gekartelde ijsnaalden deden de (christelijke) Spaanse veroveraars waarschijnlijk denken aan processies van boetelingen in witte gewaden. Verschillend smeltgedrag met sterke zonnestraling laat de structuren ontstaan.

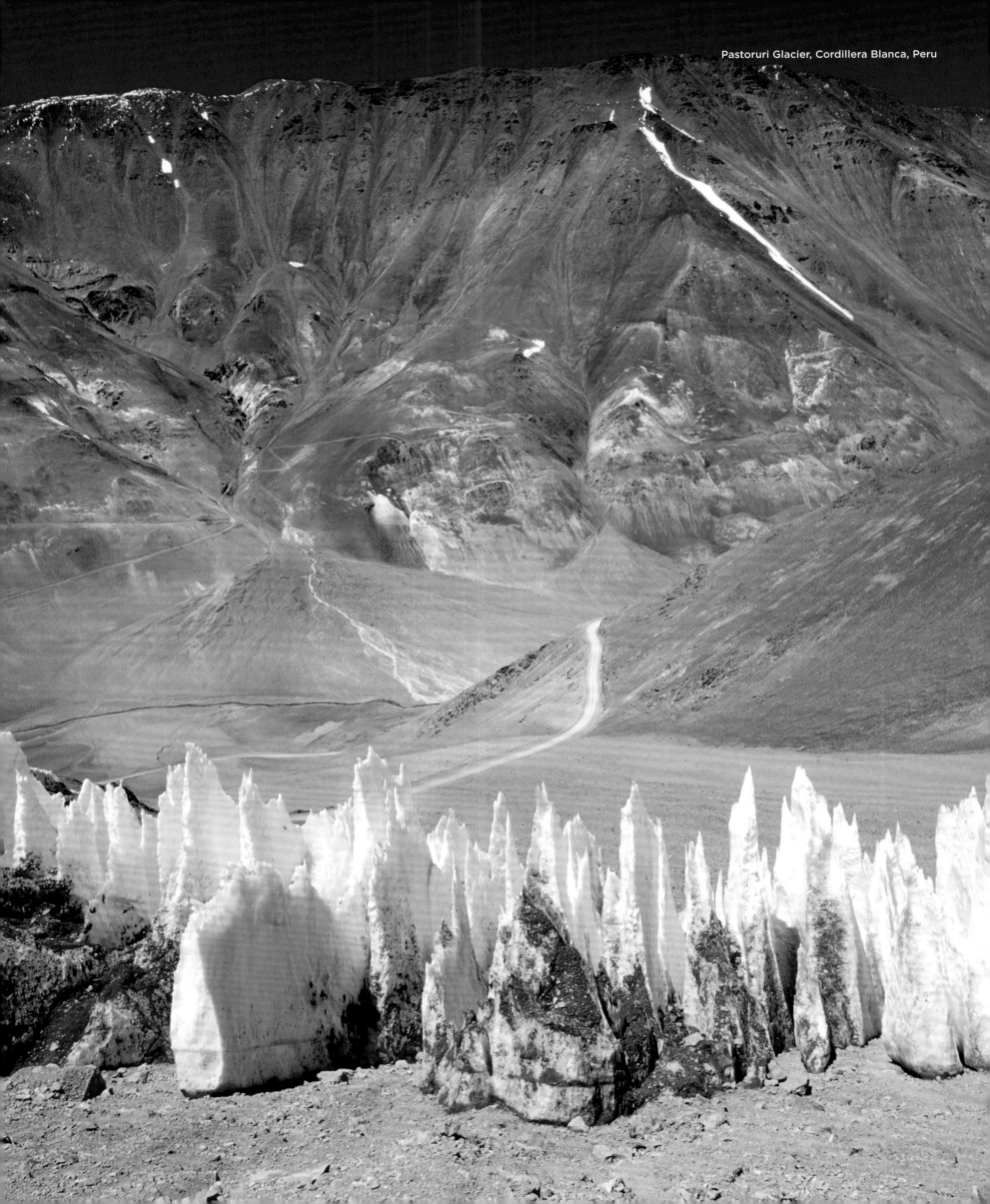

Pastoruri Glacier, Cordillera Blanca, Peru

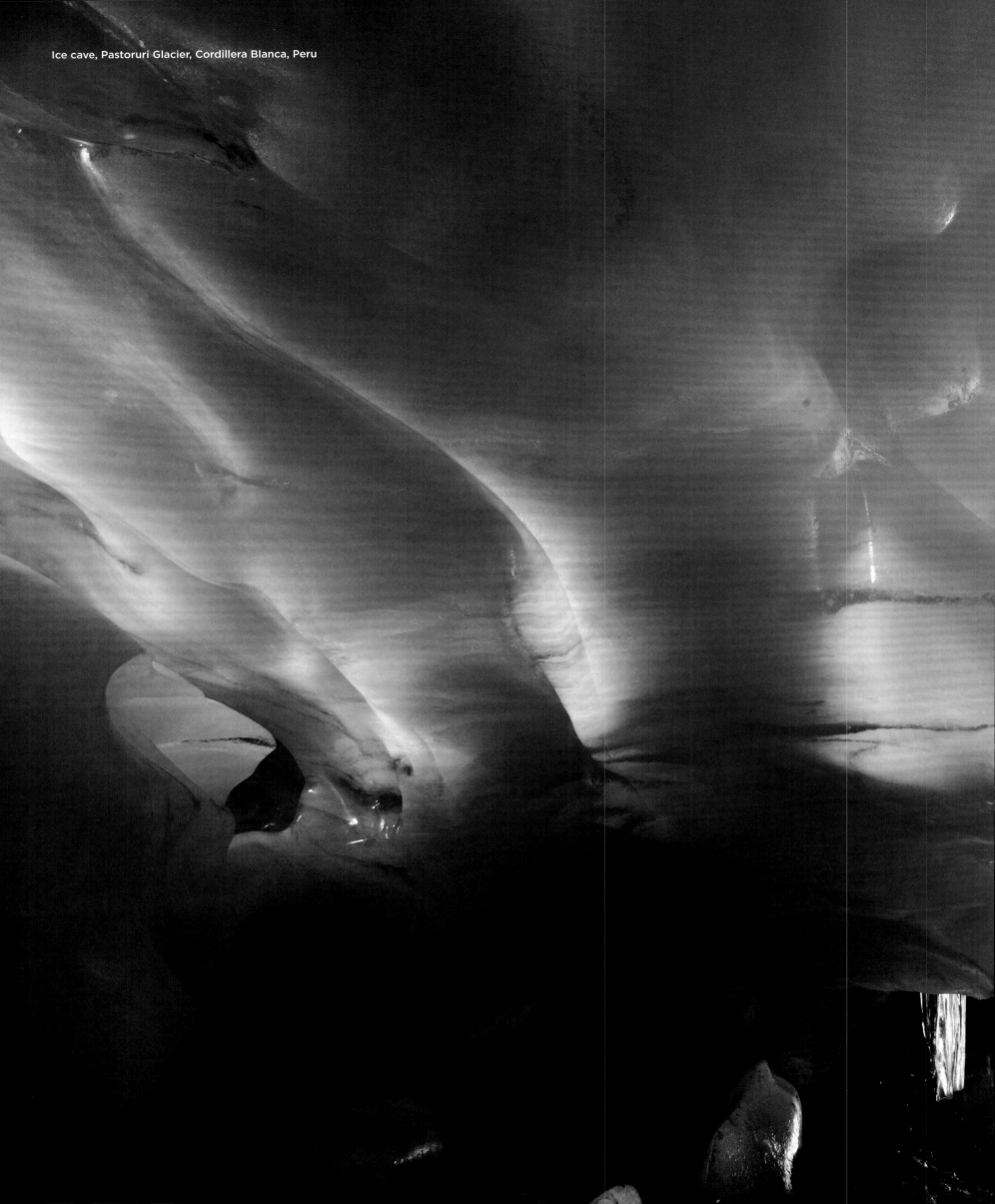

Ice cave, Pastoruri Glacier, Cordillera Blanca, Peru

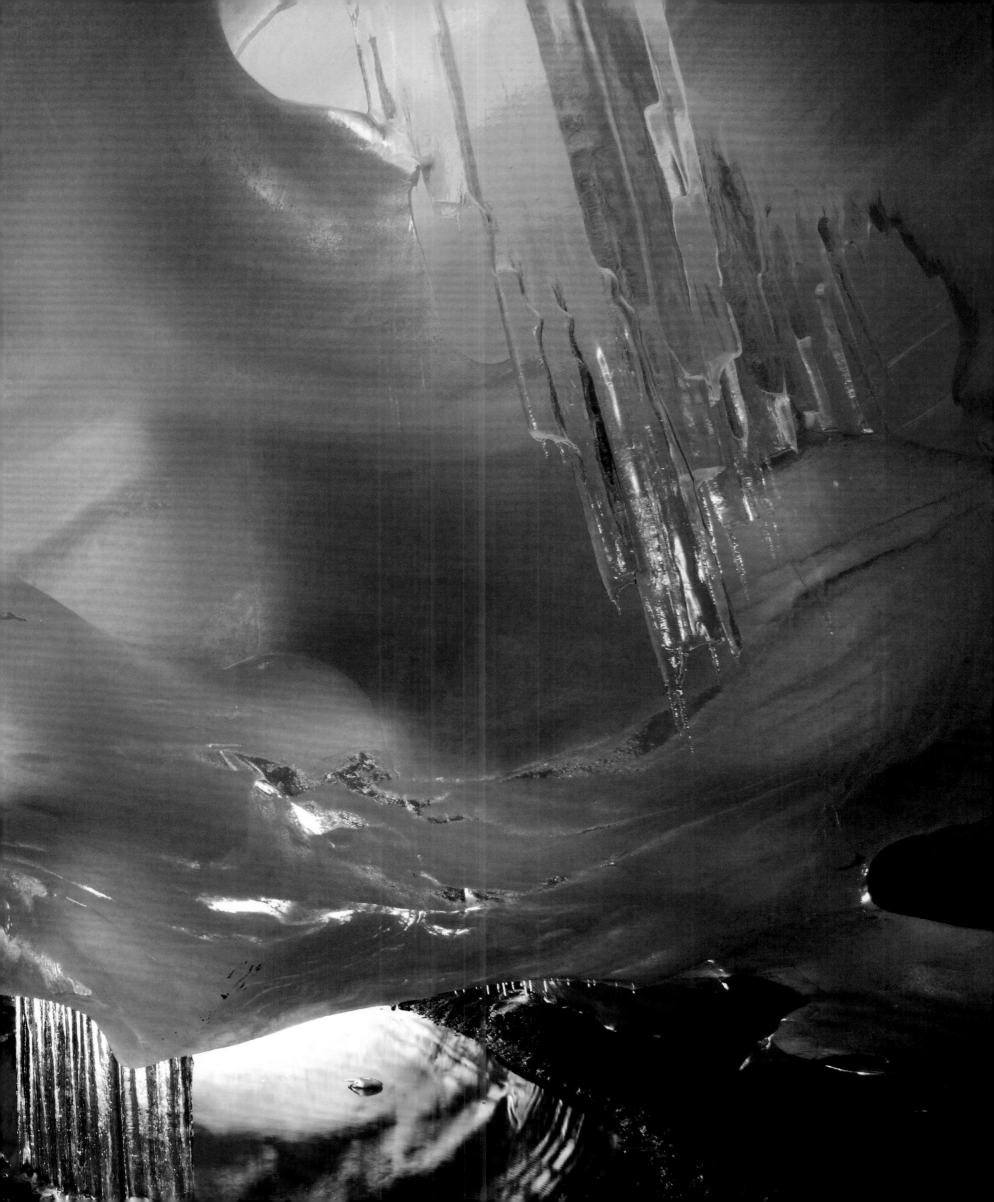

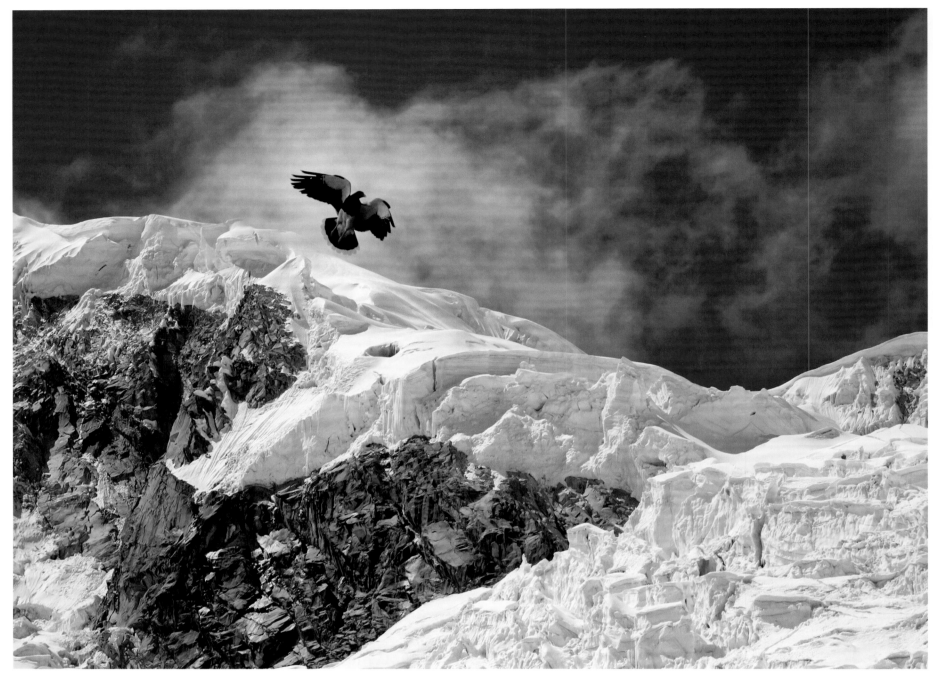

Mountain caracara, Chopicalqui, Cordillera Blanca, Peru

Cotopaxi

The crater of Cotopaxi in Ecuador is about 350 m (1148 ft) deep. At 5897 m (19347 ft) the active volcano is the second highest mountain in Ecuador. It is only 50 km (31 mi) away from the capital Quito and 70 km (43 mi) from the equator. There are often eruptions, the last major one in 1877 completely melted the summit glacier and the most recent was in 2015. Despite the danger, it is a popular excursion destination and is climbed by hundreds of people every year. Its regular shape with its ice cap makes it one of the most beautiful peaks in the Andes. For the locals it is the seat of the gods.

Cotopaxi

Le cratère du Cotopaxi, en Équateur, est profond d'environ 350 m. Ce volcan actif haut de 5 897 m est le deuxième plus haut sommet du pays. Il se trouve à 50 km seulement de la capitale, Quito, et à 70 km de l'équateur. Les éruptions sont fréquentes ; la plus virulente a entièrement fait fondre le glacier du sommet en 1877, alors que la dernière en date a eu lieu en 2015. Malgré le danger que le Cotopaxi représente, il reste une destination appréciée puisque des centaines de personnes l'escaladent chaque année. Sa forme régulière et sa calotte de glace font de lui l'un des plus beaux sommets des Andes. Pour les autochtones, il abrite la demeure des dieux.

Cotopaxi

Rund 350 m tief ist der Krater des Cotopaxi in Ecuador. Der aktive Vulkan ist mit 5897 m der zweithöchste Berg Ecuadors. Er liegt nur 50 km entfernt von der Hauptstadt Quito und 70 km vom Äquator. Trotz der Gefahr, die von ihm ausgeht – es gibt immer wieder Ausbrüche, der letzte große von 1877 schmolz den Gipfelgletscher vollständig ab, der bisher letzte datiert von 2015 –, ist er ein beliebtes Ausflugsziel und wird jährlich von Hunderten Menschen bestiegen. Seine regelmäßige Form mit der Eiskappe machen ihn zu einem der schönsten Andengipfel, für die Einheimischen ist er der Sitz der Götter.

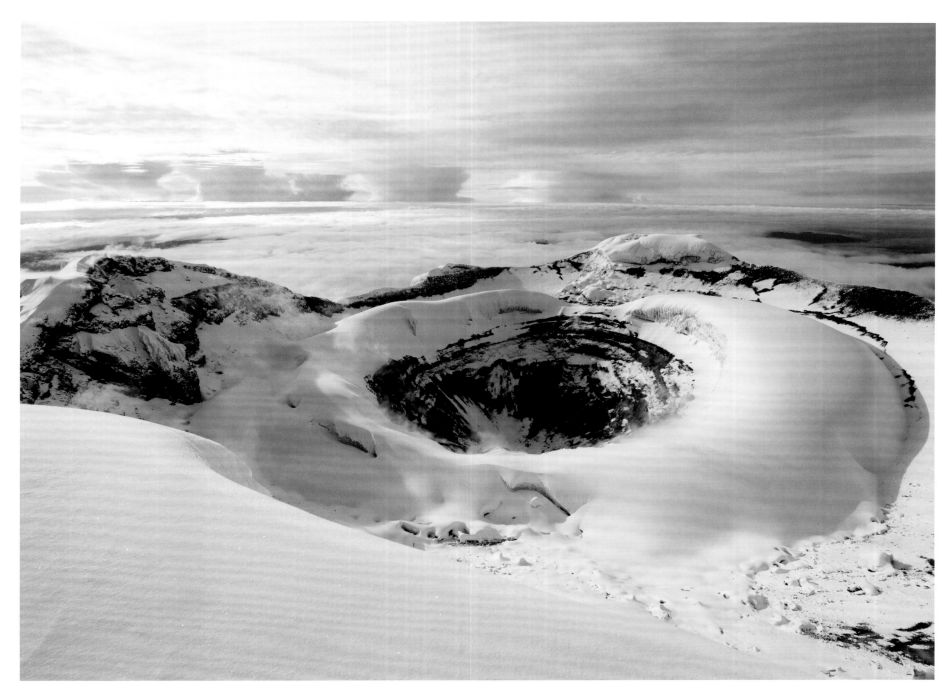

Cotopaxi Volcano, Ecuador

Cotopaxi

El cráter de Cotopaxi en Ecuador tiene unos 350 m de profundidad. El volcán activo es, con sus 5897 m, la segunda montaña más alta de Ecuador. Se encuentra a solo 50 km de la capital Quito y a 70 km del ecuador. A pesar del peligro que representa (siempre hay erupciones: la última gran erupción de 1877 derritió por completo el glaciar de la cima, y la última se produjo en 2015), es un destino de excursión popular y lo escalan cientos de personas cada año. Su forma regular con la capa de hielo lo convierte en uno de los picos más hermosos de los Andes. Para los nativos es el asiento de los dioses.

Cotopaxi

A cratera do Cotopaxi, no Equador, tem cerca de 350 m de profundidade. O vulcão ativo fica a 5897 m, a segunda montanha mais alta do Equador. Fica a apenas 50 km da capital Quito e a 70 km da linha do Equador. Apesar do perigo que representa - há sempre erupções, a última grande de 1877 derreteu completamente a geleira do cume, a última data de 2015 - é um destino de excursão popular e é escalada por centenas de pessoas todos os anos. Sua forma regular com a calota de gelo o torna um dos picos mais bonitos dos Andes, para a população local é a sede dos deuses.

Cotopaxi

De krater van Cotopaxi in Ecuador is ongeveer 350 m diep. De actieve vulkaan is met 5897 m de op een na hoogste berg van Ecuador. Het is slechts 50 km van de hoofdstad Quito en 70 km van de evenaar verwijderd. Ondanks het gevaar voor uitbarstingen - in 1877 die de gletsjer op de top volledig deed smelten, de laatste in 2015 - is het een populaire excursiebestemming en wordt elk jaar door honderden mensen beklommen. De regelmatige vorm met de ijskap maakt het een van de mooiste toppen in de Andes, voor de lokale bevolking is het de zetel van de goden.

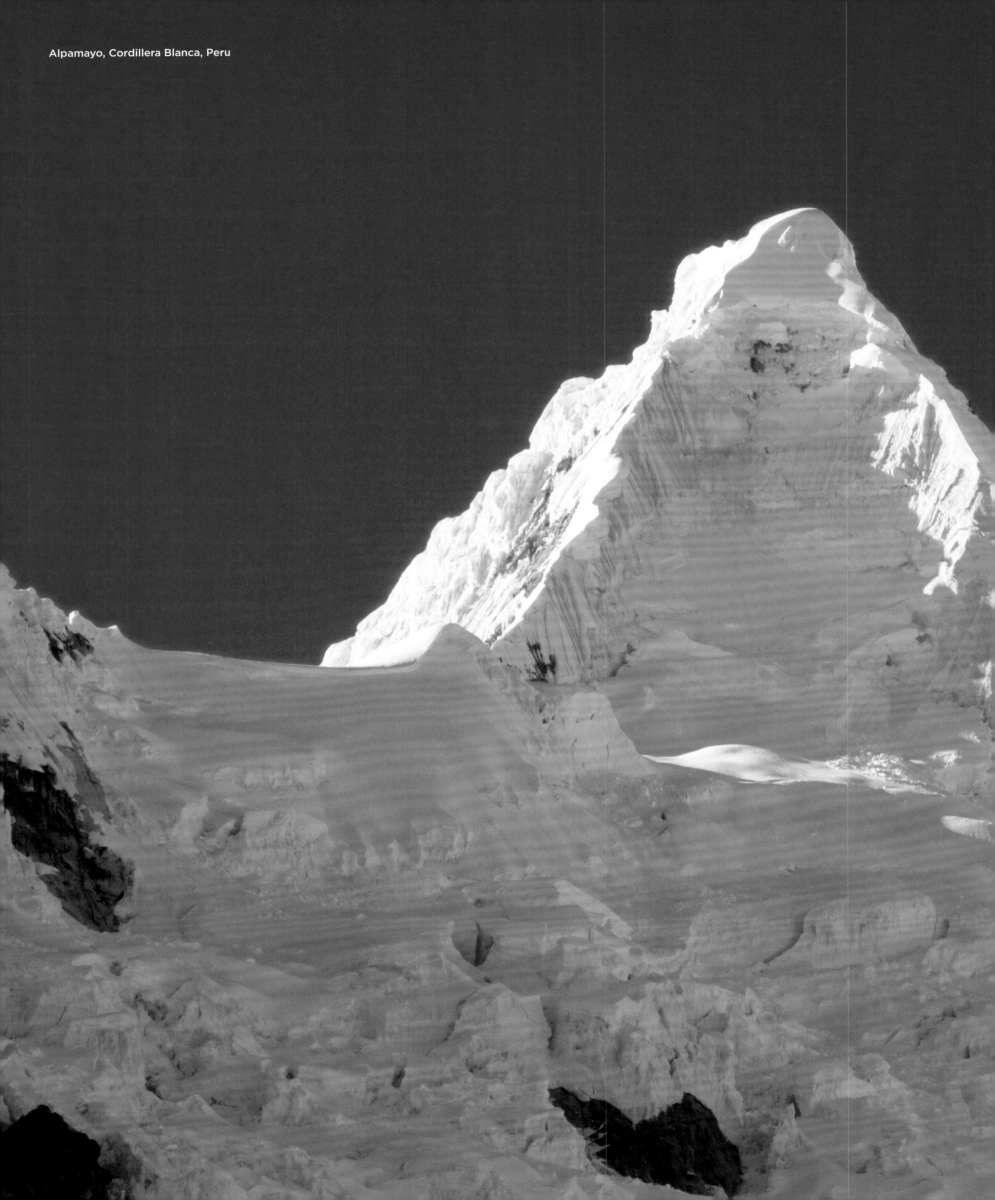

Alpamayo, Cordillera Blanca, Peru

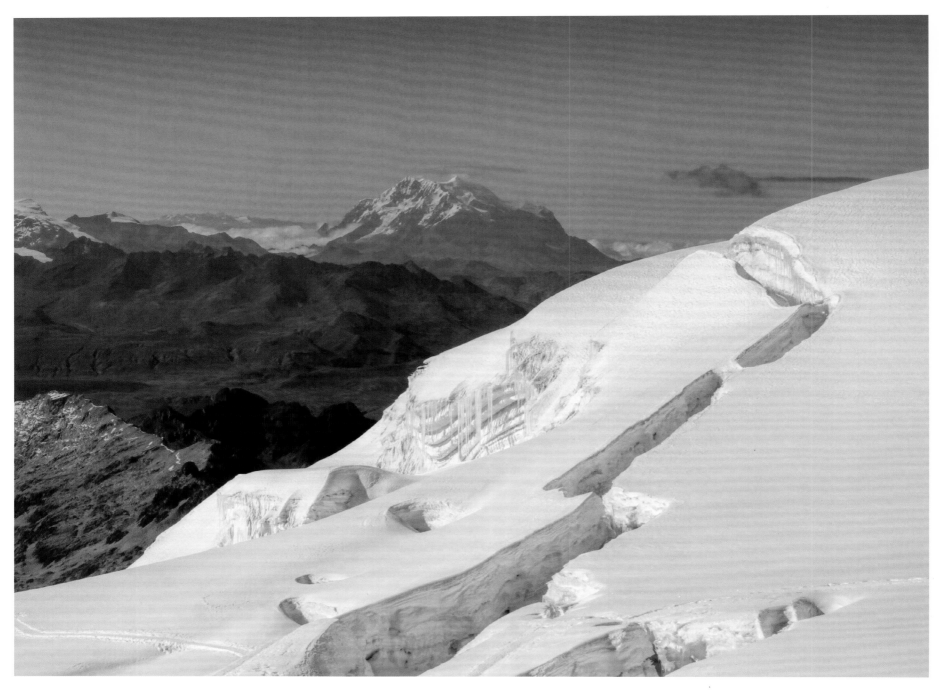

Huayna Potosí, Bolivia

Huayna Potosí

The glacier tongues of Huayna Potosí extend about 1000 m (3280 ft) down the mountain. This 6088 m (19973 ft) Andes peak near La Paz in Bolivia is of interest for a variety of reasons. It is considered to be relatively easy to climb and the mountain is easy to reach from La Paz, which is why in summer many mountaineers make their way to the summit using various routes. Scientists are intensively researching the Huayna Potosí glaciers, which are losing a lot of mass, and the melt water from the glaciers is used to power a number of power stations that supply the seat of government with electricity.

Huayna Potosí

Les langues de glace de l'Huayna Potosí s'écoulent sur environ 1 000 m. Ce sommet des Andes de 6 088 m situé près de La Paz, en Bolivie, est au cœur des intérêts pour plusieurs raisons. Facile d'accès depuis La Paz et réputé relativement simple à escalader, il attire en été de nombreux alpinistes se mettant en route vers la cime par différents chemins. Les scientifiques étudient intensivement ses glaciers, qui perdent rapidement en volume alors que toute une série de centrales électriques approvisionnant le siège du gouvernement sont alimentées par l'eau de fonte des glaciers.

Huayna Potosí

Rund 1000 m reichen die Gletscherzungen des Huayna Potosí hinab. Der 6088 m hohe Andengipfel nahe La Paz in Bolivien steht aus unterschiedlichen Gründen im Zentrum des Interesses: Er gilt als relativ leicht zu besteigen, weshalb sich im Sommer viele Bergsteiger auf verschiedenen Routen auf den Weg zum Gipfel machen – der Berg ist von La Paz aus leicht zu erreichen. Wissenschaftler erforschen intensiv die Gletscher des Huayna Potosí, die stark an Masse verlieren. Mit den Schmelzwassern der Gletscher wird eine Reihe von Kraftwerken betrieben, die den Regierungssitz mit Strom versorgen.

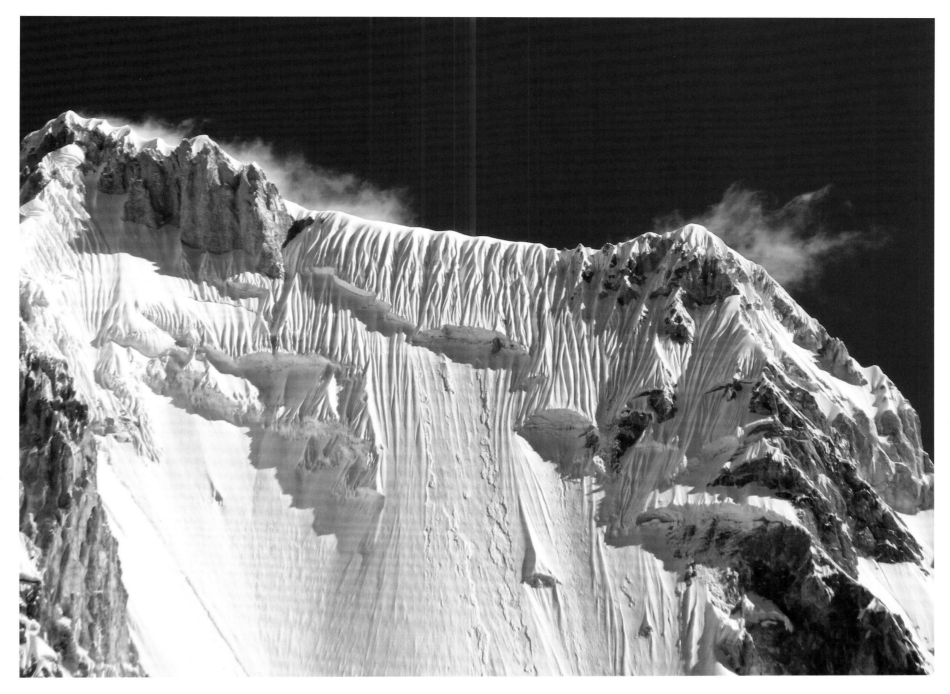

Yerupajá, Cordillera Huayhuash, Peru

Huayna Potosí

Las lenguas glaciares del Huayna Potosí alcanzan unos 1000 m de profundidad. El pico de los Andes de 6088 m de altura cerca de La Paz en Bolivia es de interés por varias razones: se considera que es relativamente fácil de escalar, por lo que en verano muchos montañeros se dirigen a la cima en varias rutas (es fácil llegar a la montaña desde La Paz). Los científicos están investigando intensamente los glaciares del Huayna Potosí, que están perdiendo mucha masa. El agua de deshielo de los glaciares se utiliza para alimentar varias centrales eléctricas que suministran electricidad a la sede del gobierno.

Huayna Potosí

As línguas glaciares de Huayna Potosí atingem cerca de 1000 m de profundidade. O pico de 6088 m de altura dos Andes, perto de La Paz, na Bolívia, é o foco de interesse por várias razões: é considerado relativamente fácil de escalar, e é por isso que no verão muitos montanhistas chegam ao cume por várias rotas - a montanha é fácil de se alcançar a partir de La Paz. Os cientistas estão pesquisando intensamente as geleiras Huayna Potosí, que estão perdendo muita massa. A água de fusão das geleiras é usada para alimentar uma série de centrais elétricas que abastecem a sede do governo com eletricidade.

Huayna Potosí

De gletsjertongen van Huayna Potosí bereiken een diepte van ongeveer 1000 meter. De 6088 m hoge top van de Andes bij La Paz in Bolivia is om verschillende redenen interessant: het wordt beschouwd als relatief gemakkelijk te beklimmen, waardoor in de zomer veel bergbeklimmers via verschillende routes hun weg naar de top vinden - de berg is gemakkelijk te bereiken vanaf La Paz. Wetenschappers doen intensief onderzoek naar de Huayna Potosí gletsjers die veel massa verliezen. Het smeltwater van de gletsjers wordt gebruikt om een aantal elektriciteitscentrales te beheren en de regeringszetel van stroom te voorzien.

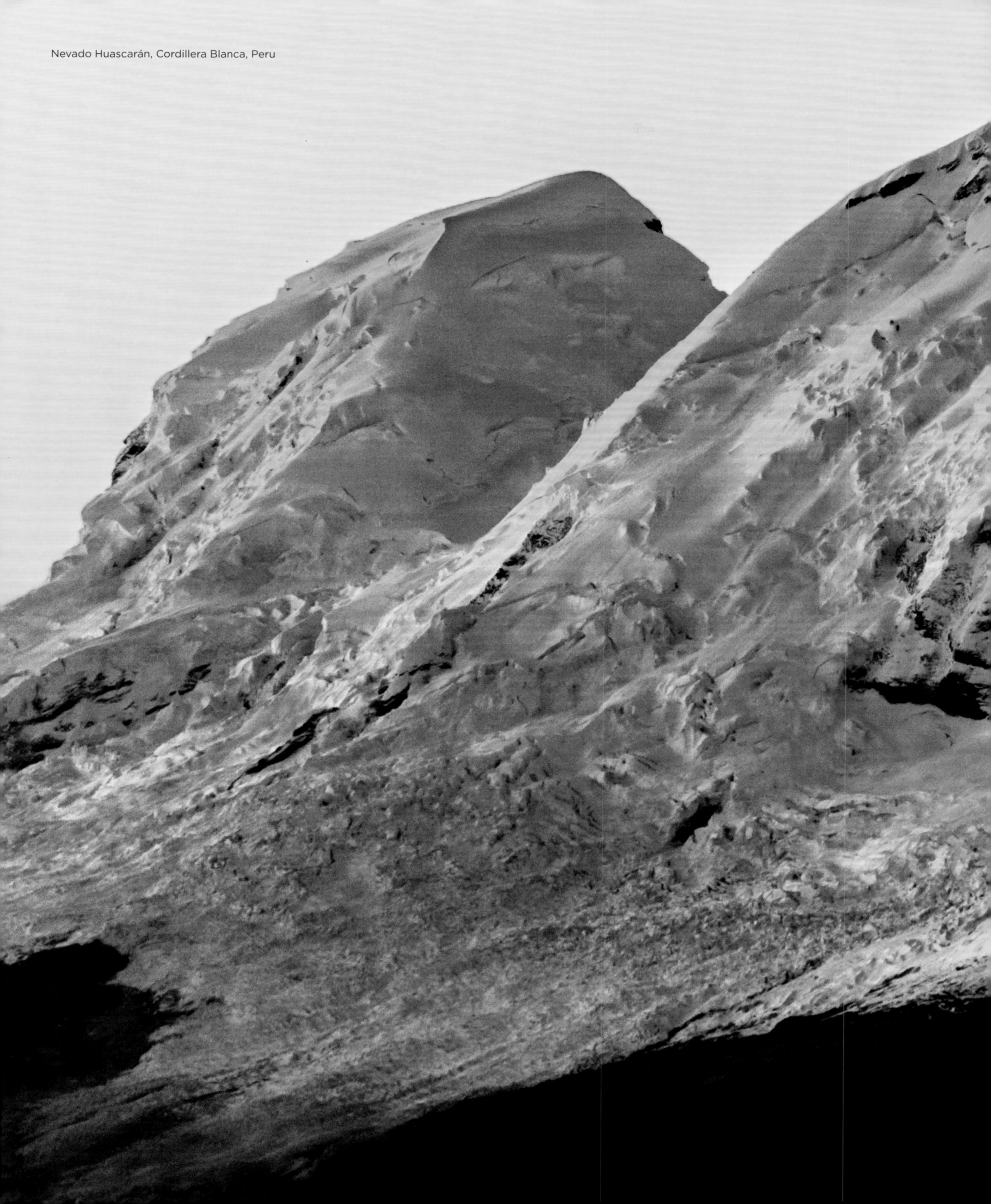

Nevado Huascarán, Cordillera Blanca, Peru

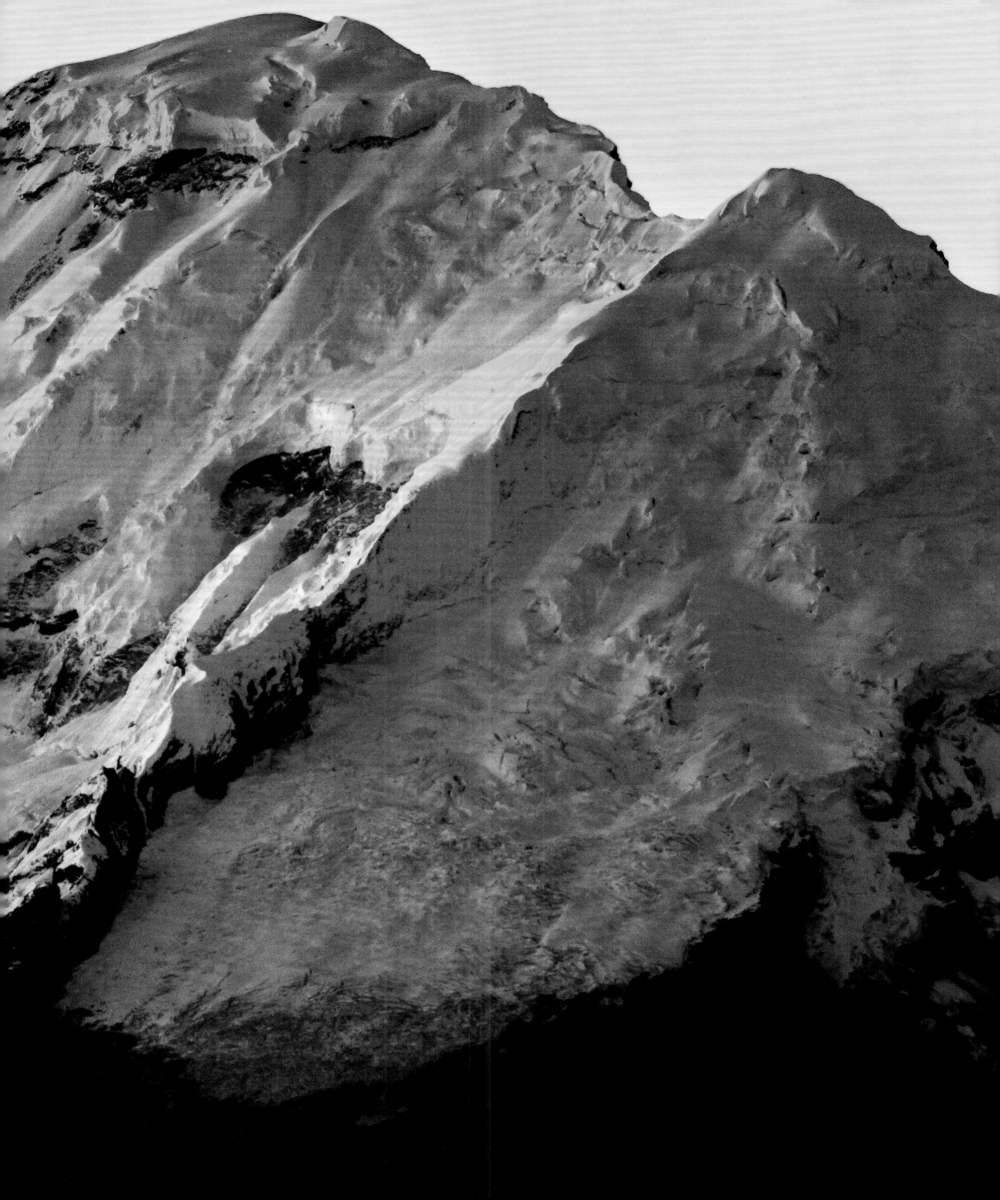

Ranrapalca, Cordillera Blanca, Peru

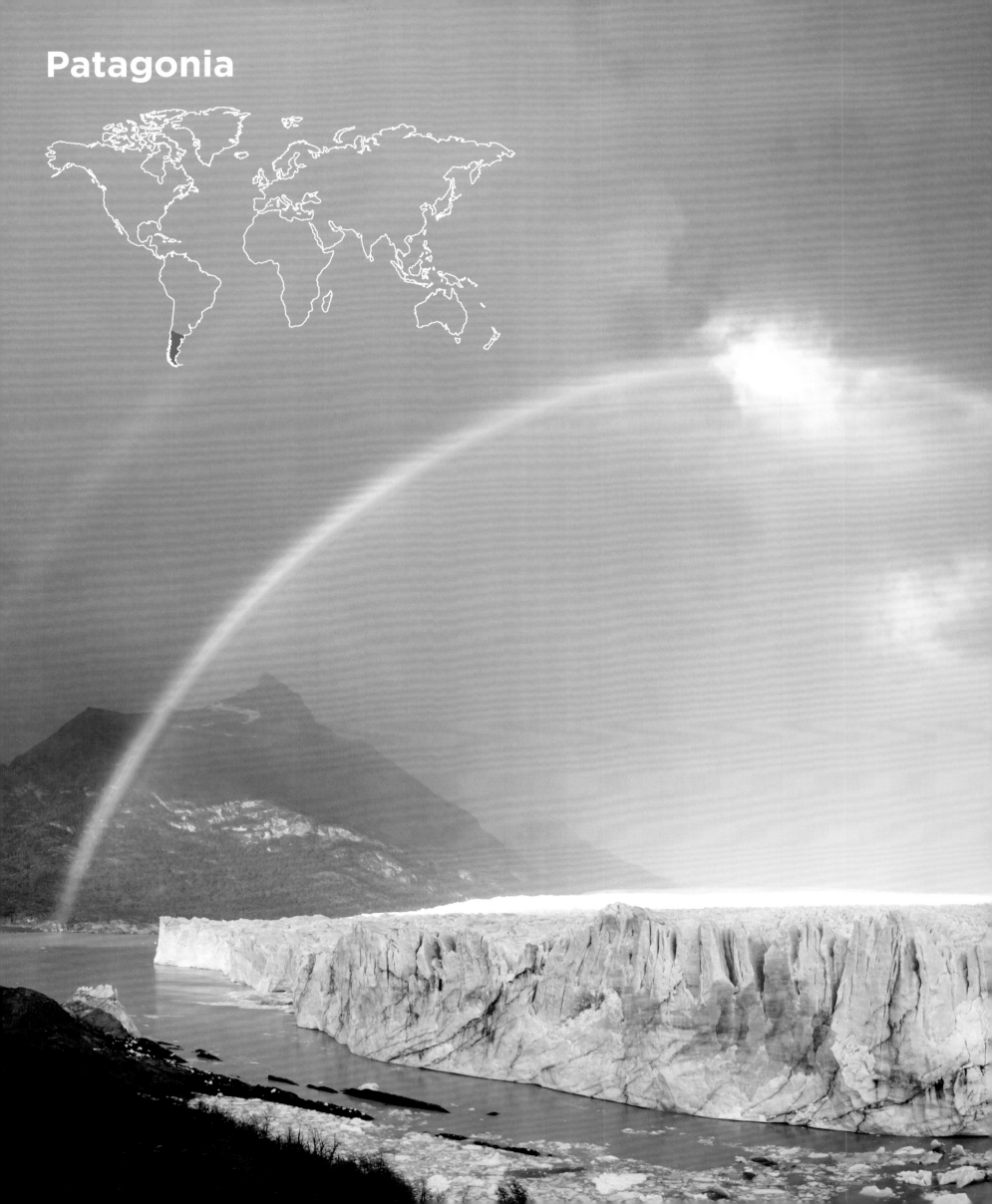

Patagonia

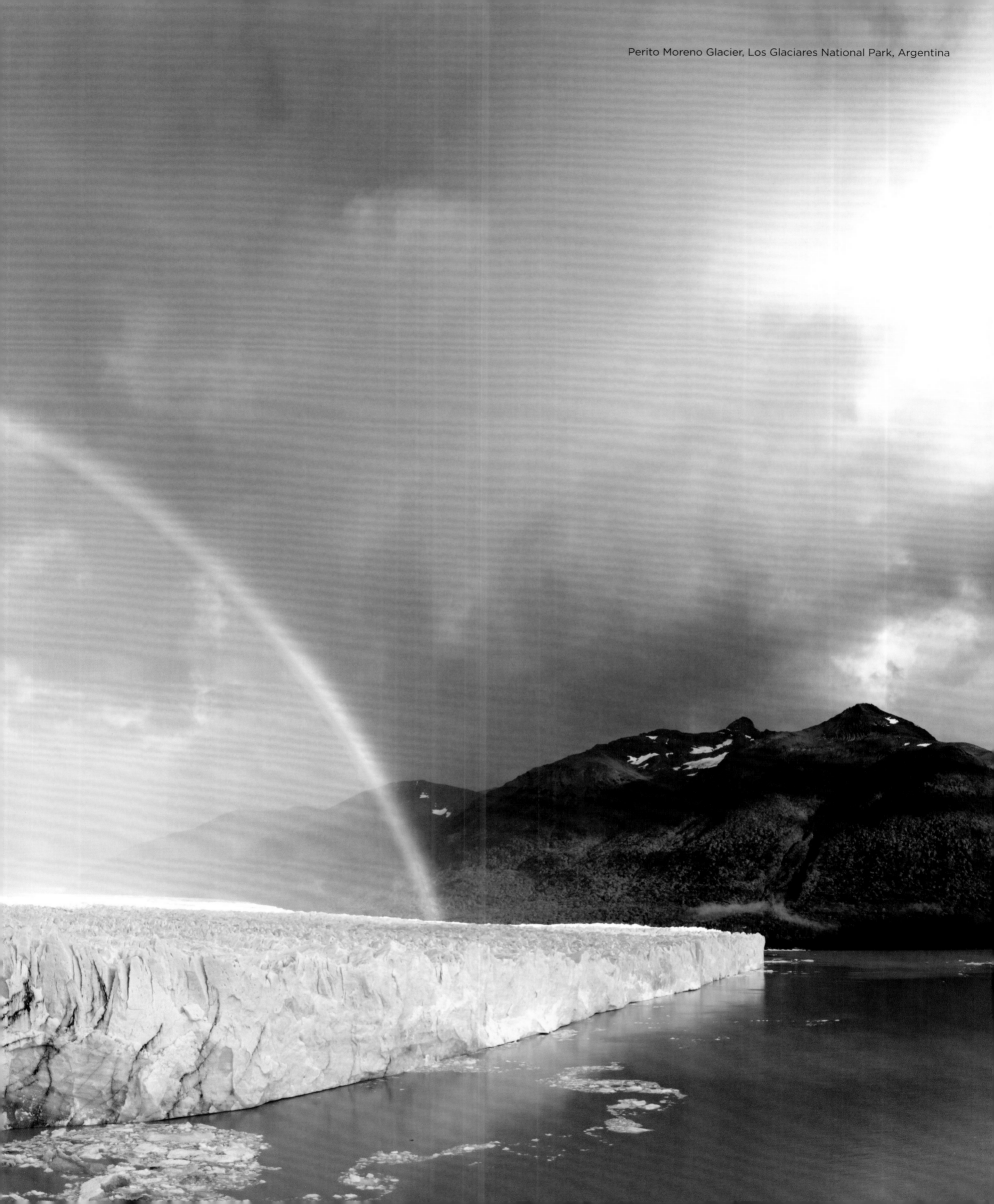

Perito Moreno Glacier, Los Glaciares National Park, Argentina

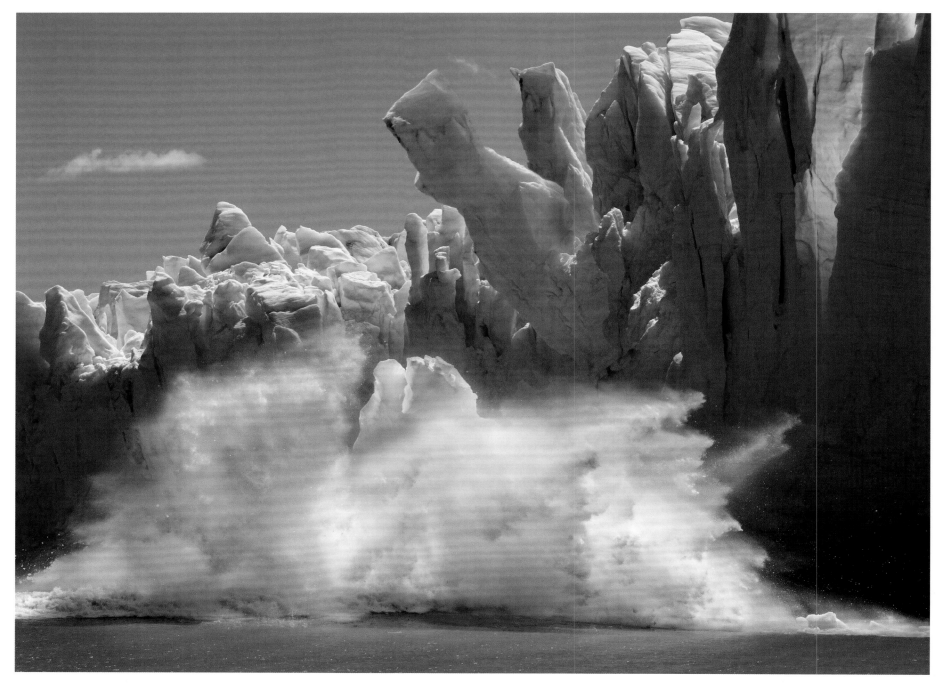

Ice calving, Perito Moreno Glacier, Los Glaciares National Park, Argentina

Patagonia

One of the world's most lonely and inhospitable regions is located in the southernmost part of South America: rugged, windy Patagonia, which is divided between Argentina and Chile, is extremely sparsely populated. There is little agriculture, cattle, sheep and fish farming and some industry, and tourism has become an important economic sector. The overpowering, untamed nature and the glacier world in the south fascinate visitors, especially in the big national parks. The various indigenous peoples who defied the harsh climatic conditions are almost extinct today.

Patagonie

L'une des régions les plus isolées et les plus inhospitalières de la planète s'étend sur la pointe de l'Amérique du Sud. La Patagonie, aux paysages rudes et balayés par les vents, courant sur l'Argentine et le Chili, est extrêmement peu peuplée. L'exploitation agricole et l'élevage de bétails, de moutons et de poissons sont faibles car la branche économique qui a pris le dessus est le tourisme. La nature toute-puissante et indomptée de la Patagonie ainsi que l'univers glaciaire du sud fascinent les visiteurs, qui explorent principalement les parcs nationaux. Les différents peuples indiens bravant les rudes conditions climatiques de la région ont presque tous disparu.

Patagonien

Eine der einsamsten und unwirtlichsten Regionen der Erde erstreckt sich im südlichsten Teil Südamerikas: Das raue, windumtoste Patagonien, das sich Argentinien und Chile teilen, ist äußerst dünn besiedelt. Es gibt wenig Landwirtschaft, Vieh-, Schaf- und Fischzucht und etwas Industrie, ein wichtiger Wirtschaftszweig ist inzwischen der Tourismus. Die übermächtige, ungezähmte Natur und die Gletscherwelt im Süden faszinieren die Menschen, die vor allem die großen Nationalparks besuchen. Die erschiedenen indianischen Völker, die den harten klimatischen Bedingungen trotzten, sind heute nahezu ausgerottet.

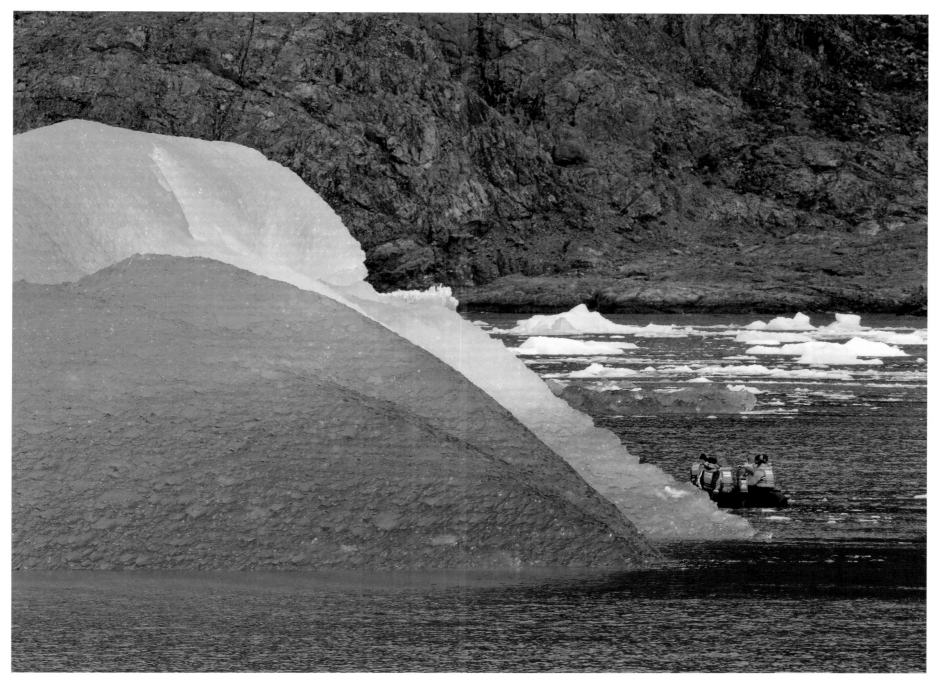

Laguna San Rafael, Laguna San Rafael National Park, Chile

Patagonia

Una de las regiones más solitarias e inhóspitas del mundo se encuentra en la parte más al sur de América del Sur: la escarpada y ventosa Patagonia, que se divide entre Argentina y Chile, está extremadamente poco poblada. Hay poca agricultura, ganado vacuno, ovino, piscicultura y alguna industria; un sector económico importante es el turismo. La abrumadora naturaleza salvaje y el mundo de los glaciares en el sur fascinan a la gente, que visita sobre todo los grandes parques nacionales. Los diversos pueblos indios que desafiaron las duras condiciones climáticas están casi extintos hoy en día.

Patagônia

Uma das regiões mais solitárias e inóspitas do mundo se estende na parte mais meridional da América do Sul: a Patagônia áspera e ventosa , dividida entre a Argentina e o Chile, tem uma densidade populacional extremamente escassa. Há pouca agricultura, criação de gado, de ovinos e de peixes e alguma indústria, um setor económico importante é agora o turismo. A natureza dominadora e selvagem e o mundo glaciar no sul fascinam as pessoas, que visitam acima de tudo os grandes parques nacionais. Os vários povos indígenas que desafiaram as duras condições climáticas estão quase extintos hoje em dia.

Patagonië

Een van de meest eenzame en onherbergzame regio's ter wereld ligt in het meest zuidelijke deel van Zuid-Amerika: het ruige, winderige Patagonië, dat verdeeld is tussen Argentinië en Chili, is zeer dun bevolkt. Er is weinig landbouw, rundvee-, schapen- en viskwekerij en een deel van de industrie, een belangrijke economische sector is nu het toerisme. De overweldigende, ongetemde natuur en de gletsjerwereld in het zuiden fascineren de mensen, die vooral de grote nationale parken bezoeken. De verschillende indianenvolkeren die de barre klimatologische omstandigheden hebben getrotseerd, zijn tegenwoordig bijna uitgestorven.

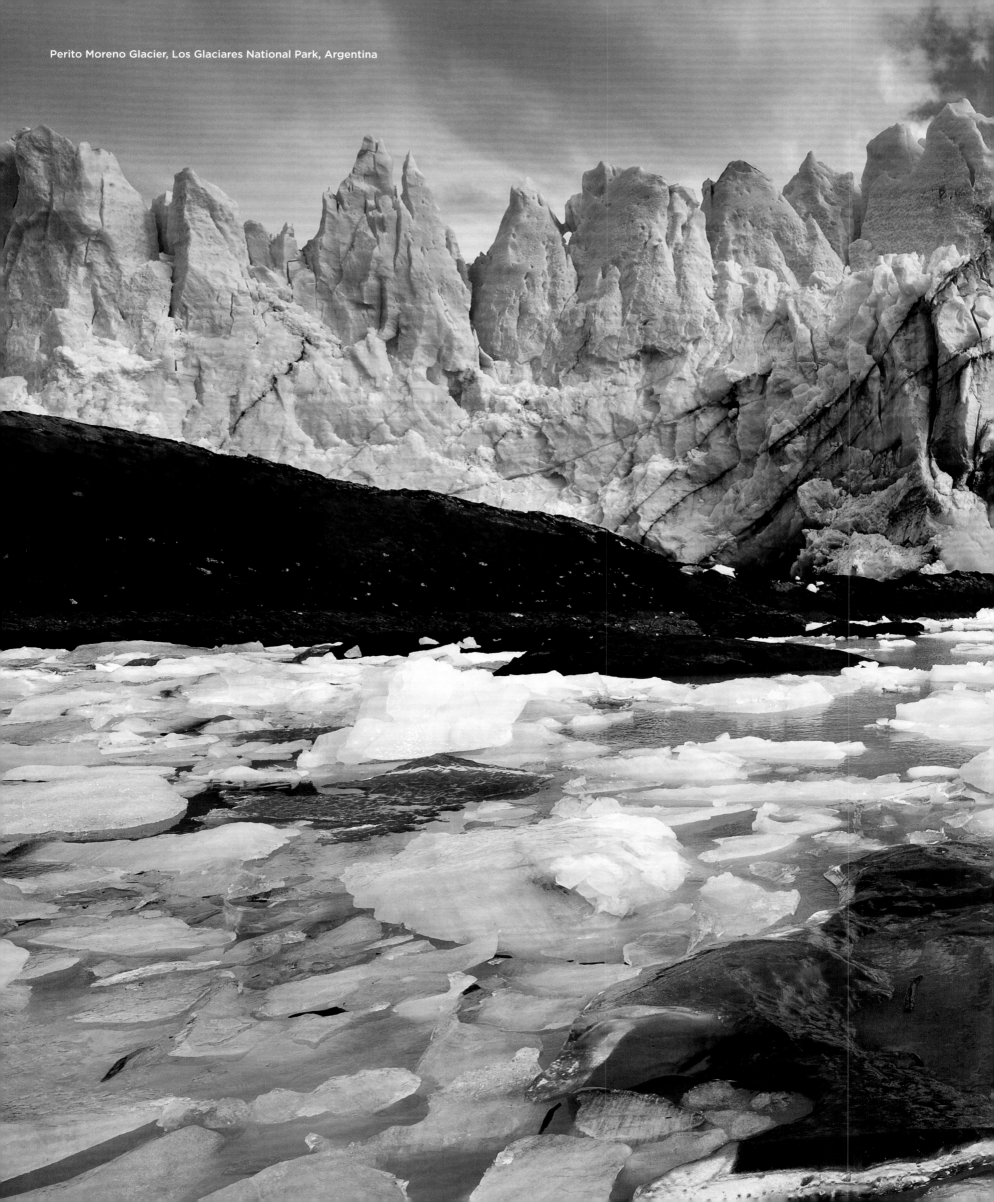

Perito Moreno Glacier, Los Glaciares National Park, Argentina

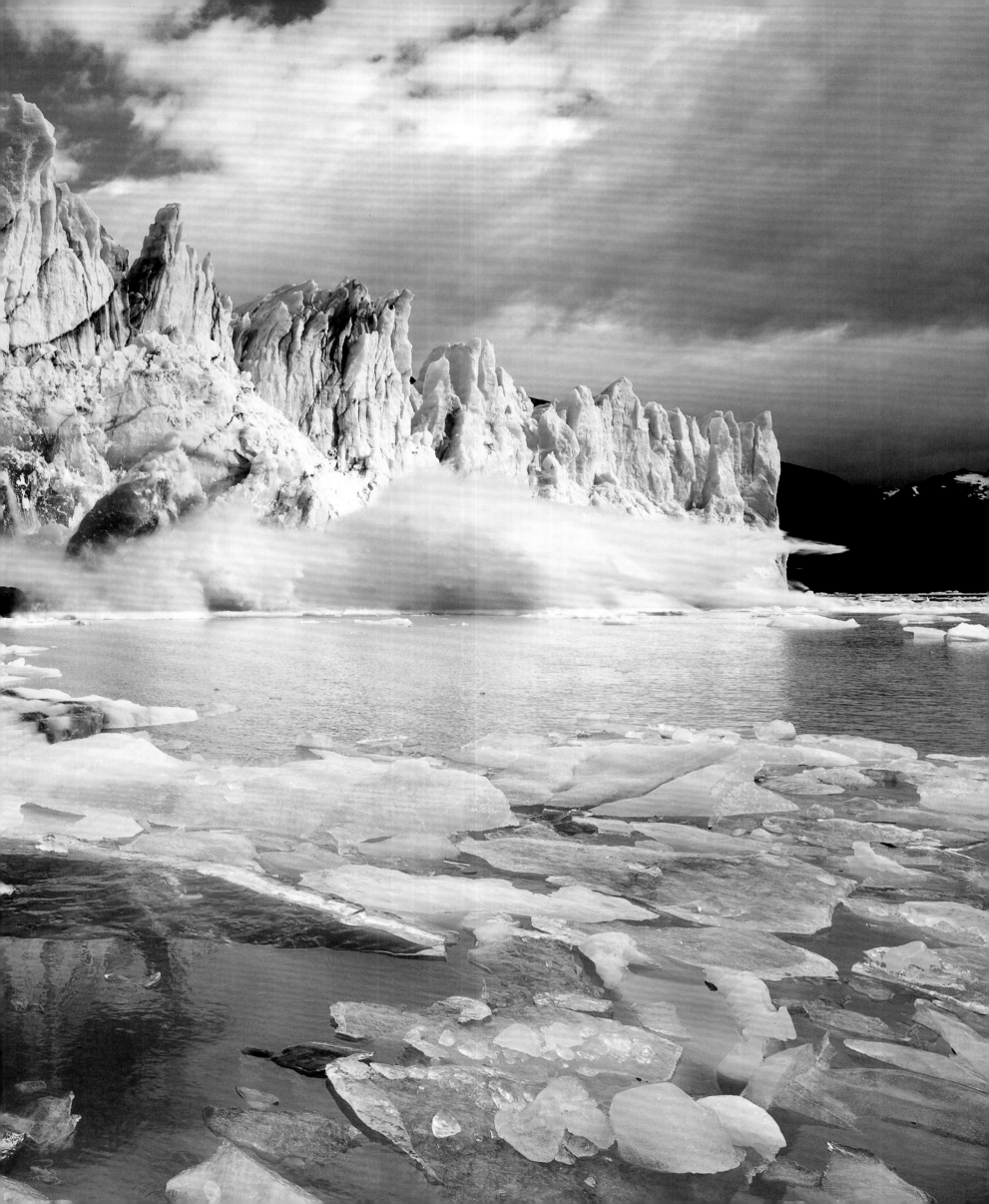

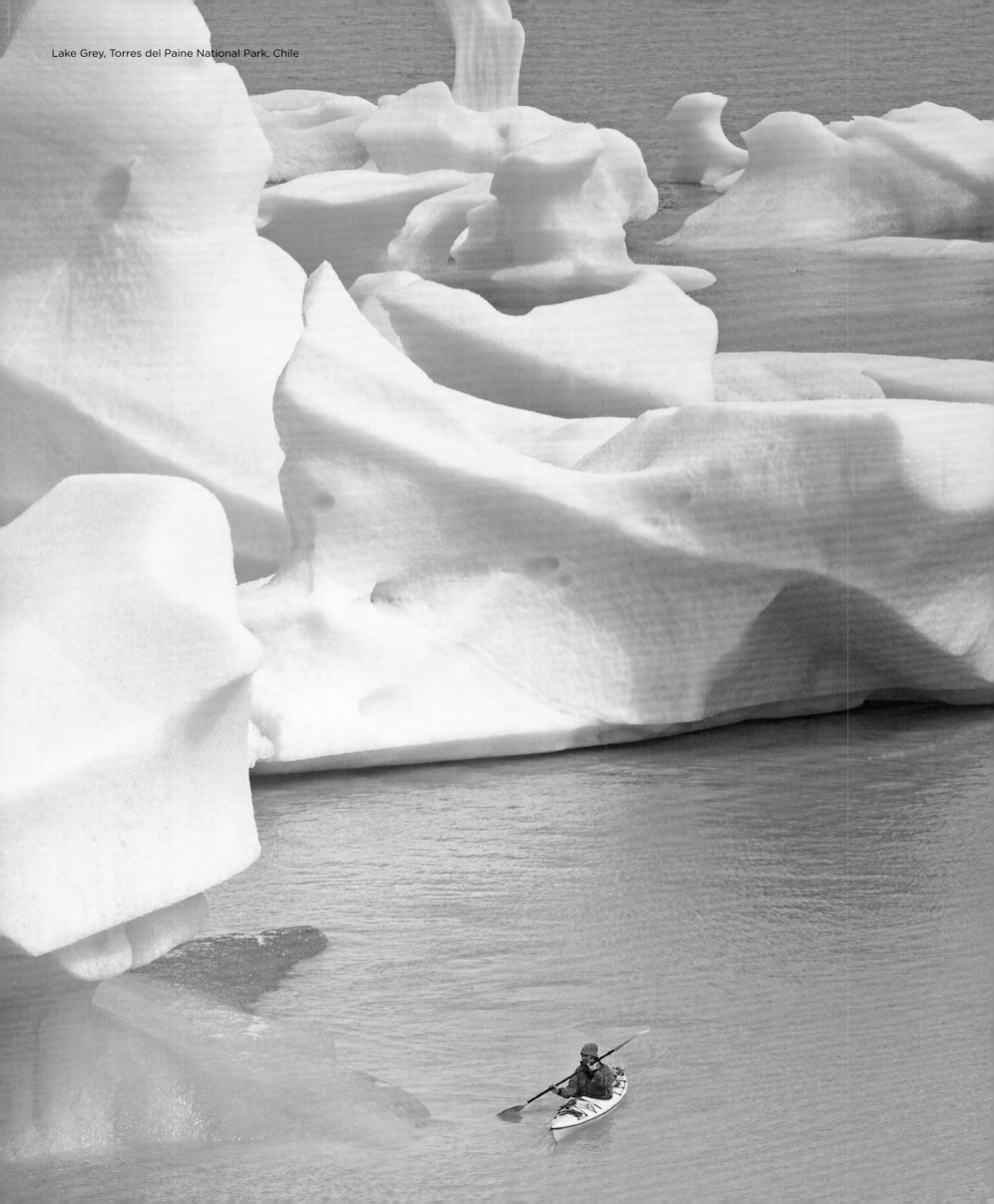

Lake Grey, Torres del Paine National Park, Chile

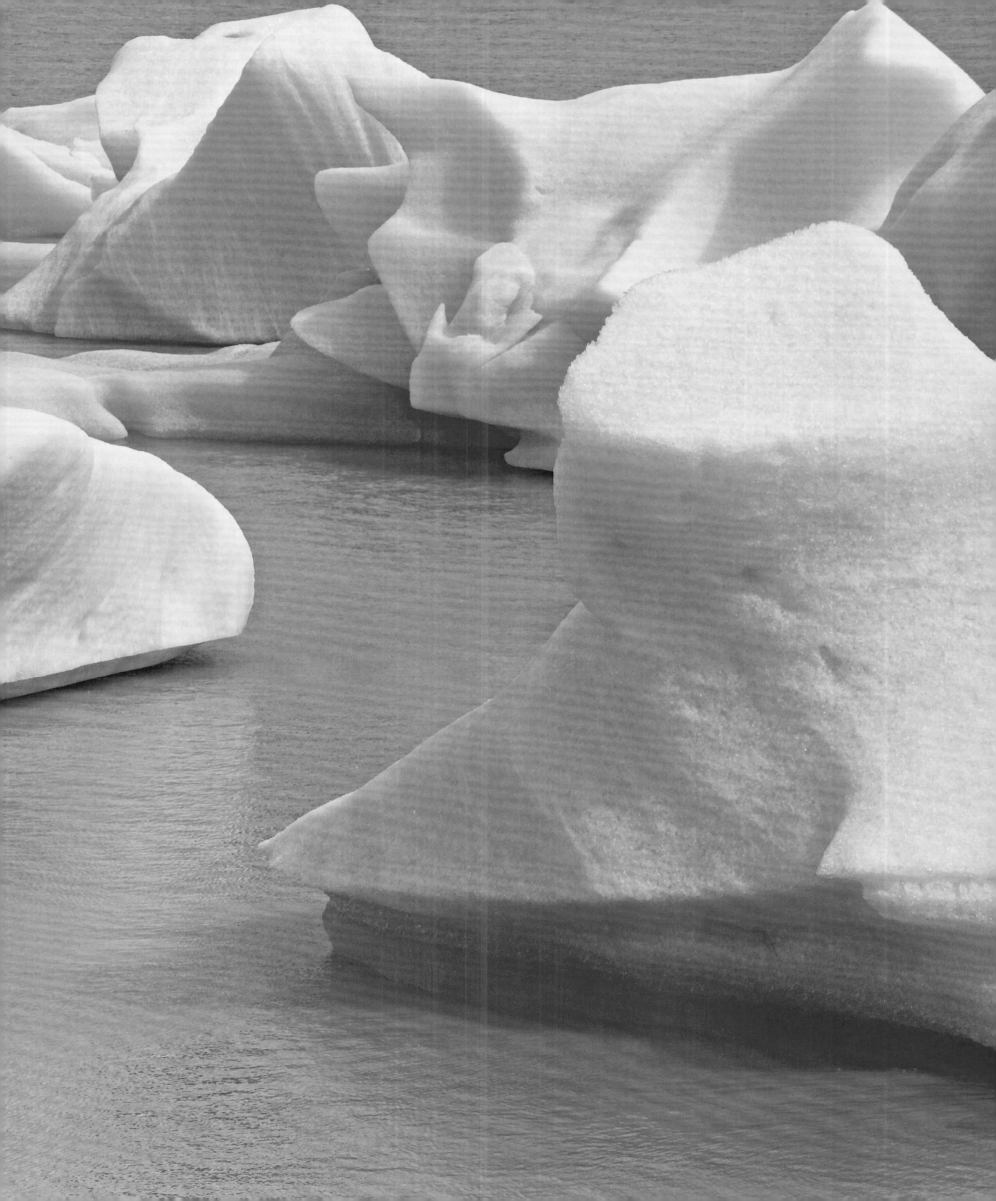

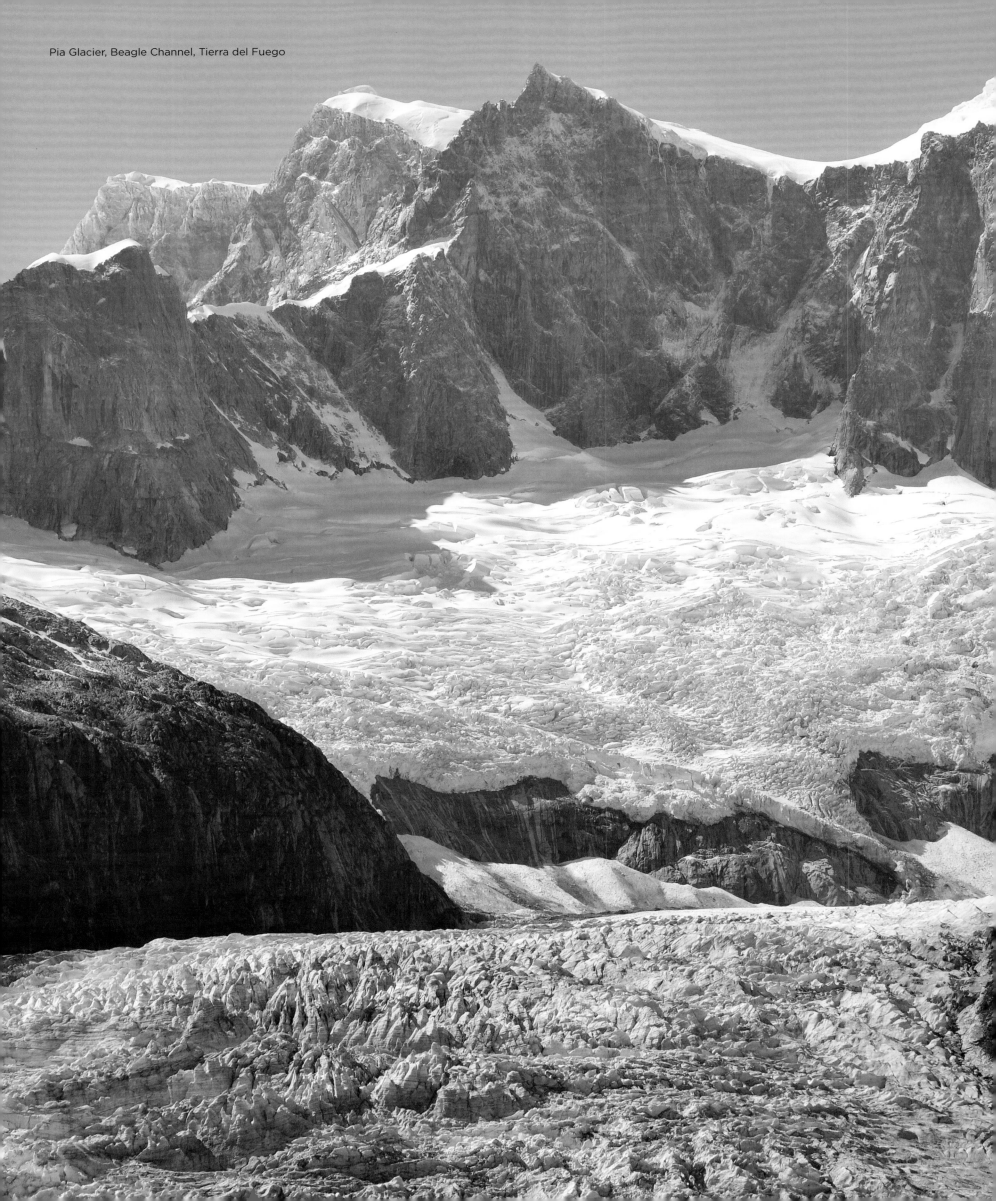

Pia Glacier, Beagle Channel, Tierra del Fuego

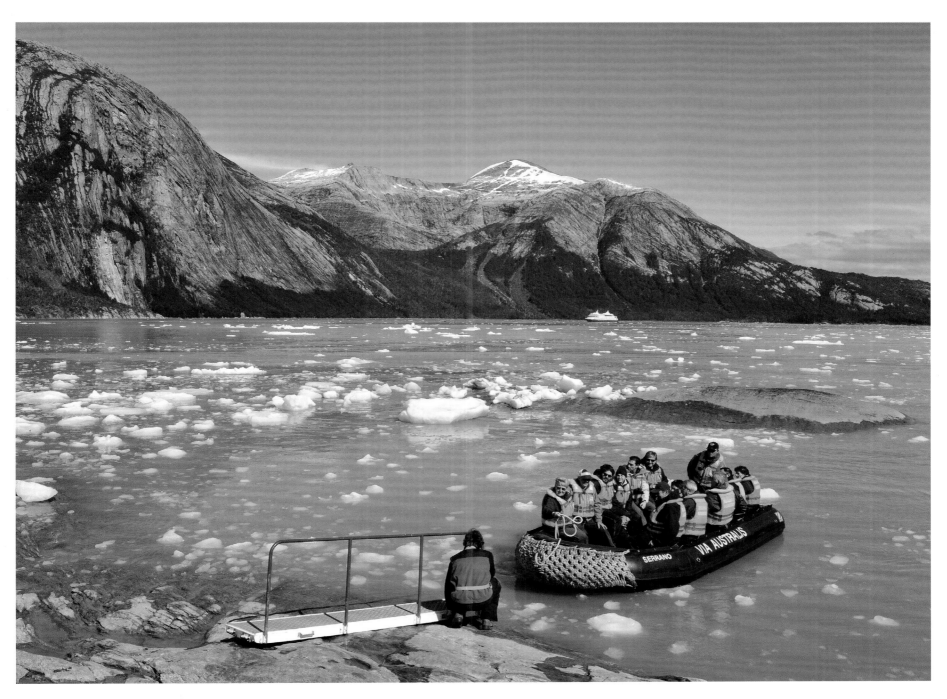

Pia Glacier, Beagle Channel, Tierra del Fuego

Glacier Tour

Cruise passengers travel with zodiacs on the Beagle Canal in Tierra del Fuego. The glacier can be observed particularly well from a boat and near to where you can go ashore , blocks of ice as high as a house are continually breaking off Pia Glacier. This impressive spectacle is also to be seen among the other ice giants in the "Avenue of Glaciers".

Recorrido glaciar

Los pasajeros de cruceros viajan con zodiacs por el Canal de Beagle en Tierra del Fuego. La actividad de los glaciares se puede observar especialmente bien desde el barco. Desde el glaciar Pía, cerca del cual se puede desembarcar, se rompen una y otra vez pedazos de hielo que llegan a alcanzar la altura de una casa. El impresionante espectáculo se repite con los otros gigantes de hielo en la «avenida de los glaciares».

Excursions sur les glaciers

Les croisiéristes embarquent sur des zodiaques pour naviguer sur le canal du Beagle, en Terre de Feu. Depuis ces bateaux, l'activité glaciaire peut être très bien observée. Des morceaux de glace hauts comme des maisons se détachent régulièrement du glacier Pia, dont il est possible de s'approcher à pied. Ce spectacle impressionnant se répète également auprès des autres géants de glace formant l'« Allée des glaciers ».

Passeio pelos glaciares

Passageiros de cruzeiro viajam em zodiacs (botes infláveis) no Canal de Beagle na Terra do Fogo. As atividades do glaciar podem ser bem observadas particularmente a partir do barco. Do glaciar Pia, perto do qual você pode desembarcar, pedaços de gelo tão altos quanto uma casa quebram repetidamente. O espetáculo impressionante repete-se com os outros gigantes de gelo na "Avenida das Geleiras".

Gletschertour

Kreuzfahrtpassagiere befahren mit Zodiacs den Beagle-Kanal in Feuerland. Vom Boot aus lassen sich die Gletscheraktivitäten besonders gut beobachten. Vom Pia-Gletscher, in dessen Nähe man an Land gehen kann, brechen immer wieder haushohe Eisstücke ab. Das beeindruckende Schauspiel wiederholt sich bei den anderen Eisriesen in der „Allee der Gletscher".

Gletsjertocht

Cruisepassagiers reizen met Zodiacs op het Beagle-kanaal in Tierra del Fuego. De gletsjeractiviteiten zijn vooral vanaf de boot goed waarneembaar. Vanaf de Pia-gletsjer, waar je aan land kunt gaan, breken steeds weer ijsstukken zo hoog als een huis af. Het indrukwekkende schouwspel wordt herhaald met de andere ijsgiganten in de „Allee der Gletscher".

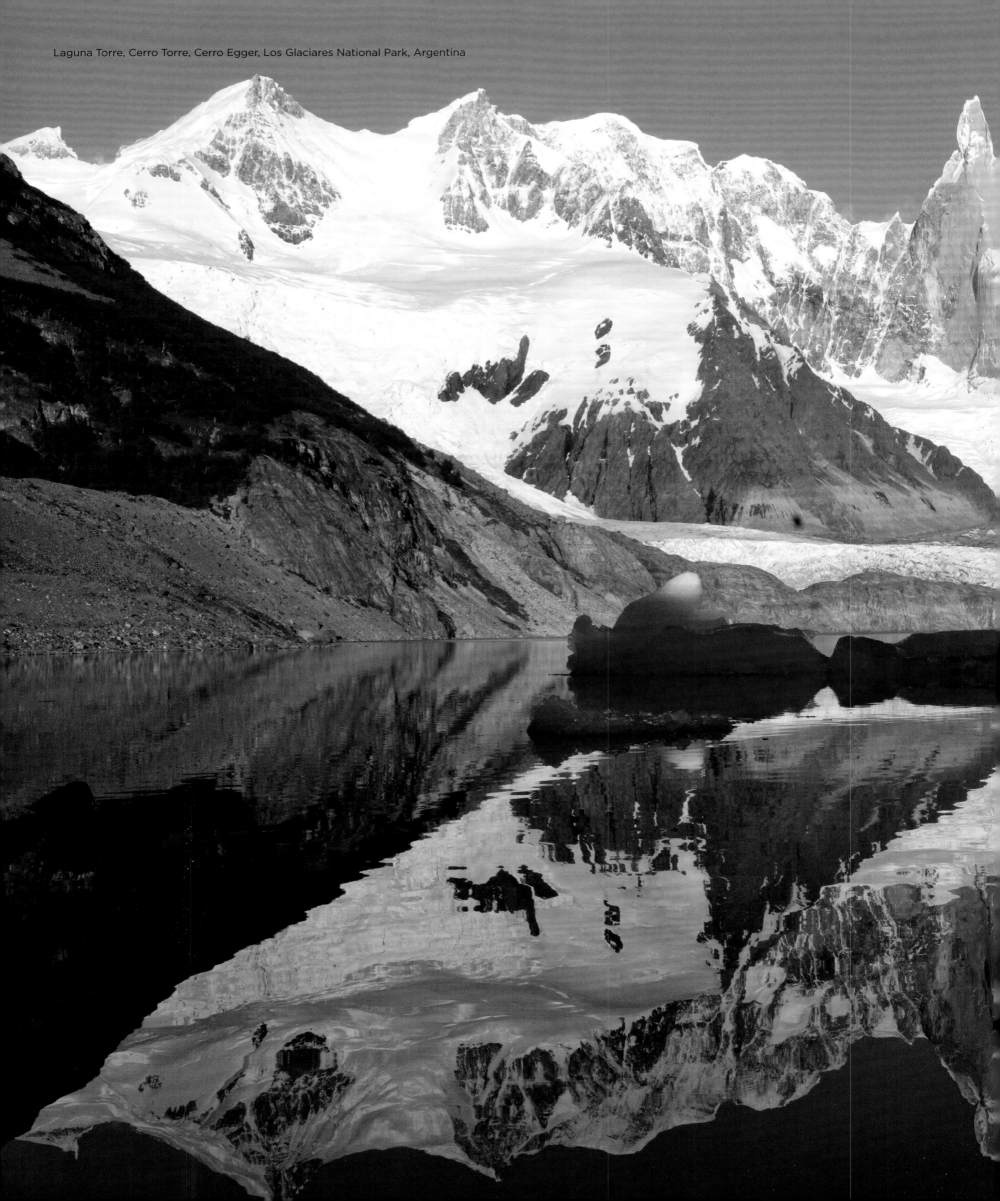

Laguna Torre, Cerro Torre, Cerro Egger, Los Glaciares National Park, Argentina

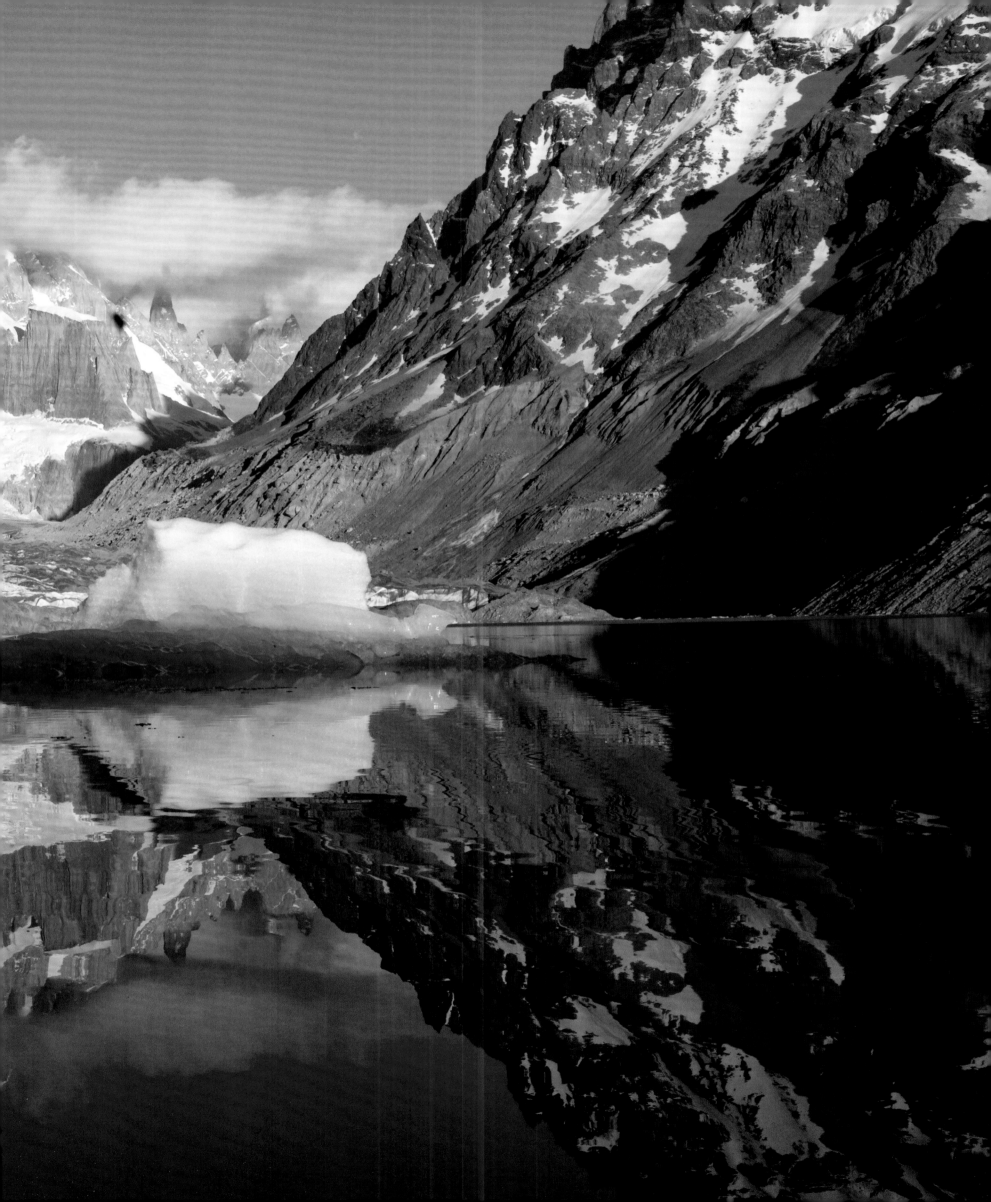

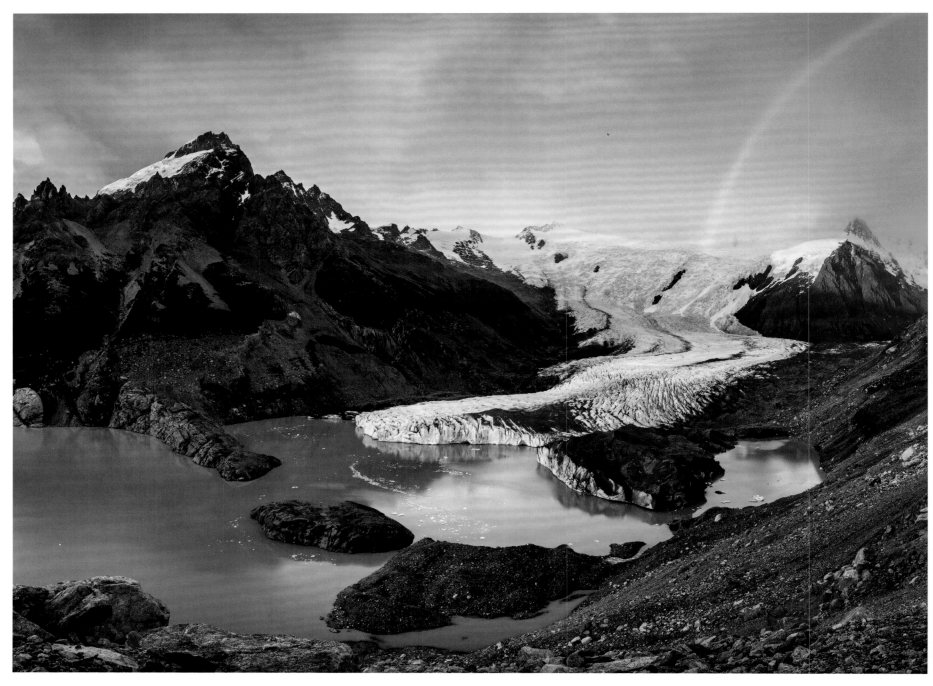

Torre Glacier, Laguna Torre, Los Glaciares National Park, Argentina

Los Glaciares

The Argentine National Park Los Glaciares is one of the most visited sights in the south of the country. Cerro Torre is especially spectacular, a 3128 m (10262 ft) steep rock needle made of granite. The smooth, almost vertical rock walls are often covered by ice, making it almost impossible to climb. The huge glaciers in the park are especially attractive for tourists. The Perito Moreno Glacier, which is 30 km (18 mi) long and approximately 250 km² (96 sq mi), flows into the Lago Argentino and is an anomaly: it is one of the few glaciers worldwide that do not show a noticeable decrease.

Los Glaciares

Le parc national Los Glaciares fait partie des sites les plus visités du sud de la Patagonie. Le Cerro Torre, un abrupt pic de granite de 3 128 m dont les parois rocheuses sont souvent recouvertes de glace – ce qui le rend impossible à escalader – est particulièrement spectaculaire. Les énormes glaciers du parc attirent nombre de touristes. Le glacier Perito Moreno, d'une longueur de 30 km et d'une superficie d'environ 250 km² se jette dans les eaux du lac Argentino ; c'est un spécimen unique : il fait partie des rares glaciers de la planète qui ne soit pas en recul visible.

Los Glaciares

Der argentinische Nationalpark Los Glaciares gehört zu den meistbesuchten Sehenswürdigkeiten im Süden des Landes. Besonders spektakulär ist der Cerro Torre, eine 3128 m hohe, steile Felsnadel aus Granit, deren glatte, fast senkrechte Felswände oft von Eis bedeckt sind, was ihn fast unbesteigbar macht. Für Touristen besonders attraktiv sind die riesigen Gletscher im Park. Der 30 km lange und rund 250 km² große Perito-Moreno-Gletscher, der in den Lago Argentino mündet, ist eine Besonderheit: Er gehört weltweit zu nur ganz wenigen Gletschern, bei denen kein merklicher Rückgang festzustellen ist.

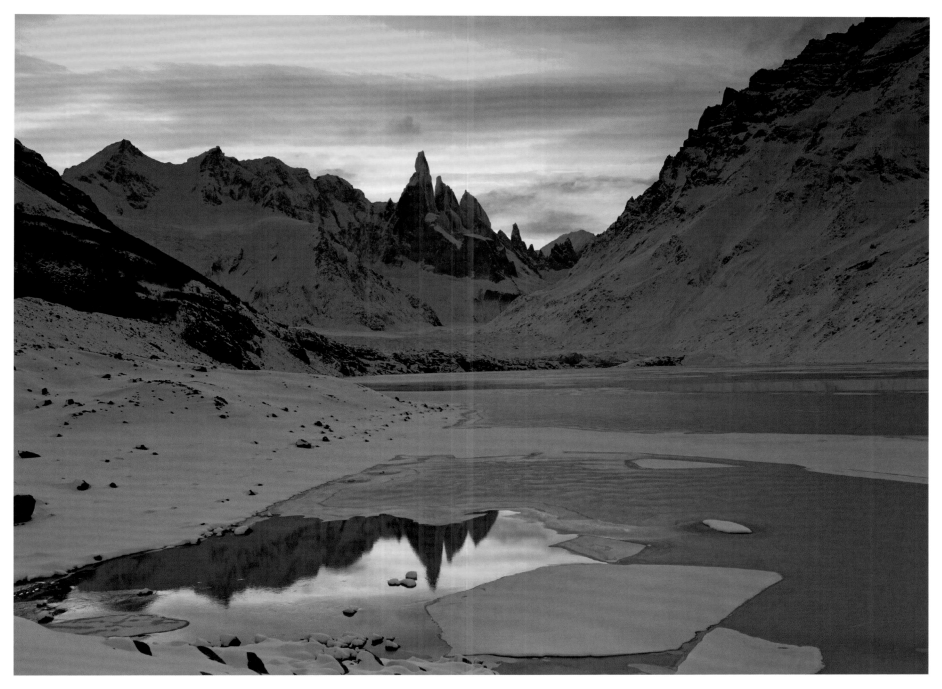

Laguna Torre, Cerro Torre, Cerro Egger, Los Glaciares National Park, Argentina

Los Glaciares

El Parque Nacional Los Glaciares en Argentina es uno de los más visitados del sur del país. Especialmente espectacular es el Cerro Torre, una escarpada aguja de granito de 3128 m de altura cuyas paredes de roca lisas y casi verticales están a menudo cubiertas de hielo, lo que hace que sea casi imposible de escalar. Especialmente atractivos para los turistas son los enormes glaciares del parque. El glaciar Perito Moreno, de 30 km de largo y aproximadamente 250 km² de superficie, que desemboca en el Lago Argentino, es una muy particular: es uno de los pocos glaciares en todo el mundo que no muestra una disminución notable.

Los Glaciares

O Parque Nacional Argentino Los Glaciares é um dos pontos turísticos mais visitados do sul do país. Especialmente espectacular é o Cerro Torre, uma agulha de rocha íngreme de 3128 m de altura, feita de granito, cujas paredes lisas, quase verticais, são frequentemente cobertas por gelo, o que torna quase impossível a subida. Especialmente atraentes para os turistas são os enormes glaciares no parque. O glaciar Perito Moreno, de 30 km de comprimento e aproximadamente 250 km² de extensão, que desemboca no Lago Argentino, tem uma característica especial: pertence a um dos poucos glaciares no mundo que não apresentam um derretimento acentuado.

Los Glaciares

Het Argentijnse Nationale Park Los Glaciares is een van de meest bezochte bezienswaardigheden in het zuiden van het land. Bijzonder spectaculair is de Cerro Torre, een 3128 m hoge, steile rotsnaald van graniet, waarvan de gladde, bijna verticale rotswanden vaak bedekt zijn met ijs, wat het bijna onmogelijk maakt om te klimmen. Bijzonder aantrekkelijk voor toeristen zijn de enorme gletsjers in het park. De 30 km lange en ongeveer 250 km² grote Perito Moreno gletsjer die uitmondt in het Lago Argentino is bijzonder: het behoord tot slechts enkele gletsjers wereldwijd die geen merkbare afname laten zien.

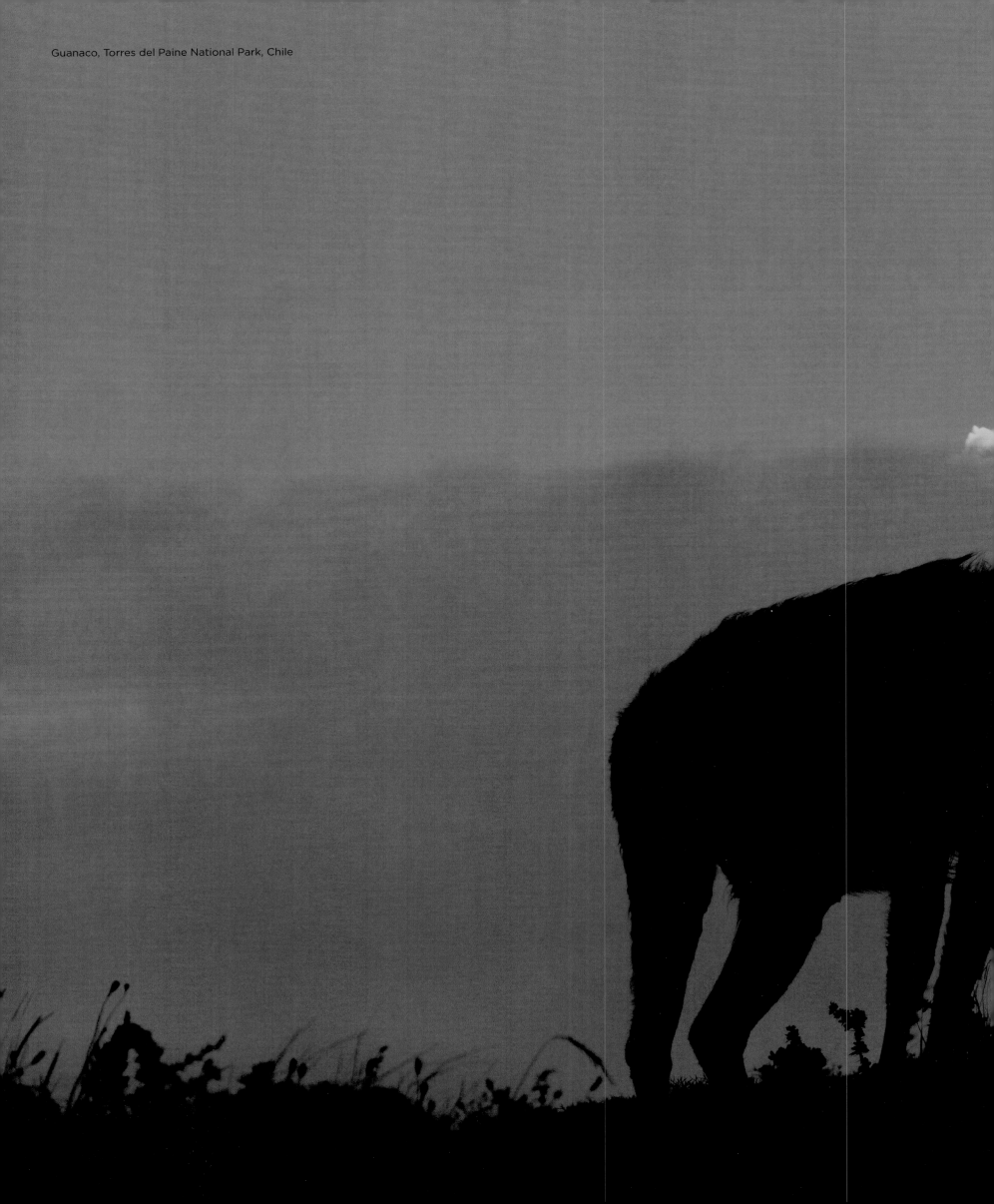

Guanaco, Torres del Paine National Park, Chile

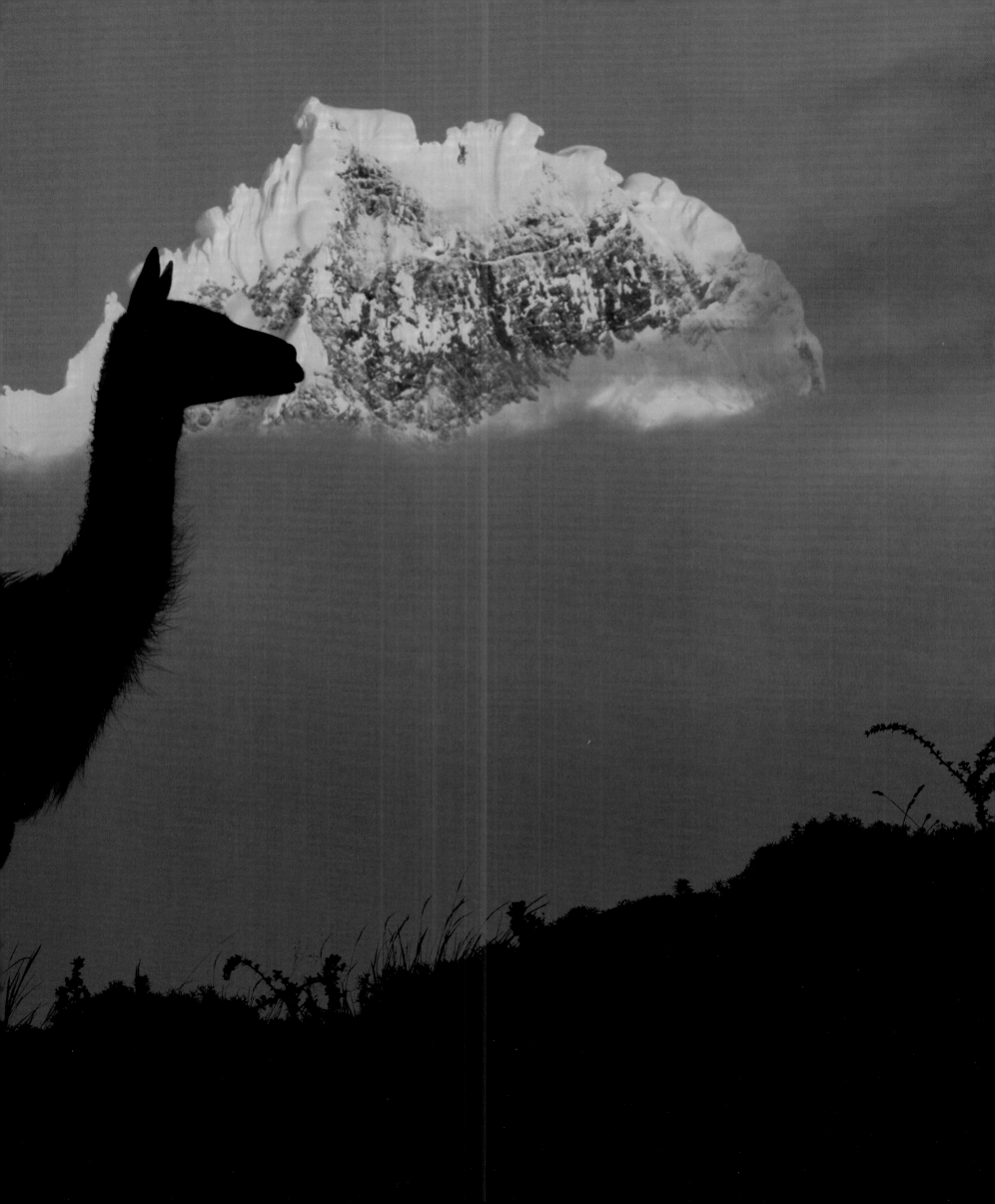

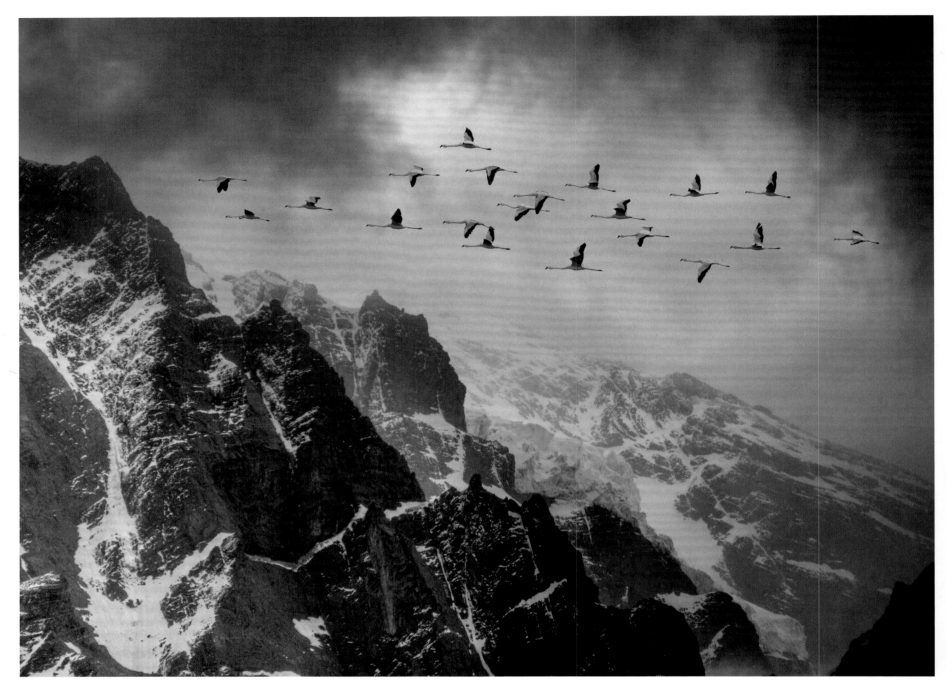

Flamingos, Torres Del Paine National Park, Chile

Torres del Paine

The Chilean National Park Torres del Paine extends over approximately 2400 km² (926 sq mi). Large parts of the park are covered by glaciers, and the park gets its name from the Torres del Paine, three steep granite needles which reach up to 2850 m (9350 ft) high. The spectacular landscape with rich fauna and flora make the park a magnet for visitors, and also attracts many climbers and glacier hikers.

Torres del Paine

Le parc national chilien Torres del Paine s'étend sur une superficie de plus de 2 400 km². De vastes espaces du parc sont recouverts de glaciers. Les Torres del Paine, qui donnent leur nom au parc, sont trois monolithes de granite raides particulièrement impressionnants qui atteignent jusqu'à 2 850 m de haut. Les paysages spectaculaires du parc, riches d'une importante faune et flore, sont un aimant à visiteurs, notamment de nombreux alpinistes et randonneurs de glaciers.

Torres del Paine

Gut 2400 km² groß ist der chilenische Nationalpark Torres del Paine. Weite Teile des Parks sind von Gletschern bedeckt. Markant sind die namengebenden Torres del Paine, drei steile, bis zu 2850 m hohe Granitnadeln. Die spektakuläre Landschaft mit reicher Fauna und Flora machen den Park zum Besuchermagneten, der viele Kletterer und Gletscherwanderer anzieht.

Torres del Paine

El Parque Nacional Torres del Paine tiene una extensión de unos 2400 km². Gran parte del parque está cubierta de glaciares. Las Torres del Paine, tres empinadas agujas de granito de hasta 2850 m de altura, dan nombre al parque. El espectacular paisaje con una rica fauna y flora hacen del parque un imán para los visitantes, ya que atrae a muchos escaladores y excursionistas de los glaciares.

Torres del Paine

O parque nacional chileno Torres del Paine tem cerca de 2400 km² de extensão. Grandes partes do parque são cobertas por glaciares. Impressionantes são as Torres de Paine de mesmo nome, com três agulhas de granito íngremes e com até 2850 m de altura. A paisagem espetacular com rica fauna e flora faz do parque um ímã de visitantes, que atrai muitos alpinistas e caminhantes de geleiras.

Torres del Paine

Het Chileense nationale park Torres del Paine is ongeveer 2400 km² groot. Grote delen van het park zijn bedekt met gletsjers. De Torres del Paine, drie steile granieten naalden die tot 2850 m hoog zijn, geven het park zijn naam. Het spectaculaire landschap met een rijke fauna en flora maken het park tot een bezoekersmagneet wat veel klimmers en gletsjerwandelaars aantrekt.

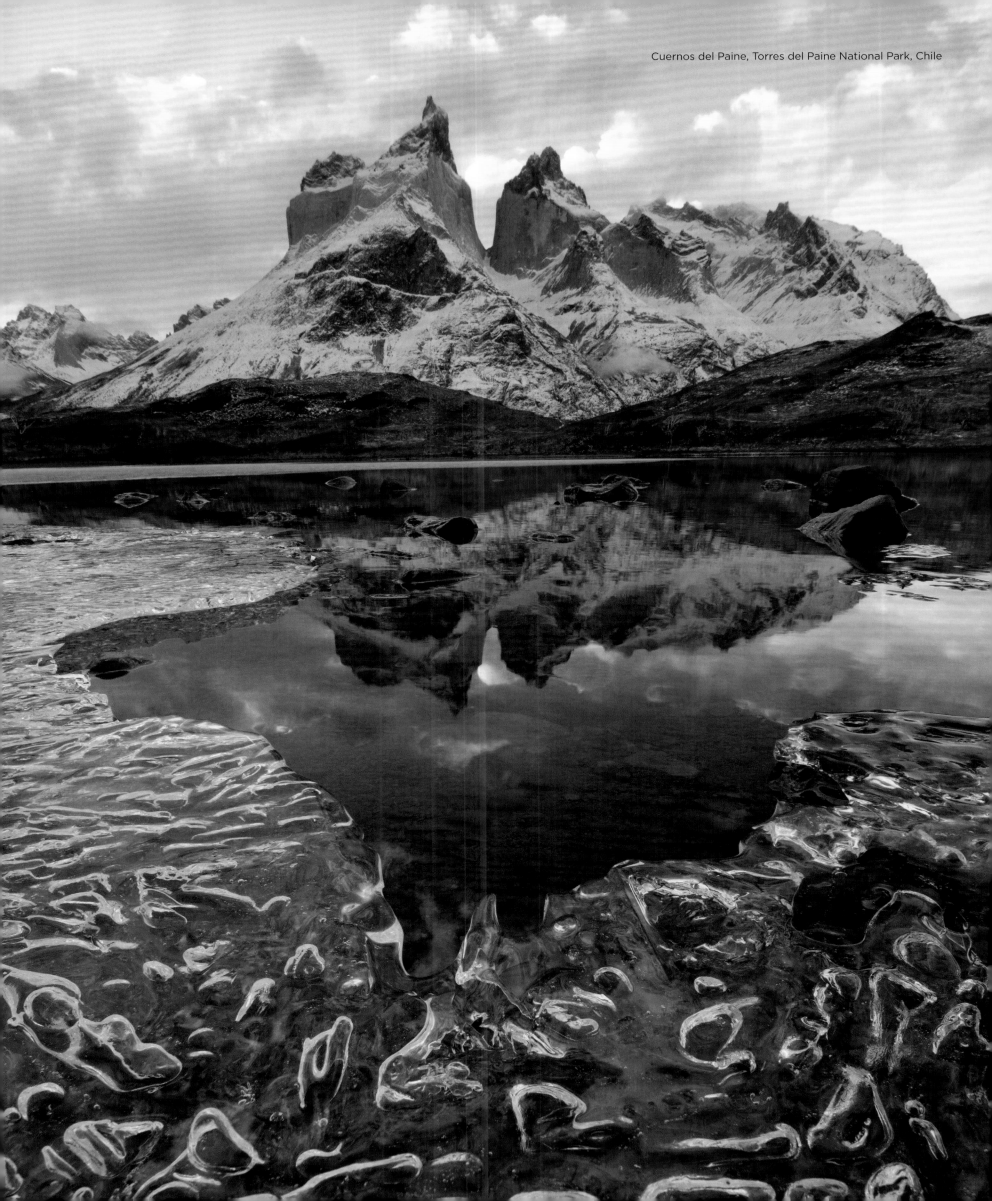

Cuernos del Paine, Torres del Paine National Park, Chile

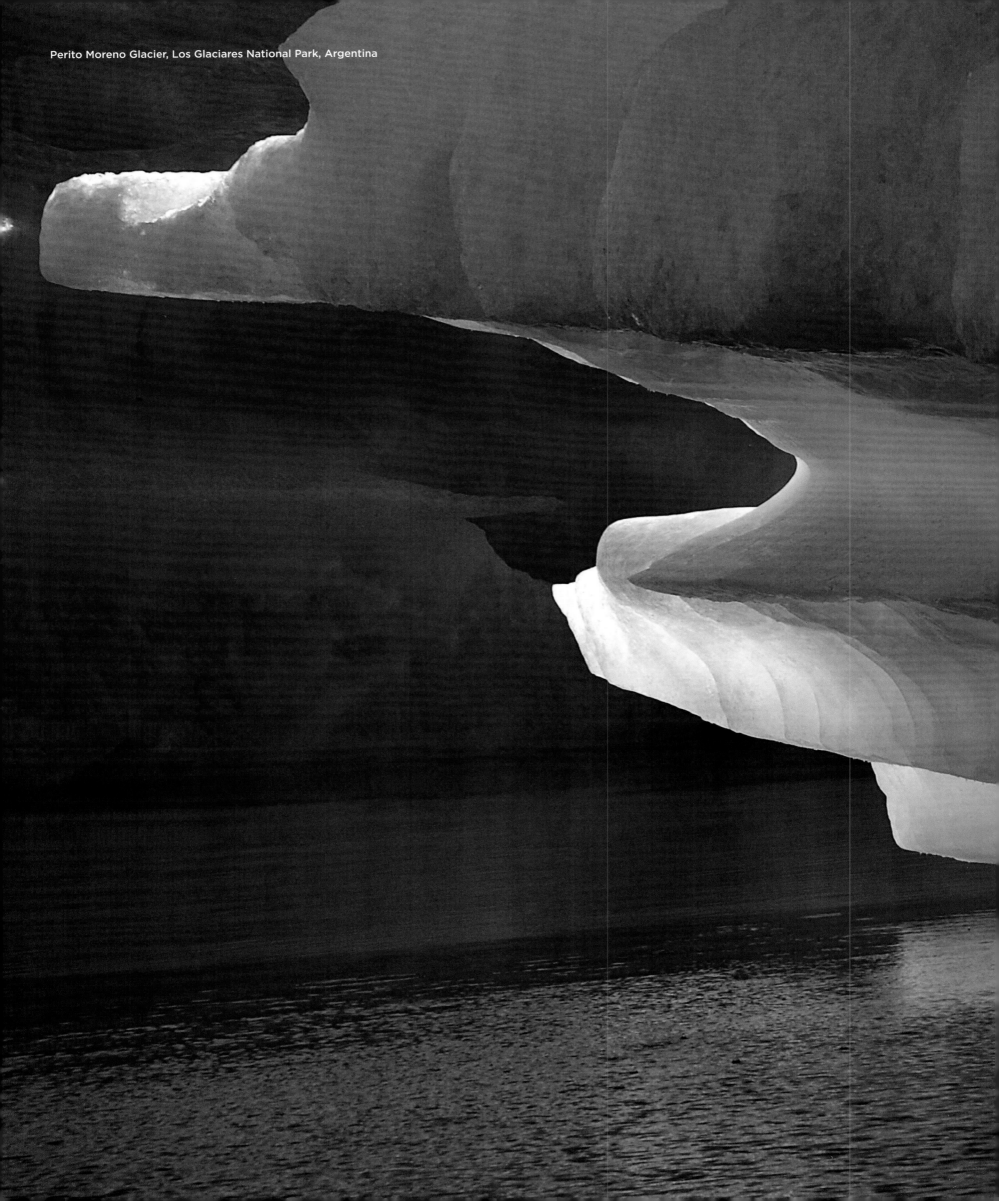
Perito Moreno Glacier, Los Glaciares National Park, Argentina

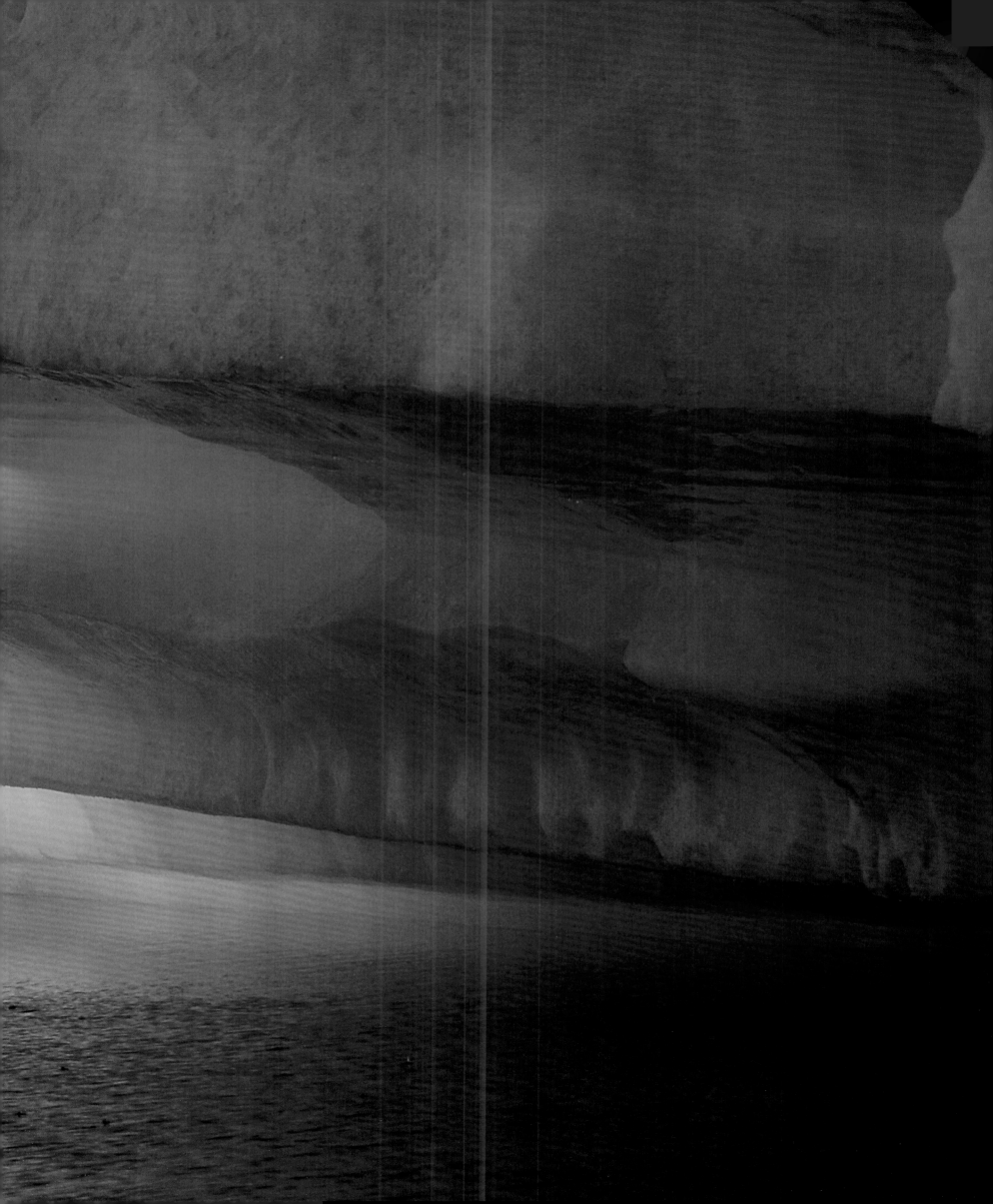

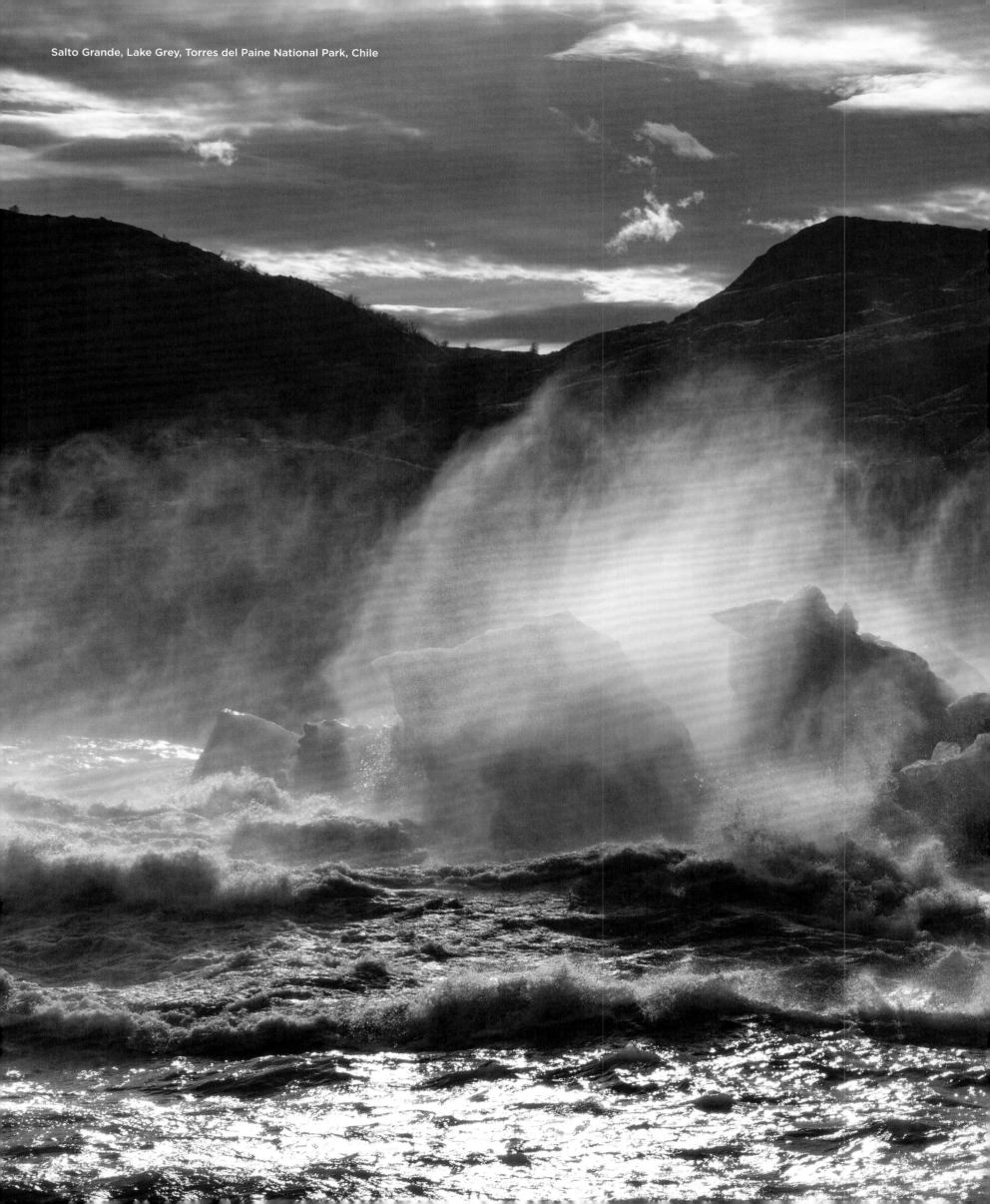

Salto Grande, Lake Grey, Torres del Paine National Park, Chile

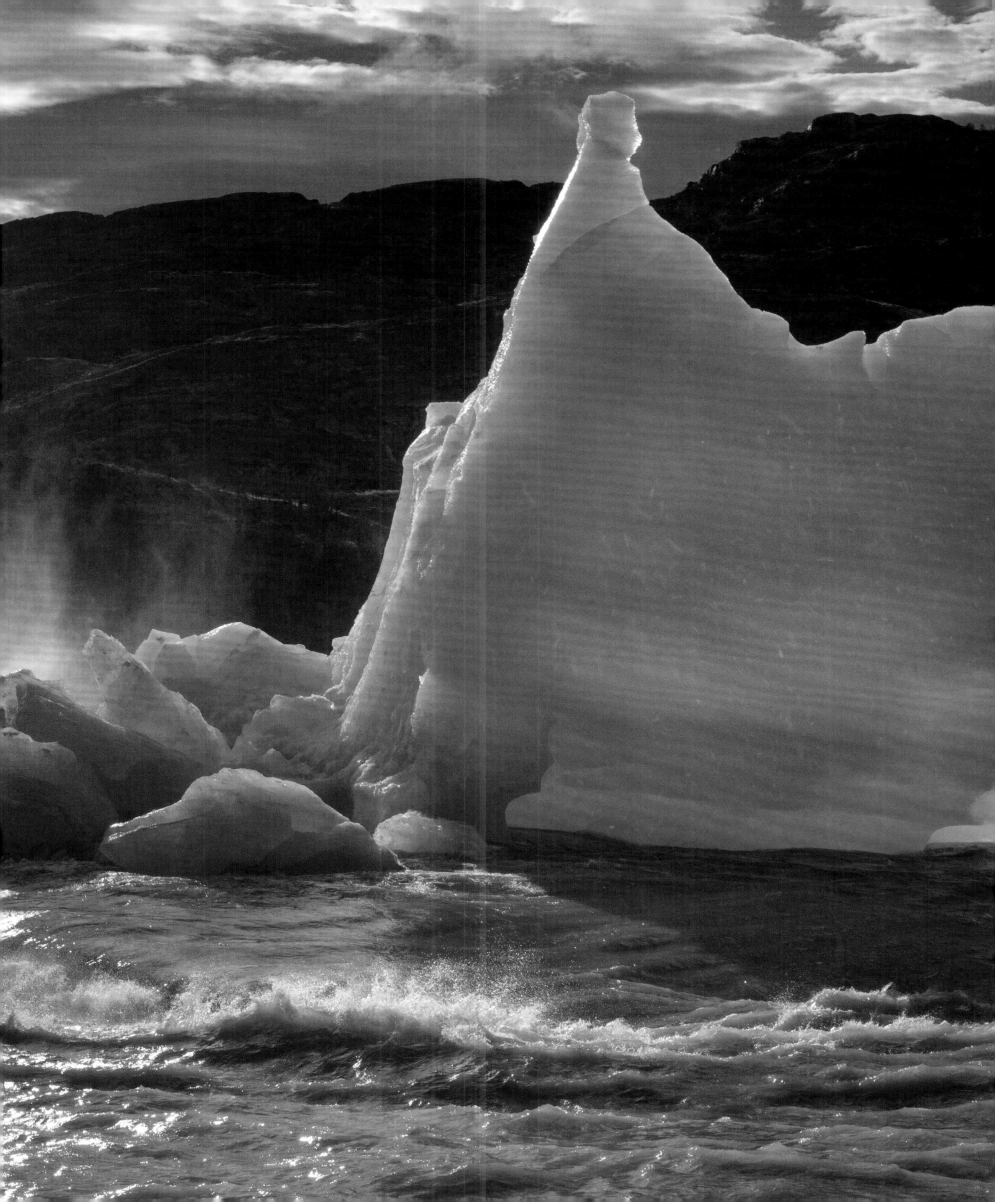

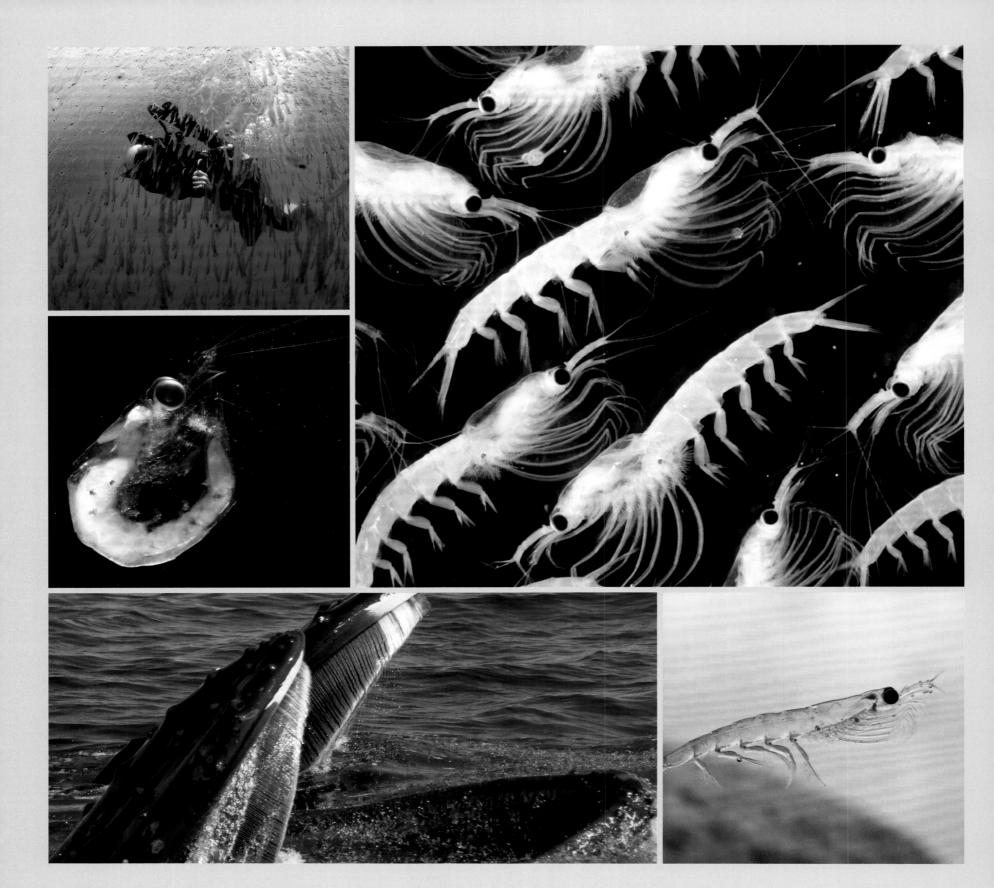

Krill

Krill (Euphausia superba) are crustaceans and reach a maximum size of 6 cm (2.4 inches). The animals live in huge swarms in the waters around Antarctica and are the most important food for a variety of creatures, including whales, seals, penguins and fish. The total global biomass of krill is estimated to be 500 million tonnes (551 million tons).

Krill

Le krill (euphausia superba) fait partie de la famille des crevettes et atteint une taille maximale de 6 cm. Ces animaux vivent en énormes essaims dans les eaux entourant l'Antarctique et constituent la source alimentaire la plus importante de nombreux êtres vivants, comme les baleines, les phoques, les pingouins et les poissons. La biomasse totale du krill est estimée à 500 millions de tonnes.

Krill

Krill (Euphausia superba) gehört zu den Krebstieren und erreicht eine Größe von maximal 6 cm. Die Tiere leben in riesigen Schwärmen in den Gewässern rund um die Antarktis und sind die wichtigste Nahrung für eine Vielzahl von Lebewesen, darunter Wale, Robben, Pinguine und Fische. Die gesamte Biomasse des Krills wird auf 500 Millionen Tonnen geschätzt.

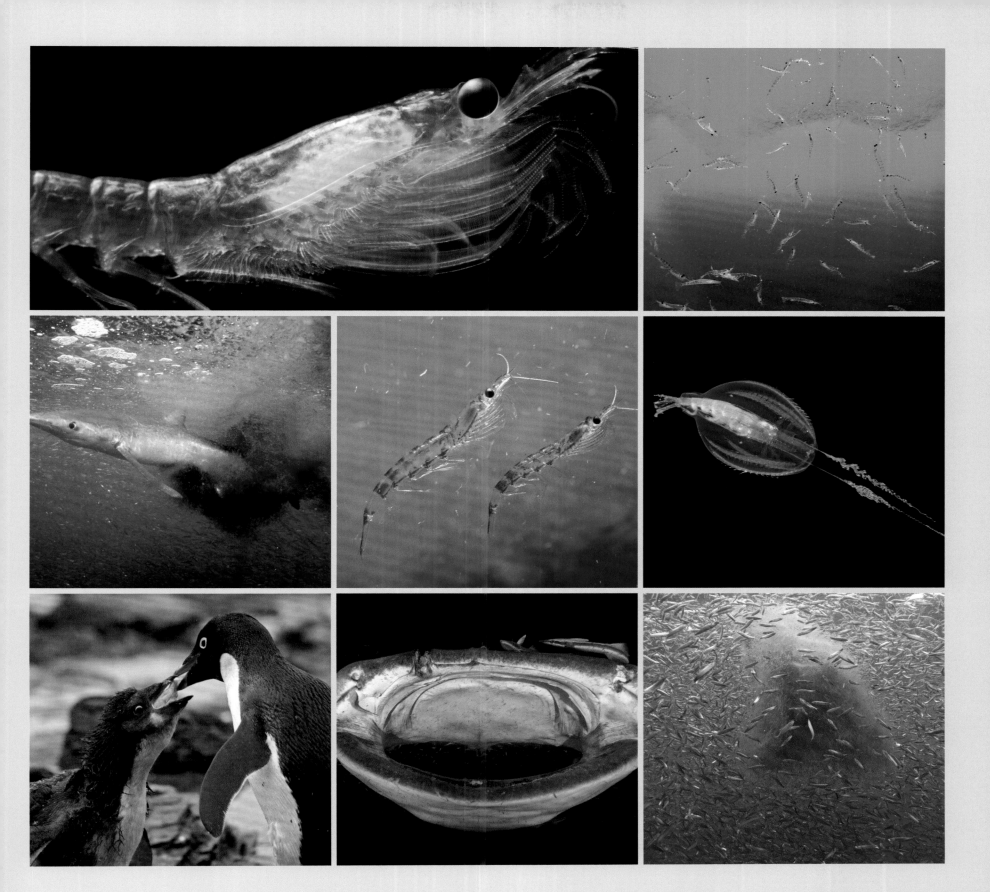

Kril

El kril antártico (Euphausia superba) es un crustáceo y alcanza un tamaño máximo de 6 cm. Este animal vive en enormes bandadas en las aguas alrededor de la Antártida y son el alimento más importante para una variedad de criaturas, incluidas ballenas, focas, pingüinos y peces. La biomasa total del kril antártico se estima en 500 millones de toneladas.

Krill

O krill antártico pertence aos crustáceos e atinge um tamanho máximo de 6 cm. Os animais vivem em enormes enxames nas águas em torno da Antártida e são o alimento mais importante para uma variedade de criaturas, incluindo baleias, focas, pinguins e peixes. A biomassa total do krill-do-antártico é estimada em 500 milhões de toneladas.

Krill

Krill (Euphausia superba) behoort tot de schaaldieren en wordt maximaal 6 cm groot. De dieren leven in enorme zwermen in de wateren rond Antarctica en zijn het belangrijkste voedsel voor verschillende dieren, waaronder walvissen, zeehonden, pinguïns en vissen. De totale biomassa van de krill wordt geschat op 500 miljoen ton.

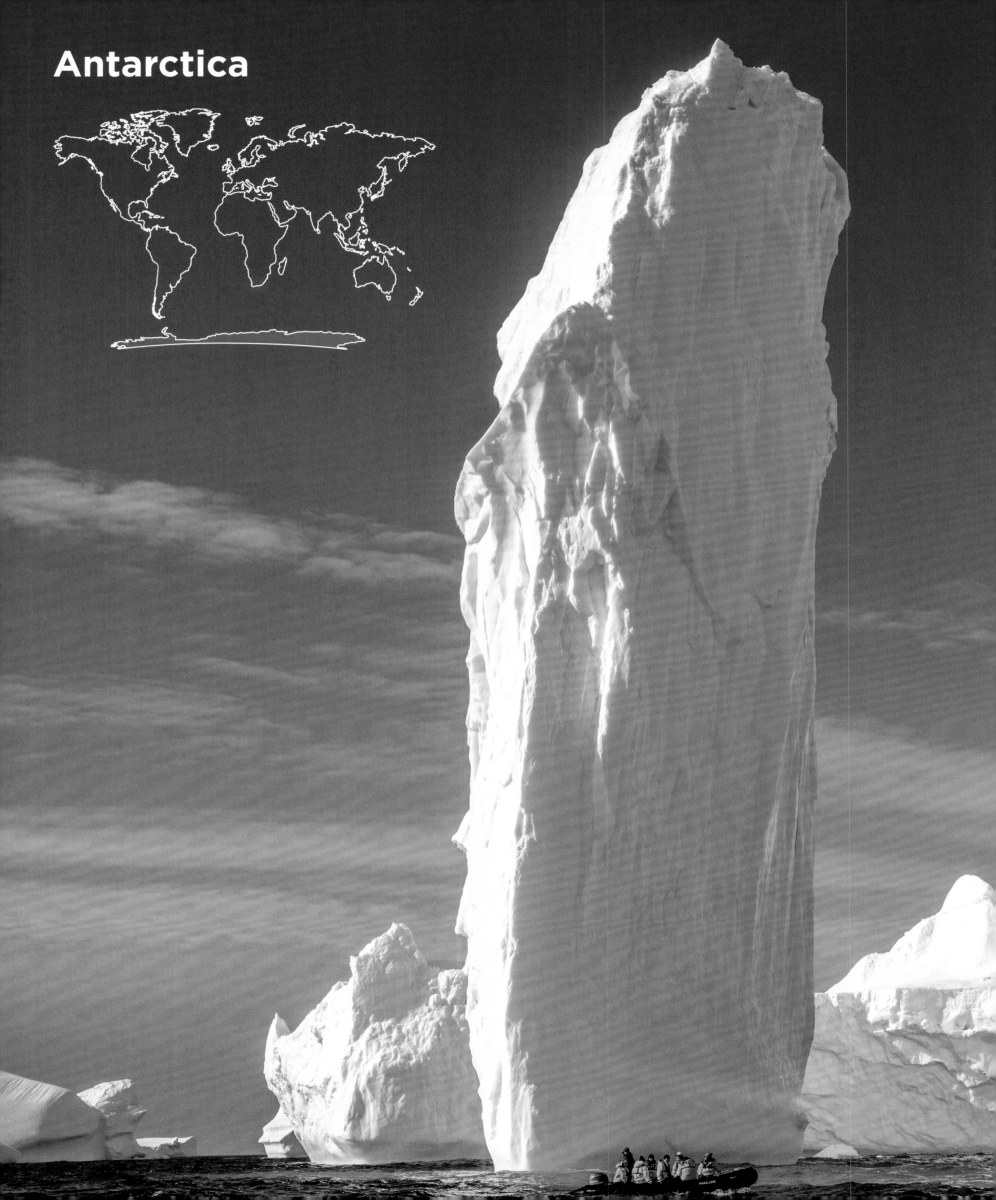

Antarctica

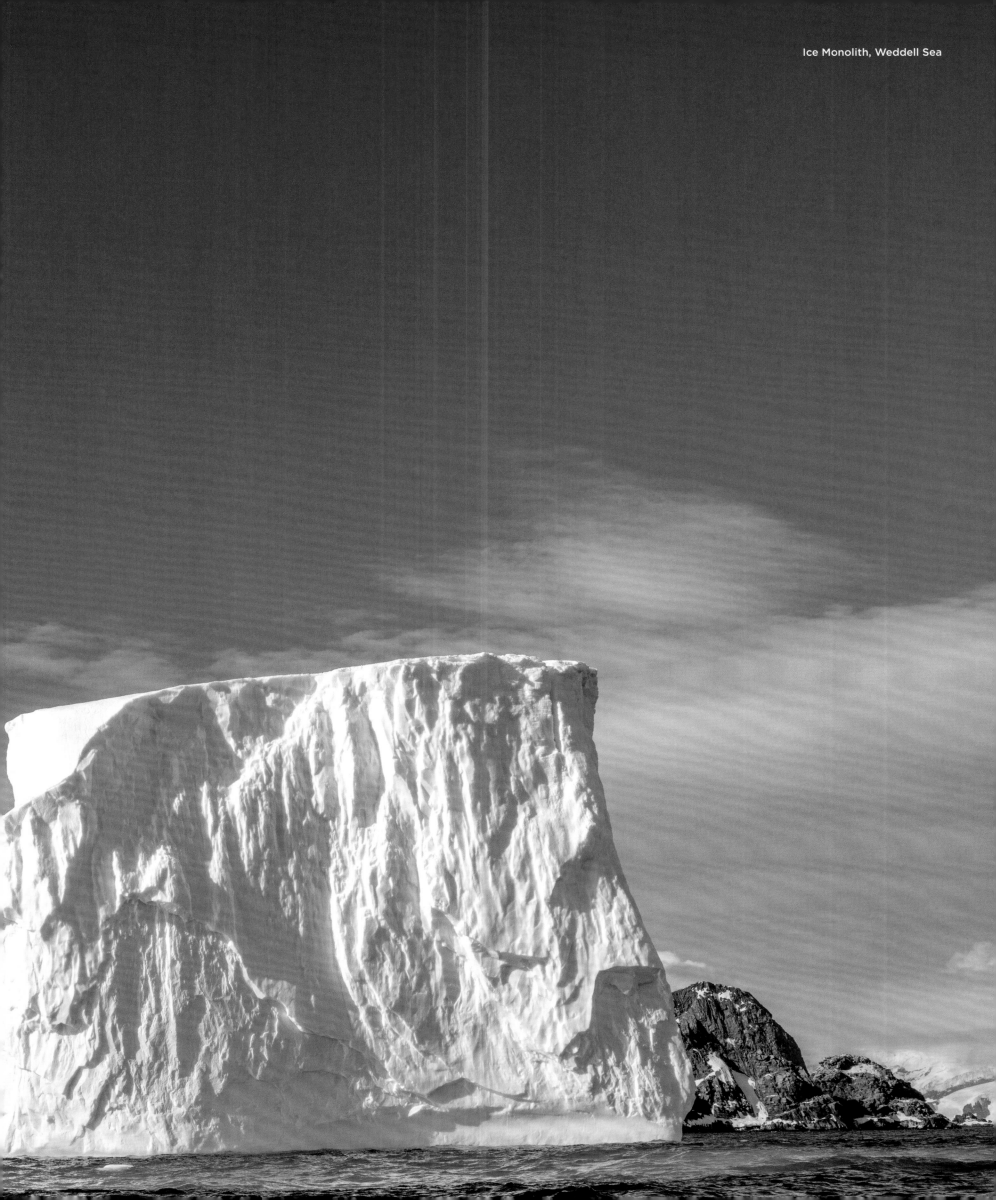

Ice Monolith, Weddell Sea

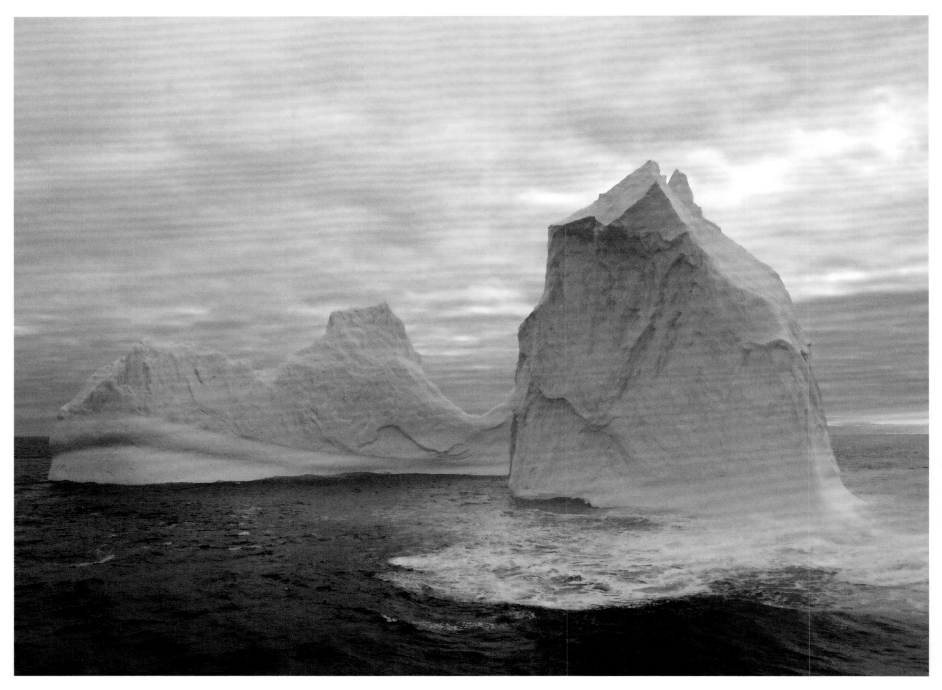

Iceberg, Antarctica

Antarctica

In antiquity it was believed that a southern continent must exist in order to act as a counterweight to the land masses of the northern hemisphere. It was thought that people may even live on this mythical southern continent with its pleasant climate. Today we know that this southern continent, which is about the size of Europe and Australia, actually exists, but the climate is hostile to life. Almost the whole continent and the surrounding sea lie under an ice sheet that is up to 4000 m (1.8 mi) thick. In summer around 4000 people work at research stations in Antarctica, while in winter temperatures fall to minus 90 °C (-130 °C) and the population drops to only 1000.

Antarctique

Dans l'antiquité, les hommes pensaient qu'il devait exister un continent sud en contrepoids des masses terrestres de l'hémisphère nord. Ils en venaient même à penser que d'autres personnes vivaient sur ce continent sud légendaire au climat agréable. Nous savons aujourd'hui que ce continent sud, presque aussi vaste que l'Europe et l'Australie réunies, existe vraiment, mais que son climat cependant est hostile. Quasiment l'ensemble du continent et de la mer qui l'entoure sont recouverts par une calotte de glace pouvant atteindre 4 000 m d'épaisseur. L'été, environ 4 000 personnes travaillent dans des stations de recherches en Antarctique. Lorsqu'en hiver les températures tombent jusqu'à -90° C, elles ne sont plus que 1 000 sur place.

Antarktis

In der Antike glaubte man, dass ein Südkontinent als Gegengewicht zu den Landmassen der Nordhalbkugel existieren müsse. Auf dem sagenumwobenen Südkontinent mit angenehmem Klima sollten sogar Menschen leben. Heute wissen wir, dass es diesen Südkontinent, der etwa so groß wie Europa und Australien ist, tatsächlich gibt, das Klima jedoch lebensfeindlich ist. Fast der gesamte Kontinent und das ihn umgebende Meer liegen unter einem bis zu 4000 m dicken Eispanzer. Im Sommer arbeiten rund 4000 Menschen auf Forschungsstationen der Antarktis, wenn im Winter die Temperaturen bis minus 90 °C fallen, sind es nur noch 1000.

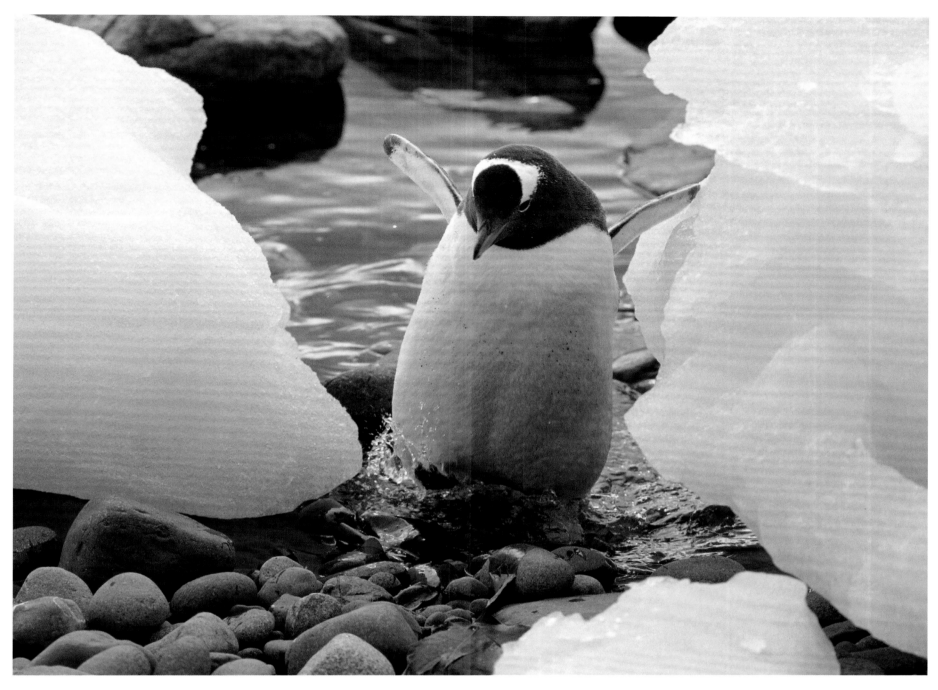

Adélie penguin

Antártida

En la antigüedad se creía que debía existir un continente austral como contrapeso a las masas terrestres del hemisferio norte. Incluso debía de vivir gente en el legendario continente del sur con su agradable clima. Hoy sabemos que este continente meridional, del tamaño de Europa y Australia, existe realmente, pero que el clima es hostil a la vida. Casi todo el continente y el mar circundante se encuentran bajo un escudo de hielo de hasta 4000 m de espesor. En verano, unas 4000 personas trabajan en las estaciones de investigación de la Antártida, mientras que en invierno, cuando las temperaturas descienden a -90 °C, la cifra es de solo 1000.

Antártida

Nos tempos antigos, acreditava-se que um continente do sul tinha de existir como contrapeso às massas terrestre do hemisfério norte No lendário continente sulista com o seu clima agradável, até pessoas devem viver. Hoje sabemos que este continente meridional, que tem aproximadamente a dimensão da Europa e da Austrália, existe de fato, mas que o clima é hostil à vida. Quase todo o continente e o mar circundante estão sob um escudo de gelo de até 4000 m de espessura. No verão, cerca de 4000 pessoas trabalham em estações de pesquisa na Antártida, quando a temperatura no inverno cai para menos 90 °C, o número de pessoas chega até apenas 1000.

Antarctica

In de oudheid geloofde men dat er een zuidelijk continent moest bestaan als tegenwicht tegen de landmassa's van het noordelijk halfrond. Op het legendarische zuidelijke continent met een aangenaam klimaat, moesten zelfs mensen leven. Tegenwoordig weten we dat dit zuidelijke continent, dat ongeveer even groot is als Europa en Australië, wel degelijk bestaat, maar dat het klimaat vijandig staat tegenover het leven. Bijna het hele continent en de omliggende zee liggen onder een tot 4000 m dik ijsschild. In de zomer werken ongeveer 4000 mensen op onderzoeksstations op Antarctica, terwijl in de winter de temperaturen dalen tot -90 °C, het aantal mensen slechts 1000 is.

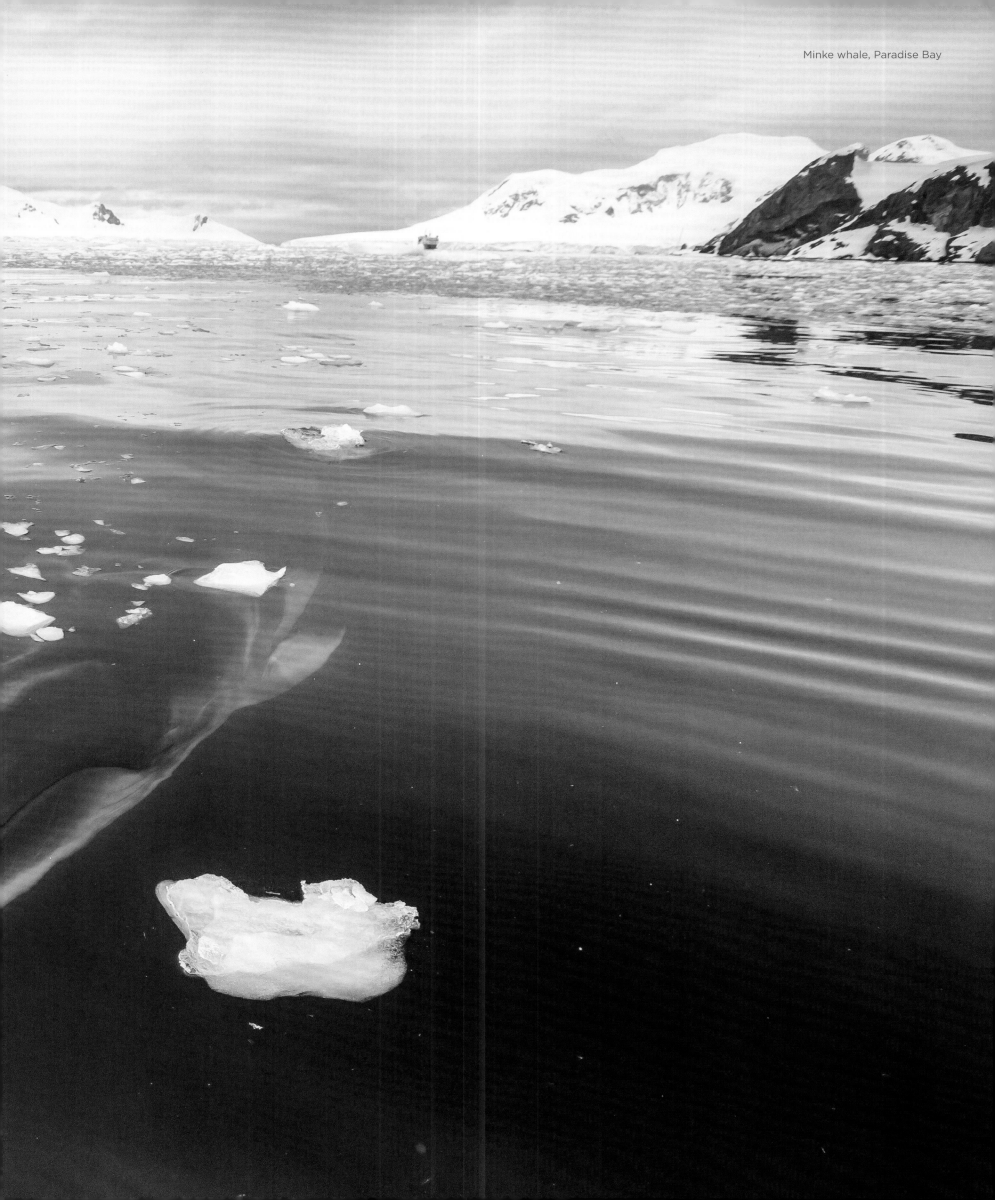

Minke whale, Paradise Bay

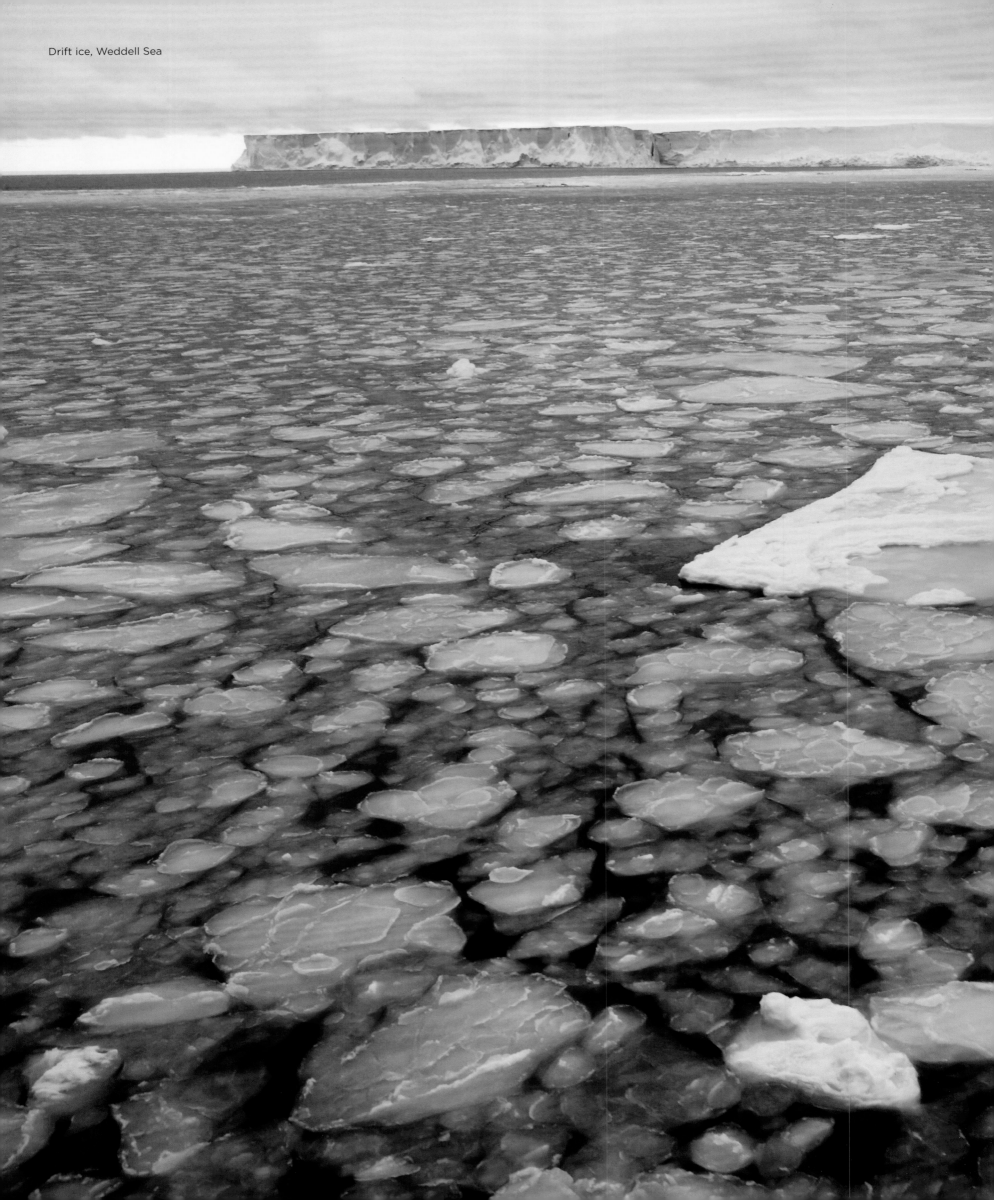

Drift ice, Weddell Sea

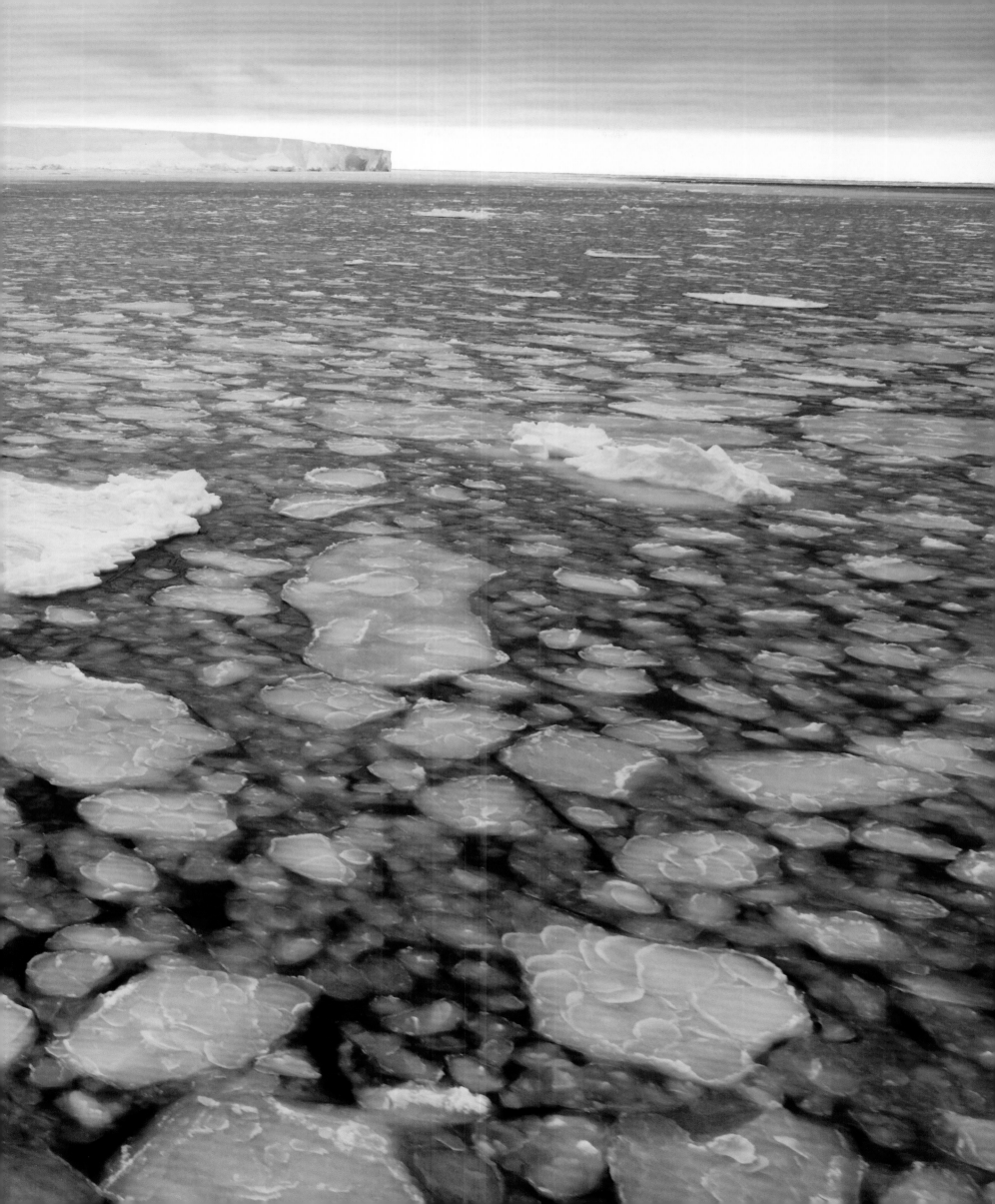

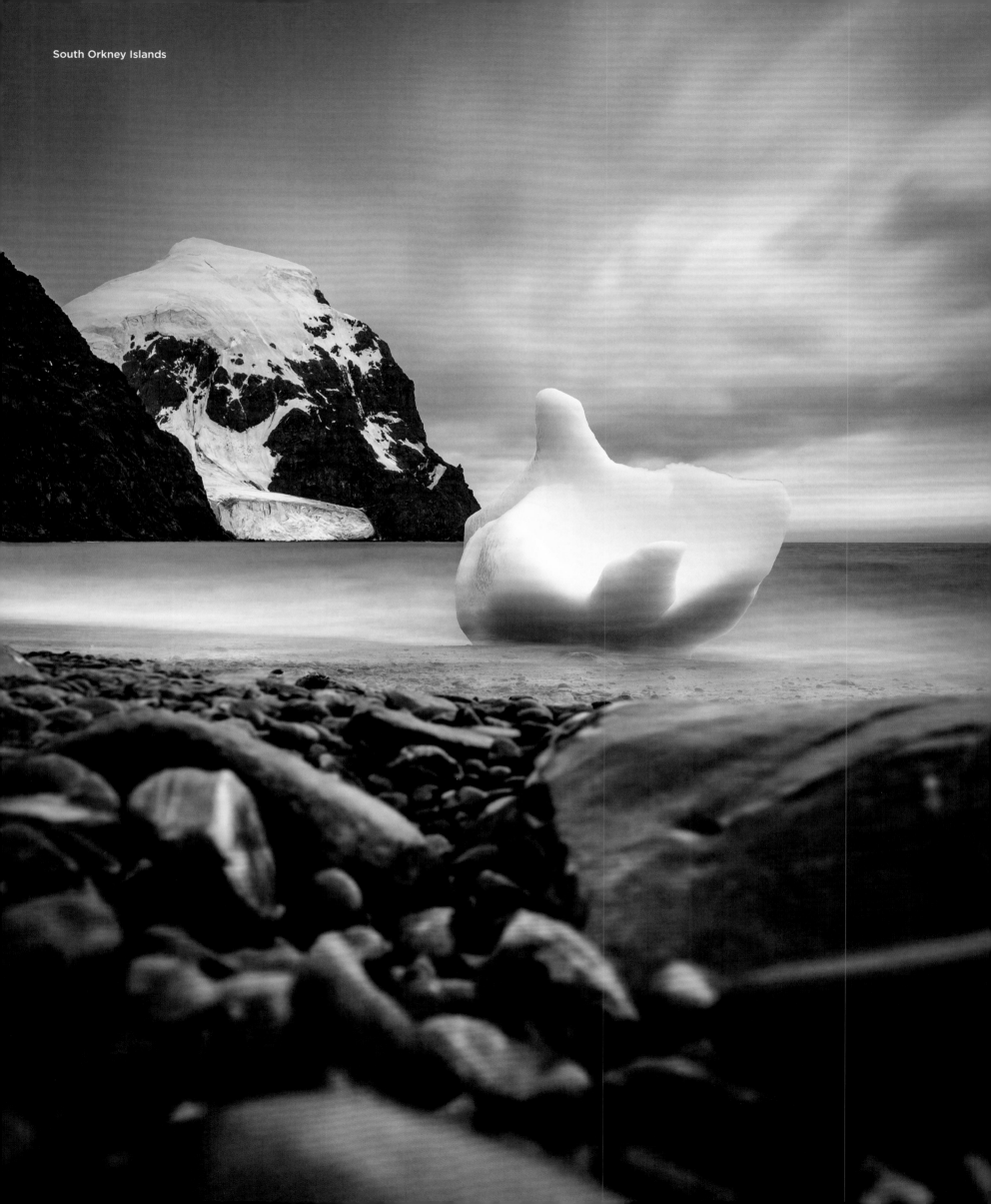

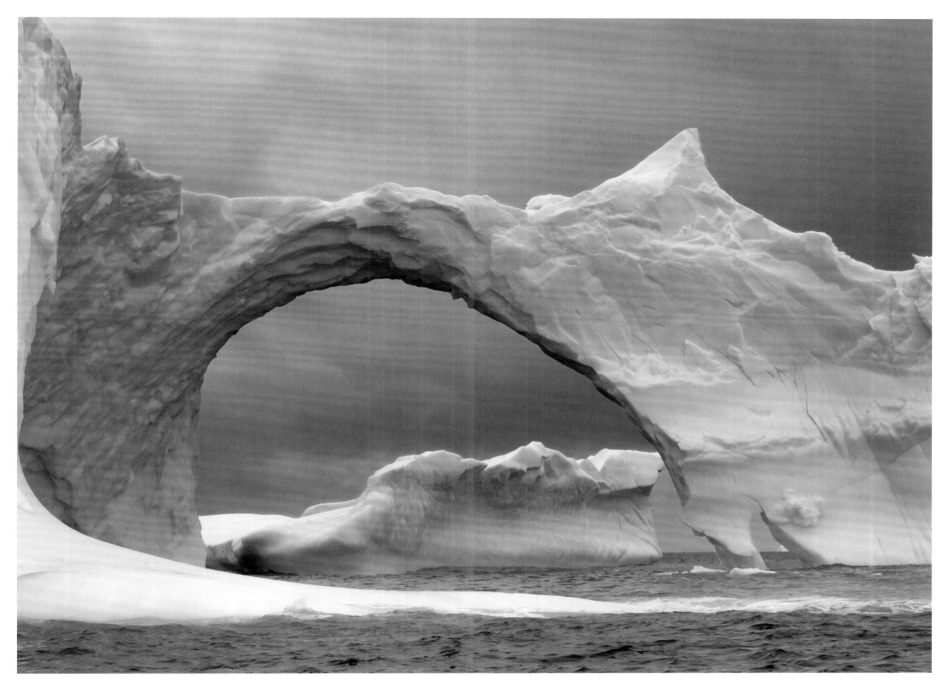

Cierva Cove, Graham Land

South Orkney Islands

This archipelago lies about 600 km (372 mi) north of the Antarctic Peninsula. The archipelago is one of the least sunny areas on earth, and the prevailing westerly wind brings clouds and fog. The Argentine Orcadas station on Laurie Island has been in operation since 1904, and is thus the oldest permanently inhabited station in Antarctica.

Islas Orcadas del Sur

El archipiélago se encuentra a unos 600 km al norte de la Península Antártica. El archipiélago es una de las zonas menos soleadas de la tierra, sobre todo el viento del oeste trae nubes y niebla. La estación argentina de Orcadas en la isla Laurie ha estado en operación desde 1904 y es, por lo tanto, la estación permanentemente habitada más antigua de la Antártida.

Îles Orcades du Sud

Cet archipel se trouve à environ 600 km au nord de la péninsule Antarctique. Il fait partie des zones les moins ensoleillées du monde car le vent d'ouest domine et apporte souvent des nuages et du brouillard. La station argentine Orcadas, située sur l'île Laurie et en fonction depuis 1904, est la plus vieille base continuellement habitée de l'Antarctique.

Ilhas Órcades do Sul

O arquipélago situa-se a cerca de 600 km ao norte da Península Antártica. O arquipélago é uma das áreas menos ensolaradas do planeta, o vento predominante do oeste traz geralmente nuvens e nevoeiro. A estação argentina das Orcadas na Ilha Laurie está em funcionamento desde 1904 e é, portanto, a mais antiga estação permanentemente habitada da Antártida.

Südliche Orkneyinseln

Die Inselgruppe liegt rund 600 km nördlich der Antarktischen Halbinsel. Der Archipel zählt zu den sonnenärmsten Gebieten der Erde, meist bringt der vorherrschende Westwind Wolken und Nebel. Die argentinische Orcadas-Station auf der Laurie-Insel ist seit 1904 in Betrieb und damit die älteste ständig bewohnte Station in der Antarktis.

Zuidelijke Orkneyeilanden

De archipel ligt ongeveer 600 km ten noorden van het Antarctische schiereiland. De archipel is een van de minst zonnig gebieden op aarde, vooral de overheersende westenwind brengt wolken en mist. Het station van de Argentijnse Orkade op het eiland Laurie is sinds 1904 in gebruik en is daarmee het oudste permanent bewoonde station op Antarctica.

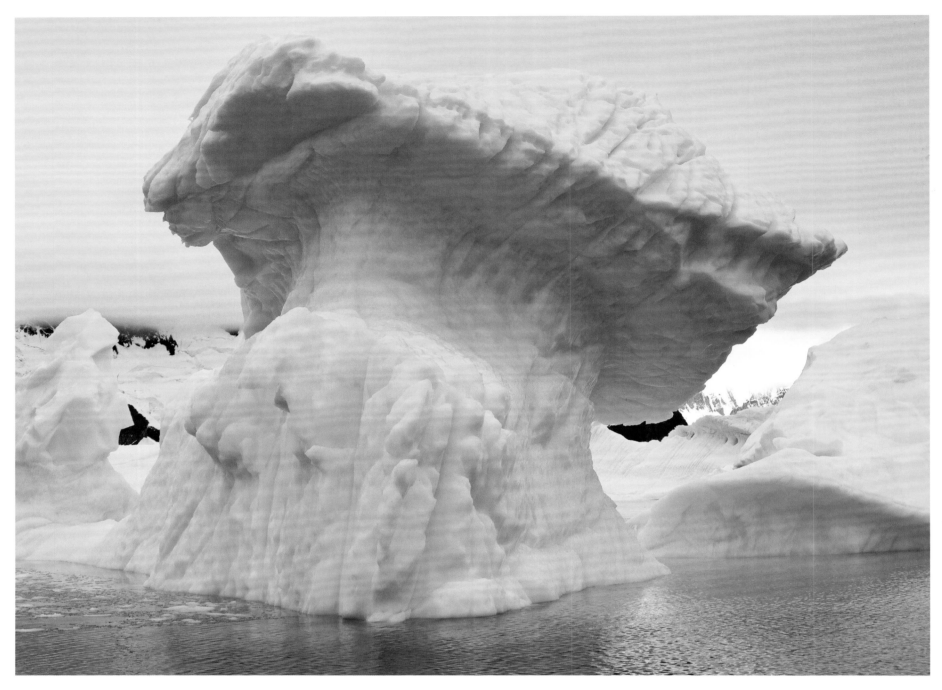

Antarctica

Icebergs

Icebergs occur in so many colors and shapes that their sight is endlessly fascinating. They consist of pressed snow with many air bubbles which scatter the light strongly and make the ice appear white. If icebergs glow deep blue, they contain only a few air bubbles. From time to time even green icebergs can be seen; their color is probably caused by organic substances or plankton. The longer icebergs drift in the water, the more they "age" due to erosion by wind and waves. Before they finally disintegrate completely, they sometimes form bizarre shapes.

Icebergs

Les icebergs peuvent prendre tant de formes et de couleurs que leur spectacle est une source constante de fascination. Ils naissent de morceaux de neige compressés contenant de nombreuses bulles d'air qui réfléchissent la lumière et donnent ainsi à la glace une couleur blanche. Si un iceberg paraît bleu foncé, cela signifie qu'il ne contient plus beaucoup de bulles d'air. Ici et là, on aperçoit même des icebergs verts, leur couleur étant probablement due à des substances organiques ou à du plancton végétal immiscés à l'intérieur. Plus un iceberg reste dans l'eau, plus il s'érode sous l'effet du vent et des vagues. Mais avant de complètement s'effondrer, il arrive que certains icebergs prennent de drôles de formes.

Eisberge

Eisberge kommen in so vielen Farben und Formen vor, dass ihr Anblick immer wieder fasziniert. Sie entstehen aus gepresstem Schnee mit vielen Luftbläschen, die das Licht stark streuen und damit das Eis weiß erscheinen lassen. Leuchten Eisberge tiefblau, enthalten sie nur noch wenige Luftblasen. Hin und wieder sind sogar grüne Eisberge zu sehen, ihre Farbe wird vermutlich durch organische Substanzen oder pflanzliches Plankton hervorgerufen. Je länger Eisberge im Wasser treiben, desto stärker „altern" sie durch Erosion von Wind und Wellen. Bevor sie schließlich ganz zerfallen, bilden sie teils bizarre Formen.

Brown Station, Paradise Bay

Icebergs

Los icebergs se presentan en tantos colores y formas que su visión fascina una y otra vez. Están hechos de nieve prensada con muchas burbujas de aire, que dispersan la luz con fuerza y hacen que el hielo parezca blanco. Si los icebergs brillan en un azul intenso, solo contienen unas pocas burbujas de aire. De vez en cuando se pueden ver incluso icebergs verdes, cuyo color probablemente esté causado por sustancias orgánicas o plancton. Cuanto más largos son los icebergs en el agua, más «envejecen» debido a la erosión por el viento y las olas. Antes de que se desintegren completamente, a veces forman formas extrañas.

Icebergs

Os icebergs têm tantas cores e formas que a sua visão sempre fascina. Eles são feitos de neve prensada com muitas bolhas de ar, que espalham a luz fortemente e, assim, fazem o gelo parecer branco. Se os icebergs brilharem azul profundo, eles contêm apenas algumas bolhas de ar. De vez em quando até mesmo icebergs verdes podem ser vistos, sua cor é provavelmente causada por substâncias orgânicas ou plâncton vegetal. Quanto mais tempo os icebergs flutuam na água, mais eles "envelhecem" devido à erosão do vento e das ondas. Antes de se desintegrarem completamente, por vezes formam formas parcialmente bizarras.

IJsbergen

IJsbergen komen in zoveel kleuren en vormen voor dat hun zicht steeds opnieuw fascinerend is. Ze zijn gemaakt van geperste sneeuw met veel luchtbellen, die het licht sterk verstrooien en het ijs wit doen lijken. Als ijsbergen diepblauw gloeien, bevatten ze slechts enkele luchtbellen. Van tijd tot tijd zijn zelfs groene ijsbergen te zien, hun kleur wordt waarschijnlijk veroorzaakt door organische stoffen of plankton. Hoe langer de ijsbergen in het water drijven, hoe „ouder" ze worden door erosie van wind en golven. Voordat ze uiteindelijk volledig uiteenvallen, vormen ze soms bizarre vormen.

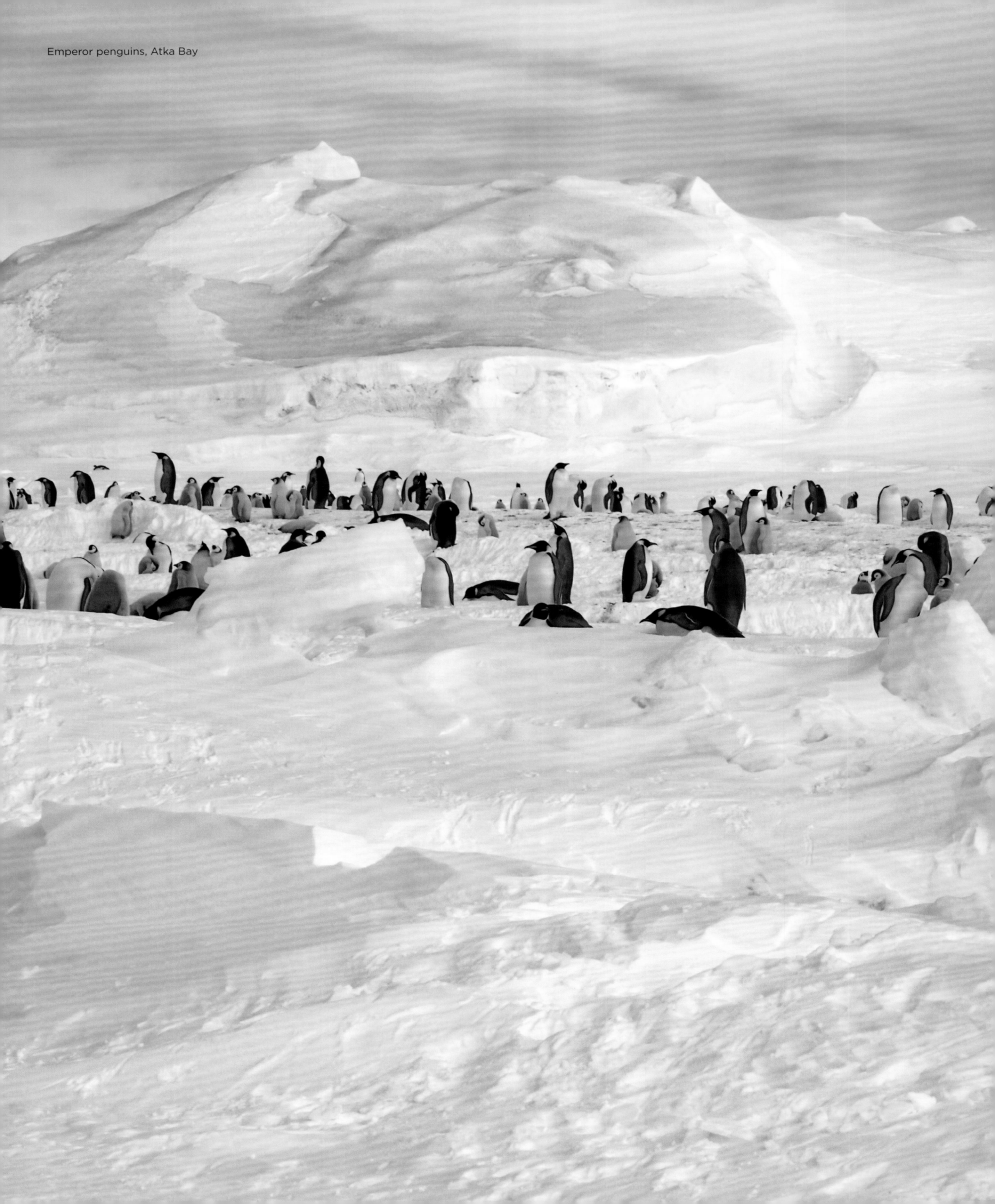

Emperor penguins, Atka Bay

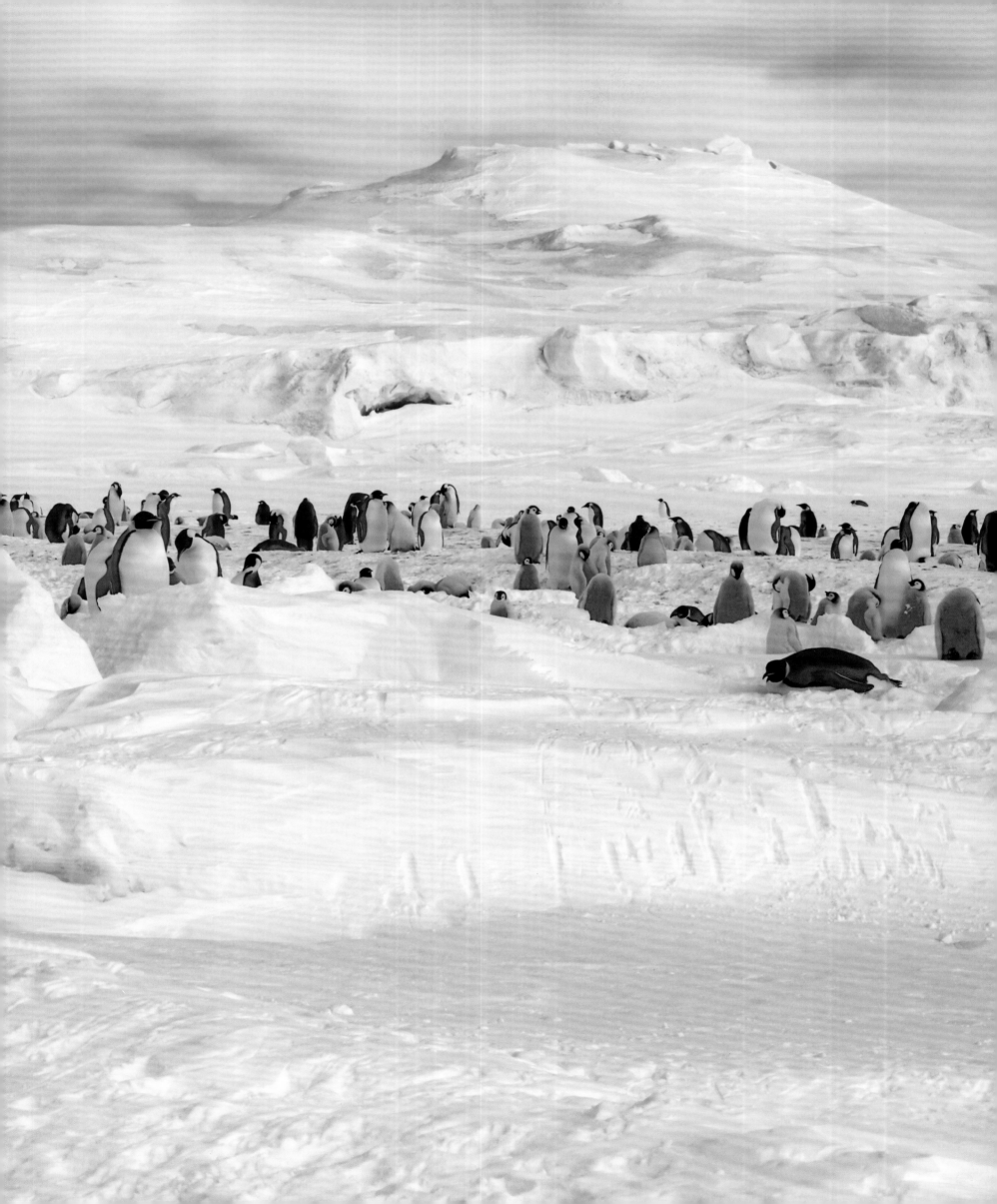

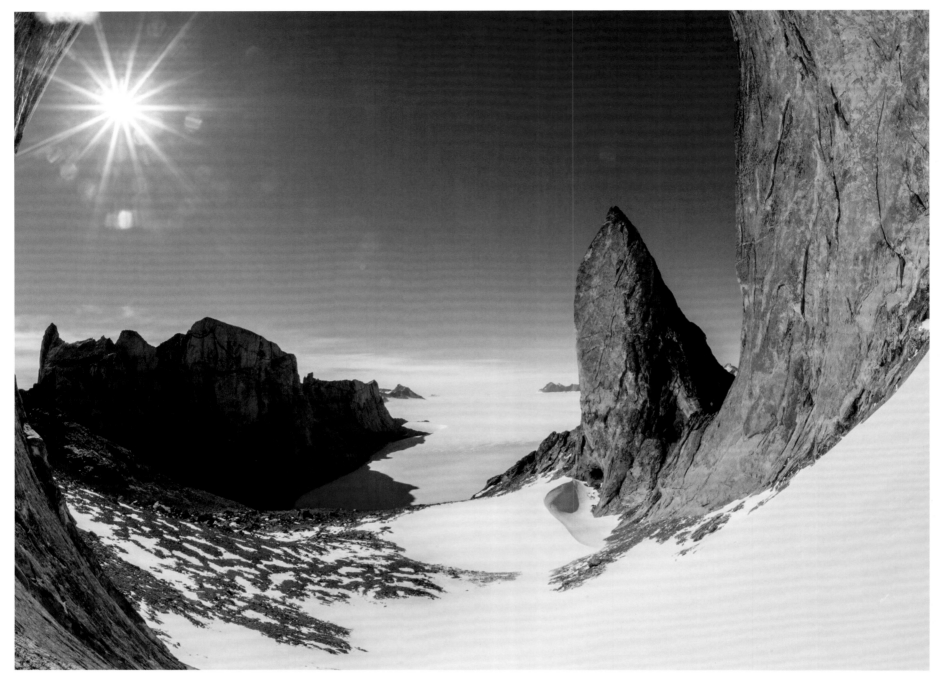

Queen Maud Land

Queen Maud Land

On a map of Antarctica, the 2.7 million km² (10 million sq mi) territory looks like a large piece of cake. It was named after Queen Maud of Norway, who was of British descent. The first explorations took place in 1949 as part of a Norwegian-British-Swedish expedition. The Alfred Wegener Institute has been operating a research station here since 1981, and it is now the third Neumayer Station on the coast of the eastern Weddell Sea. During the summer months, about 50 scientists work at the largest and most comfortable station in the history of German Antarctic research.

Terre de la Reine-Maud

Sur une carte de l'Antarctique, ce territoire d'environ 2,7 millions de km², nommé d'après la reine norvégienne d'origine britannique Maud, ressemble à une grosse part de gâteau. Les premières explorations eurent lieu dès 1949 dans le cadre d'une expédition brito-suédo-norvégienne. Depuis 1981, l'institut Alfred Wegener opère dans une station de recherches sur ces terres, la base antarctique Neumayer sur la côte au niveau de la mer de Weddell, la troisième du continent. Durant l'été, une cinquantaine de scientifiques travaille dans cette station, la plus grande et la plus confortable de l'histoire de la recherche antarctique allemande.

Königin-Maud-Land

Auf einer Landkarte der Antarktis wirkt das nach der britischstämmigen, norwegischen Königin Maud benannte, rund 2,7 Millionen km² große Territorium wie ein großes Tortenstück. Die ersten Erkundungen fanden ab 1949 im Rahmen einer Norwegisch-Britisch-Schwedischen Expedition statt. Seit 1981 betreibt das Alfred-Wegener-Institut hier eine Forschungsstation, mittlerweile ist es schon die dritte Neumayer-Station an der Küste des östlichen Wedellmeeres. In den Sommermonaten arbeiten in der größten und komfortabelsten Station in der Geschichte der deutschen Antarktisforschung ungefähr 50 Wissenschaftler.

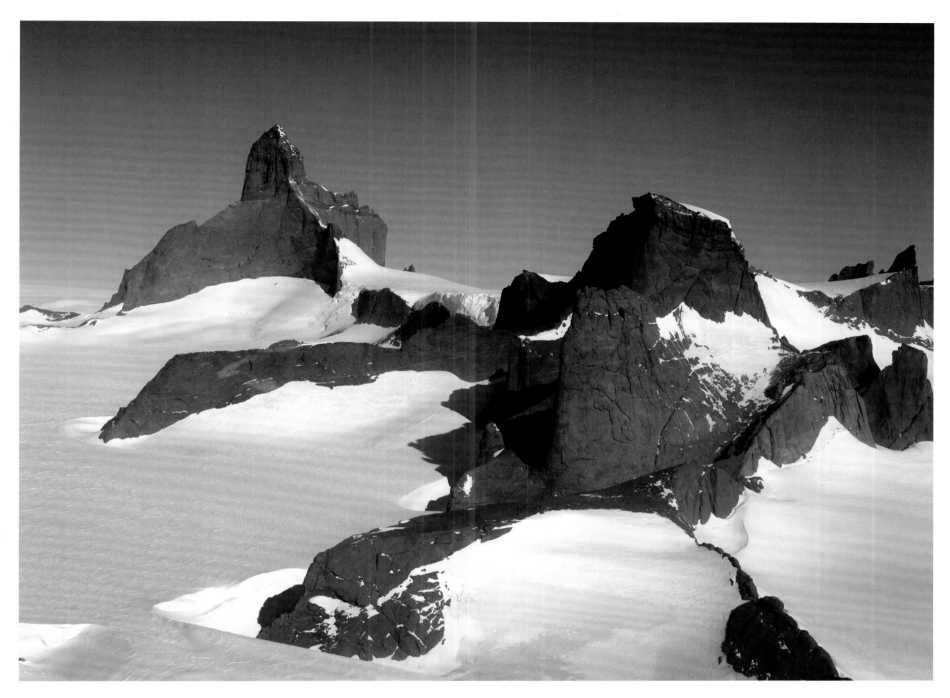

Ulvetanna Peak, Queen Maud Land

La tierra de la Reina Maud

En un mapa de la Antártida, el territorio de 2,7 millones de km², que lleva el nombre de la reina Maud de Noruega, de ascendencia británica, parece un gran pedazo de pastel. Las primeras exploraciones tuvieron lugar en 1949 como parte de una expedición noruego-británico-sueca. El Instituto Alfred Wegener opera desde 1981 una estación de investigación en esta zona, que se ha convertido en la tercera estación de Neumayer en la costa oriental del mar de Wedell. Durante los meses de verano, unos 50 científicos trabajan en la estación más grande y confortable de la historia de la investigación antártica alemana.

Terra da Rainha Maud

Em um mapa da Antártida, o território de 2,7 milhões de km², nomeado em homenagem à Rainha Maud da Noruega, de ascendência britânica, parece uma grande fatia de bolo. As primeiras explorações ocorreram em 1949, como parte de uma expedição norueguesa-britânica-sueca. O Instituto Alfred Wegener opera uma estação de pesquisa aqui desde 1981, e é agora a terceira Estação de Pesquisa Neumayer na costa oriental do Mar de Wedell. Durante os meses de verão, cerca de 50 cientistas trabalham na maior e mais confortável estação da história da pesquisa antártica alemã.

Koningin Maudland

Op een kaart van Antarctica ziet het 2,7 miljoen km² groot gebied, genoemd naar Koningin Maud van Noorwegen van Britse afkomst uit als een groot stuk taart. De eerste verkenningen vonden plaats in 1949 als onderdeel van een Noors-Brits-Zweedse expeditie. Het Alfred Wegener Instituut heeft hier sinds 1981 een onderzoeksstation en is nu het derde Neumayer Station aan de kust van de oostelijke Weddellzee. Tijdens de zomermaanden werken ongeveer 50 wetenschappers op het grootste en meest comfortabele station in de geschiedenis van het Duitse Antarctische onderzoek.

Geographic South Pole

The South Pole

The Norwegian Roald Amundsen was obsessed with the idea of being the first to reach one of the poles. After Peary had claimed to have been at the North Pole, Amundsen set off for the South Pole. After a dramatic race, he reached it a good month ahead of his rival, Robert Falcon Scott. On 14 December 1911, Amundsen hoisted the Norwegian flag at the South Pole, and ever since he has been a hero in his homeland. The American operated Amundsen-Scott South Pole station has been in existence since 1956, and has been extended several times. Only a few hundred meters away from the geographical South Pole, it lies on the inland ice at 2835 m (9301 ft) above sea level.

Le pôle Sud

Le Norvégien Roald Amundsen était possédé par l'idée d'être le premier à poser le pied sur l'un des deux pôles. Après que Robert Peary eut affirmé avoir été au pôle Nord, il se mit en route pour le pôle Sud qu'il atteignit un bon mois avant son concurrent, Robert Falcon Scott, après une course effrénée. Le 14 décembre 1911, Roald Amundsen hissa le drapeau norvégien sur le pôle Sud et devint ainsi un héros dans son pays. En 1956 fut érigée la base antarctique américaine Amundsen-Scott, agrandie à plusieurs reprises depuis sa création. À quelques centaines de mètres à peine du pôle Sud géographique, elle repose sur l'inlandsis à 2 835 m au-dessus du niveau de la mer.

Der Südpol

Der Norweger Roald Amundsen war von der Idee besessen, als Erster einen der Pole zu erreichen. Nachdem Peary behauptet hatte, am Nordpol gewesen zu sein, brach er zum Südpol auf, den er nach einem dramatischen Wettrennen gut einen Monat vor seinem Konkurrenten, Robert Falcon Scott, erreichte. Am 14. Dezember 1911 hisste Amundsen die norwegische Fahne am Südpol, in der Heimat war er seitdem ein Held. Seit 1956 gibt es die US-amerikanische Amundsen-Scott-Südpolstation, die mittlerweile mehrfach erweitert wurde. Nur einige Hundert Meter vom geografischen Südpol entfernt, liegt sie auf dem Inlandeis 2835 m ü. d. M.

South Pole

El Polo Sur

El noruego Roald Amundsen estaba obsesionado con la idea de ser el primero en llegar a uno de los polos. Después de que Peary afirmara haber estado en el Polo Norte, partió hacia el Polo Sur, al que llegó más de un mes antes que su rival, Robert Falcon Scott, tras una dramática carrera. El 14 de diciembre de 1911, Amundsen izó la bandera noruega en el Polo Sur, y en su tierra natal se convirtió en un héroe. Desde 1956 existe la base estadounidense Amundsen-Scott-en el Polo Sur, que ha sido ampliada en varias ocasiones. A solo unos pocos cientos de metros del Polo Sur geográfico, se encuentra en el hielo interior a 2835 m sobre el nivel del mar.

O Pólo Sul

O norueguês Roald Amundsen estava obcecado com a ideia de ser o primeiro a alcançar um dos pólos. Depois que Peary alegou ter estado no Polo Norte, ele partiu para o Polo Sul, que alcançou um bom mês antes de seu rival, Robert Falcon Scott, após uma corrida dramática. Em 14 de dezembro de 1911, Amundsen colocou a bandeira norueguesa no Polo Sul, e desde então em sua terra natal ele tornou-se um herói. Desde 1956 existe a Estação Pólo Sul Amundsen Scott americana, que foi ampliada várias vezes. A apenas algumas centenas de metros do Pólo Sul geográfico, encontra-se no campo de gelo a 2835 m acima do nível do mar.

De Zuidpool

De Noorse Roald Amundsen was geobsedeerd van het idee om als eerste een van de polen te bereiken. Nadat Peary beweerd had op de Noordpool te zijn geweest, vertrok hij naar de Zuidpool, die hij na een dramatische race een goede maand voor zijn rivaal, Robert Falcon Scott, bereikte. Op 14 december 1911 hijste Amundsen de Noorse vlag op de Zuidpool, en sindsdien was hij in zijn thuisland een held. Sinds 1956 is er Amerikaanse Zuidpoolstation Amundsen-Scott, dat meerdere malen is uitgebreid. Slechts een paar honderd meter van de geografische Zuidpool verwijdert, ligt het op het binnenlandse ijs 2835 m boven de zeespiegel.

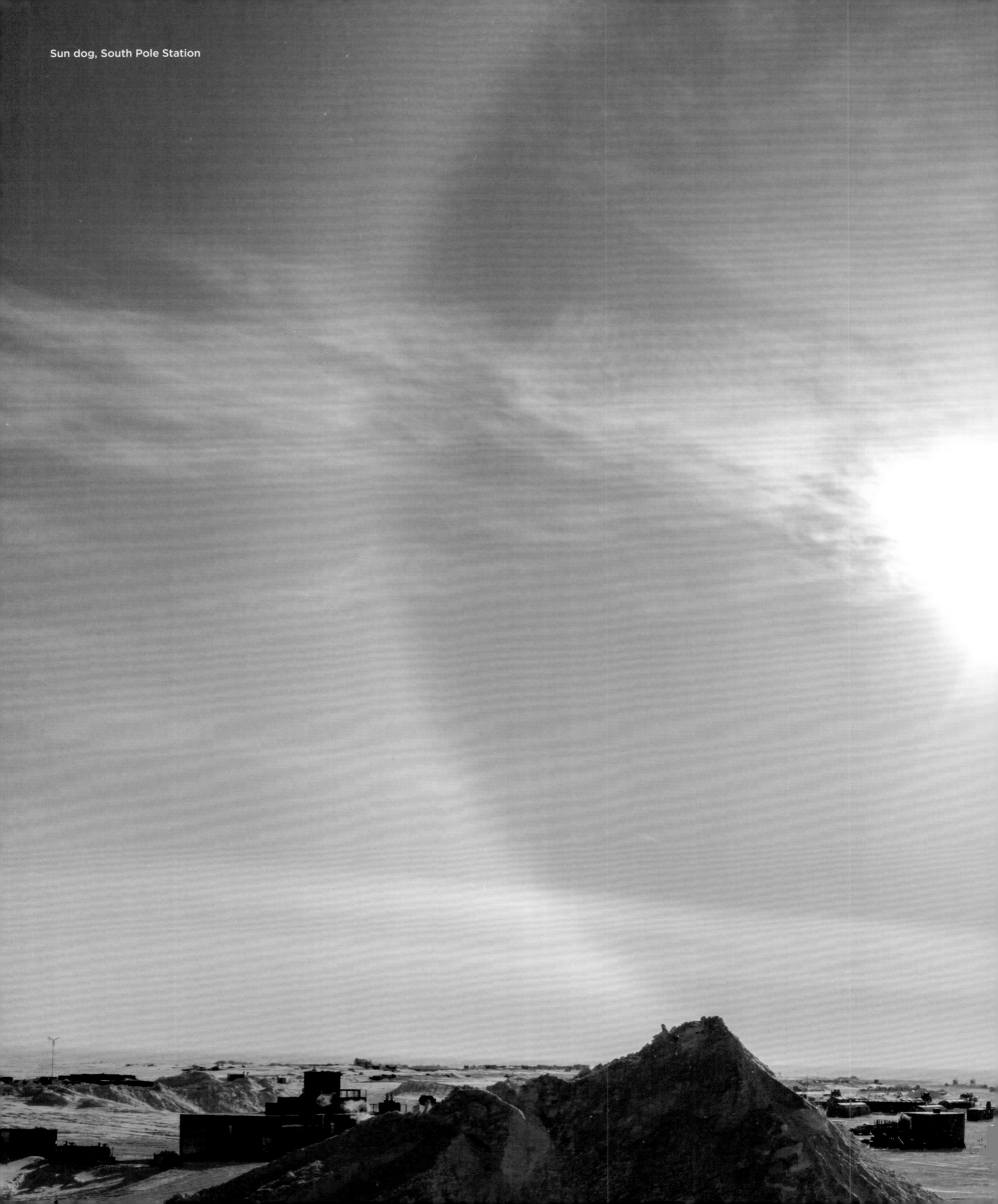

Sun dog, South Pole Station

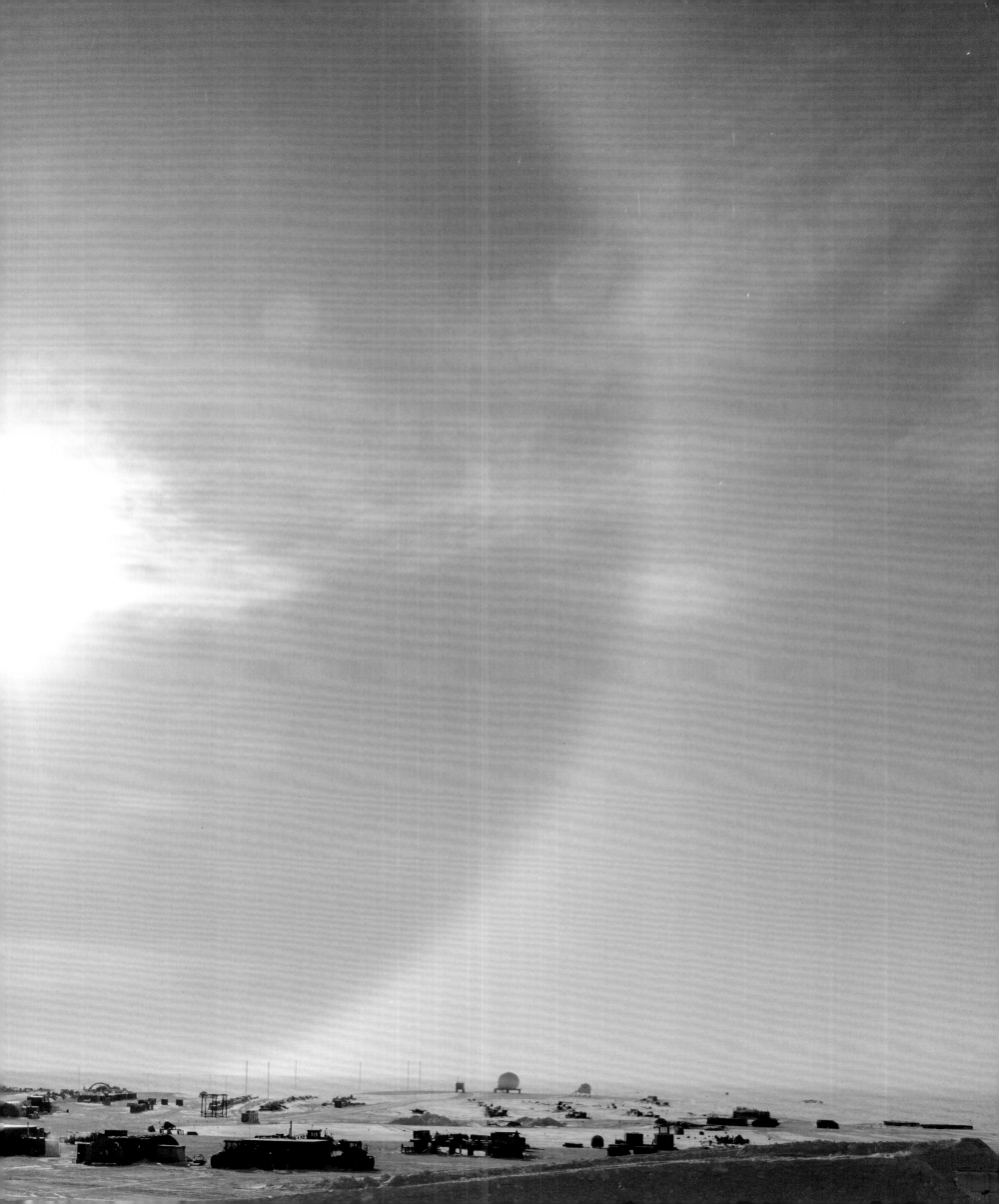

Index

KÖNEMANN

© 2019 koenemann.com GmbH
www.koenemann.com

© Éditions Place des Victoires
6, rue du Mail – 75002 Paris
www.victoires.com
Dépôt légal : 1er trimestre 2020
ISBN: 978-2-8099-1663-8

Series Concept: koenemann.com GmbH

Responsible Editor: Jennifer Wintgens
Picture Editing: Udo Bernhart
Layout: Katrin Zellmer
Colour Separation: PrePress, Cologne
Text: Bernhard Mogge, Christian Nowak
Translation into French: Virginie Pironin
Translation into English, Spanish, Portuguese and Dutch: koenemann.com GmbHMaps: Angelika Solibieda

Printed in China Shyft Publishing / Hunan Tianwen Xinhua Printting Co., Ltd.

ISBN: 978-3-7419-2222-0